Van Dyck

1599–1641

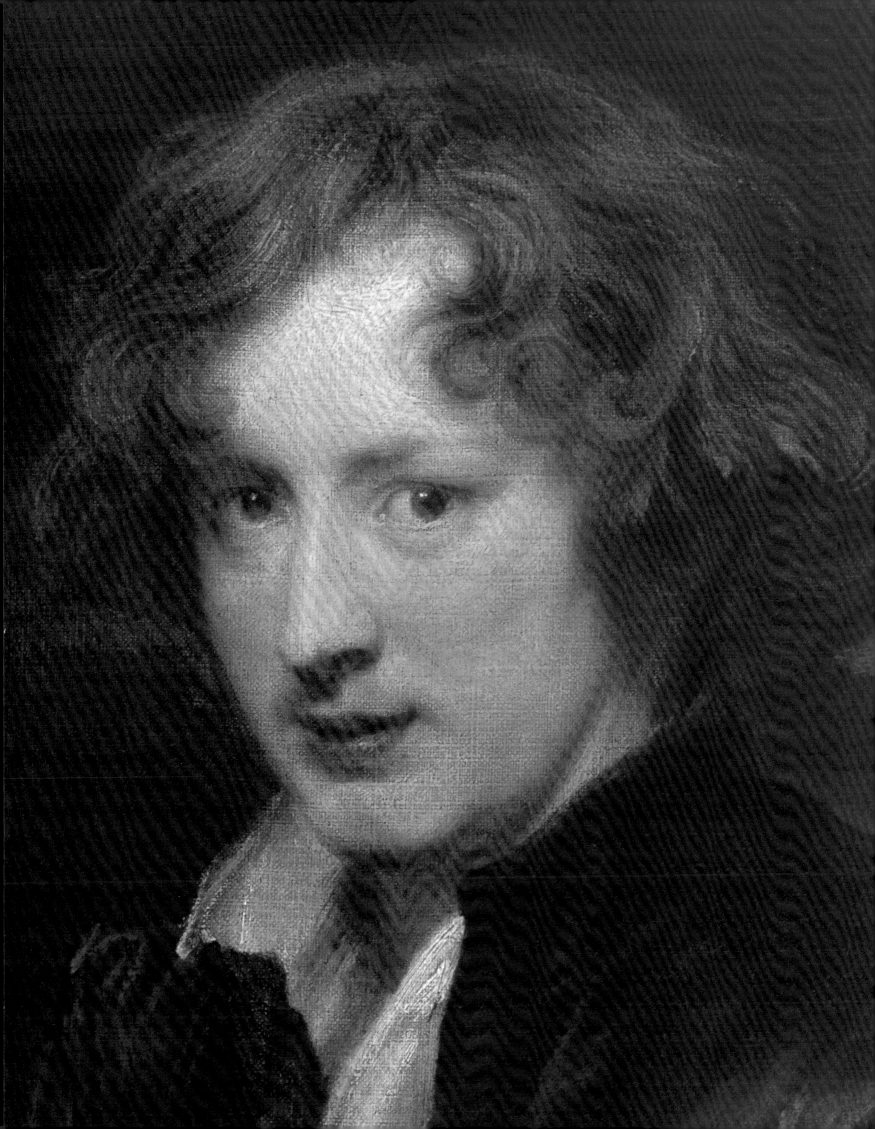

Van Dyck
1599–1641

Christopher Brown Hans Vlieghe

with contributions from

Frans Baudouin Piero Boccardo Judy Egerton

Katharine Gibson Giovanni Mendola Malcolm Rogers

Katlijne Van der Stighelen

KONINKLIJK MUSEUM VOOR SCHONE KUNSTEN, ANTWERP

15 May – 15 August 1999

ROYAL ACADEMY OF ARTS, LONDON

11 September – 10 December 1999

PUBLISHED BY

ROYAL ACADEMY PUBLICATIONS

AND

ANTWERPEN OPEN

First published on the occasion of the exhibition
Van Dyck 1599–1641
Koninklijk Museum voor Schone Kunsten, Antwerp, 15 May–15 August 1999
Royal Academy of Arts, London, 11 September–10 December 1999

The Royal Academy of Arts is grateful to Her Majesty's Government for its help in agreeing to indemnify the exhibition under the National Heritage Act 1980, and to the Museums and Galleries Commission for their help in arranging this indemnity.

ANTWERPEN OPEN / VAN DYCK 1999 is Cultural Ambassador of Flanders. ANTWERPEN OPEN is grateful to the City of Antwerp and to the Flemish Government for their structural support, and to the Koninklijk Museum voor Schone Kunsten, Antwerp, for its help in making this exhibition happen.

EXHIBITION ORGANISATION
For the ROYAL ACADEMY OF ARTS
Norman Rosenthal *Exhibitions Secretary*
Jane Martineau *Curator and Editor*
Susan Thompson *Exhibitions Organiser*
Sam Oakley *Assistant Exhibitions Organiser*
Harriet James *Assistant Exhibitions Organiser*
Miranda Bennion *Photographic and Copyright Coordinator*
Roberta Stansfield *Assistant Photographic and Copyright Coordinator*

For ANTWERPEN OPEN
Ben Van Beneden *Exhibitions Secretary*
For the KONINKLIJK MUSEUM VOOR SCHONE KUNSTEN
Veerle Vandamme *Exhibitions Assistant*

CATALOGUE
For the ROYAL ACADEMY OF ARTS
Royal Academy Publications
Jane Martineau *Editor*
Nick Tite *Catalogue Coordinator*
assisted by Sophie Lawrence and Carola Krüger
For ANTWERPEN OPEN
Joris Capenberghs *Publications and Education Officer*

Designer Roger Davies
Production and Co-editions Robert Marcuson
in association with Textile & Art Publications
Copy-editing and typesetting Paul van Calster
and Anagram
Translations Ted Alkins (Dutch to English)
Caroline Beamish (Italian to English)
Picture Research Sheila Corr
Colour Origination The Repro House,
in association with Robert Marcuson
Printed in Belgium by Blondé Artprinting International

Copyright © 1999, Royal Academy of Arts, London;
ANTWERPEN OPEN, Antwerp

ISBN 0–8478–2196–X
LC 98–68686

British Library Cataloguing-in-Publication Data

A catalogue record for this book is available from the British Library

EDITORIAL NOTE
Catalogue entries are signed with the following intials:
CB Christopher Brown
FB Frans Baudouin
JE Judy Egerton
HV Hans Vlieghe

Dimensions are given in centimetres; height before width

ABBREVIATIONS
DNB: *The Dictionary of National Biography*
GEC: G[eorge] E[dward] C[okayne], *The Complete Peerage*,
new edition, revised and enlarged, ed. The Hon. Vicary Gibbs
et al., 13 vol., London 1910
HMC: Historic Manuscripts Commission
Mauquoy-Hendrickx: M. Mauquoy-Hendrickx, *L'Iconographie
d'Antoine van Dyck*, 2 vols, Brussels 1956; 2nd ed. Brussels 1991
Vey: H. Vey, *Die Zeichnungen Anton van Dycks*, 2 vols,
Brussels 1962

Illustrations (pp. 2–12)
p. 2: cat. 31 (detail)
pp. 4–5: cat. 62 (detail)
p. 8: cat. 95 (detail)
p. 12: cat. 68 (detail)

Contents

Essays

Catalogue

Chronology

Acknowledgements

The organisers wish to thank the many people who have helped in the
preparation of this exhibition and catalogue, especially the members of
the Honorary Committee. In particular they would
like to thank the following

Paola Astrua
Christopher Baker
Nicholas Baring
Reinhold Baumstark
Annik Bogaert
Annette Bradshaw
Margaret Broadbent
Tom Caley
Constance Caplan
Rosalie Cass
Jiri Cermak
David Chambers
Tanya Chambers
Hugo Chapman
Fernando Checa
Michael Clarke
Timothy Clifford
Jean-Pierre Cuzin
Giulia Davi
Yolande Deckers
Carl Depauw
Gregory Eades
Father Dermot Fenlon
The Viscount Gage
HE Dr Paolo Galli
Veerle Geleyn
Margherita Giacometti
Michael Helston
Isabel Horovitz
David Horton-Fawkes
Sona Johnston
Leen de Jong
Larry Keith
KMSKA
Claudia Langmead
Herbert Lank
Sir Michael Levey
Neil MacGregor

Elizabeth McGrath
Els Maréchal
Anna Maris
Gregory Martin
Bert W. Meijer
Manuela Mena
Eric Van de Meulebroecke
Keith Morrison
William Mostyn-Owen
Rob Noortman
Milida Nowakova
David Pakter
Amanda Paulley
Viola Pemberton-Pigott
Mikhail Piotrovsky
Maria-Isabel Pousão-Smith
Philip Prettejohn
Jenny Richenberg
Hugh Roberts
Andrea Rose
Pierre Rosenberg
Bernard Schnackenburg
Robert Scott
Anna Somers Cocks
Lady Juliet Tadgell
Susan Thompson
Cecilia Treves
Renate Trnek
Helen Valentine
Lieve Vandeputte
Paolo Viti
Uwe Wieczorek
Eliane De Wilde
John Wilson
Angela Woodcock
Martin Wyld
and the staff of the
Rubenianum, Antwerp

The exhibition at the Koninklijk Museum voor Schone Kunsten, Antwerp,

is part of the VAN DYCK 1999 programme and is organised by

ANTWERPEN OPEN vzw

BOARD OF DIRECTORS

Leona Detiège
chairman and member of the management committee

Eric Antonis
vice-chairman and member of the management committee

Jozef Asselbergh
member of the management committee

Kaatje Caignie
member of the management committee

Jan Walgrave
member of the management committee

Baron Leo Delwaide

Luc Meurrens

Johan De Muynck

Fred Nolf

Wilfried Patroons

Hugo Schiltz

Maurice Velge

Mieke Vogels

SENIOR STAFF

Bruno Verbergt
general manager

Steven Warmenbol
financial manager

Carl Depauw
curator

Ben Van Beneden
exhibitions secretary

Annette van Soest
senior communication and P.R. manager

Ann Laenen
press officer

Karine Ven
promotion officer

Kathleen Weyts
promotion officer
(Tourist Office for Flanders)

Joris Capenberghs
publications and education officer

ANTWERPEN OPEN / VAN DYCK 1999 is Cultural Ambassador of Flanders

ANTWERPEN OPEN / VAN DYCK 1999
is funded by the Flemish Government, the City of Antwerp, the Province of Antwerp
and the Tourist Office for Flanders

VAN DYCK 1999
is generously supported by Generale Bank, Belgian Railways and GB as structural partners
and by
Radio 1, Canvas and Gazet van Antwerpen as media sponsors

Transportation of the works of art by Maertens International nv, Brussels

The VAN DYCK 1999 publications of ANTWERPEN OPEN
are produced by Blondé Artprinting International

———————————————

The exhibition at the Royal Academy of Arts, London, is sponsored by

Reed Elsevier plc

Foreword

On 22 March 1599 Van Dyck was born in the city of Antwerp. It was the eve of the 17th century, politically a dramatic and dangerous century of revolution and war. Artistically, too, it was a revolutionary century. Caravaggio was at work in Rome, nearing the end of his turbulent career. Like many other northerners, Rubens, Van Dyck's fellow citizen and sometime mentor, was soon to visit the city. Of Van Dyck's generation, Poussin and Claude Lorrain both left France to settle in Rome for life; Velázquez, born the same year as Van Dyck, also studied in Italy before returning to Spain to work as painter to the King. Inevitably Van Dyck followed in their footsteps.

One of the greatest portrait painters in an age of exceptional portraitists, a rival to Velázquez, Bernini and Rembrandt, Van Dyck transformed art wherever he worked. He was also a great painter of religious works in his native country. In his tender, romantic interpretation of *poesie*, he both looked back to Titian, and anticipated Watteau. Van Dyck's influence in England endured: it is said that Gainsborough's last words were 'We are all going to heaven, and Van Dyck is of the company'.

One hundred years ago the City of Antwerp and the Royal Academy organised a commemorative exhibition to celebrate Van Dyck's tercentenary. In 1999, Antwerp and London again are honouring the artist who worked not only in his native city but also in Genoa, Rome, Palermo, The Hague and London. Van Dyck is a genuinely European figure, and it is as such we wish to celebrate his remarkable career. As in 1899, the exhibition is being held in the Koninklijk Museum voor Schone Kunsten and in the Royal Academy. It has been organised by the Royal Academy and ANTWERPEN OPEN which, on the initiative of the City of Antwerp, is working to promote Antwerp's cultural heritage internationally. Without the support of the Flemish government this celebration would not have been possible.

The collaboration between ANTWERPEN OPEN and the Royal Academy has been a particularly happy one. We thank our scholars: Christopher Brown, who first suggested the exhibition, and his colleagues Hans Vlieghe, Piero Boccardo, Judy Egerton, Giovanni Mendola, Sir Oliver Millar, Malcolm Rogers, Nora De Poorter and Katlijne Van der Stighelen, for their help, whether in selecting the works or in writing the catalogue. We particularly wish to thank Hans Nieuwdorp, Bruno Verbergt and Ben Van Beneden for their work on this project, and in London Norman Rosenthal, Exhibitions Secretary, and Jane Martineau, who has edited the catalogue.

We are deeply honoured that Her Majesty The Queen and Their Majesties King Albert II and Queen Paola have graciously assented to patronise the exhibition. The Royal Academy is much indebted to its sponsor, Reed Elsevier plc, and to our anonymous benefactors; their generosity has made this exhibition possible. Our final thanks go to the lenders, both public and private, whose willingness to part with their works has made this exhibition both sumptuous and, we would hope, significant. In particular we wish to thank Her Majesty The Queen; the National Gallery, London; the Koninklijk Museum voor Schone Kunsten, Antwerp; the State Hermitage Museum, St Petersburg; the Kunsthistorisches Museum, Vienna; and the National Gallery of Art, Washington, for their exceptional generosity.

Leona Detiège
Mayor of Antwerp and Chairman, ANTWERPEN OPEN
Sir Philip Dowson, CBE
President, Royal Academy of Arts
Dr Paul Huvenne
Director of the Koninklijk Museum voor Schone Kunsten, Antwerp

Patrons and Committees

Her Majesty The Queen

Their Majesties King Albert II
and Queen Paola

HONORARY COMMITTEE
Susan J. Barnes
Frans Baudouin
Piero Boccardo
Jan Kelch
Alastair Laing
Walter Liedtke
Christopher Lloyd
Wolfgang Prohaska
Konrad Renger
Horst Vey
Arthur K. Wheelock, Jr

STEERING COMMITTEE
Christopher Brown
Paul Huvenne
Jane Martineau
Sir Oliver Millar
Hans Nieuwdorp
Nora De Poorter
Norman Rosenthal
Katlijne Van der Stighelen
Hans Vlieghe

Introduction[1]

CHRISTOPHER BROWN

THE PRODIGY

Peter Paul Rubens was renowned throughout Flanders when there appeared in his school in Antwerp a young man possessed of such noble generosity of manners and so fine a talent for painting that he gave every indication that he would bring it distinction and add splendour to the dignity and excellence to which the master had raised his profession. This was Anthony van Dyck, born in the same city in the year 1599.
(Giovanni Pietro Bellori, *Le Vite de' Pittori, scultori et architetti moderni*, Rome 1672)[2]

Our first sight of Anthony van Dyck is in a self-portrait showing him at the age of fifteen or sixteen (cat. 1). It is a precocious work, painted with remarkable self-assurance. The young man looks at the spectator over his shoulder, his face framed by dark brown curly hair. The collar of his shirt is suggested with a single stroke of a brush heavily loaded with white paint. There is no hesitation.

Van Dyck confidently announces himself as a prodigy, one of a very small number of artists who, by their early teens, had developed a technical facility which dazzled contemporaries. An awareness of their exceptional gifts must also affect the character of such prodigies, and a certain intensity – even a sense of vulnerability – can also be detected in the self-portrait. Twenty-five years later, in 1640, shortly after the death of Rubens, Van Dyck's mentor and friend who had dominated painting in Antwerp, the Cardinal-Infante, ruler of the Southern Netherlands on behalf of his brother the King of Spain, asked Van Dyck to complete a commission for Philip IV which had been left unfinished in Rubens's workshop. Many artists would have accepted such a commission with alacrity, to pay homage to a revered painter of the preceding generation. Van Dyck, who had once longed for such a commission, refused it. He would paint an entirely new picture but would not complete Rubens's work.[3] The man, just like the boy, had a highly developed sense of his value and gifts.

Anthony van Dyck was born in Antwerp four hundred years ago on 22 March 1599. He was the seventh child of Franchois, a successful cloth and silk merchant. Franchois's father had been an artist, and his wife's family included artists; it was no surprise that Anthony was apprenticed to one of the city's leading painters at the age of ten.

Painting was both a highly developed art and an important business in the city, and altarpieces and other religious works were produced not only for the Netherlands and Germany but exported to Southern Europe and the New World. The production of paintings occupied a large number of Antwerp's citizens – not only the painters themselves, but panelmakers, suppliers of paints and brushes, framemakers and canvas weavers. Quentin Metsys (1465–1530) was revered as the founder of the Antwerp school; its fame spread throughout both the Old and New Worlds. Successful painters were well rewarded. Even before Rubens became one of Antwerp's richest citizens – living like a prince according to contemporaries – there were many wealthy painters in the city. Frans Floris had lived in a fine house in the centre, and so had Van Dyck's teacher, Hendrick van Balen, who had bought a substantial house in the Lange Nieuwstraat in 1604 next door to Jan Brueghel the Elder.

The choice of Van Balen as Van Dyck's teacher was no surprise. Van Balen was a native of Antwerp, trained in the studio of Adam van Noort. After spending some years in Italy – the required culmination of any Antwerp painter's training – he had established himself as a leading painter of altarpieces and of mythological and classical scenes with small-scale figures in the Italian manner. He received important commissions from the city's religious institutions, and his work, often painted in collaboration with his neighbour Jan Brueghel the Elder, was admired by Antwerp's leading citizens. Van Balen played an important role in the Guild of St Luke, the professional association which regulated the training of artists and

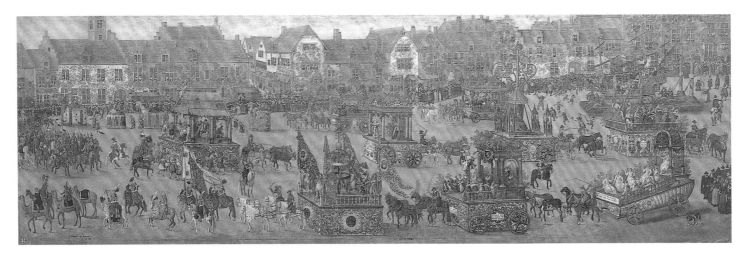

Fig 1

Denis van Alsloot, *'Ommeganck', The Triumph of Archduchess Isabella in Brussels, 31 May 1615, under the Patronage of the Church of Notre-Dame du Sablon*
oil on canvas, 116.8 × 381 cm, Victoria and Albert Museum, London

the production and marketing of their work. In 1609, the year in which Van Dyck entered his studio as an apprentice, Van Balen was one of the deans of the Guild, its senior officials.

1609 was an important year for both the political and artistic life of Antwerp. That year, a long-negotiated truce finally concluded the war between Spain, whose vast empire included the Southern Netherlands and its leading city Antwerp, and the Northern Netherlands, which had declared itself an independent Republic, free from Spanish control. The war, which by 1609 had been going on for forty years, was for religious and political independence, and the new Dutch Republic joined the Protestant camp in the larger European conflict between Catholic and Protestant powers. It had had dire economic consequences for the Southern Netherlands. The Dutch had closed the mouth of the river Scheldt, Antwerp's access to the sea, which had devastated the city's trade, and, as Antwerp declined, Amsterdam grew. In the early years of the Revolt of the Netherlands, the 1560s and '70s, Antwerp had sided with the rebels against Spanish rule, and the city witnessed some of the fiercest episodes of iconoclasm, the destruction of Catholic images by Protestants. Antwerp, however, was reconquered by Spanish troops in 1585, and Catholic domination re-established. In 1598 Philip II appointed his daughter Isabella and her future husband, Albert of Austria, as regents of the Southern Netherlands. Albert and Isabella made their formal entry into Antwerp in 1599, the year of Van Dyck's birth. The Archdukes, as they came to be known, proved to be effective rulers and sophisticated politicians, establishing in the minds of their

Flemish subjects a real sense of independence from Spain. Many decisions affecting the Southern Netherlands were made – or appeared to be made – in the Archdukes' capital city, Brussels (fig. 1), rather than in Madrid. Albert recognised the need for a ceasefire and a truce which would allow for a period of economic regeneration. He was the moving spirit on the Spanish side in the negotiations for the Truce of 1609 which, although it was to last only for twelve years, was thought at the time to be a prelude to permanent peace.

The conclusion of the truce was marked in Antwerp by elaborate celebrations which would have been witnessed by the young Van Dyck. The room in the City Hall in which it was signed was decorated with an *Allegory of Peace and Prosperity* by Abraham Janssens. The part played by the Spanish representative, Roderigo Calderón, was recognised by the presentation to him of a painting by Peter Paul Rubens of *The Adoration of the Magi*, showing the Prince of Peace worshipped by Kings (fig. 2).

RUBENS'S STUDIO

Rubens … liking the good manners of the young man and his grace in drawing, considered himself very fortunate to have found so apt a pupil … he employed Anthony as a copyist and set him to work directly on his own canvases, to sketch out and even execute his designs in paint, activities which brought him very great benefit.

After spending eight years in Italy, Rubens had returned to Antwerp in 1608. He was to be one of the principal beneficiaries of the new mood of confidence and of economic and

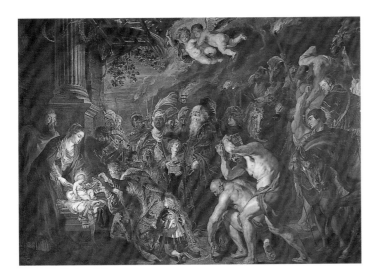

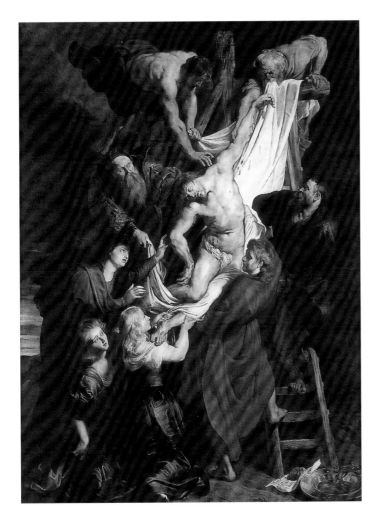

religious revival during the years following the conclusion of the Truce. Churches and religious houses commissioned altarpieces, some to replace those destroyed by the iconoclasts. The Archdukes, who were both intensely devout, led the way, encouraging the mendicant orders – the Dominicans and Franciscans – as well as the Jesuits to intensify their work in the Southern Netherlands. Between 1610 and 1614, as Van Dyck was learning the rudiments of painting in Van Balen's studio, Rubens was creating a series of breathtaking altarpieces for the churches of Antwerp, most notably *The Raising of the Cross* (cat. 61, fig. 1) for St Walburga (now in the Cathedral) and *The Deposition* (fig. 3) for the Cathedral. During his years in Italy Rubens had developed nothing less than a new visual language. Based on his study of the Antique, the High Renaissance and the innovations of Caravaggio and the Carracci, it was a language which in its ambition, drama and colour particularly suited the mood of Counter-Reformation religiosity, characterised by emotional fervour and a renewed emphasis on the cults of the Virgin and the saints.

It is impossible to over-emphasise the impact of Rubens's new style on the young Van Dyck. He was among the first to see these great altarpieces, and it was an experience he never forgot. It is not surprising that the brilliant young pupil of Hendrick van Balen moved into the orbit of the artist who was transforming the art of painting in Antwerp. In a letter written in 1618 to Sir Dudley Carleton, Rubens mentions a picture of *Achilles among the Daughters of Lycomedes* (fig. 21), painted by 'the best of my pupils' and completed by himself.[4] He was referring to Van Dyck, and the painting shows the young artist working with complete assurance in Rubens's manner. Two years later, in 1620, Van Dyck was the only assistant to be mentioned by name in Rubens's contract for the decoration of the new Jesuit church (fig. 4), the single most important ecclesiastical project in Antwerp at that date. He was to lead the team which completed the 39 ceiling paintings in the aisles and galleries from oil sketches made by Rubens and also paint an altarpiece for one of the chapels (which, in the event, was never delivered).

An artist formally completed his apprenticeship when he joined the guild as a master. Van Dyck did this in 1618, but two or three years earlier he had already set up an independent workshop in Antwerp with his friend and almost exact contemporary Jan Brueghel the Younger. One reason may have been that Franchois van Dyck's business was failing in these years and it was essential that his son began to earn a living.[5]

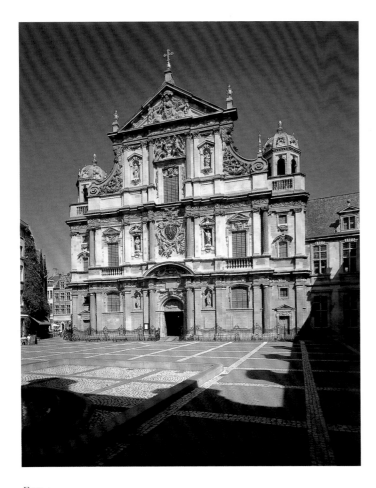

Most of Van Dyck's earliest paintings were of religious subjects rather than the portraits for which he was to become famous throughout Europe. He painted a series of half-length apostles,[6] based on a similar series by Rubens, and subjects from the Old and New Testament and the lives of the saints. All reveal the powerful, almost overwhelming influence of Rubens and yet show the younger painter struggling – sometimes with almost a sense of desperation – to create his own style. For many of these early paintings a large number of compositional drawings in pen and wash survive which reveal a highly developed and precociously sophisticated visual intelligence at work. Usually Van Dyck started working from a composition by Rubens but subsequently altered it significantly – reversing the composition, changing the setting, suppressing, adding and moving figures. He made a final detailed drawing which played the same role as the oil sketch in Rubens's working practice. Sometimes this was squared up and transferred directly to the panel or canvas.[7] However, even

then he made substantial changes during the course of painting – as for example in the various versions of *The Martyrdom of St Sebastian* (see fig. 5); Van Dyck's style is more decorative than that of Rubens, more two-dimensional, more brilliant in its effects. The crucial difference arises from Rubens's study of antique sculpture and Van Dyck's lack of interest in it: Rubens visualised his figures in the round and so made them sculptural, placing them within a credible space, while Van Dyck is more concerned with surface pattern and texture.

Van Dyck enjoyed early success as a religious painter: he was one of the group of leading Antwerp artists commissioned to paint a series of canvases of the Mysteries of the Rosary for the Dominican church in about 1617. His subject was *Christ carrying the Cross* (cat. 7), a composition with which, as his long sequence of preparatory drawings makes clear, he took infinite trouble. He also painted portraits in these years. A pair of portraits of a husband and wife (cat. 9, 10), although technically accomplished, is thoroughly conventional in character; they are dated 1618, the year Van Dyck joined the Guild of St Luke as a master.[8] Yet, although established as an independent painter, he was also working in Rubens's studio. The exact nature of the arrangement is unknown, although there is little doubt that Van Dyck enjoyed a very special status; it was at this time that Rubens painted his sensitive portrait of his young assistant (Rubenshuis, Antwerp; see cat. 1, fig. 2).[9] In the studio Van Dyck carried out works based on Rubens's designs such as the ceilings for the Jesuit church; he painted large sections of the tapestry cartoons of the story of the Roman Consul Decius Mus (see fig. 22);[10] and made precise drawings of other paintings by Rubens for the engraver to follow. It is an aspect of his remarkable facility that Van Dyck was able to paint simultaneously in Rubens's manner and in his own distinctive, personal style. This can be seen in a comparison of the two versions of *The Emperor Theodosius is forbidden by St Ambrose to enter Milan Cathedral* (cat. 20), one painted after Rubens's design in that master's style (cat. 20, fig. 1), the other (which is far smaller) in his own style and incorporating changes, one of these being, appropriately enough, the inclusion of the portrait of Nicholas Rockox, the most important patron of the arts in Antwerp.

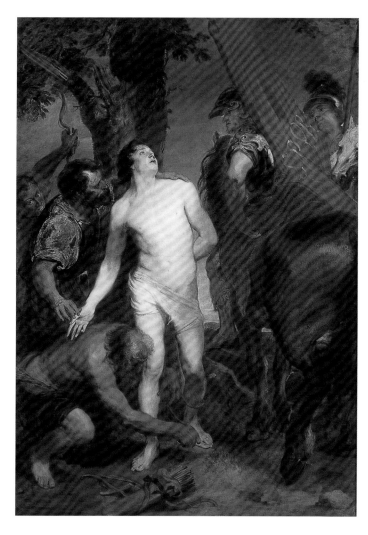

FIG 5
Anthony van Dyck, *The Martyrdom of St Sebastian*, 1619–20
oil on canvas, 229 × 159 cm
Alte Pinakothek, Munich

LONDON

The immensely gifted young painter soon attracted the attention not only of Antwerp artists and patrons but of visitors to the city. Francesco Vercellini, secretary to the Earl of Arundel, the foremost collector and patron of the arts in England, wrote to his master from Antwerp on 17 July 1620: 'Van Dyck is still with Signor Rubens, and his works are hardly less esteemed than those of his master. He is a young man of 21 years, his father and mother very rich, living in this town, so that it will be difficult to get him to leave these parts, especially since he sees the good fortune that attends Rubens'.[11] Vercellini was wrong in a number of respects: Van Dyck's mother had died in 1607, when he was eight, and his father was suffering from severe financial problems in those years. His letter is, however, a mark of Van Dyck's growing reputa-

tion, and later that year the painter was tempted to London not, it would seem, by Arundel but by the brother of the Earl's rival as a collector, the Duke of Buckingham. During his brief stay in London in 1620–21 Van Dyck worked for King James, perhaps with a view to succeeding the royal portrait painter, the Fleming Paul van Somer.[12] Van Dyck's experience in working on designs for tapestries may have recommended him to the directors of the newly established royal tapestry factory at Mortlake.[13] Whatever the precise nature of his employment in England, however, only three paintings from his stay are known: a portrait of Arundel (cat. 25), a double portrait of the Duke of Buckingham and his wife as Adonis and Venus (fig. 19),[14] and *The Continence of Scipio* (cat. 26), which was probably painted for Buckingham.

The Continence of Scipio, painted in a broadly brushed technique, reveals a change of style which was a direct consequence of Van Dyck's stay in England. In Antwerp he had studied Italian painting largely in the form of painted and engraved copies. In England, in the collection of the King, but to a greater extent in the collections of Arundel and Buckingham, he was able to study Italian painting, particularly Venetian 16th-century painting, at first hand.

Van Dyck's encounter with the art of Titian was a transforming experience. His understanding of Titian was, of course, to be profoundly enriched during his years in Italy, but it was in London that Titian came to assume a central importance in Van Dyck's artistic life. Although Titian's use of colour was certainly important, Van Dyck was chiefly inspired by Titian's skill in modelling in tone, rendering flesh and fabric in a subtle play of light and shadow. Titian's style was seen by Van Dyck as quite different from Rubens's 'sculptural' treatment of figures; Titian provided him with an alternative to the overpowering influence of Rubens. Although Van Dyck never felt the need to abandon Rubens's compositional manner, he did feel a need to develop a different stylistic language, and it was in this respect that Titian was so important. A love of Titian's work, indeed a profound self-identification with Titian, was at the core of Van Dyck's artitic personality. Van Dyck's encounter with the work of Titian and his Venetian contemporaries in London made him impatient to travel to Italy.

In February 1621, with the help of the Earl of Arundel, Van Dyck was granted a 'passe to travaile for 8 moneths'.[15] He was not to return to England until 1632. It seems likely that the Earl, who himself had made two journeys to Italy, encouraged

the young painter in his desire to travel there, and in fact he joined the Countess of Arundel not long after his arrival in Italy.[16] The eight months Van Dyck spent in Antwerp before leaving for Italy, from February to October 1621, were particularly productive. Inspired by Titian and liberated by the time spent away from the almost suffocating influence of Rubens, he painted some of his most brilliant early works. At about this time he began to paint portraits in which he broke with the formal constraints of the Flemish portrait tradition in order to give a vivid impression of the personalities of his friends and colleagues. Outstanding among these are the portraits of Frans and Margaretha Snyders (Frick Collection, New York), characterised by the elegant movement of the heads and bodies, eloquent hands, newly opened vistas in the background and spirited treatment of the curtains and still-life. The portrait of Rubens's wife, Isabella Brant (cat. 27), posed in front of the Italianate screen that Rubens had recently built in the courtyard of his house, is said to have been made as a leaving present.[17] Rubens is reputed to have given Van Dyck a horse for the journey as well, no doubt, as introductions to colleagues and patrons in Italy. It is probably also from this moment – the eve of his departure for Italy – that we can date his three-quarter length *Self-portrait* (fig. 26), elegant in black satin, with his arm resting on a ledge.

GENOA, ROME AND VENICE

… he moved to Genoa, where the beautiful style that he had acquired was much appreciated, so that he earned enough profit from it to meet all his desires and needs … even when travelling in other parts of Italy, he always found a refuge in Genoa, as if it were his native city; he was loved and held in high regard by everyone there. Yet Anthony's mind was then set on Rome, and he moved there…. He was still a young man, his beard scarcely grown, but his youthfulness was accompanied by a grave modesty of mind and nobility of aspect, for all his small stature. His manners were more those of an aristocrat than a common man, and he was conspicuous for the richness of his dress and the distinction of his appearance, having been accustomed to consort with noblemen while a pupil of Rubens; and being naturally elegant and eager to make a name for himself, he would wear fine fabrics, hats with feathers and bands, and chains of gold across his chest, and he maintained a retinue of servants. Thus, imitating the splendour of Zeuxis, he attracted the attention of all who saw him. This conduct, which should have recommended him to the Flemish painters who lived in Rome, in fact stirred up against him the greatest resentment and hatred. For they were accustomed at that time to live cheerfully together, and it was their practice, when one of them was newly arrived

in Rome, to take him to supper at an inn and give him a nickname by which he was afterwards known. Anthony refused to participate in these bacchanals, and they, taking his reserved manner for contempt, condemned him as ambitious, criticising both his pride and his art. And indeed he had come to Rome not to study, but with the intention of working and displaying his talent for a beautiful and pleasing facility in painting; but the others, disparaging his abilities and saying he did not know how to draw and could scarcely paint a head, reduced him to such a state that he left Rome in despair and returned to Genoa….

In Venice … he gave himself over completely to the painting of Titian and Paolo Veronese, sources from which his master had also drunk. He copied and drew the best history paintings, but he took the greatest pleasure in heads and portraits, of which he made a great number of drawings and canvases, and in this way dipped his brush in the fine colour of the Venetians.

Van Dyck arrived in Genoa in late November 1621. He went to the house of two friends from Antwerp, the brothers Cornelis and Lucas de Wael (cat. 45). There was a thriving commercial relationship between Genoa and Antwerp – Franchois van Dyck was one of many Antwerp merchants to have Genoese clients – and there was a community of Flemish artists in the city. The De Wael brothers' father, Jan de Wael (see cat. 53), a successful painter, was a generation older than Rubens, and his sons, who had recently settled in Genoa, were of Van Dyck's generation. His relationship with the De Wael brothers was close: their house was to be his base during the years he spent in Italy, and our knowledge of his travels around Italy and Sicily comes largely from correspondence (now lost, but used by an anonymous 18th-century biographer of Van Dyck)[18] between Cornelis de Wael and his friend Lucas van Uffel, a Flemish merchant living in Venice.

After spending the winter of 1621–2 in Genoa, Van Dyck travelled to Rome and stayed there from February until August 1622. He was also to spend most of 1623 there. In Rome he received a number of important commissions, including two from Cardinal Guido Bentivoglio, for a Crucifixion and a full-length portrait (fig. 6). Bentivoglio, who had been elevated to the cardinalate in 1621, was a patron of the Flemish community in Rome: he had been Papal Legate in Brussels from 1607 until 1615 and was to write a widely

FIG 6
Anthony van Dyck, *Cardinal Bentivoglio*, 1623
oil on canvas, 196 × 145 cm
Galleria Palatina, Florence

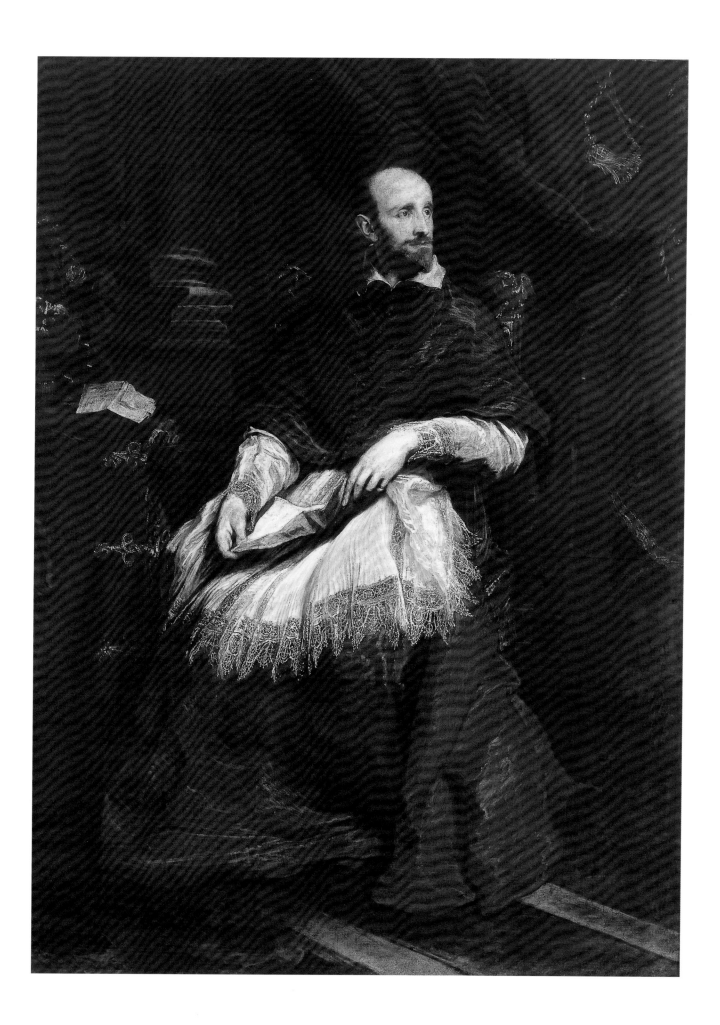

FIG 7
Anthony van Dyck, copy after Titian, *Venus blinding Cupid*
fol. 113v of the Italian Sketchbook
British Museum, London

admired account of the war in the Netherlands, published in 1632.[19] For this prince of the Church Van Dyck painted one of his finest portraits. The Cardinal's alert and highly intelligent face is turned to the right and powerfully lit. The lace of his surplice, with its delicate filigree patterns, perhaps manufactured in Antwerp, is settled in complicated folds and creases on his knees, and contrasts with the more solid shapes created by the red satin of his soutane. In Rome Van Dyck also painted Cardinal Maffeo Barberini, soon to be Pope Urban VIII (a portrait which has been lost); the poet and philosopher Virginio Cesarini (beneath whose portrait is a first version of Bentivoglio's head);[20] and Sir Robert and Lady Shirley (cat. 29, 30). In Italy Van Dyck kept a Sketchbook (British Museum, London), which is the prime document for the understanding of the early years of his stay.[21] In it he made pen drawings and colour notes of the exotic costumes of the Shirleys (cat. 29, figs. 1, 2). He also made a number of drawings from life. Above a group of figures of richly dressed Roman ladies Van Dyck has written '*nel giorno*

di S. Margritta in ciesa di essa' (on St Margaret's Day, in the church of the same name).[22] S. Margherita is in Trastevere, and the saint's date is 20 June (Van Dyck was in Rome on the saint's day in both 1622 and 1623). Two women chat while they kneel at prayer, while a third looks around in mock annoyance at the young artist sketching her.

The Antique held little fascination for Van Dyck, although he did sketch the Hellenistic fresco known as the *Aldobrandini Marriage* (Vatican Museum, Rome) which had been discovered recently and was displayed in the gardens of the Villa Aldobrandini,[23] and a statue of Diogenes in the Villa Borghese,[24] the only sculpture he drew in the two hundred pages of the Sketchbook. Van Dyck's lack of interest in the Antique is a highly significant point of difference between him and Rubens. Rubens was widely read in the classics, a serious antiquarian, a collector of antiquities and, with his brother Philip, the author of a study of the customs and dress of the ancient Romans. He carried on a learned correspondence with the French lawyer and antiquarian Nicolas-Claude Fabri de Peiresc, peppered with classical quotations, and exchanged letters with Arundel's librarian, Franciscus Junius, which are (at least in part) in Latin. Van Dyck had been apprenticed at the age of ten and had received relatively little formal education thereafter. His Latin was probably rudimentary and he had little interest in the literature (and art) of the classical world, although he naturally read Ovid and Virgil in translation. He was not a learned painter in the Renaissance tradition. His intelligence was primarily visual, and we can see this highly refined visual intelligence at work as he gradually developed his compositions through series of drawings.[25]

For Van Dyck, the most important galleries in Rome were those in Palazzo Ludovisi and Villa Borghese which contained paintings by Titian. In his bold pen and wash sketch (fig. 7) of Titian's *Venus blinding Cupid*, which then, as now, hung in Villa Borghese, he has written, with an arrow pointing to Diana's breast '*quel admirabil petto*'. At first sight this seems a surprising detail of this freely painted, almost monochromatic late work to annotate, and yet it is clear that Van Dyck admired the modelling of the breast in delicate shadows with a highlight on the nipple, a type of modelling quite different from that of Rubens which Van Dyck was himself perfecting at this time. Van Dyck also painted a copy of this picture as part of his process of studying Titian's technique.[26]

Van Dyck spent the winter of 1622 in Venice, Titian's city. His guide may well have been the painter's nephew, Cesare

FIG 8
Anthony van Dyck, copy after Titian,
Presentation of the Virgin in the Temple
fol. 54 of the Italian Sketchbook
British Museum, London

Vecellio, called Tizianello. In his Sketchbook, Van Dyck drew Titian's altarpieces in the Frari and paintings elsewhere in the city (fig. 8). It was a working sketchbook and he did not use its pages consecutively, but grouped drawings together by subject. There are, for example, several groups of consecutive pages devoted to the Mocking of the Christ, the Virgin and Child and to portraits. The only preparatory drawings in the book are for the portraits of the Shirleys.

The most striking feature of the Sketchbook is the preponderance of copies after Titian. Many drawings are identified as '*Titiano*' or '*pensiero di Titiano*'. There are sketches after Bellini, Giorgione, Tintoretto, Veronese, Raphael, Leonardo, Guercino, the Carracci and even Dirk van Baburen, but the overwhelming majority in a sketchbook of some 200 pages are after Titian. We know of very few other drawings made by Van Dyck in Italy, nor is there any record of lost drawings or another sketchbook, and so it is likely that the Italian Sketchbook accurately represents Van Dyck's interests and concerns during his Italian years. Unlike Rubens, Van Dyck did not open himself up to the whole range of art – Antiquity, Renaissance and contemporary – which was available to him in Italy. Artistically the years 1622 and 1623 were exciting ones in Rome, with Domenichino and Lanfranco at work at S. Andrea della Valle, Guercino painting his *St Petronilla* altarpiece and Bernini carving his early masterpieces. Much of this seems, however, to have passed Van Dyck by as he scoured the city for the work of Titian. He was already largely formed as an artist when he arrived in Italy: he knew what he was looking for, and that was Titian. This did not mean, of course, that when he was, for example, in Rome he did not look at the work of Raphael and Michelangelo in the Vatican, and he certainly admired the frescoes of Correggio in Parma.

PALERMO

At this time Anthony decided to move to Sicily, where he painted the portrait of the then viceroy, Prince Filiberto of Savoy. But the plague suddenly struck and the Prince died, to be succeeded by Cardinal Doria. Anthony, after this grievous setback in Palermo, left as soon as possible, as though in flight, and returned to Genoa, taking with him the canvas of a picture for the Oratory of the Company of the Rosary.

In 1624 Van Dyck travelled to Sicily, probably at the invitation of the Viceroy, Emanuele Filiberto of Savoy, whose portrait he painted during his stay (cat. 35). While he was in Palermo, there was a terrible outbreak of plague, of which the Viceroy was himself a victim. While he was there Van Dyck visited the elderly portrait painter Sofonisba Anguissola (who told him she was 96); she was married to a member of the Lomellini family of Genoa. On the page in the Sketchbook on which he drew her portrait he recorded their conversation, in which she gave him advice on portrait painting: 'As I was making her portrait, she gave me many hints, such as not to take the light from too high, in case the shadow in the wrinkles of old age become too strong, and much other good advice,

FIG 9
Anthony van Dyck, *Sofonisba Anguissola*
fol. 110r of the Italian Sketchbook
British Museum, London

while she told me the events of her life…' (fig. 9). The plague forced Van Dyck to leave Palermo and return to Genoa, but not before he had received the commission for an altarpiece in the Oratorio del Rosario, adjoining the church of S. Domenico. This altarpiece, by far the most important religious work of his Italian years, was completed in Genoa in 1627, shipped to Palermo and installed in the Oratory (where it still hangs) in the spring of 1628 (fig. 40). St Dominic and the five virgin saints of Palermo intercede with the Virgin to save the city from the plague, represented by the boy who, holding his nose against the stench of death, rushes out of the painting – a dramatic device Van Dyck had borrowed from Caravaggio's *Martyrdom of St Matthew* (S. Luigi dei Francesi, Rome). The hermit saint, Rosalia, kneels in a brown habit at St Dominic's side. While Van Dyck was in Palermo her remains had been discovered and she was proclaimed patron saint of Palermo. The massing of the figures, the saint's arms raised in adoration, the clouds that separate the altarpiece into two realms all echo Titian's great Venetian altarpieces. Van Dyck also had in mind Rubens's first altarpiece for the Chiesa Nuova in Rome which, having been rejected because it caught the light on the high altar, was taken back to Antwerp by the artist and hung above his mother's tomb in St Michael's Abbey. The large-scale Italian altarpiece was an idiom in which Van Dyck felt entirely at ease. To it he brought his exquisite sense of colour – the silvery greys and blues are especially effective – and the elegant, attenuated figures of the saints. Van Dyck bound together the two halves of the composition with an irresistible, flowing movement which culminates in the figures of the Virgin and Child.

GENOA

He remained in that city and enjoyed great financial success, making portraits of almost all the nobility and senators.

After his return from Sicily Van Dyck stayed in Genoa until he went to Antwerp in the winter of 1627. (He is said to have visited France in the summer of 1625,[27] but there is no firm evidence for this.) It is from these years that his great series of portraits of the Genoese aristocracy dates, portraits in which this relatively recently established and immensely wealthy élite were given the dignity and presence they felt they merited. Van Dyck placed them against the elegant backdrop of their palaces built in the 16th century along the Strada Nuova (now Via Garibaldi), with their gardens arranged on a sequence of terraces cantilevered up the hillside.[28] Once again, Van Dyck's model was Rubens. Rubens had stayed in Genoa and painted a handful of Genoese sitters, showing them full-length against elaborate architectural backdrops, such as the seated portrait of Maria Serra Pallavicino of 1606 (fig. 30). Van Dyck adapted Rubens's compositions, giving his sitters an even greater sense of elegance and remote grandeur. In his Italian Sketchbook he paid particular attention to portrait groups, making detailed drawings of Titian's *Paul III and his Grandsons Alessandro and Ottavio Farnese* (figs. 10, 11), which hung in Palazzo Farnese when he was in Rome. His chief concern was not to delineate the features of the three heads but rather to study the psychological drama which the three men play out. In the same spirit he sketched Raphael's portrait of *Leo X with Cardinals Lodovico de' Rossi and Giulio de' Medici* (Uffizi, Florence). Van Dyck made use of these studies in his own portrait groups; his ability to articulate the relationship between figures is evident in the Lomellini family (cat. 41), the most ambitious portrait from his Italian years. He was also a sensitive painter of children. Filippo and Maddalena Cattaneo (cat. 33, 34) are not miniature adults – as so many children in 17th-century portraits are – but

bright-eyed, mischievous and wilful children. In the so-called *Balbi Children* (cat. 40) the formality of the setting, pose and dress is deliberately undermined by the charming immediacy of the brothers' animated and engagingly direct glances.

During his years in Genoa Van Dyck was in constant demand as a portraitist to the city's aristocracy. The elegance and richness of his portrait style were ideally suited to members of the wealthy oligarchy which controlled the maritime republic, a great centre of banking and trade. He graduated from the half-lengths of his Antwerp years, and members of the Pallavicino, Adorno, Grimaldi, Doria, Lomellini and other families are shown full-length placed against strongly articulated architecture, the richness of their dress set off by the draperies which cascade across the painting and create a sense of movement within the picture space. To what was already an established formula, Van Dyck brought his gift for the depiction of lace, satin and velvet, and his ability to make his sitters appear even more elegant and remote than they were in real life. He transformed portrait painting in Genoa, which had been distinctly provincial before his arrival: the history of portrait painting in the city for many years after his departure is essentially that of the imitation of Van Dyck's work.[29]

ANTWERP

He then returned to Antwerp, his native town, after an absence of several years, to the acclaim and satisfaction of his waiting family. There too he occupied himself with portraits, but he also produced quite a number of altarpieces and other compositions for commissions throughout Flanders and elsewhere, enhancing his reputation.

Van Dyck arrived back in Antwerp shortly after the death of his sister Cornelia in September 1627. It may have been news of her illness which promoted his return. Two of Van Dyck's sisters became nuns, and his brother, Theodoor, was a priest; the artist himself was a devout Catholic and loyal servant of the church throughout his life. The death of his sister seems to have concentrated Van Dyck's mind on the condition of his soul: he drew up his will and joined the Confraternity of Bachelors, a lay brotherhood which had been formed in Antwerp by the Jesuits. In 1629 he painted the first of two altarpieces for the Confraternity's chapel in the Jesuit church, *The Coronation of St Rosalia* (fig. 44). The following year he painted the smaller, more intimate and tender *Vision of the Blessed Herman Joseph* (cat. 56). These altarpieces display a maturity which is a direct consequence of Van Dyck's

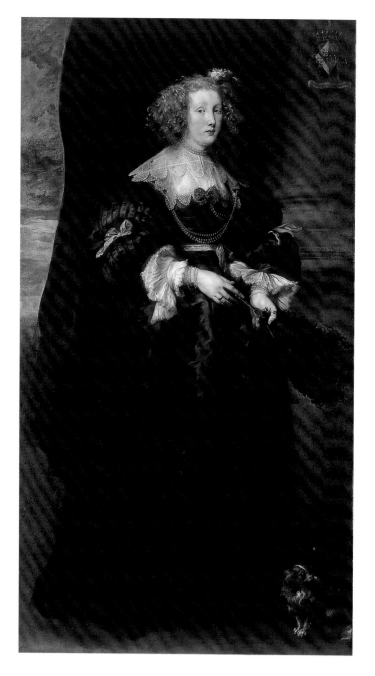

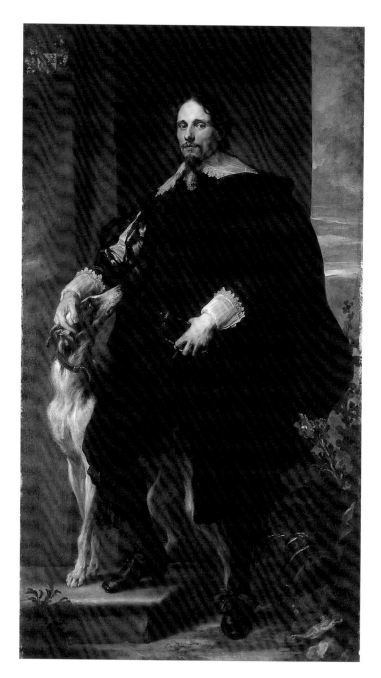

FIG 12
Anthony van Dyck, *Marie de Raet*, 1633
oil on canvas, 213.3 × 114.5 cm
The Wallace Collection, London

FIG 13
Anthony van Dyck, *Philippe le Roy*, 1632
oil on canvas, 213.3 × 114.5 cm
The Wallace Collection, London

profound study of Venetian painting in Italy. The colours
– the rose of the Virgin's robe, the gold and turquoise of the
angel – are of a new refinement.

Van Dyck returned from Italy with a well-established repu-
tation. He was appointed court painter to the Archduchess
Isabella and was commissioned to paint her portrait.[30] He was
also in great demand as a portraitist among the aristocrats at
Isabella's austere court. Many members of the noble families
of Flanders and Brabant – Arenberg, de Ligne, de Croy, de
Boischot and Tassis – sat for him during the five busy years
between his return from Italy and his departure for England.
The portraits of Philippe le Roy, Seigneur de Ravel, and his
child-bride Marie de Raet (figs. 12, 13) show the artist at the
height of his powers. Le Roy was 34: his powerful, command-
ing features are emphasised by his pose, standing with his
right foot on a step and firmly grasping his sword hilt. He is
dressed simply but richly in black and white, his height and
his aristocratic demeanour emphasised by the elegant grey-
hound at his side. Van Dyck painted him in 1632; the follow-
ing year Le Roy married the sixteen year-old Marie de Raet
and commissioned a companion portrait. Though she is
dressed in the rich, simply cut dress of the wife of a Flemish
aristocrat, Marie is still a girl, and Van Dyck has captured her
innocence and apprehension about the role she has just begun
to play. She is touchingly ill at ease in her satin, lace and
pearls and seems unsure how to hold her black ostrich-feather
fan. Far less vulnerable is *Maria Louisa de Tassis* (cat. 55), the
sitter in one of Van Dyck's most purely sensuous portraits of
a woman. She smiles knowingly, confident in her own beauty
and allure. The intricate lace of her collar is spread out behind
her head, while her elaborate satin dress, trimmed with fur
and decorated with pearls, shimmers against the dark back-
ground: the effect is breathtaking.

During these years Van Dyck also painted less formal por-
traits of friends and acquaintances like the one-armed land-
scape painter Martin Rijckaert, shown with a fur-trimmed
robe and hat, his powerful right hand dramatically highlighted
(fig. 14); the engraver Charles de Mallery (Nasjonalgalleriet,
Oslo) and the musician Hendrick Liberti, organist of Antwerp
Cathedral, leaning against a pillar holding a sheet of music
(Alte Pinakothek, Munich).

Despite the hectic activity of this period, Van Dyck found
time to travel. Although the countries were at war, he made
two trips from Flanders to the United Provinces. At The
Hague Prince Frederik Hendrik, Prince of Orange, his

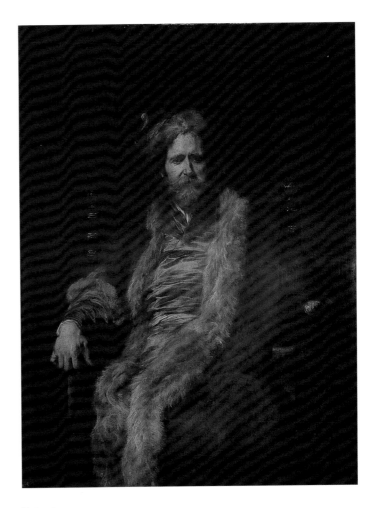

Fig 14
Anthony van Dyck, *Martin Rijckaert*, c. 1630
oil on panel, 148 × 143 cm
Museo Nacional del Prado, Madrid

consort, Amalia van Solms, and their son William sat to him
for their portraits, and he also painted for the Prince two of
his finest treatments of subjects from Italian literature, *Ama-
ryllis and Mirtillo* (cat. 62), from Guarini's *Il Pastor Fido*, and
Rinaldo and Armida (Louvre, Paris; see also fig. 59) from
Tasso's *Gerusalemme liberata*.[31] Van Dyck read Italian poetry
and drama with enthusiasm and responded with imaginative
sympathy to the romantic worlds of Christian knights and
pastoral lovers in the work of Ariosto, Guarini and Tasso.

In Antwerp, Van Dyck's production of portraits was prodi-
gious. His technical facility was absolute: for some of these
portraits preparatory black chalk drawings survive, but rarely
do they do more than describe the contours of face and body.
Van Dyck was concerned to establish the format and the pose
of the sitter. The portrait was then created directly on the
canvas. One of the finest of the portraits of these years was
that of Charles I's Master of Music, Nicholas Lanier (cat. 50),

who was also one of the King's principal agents in assembling his remarkable art collection. The portrait was probably painted as Lanier passed through Antwerp in 1628 while escorting the collection of the Gonzaga dukes of Mantua to London, the purchase of which he had helped to negotiate for Charles I. Lanier, dressed in white satin with sleeves lined in red, a black cape thrown casually over his shoulder, is shown as an elegant and perfect courtier. The spirited preparatory drawing (cat. 50, fig. 1) has little indication of facial features or of dress; such detail was added as Van Dyck worked on the canvas, often making substantial changes to his original ideas. Here, for example, he altered the position of Lanier's right hand and adjusted the position of his head, inclining it more towards the viewer.

Van Dyck did not, however, wish to devote himself exclusively to portraiture, lucrative though it was. He wished to be recognised as a history painter, and Rubens's absence from Antwerp on diplomatic business in Spain and England in the years 1628–30 gave him the opportunity he longed for. He had already established his reputation as a painter of large-scale religious works with his altarpiece of *St Augustine in Ecstasy* (cat. 51), commissioned by the Augustinians for their church in Antwerp. This huge canvas, for which he received 600 guilders, was completed by June 1628, several months before Rubens left for Madrid. It was the only occasion on which Rubens, Jordaens and Van Dyck, Antwerp's three leading artists, painted altarpieces for the same church. Rubens's painting (cat. 52, fig. 1), for which he received 3000 guilders, is the largest of the three and was placed above the high altar. Jordaens's *Martyrdom of St Apollonia* was placed above the altar of the right-hand aisle, and Van Dyck's *St Augustine in Ecstasy* stood above the altar in the left-hand aisle. It is an original and highly accomplished altarpiece in the Italian tradition developed by Rubens. The figure of Augustine is solid and vigorous; his eyes are raised toward the Trinity, his body bent back and supported by the angels who are strong young men entirely capable of sustaining his weight. Augustine wears a rich, embroidered cope over the black habit of the Augustinians. His mother, St Monica, kneels beside him and on the right is the monk who was the donor of the altarpiece, Father Marinus Jansenius.

In these years Van Dyck treated highly charged religious subjects: he painted no fewer than six Crucifixions and returned again and again to the Lamentation and the Mocking of Christ. They are all characterised by a religious emotional-ism of a kind closely identified with the Catholic revival of the Counter-Reformation and imbued with an intense and mystical religious fervour which is such an important strain in Van Dyck's personality and art.

At this time Van Dyck began to work on a project which was to occupy him until his death: a series of engraved portraits of famous men which was published posthumously under the title *The Iconography*, with his own self-portrait on the title-page.[32] During his lifetime the plates were issued individually, and it is unclear whether he intended eventually to publish them as a series. He made delicate black chalk drawings after his own painted portraits or other portraits, or taken from life, and gave them to a number of trusted engravers, among them Paulus Pontius and Lucas Vorsterman. The sitters were divided into three principal categories: princes and military commanders, statesmen and philosophers, and artists and collectors. This last group is the largest and contains many of Van Dyck's friends and acquaintances; in its entirety it provides a remarkable visual record of a generation of Flemish artists.

Van Dyck, who had been well paid for his work since his early years, formed an important collection of paintings.[33] Unsurprisingly, Titian was at the heart of his collection. When Marie de' Medici was in Antwerp in October 1631 she visited the studio of Van Dyck and there, according to the account of her secretary, Pierre de la Serre, she saw '*le cabinet de Titien; je veux dire tous les chefs d'oeuvre de ce grand maistre*'. An inventory of Van Dyck's collection of paintings taken after his death lists seventeen paintings by Titian, among them *The Vendramin Family* (National Gallery, London) and *Perseus and Andromeda* (Wallace Collection, London), as well as two paintings by Tintoretto, three by Anthonis Mor, three by Bassano, and portraits 'by various masters'. It was to these paintings – as well as those drawn in the Italian Sketchbook – that Van Dyck returned again and again for inspiration throughout his career.

LONDON

His output and his fame were such that it was almost as if he had filled Flanders with his name, and he decided to move to London, having been called to the service of King Charles. Rubens had already been honourably entertained at the court of this prince, a most generous devotee of every noble discipline and such a friend and promoter of rare talents that he attracted them from far and wide and rewarded them with great liberality. Thus, when Rubens left, Van Dyck succeeded him in royal favour, and at once began to accumulate the rewards and resources he

needed to maintain his ostentatious style and splendid way of life. However, he spent his new riches liberally, since his house was frequented by the highest nobility, following the lead of the King, who used to visit him and took pleasure in watching him paint and spending time with him. In magnificence he rivalled Parrhasius, keeping servants, carriages, horses, musicians, singers and clowns, who entertained all the dignitaries, knights and ladies who visited his house every day to have their portraits painted. Moreover, he had lavish dishes prepared for them at his table, at the cost of thirty scudi *a day.... He employed men and women who served as models for the portraits of the lords and ladies, since, having rendered the likeness of the face, he would then complete the remainder from these live models.*

...

Regarding his method of painting, he was in the habit of working without a break, and when he made portraits he would begin them in the morning to gain time, and, without interrupting his work, would keep his sitters with him over lunch. Even though they might be dignitaries or great ladies, they came there willingly as though for pleasure, attracted by the variety of the entertainments. After his meal he would return to the picture, or also do two in a day, adding the final retouching later. This was his usual practice for portraits; if he was making history paintings, he estimated how much work he could carry out in a day and did no more.

Early in 1632 Van Dyck moved to London. Two years earlier Endymion Porter had purchased *Rinaldo and Armida* (fig. 59) for Charles I; this large painting, in the tradition of Titian's *poesie* and suffused with the rich, saturated colour of Titian and Veronese, was immensely appealing to a royal collector whose passion was for Venetian art. For Charles, Titian was the greatest of all painters, and he recognised Van Dyck as his heir; in his patronage of Van Dyck there is a conscious echo of the Emperor Charles V's patronage of Titian. Van Dyck was appointed 'principalle Paynter in ordinary to their Majesties' on terms unparalleled in British royal patronage. The Dutch portrait painter Daniel Mytens was at the court when Van Dyck arrived and had prepared the ground for the revolution in portrait painting that was brought about by Van Dyck. But while the King gave important commissions to Mytens, he regarded Van Dyck in a quite different light, and once Van Dyck had settled in London, he was eclipsed. Van Dyck was knighted in July 1632, an honour never granted to Mytens, and in April 1633 was presented with a gold chain with a medallion of the King. He was awarded an annual salary of £200 and in addition was paid for his portraits of the Royal Family. He was given a studio on the river at Black-friars with a jetty built especially so that the King could dis-embark privately when he came to visit the painter. Black-

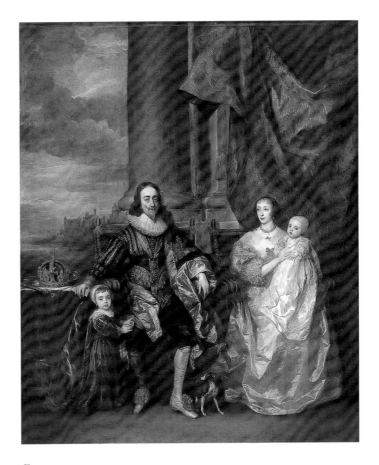

FIG 15
Anthony van Dyck, *Charles I and Henrietta Maria with their Two Eldest Children (the 'Greate Peece')*, 1632
oil on canvas, 370 × 274.3 cm, Her Majesty The Queen

friars was outside the city of London, and so beyond the juris-diction of the Painter–Stainers' Company, the painters' guild of the City, which frequently petitioned the King about foreign artists threatening its members' livelihoods.[34] For the summer months the King gave Van Dyck an apartment at Eltham Palace.

Although Charles I and his French Queen, Henrietta Maria, were painted by many artists, it is from Van Dyck's portraits that they are remembered today. He fixed their images for posterity, as well as those of the members of the Stuart Court. In 1632 Van Dyck painted the King and the Queen in the portrait known, from the royal inventory, as the 'Greate Peece' (fig. 15). They are shown seated with Prince Charles at his father's knee and the baby Princess Mary in her mother's arms. The portrait hung at the end of the Long Gallery in Whitehall Palace. A second royal portrait, painted the follow-ing year, was destined to fill the whole wall at the end of a long gallery at St James's Palace. It showed the King on horseback, riding through a triumphal arch, accompanied on foot by his

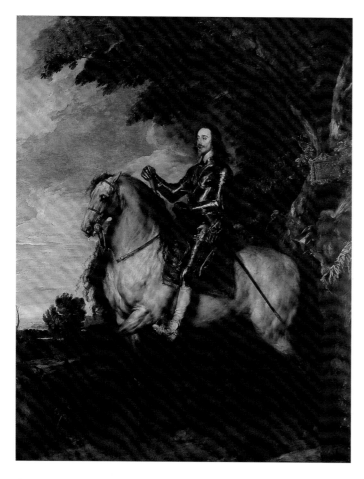

FIG 16

Anthony van Dyck, *Charles I on Horseback*, c. 1636
oil on canvas, 367 × 292 cm, National Gallery, London

riding-master (fig. 64). This painting and a second equestrian portrait (fig. 16) are both exercises in royal propaganda, idealisations of the monarch which evoke the famous statue of Marcus Aurelius on the Capitol at Rome and Titian's *Portrait of Charles V at the Battle of Mühlberg* (Prado, Madrid). In *Le Roi à la Chasse* (fig. 17), the King's demeanour is quite different. Standing, his horse held by a groom, he wears a wide-brimmed hat, doublet and riding boots. Elegant and relaxed, he surveys the countryside and the distant sea. Of all Van Dyck's portraits of the King, this is the most beautiful, with its rich colours and confident mood.

Van Dyck painted many portraits of Henrietta Maria, softening her long nose and prominent jaw by choosing the most flattering angle for her head, and emphasising the delicacy of her complexion, framed in brown curls. The full-length of her with Jeffrey Hudson (cat. 67), though formal, shows the Queen as a lively, high-spirited young woman. The finest of all Van Dyck's portraits of her is the three-quarter length

(private collection, New York) sent to Cardinal Barberini in Rome to thank him for his assistance in arranging for Bernini to carve a bust of Charles I.[35] She is dressed in amber watered silk and cups her hands just below her waist in a gesture of modesty. When painting for such a sophisticated patron in Rome, Van Dyck was anxious to be seen at his best, and the delicacy of touch and sensitivity in the description of texture make this portrait outstanding.

In 1635 Van Dyck painted two group portraits of the royal children, one of which was sent by Henrietta Maria to her sister, the Duchess of Savoy (cat. 87). It is a masterpiece of child portraiture, with each face, even that of the baby Prince James, sharply characterised. The children are caught in a moment of repose, but there is nothing solemn about them.

The Royal Family's patronage of Van Dyck was not limited to portraits. Charles already owned the *Rinaldo and Armida*, and at the end of the 1630s Van Dyck painted for him the exquisite *Cupid and Psyche* (cat. 100). The sensuous nudes, the delicate combination of blues, greens and pinks, the textures of silk, flesh, feathers and foliage, and the carefully balanced composition all combine to make this painting one of Van Dyck's greatest achievements. Here, more than in any of his portraits, he is the true heir of Titian. However, in England Van Dyck never received the great decorative commission for which he yearned: a series of tapestries recording the ceremonial of the Order of the Garter was planned to hang in the Banqueting House in Whitehall, but did not get further than an oil sketch (Belvoir Estate).[36]

On his arrival in England Van Dyck gravitated towards the group of Catholic courtiers around the Queen. Kenelm Digby became a close friend of the artist, and commissioned a number of portraits of himself, his wife and family including a portrait of his wife on her deathbed (cat. 69), a posthumous allegorical portrait of her (cat. 70) as well as a group of religious paintings which are known today only in Bellori's descriptions.[37] Another member of this circle was Endymion Porter who was portrayed with Van Dyck (cat. 88): they rest their hands on a rock which symbolises their friendship. In 1623 Porter had travelled to Spain with the King in the abortive attempt to secure the hand of the Infanta for Charles. In Madrid the two men had visited the royal collections and both refined their understanding of Venetian art there. Digby and Porter must have been valued guides to the social intricacies of the court as well as to the taste for sophisticated allegories, which was seen in its most elaborated form in the

King's favourite entertainment, the masques written by Ben Jonson, William D'Avenant and others and staged by Inigo Jones, the court architect whom Van Dyck portrayed so memorably in a black chalk drawing (Chatsworth).[38]

Where the Royal Family led, the courtiers followed, and our image of Charles's highly cultivated court is that created by Van Dyck. Among the many portraits of members of the court are the double portraits of George, Lord Digby, and William, Lord Russell (cat. 93) and Lord John and Lord Bernard Stuart (cat. 97), both of whom were to die fighting for the King in the Civil War. One of Van Dyck's most important patrons was the 4th Earl of Pembroke, for whom he painted his largest work, the *Family Portrait* which hangs in the Double Cube Room at Wilton House, near Salisbury (fig. 62). The 10th Earl of Northumberland was painted in two fine portraits with his baton of Lord High Admiral (Alnwick Castle). Other patrons during the English years included Philip, Lord Wharton (fig. 65), who built a special gallery in Winchendon House, near Aylesbury, to accommodate the series of family portraits commissioned from Van Dyck;[39] Thomas Wentworth, Earl of Strafford (cat. 68, 102), one of the King's principal advisers in the years leading up to the outbreak of the Civil War; the Earl of Arundel (cat. 89), his earliest English patron, who as premier Earl commanding the royal army against the Scots in 1639 is shown by Van Dyck in armour; the poet Thomas Killigrew (cat. 95); and the dramatist Sir John Suckling (Frick Collection, New York).[40]

Little is known about the artist's mistress, Margaret Lemon, whom he painted in a pose taken from Titian's *Girl in a Fur Wrap* (Galleria Palatina, Florence). She has a satin cloak around her bare shoulders, and exposes her right breast. Margaret Lemon is also traditionally said to have been the model for Psyche in *Cupid and Psyche* (cat. 100). The engraver Wenceslaus Hollar declared her 'a dangerous woman' and 'a demon of jealousy' who caused terrible scenes when ladies of the court sat to Van Dyck without a chaperone. In a fit of jealous rage this beautiful and high-spirited woman is said to have tried to bite Van Dyck's thumb off to prevent him from ever painting again.

ANTWERP AND BRUSSELS, PARIS AND LONDON

Turning to portraits, for which Van Dyck gained the highest reputation, while living in Brussels, he painted almost all the princes and great men who happened to be in Flanders at that time, for he had deservedly acquired the greatest name that any portraitist had merited since Titian.

And in truth, besides capturing a likeness, he gave the heads a certain nobility and conferred grace on their actions.

Van Dyck never truly settled in London, although in 1639 he married a Scottish woman, Mary Ruthven, a Catholic lady-in-waiting to the Queen. Judging by the inscriptions on his drawings his command of written English was shaky and he presumably spoke to the Queen in French or Italian and to the King in French. He often travelled to the Continent: his drawings of Rye were made when he was waiting there for a favourable wind to sail to France (fig. 70). In 1634–5 he was back in the Southern Netherlands for almost a year, working in Antwerp and Brussels. He painted a number of leading figures at Isabella's court such as John of Nassau-Siegen (cat. 76) and visitors like the Marquess of Leganés.[41] His most important patron was the Abbé Scaglia, for whom he painted one of the finest of all his full-length portraits (cat. 78), a half-length of the Abbé in adoration to the Virgin and Child (cat. 78, fig. 3), and a *Lamentation* (cat. 85). He also received the commission for an immense group portrait of the aldermen of Brussels surrounding the figure of Justice to decorate the City Hall in Brussels. This ambitious scheme, much praised by contemporaries, was destroyed in 1695 during the French bombardment of Brussels and only survives in an oil sketch (cat. 84) and a group of preparatory studies.

By 1640 Van Dyck was becoming frustrated by the lack of opportunity in London and, with the political situation deteriorating, he began to consider returning to the Southern Netherlands permanently. When Rubens died in May 1640, he was invited to Antwerp to supervise his workshop. As he started to make arrangements for the move, Van Dyck heard that Louis XIII was about to award the commission for the decoration of the principal galleries of the Louvre. This was the large-scale project for which he felt himself uniquely well suited. Rubens's cycle of paintings celebrating the life of Marie de' Medici had created a precedent of a Flemish artist working for the French Crown. Van Dyck went to Paris in January 1641, but was back in London in May when he painted the double portrait of Princess Mary and William, Prince of Orange, on the occasion of their marriage (cat. 105). He was in Antwerp again in October and in Paris in November, where he heard the news that the Louvre commission had gone to Nicolas Poussin and Simon Vouet.

During these months of intensive work and travel, contemporaries commented on the painter's poor health, and on his return to London it gave cause for alarm. The King sent his

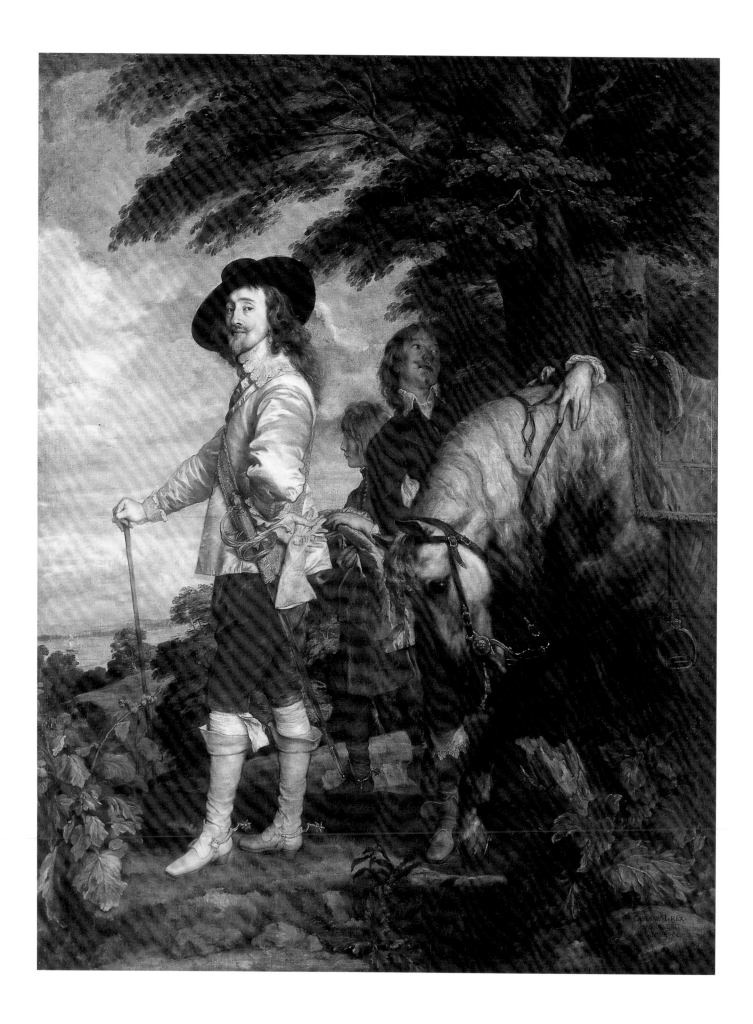

own physician, offering him £300 if he could restore the painter to health. On 1 December, Lady Van Dyck gave birth to a daughter, Justiniana. Three days later Van Dyck made his will, providing for his family and for an illegitimate daughter in Antwerp, and five days after that, on 9 December 1641, he died, at the age of 42. He was buried in St Paul's Cathedral and over his grave the King erected a monument to the memory of his favourite painter.

Anthony returned to England, and shortly afterwards he died in London, piously rendering his spirit to God as a good Catholic, in the year 1641. He was buried in Saint Paul's, to the sadness of the king and court and the universal grief of lovers of painting. For all the riches he had acquired, Anthony van Dyck left little property, having spent everything on living magnificently, more like a prince than a painter.

NOTES

1. I am especially grateful to Sir Oliver Millar, who was kind enough to read my manuscript and make valuable suggestions for its improvement.
2. The life of Van Dyck by Giovanni Pietro Bellori was in part based (as Bellori explains) on conversations with the artist's close friend Sir Kenelm Digby which took place in Rome in 1645 or 1647. It is the most important early life of Van Dyck, although it has surprising omissions such as his first visit to England. The translation used here is that published in full in Brown 1991.
3. The Cardinal-Infante wrote to Philip IV on 10 November 1640 that Van Dyck was too proud to complete another's work (*'que es loco rematado'*).
4. Rubens offered Carleton for 600 guilders 'A picture of Achilles clothed as a woman, done by the best of my pupils, and the whole retouched by my hand; a most delightful picture, and full of many very beautiful young girls'. Magurn 1955, no. 28, p. 61.
5. For Franchois van Dyck's business difficulties, see Van der Stighelen 1994, pp. 17–46.
6. Van Dyck painted at least two series of half-length apostles at this time. See discussion under cat. 2–3, 16–17.
7. For a detailed discussion of Van Dyck's use of drawings during his first Antwerp period, see Brown 1991 and Brown 1994.
8. In the Dresden *Portrait of a Man* (Glück 1931, p. 82; Washington 1990–91, no. 7), which belongs to this early group and dates from about 1618, Van Dyck shows him putting on (or removing) a glove, an action which gives the portrait a real sense of movement, an innovation in Flemish portraiture.
9. Elsewhere in this catalogue Katlijne Van der Stighelen argues that this painting is a self-portrait by Van Dyck. In my view, however, it is a portrait by Rubens of the young Van Dyck painted in about 1616.
10. Bellori notes that 'Anthony made the cartoons and painted pictures for the tapestries of the stories of Decius...' (Brown 1991, p. 17). In New York 1985–6,

pp. 338–55, Reinhold Baumstark argued that the tapestry cartoons now in the Liechtenstein collections at Vaduz should be attributed to Rubens and his workshop rather than to Van Dyck. They are certainly products of the Rubens studio, but Van Dyck was the principal assistant at that time and in my view his stylistic mannerisms can be detected in a number of important passages.
11. The Italian text was published in Hervey 1921, pp. 175–6.
12. Van Somer died in January 1622.
13. This suggestion was first made by Millar, in London 1982–3, p. 14.
14. This painting was first exhibited and published in Washington 1990–91, no. 17. The attribution to Van Dyck has not been universally accepted. In my view the figures and the dog are certainly by Van Dyck, but the landscape is by another hand.
15. This document was first published by Carpenter 1844, p. 10.
16. Hervey 1921, pp. 201, 207.
17. See Félibien 1666–88, III, p. 342.
18. For this biography, see Larsen 1975.
19. Guido Bentivoglio, *Storia della guerra di Fiandra*, 3 vols., 1632–9.
20. For the identification of this portrait, which is in the Hermitage, see Freedberg, in Barnes and Wheelock 1994, pp. 153–74.
21. Adriani 1940. I am completing a new facsimile edition of the Sketchbook.
22. Adriani 1940, fol. 112.
23. Ibid., fol. 50v and 51r.
24. Ibid., fol. 33v.
25. Brown 1994.
26. See Wood 1990, p. 695 (inv. no. 20).
27. This trip, which is said to have included a visit to Peiresc in Aix-en-Provence, is mentioned in the 18th-century life of Van Dyck; see Larsen 1975.
28. The Genoese palaces had so impressed Rubens that on his return from Italy he published a study of them, *Palazzi Moderni di Genova raccolti e disegnati da Pietro Paolo Rubens*, Antwerp 1622.
29. For Van Dyck's impact on portrait painting in Genoa, see Genoa 1997, pp. 105–31.
30. Glück 1931, p. 299. Van Dyck's portrait of Isabella may be based on a Rubens prototype rather than being *ad vivum*. There are many workshop versions of Van Dyck's composition.
31. For Van Dyck and the House of Orange, see P. van der Ploeg and C. Vermeeren, *Princely Patrons: The collection of Frederick Henry of Orange and Amalia van Solms*, exh. cat. Mauritshuis, The Hague 1997–8.
32. For *The Iconography*, see Mauquoy-Hendrickx 1991.
33. For Van Dyck's collection, see Wood 1990 and Brown and Ramsay 1990.
34. For the Painter–Stainers' Company, see S. Foister, in Howarth 1993, pp. 32–50.
35. For the negotiations over the Bernini bust, see Lightbown 1981.
36. Washington 1990–91, no. 102.
37. Brown 1991, p. 21.
38. The drawing was used for the engraving by Robert van Voerst in *The Iconography*, Mauquoy-Hendrickx 1991, no. 72.
39. For the Wharton series, see Millar 1994.
40. For the portrait of Suckling, see Rogers 1978.
41. The full-length portrait of Leganés is known in two autograph versions: one is in the National Museum of Western Art in Tokyo and the other in the collection of the Banco Hispano-Americano in Madrid.

FIG 17
Anthony van Dyck, *Le Roi à la Chasse*, c. 1635
oil on canvas, 272 × 212 cm, Musée du Louvre, Paris

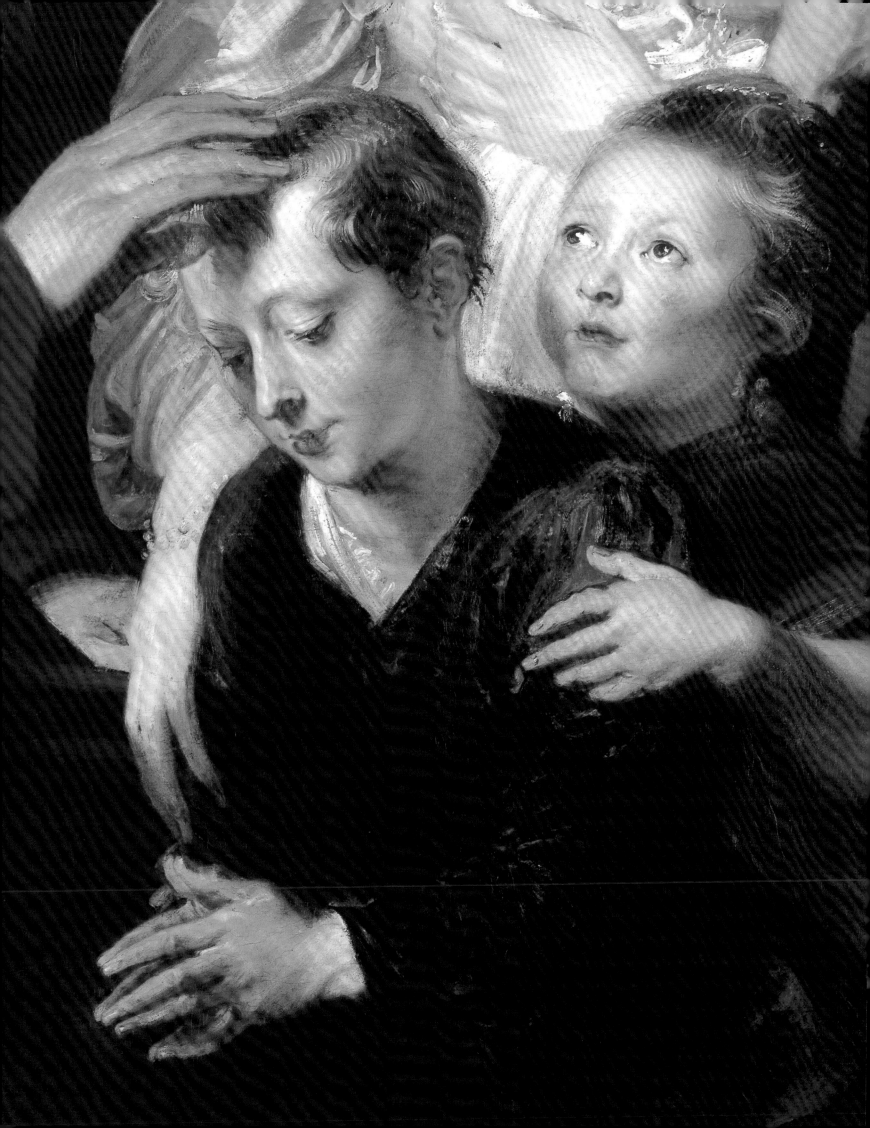

Van Dyck's First Antwerp Period

Prologue to a Baroque Life Story

KATLIJNE VAN DER STIGHELEN

'Inconstance'. – Les choses ont diverses qualités, et l'âme diverses inclinations; car rien n'est simple de ce qui s'offre à l'âme,
et l'âme ne s'offre jamais simple à aucun sujet. — Blaise Pascal, *Pensées*, 112–54

Anthony van Dyck was born in Antwerp and always returned there. The path of his future career was mapped out between his birth, in the spring of 1599, and the autumn of 1621. Van Dyck was moulded socially, professionally and emotionally in these years. He departed on 3 October 1621, distancing himself from the bourgeois milieu in which he had grown up and extricating himself from the influence of Peter Paul Rubens by following in Rubens's footsteps to Italy some 21 years later.

Anthony van Dyck was born on 22 March 1599 in a house called 'Den Berendans' (The Dancing Bear; fig. 18).[1] It was located on the city's main square – the Grote Markt – near Cornelis Floris de Vriendt's Town Hall in the Renaissance style, which had been built only a few decades earlier (1561–5). The house was purchased by Van Dyck's grandfather – another Anthony – on 30 December 1579 and was described in the sale documents as 'standing by the iron bridge near the new Town Hall'. The elder Anthony van Dyck had not always been so prosperous. Just over ten years earlier, in 1568, he had complained to the civic authorities that his house, 'Den Hercules', in the Mansstraat was too small to have troops billeted on it. The document identifies him as 'Anthony van Dyck, merchant, dealing in silk and fancy goods'.[2] Five years earlier, however, when Van Dyck had testified on behalf of Jan van Ghendrick, alias Van Cleve, he was described as an 'independent master painter'. The same document, dated 30 September 1563, noted that he was a guildsman: 'Anthony van Dyck, who also used to be a painter here, 33 years old and a citizen of this town'. Thus he began his career as a painter and in 1563 was still described as such

when he testified for his former teacher. This is confirmed by the register of the Guild of St Luke in 1546: 'Tuenken [little Anthony] van Dyck (painter) trained by Jan van Cleve (painter)'.[3] He abandoned painting shortly before 1563 in favour of a career as a merchant. His wife, Cornelia Pruystinck – possibly a relative of the religious reformer Eligius Pruystinck[4] – continued the business after Anthony's death in 1581. She showed great business acumen and expanded the range of merchandise. Together with her sons Franchois and Ferdinand, she traded in goods such as ribbons, shoelaces, needles, bedclothes, underwear and a variety of costume accessories. Her customers lived mostly in towns like Bruges, Lokeren and Lier, although she also supplied clients in the Northern Netherlands and as far away as Paris, London, Lübeck and Cologne. Clearly, business was good.[5]

The first wife of Franchois van Dyck, Anthony's father, was Maria Comperis, whom he married on 4 October 1587.[6] She died giving birth to their first son, who did not survive.[7] Seven months later, on 6 February 1590, the widower married Maria Cuypers, daughter of Dierick (or Theodorus) Cuypers and Catharina Conincx. Dierick Cuypers's profession is unknown, but he was related to another Dierick Cuypers who was apprenticed to the painter Frans Francken the Elder in 1596, becoming a master in his own right in 1604.[8]

In the space of seventeen years, Maria Cuypers and Franchois van Dyck produced eight daughters and four sons, three of whom died in infancy. Anthony, born in 1599, was the seventh child and had four older siblings, Catharina, Maria, Franchois the Younger and Cornelia II. He was followed by Susanna, Anna, Dierick and Elisabeth, or Isabella.[9]

CAT 8, detail

By 1599, the house on the Grote Markt had become too small and, since business was still flourishing, Franchois van Dyck and his family moved to a new home in the Korte Nieuwstraat. In the spring of 1607, he and his wife bought the adjoining buildings, including the spacious house 'De Stadt van Ghendt' (The City of Ghent).[10] This had gates, a courtyard, galleries, a well, a garden, storehouses, a kitchen, laundry, parlour, study, bathroom, stables and cellars. The Van Dycks also bought some of the contents: 'all display cabinets, clothes-presses, beds and all other furnishings, all the paintings without exception and all the permanent fixtures and fittings within the said dwelling'.[11] The building had ample space and was luxuriously furnished; it had the modern luxury of a bathroom. The purchase was agreed on 7 March 1607. Anthony van Dyck celebrated his eighth birthday fifteen days later. But a month later, on 16 April, Van Dyck's parents drew up a will stating that 'Mistress Maria Cuypers [has been] confined to her bed with illness and [is] reflecting on the fragility and frailty of the human constitution'. She died the next day.

Already in the 17th century it was generally held that Van Dyck inherited his talent from his mother who, while preg-

nant, had embroidered a wall-hanging with the story of the chaste Susanna. Cornelis de Bie, a notary and amateur art historian from Lier, wrote in 1661: 'His mother was gifted with great skill in embroidery, for which she was famed. She first drew entire figures before embroidering them with the sweet colours of silk.'[12] Although his words suggest he knew the works, De Bie appears to have been relying on oral tradition.[13] It is most unusual for an artist's talent to be ascribed to his mother rather than his father.[14]

The young Anthony van Dyck was helped by his father's social standing as he embarked on his training. His parents belonged to the ranks of Antwerp's *nouveaux riches*. The youth lived in a luxurious house and his father's business brought him into contact with foreign merchants. The goods on offer included cloaks edged with velvet, silk braid, and embroidered satin stomachers and Burgundy cloth.[15] Van Dyck was familiar from an early age with the textures of a variety of fabrics. The tactile manner in which he later painted textiles may be traced back to his youthful experience of such materials.

Van Dyck was apprenticed to Hendrick van Balen in 1609. His father was by then a wealthy merchant, as reported by Bellori in 1672: 'His father was a merchant trading in fabrics, of which those made in Flanders surpass all others in fineness and workmanship.'[16] A more recent commentator wrote in 1987 that 'Anthony van Dyck began his precocious career with the advantages of wealth and an excellent education'.[17] These advantages were, however, to prove short-lived.

Anthony's eldest sister, Catharina, married the Antwerp notary Adriaen Diericx in the spring of 1610.[18] Problems began to beset the Van Dyck household in December of that year. That month the municipal *Correctieboek* (book of punishment) records that Jacobmyne de Kueck from Hondschoot was banished from Antwerp 'on pain of the gallows' for 'singing and spreading some defamatory song to the calumny and blame of Franchois van Dyck, citizen and merchant of this town, and his daughters and household'. Whatever the woman's motives, she was clearly in earnest. She smashed the Van Dycks' windows on several nights and threatened to kill Anthony's father. The incidents were almost certainly prompted by some private dispute, but they also reflected tensions at home. Shortly before 5 June 1615, Maria van Dyck, Anthony's second eldest sister, was married to Lancelot Lancelots, a merchant.[19] The situation became acute the next summer: in a document dating from 17 July

1615, the two sons-in-law referred to 'the disgrace that has befallen Franchois van Dyck, their father-in-law'. Diericx and Lancelots repeated their statement almost word for word two years later.[20] In July 1615, they brought a lawsuit against their father-in-law, demanding that he pay out the inheritance owing to 'their under-age brothers- and sisters-in-law from their mother and grandmother'. Franchois's assets were inventoried and duly sold. Anthony van Dyck was unhappy with the situation and brought a suit before the aldermen on 3 December 1616 requesting that a commissioner be appointed to oversee the management of the family's affairs by his two brothers-in-law.[21] The seventeen year-old painter boldly described himself in his petition as 'aged about eighteen years' and mentioned his own 'good conduct'.

Some of Franchois van Dyck's possessions were auctioned off on Antwerp's Vrijdagmarkt (Friday Market) in the summer of 1617. Anthony's brothers-in-law bought several items, including a Ruckers harpsichord for 100 guilders and a red tapestry for 43 guilders, which were subsequently loaned to Franchois van Dyck the Younger, Anthony's elder brother, who was attempting to earn his living by running a tavern, 'De Goublomme' (The Sunflower).[22] They were not destined to embellish the tavern for long, however, as Franchois the Younger also suffered from financial difficulties, and the contents of the tavern were carted off by the rag-and-bone men (oudekleerkopers).[23] Anthony took his brothers-in-law back to court in September 1617, appealing to the city magistrates to restore not only his own possessions but those of 'his other brothers and sisters, being also minors and very young'. He argued that the situation was acute as he and his siblings were otherwise liable to lose all they possessed. His motive in bringing the lawsuit was 'brotherly affection' and a desire to avoid being held responsible by his young relatives for the fact that 'all their assets had been used up by their guardians'.[24]

Franchois van Dyck's family had gone from being a flourishing merchant family in 1599 to a motherless household with acute financial problems in 1617. The paterfamilias was pursued by his creditors, while the contents of the tavern run by his eldest son were being seized. Around Christmas 1616, father and son decided to rent a house together opposite the church of St James. Barely two months later, Franchois the Younger broke the rental contract on 'De Cleyn Sonne' (The Little Sun), on the grounds that his father would not, after all, move in with him and his new wife. He excused himself to the landlord, stating that 'they had believed that [his] father would move in with them. The other sisters and brothers would not, however, allow it.'[25]

Anthony van Dyck's two elder sisters, Catharina and Maria, had married respectively a notary and a merchant. Franchois the Younger was married in 1616 to a girl from the Parish of St George. No other members of the family married, apart from the artist, shortly before his death. Anna became a nun at the local Augustinian convent, Susanna, Isabella and Cornelia II entered the Beguinage in the Rodestraat, Antwerp, while Dierick first became a Norbertine canon and later a parish priest at Minderhout. The question arises as to whether this renunciation of the world was the result of growing religious fervour in the family, as has often been suggested.[26] Another conclusion could be drawn: the Van Dycks were no longer socially acceptable in Antwerp. Certainly Franchois van Dyck and his unmarried children were 'socially stigmatised' around 1620. The family name could only be saved by his son, the promising painter, who had enrolled as a master in Antwerp's Guild of St Luke on 11 February 1618. Early in his career he was to witness the public sale of his parental home, 'De Stadt van Ghendt', on 20 May 1620.

Less than five months later Anthony van Dyck left for the first time for England. His new surroundings enabled him to distance himself from his disgraced family[27] and to emerge, for a while, from Rubens's shadow. On 28 October 1620, Thomas Locke of London wrote to William Trumbull in Brussels: 'The Young Painter Van Dyke is newly come to the town.'[28] His 'escape' was a great success. The Earl of Arundel, an outstanding patron of the arts, immediately had the young master paint his portrait (cat. 25). Van Dyck returned to Antwerp in February 1621.[29] Several intriguing questions arise. Did he speak any English at this stage? Did life at the London Court come as a cultural shock, or did the tastes of his aristocratic patrons, with their rich collections of Italian paintings, correspond to his own? Paintings like *The Continence of Scipio* (cat. 26) and the *portrait historié* of *Sir George Villiers and Lady Katherine Manners as Venus and Adonis* (fig. 19) suggest the latter. Both works were painted during Van Dyck's first visit to London. Seven months later, the artist moved to Italy for seven years.

Van Dyck had already been confronted with extreme social circumstances at an early age. He was born into a merchant family whose status rose and, equally rapidly, fell. However, when he was apprenticed to Hendrick van Balen in 1609, he was still a member of Antwerp's *jeunesse dorée*. His father's

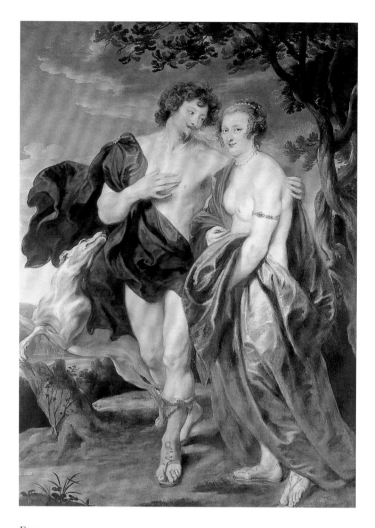

FIG 19
Anthony van Dyck, *Sir George Villiers and
Lady Katherine Manners as Adonis and Venus*, 1620–21
oil on canvas, 223.4 × 160 cm
Private collection

financial status helped secure him an excellent teacher. Van Balen was a celebrated painter of cabinet pictures (small paintings made for the market rather than for a particular patron) and had been appointed Dean of the St Luke Guild that year. Van Dyck was one of six apprentices he took on in 1609, which testifies to Van Balen's popularity as a teacher and also, perhaps, to the productivity of his workshop.[30] Van Balen was a cultivated man with a high artistic reputation;[31] he had an extensive library and a wide-ranging interest in and knowledge of languages.[32] To move from 'De Stadt van Ghendt' to Van Balen's house, 'Den Wildeman', merely required Anthony van Dyck to cross the Katelijnevest. The apprenticeship was the first opportunity for this ten year-old to develop intellectually and to be trained in the art of painting.

Was Franchois van Dyck in the position to choose between the 34 year-old Dean of the Guild, Hendrick van Balen, and the 32 year-old Peter Paul Rubens? This is unlikely: since his return from Italy in 1608, Rubens preferred to train older assistants. He wrote to Jacques de Bie in 1611 that he had had to turn down over a hundred pupils.[33] He took the view that apprentices should get their initial training elsewhere and then join his studio as skilled assistants. In other words, the possibility of studying under Rubens at a later age would have remained open.

We do not know how long Van Dyck trained under Van Balen. An 18th-century biography states that the apprentice *'reçut des leçons pendant deux ans'*.[34] That seems a very short time, however, given that it was normal to remain with the same master for three to four years.[35] Van Dyck was only twelve years old in 1611–12 and his father's business was still healthy. It would not be unreasonable to conclude that he remained with Van Balen a couple of years longer.

Van Dyck's earliest dated portrait was made in 1613 (fig. 20): the painting of a 70 year-old man bears the inscription 'AVD · F AETA · SUE · 14'. The fourteen year-old painter used a monogram as his signature and considered his talent to be sufficiently precocious to warrant the inclusion of his age. The portrait was painted five years before Van Dyck became a master. It may have been produced under Van Balen's supervision, as it betrays the influence of that master's conservative portrait style.[36] Van Dyck's *Self-portrait* in Vienna (cat. 1) looks entirely different: no trace remains of Van Balen's descriptive and highly polished technique in its heavy impasto, the pose is no longer frontal, and the sitter's gaze is brashly self-aware rather than introspective. Thus the brilliant and precocious young painter presented himself on the artistic stage. At the time he was painting this self-portrait, his two brothers-in-law were taking legal steps to keep Franchois van Dyck and Maria Cuypers's assets out of the hands of their creditors. Anthony had completed several years of training and seized the opportunity to embark on an independent career. This may appear surprising – after all, he did not officially attain the status of an independent master until 1618 – but all the sources of this period suggest that he had his own workshop.

The painter Jan Brueghel the Younger, Pieter Bruegel the Elder's grandson, stated on 5 September 1660 that Van Dyck had his own workshop in the house 'Den Dom van Ceulen' (The Cathedral of Cologne) on Antwerp's Lange Minderbroedersstraat (now Mutsaertstraat) even before he left for Italy in 1621. He added that there Van Dyck had produced a series of paintings of 'the Twelve Apostles and Our Lord'.

Although Brueghel did not give a precise date for these works, a second testimony, also of 1660, sheds some light. Guilliam Verhagen stated that he had commissioned the Apostle series some '44 to 45 years ago'.[37] These facts prompted the hypothesis, proposed by such scholars as F.J. Van den Branden, that Van Dyck had his own studio at an early date.[38]

This hypothesis was challenged by Margaret Roland. Having re-examined the documents relating to the 1660 lawsuit, she concluded that the studio at 'Den Dom van Ceulen' can only have been set up after Van Dyck's return from England in 1621. Only then, she contends, did he enjoy sufficient prestige to operate as an independent master.[39] Further scrutiny of the information and of new sources suggests, however, a different interpretation. A diary kept by Sister Sara Derkennis (Municipal Archives, Antwerp) provides a detailed report of the flight of the sub-prioress and several nuns from their convent at Temse to Antwerp, where they arrived on 19 April 1621. The next day they rented a house 'in the Minderbroedersstraat, known as "Den Dom van Ceulen"', moving in 'at the end of May' 1621.[40] In other words, if Van Dyck set up a studio in the house after returning from England in March of that year, he could only have used it for two or three months at the most. It seems more likely, therefore, that the young painter indeed had his own studio before qualifying as a master. This may have contravened the regulations of the Guild of St Luke, but in 17th-century Antwerp, as elsewhere, rules were not always obeyed.[41]

The Vienna self-portrait almost certainly recalls this stage of the artist's life. A date of around 1615 seems likely in my opinion when we compare it to other early works.[42] Jan Brueghel the Younger's testimony, quoted above, refers to several works including a painting of the drunken Silenus. Herman Servaes, one of Van Dyck's assistants, claimed on 12 December 1668 that he had seen his young master putting the finishing touches to a painting of that subject.[43] It would be logical to identify it with the early version of the *Drunken Silenus*, now in Brussels (cat. 11), which dates from around 1618–19 and was painted shortly after Rubens's work of the same subject (Alte Pinakothek, Munich). Van Dyck's metamorphosis between 1615 and 1618 had everything to do with Rubens's presence in Antwerp.

We have no way of knowing how and when Rubens and Van Dyck first met. If we are to believe Guilliam Verhagen, their initial contact may be dated to shortly before 1615. It was then that Van Dyck received the commission for the Apostle series,

FIG 20
Anthony van Dyck, *Portrait of a Man aged Seventy*, 1613
oil on canvas, 63 × 43.5 cm
Musées Royaux des Beaux-Arts de Belgique, Brussels

after which Verhagen became a frequent guest at the artist's home. He was not the only one. The same document records that illustrious painters like 'Petro Paulo Rubens, Zegers [Daniel Seghers], David Rijckarts' and others also frequently visited Van Dyck's house 'with no other aim than to see and inspect the said paintings'. Thus, the leading baroque artists of Antwerp were prepared to visit the studio of this up-and-coming master. Perhaps they were sceptical about his precocious genius, or perhaps they wished to make certain that his work, 'which was being praised and extolled all the time', was genuinely his own.[44] Van Dyck had his own studio and took on an apprentice who was ordered to produce copies of his master's work. This 'adolescent studio' no doubt aroused widespread surprise and admiration. After all, the painter can have been no more than seventeen years old and his assistant, Herman Servaes, barely a year older.[45] Rubens recognised the potential offered by an assistant of Van Dyck's calibre. Hard

evidence of collaboration between the two painters only exists from 1617, although there is nothing to suggest that Van Dyck gave up his own studio at that point to work with Rubens. The 'early studio' hypothesis is also supported by a remark (cited by Roger de Piles) of the German banker and patron Everhard Jabach, who once asked Van Dyck how he managed to work so quickly. The artist replied that his early works had been laboriously slow to produce, but that he had learned how to paint faster 'during a time when he was working in order to have enough food to eat'.[46] The comment can only have referred to the beginning of his career.

The portrait Rubens supposedly painted of Van Dyck around 1615 is often cited as evidence of a close personal relationship with his brilliant pupil (cat. 1, fig. 2). The date and the identity of the sitter cannot be disputed, given its similarity with the Vienna self-portrait (cat. 1). There is no convincing evidence, however, that Rubens was its author. If he had wished to paint the boy's portrait as a tribute to his talents, he would surely have opted for a different form. A sketch-like study of a head is not the most obvious vehicle for expressing affection. Then there is the style of this wayward little portrait. It has been noted that it bears a striking resemblance to the early self-portrait. Particularly noteworthy are 'the intimacy of the image and its unusual form'.[47] To my mind, any suggestion that Rubens would have painted the portrait as a response to Van Dyck's own self-portrait is to turn upside-down the probable relationship between an internationally renowned painter and his precocious pupil. The probing intimacy and unusual close-up presentation take on an entirely different significance, however, if we interpret the painting as a self-portrait. If we compare the Vienna painting with the one in Antwerp, the conceptual similarities become even clearer. In stylistic terms, the portrait in the Rubens House serves as a touchstone for the assessment of Rubens's influence on the young Van Dyck.[48] Furthermore, the retouching of the hat suggests that certain parts were initially less successful. Although the hat as it now appears is a later addition, there must always have been some sort of headgear.[49] The rendering of the hair is identical to that in the Vienna self-portrait and lacks the discipline of line that is always present in Rubens. The face is the most Rubensian part of the composition, while the smoothness of touch is also taken from Rubens, who around 1616–17 began to tone down his earlier classicism.[50]

Rubens and Van Dyck were partners on the same project

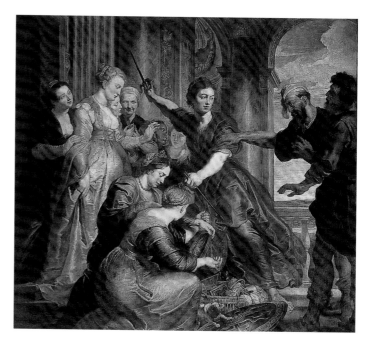

F IG 21
Peter Paul Rubens and Anthony van Dyck,
Achilles among the Daughters of Lycomedes, 1616–18
oil on canvas, 246 × 267 cm
Museo Nacional del Prado, Madrid

shortly before 1617, when fifteen paintings illustrating the mysteries of the Rosary were produced by famous and lesser-known masters for St Paul's church, Antwerp (see cat. 7). The works were commissioned from various artists by a number of donors, thirteen of whom we know by name.[51] Although we cannot be certain, Rubens or Van Balen may have recommended Van Dyck for the project. Rubens's contribution to the cycle was paid for by Louis Clarisse, whose brother Rogier had earlier been portrayed by him. Jan van den Broeck paid for the work by the seventeen or eighteen year-old Van Dyck.[52]

Van Dyck certainly became Rubens's assistant during 1617. The older artist took him on for a variety of projects before Van Dyck's registration as an independent master on 11 February 1618. It may be evidence of Rubens's respect for guild regulations that he never referred to Van Dyck by name before the latter had earned the title of master. In practice, however, they must already have been collaborating on many projects before that date. On 28 April 1618, Rubens wrote in a letter to Sir Dudley Carleton, English Ambassador to the States General in The Hague, that the painting *Achilles among the Daughters of Lycomedes* (fig. 21) was for sale for the price of 600 guilders. He described it as *'fatto del meglior mio discepolo'* (done by my best pupil) and retouched by Rubens himself.

He did not give the name of his young assistant, probably because he felt it would not mean anything to the English diplomat.[53] A fortnight later, Rubens wrote again to Carleton to tell him that a series of tapestry cartoons illustrating the *History of Decius Mus* had arrived at the Brussels workshops where the tapestries were to be woven. The cycle had been ordered in November 1616. Although Van Dyck produced the cartoons after designs by his master, Rubens failed to mention his name. Van Dyck's involvement is, however, confirmed by a variety of sources. In 1661, for instance, the portrait painter Gonzales Coques and his neighbour, Jan Baptist van Eyck, stated that they had bought five paintings for a total of 2400 guilders on the 'History of Emperor Decius, painted by Anthonio van Dyck'. Van Eyck already owned the sixth canvas of the series.[54] The cartoons (Liechtenstein collection; see fig. 22) illustrate Van Dyck's style immediately before his registration as a master: by this time Van Dyck's work was barely distinguishable from that of Rubens. In the words of Julius Held, 'It is solidly anchored in Rubens' canon'.[55] The 'best pupil in his studio' soon managed to equal his master. Not only did he follow the typology of Rubens's figures, he also imitated his master's style. He increasingly adjusted his palette to that of his master, while he also adopted Rubens's characteristic highlights.[56]

Van Dyck was active in Rubens's workshop both before and after he was registered as a master painter. Both artists will have been well aware of the benefits of their collaboration: Rubens was able to delegate important commissions, while Van Dyck was introduced into an international circle of connoisseurs, both aristocratic and non-aristocratic. He also learned how to run a large studio, while receiving an important intellectual stimulus: Rubens had studied at Rombout Verdonck's Latin School and later served as a page at the court of Marguerite de Lalaing d'Arenberg, Comtesse de Ligne; he was thus familiar with both classical culture and court etiquette. He spent the years 1600–8 in Italy, returning as a universally acclaimed history painter. Rubens's wide-ranging intellectual interests and thorough knowledge of the art and literature of classical Antiquity must have had a profound impact on the nineteen year-old.[57] He could not have hoped for a better master or role model.

How were the practicalities of their collaboration arranged? Did Van Dyck keep up 'Den Dom van Ceulen', or did he make Rubens's workshop his own? Several items listed in inventories suggest the latter: 'Study of a bald-headed man,

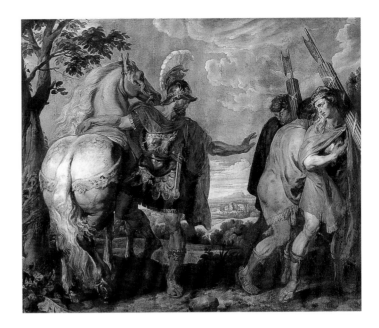

FIG 22
Peter Paul Rubens and Anthony van Dyck,
*Decius Mus giving Leave to the Lictors, c.*1616
oil on canvas, 288 × 346 cm
Liechtenstein collection, Vaduz

painted by Van Dyck at Rubens's studio' and 'item, an old man's inclined head, painted by Van Dyck at Rubens's studio'.[58] The young master appears to have had free use of Rubens's workshop. This was the view of Francesco Vercellini, secretary to the Earl of Arundel, who wrote to the Earl in the summer of 1620 '*Van Deick sta tuttavia con il Sr. Ribins*' (Van Dyck is still with Signor Rubens).[59] The relationship had grown even stronger by 1620. On 29 March Rubens signed a contract with the Antwerp Jesuits to paint 39 paintings for the ceiling of what is now the church of St Carolus Borromeus. Rubens would supply the designs, which would be executed by 'Van Dyck and certain other of his pupils'. It was also stated that Van Dyck would be permitted at a later date to produce a painting for one of the side altars in the same church.[60] He had reached the age of 21 a week earlier and was beginning to assert himself.

Van Dyck had already undertaken commissions in his own name. Around 1618 he received many in Antwerp, admittedly for projects on a smaller scale than those he worked on with his master. Several of them were almost certainly arranged by Rubens. One might go so far as to say that all the important portraits painted during Van Dyck's first Antwerp period were of sitters connected with Rubens in one way or another. This was the case with Cornelis van der Geest (cat. 22), Gaspar (?) Charles (fig. 23), Maria van de Wouwer-

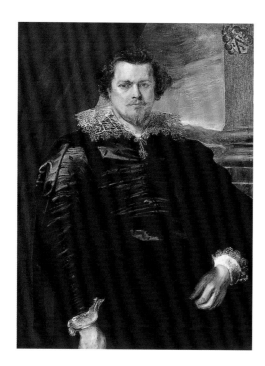

Clarisse (fig. 24), Nicholas Rockox (Hermitage, St Petersburg), the painter Frans Snyders and his wife Margaretha de Vos (Frick Collection, New York) and Isabella Brant (cat. 27).[61] Mensaert wrote in 1763 that occasionally Rubens referred potential customers to Cornelis de Vos, whom he said could paint portraits as fine as his own.[62] Probably the anecdote can be applied more accurately to Van Dyck: portrait commissions provided the young artist with a unique opportunity to specialise in a genre to which Rubens had never wholeheartedly devoted himself. Between 1618 and 1620 Van Dyck steadily reduced the degree of heavy impasto in his portraits, seemingly tempering his impulsive and radical style, and concentrated instead on achieving a fluid finish. It is revealing to compare the portrait of an unidentified 55 year-old man (cat. 9), painted on panel, and the portrait of Isabella Brant, made two years later and painted on canvas, in which Van Dyck shows a growing ability to control his unruly talent.

Rubens's influence is even more evident in his subject paintings of this period. The paint is handled in an exceptionally Rubensian manner in the panel of *St Martin dividing his Cloak* (cat. 18), which also dates from around 1619. So strong is Rubens's stamp on the work that Susan Barnes has wondered if the commission might have been given to Rubens.[63] Whether that is the case or not, I believe that in this work Van Dyck was adapting his touch to satisfy the tastes of his patron. He was evidently not too proud to display flexibility when needed, allowing the customer to choose between the established Rubensian idiom and his own, more experimental approach. The fact that his style became more controlled in the period up to 1621 almost certainly reflects the reluctance of his Antwerp patrons to accept such an avant-garde style.

Exactly what drove this ambitious young artist between his fifteenth and twenty-first year is unknown. Self-portraits are difficult to interpret, and details of Van Dyck's personal life are lacking, apart from a few indirect hints. The motherless adolescent from a socially unstable background quickly displayed an exceptional capacity for work. Demand for portraits was plentiful, and he soon realised how lucrative the genre could be. He practised painting his own face frequently during his first Antwerp period. In the space of about six years, he produced at least four self-portraits and incorporated his own face into at least two subject paintings.[64]

Van Dyck painted his first self-portrait at the age of fifteen or sixteen (cat. 1). He began work on a second study a little later, this time including a hat (cat. 1, fig. 2). The third self-

portrait certainly produced during his first Antwerp period is in Munich (fig. 25), rightly dated *c.* 1618, although it was extensively retouched later on. Technical examination has shown that Van Dyck's right hand was originally positioned in the same way as in the New York self-portrait (fig. 26).[65] The Munich portrait may be the work described in an Antwerp private collection in 1691 as 'A likeness of Van Dyck with a cloak and hand'.[66] The correspondence of the hand gesture makes the Munich portrait an obvious trial run for the more sophisticated New York composition, which was probably painted in England in the winter of 1620–21.[67] While still using fairly thick brushwork, the painter succeeds in making the flesh almost translucent. There are no heavy outlines, and the impasto technique is particularly beguiling in the silk shirt, the collar and cuffs of which can barely be deciphered. The tip of his forefinger is hidden in his shirt collar, giving his sophisticated pose a surprisingly informal feel. On the little finger of his right hand, Van Dyck wears a ring set with a dark, heart-shaped stone.[68] His velvet jacket is purple – a frivolous touch that appears only in the New York portrait. If the detail was intended as an allusion to the ancient Greek painter Parrhasius, who was said to have worn a purple cloak, then it is evidence of high ambition.[69] It may have been Rubens who suggested the idea that Van Dyck should compare himself to the ancient master. Rubens was familiar with Pliny's *Historia Naturalis* and no doubt had the story of the rivalry between Zeuxis and Parrhasius read aloud at his studio.[70] The painter Zeuxis supposedly made an illusionistic painting of a bunch of grapes that was so realistic that the birds pecked at the fruit. Parrhasius responded with an even more brilliant *trompe-l'œil* curtain, which Zeuxis himself believed to be real and attempted to open. The young Van Dyck was no doubt challenged by this example. He shared Parrhasius' flamboyant way of life.[71] According to Pliny, Parrhasius was the first to introduce a canon of proportions in painting and the first to give vivacity to facial expressions, elegance to hair and beauty to the mouth.[72] Van Dyck will no doubt have enjoyed following in Parrhasius' footsteps,[73] concluding that the best lessons were to be learned from his own face.

It is very difficult to determine – 400 years on – whether Van Dyck's relationship with Rubens was stimulating, frustrating or both. There is, however, no evidence of any particular affection.[74] Perhaps Rubens was initially taken with his highly talented assistant but grew apprehensive towards 1620, when Van Dyck – 22 years his junior – became his technical

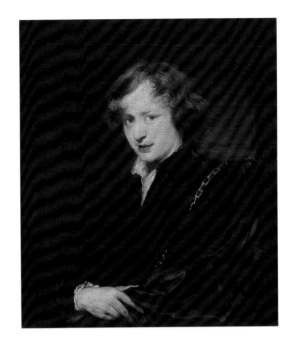

FIG 25
Anthony van Dyck, *Self-portrait*, 1617–18
oil on canvas, 82.5 × 70 cm
Alte Pinakothek, Munich

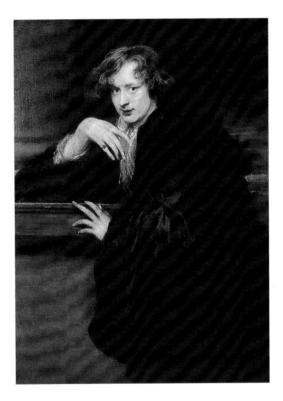

FIG 26
Anthony van Dyck, *Self-portrait*, 1620–21
oil on canvas, 119.7 × 87.9 cm
The Metropolitan Museum of Art, New York,
The Jules Bache Collection

equal. If present-day art-historians are unable to distinguish between the hands of Rubens and Van Dyck in a number of collaborative projects, their stylistic similarity must also have aroused comment in the circle of Antwerp baroque painters – well-matched talent can spark off rivalry. The question also remains as to whether Rubens behaved as generously towards Van Dyck as is generally presumed. Many Rubens scholars have argued that envy of the young Van Dyck would have been out of character with Rubens's personality as revealed in his own writings. Earlier literary sources, however, contain references to Rubens's jealousy – alleged or otherwise – of artists like Jacob Jordaens, Maarten Pepijn and Abraham Bloemaert.[75] Given that Van Dyck clearly belonged to a different class to these artists, envy on Rubens's part would be even more plausible. Bellori's story, that Rubens was willing to concede Van Dyck glory only in the field of portraiture, dates from just 30 years after his death. Bellori tends to be a good source, listening as he did to reliable informants.[76]

Van Dyck's subordinate position in relation to Rubens, the scars of his father's financial troubles and the loss of his mother at an early age saddled him with feelings of uncertainty and instability that he never overcame. He rarely stayed in one place for long and married only shortly before his death. During his early years in Antwerp, a young woman bore him a daughter. Although Van Dyck's girlfriend has disappeared into the mists of time, the life of their daughter, Maria Theresa, is quite well documented. The painter's sisters brought the girl up at the Beguinage in Antwerp and she married Gabriel Essers, who later became Bailiff (drost) of Boechout. She gave birth to her first child on 16 February 1642 in Lier.[77]

Van Dyck was marked for life by the experiences of his childhood and adolescence in Antwerp. Painful childhood memories left their imprint on the artist and made him a homo inconstans, whose brilliance in the subliminal rendering of love, passion and suffering was unsurpassed.

NOTES

1. Katlijne Van der Stighelen, 'Cornelia Pruystinck en Lynken Cuypers: over de grootmoederlijke erfenis van Anton Van Dijck', Jaarboek Koninklijk Museum voor Schone Kunsten Antwerpen, 1995, pp. 150–52.

2. Id., 'Young Anthony: Archival Discoveries Relating to Van Dyck's Early Career', in Barnes and Wheelock 1994, p. 17 and doc. 2.

3. P. Rombouts and T. Van Lerius, De Liggeren en andere historische archieven der Antwerpsche Sint Lucasgilde, I, Antwerp and The Hague 1864, p. 157.

4. E.M. Braekman, 'Un cas de dissidence à Anvers: Eloy Pruystinck', in M. Lienhard, Les dissidents du 16ᵉ siècle entre l'humanisme et le catholicisme, Baden-Baden 1985, p. 191ff; Leontine Buijnsters-Smets, 'Jan Massijs. Een Antwerps schilder uit de zestiende eeuw', published doctoral thesis, Zwolle 1995, pp. 20–21, 23–4, 30–31, 44. The man was nicknamed 'Loy the Slater' because he worked as a roofer (p. 20).

5. Van der Stighelen 1995, op. cit., pp. 255–6.

6. Id. 1994, op. cit., pp. 19, 30, notes 14–15.

7. Relations between Franchois van Dyck and the Comperis family remained good after Maria Comperis's death. Jan Comperis acted as witness at the marriage of Franchois van Dyck and Maria Cuypers and Franchois van Dyck was appointed Jan Comperis's joint executor on the latter's death on 27 July 1607 (Stadsarchief [hereafter SAA], Antwerp, N 1188, [fol. IV]).

8. Id. 1994, op. cit., pp. 19, 30–31, note 22. F.J. Van den Branden's notes (SAA) refer under the heading of 'Cupers' to 'Abraham Cupers, Michielssone', son of a master painter, who was said in January 1600 to have been a pupil of Otto van Veen. This implies that he may have trained at Van Veen's studio at the same time as Rubens. Van den Branden does not cite the source fully and I have been unable to locate it. On 8 May 1655, three 'portrait painters' appeared before the notary A. Rademakers (SAA, N 995, no foliation). Their names were Joan Paulo Gilemans, 37 years old, Johannes van Dale, also 37, and Christoforos Cuypers, 55. The relationship is not clear, but we are dealing here with a portrait painter born a year later than Anthony van Dyck with his mother's maiden name. No further information is forthcoming from the register of the Guild of St Luke. Maria Cuypers was also related to Paulina Cuypers, wife of the painter Jan Snellinck. See Adolf Monballieu, 'Aantekeningen bij de schilderijeninventaris van het sterfhuis van Jan Snellinck (1549–1638)', Jaarboek van het Koninklijk Museum voor Schone Kunsten Antwerpen, 1989, pp. 245–68.

9. Catharina, b. 18 Oct. 1590; Maria, b. 30 Oct. 1592; Franchois, b. 29 Oct. 1594; Cornelia, b. 4 Jan. 1598; Susanna, b. 15 Sept. 1600; Anna, b. 9 Dec. 1601; Dierick, b. 7 April 1605; Elisabeth, b. 2 Oct. 1606. See F.J. Van den Branden, notes (SAA) under 'Van Dyck'.

10. The grandmother, Lynken Cuypers, probably moved in at that time to 'tCasteel van Ryssel', a property purchased by the couple in 1599. Her will was drawn up on 21 December 1607 'ten woonhuyse van voirgenoemde testatrice genoemt tCasteel van Rijssel gestaen ende gelegen inde Cortte Nieuwstrate binnen deser stadt van Antwerpen'. See Van der Stighelen 1995, op. cit., p. 287. Cf. F.J. Van den Branden, Geschiedenis der Antwerpsche Schilderschool, Antwerp 1883, p. 694.

11. Van der Stighelen 1994, op. cit., pp. 34–5, doc. 4.

12. Cornelis de Bie, Het gulden cabinet vande edel vry schilder const, Antwerp 1661, p. 78. The text continues: 'Soo heeft sy mette naeld' seer aerdich net gesteken, een chou cleet wonder fray, en vol van cloecke treken, Seer wel gecoloriert en wonder wel ghestelt, Dat de Histori van de schoon Susan af belt.' Van den Branden 1883, op. cit., II, p. 213, refers to 'zijne kunstlievende moeder, door wie hem zijne begaafdheden ingeboren waren'. Bellori 1672, p. 254, also mentions 'la madre s'impiega nel ricamo'.

13. Cornelis de Bie lived in Lier where Van Dyck's illegitimate daughter Maria Theresa also lived from 1642. It is possible, therefore, that he received the information from her. See also Katlijne Van der Stighelen, Van Dyck, Tielt 1998, p. 33.

14. In his account of the artist's life, Vasari quotes Michelangelo as saying: 'with my mother's milk I sucked in the hammer and chisels I use for my statues.' This does not imply, however, that Michelangelo owed his gifts to his mother.

CAT 27, detail

See Giorgio Vasari, *Lives of the Artists*, transl. by George Bull, Harmondsworth 1987, 1, p. 326.

15. See Van der Stighelen 1995, op. cit., pp. 251–6.

16. Bellori 1672, op. cit., p. 253.

17. Zirka Zaremba Filipczak, *Picturing Art in Antwerp*, Princeton 1987, p. 91.

18. See Van der Stighelen 1995, op. cit., pp. 244–5.

19. Ibid., p. 245, and Van der Stighelen 1994, op. cit., p. 40, doc. 14.

20. Van der Stighelen 1994, op. cit., p. 37, doc. 8.

21. He argued that neither was entitled to act as guardian and complained that their administration was abysmal.

22. SAA, PR 256, fol. 179. He married Katelijn Kanewers on 8 February 1616. His brother-in-law Adriaen Diericx acted as witness.

23. Van der Stighelen 1994, op. cit., pp. 38–9, doc. 11.

24. Ibid., p. 39, doc. 12.

25. Van der Stighelen 1995, op. cit., p. 249.

26. Cf. White 1995, p. 29: 'The family was very religious; three of his sisters became nuns and his youngest brother a priest. Anthony, like his father before him, joined a religious confraternity in Antwerp.' Membership of religious groups was normal at the time. Most artists belonged to one of the Jesuit brotherhoods. See Walter Scheelen, *De Brusselse Jezuïeten en de schilderkunst*, 1, unpublished dissertation, K.U. Leuven 1985, pp. 149–57.

27. The image of Van Dyck's family remained untarnished in contemporary sources. Reference has already been made to Bellori (see note 16, above) and a similar conclusion is suggested by a letter from Francesco Vercellini to the Earl of Arundel on 17 July 1620. See White 1995, p. 58.

28. Howarth 1990, p. 709.

29. For Van Dyck's relationship with the Earl of Arundel, see White 1995, pp. 57–66.

30. Cf. Van der Stighelen 1994, op. cit., pp. 20–21.

31. This is evident from the payment for his contribution to the Rosary cycle in the church of St Paul, Antwerp, in 1617. See cat. 7 and Mark Robbroeckx, 'De vijftien Rozenkransschilderijen van de Sint-Pauluskerk te Antwerpen', unpublished thesis, R.U. Gent, 1972, p. 10.

32. Cf. Erik Duverger, *Antwerpse kunstinventarissen uit de zeventiende eeuw*, Fontes Historiae Artis Neerlandicae. Bronnen voor de kunstgeschiedenis van de Nederlanden, IV, Brussels 1989, pp. 200–11.

33. Letter from P. P. Rubens, 11 May 1611. See Max Rooses and Charles Ruelens, *Correspondance de Rubens et documents épistolaires concernant sa vie et ses œuvres*, II, Antwerp 1898, pp. 35–6.

34. Cf. Larsen 1975, p. 47.

35. Cf. Ronald de Jager, 'Meester, leerjongen, leertijd. Een analyse van zeventiende-eeuwse Noord-Nederlandse leerlingcontracten van kunstschilders, goud-en zilversmeden', *Oud-Holland*, CIV, 1990, pp. 69–112.

36. Van Balen was anything but a portrait specialist; see the portrait he painted of himself and his wife for their memorial in the Antwerp church of St James. See *Verzameling der Graf- en Gedenkschriften van de Provincie Antwerpen. Arrondissement Antwerpen, 2, Antwerpen – Parochiekerken, I*, Antwerp 1863, p. 215.

37. See Van der Stighelen 1994, op. cit., pp. 45–6, doc. 22–3, with reference to Galesloot 1868, pp. 561–606.

38. Van den Branden 1883, op. cit., II, p. 215: '*ten jare 1615, eer van Dijck naar Italië vertrok*'.

39. Margaret Roland, 'Van Dyck's early workshop, the Apostle Series, and the Drunken Silenus', *The Art Bulletin*, 1984, p. 216: 'Surely, having entered the services of the King of England, Van Dyck would set up a studio of his own, the one in the Dom van Ceulen.'

40. Van der Stighelen 1994, op. cit., p. 27, doc. 16 ('*Gestoriboek van ons clooster van Sinte Caterina van sene in Antwerpen*').

41. For examples where this rule was contravened, see Van der Stighelen 1994, op. cit., p. 32, notes 49 and 52. Another painter who worked in Antwerp autonomously without a master's title is Christiaan Luyckx. Although he did not become a master until 1645, he was already working on his own account in 1644. He produced some paintings on commission, while others were sold '*vuytter handt*' (privately). See Erik Duverger, *Antwerpse kunstinventarissen…*, V, Brussels 1991, pp. 179–81.

42. In Washington 1990–91, p. 80, the portrait is dated to c. 1613, which seems untenable to me in the light of the 1613 portrait.

43. See Roland 1984, op. cit., p. 223, Appendix V: '… *Comparuit Sr. Herman Servaes constschilder … ende Peeter Bom oock constschilder … presenterende waerachtich te sijne te weten den eersten affirmant dat hij in den tweelffjarigen treves … als discipel werckende ende frequenterende de conste ten huyse van den chevallier van Dijck in sijnen leven constschilder alhier was, heeft gesien dat den voors. van Dijck heeft geschildert aen seker stuck representerende eenen Droncken Silenis…*'

44. Van der Stighelen 1994, op. cit., p. 46, doc. 23, with reference to Galesloot 1868, op. cit., p. 598.

45. The age of Herman Servaes is revealed in a 1668 document in which he says he is '*ontrent de t'seventich jaeren*'. In other words, he was born in 1598. See note 43 for the source.

46. See Brown 1991, pp. 34–5, note 43.

47. Washington 1990–91, p. 19.

48. The Antwerp portrait (from the collection of the Kimbell Art Museum, Fort Worth, Texas, inv. no. ACF 55.1) has been attributed to Van Dyck by several authors. For an overview, see Hans Vlieghe, *Portraits*, Corpus Rubenianum Ludwig Burchard, XIX–2, London 1987, pp. 77–8, no. 89.

49. See Vlieghe 1987, op. cit., and compare with the drawing in the Albertina, Vienna, which was almost certainly copied from the first version of the portrait.

50. Hans Vlieghe's observation that there is a striking similarity to Rubens's portrait of Jan Brueghel the Elder's son in the Courtauld Gallery, London (see cat. 15, fig. 1) does not imply an attribution to Rubens. Van Dyck was a close friend of Jan Brueghel the Elder's eldest son and could have seen the portrait at the Brueghel family home, serving in this way as a source of inspiration.

51. See Robbroeckx 1972, op. cit., pp. 3–12.

52. For the 1611 portrait of Rogier Clarisse and his wife Sara Breyll, see Vlieghe 1987, op. cit., pp. 71–3, nos. 84–5. For the relations between Rubens, Richardot, Woverius and members of the Clarisse family, see Chris De Maegd, 'Een einde en een nieuw begin: de creatie van een hof van plaisantie te Lembeek in 1618', *Monumenten & Landschappen*, XVII, 1998, pp. 6–14. Jan van den Broeck may have been related to Alexander van den Broecke, an Antwerp silk merchant who also served as alderman on several occasions. See Floris Prims, 'De Spiegel op de Oude Beurs', *Antwerpiensia*, III, 1929, pp. 421–8. Nor could any information be found regarding the patron of Van Balen's *Annunciation*, although Peter Spronck paid the highest price for his painting. See note 31, above.

53. As noted by Julius S. Held in 'Van Dyck's Relationship to Rubens', in Barnes and Wheelock 1994, p. 67, the painting in question may be identified as the work of the same name in the Prado, Madrid. His assessment of the style is particularly relevant: 'To the best of my knowledge no one has tried, let alone succeeded, in discovering a hand different from that of Rubens in the work.'

54. Van den Branden 1883, op. cit., p. 702. Coques confirmed in 1682 that he still had a financial stake in '*de stucken van Decius, geschildert van van Dijck, naer de schetzen van Rubbens*'. They are described in the inventory of Jan Baptist van Eyck's estate of 6 July 1692 as '*Ses stucken schilderije, geordonneert door den heere Rubbens ende opgeschildert door den heere van Dijck, wesende de Historie van den Keyser Dicius*'. Bellori (1672, op. cit., p. 254) also attributed the cycle to Van Dyck: '*Fece li cartoni e quadri dipinti per le tapezzerie dell'istorie di Decio ed altri cartoni ch'egli per lo grande spirito risolveva facilmente*'.

55. Held, in Barnes and Wheelock 1994, pp. 67–8. In spite of the documentary evidence, Held plays down Van Dyck's share in the overall project: 'What we surely will have to accept is that Van Dyck must have been involved to some degree in the production of the large canvases, as other collaborators may have been'.

56. The stylistic relationship is also illustrated by the fact that several art historians have yet to be persuaded that Van Dyck was the author of the ensemble, in spite of the extant documents. For a review of the literature, see Reinhold Baumstark, *Peter Paul Rubens: Tod und Sieg des römischen Konsuls Decius Mus*, Vaduz 1988, p. 23, note 37.

57. For the intellectual circle around Rubens and his brother Philip (a pupil of Lipsius), see Mark Morford, *Stoics and Neo-Stoics: Rubens and the Circle of Lipsius*, Princeton 1991, *passim*, and Frances Huemer, *Rubens and the Roman Circle: Studies of the First Decade*, New York and London 1996, pp. 3–86. Rubens's intellectual interests are also apparent from the way he built up his collection. See also Muller 1989, p. 65.

58. See Jan Denucé, *De Antwerpsche 'konstkamers'. Inventarissen van kunst-verzamelingen te Antwerpen in de 16e en 17e eeuwen*, Antwerp 1932, pp. 316, 318.

59. Barnes, in Washington 1990–91, pp. 24–5.

60. Washington 1990–91, p. 75.

61. See Katlijne Van der Stighelen, 'Anthony van Dyck et Cornelis de Vos face à face', in *L'Art et les révolutions, XXVIIᵉ Congrès International d'Histoire de l'Art, Strasbourg 1–7 septembre 1989. Actes*, Strasbourg 1992, pp. 63–76.

62. J.P. Mensaert, *Le peintre amateur et curieux, ou description générale des tableaux des plus habiles maîtres, qui font l'ornement des églises, couvents, abbayes, prieurés et cabinets particuliers dans l'étendue des Pays-Bas autrichiens*, 1, Brussels 1763, pp. 127–8: '*Aussi est-il arrivé quelquefois que des personnes de qualité & autres ayant envoyé demander à Rubens de faire leur portrait, il les a renvoyées à de Vos, disant que ce peintre s'en acquitterait tout au moins aussi bien que lui.*'

63. See Barnes, in Washington 1990–91, p. 23.

64. I hope to expand the argument at the Van Dyck colloquium in Antwerp in May 1999.

65. See Arthur K. Wheelock, in *Masterworks from Munich: Sixteenth- to Eighteenth-Century Paintings from the Alte Pinakothek*, exh. cat., Washington 1988, p. 95; Liedtke 1984–5, p. 20.

66. Barnes, in Washington 1990–91, p. 167. See Denucé 1932, p. 356: the painting was estimated at 200 guilders.

67. This date is generally accepted, as the canvas was already in England in the 17th century, where it was described by John Evelyn in the Earl of Arlington's house in 1677. See Liedtke 1984, p. 68.

68. There was nothing unusual about men wearing rings on their little fingers in the 17th century. I have been unable, however, to find any parallel for the heart-shaped jewel. There is no evidence that the painter actually wore a ring like this – it remains an unusual accessory. The artist does not wear a ring in other self-portraits.

69. Bellori 1672, op. cit., p. 259, made an early comparison of the 'pittore cavalleresco' and Parrhasius: '*Contrastava egli co la magnificenza di Parrasio, tenendo servi, carrozze, cavalli, suonatori, musici e buffoni…*'. Concerning the tradition that Parrhasius wore a purple cloak, see M.G.L. Hammond and H.H. Scullard, eds., *The Oxford Classical Dictionary*, 2nd ed., Oxford 1978, pp. 784–5. Pliny also mentioned Parrhasius' arrogance and self-promotion. See *Pliny Natural History in ten volumes*, Volume IX: Libri XXXIII–XXXV, trans. H. Rackham, Cambridge and London 1968, pp. 314–15: 'Parrhasius was a prolific artist, but one who enjoyed the glory of his art with unparalleled arrogance, for he actually adopted certain surnames, calling himself the "Bon Viveur", and in some other verses "Prince of painters", who had brought the art to perfection…'

70. We know from the biography of Philip Rubens, the painter's nephew, that Rubens liked to have passages from antique authors read aloud when he was working. Cited in Roger de Piles, *Conversations sur la connoissance de la peinture et sur le jugement qu'on doit faire des tableaux. Où par occasion il est parlé de la vie de Rubens*, Paris 1677, p. 181ff. The fact that Rubens drew inspiration from

Parrhasius has been persuasively argued by Julius S. Held. See Vlieghe 1987, op. cit., p. 177, no. 142.

71. The question arises of whether his lifestyle could already be described as luxurious around 1620. Details are scarce, but we know that 'Den Dom van Ceulen' cost 420 guilders a year to rent, which was an exceptionally high price. The sub-prioress mentions '*des groote huyshuer*'. See Van der Stighelen 1994, op. cit., p. 42. The average rent paid by painters in Antwerp did not exceed 150 guilders; see Francine Van Cauwenberghe-Janssens, 'De sociale toestand van de Antwerpse schilders in de 17de eeuw', *Jaarboek Koninklijk Museum voor Schone Kunsten Antwerpen*, 1970, pp. 233–40.

72. See *Pliny Natural History…*, 1968, op. cit., pp. 310–11.

73. Bellori also associated Van Dyck with Zeuxis in an aside when writing about the artist's time in Italy: '*Siché imitando egli la pompa di Zeusi…*' See Bellori 1672, op. cit., p. 255. Significantly, Carel van Mander also stressed Parrhasius' expressive qualities in *Den Grondt…*. See ed. Hessel Miedema, *Karel van Mander, Den grondt der edel vry schilder-const*, 11, Utrecht 1973, p. 509: 'VI 66a: Parasius: 'He was the first who really paid attention to the expression and vivacity of the countenance.'

74. If the portrait of Van Dyck in the Rubens House in Antwerp is not by Rubens, the only evidence of a close emotional bond between the two painters disappears. The portrait of *Isabella Brant* belongs to a different category, in that it could equally well have been a 'normal' commission placed by Rubens with Van Dyck. There might also be some truth in the tradition that Van Dyck gave Rubens the portrait as a farewell present (see Washington 1990–91, pp. 141–2). It is not clear to me that a gift of this kind has necessarily to be interpreted as a token of appreciation towards his master. In the first place, it might have reflected Van Dyck's affection for Isabella Brant rather than for Rubens. Secondly, Van Dyck will surely have been aware that his portrait of *Isabella Brant* was all but assured a permanent place of honour in Rubens's house. Viewed in this light, if the painting was indeed intended as a gift, it may have been part of a clever public relations strategy on Van Dyck's part.

75. For a review of how Rubens was seen on a personal basis, see Arnout Balis, 'Rubens: beeld en tegenbeeld. iets over dissidente Rubensbiografieën', in *Rubens and his World. Bijdragen-Etudes-Studies-Beiträge. Dedicated to Prof. R.-A. d'Hulst*, Antwerp 1985, pp. 333–5.

76. Ibid. and see Bellori 1672, op. cit., p. 254. In an interesting passage, Bellori also claimed that Van Dyck saw through this manoeuvre on Rubens's part, which is why he left the studio: '*Se distolse peró Antonio dalle scuola del Rubens*'. See also in this context: Christiaan Mees, '*En seggen wat Van Dyck was voor een edel-man'. Een kritische bijdrage tot de studie van de zeventiende-eeuwse biografieën van Anthony van Dyck*, unpublished thesis, K.U. Leuven 1989, pp. 6–10.

77. See Van den Branden 1883, op. cit., p. 746, and Stadsarchief, Lier, Parochieregister 378, 16 February 1642: Gabriel Franciscus is baptised as the son of Gabriel Essers and Maria Lycretia [sic] van Dyeck, '*coniuges*'.

Genoa and the Genoese
at the Time of Van Dyck

PIERO BOCCARDO

In memory of Giorgio Doria

One of the most faithful 'portraits' of Genoa, the painting of 1616 attributed to Gerolamo Bordoni (fig. 27), gives a panoramic view of the city very much as Anthony van Dyck must have seen it on his arrival five years later.[1] On its northern side, Genoa is encircled by 16th-century walls[2] which meander sinuously over the uneven terrain, and by hills that rise abruptly from the sea; in the painting the hills form part of the horizon. The southern part of the city, by contrast, opens towards the sea like an amphitheatre: in the foreground are the jetties and docks of the Porto Vecchio, and an expanse of sparkling water criss-crossed by craft of every size and type, from rowing boats to men-of-war. It is immediately apparent how essential maritime trade was to the Ligurian capital, compared with over-land routes. The fabric of the city, which has survived almost intact to this day, consists of buildings packed tightly together, with few open spaces and even fewer squares, interspersed with churches, public buildings and, most striking of all, the monumental private palaces for which the city had been famous since medieval times. On the edge of the city, to the east and west of the port, are gardens and vegetable plots; in this view it is difficult to spot the extraordinary number of fine houses concealed along the coast from the suburb of Albaro (fig. 28) to Nervi, and from Sampierdarena (fig. 29) to Voltri.[3]

It is the palaces, in the city and beyond its walls, that provide the most telling evidence of the exceptionally favourable economic circumstances enjoyed in Genoa at this period, the consequence of policies adopted by Andrea Doria in 1528.

FIG 27
Attributed to Gerolamo Bordoni, *View of Genoa in 1616*
oil on canvas, 125 × 172 cm
Collection of Prince Domenico Pallavicino

FIG 28
Carlo Antonio Tavella, *View of the Hill of San Nazaro in Albaro*
pen and ink, 29.9 × 43.9 cm
Gabinetto Disegni e Stampe di Palazzo Rosso, Genoa

CAT 32, detail

That great admiral made a pact with the Emperor Charles V under the terms of which Genoa came into the orbit of the Spanish Empire thereby forfeiting her independence; at the same time he managed temporarily to halt internal feuding by introducing a rigorous republican constitution which placed power in the hands of a restricted number of families, from whose ranks were selected the members of the government and the Doge, who was elected every two years.[4] At that date too, the Genoese merchants, anticipating the end of the possibility of trading in the former colonies in the Near East – which were threatened by the rapid expansion of the Turkish Empire – had switched their attention to the western and central Mediterranean and to the North Sea. Soon they set up an exceptionally efficient commercial network, frequently based on family connections, which reached from southern Italy to the Iberian peninsula and to Flanders, and which coincided with the European possessions of the Spanish Habsburg monarchy. Most of the mercantile activity was, initially, tied to the production of, and trade in, fabrics, but, as one of the chief problems of the kingdom on which 'the sun never set' was that of maintaining a regular flow of capital throughout its territories, and in particular to assure that the army was regularly paid every month, the movement of money and loans became the major source of speculation and of income for the Genoese. At the end of the 16th century there were at least 20,000 Genoese merchants and bankers in Castile and Aragon, while in Antwerp, the 37 commercial and financial agencies active in 1551 grew to 147 by 1640: the Genoese community was by far the most important of the foreign colonies, designated a 'nation' with its own consul from 1720.

After 1528 money began to flow into the pockets of the urban ruling class; it was raised through traditional commercial activities, such as the chartering of ships (particularly warships) and, above all, through interest earned on the immense loans sought by (and often granted to) the Spanish Crown. Genoa soon became the chief beneficiary of the precious metals that began to arrive in large quantities from the mines of Mexico and the Andes. In 1595 the Venetian ambassador Francesco Vendramin estimated that over the past 60 years approximately 30% of the gold and silver imported from the New World into Spain ended up 'in Genoese pockets'; in the five years between 1626 and 1630, more than half of the money coming into Seville found its way to Genoa. It was at this time that Francisco de Quevedo described the flow of money in a few acerbic lines:

> *Poderoso caballero es don Dinero*
> *nace en las Indias onorado*
> *donde el mundo le acompaña*
> *vien a morir en España*
> *y es en Génova enterrado.*[5]
> (Lord Money is a powerful gentleman, born with honour in the Indies, where the world is at his feet; he comes to die in Spain and is buried in Genoa.)

The capital that accumulated was never 'buried' but, following the example of Andrea Doria, was reinvested in property, in the purchase of estates, especially in southern Italy, in silver, works of art or other 'luxury items'.[6] In 1601 Monsignor Agostino Agucchi was travelling to France in the entourage of Cardinal Aldobrandini and noted in his diary apropos Genoa: 'In few other places in Italy can such magnificence be displayed, as in very few places can such gold and silverware, such jewellery and fabrics, and such rich furnishings be seen as here, in addition to the palaces and royal residences, which have no rivals elsewhere; and most striking of all is the enormous abundance of ready cash.'[7]

Vincenzo I Gonzaga, Duke of Mantua, stayed in Genoa several times in the first decade of the 17th century, favouring in particular the villas of Sampierdarena; he was attracted as much by the bracing climate and pleasant location as by the luxurious lifestyle described by Monsignor Agucchi, and also enjoyed the opportunity to raise loans to offset Mantua's debts. In the relations between the Duke and the Genoese

bankers – who were also often his hosts – Peter Paul Rubens assumed an important role; he was in the service of the Duke of Mantua from the summer of 1600. As part of the Duke's diplomatic campaign, the great Flemish artist produced paintings which help us to understand Genoese life and society at this date. It is not certain if Rubens's first Genoese commission, to paint the enormous altarpiece of the *Circumcision* for the high altar of the Jesuit church, S. Ambrogio, came to him from the family of the Duke's chief financier, Nicolò Pallavicino; but Rubens's portrait of Pallavicino's wife, Maria Serra (fig. 30), provides the most dazzling picture of the Genoese aristocracy of the day and could justifiably be interpreted, given its dedication, as a princely gesture of gratitude on the part of the painter to his hosts (the Genoese banker subsequently became godfather to the painter's second son).[8] Interestingly, Rubens depicted his sitter as a sovereign rather than as a member of the ruling class of a republic and, equally interestingly, he found the Genoese palaces – which he described as 'exceedingly beautiful and comfortable' – so admirable that he decided, on his return to Antwerp, to publish a set of plans and elevations of those he most admired: the collection of engravings in the two editions of *Palazzi di Genova* is one of the indispensable documents for the study of the way of life of the period (figs. 31, 32, 37).[9]

As the effusive literary outpourings of the 17th to the 19th centuries make clear, the private palaces of Genoa were always admired; evidently they represented supreme status symbols for their owners, but it is also worth considering the extent to which they were symptomatic of the curious relationship that had grown up between the Republic and the members of the ruling oligarchy. The history of Genoa between the 13th and the 15th centuries, and the prevalence of private rather than public ownership, meant that the state's seat of government did not carry the symbolic weight that in other Italian cities was translated into imposing and monumental buildings. Even after substantial alterations made in the 1590s, the Ducal Palace in Genoa could never compete in magnificence with the palaces of the ruling oligarchy. This made it necessary for the Senate, in 1576, to draw up lists of palaces and their owners who would draw lots for the honour of providing hospitality or lodging to visiting foreign dignitaries. The lists were divided into two, then three (1588, 1599, 1614) and finally four categories (1664). Palaces within the walls were chosen according to the rank of the visitors, and even if few were judged suitable for the reception of 'Popes,

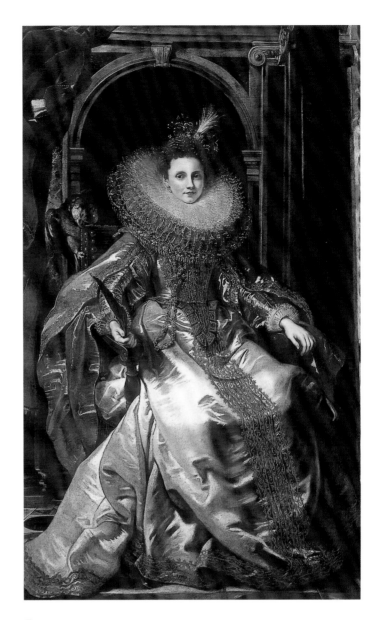

FIG 30
Peter Paul Rubens, *Maria Serra Pallavicino*, 1606
oil on canvas, 241 × 140 cm
The National Trust, Kingston Lacy

Emperors, Queens and their sons, brothers and nephews', there were still about twenty houses deemed to be 'first class for Cardinals and great Princes, independent princes, and for the Viceroys of Naples and Sicily and the Governors of Milan', and sixty 'of second class for other, lesser Princes and for the Ambassadors from Popes, Emperors and Kings or others whom the Most Serene Senate deems it desirable to honour with accommodation'.[10]

The requirement that private citizens should perform formal public duties may seem paradoxical but was inevitable, given that the state itself was not (or did not wish to be) in a position to carry them out. On the other hand, the lists allow

FIG 31
*Section through the Villa of
Tobia Pallavicino, called
'delle Peschiere'*
pen and ink
Royal Institute of British
Architects, London

FIG 32
*The Façade of Palazzo
Doria, Duchi di Tursi,
formerly the Palace of
Nicolò Grimaldi*
engraving in Peter Paul
Rubens, *Palazzi moderni
di Genova*, Antwerp 1622,
pl. 67

FIG 33
Domenico Fiasella, *The Feast of Ahasuerus*
Palazzo Lomellini, now Palace of the Comando Militare di Zona, Genoa

us to appreciate the number of private citizens whose palaces were of a quality and whose finances were buoyant enough to fulfil these obligations. Paintings of the period give a vivid picture of the financial and social investment made on behalf of the Republic's illustrious guests (fig. 33).

It is not my intention, however, to give the impression that the Genoese upper class constituted a homogeneous social group. In fact, within the three hundred or so families inscribed in the *Libro d'oro* at the beginning of the 17th century from whose ranks government servants were selected, political and social rivalries were as bitter and intractable as elsewhere.[11] The main division was between the 'Old Nobility', those families belonging to the older aristocracy of the city, who were, however, engaged in trade and finance, and the 'New Nobility', those families who had made their fortunes in trade in the 16th century – generally in silk and other textiles – and who, thanks to their new-found wealth, were now eligible to serve in government. Even the first group, however, was not particularly homogeneous: for example, some of the famous families like the Spinola, the Doria or the Lomellini were divided into numerous branches, so that people with the same name might have very different financial circumstances, political allegiences and cultural interests. It is not possible to generalise about families without distorting the facts; in the case of the dynasties already mentioned, the term 'family' is probably inadequate to express the innumerable ramifications between the various branches.

The Genoese ruling classes generally conducted commercial and financial business, as well as affairs of state, in the privacy of their palaces. Financial boom and bust (far more frequent than might be imagined because it was often linked to the uncertainties of shipping) and the movement of capital for the payment of dowries and inheritances led to the rise of some families and the fall of others. These factors inevitably affected the attitude of the Genoese ruling classes to building and maintaining one or more palaces, in the city or beyond its walls, and, more generally, their attitude to commissioning works of art.[12] Art collections were assembled by people motivated by a genuine interest, or simply by fashion or by the desire to speculate. Art was one of the most eloquent status symbols, indicative of an elevated social position, yet in Genoa there was no 'official' taste such as might have existed at a court presided over by a ruler.

A characteristic example of the symbolism attached to the external appearance of a palace involves Nicolò Grimaldi,

known in his day as 'the monarch' because of his colossal wealth. Grimaldi, one of the leading financiers to Philip II, King of Spain, was involved in the extraordinary scheme, both in terms of town-planning and social engineering, which resulted in the opening of the Strada Nuova (now called Via Garibaldi) in the second half of the 16th century (fig. 34). In this new street the palaces of virtually all the richest and most noble Genoese families were subsequently built; thereby all the most powerful dynasties were concentrated in one area of the city. In order to construct his own palace (fig. 32), Grimaldi acquired three adjacent building plots, reserving the two on either side – in a city where open space was at a premium – for gardens.[13] In contrast to this extravagance was the simple house of the younger Nicolò Pallavicino, the brother and brother-in-law of the owners of palaces illustrated in *Palazzi di Genova* and a generous patron of Rubens; evidently his house was unexceptional since it never appeared in the lists of residences suitable for state hospitality. The house of Giovanni Carlo Doria must have seemed almost equally modest: it figured only once in the lists (in the lowest category), yet at this period its owner had assembled one of the most outstanding collections of paintings in living memory. The fact that Doria, who had been painted by Rubens (fig. 35), Vouet and other major artists, was entirely forgotten until recently is indicative of one aspect of Genoese history, namely that, alongside official and public history,

there exists an equally important private history. Recent research has brought to life certain characters and has helped our understanding of the social and cultural environment in which Van Dyck worked.

Art and collecting in early 17th-century Genoa revolved around the figure of Giovanni Carlo Doria. His family background was unusual. His grandfather Giacomo Doria had been painted by Titian (Wernher Collection, formerly at Luton Hoo), the only Genoese sitter of Titian's on record; evidently he regarded the act of having his portrait painted by one of the most celebrated artists of the 16th century as a means of promoting himself outside Genoa. His uncle was painted by Tintoretto (private coll., New York), while in 1606 his father, his older brother's wife, Brigida Spinola Doria, and he himself were all painted by Rubens. The extraordinary number of family portraits, probably only rivalled by portraits of royalty, suggests that they were regarded as status symbols; Van Dyck's later success as a portrait painter was built on the high esteem in which portraiture was already held in Genoa.[14]

These portraits all hung in Giovanni Carlo's palace, but made up only a fraction of his collection, which comprised about 900 works, including a *St Jerome*, a *Danaë* and a *Venus and Adonis* by Titian, several paintings by Tintoretto, *The Battle for the Standard* (recently attributed to Leonardo da Vinci; previously in a private collection in Naples, present whereabouts unknown); a 'small painting with three figures'

F I G 3 4
Giovanni Lorenzo Guidotti after Antonio Giolfi, *View of the Strada Nuova, Genoa*, 1769
engraving
Collezione Topografica del Comune di Genova

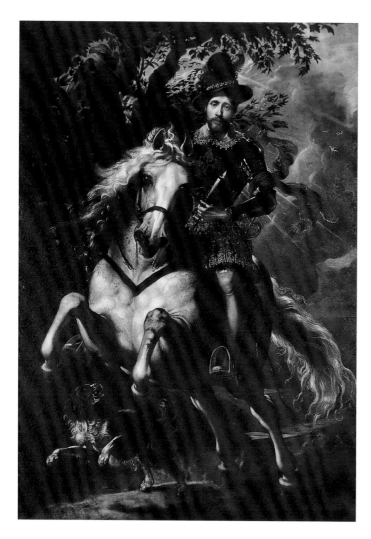

F I G 3 5
Peter Paul Rubens, *Equestrian Portrait of Giovanni Carlo Doria*, 1606–7
oil on canvas, 265 × 119.5 cm
Galleria Nazionale della Liguria a Palazzo Spinola, Genoa

by Perugino; works by Bronzino and Rosso Fiorentino, by one of the Carracci, by Guido Reni, and an exceptional group of paintings by Giulio Cesare Procaccini. Of Flemish painters there were, besides Rubens, Guilliam van Deynen and Jan Wildens who, before Van Dyck's arrival, had settled temporarily in Genoa. It is not surprising to learn that in Genoa between 1602 and 1619, and especially between 1620 and 1650, there was an active colony of Flemish painters second only in importance to that in Rome: the frequent contact with the Genoese community in Flanders, and the opportunities for work in a city in which a significant section of the ruling class had ample funds for artistic patronage, made the Ligurian capital almost an obligatory stop for artists travelling from Flanders to Rome.[15]

Genoese artists were also well represented in Doria's collec-

tion, including Luca Cambiaso, Giovan Battista Paggi and Bernardo Strozzi. Giovanni Carlo allowed artists to copy works in his collection and in his *Wunderkammer* with its heterogeneous collection of natural curiosities. Among those who frequented this private school were Sinibaldo Scorza, Gioacchino Assereto and Luciano Borzone. Strozzi, who at an early age became a Capuchin friar, was able, thanks to the protection of the Doria family, to pursue a career as a painter outside the monastery for nearly fifteen years; however, only months after the death of Giovanni Carlo in July 1625, Strozzi was indicted by the ecclesiastical authorities for working as a painter, something he had been doing quite openly for years.[16]

It is impossible to explain why this indefatigable collector, who was commissioning paintings from Procaccini and Vouet in 1621–2, did not take advantage of Van Dyck's presence in the city, particularly since the Italian Sketchbook proves that Van Dyck visited his house and sketched pictures in his collection (fig. 36). It cannot be excluded, however, that the chief obstacle was the hostility of the Genoese artists most closely associated with the Doria family: with the exception of Giovan Battista Paggi, who, because he belonged to the nobility, did not practice painting as a profession, Castellino Castello and, perhaps, the young Giovanni Benedetto Castiglione, later called Grechetto – most Genoese artists did not view favourably the remarkable success of the Fleming. Not only did Van Dyck not paint genre subjects like his fellow-countrymen, but he was treated with respect, if not with familiarity, by his noble patrons.[17] Van Dyck was also received in the palace in which a cousin and a brother of Giovanni Carlo Doria both had apartments. The cousin, Giovanni Stefano Doria, was reputed to be 'the richest man in Italy'; the brother, Marcantonio Doria, was painted by Fabrizio Santafede, Giovanni Bernardo Azzolino, Battistello Caracciolo, Simon Vouet and Justus Sustermans in the course of his long life. He liked Neapolitan painting, acted as a host to Caravaggio and commissioned Caravaggio's last great work, *The Martyrdom of St Ursula* (Banca Commerciale Italiana, Naples).[18]

Paintings by such masters helped Van Dyck familiarise himself with Italian painting. Other works he may have found less interesting. For example, the collection of Giovanni Agostino Balbi, a member of one of the most upwardly mobile families of the 'New Nobility', included a priceless group of 16th-century Flemish paintings, bought by Balbi in

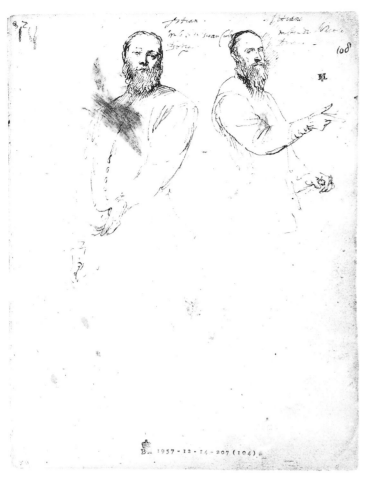

FIG 36
Anthony van Dyck, studies after two portraits by Tintoretto,
once in the collection of G. C. Doria, now in the Uffizi, Florence,
and the Museo Cerralbo, Madrid
fol. 104r of the Italian Sketchbook, erroneously inscribed by Van Dyck *'Titian'*
British Museum, London

FIG 37
The Façade of the Palace of Giovanni Agostino Balbi
engraving in Peter Paul Rubens, *Palazzi moderni
di Genova*, Antwerp 1622, pl. 21

Antwerp on his numerous trips to that city when trading in yarn and fabrics.[19] Van Dyck may have seen at least some of those paintings in Antwerp, since Balbi had visited the city in 1620–21. Before he left for Italy, Van Dyck had painted a portrait of Balbi who thus became the artist's first Genoese patron. They never met again: Balbi set off to Italy, travelling through the Franche-Comté and Switzerland, but was taken ill and died on the St Gotthard Pass. Van Dyck's portraits of Balbi's nephews prove that he renewed contact with the Balbi family in Genoa.[20] An oral tradition that has persisted over the centuries, even when Van Dyck's acquaintance with Giovanni Agostino Balbi in Antwerp was forgotten, identifies a room in Balbi's palace as one in which the artist stayed during his frequent sojourns in Genoa (fig. 37). This information, although unproven, accords well with the only other contemporary record, that Van Dyck was the guest of Lucas and Cornelis de Wael. In fact, since virtually all the Flemish artists who passed through Genoa are said to have stayed with the two brothers, it is as if the De Waels had assumed the role of hoteliers. One might instead suggest that the brothers helped Van Dyck and other Flemish artists by putting at their disposal – perhaps for money – space in their studio. (This would explain how artists who were not working continuously in the city were always able to find studio assistants.) Giovanni Agostino's palace was the first, and most opulent, of several built by the various branches of the Balbi family in the street that still bears their name; it was designed to rival the magnificent residences recently erected in the Strada Nuova by other Genoese families.[21]

Although Genoese women were excluded from holding government office, their position both in society and within the family was very strong.[22] In a city devoted exclusively to trade and finance, where decisions had to be reached swiftly, it was necessary to allow women to manage funds in case of the absence, illness or death of their husbands. Evidence abounds of women's business activities; the Venetian Cesare Vecellio in his treatise on local customs observed: 'These women are the most affable and pleasing women to talk to, with their practical and affectionate conversation. They seem to be the sisters of all the men engaged in traffic and trade'. Their independence corroborated the image of 'liberated women' which characterised the women of Genoa for at least two centuries.[23] What the humanist and future Pope Enea Silvio Piccolomini noted in the 15th century was repeated until the end of the 18th, namely that 'in Italy the city of Genoa could be termed

FIG 38
Giovanni Battista Bianco after the design of Domenico Fiasella,
The Virgin Mary as Queen of Genoa, with plan of the city of Genoa
at her feet, *c.* 1637
bronze, high altar, Cathedral of San Lorenzo, Genoa

the women's Paradise, because women are not as strictly guarded here as they are in other cities'. Bearing this in mind, most of the female portraits – and there are more of them than there are male portraits – painted by Rubens and Van Dyck in Genoa should be viewed in a rather different light. In the case of Van Dyck, the decision of certain upper-class women to have their portraits painted without their husbands was perfectly acceptable, as, for instance, *Geronima Sale Brignole with her Daughter Aurelia* (Palazzo Rosso, Genoa); others were portrayed after they had been widowed, as is the case of *Battina Balbi Durazzo with her Two Sons* (private collection, Genoa), or the unknown lady (Frick Collection, New York), once erroneously identified as Paolina Adorno Brignole, or again the *Genoese Noblewoman and her Son* (cat. 37).

Like these rich, independent women, men also used portraiture to promote themselves. It is no coincidence that the members of the 'New Nobility' painted by Van Dyck adopted the most swaggering poses, or chose to be shown on horseback. Similarly, displays of patriotism during the so-called War of 1625 were expressed in the surprising number of portraits of men dressed in full armour painted by Van Dyck at that time (see cat. 41, 43). In 1625 the Duke of Savoy invaded the Republic in order to gain direct access to the sea; Genoa, which had never before been threatened by a neighbouring state, was totally unprepared and defenceless. Many members of the upper classes took up arms for the first time and drove the enemy from their territory.

One of the first portraits painted by Van Dyck after his arrival in Genoa late in 1621 had the same celebratory intent: Agostino Pallavicino (Getty Museum, Los Angeles) wears a flowing robe – *robone* in Italian – of an unusual red colour. In the spring of 1621 he was sent to Rome to convey the congratulations of the Genoese state to the newly elected Pope, Gregory XV. This embassy explains Pallavicino's red robe: it was customary for Genoese men to wear black.[24] The garment painted by Van Dyck is so magnificent that the Genoese – a century later – believed it was the portrait of a Doge; only Doges wore red, but trimmed with ermine, and they carried a sceptre.

Pallavicino was finally elected Doge in 1637, after a long political career during which his administrative talents were turned to good account working for the Banco di San Giorgio, the cornerstone of Genoese finance, and his diplomatic skills were recognised in a mission to Louis XIII of France. Overweening ambition and self-importance radiate from Van Dyck's portrait, as they do from Pallavicino's other portraits – a second by Van Dyck and one by Fiasella.[25] These portraits were intended to record his career as it progressed, a career that culminated in a remarkable event. When Pallavicino was sent to Rome in 1621, Genoa was ranked only as a duchy, according to the privileges granted by Charles V, although its ambassadors had precedence over those of Florence, Ferrara and Mantua. Genoa was hoping to attain a more elevated status, but the fact that the state was a republic did not help. However, when Urban VIII decreed that all but crowned heads should address cardinals as 'Your Eminence', Genoese pride was stung: an ingenious plan was hatched which won governmental approval, and on 25 March 1637 the Madonna was acclaimed Queen of the Most Serene Republic (the Serenissima). In consequence, the Doge – Pallavicino – wore a royal crown, and the Doge's Palace became a Royal Palace. Initially, the Pope refused to endorse this act of

defiance which threatened the Holy See's relations with other Italian states, but by 1643, thanks to the 'persuasive' use of money, the Emperor Ferdinand III recognised Genoa's claim and the Doge's title of Serenissimo; France, England, Poland and even the Sultan soon followed his lead.[26] Rubens, and, to an even greater extent, Van Dyck, had already explored the peculiar 'Genoese connection' between money and image.

NOTES

1. In this view the mouth of the Strada Balbi, where Van Dyck would have seen the first new palaces, is not clearly shown. For the impact of the city on Van Dyck, see S. J. Barnes, in Genoa 1997, pp. 64–81.

2. In 1626 the Republic began building a new, larger and stronger city wall. This was completed within the space of about seven years and is still almost intact (see fig. 38).

3. On the history of town planning in Genoa, see E. Poleggi and P. Cevini, *Genoa*, Rome and Bari 1981.

4. On these events and their implications, see A. Pacini, 'I presupposti politici del "secolo dei genovesi": la riforma del 1528', *Atti della Società Ligure di Storia Patria*, XXX, 1990.

5. See G. Doria, 'Conoscenza del mercato e sistema informativo: il know-how dei mercanti-finanzieri genovesi nei secoli XVI e XVII', in *La repubblica internazionale del denaro tra XV e XVII secolo*, ed. A. De Maddalena and H. Kellenbenz, Bologna 1986, pp. 57–121; and G. Doria, 'Un pittore fiammingo nel "secolo del genovesi"', in *Rubens e Genova*, exh. cat., Genoa 1977, pp. 13–29, from which the verse by De Quevedo is also taken. The two essays were republished in G. Doria, *Nobiltà e investimenti a Genova in Età moderna*, Genoa 1995. C. Alvarez Nogal, 'Los banqueros de Felipe IV y los metales preciosos americanos (1621–1665)', *Estudios de Historia Económica*, XXXVI, 1997, pp. 23–6, also documents that between 1621 and 1626 Genoese bankers were the creditors for 76% of the Spanish public debt.

6. See P. Boccardo, *Andrea Doria e le arti. Committenza e mecenatismo a Genova nel Rinascimento*, Genoa 1989; and G. Doria, 'Investimenti della nobiltà genovese nell'edilizia di prestigio', *Studi storici*, XXVII, 1986, pp. 5–55.

7. See A. Neri, 'Passaggio del cardinale Pietro Aldobrandini nel Genovesato l'anno 1601', *Giornale ligustico*, IV, 1877, pp. 263–78.

8. See P. Boccardo, catalogue entries in Genoa 1997, pp. 190, 194 and 204. The entries for other paintings in that extraordinary gallery of early 17th-century painting, the Jesuit church, S. Ambrogio, in Genoa, are also relevant. This gives me the opportunity to state that, when examined closely, the coat of arms in Rubens's supposed portrait of Nicolò Pallavicino (see M. Jaffé, 'Rubens and Nicolò Pallavicino', *The Burlington Magazine*, CXXX, 1988, pp. 523–7) suggests that the portrait is not that of the banker, because the Pallavicino and Serra arms are presented side by side: normally a man could use the arms of his father or his mother, but never those of his wife. As Nicolò was the son of Maddalena Spinola, the man in the portrait is more likely to be one of the sons of Nicolò and Maria Serra.

9. See I. M. Botto, 'P. P. Rubens e il volume i "Palazzi di Genova"', in *Rubens e Genova*, exh. cat., Genoa 1977, pp. 59–83; E. Poleggi, 'Un documento di cultura abitativa', ibid., pp. 85–148.

10. See *Una reggia repubblicana. Atlante dei Palazzi di Genova 1530–1664*, ed. E. Poleggi, Turin 1998.

11. See G. Doria and R. Savelli, '"Cittadini di governo" a Genova: ricchezza e potere tra Cinque e Seicento', in *Materiali per una storia della cultura giuridica*, X, 1980, pp. 277–355 (reprinted in Doria 1995); and C. Bitossi, *Il governo dei magnifici. Patriziato e politica a Genova fra Cinque e Seicento*, Genoa 1990.

12. For example, as the financial fortunes of their owners fluctuated, these noble town houses changed hands and names were changed or added; the collections of paintings might be moved to the owner's new residence, sold at auction, divided among heirs or dispersed among other collections.

13. Grimaldi was heavily involved in Philip II of Spain's second bankruptcy and was unable to complete the interior decoration of the building. He ended his days in Madrid in the vain hope of recouping some of his losses.

14. Of the Rubens portraits, the first is lost, the second is in the National Gallery of Art in Washington, DC, and the third has recently returned to the Galleria Nazionale di Palazzo Spinola in Genoa. On the life and collection of these members of the Doria family, see P. Boccardo, 'Ritratti di collezionisti e committenti', in Genoa 1997, pp. 29–58.

15. On the other Flemish painters in Genoa in the first half of the 17th century, see C. Di Fabio, 'Due generazioni di pittori fiamminghi a Genova (1602–1657) e la bottega di Cornelis de Wael', in Genoa 1997, pp. 82–104; and C. Di Fabio, 'Dai Van Deynen ai De Wael. I fiamminghi a Genova nella prima metà del Seicento', in *Pittura fiamminga in Liguria (secoli XIV–XVII)*, ed. P. Boccardo and C. Di Fabio, Cinisello Balsamo 1997, pp. 203–25.

16. See P. Boccardo, 'L'opera grafica: caratteri generali e vicende', in *Bernardo Strozzi (Genova 1581/82–Venezia 1644)*, exh. cat., ed. E. Gavazza, G. Nepi Sciré, G. Rotondi Terminiello, (Genoa), Milan 1995, pp. 277–81. For early 17th-century Genoese painting, see F. R. Pesenti, *La pittura in Liguria. Artisti del primo Seicento*, Genoa 1986; and G. V. Castelnovi, 'La prima metà del Seicento: dall'Ansaldo a Orazio de Ferrari', in *La pittura a Genova e in Liguria dal Seicento al primo Novecento*, Genoa 1987, pp. 59–150.

17. For more detail, see Boccardo 1997, pp. 29–58; and F. Boggero and C. Manzitti, 'L'eredità di Van Dyck a Genova', in Genoa 1997, p. 105.

18. See P. Boccardo, 'Dogi, "Magnifici" e Cardinali: committenza e collezionismo nella classe dirigente genovese nel Seicento', in *Genova nell'età Barocca*, exh. cat., ed. E. Gavazza and G. Rotondi Terminiello, (Genoa), Bologna 1992, pp. 459–63; and Boccardo 1997, op. cit., pp. 29–58.

19. See P. Boccardo, 'Dipinti fiamminghi del secondo Cinquecento a Genova: il ruolo di una collezione Balbi', in *Pittura fiamminga...*, op. cit., 1997, pp. 151–75; and, on the family, see E. Grendi, *Storia di una famiglia genovese: i Balbi tra onore e mercato*, Turin 1997.

20. The portraits are now in the Fondazione Magnani Rocca, Mamiano di Traversetolo; Palazzo Reale, Genoa; a private collection; a fourth, documented portrait is untraced.

21. On these two building enterprises, see C. Di Biase, *Strada Balbi a Genova: Residenza aristocratica e città*, Genoa 1993; and E. Polaggi, *Strada nuova: Una lottizzazione del Cinquecento a Genova*, Genoa 1972.

22. See Grendi 1997, op. cit.

23. These quotations and more on the subject can be found in R. Savelli, 'Genova nell'età di Van Dyck. Sette quadri con un epilogo', in Genoa 1997, pp. 18–28.

24. For more on fashion in Genoa, see M. Cataldi Gallo, 'La moda a Genova nel primo quarto del Seicento', in Genoa 1997, pp. 132–49.

25. See P. Boccardo and C. Di Fabio, entries in Genoa 1997, pp. 274–6.

26. On this see V. Vitale, *Breviario della storia di Genova*, Genoa 1955, pp. 250–59; M. G. Bottaro Palumbo, '"Et rege eos": la Vergine Maria Patrona, Signora e Regina della Repubblica (1637)', *Quaderni Franzoniani*, IV, 1991, no. 2, pp. 36–49.

Van Dyck in Sicily

GIOVANNI MENDOLA

It has always been evident that Sicilians were partial to Flemish painting; evidence of the presence of artists from northern Europe on the island, however, is harder to come by. Recently it has been possible to identify a group of painters from Flanders working in Palermo in the early 1620s. To the well-known names of Van Dyck, Jan Brueghel the Younger,[1] Matthias Stomer and the problematic 'Guglielmo Walsgart' (Willem Walsgart; 1612–66) have been added those of 'Gaspar Mompeer' (Gaspard de Momper), who was in Palermo in 1619, 'Giovanni Basquens' or 'Vasquens' (Jan Basquens; doc. 1620–37) of Antwerp, and 'Geronimo Gerardi' (Hieronymus Gerards, or Gerardi; doc. 1620–48), the last two both being mentioned in documents of 1620.[2] The presence of these three artists in Palermo virtually at the same time suggests that a considerable number of painters of the school of Rubens were arriving in Sicily in those years.[3]

Unlike De Momper, whose visit was brief, the other two painters settled permanently in Palermo, and worked in close collaboration with each other. Their arrival was probably connected with the advent of another Fleming, Hendrik Dych of Antwerp, Consul-General of Flanders and of the German community in Sicily from 1619. Dych was a wealthy merchant, stockbroker, importer and collector of art, who later had dealings with Van Dyck in Palermo, with the Van Uffel brothers and with the Genoese families of Pilo and Della Torre; all were collectors and patrons of Van Dyck.

Although his name figures in a considerable number of documents, the painter Basquens has proved elusive. Gerardi, on the other hand, merits attention both for the quality of his work and for the role he seems to have played as intermediary in the introduction of 'foreign' painters into Sicily,[4] and also probably in the move to the island of artists such as Matthias Stomer.[5]

Interesting in this context are Gerardi's contacts with Fabrizio Valguarnera, a doctor of Canon and Roman law (*utriusque iuris doctor*) whose name appears in Van Dyck's Italian Sketchbook (fig. 39). In 1623 Valguarnera commissioned Gerardi to make four copies of paintings of Old

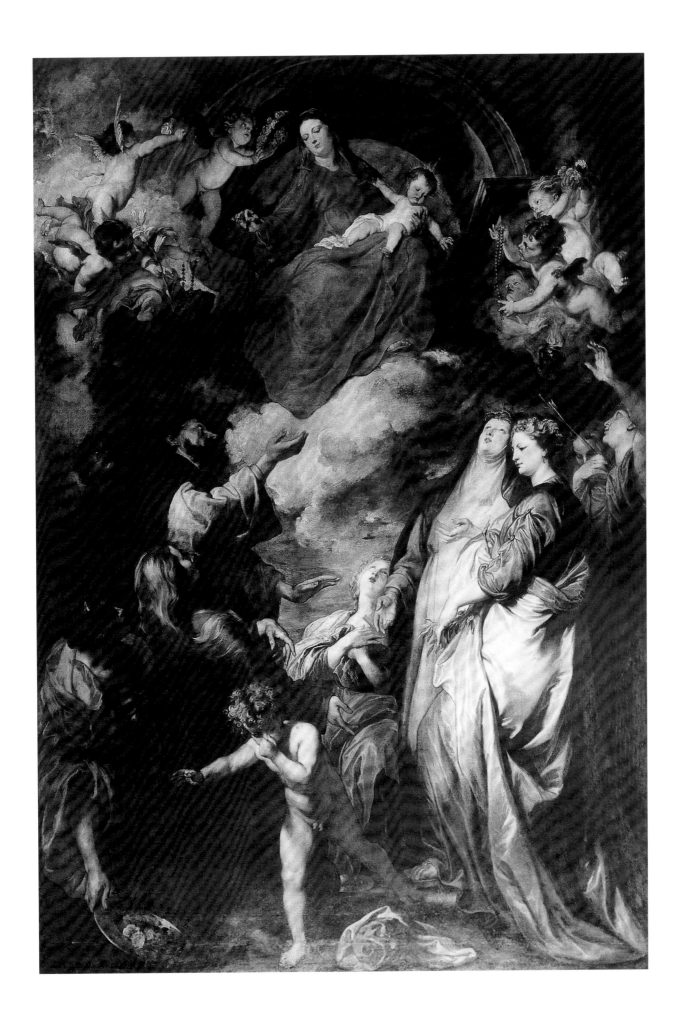

Testament subjects.[6] Several years later, in 1631, Valguarnera was on trial in Rome for the theft of some diamonds; an unscrupulous character, 'versed in the art of painting' (*'prattico di pittura'*), he was an art dealer and collector[7] who befriended Rubens while he was in Madrid. It is possible that the astute Don Fabrizio may have begun his nefarious activities at an earlier date, as a dealer in forgeries – fake paintings or copies – such as the four paintings ordered from the unwitting Gerardi.

When Van Dyck arrived in Palermo, probably in the spring of 1624,[8] possibly summoned there by the Viceroy, Emanuele Filiberto of Savoy, to paint his portrait (cat. 35), the artist could boast several acquaintances among his fellow-countrymen already resident in the city, and he refers constantly to Genoese acquaintances among the large community of Ligurians then living in Palermo.

Van Dyck's stay in Palermo is well established in the literature; in his sketchbook the painter himself records a visit to Sofonisba Anguissola, who was almost one hundred years old, on 12 July 1624 (fig. 9). Until now it has been repeatedly asserted that Van Dyck's stay was ended abruptly by an outbreak of plague which forced the artist to leave Palermo suddenly in September 1624.

However, a series of unpublished documents, discovered recently, has made it possible to clarify some hypotheses, and to correct dates and add details to the painter's biography and to the catalogue of his works. The documents suggest that the artist's sojourn in Palermo was much longer than has been suspected. The documents themselves provide no trace of Van Dyck's presence in Palermo before 12 July 1624, the date of his meeting with Sofonisba, although later records mention him several times before that date.

The earliest new document dates from 21 November 1624. Van Dyck is present at the drawing up of the deed in which Jan Brueghel the Younger declares that he has received from Hendrik Dych, on 29 July of the same year, 19 Sicilian *onze*, the equivalent of 125 Antwerp guilders, through a bill of exchange from his father, Jan Brueghel the Elder, with 'Anthony van Dyck, the Flemish painter who is living here in Palermo these days' as guarantor.[9]

In the second document, dated 6 April 1625, Van Dyck, 'the Flemish painter who is living here in Palermo' (*'pictor fiamengus hic pan*[ormi] *degens'*), declares that he has received from Dych 36 Sicilian *onze* and 12 *tari*, the equivalent of 91 Genoese *scudi*, for which sum he sent a bill of exchange to Cornelis de Wael in Genoa; Marcantonio Gandolfo, an engineer (*'ingingnerius'*),[10] stood as guarantor for the sum. In a note appended to the deed, dated 20 August 1625, 'Ettore Vanachtoven' (Hector Vanachtoven), standing proxy for Hendrik Dych, declares that he has received from Van Dyck, who was present at the signing of the deed, the sum of 38 *onze* and 12 *tari*, when the bill of exchange was not accepted.[11]

Another document is also dated 6 April. Dych and Van Dyck declare themselves mutually satisfied by the negotiations, in particular 'for all the food he [Dych] had given him [Van Dyck] at his home, the said Van Dyck promised the same Dych all the paintings he had hitherto made for him'.[12] Evidently, Van Dyck had made paintings for Dych in return for the hospitality he had received.

On 7 May 1625 Van Dyck declared that he had received four *onze* from Clemente Pilo 'who had promised to pay the said four *onze* for the execution by the said Van Dyck of a painting of the Crucifixion for Hendrik Dych, who is now in the possession of the said painting'; another six *onze* were added to this sum 'for a painting with the image of the crucified Christ made for him [Dych] by himself [Van Dyck] and delivered at an earlier date'.[13] Therefore, Van Dyck painted at least two crucifixions in Sicily.

More than three months later, on 18 August, again in Palermo, Van Dyck declares that he has received from Jacopo and Giovanni Battista Brignone, the sum of ten *onze*, through a bill of exchange from Giovanni Battista Cattaneo issued in Genoa on 23 May.[14] This probably refers to a payment for one of the portraits painted for the Cattaneo family in Genoa (cat. 33, 34).[15]

Four days later, on 22 August, we find Van Dyck undertaking what was to be the most important commission of his Italian sojourn, the altarpiece of the *Madonna of the Rosary* for the Oratorio del Rosario, which stands beside the Monastery of S. Domenico in Palermo (fig. 40).

The contract was signed in the presence of the Governor and members of the Compagnia del Rosario, including one of the confraternity brethren, Antonio della Torre, a haberdasher who originally came from Genoa. Della Torre appears again in 1628 in connection with payment by the Compagnia del Rosario for the delivery and installation of the altarpiece above the high altar in the Oratory.[16] The deed drawn up to commission the painting specifies that SS. Dominic, Vincent and Catherine of Siena (all Dominicans) should be portrayed, plus the local saints Rosalia, Christina, Ninfa, Olivia and Agatha.

The painter undertook to provide three coloured sketches, 'and to send these from Palermo, Naples or elsewhere', while the clients undertook to choose one of the designs. Van Dyck would execute the painting from the selected design. The agreed price was 260 Neapolitan ducats.[17]

The last new document dates from 3 December 1625; this is a power of attorney granted by Van Dyck to Gerardi to enable Gerardi to repossess from a certain Domenico Martinetto, Van Dyck's *creato*, or servant, in Palermo, various paintings of heads, on canvas and on paper: 'a head of a young man named Baldassaro with black curly hair, a head of Simon disguised as a woman, a head of a sailor, a head of St Peter, a head of a woman with sparse hair, a head of Lucia with a firm breast ['*lu pettu rigido*'], a satyr-like, or satirical head of a reader (?) ['*una testa di lettore alla satiresca*'] and a head shouting with mouth open'.[18]

These new documents make it possible to redefine Van Dyck's stay in Palermo. Unless one wishes to propose that he left the island on fleeting trips (which would be particularly unlikely in the latter half of 1624 when measures taken to check the spread of the plague put a stop to travel), he stayed in Sicily from July 1624 until at least early September 1625. Apart from the documentary lacuna between July and November 1624, there are two other gaps, from the end of November 1624 to the beginning of April 1625 and between May and August of 1625. Not long, but not so short as to exclude the possibility of a brief trip to Genoa.[19] His rumoured departure for Marseille on 4 July 1625 seems, however, highly unlikely.[20]

It seems probable that Van Dyck left a considerable number of paintings in Palermo given the artist's prolific output throughout his career. The few Sicilian inventories surviving from the 17th century list a number of original paintings by Van Dyck in local collections. The collection belonging to the Genoese Desiderio Signo, a long-term resident of Sicily, included, in 1630, a portrait of Signo, a 'Deposition' ('*deposizione in croce*') and a 'yawning head' (*'testa che badiglia'*).[21] The inventory of Tommaso Joppolo in 1637 includes a 'Magdalene', a 'Virgin with the Child holding his crown in his hand', a 'Madonna of the Rosary' with various figures, and a 'Virgin holding the Child in her arms'.[22] In the celebrated collection of Antonio Ruffo of Messina there was a St Rosalia 'with eleven small angels drawing her up to heaven', bought in Palermo between 1646 and 1649,[23] as well as 'a doctor surprised with a book in his hand', a 'head', a painting with 'two

heads' and a 'head of a satyr' on paper.[24] In 1651 Antonino Lucchesi, Prince of Campofranco, bequeathed 'a painting of Our Lady of Mercy', and 'a painting of the Virgin and Child'.[25] In the inventory of Don Marco Gezio, chaplain of Palermo Cathedral and a great collector, there is a 'St Rosalia' measuring five *palmi* by four.[26] Among the possessions of Cristoforo Papè in 1666 was a large *Ecce Homo*, a 'Madonna in a garland of roses', and a copy of the *Madonna of the Rosary*.[27] There seem also to have been preparatory drawings circulating in Palermo, like the '*sbozzi di Vannic in carta ogliati*' ('oil sketches on paper by Van Dyck'), owned in 1666 by the little-known painter Filippo Fini.[28]

To this list we can now add a very early unpublished reference to a *Martyrdom of St Stephen* measuring nine by seven *palmi* (225 × 175 cm) which, on 22 April 1626, Desiderio Signo declares he is holding as security, together with four works by Titian, all of which are the property of Don Fabrizio Valguarnera.[29] Among the possessions of Simone Sitaiolo in 1632 are a portrait of Sitaiolo, 'painted by the hand of Antonio Vandic, the Fleming',[30] a 'Satyr', a large 'St John', a 'St Rosalia' and a 'Virgin and Child between SS. Rosalia and John'.[31]

The documents refer to copies being made from Van Dyck's paintings, such as 'St Rosalia copied from Antonio Bandichi [Van Dyck], with the angels in glory similar to the one copied from Antonio Bandichi', executed by the painter Giovanni Battista Grasso on 18 June 1626,[32] an 'unfinished Annunciation', and a painting of 'The Madonna, St Rosalia and other figures', sold in 1667.[33] Finally, in the 1682 inventory of Vincenzo Gallego, Prince of Militello, there is an 'Ecce Homo copied from Vannicchi' and two heads of shepherds 'from originals by Geronimo lo fiamingo' (almost certainly Gerardi).[34]

Although these paintings are not easy to identify, they were all painted by Van Dyck in Palermo; combined with the artist's notes and sketches of street scenes and actors from the Commedia dell'Arte in the pages of his Italian Sketchbook (figs. 41–3) they suggest that he stayed for some time in the city; very few surviving paintings, however, can be directly related to that stay. Perhaps the paintings still in Palermo should be studied more carefully, as well as those definitely attributable to Van Dyck's Sicilian period, including all the works related to the St Rosalia altarpiece.[35]

It might be opportune to reconsider *The Lamentation over the Dead Christ* in Palazzo Abatellis in Palermo, thought until

recently to be a studio painting; a second painting of the same subject, now in a private collection in Rome, came originally from the collection of Duke Airoldi di Cruillas of Palermo.[36]

It is not yet possible positively to identify the paintings recorded in these new documents. *The Martyrdom of St Stephen* owned by Fabrizio Valguarnera may be the one formerly in Palermo published by Vincenzo Abbate (present whereabouts unknown),[37] a replica of the Tatton Park canvas (cat. 32). The 'large' *St John* from the Sitaiolo collection could perhaps be identified with the *St John the Baptist* now in the Los Angeles County Museum of Art,[38] which strongly influenced the painting of the Sicilian artist Pietro Novelli. The *Ecce Homo* now in a private collection in Palermo[39] could possibly be identified as the painting listed in the inventory of Cristoforo Papè. We cannot discuss here the many documented versions of subjects like the Crucifixion or the Virgin and Child.[40] Similarly, we can only skim over the intriguing and complex subject of St Rosalia, not only in the familiar iconography of the Saint at prayer on Monte Pellegrino,[41] but also the Saint presented to the Trinity by the Virgin Mary; this recalls the altarpiece in the Alte Pinakothek in Munich which we can be fairly sure was painted in Palermo because a replica is still in a private collection in the city. A drawing of the same subject, with significant variations, is in the collection in Palazzo Abatellis and was recently attributed to the circle of Van Dyck.[42]

The presence of Van Dyck in Palermo exerted a strong influence on local artists, as it did in Genoa. Evidence is provided by the work of the two most skilled painters working in the city at the time: the Sicilian Pietro Novelli and the Fleming Gerardi.

Whether Van Dyck moved on from Palermo to Naples, as the new documents seem to suggest, and as Mariette noted without comment,[43] is something that we shall leave to the Neapolitans to find out.

FIG 41
Anthony van Dyck, *A Woman Condemned for Heresy,*
inscribed *'una striga in Palermo'*
fol. 58v of the Italian Sketchbook
British Museum, London

FIG 42
Anthony van Dyck, *A Troupe of Actors in Palermo*
including Musicians and Dancers
fol. 6or of the Italian Sketchbook
British Museum, London

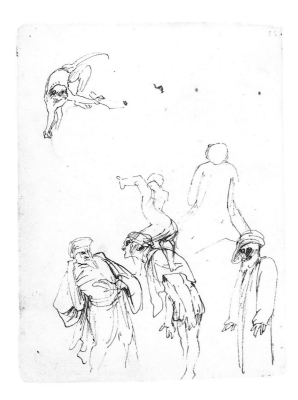

FIG 43
Anthony van Dyck, *A Troupe of Actors in Palermo*
fol. 59v of the Italian Sketchbook
British Museum, London

NOTES

1. Unpublished documents testify to Brueghel's presence in Palermo in June and November 1624 and in May 1625. For these and other details quoted in the present essay, I refer the reader to my forthcoming study in *Dalla Maniera alla dimensione del reale*, exh. cat., Palermo 1999, forthcoming.

2. Gaspard de Momper was the son of Joos II de Momper (1564–1634/5) of Antwerp and the brother of Philip I (fl. 1622–34), who travelled to Rome with Jan Brueghel the Younger. T. Viscuso, 'Anton Van Dyck', in *Pittori del Seicento a Palazzo Abatellis*, Milan 1990, pp. 101–14; E. De Castro, Documentary Appendix in *Pietro Novelli e il suo ambiente*, Palermo 1990, p. 521.

3. F. Negri Arnoldi, 'Pittori fiamminghi in Sicilia tra Rubens e Caravaggio', *Prospettiva*, XXXIX, 1984, pp. 60–67. This small group was joined in 1634 by a colleague, Philip de Vadder, named in documents relating to Basquens; De Castro 1990, op. cit., p. 531.

4. I am thinking particularly of the paintings in the Oratorio del Rosario in S. Domenico, regarded as one of the most important assemblies of 17th-century religious art in southern Italy. According to M. G. Paolini, 'Preistoria di Pietro Novelli: proposte per la formazione', in *Pietro Novelli e il suo ambiente*, Palermo 1990, p. 54, some of the paintings in the Oratory may be the work of Gerardi.

5. M. G. Mazzola, 'Matthias Stomer a Palermo: alcuni inediti per la sua biografia', *Storia dell'arte*, LXXXIX, 1997, p. 70.

6. Archivio di Stato, Palermo, henceforth ASP, Notary Antonio Mariano D'Amelia, vol. 1249, c. 238.

7. V. Abbate, 'Collezionismo grafico a Palermo tra il Cinque e il Settecento: una traccia', in *Maestri del disegno nelle collezioni di Palazzo Abatellis*, Palermo 1995, p. 30.

8. Vaes 1924, p. 216.

9. 'Antonius van dych quoq[ue] pittor fiamenghus et ad p[raese]ns hic pan[ormi] degens'. ASP, Not. Francesco Sergio, vol. 17619, c. 306; vol. 17582, c. 146.

10. This refers to a hitherto unknown artist, painter and engraver, and architect, working in Palermo at that time; he is documented in Sicily between 1621 and 1626.

11. ASP, Not. Francesco Sergio, vol. 17619, c. 771.

12. 'de o[mn]ibus alimentis per eum [Hendrik] sibi [Anthony] prestitis in eius domo et d[ittus] de vandych ab eodem de dich stip[ulan]te de o[mn]ibus picturis per eum factis d[ict]o de dich usque ad p[raese]ns'. Ibid., c. 773.

13. 'pro manifactura unius quatri cum Inmagine Crucifissi per eum sibi facti et consig[na]ti t[emp]oribus pret[eritis]'. Ibid., c. 873v.

14. ASP, Not. Francesco Manso II, vol. 8098, c. 371v; vol. 8114, c. 246.

15. Boccardo, in Genoa 1997, pp. 53–7.

16. G. Meli, 'Documento relative a un quadro dell'altar maggiore dell'Oratorio della Compagnia del Rosario di S. Domenico', *Archivio Storico Siciliano*, III, 1878, p. 210.

17. ASP, Not. Vincenzo Sarago, vol. 1870, c. 562; vol. 1862, c. 419.

18. 'una testa d'un Giovene nominato Baldassaro con i capelli nigri et rizzi una testa di simuni fatta a guisa di donna una testa di marinaro una testa di san Petro una testa d'una donna con li capelli sparsi una testa di lucia co lu pettu rigido una testa di lettore alla satiresca et una testa che grida con la bocca aperta'. ASP, Not. Matteo D'Alessandro, vol. 3427, c. 14.

19. Chronology in Genoa 1997, p. 386.

20. Larsen 1975, p. 62.

21. V. Di Giovanni, 'I Paruta in Palermo e nella Signoria del Castello di Sala di Madonna Alvira, indi Sala di Paruta', *Archivio Storico Siciliano*, XIV, 1889, p. 285.

22. A. Morreale, *Libri, quadri e 'artificiose macchine'. L'inventario di don Marco Gezio cappellano della Cattedrale di Palermo (1658)*, Palermo 1990, p. 25; Abbate 1995, op. cit., p. 48.

23. Barnes 1986, p. 170, identifies Ruffo's *St Rosalia*, considered to be the one from the Signo collection, with the one now in New York.

24. V. Ruffo, 'La Galleria Ruffo nel secolo XVII in Messina', *Bollettino d'Arte*, X, 1916, pp. 29, 31, 306–7, 320.

25. V. Abbate, 'Quadrerie e collezionisti palermitani del Seicento', in *Pittori del Seicento a Palazzo Abatellis*, Milan 1990, p. 29.

26. Morreale 1990, op. cit., pp. 42, 74.

27. Ibid., pp. 149, 151.

28. Abbate 1990, op. cit., p. 50; 1995, p. 32.

29. ASP, Not. Francesco Comito, vol. 923, c. 507.

30. ASP, Not. Giovanni Lo Piccolo, vol. 1481, c. 191.

31. Ibid., c. 222.

32. 'Sancta Rosolea copiata d'Antonio Bandichi con la gloria dell'angeli conforme a quillo copiato d'Antonio Bandichi'. ASP, Not. Vincenzo Lenza, vol. 2678, c. 966.

33. Abbate 1990, op. cit., p. 50.

34. ASP, Not. Salvatore Miraglia, vol. 424, c. 1970.

35. The new documents support the hypothesis that he was instrumental in creating a new iconography for the saint, following the discovery of her relics and her election as patron saint of Palermo, which happened during Van Dyck's stay in Palermo.

36. Viscuso 1990, op. cit., pp. 166–9.

37. Abbate 1990, op. cit., p. 46, fig. 27.

38. Barnes, in Genoa 1997, p. 322, no. 68.

39. M. T. Bonaccorso, 'L'ultimo dei grandi. Sulla mostra "Pietro Novelli e il suo ambiente"', in *Quaderni dell'Istituto di Storia dell'Arte Medioevale e Moderna Facoltà di Lettere e Filosofia Università di Messina*, XIV, 1990, p. 22, fig. 1.

40. Giulia Davi of the Soprintendenza of Palermo is currently studying two unpublished paintings from the circle of Van Dyck both in Palermo, one in the Presidenza della Regione Sicilia, the other in the sacristy of the Jesuit church of Casa Professa.

41. Bonaccorso 1990, op. cit., pp. 22, 25, figs. 22, 25, contains a hitherto unpublished *St Rosalia* which is in the church of S. Annuzza in Palermo, and attributes the painting to Van Dyck with collaborators, and a *'Santa Rosalia in preghiera'* now in the Palazzo dei Normanni in Palermo; the two paintings could be added to the two celebrated versions of the same subject, in the Palazzo Abatellis and the Oratorio dei SS. Pietro e Paolo. On the painting in Sant'Annuzza, see also Bonaccorso 1990, p. 73.

42. Bonaccorso 1990, op. cit., p. 25, fig. 24.

43. Mariette recorded that 'M. Bordone, peintre génois, told Bachelier that "… Van Dyck, dans le temps de la peste qui régnoit en Sicilie et qui l'obligea d'abandonner Palerme, passant sur les frontières du royaume de Naples sans bulletin de santé…"', that for this he was condemned to the galleys but was reprieved on account of his drawings which were given to the Viceroy; that he worked in Naples and returned from that city to Genoa. See P. J. Mariette, *Abecedario de P.J. Mariette et autres notes inédites de cet auteur sur les arts et les Artistes*, II, Paris 1851, p. 175.

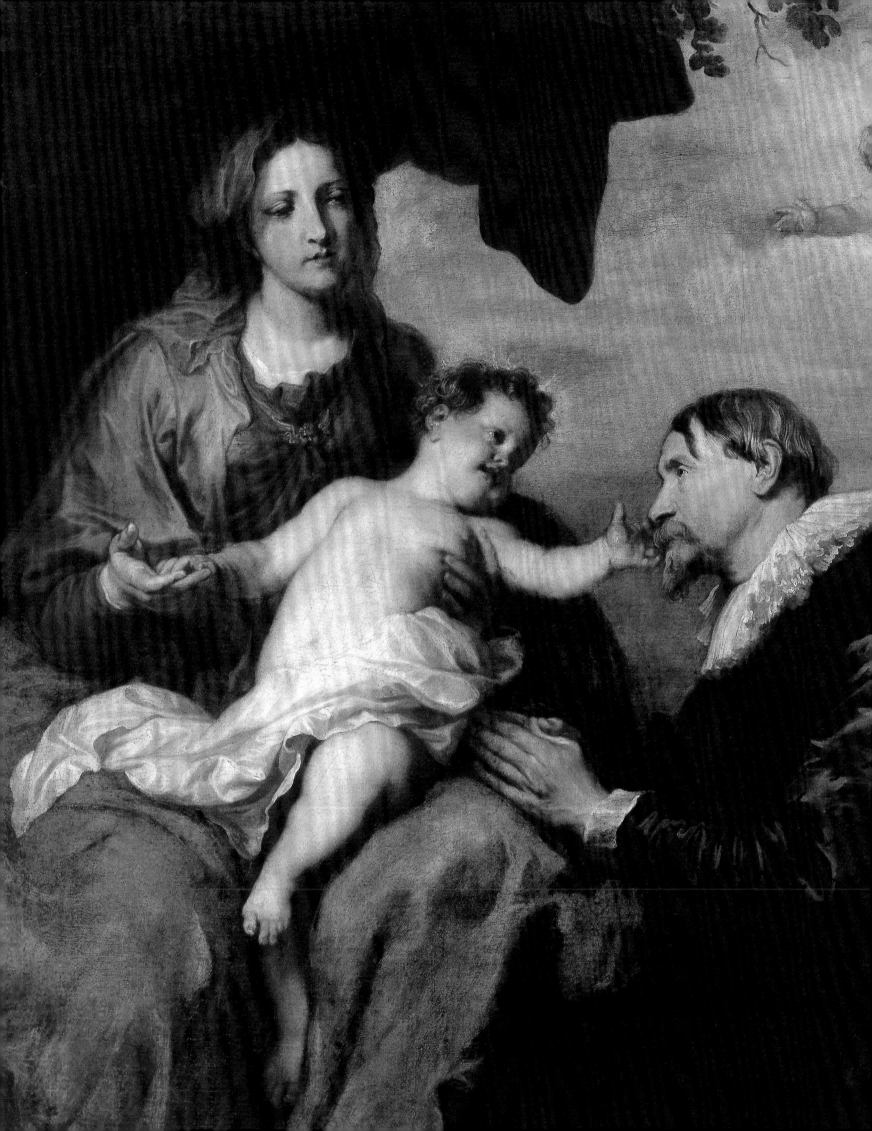

Images of Piety and Vanity

Van Dyck in the Southern Netherlands

1627–32, 1634–5, 1640–41

HANS VLIEGHE

Anthony van Dyck had no difficulty in establishing himself as a painter on his return to Antwerp from Italy. His reputation for artistic brilliance evidently preceded him. The painter's prosperity in those years can be gauged from the substantial sum of 4800 guilders he invested in a 100,000 guilder loan issued by the City of Antwerp in 1630 – an investment that yielded him a healthy 300 guilders in interest per annum.[1] Van Dyck was a prominent citizen of Antwerp, so it is surprising that we know so little about his circumstances in this period – not even his address. He must have lived in a reasonably big house, however, as he painted many large altarpieces there, which will have required a fair amount of space. Several prominent individuals visited his home and praised the painter's art collection, which again suggests more than a modest dwelling.

THE PRE-EMINENCE OF RELIGIOUS PAINTING

Van Dyck made his most important and influential contribution during his second Antwerp period in the field of religious painting. Following his return from Italy, his religious works were much in demand, and he painted dozens of them between 1627 and 1632. With their highly charged religious sentiment, articulated through languorous expressions and delicate gestures, they made a very personal contribution to the art of the Counter-Reformation. This style had been shaped in Italy, mostly under the influence of Correggio, of Venetian Renaissance masters and of the expressive idiom of contemporary baroque painting. Van Dyck appears to have responded to a shift in sensibility, whereby sentiment was to feature more prominently, particularly in religious devotional practice.[2] In the 1620s a similar sensibility was beginning to appear in the work of older, established masters of Antwerp, suggesting that, on his return, Van Dyck found it relatively easy to adapt himself to the new prevailing taste. This sensibility is, perhaps, most evident in his smaller paintings, which served as *Andachtsbilder* for private devotion (see cat. 60).

I intend to concentrate, however, on the large altarpieces that Van Dyck produced in this period. Not only are they his most spectacular works, they are also the best documented. Moreover, thanks in part to the engravings made after them, they helped to establish early on Van Dyck's reputation as Rubens's *alter ego*. The high esteem in which he was held is evident from the speed with which the new devotional sentiment of his altarpieces of the years 1627–32 began to influence the religious works of a younger generation of Flemish painters and sculptors in the 1640s, and particularly in the period 1650–70. It also sparked off a change of style in the work of older masters.[3]

The Southern Netherlands were receptive to the translation of Counter-Reformation dogma – especially the importance of the Virgin, the intercession of saints and the doctrine of transubstantiation – into a monumental, baroque language. The decoration of countless churches and monasteries in this new style was still far from complete, and clergy, aristocracy and bourgeoisie were willing to provide the necessary funds. Van Dyck took advantage of this and also benefited from the fact that Rubens was abroad most of the time between the autumn of 1628 and the spring of 1630 on diplomatic

CAT 57, *detail*

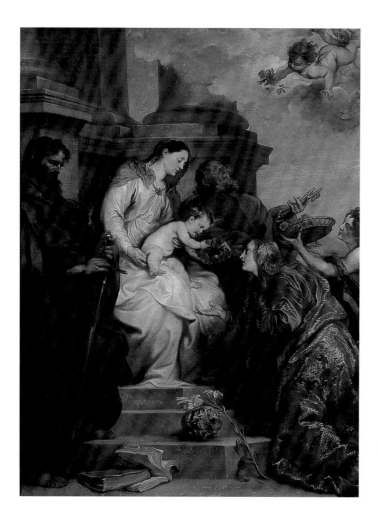

FIG 44
Anthony van Dyck, *The Coronation of St Rosalia*, 1629
oil on canvas, 275 × 210 cm
Kunsthistorisches Museum, Vienna

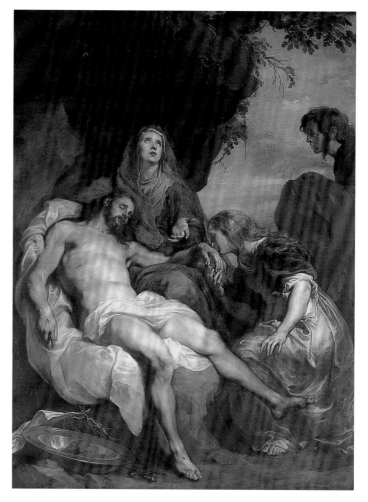

FIG 45
Anthony van Dyck, *The Lamentation over the Dead Christ*, c. 1628
oil on canvas, 303 × 225 cm
Koninklijk Museum voor Schone Kunsten, Antwerp

missions to Spain and England. Moreover, by 1627 large-scale religious painting no longer formed so important a part in Rubens's *oeuvre* as it had in the first decade after his return from Italy, when his synthesis of the Netherlandish tradition and the new Italian monumentality revolutionised Flemish painting.

Meanwhile, from around 1620, younger painters had been following in Rubens's footsteps, responding to the ceaseless demand for extravagant ecclesiastical decoration. Artists like Gaspar de Crayer (1584–1669), Gerard Seghers (1591–1651) and Jacob Jordaens (1593–1678) all established their reputations in the 1620s. When Van Dyck returned to Antwerp in 1627, he was able to exploit both his old connections with Rubens's workshop and his new-found fame in Italy to win prestigious commissions in his native city.

COMMISSIONS FOR ALTARPIECES IN ANTWERP

In 1628 the Augustinians commissioned Van Dyck to paint *St Augustine in Ecstasy* (cat. 51) for their church. Together with Rubens's *Mystic Marriage of St Catherine* (cat. 52, fig. 1) and Jordaens's *Martyrdom of St Apollonia*, the painting was destined for the choir of their new monastery church.[4] It is possible that Rubens himself recommended his two most talented pupils for this prestigious undertaking. The Augustinians originally may have wanted Rubens to do all the work, only to learn that the artist would be absent for a prolonged period. It may also have been thanks to Rubens that Van Dyck was given two commissions from the Jesuits in 1629 and 1630 for *The Vision of the Blessed Herman Joseph* (cat. 56) and *The Coronation of St Rosalia* (fig. 44), painted for the Jesuit Confraternity of Bachelors, of which Van Dyck himself was a member.[5] It is plausible that Van Dyck received the

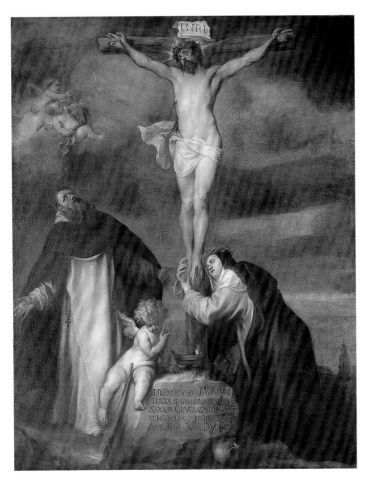

FIG 46
Anthony van Dyck, *The Crucified Christ with St Dominic
and St Catherine of Siena*, 1629
oil on canvas, 314 × 245 cm
Koninklijk Museum voor Schone Kunsten, Antwerp

large *Lamentation over the Dead Christ* (fig. 45) for the high altar of the church is unknown, but it is possible that its funerary theme was chosen in part by Van Dyck because of his avowed intention to be interred in the choir, close to the high altar. It may also reflect the fact that his sister Cornelia had died in 1627:[9] Van Dyck may have donated it shortly after his return to the city. Another sister, Anna, was an Augustinian nun at the Falcon Convent; the print engraved by Paulus Pontius after the Beguinage *Lamentation* is dedicated to her.[10] The composition appears, therefore, to have had a particular significance for Van Dyck's sisters. The theme of the grieving Mary Magdalene, prominent in the *Lamentation*, was important for the devotional practices of nuns and Beguines because of the Magdalene's empathy with Christ's suffering.[11] Van Dyck displayed a similar piety towards the memory of his father Franchois, who died in 1622. In 1629, he painted his *Crucified Christ with St Dominic and St Catherine of Siena* (fig. 46) for the convent of Dominican nuns, who had cared for Franchois van Dyck in his dying days.[12]

COMMISSIONS FOR ALTARPIECES OUTSIDE
ANTWERP: MINORITES AND CAPUCHINS

Van Dyck received equally important commissions from institutions outside Antwerp. In this, he did not differ from his fellow citizens, who found a market for their works in other towns in Brabant and Flanders. The Franciscan orders of the Minorites and Capuchins were particularly important for Van Dyck. He painted scenes of the Crucifixion for the Minorites of Mechelen and Lille (figs. 47, 49). In both cases, the crucified Christ is positioned diagonally to the picture plane, suggesting that the superiors of the two monasteries had consulted one another. This certainly was the case with his two virtually identical versions of *St Anthony of Padua and the Ass of Rimini*, made (possibly with workshop assistance) for the same monasteries. One version has survived (fig. 48), while Descamps's description of 1769 indicates that the Mechelen altarpiece was very similar.[13] He also painted a *Communion of St Bonaventure* (Musée des Beaux-Arts, Caen) for the Minorites of Mechelen which does not appear to be entirely autograph.[14] These paintings of St Anthony and St Bonaventure must originally have formed part of an impressive decorative scheme in the choir of the Minorite church comprising a Crucifixion flanked by the paintings of the saints.[15] It is logical to assume that the three works were commissioned together as part of a coherent scheme since the two

commissions only because Rubens was away: Rubens's great contribution to both the interior and exterior decoration of the Jesuit church suggests that the Order would have turned to him before approaching Van Dyck. Not that Van Dyck was a stranger to the Jesuits – he had contributed to the ceiling paintings in the aisles and galleries of their church in 1620.[6] A letter from the Earl of Carlisle to the Duke of Buckingham of 27 May 1628 gives evidence of the enduring relationship between Rubens and Van Dyck. The Earl reported that he had not seen Rubens at home during his visit to Antwerp, but had met him at *'Monsr Van-digs'*, where he had gone to see 'some curiosities'.[7]

Family ties appear to have played a role in several of Van Dyck's Antwerp commissions. Three of his sisters, Cornelia, Isabella and Susanna, were Beguines, and in his will of 6 March 1628 Van Dyck himself stated that he wished to be buried in the choir of the Beguinage church.[8] The date of the

saints form a symmetrical pair: St Anthony, on the left, stands to the left and looks to the right, while St Bonaventure, on the right, looks to the left. There is an explicit reference to the *Imitatio Christi* which was so important to the Minorites and Capuchins, and Christ's sacrifice on the Cross is also emphasised through the sharing of the body and blood of Christ in the two communion scenes.[16] The themes are combined in the *Crucifixion with St Francis*, probably painted by Van Dyck in 1629 for the Capuchin church in Dendermonde (fig. 50).[17] For the Capuchins of Brussels, he painted two Franciscan saints, *St Francis* and *St Felix of Cantalice* (both in the Musées Royaux des Beaux-Arts, Brussels), probably in 1631.[18]

Private donors played a crucial role in paying for such schemes. Most of the refurbishment and rebuilding of the church, as well as the paintings of St Francis and St Felix, were probably paid for by the Arenberg family, from whom Van Dyck received other important portrait commissions.[19] Chevalier Jan van der Laen, Lord of Schriek and Grootloo, paid for the Mechelen *Crucifixion*, and probably also for

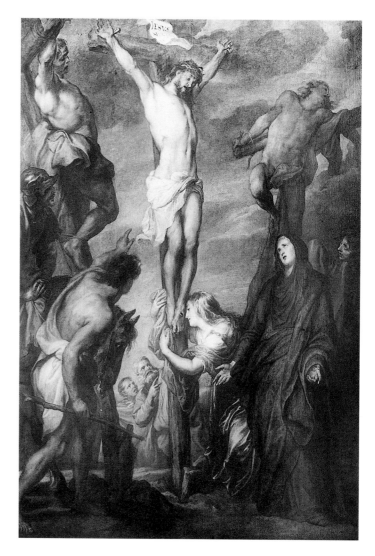

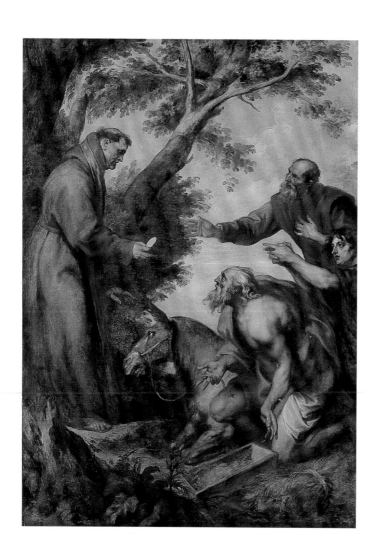

Fɪɢ 47
Anthony van Dyck, *The Crucifixion*, 1630–32
oil on canvas, 385 × 190 cm
Cathedral, Mechelen

Fɪɢ 48
Anthony van Dyck, *St Anthony of Padua and the Ass of Rimini, c.* 1631
oil on canvas, 325 × 212 cm
Musée des Beaux-Arts, Lille

Fɪɢ 49
Anthony van Dyck, *The Crucifixion*, 1630–32
oil on canvas, 400 × 245 cm
Musée des Beaux-Arts, Lille

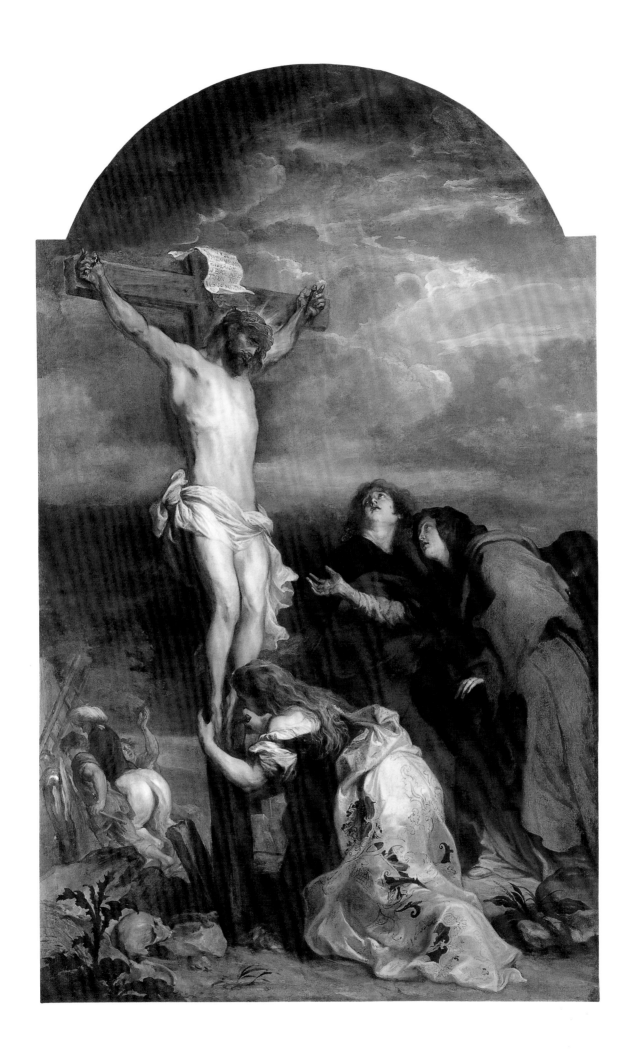

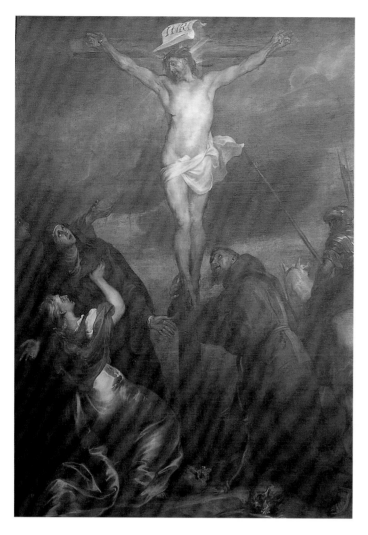

FIG 50
Anthony van Dyck, *The Crucifixion with the Virgin,*
SS. Mary Magdalene, John the Evangelist and Francis of Assisi, 1629–30
oil on canvas, 382 × 270 cm
Onze-Lieve-Vrouwekerk, Dendermonde

FIG 51
Anthony van Dyck, *The Adoration of the Shepherds*, 1631–2
oil on canvas, 245 × 173 cm
Onze-Lieve-Vrouwekerk, Dendermonde

St Anthony and *St Bonaventure* for the same church.[20] Antonius Triest, Bishop of Ghent, an influential art patron, commissioned the Dendermonde version.[21] There are several possible explanations for this. Triest had close links with the Dendermonde Capuchins, and his brother was a member of the Order;[22] he was also a great admirer of Van Dyck and was portrayed by the artist several times.[23]

Both the connection with Triest and the fact that the Dendermonde Capuchins already possessed an important painting by Van Dyck may have paved the way for two further commissions. In 1631–2 Van Dyck completed an *Adoration of the Shepherds* for the altar of the Dendermonde Confraternity of Our Lady in Our Lady's church (fig. 51).[24] Both the ecclesiastical and civic authorities were keen for the church to be decorated by leading painters from Rubens's school.[25]

Triest may also have been involved in arranging an important commission in his own diocese of Ghent. In 1630, Van Dyck painted another *Crucifixion* for the Confraternity of the Sacred Cross at the church of St Michael, where it hangs to this day (fig. 52).[26] The Confraternity had already shown its interest in the new painting style emanating from Antwerp: in 1626 Abraham Janssens was commissioned to paint a *Flagellation of Christ*.[27] But ultimately Van Dyck may have owed the commission to Rubens: it had been offered first to Rubens, who turned it down, again probably because he anticipated a long absence from the Low Countries.[28]

The *Raising of the Cross* at Kortrijk (cat. 61) was ordered by the elderly Canon Rogier Braye for his own tomb. The theme of redemption through the Cross was most appropriate for a funerary monument, while the theme of the crucified Christ

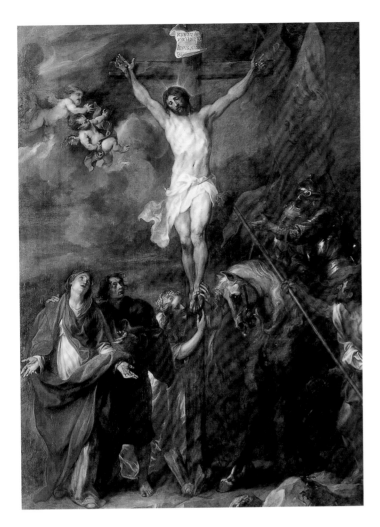

FIG 52
Anthony van Dyck, *The Crucifixion*, 1629–30
oil on canvas, 400 × 290 cm
St Michielskerk, Ghent

Following his return to Antwerp, Van Dyck took his place among the group of leading painters who were regularly given commissions by Church authorities. He was not viewed as exceptional, however, as Rubens had been in 1609. This is evident from the prices he was paid for altarpieces of varying sizes. Van Dyck does not appear to have received more than 500 to 800 guilders for a painting, which is about the same as his contemporaries. He was paid 500 guilders for the Dendermonde *Adoration of the Shepherds* (fig. 51) and 600 guilders each for the Antwerp *St Augustine in Ecstasy* (cat. 51) and the Kortrijk *Raising of the Cross* (cat. 61). The artist appears to have made a special arrangement for his two paintings for the Confraternity of Bachelors at the Jesuit convent. The prices charged for those works were considerably lower, presumably because the artist belonged to the Confraternity. He was paid 300 guilders for *The Coronation of St Rosalia* (fig. 44) and a mere 150 guilders for *The Vision of the Blessed Herman Joseph* (cat. 56); the particularly low price for the latter work also reflects its significantly smaller scale. Van Dyck's Ghent *Crucifixion* (fig. 52) was his most expensive work, earning him in the sum of 800 guilders. This prompted him to ask a similar amount for his *Raising of the Cross* for Kortrijk; but he had to make do with 200 guilders less and a packet of waffles as a consolation prize. It would certainly not have escaped the patron's notice that the altarpiece was over a metre smaller than its Ghent counterpart. Jean-Baptiste Descamps stated in 1769 that Van Dyck was paid the inordinately high sum of 2000 guilders for the *Crucifixion* he painted for the Mechelen Franciscans (fig. 47): it seems more likely that this sum in fact was for all three altarpieces that decorated the Minorite church until they were removed during the French Revolution.[30]

VAN DYCK'S MODELS: THE WORK OF RUBENS

In spite of his strongly Italianising, high-baroque style, Van Dyck was acutely aware of local artistic trends in the Southern Netherlands. This is evident from the typology, compositional structure and iconography of the many altarpieces emanating from his workshop between 1627 and 1632.

It goes without saying that Van Dyck incorporated many of Rubens's pictorial schemes into his compositions, a reflection of the intense formative influence and close collaboration between the two artists in Van Dyck's early years. There are also indications, however, that the Rubensian compositions of

recurs frequently in the canon's poetry. His fellow clergy at the church of Our Lady particularly favoured painters in the Rubensian tradition: Gaspar de Crayer supplied them with four paintings between 1617 and 1623. Braye may originally have considered De Crayer, but because of financial difficulties the Chapter had been late in paying him for his earlier works, which may have deterred the artist from accepting any further commissions from them. Negotiations with Van Dyck were arranged through the Antwerp cloth merchant Marcus van Woonsel, a relative of Braye; they were discussing the matter by 8 November 1630, and must have reached an agreement quickly, since the *Raising of the Cross* was installed by May 1631.[29]

several Van Dyck works were specifically requested by his patrons. The Crucifixions he painted for the Franciscans of Mechelen and Lille (figs. 47, 49) are indebted to Rubens's *Christ pierced by the Lance* (*'Le Coup de Lance'*; fig. 53) painted for the Antwerp Franciscans around 1620.[31] The Franciscans must have regarded that work, with the striking diagonal positioning of the Cross and the dynamic spatial effects, as an astonishing stylistic innovation, and were eager that it should be used in altarpieces for other churches belonging to their Order. The Minorites and Capuchins' liking for this type of Crucifixion is evident from a composition conceived by Rubens and copied on numerous occasions, in which a cross placed on a diagonal to the picture plane is combined with St Francis sitting or standing at its foot.[32]

The Mechelen *Crucifixion* (fig. 47) is particularly close to Rubens's painting: from it Van Dyck took the figure of the crucified Christ and the twisted and agonised poses of the two thieves. He also borrowed the stoical, resigned Virgin Mary and the figure of Mary Magdalene kneeling at the foot of the Cross, reversing these figures but not the bystanders. This may be interpreted as an attempt to retain a spark of originality, in spite of the obvious borrowings.[33] Van Dyck's originality is chiefly expressed, however, through the intensely emotional rendering of Christ's suffering. Whereas the figure of Christ in Rubens's work has an athletic body and is heroic in mood, Van Dyck's weak, slender and more sensual Christ conveys a sense of vulnerability. Mary Magdalene's embrace is also highly eloquent. In Rubens's painting she expresses her sorrow forcefully by stretching out her arms; in Van Dyck's, by contrast, her grief is internalised. Similarly, Van Dyck evokes the suffering of the Virgin Mary in a more intense and sensitive manner than Rubens.

The other great work that Rubens painted for Antwerp's Franciscans, *The Last Communion of St Francis* (1618–19; Koninklijk Museum voor Schone Kunsten, Antwerp),[34] seems to have served as the model for the two communion scenes with St Anthony (fig. 48) and St Bonaventure (Musée des Beaux-Arts, Caen). The contrast in the *Miracle of St Anthony* between the monumental, standing saint giving communion and the emotional group kneeling opposite him shows that Rubens's communion scene provided the starting point, possibly at the Minorites' express wish. Again, Van Dyck's more emotionally charged interpretation is manifested through the extreme pathos of the facial expressions.

Van Dyck's religious compositions were not always deter-

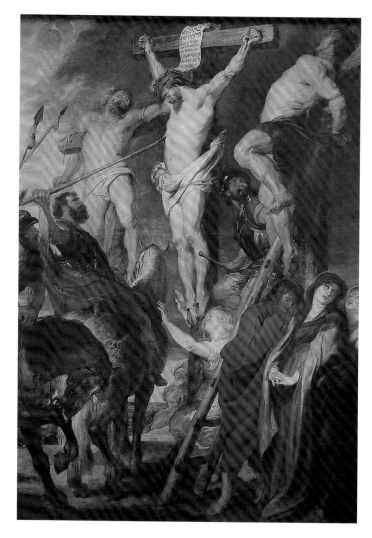

FIG 53
Peter Paul Rubens, *Christ pierced by the Lance* (*'Le Coup de Lance'*), c. 1620
oil on panel, 424 × 310 cm
Koninklijk Museum voor Schone Kunsten, Antwerp

mined by the specific iconographic requirements of the religious order that had commissioned them. For instance, the two Franciscan saints painted by Van Dyck for the Capuchin church in Brussels (probably in 1631; Musées Royaux, Brussels) took their inspiration from Rubens's paintings of St Ignatius and St Francis Xavier placed on either side of the high altar of the Jesuit church in Brussels (until 1777).[35] Not only are the saints shown in the same ecstatic poses, the gaze of both pairs is explained by their position on either side of the high altar. In the Jesuit church, the two saints gazed at a painting of *The Adoration of the Magi* by Abraham Bloemaert,[36] while those in the Capuchin church looked towards *The Lamentation with St Francis* – a theme invented expressly for the Franciscan Order.[37] The presence of Rubens's two saints in Brussels's most important new church in the

Counter-Reformation style may also have acted as a stimulus for the Capuchins and Van Dyck.

VAN DYCK'S MODELS: THE WORK OF SEGHERS

Rubens was not, however, Van Dyck's only point of reference in Antwerp. It is well known that his *Raising of the Cross* (cat. 61) was based on Rubens's painting of the same subject of 1610–11 (cat. 61, fig. 1).[38] The central motif – the group of executioners raising the cross to which Christ has been nailed – is a mirror-image of Rubens's painting for St Walburga. Again, the inversion of the image may be read in part as an attempt to inject a degree of originality. A similar effect is achieved by the more highly charged rendering of emotion, accentuated by the elongated bodies and the more nervous rhythm of both gestures and drapery. The *mise-en-scène* also differs from Rubens's: the figures are located deeper in the field of composition, reducing the Rubensian effect of dramatic compression. The subject of the Raising of the Cross had, however, already been treated in a similar way in Antwerp. It appears, probably for the first time, in an altarpiece painted by Gerard Seghers before 1626 (presumably in 1624) for Antwerp's Jesuit church (cat. 61, fig. 3).[39]

The genesis of the *Raising of the Cross* suggests that Van Dyck was also aware of the Seghers painting. An oil sketch (cat. 61, fig. 2) places much greater emphasis on the raw strength and brutality with which the executioners raise the cross; it evokes the spirit of Rubens's central panel more strongly than the final painting. The eye is drawn to the man with the muscular back seen in the lower centre of the composition. This motif does not feature in Rubens's painting but appears in Seghers's altarpiece for the Antwerp Jesuits.[40] The motif is replaced in the Kortrijk painting by a man whose back is parallel to the picture plane. It is less effective, but may have met the patron's requirements in terms of decorum.

There is nothing surprising about Van Dyck looking to Seghers for inspiration. Seghers, his senior by eight years, was one of Antwerp's most successful painters when Van Dyck returned to the city. His reputation, which had spread beyond Antwerp, is evident from the dozens of religious works and large altarpieces that he produced between *c.* 1620 and 1630.[41] Seghers's *Raising of the Cross* is still above the high altar of St Carolus Borromeus (see fig. 4), then Antwerp's most modern church, which Van Dyck himself had helped to decorate. It must have caused an immediate stir since other artists quickly adopted it as an example.[42] Like Van Dyck, Seghers

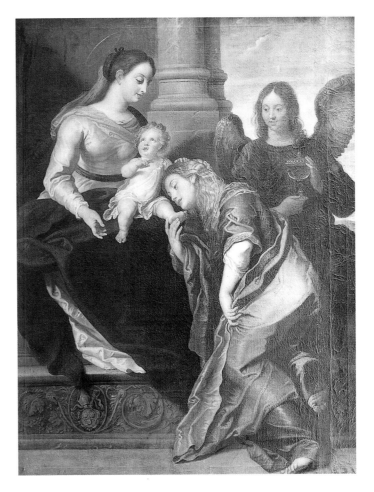

FIG 54
Gerard Seghers, *The Virgin and Child with St Mary Magdalene*, 1627
oil on canvas, approx. 190 × 140 cm
Cathedral, Tournai

had spent many years in Italy, living in Rome and Naples from 1611 to 1620. In Italy he first encountered the nascent baroque style, from which he derived his characteristic emotionally charged classicism. He introduced to Antwerp this new Italian baroque style, derived from both Caravaggio and the school of Carracci, particularly Guido Reni, at a time when Rubens was also introducing a baroque pathos into his works. The new style is particularly evident in Seghers's compositions of the 1620s – not least his graphic work – in the eloquent saints and angels, with elongated bodies, acting as guides and comforters. Seghers made his contribution to religious iconography just as devotional subjects began to play a less prominent role in Rubens's *oeuvre* than they had in the previous decade.[43] It seems probable that Van Dyck was drawn to Seghers's style, with its characteristic elongated figures and highly emotional facial expressions, because he, too, was attempting to express in his religious works a heightened

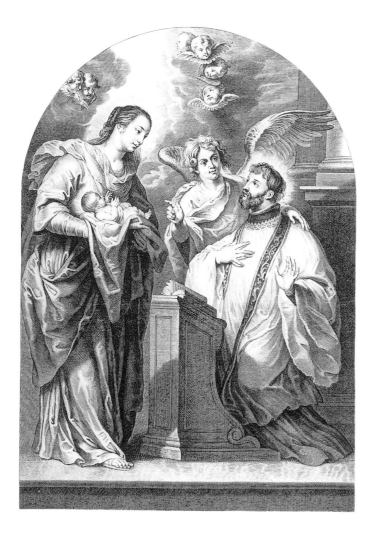

guorous expressions and the emotional gestures of Herman Joseph, the Virgin and the angel as their hands touch.[45] Here too, Van Dyck's Jesuit patrons, who had commissioned Seghers's altarpiece before 1629,[46] may have drawn Van Dyck's attention to that composition. The Society of Jesus was Seghers's most important patron; he enjoyed particularly good relations with the Antwerp Jesuits, for whom he painted no fewer than ten works.

Van Dyck's interest in Seghers is also apparent from the fact that Thomas Willeboirts Bosschaert, the earliest follower of Van Dyck in Antwerp, was initially trained by Seghers before entering Van Dyck's workshop. Although there is no documentary evidence that he worked with Van Dyck, it seems to be almost certain.[47]

LATER COMMISSIONS

Van Dyck returned to the Low Countries between the spring of 1634 and that of 1635, dividing his time between Antwerp and Brussels. He devoted most of his time to painting portraits of the political and diplomatic élite, religious compositions being of less importance. An exception is the *Lamentation* (cat. 85), commissioned by Cesare Scaglia, who had served as the ambassador of Savoy at several courts and had lived in the Netherlands since 1631; he remained in Flanders until his death in 1641. Like so many of his rank, he had his portrait painted by Van Dyck (cat. 78). The commission for the *Lamentation* may have been prompted by a severe illness that struck him in 1635, bringing him close to death. Later, he had an altar devoted to the Virgin of the Seven Sorrows installed at the Franciscan church in Antwerp and expressed his desire to be buried beneath it. Van Dyck's *Lamentation* was incorporated into the altar, underlining its funerary function.[48]

Van Dyck returned to Antwerp in the autumn of 1640, and again in the autumn of 1641. At that time he was commissioned to paint an important altarpiece – perhaps the most prestigious commission of his career.[49] The deans of the local archery guild 'De Jonge Voetboog' ordered a *Martyrdom of St George* for their altar in the Cathedral, where it was given as prominent a place as Rubens's *Descent from the Cross*. That altarpiece had been commissioned by another of the city's militia companies, the Arquebusiers ('Kolveniers'). Two surviving oil sketches (see fig. 56) and a copy of a third[50] show that Van Dyck accepted the assignment. His sudden death in December 1641 prevented him from painting the altarpiece. The fact that Van Dyck was at the zenith of his career – par-

emotionalism. Van Dyck was not alone in his interest in Seghers – other contemporaries also borrowed motifs from him.[44]

Van Dyck's *Coronation of St Rosalia* of 1629 (fig. 44), for instance, seems to display a more than coincidental similarity to Seghers's *Virgin and Child with St Mary Magdalene*, painted in 1627 for Tournai Cathedral (fig. 54). In terms of composition both are highly Venetian. Van Dyck may have been particularly drawn to the figure of the Magdalene, evidently derived from Correggio, whom he much admired. Van Dyck's other painting for the Antwerp Jesuits – his 1630 *Vision of the Blessed Herman Joseph* (cat. 56) – was influenced by another composition by Seghers, as is evident from the 1629 engraving (in reverse) made by Pontius after Seghers's *Vision of St Francis Xavier* (fig. 55). The only difference is that Van Dyck's vision is more ecstatic, conveyed through the lan-

ticularly after his time at the English Court – is evident from the exorbitant sum of 2200 guilders the deans of the guild were prepared to pay for the painting.

TRADITION AND INNOVATION IN PORTRAITURE

Van Dyck was already much in demand as a portrait painter in the years 1627–32. Around 1620, when still living in Antwerp, he had been developing a new type of portrait, based on Venetian art of the 16th century, which he developed during his long stay in Italy. On his return to his native city in 1627, his portrait style became very fashionable. A calculated nonchalance, elegance, grace, and engaging expressions, were as important as the costume of the sitters, in which French-inspired style, colour and adornment were replacing the earlier sober style dictated by Spanish etiquette. This new style owed part of its success to a growing desire on the part of wealthy citizens to pursue a luxurious, even aristocratic, lifestyle. This was also apparent in other aspects of life, not least the fashion for collecting works of art and other expensive items.[51] Van Dyck's abiding interest in Venetian art, especially in the work of Titian, was also evident from the remarkable collection of paintings by the Venetian master he assembled, as reported admiringly in 1631 by Jean Puget de la Serre, secretary to Marie de' Medici.[52]

Yet, Van Dyck evidently had to adjust his designs to the traditional taste of his Netherlandish patrons. Despite their pursuit of elegance and nobility, the bourgeoisie still preferred half- or knee-length portraits in the traditional Netherlandish style (cat. 48, 49, 53, 55). In the genre of the votive portrait (cat. 57), Van Dyck achieved a synthesis between the Flemish tradition and the Venetian style of Titian and Veronese. The ostentatious full-length portrait was reserved for nobles (cat. 64). Even here, however, we note that sometimes concessions were still made to earlier types. For example, Van Dyck adopted an earlier Rubens prototype when he painted the Archduchess Isabella in 1628 (full-length version Galleria Sabauda, Turin). The assignment earned him a gold chain worth 750 guilders and the right to call himself '*Schilder van Heure Hoocheyd*' (Painter to Her Highness).[53] It also helped Van Dyck to win further princely commissions. Through the Court at Brussels he came into contact with the exiled Queen of France, Marie de' Medici, and her retinue. In his 1631 portrait, he placed the Queen on a throne with a view of Antwerp in the background (Musée des Beaux-Arts, Bordeaux). The type is derived from his Genoese female portraits but was also

FIG 56
Anthony van Dyck, *The Martyrdom of St George*
oil on panel, 43 × 35 cm
Christ Church Picture Gallery, Oxford

adapted to the stricter etiquette of the Habsburg Court in Brussels.[54]

The Court at The Hague was the first to commission work from Van Dyck on his return from Italy.[55] Apart from a number of subject paintings with a pronounced Venetian Arcadian flavour (cat. 62), Van Dyck also painted portraits in The Hague. Those of the Stadtholder of Holland, Frederik Hendrik, and his consort Amalia van Solms, are somewhat subdued and conventional half-lengths, harking back to portraits by Mierevelt and Van Ravesteyn.[56] Other patrons in The Hague appear to have been more attracted to Van Dyck's novel grace and elegance, perfectly attuned to the cultivation of refinement in court circles, in particular by Frederik Hendrik's secretary, Constantijn Huygens,[57] and by the exiled King Frederick of Bohemia, the Elector Palatine, and his family.

As he had even before 1621, Van Dyck continued to receive commissions to paint portraits of fellow artists, revealing a new sense of artistic self-awareness and emancipation among

the most prominent and wealthy Flemish painters (cat. 82).[58] But it was chiefly in his *Iconography* – a collection of dozens of prints portraying famous contemporaries, including many artists – that Van Dyck most effectively immortalised his colleagues. A striking feature of these portraits is the way each artist is distinguished through gesture and facial expression rather than by the inclusion of the tools of the trade found in earlier artists' portraits.[59] Ultimately, the engravings did more to promote Van Dyck's influence in portraiture in the Southern Netherlands and beyond than did his paintings.

Van Dyck completed a remarkable number of portraits during his brief sojourn in the Southern Netherlands in 1634–5. Unlike the period 1627–32, a significant number were large-scale portraits of aristocrats (cat. 76). The fame he had won as the painter to the King of England obviously preceded him; he also gained kudos from his appointment as honorary dean of Antwerp's Guild of St Luke, an honour that hitherto had been paid only to Rubens.[60] His reputation also enabled him to command high prices for his work; indeed, he was regarded as an expensive painter during his time in the Netherlands in 1634–5, when he worked chiefly as a portraitist.[61] Brussels court circles took advantage of Van Dyck's presence in the Netherlands to commission a series of imposing portraits: in these he expressed himself as brilliantly as he had in the best of his English works.

NOTES

1. See F. J. Van den Branden, *Geschiedenis der Antwerpsche schilderschool*, Antwerp 1883, p. 717.

2. For this change in taste, see F. Baudouin, 'Iconografie en stijlontwikkeling in de godsdienstige schilderkunst te Antwerpen in de XVIIe eeuw', in *Antwerpen in de XVIIde eeuw*, Antwerp 1989, pp. 329–64.

3. See Vlieghe 1994, pp. 199–220; id., in ed. H. De Nijn, H. Vlieghe, H. Devisscher, *Lucas Faydherbe. Mechels beeldhouwer en architect*, exh. cat. Mechelen 1997, pp. 27, 163.

4. See C. Van de Velde, 'Archivalia betreffende Rubens' "Madonna met Heiligen" voor de Kerk der Antwerpse Augustijnen', *Jaarboek Koninklijk Museum voor Schone Kunsten Antwerpen*, 1977, pp. 221–34.

5. See Van den Branden, op. cit., p. 713. For Van Dyck's membership of the Confraternity, see P. Rombouts and T. van Lerius, *De Liggeren en andere historische archieven der Antwerpsche Sint-Lucasgilde*, I, Antwerp 1864, p. 458.

6. See J. Rupert Martin, *The Ceiling Paintings for the Jesuit Church in Antwerp*, Corpus Rubenianum Ludwig Burchard, I, Brussels and London 1968, pp. 32, 39–40, 214–17.

7. See M. Rooses and C. Ruelens, *Codex Diplomaticus Rubenianus. Correspondance de Rubens et documents épistolaires concernant sa vie et ses œuvres*, IV, Antwerp 1904, p. 218.

8. See Van den Branden, op. cit., pp. 711–12.

9. Ibid., p. 712.

10. See I. M. Veldman and D. de Hoop Scheffer, *Hollstein's Dutch and Flemish Etchings, Engravings, and Woodcuts, c. 1450–1700*, XVII, Amsterdam 1976, p. 151, no. 13.

11. See P. Vandenbroeck, 'Zwischen Selbsterniedrigung und Selbstvergottung. Bilderwelt und Selbstbild religiöser Frauen in den südlichen Niederlanden. Eine erste Erkundigung', *De Zeventiende Eeuw*, V–1, pp. 67–88; id., *Hooglied. De beeldwereld van religieuze vrouwen in de Zuidelijke Nederlanden, vanaf de 13de eeuw*, exh. cat. Brussels 1994.

12. According to the account of the Prioress Sara Derkennis (printed in Rombouts and Van Lerius, op. cit., p. 458; see also Van den Branden, op. cit., p. 704). The meaning of the painting is made explicit by Van Dyck's inscription on a rock at the bottom: NE PATRIS SVI MANIBVS / TERRA GRAVIS ESSET HOC / SAXVM CRVCI ADVOLVEBAT ET / HVIC LOCO DONABAT / ANTONIVS VAN DYCK (Anthony van Dyck rolled this rock before the Cross and gave this work to the Church so that the earth would not weigh too heavily on his father's remains).

13. See note 15, below. There is another version in the Musée des Augustins, Toulouse (inv. no. 440), but I do not detect Van Dyck's hand in it.

14. See F. Debaisieux, *Caen, Musée des Beaux-Arts. Peintures des écoles étrangères*, Paris 1994, pp. 222–4; see also J. D. Stewart, 'Pieter Thijs (1624–77). Recovering a "scarcely known" Antwerp Painter', *Apollo*, 1997, pp. 39–40, fig. 5, which attributes the Caen canvas to Van Dyck's follower Pieter Thijs and dates it c. 1655–60. I, too, have my doubts about whether this is a completely autograph work, but I see no reason not to regard it as a Van Dyck composition.

15. This reconstruction is suggested by the detailed description by Descamps, who saw the complete work in its original location (Descamps, I, 1769, pp. 120–21); Bellori (1672, p. 258) provided a brief description of the three paintings in his biography of Van Dyck. See also the second, posthumous, edition of A. Sanderus, *Chorographia Sacra Brabantiae*, The Hague 1727, pp. 174–5.

16. For Franciscan themes in 17th-century Flemish painting, see W. Savelsberg, *Franziskus von Assisi in der flämischen Malerei und Graphik*, Rome 1992.

17. See A. Blomme, 'Deux tableaux de Van Dyck', *Bulletin de l'Académie royale d'archéologie de Belgique*, I, 1898–1901, pp. 421–2.

18. This date appears on the red-chalk preparatory drawing for St Francis – now Stedelijk Prentenkabinet, Antwerp (see Savelsberg, op. cit., pp. 288–90, fig. 128a).

19. For the church, its decoration and the Arenbergs' role in it, see Pater Hildebrand, *De Kapucijnen in de Nederlanden en het Prinsbisdom Luik*, V, Antwerp 1950, pp. 50–51; Van Dyck painted a *Portrait of Prince Albert of Arenberg* (see Glück 1931, pp. 320, 358).

20. See Sanderus, loc. cit.; E. Neeffs, *Inventaire des tableaux et des sculptures se trouvant dans les édifices religieux et civils de Malines*, Louvain 1869, pp. 59–61.

21. See note 17, above.

22. Ibid.

23. See R. Matthijs, 'Een reeks portretten van bisschop Triest naar Van Dyck', *Gentsche Bijdragen tot de Kunstgeschiedenis*, III, 1936, pp. 115–29; id., *Iconographie van bisschop Triest met biografische aanteekeningen*, Ghent and Aalst 1939, pp. 45–64.

24. See the entry in the Dendermonde church accounts for the years 1630–5, published in Blomme, op. cit., pp. 425–6, and Van Dyck's letter of 21 November 1631, which records the commission and the patron (see Cust 1900, p. 96). The Confraternity was represented at the time of payment by its treasurer, the local alderman Cornelis Gheerolfs. As a result, the latter has generally and incorrectly been identified as the patron (see Glück 1931, p. 546, and A. K. Wheelock, in Washington 1990–91, p. 243).

25. Shortly after Van Dyck, Gaspar de Crayer was also approached to paint an Assumption for the high altar (see H. Vlieghe, *Gaspar de Crayer. Sa vie et ses œuvres*, Brussels 1972, pp. 128–30, pl. 68). David Teniers the Elder had already produced an important triptych, while Antwerp painters like Pieter Thijs, Antonie Goubau, Jan IJkens and Godfried Maes later painted significant works for the main church in Dendermonde (see E. Dhanens, *Dendermonde, Inventaris van het kunstpatrimonium van Oostvlaanderen*, IV, Ghent 1961, pp. 120–21, 125–8).

26. See P. Kervyn de Volkaersbeke, *Les églises de Gand*, II, Ghent 1858, pp. 91–3.

27. Ibid., p. 51.

28. Ibid., p. 93. Very persuasively Horst Vey (Vey 1962, I, p. 194, under no. 125) and Julius Held (Held 1980, I, p. 485, under no. 353) argued that Rubens's sketch (Rockoxhuis, Antwerp; see Held, op. cit., II, pl. 348), datable

c. 1627, may well be Rubens's initial concept for the Ghent altarpiece which was eventually executed by Van Dyck.

29. See in particular G. Caullet, 'Le Van Dyck de Courtrai d'après la correspondance originale du maître et les écrits du XVIIIᵉ siècle', *Mémoires du Cercle Royal Historique et Archéologique de Courtrai*, X, 1912–13, pp. 64–101; De Man 1980b, pp. 233–59.

30. See Vlieghe 1994, pp. 199–200, 218, nn. 7–10. Horst Vey, in conversation, came to the conclusion that the large sum of 2000 guilders can only refer to the three altarpieces once in the Minorites' church.

31. See Rooses 1888, pp. 95–8, no. 296; R. Oldenbourg, *Rubens. Des Meisters Gemälde*, Klassiker der Kunst, IV, Stuttgart and Berlin 1921, pp. 216, 463.

32. This type is dealt with by Vlieghe 1972, pp. 155–6, no. 101, and Savelsberg, op. cit., pp. 213–14, who refers to an earlier engraved prototype by Hieronymus Wierix (fig. 48a) that also shows the crucified Christ at an angle. It is also possible – though this is pure hypothesis – that the oblique positioning of the Cross reflects *The Stigmatisation of St Francis at La Verna*. The archetype of the miraculous, winged cross transmitting the Stigmata to St Francis in the upper church at Assisi is positioned in a similar way in the picture plane.

33. Borrowing motifs and compositional schemes from other artists was considered normal and even recommended at the time, provided that they were assimilated in a personal manner; see J. A. Emmens, *Rembrandt en de regels van de kunst*, Utrecht 1964, pp. 111–15.

34. This work is discussed by Vlieghe 1972, I, pp. 156–9, no. 102, pl. 178.

35. For details of these two paintings, see Vlieghe 1973, VIII–2, pp. 68–72, nos. 113–14, pls. 36–7; W. Scheelen, 'De herkomst en de datering van Rubens' voorstellingen van de H. Ignatius van Loyola en de H. Franciscus-Xaverius', *Jaarboek Koninklijk Museum voor Schone Kunsten Antwerpen*, 1986, pp. 153–72.

36. See G. Seelig, *Abraham Bloemaert*, Berlin 1997, pp. 183–4, fig. 34.

37. See Savelsberg, op. cit., pp. 223–5, fig. 56.

38. See J. R. Martin, *Rubens: The Antwerp Altarpieces*, London 1969, and U. Heinen, *Rubens zwischen Predigt und Kunst. Der Hochaltar für die Walburgenkirche in Antwerpen*, Weimar 1996.

39. See K. Van der Stighelen, 'Gerard Seghers' Drawing for the Raising of the Cross', *Master Drawings*, XXVI–1, 1988, pp. 44–9; D. Bieneck, *Gerard Seghers*, Lingen 1992, p. 154, no. A27.

40. Seghers may have borrowed it in turn from his probable teacher, Abraham Janssens: see Janssens's *Raising of the Cross* at St Waudru in Mons (J. S. Held, 'The Authorship of Three Flemish Paintings in Mons', *Bulletin Koninklijke Musea voor Schone Kunsten van België*, II, 1953, pp. 109–14, fig. 8).

41. For work of this period, see Bieneck, op. cit., pp. 48–76, 135–84; for Seghers's importance as a history painter, see also C. Van de Velde, 'De schilder Gerard Zegers', in ed. G. Van Brussel, *Een traditie met toekomst*, Antwerp 1986, pp. 31–40.

42. *The Raising of the Cross* that Cornelis de Vos painted in 1626 for the church of St Amelberga in Wechelderzande is largely copied from Seghers's canvas (see K. Van der Stighelen and H. Vlieghe, 'Cornelis de Vos (1584/5–1651) als historie-en genreschilder', *Academiae Analecta. Mededelingen van de Koninklijke Academie voor Wetenschappen, Letteren en Schone Kunsten van België, Klasse der Schone Kunsten*, LIV, 1994, pp. 12–13, fig. 24).

43. Typical examples are given by Bieneck, op. cit., nos. A23, A27, A29–A35, A38–A63, A65–A69.

44. The best-known examples are Cornelis de Vos (see above, note 42) and Gaspar de Crayer (see H. Vlieghe, *Gaspar de Crayer...*, op. cit., pp. 107, 143).

45. It is not obvious to me that Van Dyck had in mind the composition (based on *contrapposto*) of Rubens's lost *Ecstasy of St Theresa* (formerly church of the Discalced Carmelites, Brussels; see Vlieghe 1973, pp. 159–61, no. 150, pl. 119), as suggested by Wolfgang Prohaska in *De Vlaamse Schilderkunst in het Kunsthistorisches Museum te Wenen* (Flandria Extra Muros), Antwerp 1987, p. 190.

46. See Bieneck, op. cit., pp. 175–6, nos. A54–A54A.

47. The register of Antwerp's Guild of St Luke records Willeboirts Bosschaert as Seghers's pupil in 1628–9 (see Rombouts and Van Lerius, op. cit., p. 661). The work of Bosschaert, who only enrolled as a master in the Antwerp guild in 1636/7, is stylistically close to Van Dyck's work in the years after 1627, in a manner not found in the work of any of his contemporaries. I find it difficult to believe, therefore, that he was not associated with Van Dyck's workshop in the period between his registration as Seghers's pupil and Van Dyck's departure for England (see also Vlieghe 1994, p. 210).

48. See Monballieu 1973, pp. 247–68.

49. Baudouin 1994, pp. 175–90.

50. The respective works are now at Christ Church, Oxford; Musée Bonnat, Bayonne; and Detroit Institute of Arts.

51. For this phenomenon, see R. Baetens, *De nazomer van Antwerpens welvaart*, 2 vols, Brussels 1976, esp. I, pp. 312–16.

52. For Van Dyck as a collector of Titian, see Wood 1990, pp. 680–95.

53. See M. De Maeyer, *Albrecht en Isabella en de schilderkunst*, Verhandelingen van de Koninklijke Vlaamse Academie voor Wetenschappen, Letteren en Schone Kunsten van België, 9, Brussels 1955, pp. 193–7, pl. XXIX.

54. See Glück 1931, p. 316. Certain remarkable parallels are apparent with Rubens's portrait style immediately after his return to the Netherlands from Italy. He too adapted his portraits – especially those of Archduke Albert and the Infanta Isabella – to the earlier formulae associated with the portrait tradition of Anthonis Mor, Frans Pourbus the Younger and Otto van Veen (see H. Vlieghe, *Rubens' Portraits of Identified Sitters Painted in Antwerp*, Corpus Rubenianum Ludwig Burchard, XIX–2, London 1987, pp. 22–3, 38–9).

55. See Van Gelder 1959, pp. 43–86. See also A. L. Walsh, 'Van Dyck at the Court of Frederik-Hendrik', in Barnes and Wheelock 1994, pp. 223–46, in which it is incorrectly stated that several Van Dyck paintings in the Stadtholder's collection featuring typically Catholic themes are evidence of an allegedly Remonstrant or even pro-Catholic attitude on the part of Frederik Hendrik. There can be little doubt that the latter's prime motive in purchasing the paintings was aesthetic (see also H. Vlieghe, 'Constantijn Huygens en de Vlaamse schilderkunst van zijn tijd', *De Zeventiende Eeuw*, III–2, 1987, pp. 198–200, 209, n. 39). Van Dyck's commissions for the House of Orange and the aristocratic circle in The Hague have also been dealt with more recently by P. van der Ploeg and C. Vermeeren (ed.), *Vorstelijk verzameld. De kunstcollectie van Frederik Hendrik en Amalia*, exh. cat. (The Hague 1997–8), Zwolle 1997, passim.

56. See Van der Ploeg and Vermeeren, op. cit., pp. 120–21, no. 6; these portraits may be dated c. 1628–9 on the basis of a chronological list in Arnold Houbraken's *Groote Schouburgh der Nederlantsche konstschilders en schilderessen* (2nd edition, Amsterdam 1753, p. 185), which places them with *St Augustine in Ecstasy* in the Augustinian church (1628) and *The Crucifixion with St Francis* for the Capuchins of Dendermonde (1629). A. K. Wheelock (in Washington 1990–91, pp. 236, 243) sought incorrectly to give the paintings a later date, around 1631–2, as Van Dyck was working in The Hague at that time on his portrait of Huygens. Wheelock, who was followed by Van der Ploeg (loc. cit.), also based his conclusion on the erroneous supposition that Houbraken's reference to 'an altarpiece for the Capuchins of Dendermonde' referred to *The Adoration of the Shepherds* in Dendermonde's church of Our Lady, which he wrongly seems to believe was also commissioned by the local Capuchins.

57. See Vlieghe, 'Constantijn Huygens...', op. cit., pp. 198, 201, fig. 4.

58. See *The Portrait of Frans Snyders* (Frick Collection, New York; see ill. in Glück 1931, p. 98).

59. Details of this development in the typology of 17th-century artists' portraits, and especially those in Van Dyck's *Iconography*, may be found in H.-J. Raupp, *Untersuchungen zu Künstlerbildnis und Künstlerdarstellung in den Niederlanden im 17. Jahrhundert*, Hildesheim, Zurich and New York 1984. Van Dyck made several of these portraits immediately after his return from Italy (some of them refer back to even earlier examples), as indicated by their inclusion in Willem van Haecht's 1628 *Picture Gallery of Cornelis van der Geest* (see cat. 49, fig. 2).

60. See Van den Branden, op. cit., p. 733.

61. An example of this is the large sum Van Dyck requested in the winter of 1634–5 to copy his earlier portrait of the Cardinal-Infante Ferdinand as part of the city's decorations to mark Ferdinand's Triumphal Entry into Antwerp. The price was rejected by the civic authorities (see Martin, *The Ceiling Paintings...*, op. cit., p. 31).

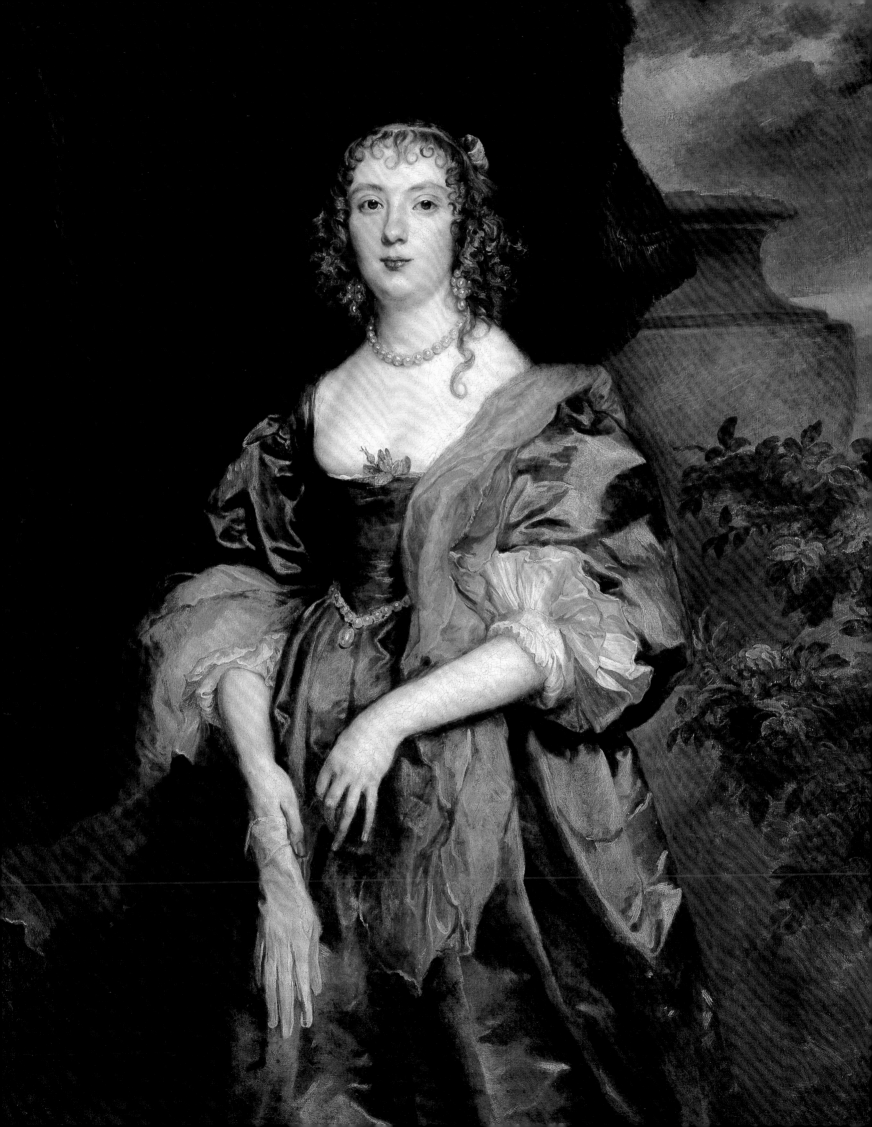

Van Dyck in England

MALCOLM ROGERS

The nine and a half years that constitute Van Dyck's final phase – from his arrival in London on or around 1 April 1632 until his death at Blackfriars in December 1641 – are arguably the most glorious in the history of painting in Britain.[1]

Nevertheless, the evidence suggests that the artist never intended London to be his final home. Between spring 1634 and spring 1635, he was working in Flanders, and early in 1640 he was again anxious to leave London. There followed fourteen months in which Van Dyck, struggling with ill health, travelled to the Low Countries and to Paris looking for opportunities. All too tantalising is the projected portrait of 'the Cardinal' (Richelieu or Mazarin) that ill health forced him to abandon in November 1641, and which anticipates an era of patronage that was not to be. In less than a month Van Dyck was dead and buried.

Van Dyck had first come to London, as a young man of 21, in October 1620. His stay was short, not to say abortive. Despite a generous stipend from James I, and the patronage of such powerful men as the Duke of Buckingham (see cat. 26) and the Earl of Arundel (cat. 25), the artist did not settle. In February 1621 he received a permit, signed by Arundel, to travel abroad for eight months. He did not return for eleven years.

The 33 year-old who came back to London in 1632 to work for James's son, Charles I, was a different man; the circumstances far more propitious. Van Dyck was now an artist with an international reputation and was widely travelled, above all in Italy, where he had studied the great masters of past generations, especially Titian. He was distinguished in appearance and an excellent conversationalist: the Earl of Newcastle valued 'the Blessinge off your Companye, & Sweetnes off Conversation'.[2] He knew the art of pleasing distinguished and demanding patrons; he was equipped with a brilliant technique, and had at his command the whole repertoire of baroque painting. Above all, he possessed extraordinary imaginative powers, and, as a portraitist, an almost unequalled feeling for character and nobility of spirit.

The move to England was to take him into the protection of

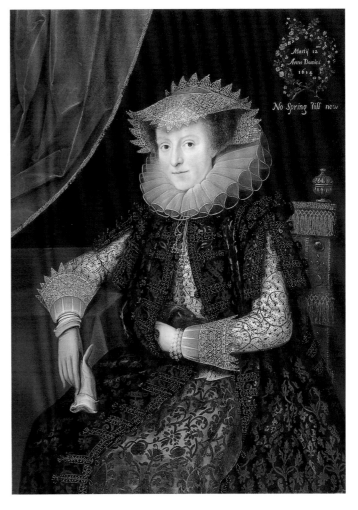

FIG 57
Marcus Gheeraerts the Younger, *Lady Scudamore*, 1614
oil on panel, 114 × 82.6 cm
National Portrait Gallery, London

Charles I, arguably the most single-minded connoisseur in Europe. Moreover, he had the security of knowing that, as a Roman Catholic moving to a Protestant country, Charles's Queen, Henrietta Maria, daughter of Henri IV of France and Marie de' Medici, was a Roman Catholic, and that the Caroline Court had at its heart a group of Catholics and Catholic sympathisers. Artistically, Van Dyck had the field to himself. Marcus Gheeraerts the Younger, *par excellence* the court painter of Elizabeth I and of the King's mother, Anne of

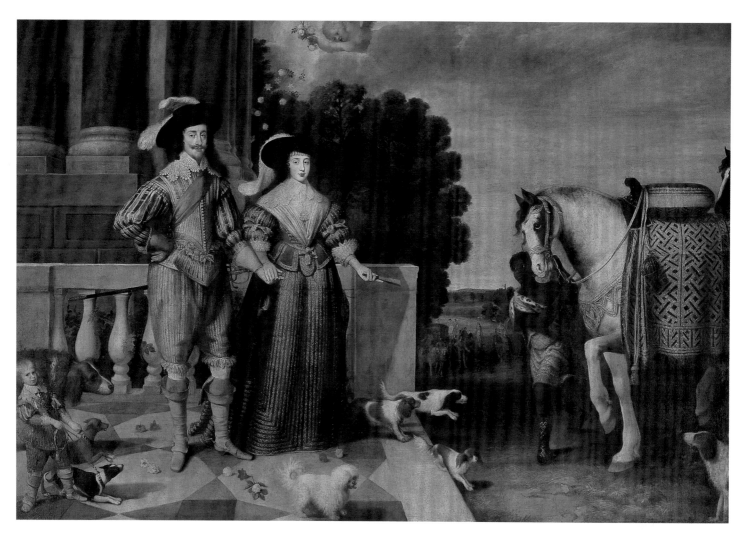

FIG 58
Daniel Mytens, *Charles I and Henrietta Maria departing for the Chase*, 1630–32
oil on canvas, 282 × 408.3 cm
Her Majesty The Queen

Denmark, was still alive, but his artistic vocabulary was long outmoded (fig. 57). The Dutchman Daniel Mytens, whom the King had appointed 'one of our picture-drawers of our Chamber in ordinarie' for life shortly after his accession (and who had, like Van Dyck, first come to England under the patronage of the Earl of Arundel), was quite simply eclipsed (fig. 58). So too was Mytens's occasional collaborator, Cornelius Johnson, who had been sworn in as 'his Majesty's servant in the quality of Picture Drawer' in December 1632. The King had at last the court painter of genius for whom he had yearned since his accession: 'the glory of the World, Vandike'.[3] Charles had watched Van Dyck's career since his first visit to London, and as Prince of Wales had purchased 'an old mans heade without a frame with gray haire & beard'.[4] Later he owned the artist's portraits of *Count Hendrick van*

den Bergh (Prado, Madrid), of the musician *Hendrick Liberti* (Prado version), the *Nicholas Lanier* (cat. 50), as well as a *Mystic Marriage of St Catherine*, and in 1629 had paid for the huge *Rinaldo and Armida* (fig. 59). It is not hard to imagine the sensation that this mythology, its subject taken from Torquato Tasso's romantic epic *Gerusalemme liberata*, must have caused on its arrival in London in 1630. No more effective advertisement for Van Dyck's powers could be imagined: full of movement and drama, of powerful emotion and eroticism. The colouring is wonderfully rich in a Titianesque vein calculated to appeal to the King, and there are allusions to Titian's *Worship of Venus* (Prado, Madrid) in the figure of Armida, and above all in the wittily observed *amorino*, sucking his thumb, who warily watches the spectator, ignoring the adult goings-on around him. Nothing of this

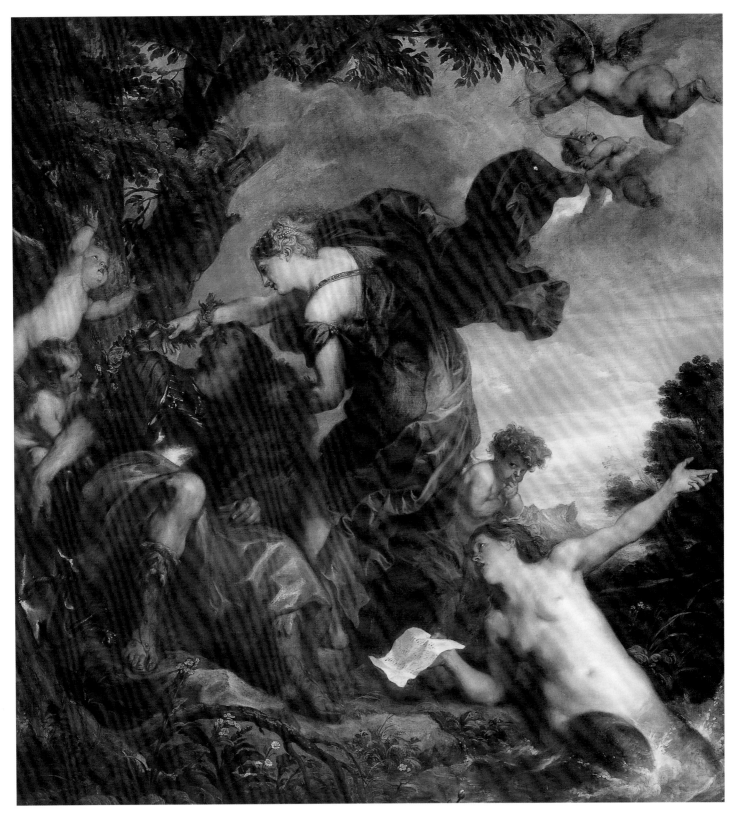

FIG 59
Anthony van Dyck, *Rinaldo and Armida*, 1629
oil on canvas, 236 × 224 cm
Baltimore Museum of Art

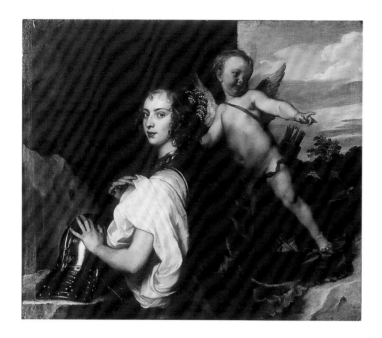

sophistication had previously been seen in London, and its aesthetic impact can hardly be overstated.

Van Dyck followed this great painting to London some two years later. He received a warm welcome, and was lodged at royal expense, until a house with a garden by the Thames was found for him in Blackfriars, the rent again paid by the Crown. In the summer he had for his use a residence at Eltham Palace, south of London. On 5 July 1632 Van Dyck, by then described as 'principalle Paynter in ordinary to their Majesties', was knighted at St James's Palace, and just over a year later was granted a substantial annuity (though this was often to be in arrears). He had an international reputation, royal favour, and the promise of a stream of commissions from the royal family and the powerful figures in and around the court: the Duke of Richmond, the Earls of Arundel, Northumberland, Pembroke, Strafford and Warwick, and the Duchess of Buckingham, widow of the murdered royal favourite. He had also the society and patronage of courtiers of lesser rank: Lord Wharton and Sir Thomas Hanmer (cat. 96), the diplomat Endymion Porter (cat. 88), the writers Thomas Killigrew (cat. 95) and Sir John Suckling, the soldier and virtuoso Sir Kenelm Digby (cat. 69, fig. 1); men of energy and intelligence, free discourse, and, some of them, free morals; men with whom he could perhaps relax.

Stimulated by this new environment, Van Dyck produced some of his finest works, works characterised by their ambition, their originality, and a fresh style that is particular to the English period. Portraiture predominates, though our view is

Fig 60
Anthony van Dyck, *Portrait of a Girl as Erminia (Margaret Lemon?)*, 1636–40
oil on canvas, 109.2 × 129.5 cm
His Grace the Duke of Marlborough, Blenheim

Fig 61
Anthony van Dyck, *Frances Howard, Duchess of Lennox and Richmond*, 1633
oil on canvas, 203.2 × 121.2 cm
Bass Museum Collection, Miami Beach, Florida, Gift of John and Johanna Bass

Fig 62
Anthony van Dyck, *Philip Herbert, 4th Earl of Pembroke, and his Family*, c. 1635
oil on canvas, 330 × 510 cm
Collection of the Earl of Pembroke, Wilton House, Salisbury

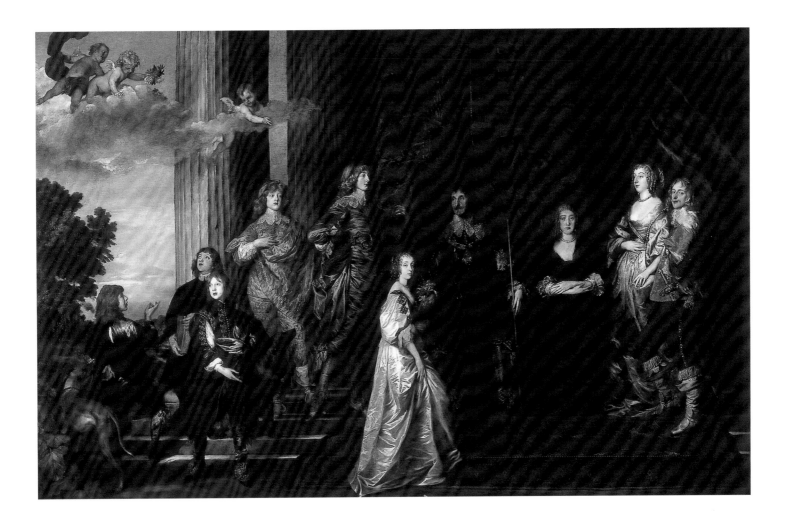

a little distorted by the accidents of history. Bellori, Van Dyck's first biographer, lists a number of religious paintings executed in the English period, for the Queen, the Earl of Northumberland and for Kenelm Digby, as well as several subject pictures, but not one of these is now certainly identifiable. Only the late Titianesque idyll *Cupid and Psyche* (cat. 100) survives to give us an idea of what these may have been like, along with the beautiful historicising portrait of Van Dyck's mistress Margaret Lemon in the guise of Erminia from Tasso's *Gerusalemme liberata* (fig. 60). Add to these, tantalising references in royal inventories to 'Vandyke. A Sea Peice with a great Rocke & some fisher men upon the Shore' and 'A Picture of a large Reddish Spaniell by Van Dyck'.[5] This very incompleteness serves to underline the basic truth that Van Dyck's English patrons had, like their predecessors and descendants, an unquenchable thirst for portraits – of themselves, their families, allies and ancestors.

It is no coincidence that the most ambitious of all Van Dyck's family groups was painted in England: *Philip Herbert, 4th Earl of Pembroke, and his Family* (fig. 62). This strikes emphatically the dynastic note, for it shows the Earl surrounded by his family; dead infants are recorded as *putti* in the sky, and the family descent is recorded in the hanging emblazoned with arms displayed behind him. Centre stage, in this theatrical composition, is the figure, in white, of Lady Mary Villiers, daughter of the King's late favourite the Duke of Buckingham, who married the Earl's eldest son, Lord Herbert, in January 1635. We may suppose that this group was painted shortly after the marriage, after Van Dyck's return from Flanders in the spring, and before Herbert went on his travels later that year. Evidently it is contrived so as to commemorate Lady Mary's entry into the family – and into the family tree.[6]

Like Holbein before him, and Sir Peter Lely, Sir Godfrey Kneller, Sir Joshua Reynolds and John Singer Sargent after, Van Dyck had little alternative but to comply with this overwhelming taste for portraiture. So it is that in England an almost unbroken series of portraits issued from his studio, perhaps as many as four hundred in the space of seven and a half years: more than one painting a week; and the more

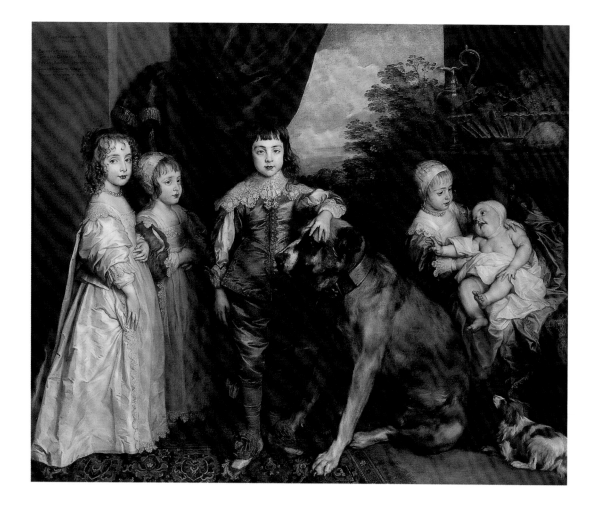

ambitious works must have taken far longer to produce. The pressure of work was intense, and at times the commissions must have seemed beneath his dignity. He painted posthumous portraits of forebears for the Earl of Northumberland and for the King. Perhaps also for the King was the full-length of a nearly royal sitter, Frances Howard, wife of Lucovick Stuart, Duke of Lennox and Richmond, the cousin of James I (fig. 61), which once hung in the Bear Gallery at Whitehall Palace. But for the sparkle in the Duchess's eye and superb handling of paint, this might in design at least have been painted by Gheeraerts some twenty years earlier. It epitomises the static, iconic tradition of an earlier generation, and one wonders whether Van Dyck painted it with teeth clenched or a determination to beat the previous generation at its own game.

Undoubtedly, success compelled Van Dyck to rely increasingly on the sometimes imperfectly coordinated work of studio assistants, so as to sustain a production that in its turn sustained his life-style as *bon viveur* and art collector. His studio methods are well known – virtually a production line

for portraits – though the names of his studio assistants were for the most part a well-kept trade secret. These anonymous presences must account for some of the variety of handling that characterises the English period. Undoubtedly Van Dyck himself made distinctions of handling and finish between works that were to be admired close-to, such as the *Sir Thomas Hanmer* (cat. 96), and ones that were to be seen as part of the *mise-en-scène* of a grand gallery, as in the case of the *Charles I in Robes of State* (cat. 90), which is surprisingly broad in technique, and which was intended for the massed display of royal family portraits in the Cross Gallery at Somerset House.

It is, however, likely to be a combination of haste and increased studio participation which accounts for the perceptible decline in quality of both touch and invention between a work like the miraculously poised *George, Lord Digby, and William, Lord Russell* (cat. 93), one of the very few works which Van Dyck seems to have signed, and the rather later *Lord John and Lord Bernard Stuart* (cat. 97), much pose and less substance, comparatively cold in atmosphere and broad in handling. It is a decline that we can follow in the

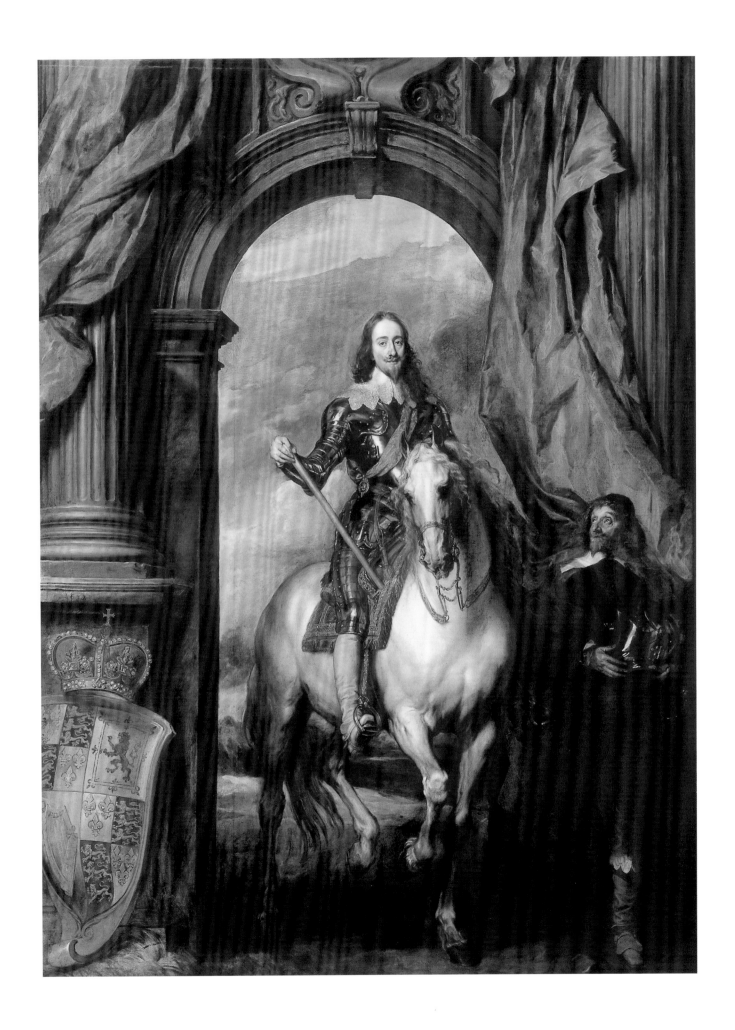

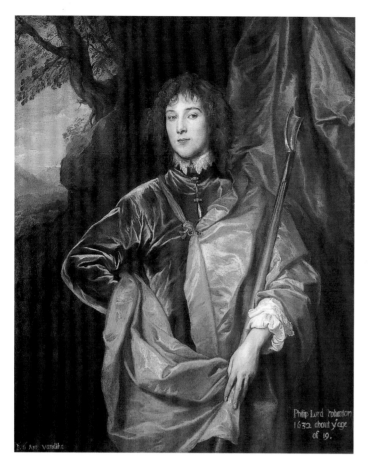

FIG 65

Anthony van Dyck, *Philip, Lord Wharton*, c. 1632
oil on canvas, 133 × 106 cm
National Gallery of Art, Washington, DC, The Andrew W. Mellon Collection

ill-coordinated *Philadelphia and Elizabeth Wharton* (cat. 103), where the heads of the two girls are of ravishing quality, but are set within a design so meagre as barely to sustain the size of the canvas. Other late works, like the *William II, Prince of Orange, and his Bride, Mary, Princess Royal* (cat. 105), seem oddly cold and clammy.

But this is to dwell on the negatives in a period which is marked by prodigious feats, both of technique and imagination. Among Van Dyck's royal commissions alone there stand out the so-called 'great peece of our royal self, consort and children' (fig. 15), painted early in 1632 to hang, almost certainly, at the end of the vista of the Long Gallery of the Palace of Whitehall: a previously unattempted blend of royal state and familial intimacy, and on an unparalleled scale. The series of group portraits recording the royal children that began with cat. 87 and culminated in *The Five Eldest Children of Charles I* (fig. 63), for which cat. 91 is a preliminary study, is unequalled. This last, painted in 1637, is the most complex of

all Van Dyck's groups of children, a perfect blend of slightly self-conscious dignity and childish artlessness: the royal children on their best behaviour, surrounded by their favourite dogs, and dwarfed – a witty and charming touch – by the laden table. The three prodigious equestrian portraits of the King himself make an unprecedented sequence: *Charles I on Horseback with Monsieur de St Antoine* (fig. 64) of 1633, grand and sensationally illusionistic, painted for the Gallery at St James's Palace; the somewhat later equestrian portrait in the National Gallery, London (fig. 16), painted for Hampton Court, that shows the King as a military commander of well-nigh imperial authority (something he emphatically was not), in its evocation of Titian's great portrait *The Emperor Charles V at the Battle of Mühlberg* (Prado, Madrid), and the unique *Le Roi à la Chasse* (fig. 17), one of the most original and relaxed statements of royal authority ever created.

In between these monumental commissions, Van Dyck painted a series of, by his own standards only, more modest portraits of the King and Queen of great distinction and originality. They include, of course, *Queen Henrietta Maria with Jeffrey Hudson and an Ape* (cat. 67), in which the Queen is dressed for riding. This alone is enough to show the way in which Van Dyck's work superseded that of his English predecessors, inviting as it does comparison with Mytens's most ambitious work, *Charles I and Henrietta Maria departing for the Chase* (fig. 58), in which Sir Jeffrey also appears and in which the Queen wears an almost identical outfit. In Mytens's hands the Queen's dress, that sparkles under Van Dyck's touch, is dull and leathery; the figures are stick-like, the perspective awkward; the whole utterly devoid of atmosphere and of any feeling for character or royal dignity. In contrast, Van Dyck's *Triple Portrait of Charles I* (cat. 86) is one of the internationally recognised icons of majesty, and completely eclipses the utilitarian nature of its commission as a documentary likeness for the sculptor Bernini. It shows Van Dyck thinking of a sophisticated Roman audience, and creating an image of unique power.

In these, as in portraits at three-quarter length, whether of the King in armour (a convention new to England and derived from Titian) or of the Queen in silks and satins, Van Dyck achieves a blend of sophistication and sensitivity never before seen in England, not least in his ability to create a convincing if subtly enhanced likeness. As it was put by De Piles, 'He took his Time to draw a Face when it had its best looks on'.[7] The poet Edmund Waller commented on this idealising function and takes it one stage further:

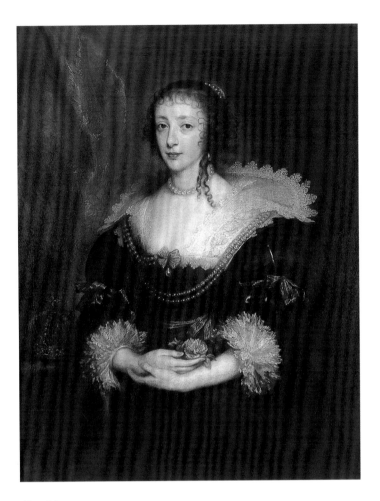

FIG 66
Anthony van Dyck, *Queen Henrietta Maria*, 1632
oil on canvas, 106 × 81 cm
Private collection, England

Strange that thy hand should not improve
The beauty only, but the fire;
Not the form alone, and grace,
But act and power of a face.[8]

In this context we should consider the reaction of the Queen's niece, the Princess Sophia, whose idea of English good looks had been formed by 'the fine portraits of Van Dyck', when years later she found the Queen '[so beautiful in her picture] a little woman with long lean arms, crooked shoulders, and teeth protruding from her mouth like guns from a fort'.[9] Not everyone, of course, agreed, as, for instance, the Countess of Sussex who sat to Van Dyck in 1639–40, and found herself 'very ill favourede, makes me quite out of love with myselfe, the face so bige and so fate that it pleses me nott att all. It lokes lyke on of the windes poffinge…'.[10]

In the English period there is a perceptible change in Van Dyck's response to character and, while he is still capable of painting a haughty commander or an intense and intellectual statesman, as, for instance, in his portraits of the 1st Earl of Strafford (cat. 68, 102) or Lord Danby (cat. 73), nevertheless, he increasingly evokes a gentler, more reflective quality: an aristocratic *sprezzatura*, or ease of manner. We do not look to Lords John and Bernard Stuart (cat. 97) for martial qualities (though both were to die on the battlefield); to Lord Wharton (fig. 65) for his statesmanship (though there is ample historical evidence of this later in his career); nor to *Anne Killigrew with an Unidentified Lady* (cat. 99) for gifts of intellect. The mood of Van Dyck's English ladies ranges from the mildly flirtatious to one of soporific reverie; *Lady Anne Carr, Countess of Bedford* (cat. 98) momentarily assesses the spectator as she is interrupted in the act of putting on – or perhaps taking off – her glove. The aspect of his male sitters – the tone set by the King himself – seems to be a shade melancholy and remote.

It is notable in this period that the seated full-length portrait all but disappears from Van Dyck's repertoire, except in the case of a handful of allegorical portraits of women, of which *Rachel de Ruvigny, Countess of Southampton* (cat. 104) is the most ambitious example. It is a format which Van Dyck had used throughout his earlier career to convey the forceful character of powerful men who sat at councils, noble women with large households at their command, and in deference to age. However, in England he favoured the full-length, standing or in motion, or the more intimate format of the standing three-quarter length portrait, or the double three-quarter length of two relatives or friends (cat. 95, 99). This last form Van Dyck virtually created, and it expresses intimacy, social nuance and ultimately the closeness of the court circle.

These changes and others suggest that Van Dyck's style and tone as a portraitist were modified by the places and societies in which he found himself. Encouraged by the relaxed fashions of the English court, he adopts a wider palette in his portraits than at any other time in his career. He does of course continue to deploy the sonorous harmonies of black, red or gold that he had used with such distinction in Genoa, Antwerp and elsewhere, as in one of the earliest of his portraits of the Queen, dated 1632 (fig. 66), an especially tender characterisation that shows Henrietta Maria holding a rose in her gracefully cradled hands, wearing a formal black court dress with virago sleeves. But such a portrait is the exception, and he now favours a repertoire of blues, pinks, yellows, silvers and greens. In addition, his colour schemes, no doubt

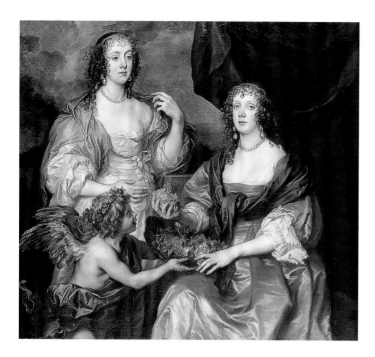

FIG 67
Anthony van Dyck, *Dorothy Savage, Viscountess Andover,*
*and her Sister Elizabeth, Lady Thimbleby, c.*1637
oil on canvas, 132.1 × 149.9 cm
National Gallery, London

A sweet disorder in the dresse
Kindles in cloathes a wantonnesse:
A Lawne about the shoulders thrown
Into a fine distraction…[13]

This 'fine distraction' of dress is also evident in his treatment
of male attire: cloaks, for instance, which are so handsomely
deployed in his earlier portraits, are gradually simplified until
they become swags of drapery, less functional if no less
dramatic. Thomas Killigrew and his companion (cat. 95) are
swathed in yards of black silk, imparting to this sombre and
otherwise static portrait both movement and light. The very
impatience of Lord Warwick's arrested mobility (cat. 72) is
emphasised by the swag of red silk that cascades around him.
And in that grandest of all groups *Philip Herbert, 4th Earl of*
Pembroke, and his Family (fig. 62), the flow of silks, in dress, in
draperies and in curtains, the clouds overhead, the rhythmic
gestures, all work together to create an effect of courtly
drama.

Hand in hand with this new freedom of dress, goes a fond-
ness on the part of Van Dyck and his sitters for specifically
'fancy' dress, as in *Sir John Suckling* (*c.*1638; Frick Collec-
tion, New York), whose loosely belted tunic was probably
inspired by contemporary ideas of Persian costume;[14] *Philip,*
Lord Wharton (fig. 65), portrayed in the guise of a shepherd,
complete with *houlette*, or *Rachel de Ruvigny, Countess of*
Southampton (cat. 104). Such fancies may not have seemed
unusual to young men and women used to performing in
the elaborately staged masques that were such a feature of
court festivities in this period, but they were certainly new to
portraiture, and must have seemed avant-garde to many
observers.

The effect of this new manner is idealisation and timeless-
ness, reflecting a taste among Van Dyck's sitters for the neo-
Platonism, seen in the poetry of the period, that considered
earthly beauty to be the image of a higher, heavenly reality,
rather than of earthly vanity and impermanence. Their prede-
cessors had usually insisted on being portrayed with every
stitch of their fashionable dress delineated, and the date of the
likeness recorded on the panel or canvas as a reminder of
mortality. It is instructive to compare the precision of Marcus
Gheeraerts the Younger's *Lady Scudamore* (fig. 57), dated
12 March 1614, and intriguingly inscribed 'No Spring till
now',[15] with the timeless romanticism of Van Dyck's *Countess*
of Bedford (cat. 98) of some twenty years later.

to an extent following fashions, are more diffuse and sophisti-
cated: harmonies of contrasts; the *discordia concors* evident in,
for instance, *Henrietta Maria with Jeffrey Hudson* (cat. 67) or
Philip, Lord Wharton (fig. 65). Heavy damasks and embroid-
ered materials are seen less and less frequently as the 1630s
advance, and Van Dyck prefers light, shimmering silks, often
with scalloped edges, sometimes with stylised slashings, worn
with diaphanous gauzes, with pearl drop earrings and strings
of pearls. The favourite accessories are flowers (above all,
roses, emblems of the pleasures and pains of love, of beauty
and mortality), motifs infrequently found in the portraits of
Van Dyck's earlier periods.

As fabrics become lighter, so Van Dyck tends to abandon,
except in his portraits of the royal family, formal day dress.
William Sanderson, Van Dyck's near contemporary, writes in
his *Graphice* that Van Dyck was the first painter 'that e're put
ladies' dress into a careless romance',[11] an effect described in
verse in two lyrics by Robert Herrick:

Whenas in silks my Julia *goes,*
Then, then (me thinks), how sweetly flowes
That liquefaction of her clothes.[12]

≈

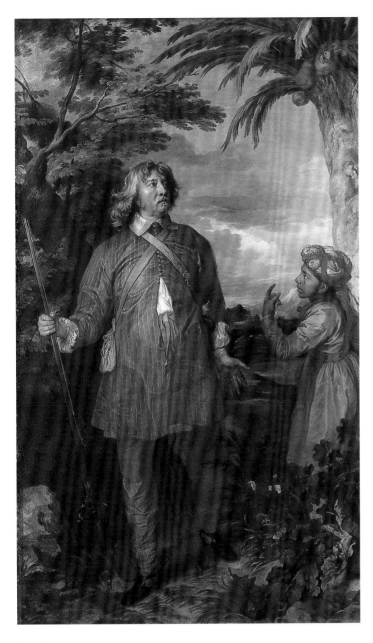

Still some of Van Dyck's sitters, like their ancestors, kept a taste for the *memento mori* or for symbolism of a more or less esoteric kind. Patrons might well suggest quite complex programmes, as in *Thomas Killigrew and a Man 'not known certainly'* (cat. 95), where the two young men – Roman Catholics or Catholic sympathisers – are shown in mourning for Killigrew's wife Cecilia Crofts, and for her sister Anne, Countess of Cleveland, who had died within days of one another. Killigrew almost lets slip from his hand a paper which is in shadow, and on which are depicted two statues of

females on pedestals; the one, with a figure of a child clutched to her side, may be Cecilia Killigrew and her son; the other Lady Cleveland. His companion holds in the light, at the centre of the composition, a sheet of paper that is blank, pointing out the absoluteness of the bereavement so that it may be the more keenly felt.[16] In the same spirit Sir Kenelm Digby commissioned Van Dyck to paint Lady Digby on her deathbed (cat. 69), not to remind him how she looked when living, but when dead. He kept the portrait by him and meditated on it, and, as he wrote, 'by the faint light of candle, me thinkes I see her dead indeed'.[17]

In tribute to the same lady, Van Dyck painted the posthumous (as it surely must be) portrait as Prudence (cat. 70), and he was arguably more at home with allegory, a standard element of the baroque repertoire, than with symbolism of a more personal nature. We see him again in this vein in the portrait of Lady Southampton as *Fortuna* (cat. 104), and in the remarkable *Dorothy Savage, Viscountess Andover, and her Sister Elizabeth, Lady Thimbleby* (fig. 67), painted about the time of Lady Andover's marriage in 1637. She is depicted in the saffron robes of a Roman bride and is attended by an angel presenting a basket of roses, the attribute of St Dorothea of Cappadocia. This reference to her name saint is pointed, for Lady Dorothy had converted to Catholicism at the time of her marriage, amid considerable controversy.

It is in England that Van Dyck for the first time regularly sets his sitters in open country (fig. 69). Earlier, they are usually seen in umbrageous interiors or on the terraces of palaces, a suggestion of landscape beyond, but framed by column or balustrade. An exception is the *Tobia Pallavicino* (*c*. 1625–7; Palazzo Durazzo-Pallavicino, Genoa), which anticipates one of Van Dyck's greatest English full-lengths, *William Feilding, 1st Earl of Denbigh*, 1633–4 (fig. 68). This shows the Earl after his return from Persia and India with his Indian page, striding through a jungle landscape. He wears pyjamas, and turns dramatically in the direction of a parrot, as if he has just heard its shriek. Many of Van Dyck's sitters move through the landscape: Charles I on horseback, like an emperor; Lord Warwick (cat. 72), the man of action; Mrs Endymion Porter (fig. 69), a nymph, on foot in a barren terrain. It is hard to envisage, in contrast, the unknown Genoese noblewoman (cat. 37) or, indeed, Gheeraerts's Lady Scudamore (fig. 57), contemplating so rash an excursion among the rocks and bushes, wearing only her shift and a few yards of silk. Yet, what a noble figure Mrs Porter appears. The effect is

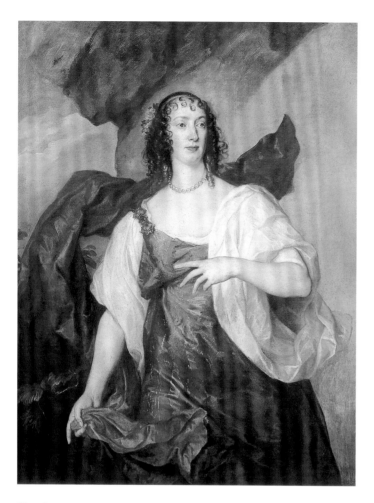

FIG 69
Anthony van Dyck, *Mrs Endymion Porter, c.*1640
oil on canvas, 135.9 × 106.7 cm
The Duke of Northumberland

also very different from the mood of reverie of the *Lord Wharton* of about 1632 (fig. 65), one of the artist's earliest English portraits, where the nineteen year-old is portrayed in a wooded and mountainous landscape, a melancholy shepherd, viewing the spectator with an expression of enquiring aloofness.

It is works such as these that anticipate in mood and motif the allegorising portraits of Sir Joshua Reynolds and the idyllic, 'fancy' portraits of Reynolds's rival Thomas Gainsborough, and it is generally arguable that more of Van Dyck's essential style and spirit is felt in the portraits by his 18th-century followers in England than in the work of his own contemporaries. That is not to say that his fellow artists were not watching and learning what they could. Indeed, soon after Van Dyck's arrival in England wisps of drapery begin to appear in the portraits of artists like Cornelius Johnson. Sitters no longer face monotonously to the front, and, at full

length, there are hints of movement. Yet, with the exception of the short-lived William Dobson, who may or may not have worked in the master's studio, and who brought to his portraiture of the Civil War court of Charles I a stolid reinterpretation of the Van Dyckian style, there was no natural successor. Dobson's rival on the Parliamentarian side, Robert Walker, freely admitted that he knew no better than to imitate the poses of Van Dyck, but the results are generally feeble. It is only in the work of Sir Peter Lely who came to England from Holland in the 1640s, and who collected paintings by Van Dyck as well as his Italian Sketchbook (see figs. 7–10) as avidly as Van Dyck had collected works by Titian, that we see a serious attempt to revive Van Dyck's manner. Yet in his hands, as the pre-eminent artist of the Restoration court of Charles II, the results, for all their sumptuousness, pale by comparison: the characterisations monotonous, the compositions static, the atmosphere stultifying and airless. Van Dyck was quite simply unequalled and his achievements timeless. In the words of De Piles:

> *If his Performances are not alike perfect, all in the last degree, they carry with them, however, a* Great Character of Spirit, Nobleness, Grace *and* Truth, *insomuch that one may say of him, that excepting* Titian, *only* Vandyck *surpasses all the* Painters *that went before him, or have come after him, in* Portraits.[18]

Van Dyck died aged 42 in 1641, just before the brilliant society he had portrayed was destroyed by Civil War. His patron the Earl of Strafford (cat. 68, 102) had been executed, the King's rule was questioned, his ministers threatened, and the power of the mob felt in the streets of London. Many of those who had supported the King had moved, or were to move, into opposition, among them Van Dyck's patrons, the Earls of Bedford, Danby, Northumberland and Warwick. Van Dyck himself, his health failing, planned to quit the country. Nevertheless, at his death the King he had served so well in better times ordered this Latin text to be inscribed on his monument in St Paul's Cathedral:

> *Antonius Van Dyck, qui, dum viveret, multis immortalitatem donaverit vitam. Functus est Carolus Primus, Magnae Britanniae, Franciae et Hiberniae Rex, Antonio Van Dyck, Equiti Aurato.*[19]

FIG 70
Anthony van Dyck,
An English Landscape, 1635–41
watercolour and bodycolour with
pen and ink, 18.9 × 26.6 cm
The Trustees of the Barber
Institute, University of Birmingham
(Vey 304)

NOTES

1. It is impossible for me to write about Van Dyck's English period without acknowledging with profound gratitude the writings, advice and friendship of Sir Oliver Millar. I hope he will forgive the occasional echo.

2. R. W. Goulding and C. K. Adams, *Catalogue of the Pictures … at Welbeck Abbey*, Cambridge 1936, p. 485.

3. Robert Herrick, 'to his Nephew, to be prosperous in his art of Painting', *Hesperides*, 1648.

4. Millar 1963a, p. 92.

5. Ibid.

6. A further dynastic note is struck by the Countess, seated to the Earl's left, forlorn and in deep shadow, with arms folded in the attitude of a Roman funerary monument. This figure has usually been taken to represent Pembroke's second wife Lady Anne Clifford, from whom, however, he was estranged by 1635. It is surely more probably a posthumous portrait of Lady Susan de Vere, his first wife, who had died in 1629, but who was the mother of his children, an idea first drawn to my attention by Mr Alastair Laing.

7. R. de Piles, *Art of Painting*, trans. and ed. B. Buckeridge, London 1744.

8. Edmund Waller, 'To Vandyck', in *The Poems*, ed. G. Thorn Drury, London and New York 1893, p. 45.

9. *Memoirs of Sophia, Electress of Hanover*, trans. H. Forester, London 1888, p. 13.

10. *Memoirs of the Verney Family during the Civil War*, compiled by Frances P. Verney, London 1892, 1, pp. 257–61.

11. William Sanderson, *Graphice*, London 1658, p. 19.

12. 'Upon Julia's Clothes', *Hesperides*, no. 779.

13. 'Delight in Disorder', *Hesperides*.

14. Rogers 1978, pp. 741–5.

15. The date and inscription refer to the marriage of her son.

16. For a more detailed analysis see Rogers 1993, pp. 224–7.

17. Sir Kenelm Digby, letter to his brother, quoted by V. Gabrieli, *Sir Kenelm Digby, Un Inglese Italianato*, Rome 1957, p. 246.

18. Cited by Millar 1982, p. 44.

19. 'Anthony van Dyck, who while he lived gave immortality to many. Charles I, King of Great Britain, France and Ireland, provided this monument for Sir Anthony van Dyck'.

1 *Self-portrait,* 1613–14

oil on panel, 25.8 × 19.5 cm, set into a larger
octagonal panel, 43 × 32.5 cm

Gemäldegalerie der Akademie der bildenden
Künste, Vienna (inv. no. 686)

PROVENANCE Franz von Imstenrad;
11 February 1678, offered for sale in a letter to
Prince Karl Eusebius of Liechtenstein, described
as a self-portrait of Van Dyck: '*No. 82 Dass
Portrait von Antonio von Dyck, wie er sich selbsten
hatt abcontrefeit, in seiner Jugendt'*, valued at
30 *Reichstaler*; Karl Eusebius of Liechtenstein
(1611–84); by descent to Prince Johann Nepomuk
Karl of Liechtenstein (seals on front and back of
the Guardianship Administration for Prince
Johann Nepomuk Karl of Liechtenstein, 1732–48);
Count Anton Lamberg-Sprinzenstein; 1822,
presented by him to the Akademie

REFERENCES Hymans 1899, pp. 400–20; Cust
1900b, pp. 19, 235, no. 39; Schaeffer 1909, pp. 129,
501, n.; Cust 1911, no. 1; Hymans 1920, 11,
p. 565; Eigenberger 1927, 1, pp. 119–20, inv. 686,
11, pl. 89; Rosenbaum 1928a, p. 31 (wrongly
doubted as a self-portrait and erroneously dated
c. 1620); Glück 1931, pp. 3, 517, n.; id. 1934,
p. 195; Van Puyvelde 1941, p. 182; id. 1950,
pp. 45, 123, pl. 16; Münz 1955, pp. 20–21, no. 25;
Baldass 1957, p. 256; Van Puyvelde 1960, pp. 110,
130, 143, pl. 14; Jaffé 1966, 1, pp. 47–8; Poch-
Kalous and Hutter 1968, p. 181; id. 1972, pp. 98–9,
no. 170; Jaffé 1977, pp. 605–8; Larsen 1988, no. 2;
*Gemäldegalerie der Akademie der Bildenden Künste
in Wien: Illustriertes Beständsverzeichnis*, Vienna
1989, p. 69

EXHIBITIONS London 1953–4, no. 339; Delft
1964, no. 37; Ottawa 1980, no. 1; Minneapolis,
Houston, San Diego 1985, no. 11

NOTES
1. Jaffé 1977. In the view of the present writer, the
painting published by Jaffé is a copy which records
a lost original by Rubens.
2. In this catalogue Katlijne van der Stighelen
argues that this painting is, in fact, a self-portrait
by Van Dyck. The present writer, however,
believes it to be by Rubens.

Van Dyck looks over his right shoulder, creating the illusion that he has just turned
round to face the viewer and is being glimpsed momentarily. In fact he is looking into
a mirror and painting this remarkably assured self-portrait. The expression is intense;
the features, framed in a mass of unruly brown hair, are described with great precision.
The treatment of the hair in thin wavy strokes of white paint and the use of white
highlights on hair and face are striking characteristics of Van Dyck's early style.
In contrast to the careful delineation of the face, the white collar of Van Dyck's shirt
is indicated with a single bold stroke of lead-white, a brushstroke of extraordinary
confidence for so young an artist. It is difficult to be sure how old Van Dyck is in
this self-portrait, probably fourteen or fifteen years old, which would date the picture
to 1613 or 1614.

The tradition of self-portraits by northern artists was well established by this date.
Jan van Eyck showed himself full-face wearing an elaborate turban in 1433 (National
Gallery, London). Lambert Lombard, Frans Floris, Jan van Scorel, Maarten van
Heemskerck and many others painted self-portraits. What is remarkable about Van
Dyck's self-portrait is that he painted it so early in his career. He knew that he had
been given remarkable gifts, and from a very early age had a sense of his own unique
qualities. At this age he was still, at least nominally, working in the studio of his master,
Hendrick van Balen, yet he was already moving into the orbit of Rubens. Van Dyck's
self-portrait recalls an early self-portrait by Rubens, known from a copy (fig. 1),[1] which
had the same sense of intensity and immediacy; it is quite likely that Van Dyck had that
self-portrait by Rubens in mind.

At the same time that Van Dyck painted this self-portrait or possibly slightly later,
Rubens also painted a portrait of Van Dyck (fig. 2).[2] A comparison of the two is an
eloquent demonstration of the difference in style of the two artists: the head in
Rubens's portrait is more three-dimensionally modelled and has little of the bravura
treatment that characterises Van Dyck's.

During the course of his career Van Dyck painted a number of self-portraits, four of
which are included in this exhibition. One shows him as an elegantly dressed and even
more self-assured twenty year-old on the eve of his departure for Italy (cat. 31);

another as a courtier declaring his loyalty
to his new royal master, Charles I, in
England (cat. 66); the third is a
'friendship portrait' with Endymion
Porter (cat. 88). These are not self-
questioning or introspective self-
portraits: all show an artist confident
in his own abilities and in the value
that the world placed upon them. CB

FIG 1
After Peter Paul Rubens, *Self-portrait*,
copy of a lost original
oil on panel, 61.6 × 45.1 cm
Koninklijk Museum voor Schone Kunsten,
Antwerp, on loan to the Rubenshuis, Antwerp

FIG 2
Peter Paul Rubens, *Anthony van Dyck*, 1614–15
oil on panel, 36.5 × 25.8 cm
Rubenshuis, Antwerp

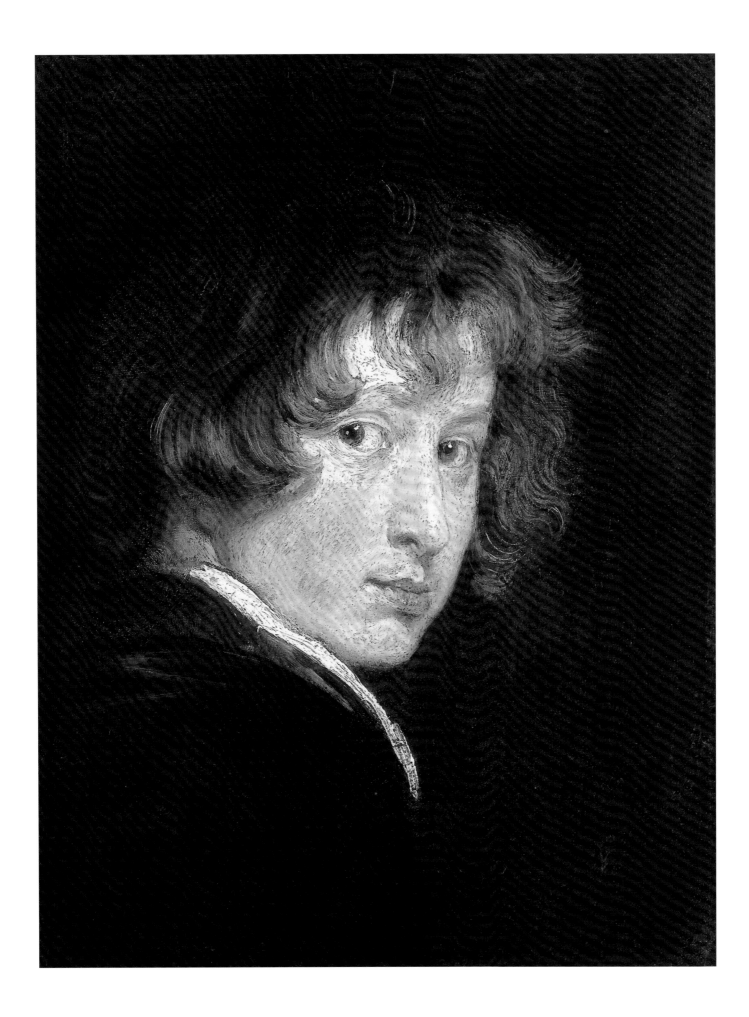

2 St Matthew
1615–16

oil on panel, 64 × 48 cm

Private collection

3 St James the Greater
1615–16

oil on panel, 64 × 48 cm

Private collection

PROVENANCE Robert Spencer, 2nd Earl of
Sunderland (1641–1702); thence by descent

REFERENCES T. F. Dibdin, *Aedes Althorpianae*,
1822, p. 275; *Catalogue of the Pictures of Althorp
House,* 1851; Galesloot 1868, pp. 561–606;
Schaeffer 1909, pp. 3–4; Glück 1931, p. 35 (cat. 2);
id. 1933, pp. 288–302; Garlick 1976, nos. 142, 143;
Princeton 1979, p. 22; Ottawa 1980, pp. 38–9;
Brown 1982, pp. 12–13; Urbach 1983, pp. 5–36

EXHIBITIONS (cat. 2) Royal Academy, London
1907, no. 70; London 1938, no. 108; ibid. 1947b,
no. 36; ibid. 1953–4, no. 219; Bruges 1956, no. 82;
King's Lynn 1963, no. 1; London 1968a, no. 3;
ibid. 1984, no. 41

(cat. 3) London 1947b, no. 38; ibid. 1953–4,
no. 217; Bruges 1956, no. 83; Nottingham 1960,
no. 2; King's Lynn 1963, no. 2; London 1968a,
no. 2; ibid. 1984, no. 41

Van Dyck made several series of paintings of Christ and his apostles early in his career.
In doing this he was following an old Netherlandish tradition stretching back at least to
Quentin Metsys. There was, for example, a famous series of apostles by Frans Floris
(now lost) in the collection of Archduke Ernst of Austria in 1595. It was traditional to
show Christ and the apostles as half-length figures, stressing the individuality of their
features and dress, and including their attributes. Many such paintings seem to have
been based on studies of elderly men made from the life, and they were later used as
a repertory of heads for other religious and mythological paintings. Van Dyck used his
heads of apostles in this way: individual heads were reused in subject paintings such as,
for example, *Suffer the Little Children to come unto Me* (cat. 8). Van Dyck's immediate
source was, as so often in his early years, Rubens, who had painted such a series for
the Duke of Lerma (Prado, Madrid). *St James the Greater* is closely based on the
Rubensian composition, but painted in reverse with a few, very small changes.

The grouping and dating of Van Dyck's early series of apostles present complex
problems. In my view a first series was painted *c.* 1615–16, five of which were until
quite recently at Althorp House, two of which are shown here. A second series,
usually known as the Böhler series, mostly repeats the compositions of the first series
(see cat. 16, 17).

The earlier series is painted in a sketchy technique, with bright white highlights, close
to such paintings as *The Martyrdom of St Peter* (cat. 5) and the Louvre *Martyrdom of
St Sebastian* (cat. 4, fig. 1). The apostles' robes and attributes are simplified and broadly
painted so as to emphasise their forceful, idealised features which are accentuated by a
shaft of brilliant light falling from the top left.

A court hearing concerning the authenticity of a series of apostles by Van Dyck took
place in Antwerp in 1660–61. A number of Antwerp artists, many of whom had known
Van Dyck personally, gave evidence, and the proceedings give a rare and vivid glimpse
of the Antwerp art world of the 17th century. The documents have been much pored
over and sometimes misinterpreted. As far as we are concerned here, we learn that Van
Dyck had established a studio at a very early age, probably in 1615 or 1616, and that
among his earliest productions was a series of apostles. This may well be the series to
which cat. 2 and 3 belong. We also learn that copies of that series were made by
Herman Servaes and Justus van Egmont and then had been retouched by Van Dyck.
It was that series which was the subject of the court case and may be identical with the
series now at Aschaffenburg. CB

4 *Armed Soldier on Horseback*
1615–16

oil on canvas, 91 × 55 cm

By permission of the Governing Body of Christ Church, Oxford (inv. no. 246)

PROVENANCE General John Guise; 1765, bequeathed by him to Christ Church

REFERENCES *English Connoisseur*, 11, 1766, p. 66 ('A finished sketch of King Charles The First's white horse'); Christ Church 'A' catalogue, 1766, p. 3; Christ Church catalogue 1833, no. 160; Guiffrey 1882, no. 970; Cust 1900, p. 233 (under no. 11); Borenius 1916, no. 232; Glück 1925–6, p. 261; id. 1931, pp. 4–5; Vey 1956, pp. 168–9; Byam Shaw 1967, p. 126, no. 246; Ottawa 1980, p. 55; Princeton 1981, p. 399, under no. 3; Larsen 1988, no. 316

EXHIBITIONS [London and] Manchester 1857, no. 585; Antwerp and Rotterdam 1960, no. 123; Liverpool 1964, no. 17; Washington 1990–91, no. 88

COPY Sale Sotheby's, London, 26 October 1988, lot 51 (from the collection of Sir Evelyn de la Rue, Bt., Cookham), canvas, 85 × 54 cm

NOTES
1. Vey 1956.
2. Wethey, no. 134. A version was in the Arundel collection.
3. For a discussion of this group of paintings of St Jerome, see Washington 1990–91, no. 2.

Glück (1931) first pointed out that this spirited oil sketch was made in preparation for *The Martyrdom of St Sebastian* in the Louvre (fig. 1). Subsequently it was argued that the sketch was made as an independent study and only later used by Van Dyck for the Louvre painting,[1] but the way in which both rider and horse turn their heads towards an event happening outside the picture space makes it clear that it was made in preparation for the work in Paris. This oil sketch is most unusual in Van Dyck's working practice at this date: his usual procedure for his early religious and mythological paintings was to evolve the composition in a series of pen and wash drawings, as, for example, in *Christ carrying the Cross* (cat. 7). He was, however, only about seventeen when he made this sketch and was still experimenting in the planning of his compositions.

Sebastian, a captain in the Roman army who had converted to Christianity, was shot by his own company of archers on the orders of the Emperor Diocletian. He survived and was nursed back to health by St Irene, only to be beheaded and his body thrown in the Cloaca Maxima, the principal sewer of Rome. Van Dyck returned to the subject on at least three occasions in his early years, always choosing to illustrate the moment in the story when the saint is bound to a tree in preparation for his martyrdom. In this he may have been inspired by Wenzel Coebergher's altarpiece of the subject (Musée des Beaux-Arts, Nancy) painted in 1598–9 for the chapel of the Guild of Longbowmen (*Jonge Handboog*) in Antwerp Cathedral. Another possible source was a *Martyrdom of St Sebastian* by Titian.[2] All Van Dyck's treatments of this subject concentrate on the near-naked body of the saint – a handsome, well-proportioned young man – as yet unmarked by arrows. The Louvre painting, in which the saint adopts a mannered pose and looks sulkily at the viewer, is his earliest treatment of this subject. It is painted in the same broad and sketchy manner, with eye-catching white highlights, as *The Martyrdom of St Peter* (cat. 5) and the versions of St Jerome in Vaduz, Rotterdam and Stockholm;[3] these pictures constitute his earliest group of history paintings, dating from about 1615–16. Van Dyck later developed his treatment of St Sebastian in a canvas of about 1620 (National Gallery of Scotland, Edinburgh) which has a composition visible in the x-ray substantially different from the finished work. Subsequently he painted the version in Munich (Alte Pinakothek; p. 19, fig. 5).

In all the versions of the subject Roman soldiers on horseback are shown on the right supervising the binding of the saint to the tree, and it was to create one of these figures that Van Dyck took the unusual step of making this oil sketch. It is very fluent, with all the immediacy of a drawing. He outlined the horse and its rider in dark brown paint and then applied dense white highlights to the horse's head and flanks and to the rider's shoulders and helmet. He was particularly anxious to establish the pose of the soldier who leans forward to observe the binding of the saint. In the event, the horse and rider are placed high up in the right-hand corner of the Louvre painting, the horse being partially obscured by the old man bending to tie up Sebastian. CB

FIG 1
Anthony van Dyck, *The Martyrdom of St Sebastian*, 1615–16
oil on canvas, 144 × 117 cm
Musée du Louvre, Paris

5 *The Martyrdom of St Peter* 1615–16

oil on canvas, 204 × 117 cm

Musées Royaux des Beaux-Arts de Belgique, Brussels (inv. no. 215)

PROVENANCE Probably the painting of St Peter mentioned in the inventory of the Antwerp silversmith Jan Gillis, Antwerp, 28–30 July 1682 (*'een groot stuck Van Dick wtbeldende de Cruysinge van Sint Peeter'*; Denucé, p. 310); in the inventory of Jan-Baptista Anthoine, Director of the Post, 1691, is *'Eenen St Peeter gecruyst naer van Dijck'* (Denucé p. 362) which is probably a copy; 29 July 1822, sale H. J. Stier d'Aertselaer, Antwerp, lot 10; bought by Rottiers; 1830, acquired from Colonel Rottiers by the Museum

REFERENCES Smith 1829–42, III, p. 14, no. 38; Fromentin 1876, p. 138; Guiffrey 1882, p. 251, no. 207; Hymans 1899a, p. 235; id. 1899b, p. 419; Cust 1900, pp. 45, 210, no. 30, p. 240, no. 41; Schaeffer 1909, p. 27; Rosenbaum 1928a, pp. 46–7; Glück 1931, XXVII, p. 7; Denucé 1932, p. 310; Glück 1933, pp. 282–4; Van Puyvelde 1941, p. 182; id. 1950, p. 123; Vey 1962, p. 92; Brussels 1984, p. 96, no. 215; Larsen 1988, no. 238

EXHIBITIONS Antwerp 1899, no. 30; ibid. 1949, no. 9; Genoa 1955, no. 9; Washington 1990–91, no. 3

NOTES
1. See cat. 4, n. 3.
2. Vlieghe, *Saints*, Corpus Rubenianum, 1972, VII, no. 39.

St Peter was, at his own wish, crucified upside-down. According to *The Golden Legend*: 'Pope Leo and Marcellus assert that when Peter came to the cross, he said: "Because my Lord came down from heaven to earth, his cross was raised straight up; but he deigns to call me from earth to heaven, and my cross should have my head towards the earth and should point my feet towards heaven. Therefore, since I am not worthy to be on the cross the way my Lord was, turn my cross and crucify me head down!" So they turned the cross and nailed him to it with his feet upwards and his head downwards'. In Van Dyck's painting of this rarely represented subject the saint has been bound to the cross which three men are straining to plant in the ground. The man on the right wears a helmet and breastplate, but the others are naked to the waist. The figures of the two half-naked men and of St Peter himself are strongly lit from the left, while in the background the light blue sky is illuminated by the rays of the sun. Van Dyck's painting is in his earliest style, characterised by the sketchy use of paint applied with a brush that is almost dry, and with bold, broken white highlights. With the Louvre *St Sebastian* (cat. 4, fig. 1) and the various versions of St Jerome,[1] this painting is in the manner described by Gustav Glück as Van Dyck's rough, or awkward, style. It should therefore be dated at the very beginning of his career in 1615–16. Like the *St Sebastian* its true subject is the near-naked body of Peter: in some respects both paintings are life studies from the nude.

At the end of his career, in about 1638, Rubens painted an altarpiece of this subject for St Peter's church in Cologne. The source of that composition has been identified as a painting (Hermitage, St Petersburg) once thought to have been a copy of Caravaggio's first treatment of the subject; now it is considered to be by an unidentified follower of Caravaggio. Yet, if it was available for Rubens in the late 1630s, it may well have been in Antwerp in about 1615 and so could have also provided the inspiration for Van Dyck.[2]

A sheet of black chalk studies of the hands of St Peter and the figure on the right was sold from the Oppenheimer collection by Christie's in 1936; its present whereabouts are unknown. CB

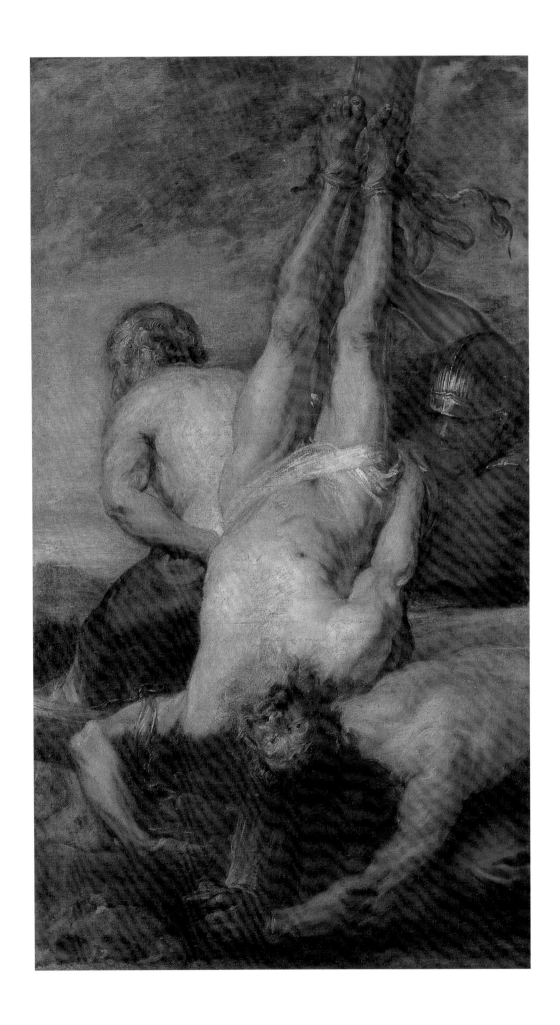

6 *Portrait of a Man and his Wife* 1617–18

oil on canvas, 113 × 131 cm

Szépművészeti Múzeum, Budapest (inv. no. 754)

PROVENANCE Prince Wenzel Kaunitz-Rietberg (1711–94), Vienna; Prince Nikolaus Esterhazy (died 1833), Vienna (Inventory Journal 1821, no. 1040); 1865, transferred to Budapest with the entire collection; 1871, purchased by the Museum with the collection

REFERENCES Schaeffer 1909, p. 156; Brussels 1910, 1912, p. 140, no. LX (120); Glück 1931, p. 113; H. Vlieghe, 'Het portret van Jan Breughel en zijn gezin door Rubens', *Bulletin Kon. Musea voor Schone Kunsten van België*, XV, 1966, p. 186; A. Pigler, *Katalog der Galerie Alter Meister, Museum der bildenden Künste, Budapest*, p. 754 (with extensive bibliography); J. S. Held, *Flemish and German Paintings of the 17th century, The collections of the Detroit Institute of Art*, Detroit 1982, p. 28; *The Budapest Museum of Fine Arts*, ed. K. Garas, Budapest 1988, pp. 131, 165; Larsen 1988, no. 83; S. Urbach, *Meisterwerke des Museums der bildenden Künste*, Budapest 1990, no. 84

EXHIBITIONS Brussels 1910, no. 120; Bad Homburg and Wuppertal 1995, pp. 74–5, no. 20 (entry by A. Gosztola)

NOTES
1. Ed. P. M. Daly and S. Cuttler, *Andreas Alciatus, 2: Emblems in Translation*, Toronto 1985, emblem 191.
2. On this motif in portraits of elderly couples and examples from legal doctrine and ecclesiastical history, see E. de Jongh, *Portretten van echt en trouw: Huwelijk en gezin in de Nederlandse kunst van de zeventiende eeuw*, exh. cat., Haarlem 1986, pp. 154–7, 314, fig. 78b.

The expressions of this well-to-do middle-aged couple suggest that they were calm, composed, but perhaps rather solemn characters. They are shown half length with, as was customary in such double portraits, the man on the left (the heraldic right) and his wife on the right (the heraldic left). He holds the fingers of his wife's right hand affectionately in his own right hand, while resting his left arm protectively on her chair covered with Spanish leather. Both are dressed in black in the dignified Spanish fashion; the woman wears a starched lace cap and, as in most of Van Dyck's female portraits of this period, bracelets on both wrists. In her left hand she holds an embroidered glove.

Stylistically the portrait belongs to Van Dyck's first Antwerp period and may be dated to around 1617–18. As Vlieghe noted, the man's pose largely corresponds with that of the father in Van Dyck's *Portrait of a Family* (formerly Cook Collection; fig. 1), which was painted around the same time.

The most striking motif in this work is the contact between the couple's right hands. It alludes to the joining of the bride and groom's right hands, the *dextrarum iunctio*, in the marriage service after they have made their vows. Clasped hands had been a symbol of marital fidelity since Roman times. The motif of joined right hands is used as the emblem symbolising marriage by Andreas Alciati in his emblem book. The motto beneath the image in the Italian edition of his work (Lyons 1569) reads: *'nelle fede, che debbone insieme hauere marito et mogle'* (concerning the fidelity that husband and wife must possess).[1] The motif is also found in Rubens's portrait of *Rubens and Isabella Brant: The Honeysuckle Bower* (Alte Pinakothek, Munich), probably painted in 1609, the year they married.

Van Dyck painted this older couple about ten years later, incorporating the same symbolism of marital fidelity in a personal manner.[2] In a similar portrait of the same date, a couple clasp their right hands together (Detroit Institute of Arts), and in the *Portrait of Sebastiaan Leerse with his Wife and Son* (Gemäldegalerie, Kassel), a work from his second Antwerp period, the man places his right hand on that of his wife. FB

FIG 1
Anthony van Dyck, *Portrait of a Family*, 1617–18
oil on canvas, 112 × 111 cm
Private collection, England

Christt carrying the Cross
1617–18

oil on canvas, 211 × 161.5 cm

Kerkfabriek Sint-Paulus, Antwerp

PROVENANCE Painted for St Paul's, Antwerp

REFERENCES Bellori 1672 (ed. 1976), p. 272; Smith 1829–42, III, no. 408; Guiffrey 1882, pp. 15–16 and no. 101; Cust 1900, p. 233, no. 5; Rooses 1906, p. 10 (documents for the commission); Schaeffer 1909, p. 496, no. 17; Rosenbaum 1928a, pp. 52–3; Glück 1931, p. 518, no. 11; Delacre 1934, p. 90ff; Van den Wijngaert 1943, pp. 25–6; Van Puyvelde 1950, pp. 123–4; Vey 1958, pp. 11–35; Van Gelder 1961, pp. 3–18; Vey 1962, nos. 7–13; Larsen 1988, no. 269

EXHIBITIONS Antwerp 1899, no. 11; ibid. 1949, no. 1

ENGRAVING by Cornelis Galle the Elder

NOTES
1. For this sequence of drawings, see Vey 1962, nos. 7–13, and Brown 1991, pp. 48–59.
2. Held, *Oil Sketches*, no. 344.

During the second decade of the 17th century, the Dominicans of Antwerp, taking their lead from other religious orders in the city, notably the Jesuits and Augustinians, commissioned for their church, St Paul's, a cycle of fifteen paintings representing the Mysteries of the Rosary. According to tradition, St Dominic had received a chaplet of beads from the Virgin, and the cult of the rosary was promoted by the Dominicans, particularly after the Council of Trent. The paintings, which are still in the church, can be seen hanging in their original setting in a painting of 1636 by Pieter Neeffs the Elder (fig. 1). A document in the church archives records the names of the artists who worked on this major cycle, the payments they received and the names of the donors. The painters included Rubens, Van Dyck, Jordaens, Frans Francken the Younger, David Teniers the Elder, Cornelis de Vos, Hendrick van Balen and other, lesser figures. Van Balen was the highest paid, receiving 216 guilders; Van Dyck, like Rubens and Jordaens, was paid 150 guilders. The donor of Van Dyck's painting was Jan van den Broeck. Although the document is not dated, Rubens's painting for the series, *The Flagellation of Christ*, bears the date 1617, which, while probably not contemporary, would seem to be based on an earlier inscription or document, and therefore gives the approximate date for the whole series.

It would seem to have been most unusual for an artist to receive such an important commission before having completed his apprenticeship, and Van Dyck did not enter the Antwerp Guild of St Luke as a master until 11 February 1618. It is not clear how strictly guild regulations were enforced, and we know that Van Dyck had been active as an independent painter from at least about 1616. In his life of Van Dyck, Bellori mentions the *Carrying of the Cross* as one of the painter's earliest works, and it seems reasonable to assume that he was at work on it in 1617 and 1618.

This was a highly important commission for the young artist, and it is no surprise to discover that ten preparatory drawings for it survive.[1] Nine show him working out the composition, and the tenth is a study in black chalk, made from a model posed in the studio, for the figure dragging Christ along by his robe. Van Dyck's starting point, as so often in his early drawings, was a design by Rubens, an oil sketch of *Christ carrying the Cross*, painted in about 1614–16 (fig. 2),[2] and Van Dyck's first drawing (fig. 3) is

FIG 1
Pieter Neeffs the Elder, *Interior of the Dominican Church at Antwerp*, 1636
oil on panel, 68 × 105.5 cm
Rijksmuseum, Amsterdam

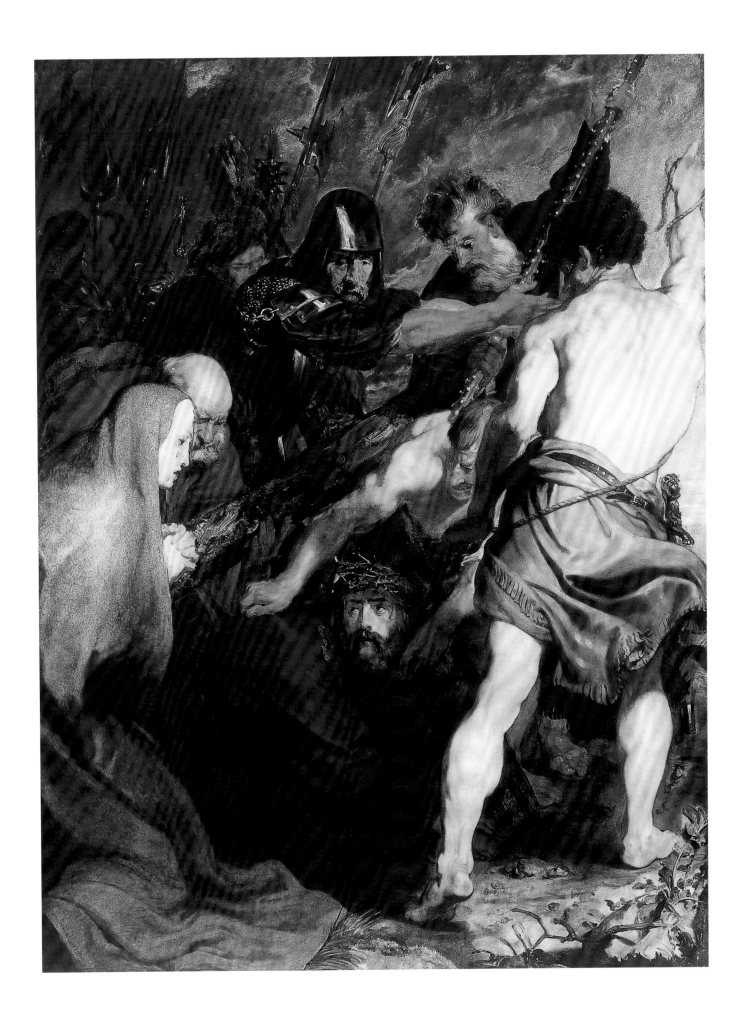

FIG 2
Peter Paul Rubens,
Christ carrying the Cross, 1614–16
oil on panel, 64 × 49 cm
Gemäldegalerie der Akademie
der bildenden Künste, Vienna

based on Rubens's composition. Although the painting's position in the church dictated that the procession should move from left to right, Van Dyck at this stage retained Rubens's direction, from right to left. He omitted St Veronica holding the *sudarium*, instead making the focal point of the composition the glance exchanged between Christ and his mother. This is entirely appropriate for a cycle of paintings of the Mysteries of the Rosary, as Christ carrying the cross on the procession to Calvary is one of the seven Sorrows of the Virgin. Van Dyck made many other changes to Rubens's composition, abandoning the low viewpoint and diagonal movement, instead placing the viewer on eye level with the sacred figures, which are larger in scale. In the Providence drawing the pose of Christ, the figure of a Roman soldier with a plumed helmet and the heavily muscled figure on the right pulling along the first thief are taken from Rubens. Van Dyck introduces the standing figure of the heavily veiled Virgin on the left. In a second drawing, in Berlin, the Virgin has been moved to the right and Christ looks back at her over his left shoulder. This composition is elaborated in a sheet in Turin (Vey 8), and it was in a further drawing on the back of that sheet that Van Dyck first reversed the direction of the procession. Then comes a drawing in Lille (Vey 9) in which the composition is close to that in the finished painting, with the Virgin and the two figures dragging Christ in their final positions. In this drawing, however, the composition is in a horizontal format, although it must have always been known that the final format was to be vertical. The vertical format is adopted, the poses and relative positions of the remaining figures resolved, and the disposition of light and shade refined in the three further drawings (in Chatsworth, a private collection, and formerly Kunsthalle, Bremen; Vey 10–12). Finally there is a squared-up drawing, the *modello* for the painting in Antwerp (Prentenkabinet; Vey 13). Following Rubens's procedure Van Dyck then posed models in the studio to make individual figure studies: one such black chalk study survives (Courtauld Institute Galleries, London; Vey 14). CB

FIG 3
Anthony van Dyck,
Christ carrying the Cross, 1617–18
black chalk with pen and ink
and washes, 20.3 × 17 cm
Museum of Art, Rhode Island School
of Design, Providence, Rhode Island (Vey 7)

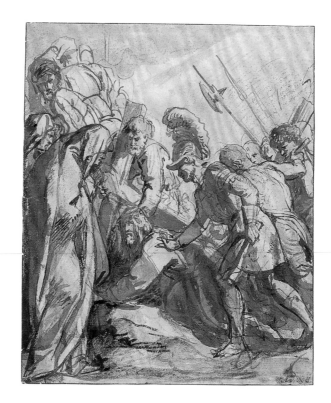

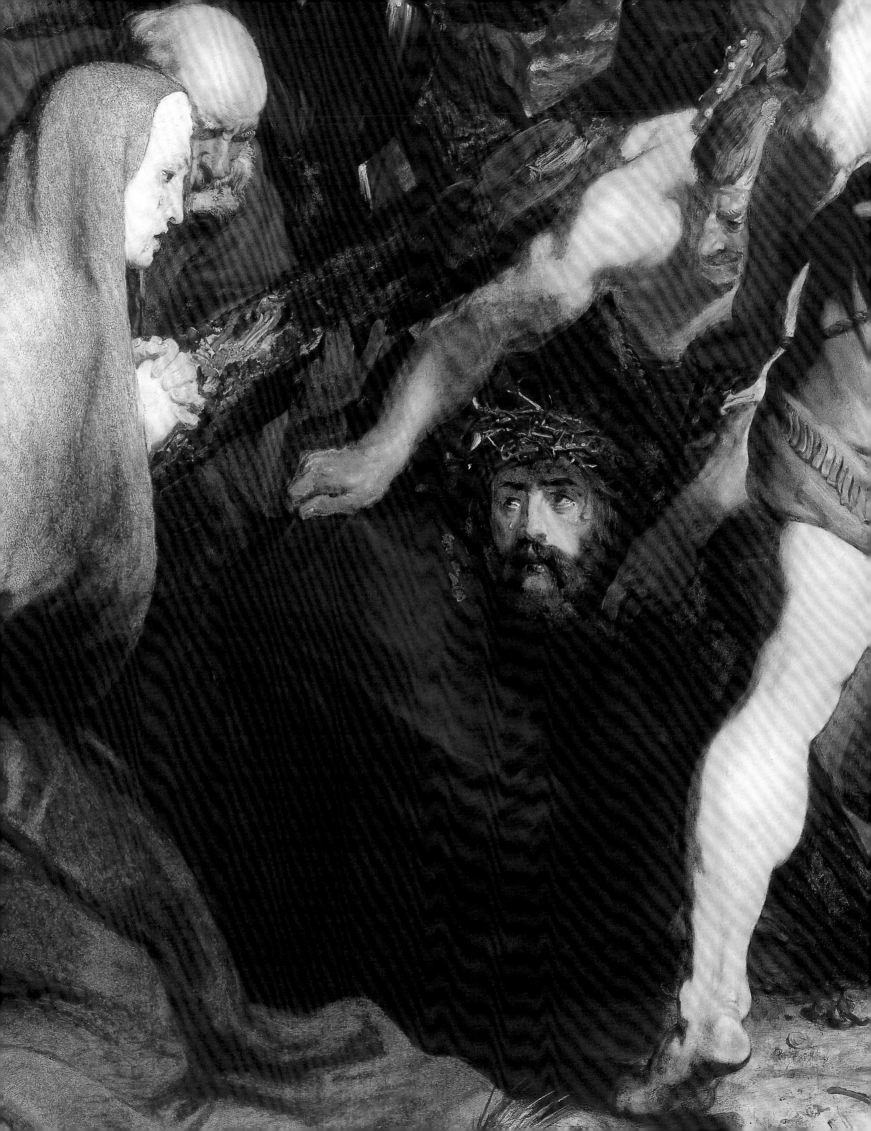

Suffer the Little Children to come unto Me, c. 1618

oil on canvas, 131.4 × 199.4 cm

National Gallery of Canada, Ottawa (inv. no. 4293)

PROVENANCE 1718, listed in an inventory of
Blenheim Palace written by the Duke of
Marlborough's steward Charles Hodges (British
Library Add. MS. 9125, fol. 6v): 'The Family of
Rubens done by Vandike of Ten figures bought
at Mr. Talmashes Auction, half by my Lady
Dutchess and half by My Lord Duke, cost Two
hundred fifty-five pounds.' (In the same inventory
there are two other paintings from this auction
which may have been owned by Marlborough's
military colleague and rival Thomas Tollemache,
killed at Brest in 1694.); 24 July 1886, Blenheim
Palace sale, Christie's, London, lot 64 (as
Rubens); bought by Bertram Wodehouse Currie,
Minley Manor, Hants, through Charles Fairfax
Murray (as Rubens); by descent to Bertram
Francis George Currie, Minley Manor; 16 April
1937, sale Christie's, London, lot 125 (as Van
Dyck); bought by Heather; with Bottenweiser
(dealer), London; Asscher and Welker (dealers),
London; 1937, bought by the Gallery

REFERENCES New Oxford Guide, 1759, p. 100
(as 'scholar of Rubens'); W. Hazlitt, Sketches of the
Principal Picture Galleries in England, 1824, p. 171
(as Rubens); Smith 1829–42, 11, p. 249, no. 845
(as Diepenbeck); Waagen 1854, 111, p. 125
(as Rubens); G. Scharf, Catalogue of the Pictures
in Blenheim Palace, London 1862, pp. 54–5
(as Rubens); W. B. [Wilhelm von Bode],
'Die Versteigerung der Galerie Blenheim in
London', Repertorium für Kunstwissenschaft, x,
1887, p. 61 (as Van Dyck); Rooses 1888–92, 11,
p. 421 (as Adam van Noort); Bode 1906, p. 264
(as Van Dyck); M. MacFall, Catalogue of the
Collection of Works at Minley Manor, 1908, p. 7
(as Rubens); Burchard 1938, pp. 25–30; Garas
1955, pp. 189–200; Vey 1962, p. 102; Waterhouse
1978; Brown 1982, pp. 46, 50; National Gallery of
Canada 1987, 1, pp. 99–101; Larsen 1988, no. 255;
Muller 1989, p. 148, n. 2

EXHIBITIONS Chicago 1954, no. 34; McIntosh
Memorial Gallery, University of Western Ontario,
Loan Exhibition 15th-, 16th-, 17th-Century Flemish
Masters, 1957; Art Gallery of Hamilton, Ontario,
Old Masters, An Exhibition of European Paintings
from the Sixteenth, Seventeenth and Eighteenth
Centuries, from North American Collections, 1958,
no. 33; Princeton 1979, no. 21; Ottawa 1980,
no. 71; Washington 1990–91, no. 18

NOTE

1. There are two studies in oil said to be
preparatory for this figure. Both were in the
E. Warneck sale, by Georges Petit, Paris,
27–8 May 1926, lot 36 (without hands) and lot 37
(with hands; obtained by Warneck at Hamilton
Palace sale, 1882). The former, from the collection
of President Charles d'Heucqueville, sold at

Christ, accompanied by three apostles, is blessing a boy, the eldest of four children.
The parents gaze at Christ, the mother is holding the baby. It is evident that the family
group is a portrait, and indeed, an oil study for the boy receiving the blessing (fig. 1)
is a wonderfully vivid sketch, made from life.[1] The painting's portrait-like quality was
recognised as early as 1718 when it was described in a Blenheim Palace inventory as
'The Family of Rubens done by Vandike'; later on the attribution was forgotten, and it
was variously attributed to Rubens, Diepenbeeck and Adam van Noort. Subsequently
the attribution to Van Dyck has been universally accepted. Garas argued that it showed
Rubens, Isabella Brant and their children, Clara Serena, Albert, Nicholas and another
baby. Waterhouse agreed, adding that it may have come to the Marlborough collection
with two other paintings – Helena Fourment and her Son as a Page (Louvre, Paris) and
Rubens, Helena Fourment and their Eldest Child (Metropolitan Museum of Art, New
York) – from the sale of Rubens's collection. However, we now know that the painting
came to the Marlborough collection from that of a member of the Tollemache family,
and close comparison of the heads of the parents with documented portraits of Rubens
and Isabella Brant makes the identification extremely unlikely; in addition the ages of
the children (and the presence of a fourth, unrecorded child) do not accord with the
biographical facts of Rubens's life.

Presumably the painting was commissioned from Van Dyck by an Antwerp family to
mark the confirmation and first communion of the eldest boy, as Burchard suggested.
Van Dyck had treated the subject earlier in a drawing (fig. 2), although there the
composition was reversed. The poses of Christ and the apostles, shown three-quarter

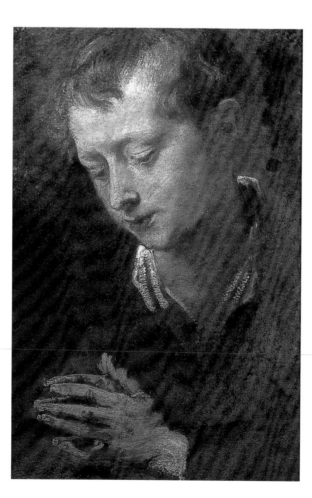

FIG 1
Anthony van Dyck,
Head of a Boy, c. 1618
oil on paper, 45.1 × 29.5 cm
Henry Welden Collection,
New York

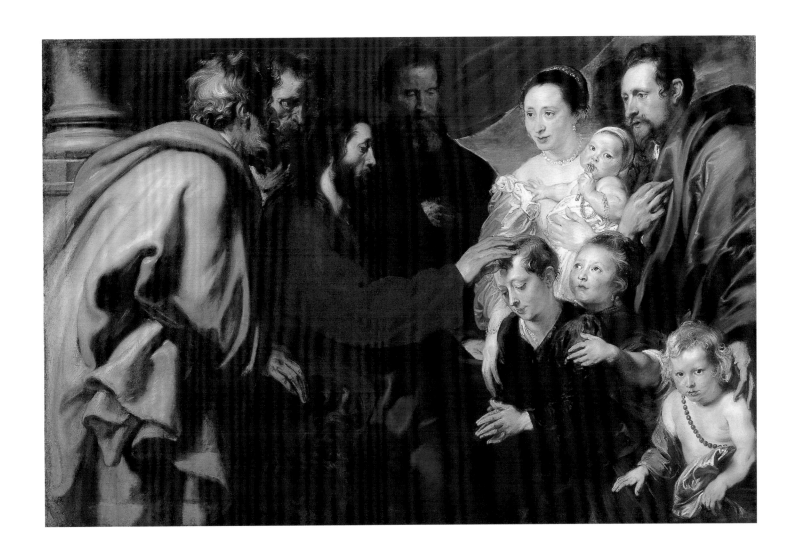

Charpentier, Paris, 24 March 1936, on panel, is now in the Louvre (RF 1961–83) and is a copy. The latter was sold at Cassirer-Fischer, Lucerne, 1 September 1931 (Fritz Hess Collection, lot 13) and is now in the Welden Collection (fig. 1).

length, are, however, very similar. On the left of the drawing the mother bows as she presents her child to Christ for his blessing.

The story of Christ blessing the children is told in all three synoptic gospels (Matthew XIX, 13–15; Mark X, 13–16; Luke XVIII, 15–17). The subject was popular in Antwerp at this time. It had been painted by Adam van Noort (Musées Royaux des Beaux-Arts, Brussels) and subsequently by his pupil and son-in-law Jacob Jordaens in about 1616–18 (St Louis Museum of Art). However, the idea of combining this biblical scene with a family portrait seems to have been Van Dyck's own.

The head of the apostle on the left is based on that of St Simon (Getty Museum, Los Angeles) from Van Dyck's early Apostle series. The technique is rougher than *St Simon* (Kunsthistorisches Museum, Vienna) in the Böhler series and so the painting should probably be dated earlier. The family group bears a striking similarity to the *Family Portrait* (cat. 15), and in my view Burchard's dating of about 1618 is correct. CB

FIG 2
Anthony van Dyck, *Suffer the Little Children to come unto Me, c.* 1618
pen and ink with washes, 17.7 × 19.5 cm
Musée des Beaux-Arts, Angers (Vey 32)

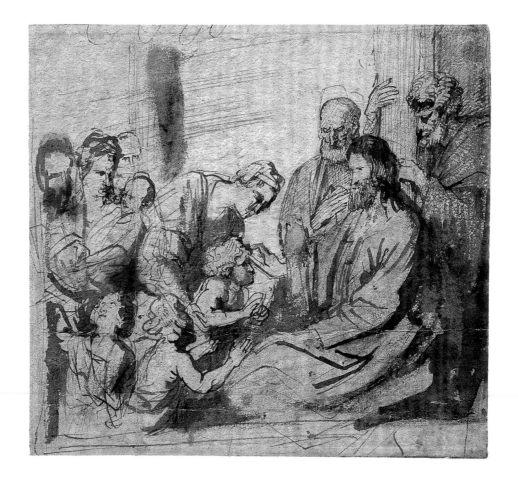

9 *Portrait of a Man*
1618

oil on panel, 105.8 × 73.5 cm
inscribed: *A° 1618·Aet 57*

Collections of the Prince of Liechtenstein,
Vaduz Castle (inv.no.70)

10 *Portrait of a Woman*
1618

oil on panel, 104.5 × 75.6 cm
inscribed: *A° 1618·Aet·58*

Collections of the Prince of Liechtenstein,
Vaduz Castle (inv.no.71)

PROVENANCE Acquired before 1712

REFERENCES Fanti 1767, nos.366, 367;
Dallinger 1780, pp.212, 217, nos.649, 662; Falke
1873, nos.122 and 146 (as Van Dyck); id. 1885,
nos.70, 71 (as Rubens); Bode 1889, p.44 (cat.10);
Rooses 1890, p.317 (as Rubens); Liechtenstein
catalogue 1896, pp.42–3; Bode 1906, p.268 (as
Van Dyck); Schaeffer 1909, p.131; Rosenbaum
1928a, pp.15–17; id. 1928b, p.332; Glück 1931,
pp.81, 528; Kronfeld 1931, nos.70, 71
(as Rubens); Van Puyvelde 1950, p.112 (cat.10);
Baldass 1957, pp.253, 256–7, 259–60; Ottawa
1980, pp.7, 116, 270; Schinzel 1980, pp.114–15,
130–31; London 1982–3, p.11 (cat.9); New York
1985–6, p.309; Müller Hofstede 1987–8, pp.135–6
(cat.9); Larsen 1988, nos.8, 9

EXHIBITIONS Lucerne 1948, nos.120, 127;
Vaduz 1955, nos.195, 196; New York 1985–6,
nos.195, 196; Washington 1990–91, nos.4, 5

Van Dyck was formally registered as a master in the Antwerp Guild of St Luke (the painters' guild) on 11 February 1618. His first portraits date from 1618 and mark the start of his official career. This pair, and another pendant pair in Dresden, date from this year. Van Dyck followed the format of Rubens's Flemish portraits – by 1618 he was probably already an assistant in Rubens's studio – themselves modelled on the highly successful formula of Anthonis Mor. A portrait of *Jan Vermoelen*, dated 1616 (Liechtenstein coll., Vaduz) is so close in style to this pair of portraits that the attributions of all three have been confused. However, it is now clear that *Jan Vermoelen* is the work of Rubens and this pair of 1618 are by Van Dyck working in a profoundly Rubensian manner, emphasising the presence and three-dimensionality of the portraits in a way he abandoned shortly afterwards. This is evident when, for example, these staid and somewhat stolid figures are compared to the *Portrait of a Family* (cat.15) with its sparkling highlights and agitated draperies.

While the pair of portraits in Dresden are bust length, here Van Dyck includes the hands, which are characteristically delicate and elegant, showing great refinement and expressiveness. The man's left hand hangs lifelessly at his side: it was damaged and overpainted, and has only recently been revealed again. So lifeless is it that Baumstark suggested that it 'seems to be an artificial wooden limb'.

In painting these portraits Van Dyck used a grey priming layer which can be seen by the naked eye in, for example, the woman's collar. Shortly after he arrived in Italy, Van Dyck was to abandon this technique and use warm reddish grounds. It is noteworthy that the woman's portrait is painted more economically than her husband's; his was presumably painted first. CB

11 *Drunken Silenus*
1618–19

oil on canvas, 133.5 × 109.5 cm

Musées Royaux des Beaux-Arts de Belgique, Brussels (inv. no. 217)

PROVENANCE 1776, Sassenius collection; 1814, sold by Vinck Wessel in Antwerp; 28 May 1827, sale of the collection of Baron Vinck d'Orp, Brussels, lot 1; acquired by the Museum

REFERENCES Smith 1829–42, III, no. 206; Rooses 1879, p. 134; Guiffrey 1882, no. 263; Van den Branden 1883, p. 699; Cust 1900, p. 241, no. 58; Schaeffer 1909, p. 53; Rosenbaum 1928a, p. 55ff; Glück 1931, p. 6; id. 1933, p. 281ff; Van Puyvelde 1941, p. 182; Van den Wijngaert 1943, pp. 23, 25; Van Puyvelde 1950, p. 43; Gerson and Ter Kuile 1960, p. 112; Brussels 1984, p. 96; Larsen 1988, no. 304

EXHIBITIONS Antwerp 1899, no. 36; ibid. 1949, no. 19; Genoa 1955, no. 10; Brussels 1965, no. 58; Ottawa 1980, no. 13; Cologne, Antwerp, Vienna 1992–3, no. 34.2

The story of the drunkenness of Silenus is told by Ovid (*Metamorphoses* XI, 85–193). Silenus, foster father and tutor of the god of wine Dionysus, one day lost his way in a drunken stupor. He was discovered by Phrygian peasants who crowned him with vine leaves and took him to their king, Midas. Midas recognised him, entertained him lavishly and returned him to Dionysus. In gratitude Dionysus granted him a wish which led Midas to choose the fateful golden touch.

Rubens was intrigued by this subject and painted it in a remarkable picture in Munich (fig. 1), begun in 1617–18 as a half-length and subsequently expanded to a full-length composition in about 1626. Van Dyck's two closely related paintings of this subject were made in direct response to the first stage of that picture. This version, in which Silenus lacks the crown of vine leaves and holds a jug of wine in his right hand as a pair of amorous Phrygians support him, was probably painted in about 1618–19, shortly before the more elaborate composition in Dresden (cat. 23). A preliminary drawing is known from a copy in Braunschweig (Vey 99).

Until its recent cleaning, the painting was obscured by a discoloured varnish. Its vigorous handling and bold highlights are now revealed, as is the direct and powerful rendering of Silenus's fleshy torso. CB

FIG 1
Peter Paul Rubens, *Drunken Silenus*, 1617–18, and 1626
oil on panel, 205 × 211 cm
Alte Pinakothek, Munich

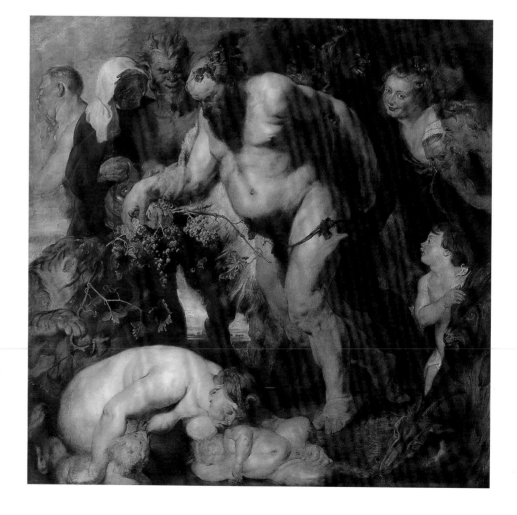

12 The Mystic Marriage of St Catherine
1618–20

oil on canvas, 121 × 173 cm

Museo Nacional del Prado, Madrid (inv. no. 1544)

PROVENANCE A painting of this subject by Van Dyck is listed in 1655, in the inventory of the estate of the Marqués de Leganes: '*no. 286: El desposorio de Santa Catalina con el Niño Jesus que le tiene su madre, y otras tres figuras de la misma mano, de vara y tercia de alto y dos de ancho en 1.000*'; 1746, the painting was owned by Isabella Farnese, wife of Philip V, King of Spain (it bears the Farnese *fleur-de-lis*); 1746, listed in the inventory of the royal palace of La Granja (as Rubens), inv. no. 239: '*Una pintura original en lienzo de mano de Rubens que representa el desposorio del Niño Dios con Santa Catalina Virgen en accion de haberle puesto el anillo, de vara y cuarta y seis dedos de alto y dos de ancho*'; 1794, inventory of the palace of Aranjuez, valued at 3000 *reales*; transferred to the Museum

REFERENCES Ponz 1793, X, p. 139 (as Rubens); Viardot 1860, p. 100; Waagen 1868, p. 98; Rooses 1879, p. 553 (as Jordaens); Ricketts 1903, p. 183; de Madrazo 1913, p. 312, no. 1544 (as Jordaens); Mayer 1922, pl. 288 (as Jordaens); Glück 1931, p. 60; Van Puyvelde 1941, p. 185; Vey 1962, nos. 44 verso, 52–9; Jaffé 1966, I, p. cxxviii; II, p. 63v; Prado 1972, p. 330, no. 1544; Díaz Padrón 1975, pp. 116–17, no. 1544 (dated 1618–20); Princeton 1979, pp. 84–9; Larsen 1988, no. 216; Díaz Padrón 1995, I, pp. 478–80

EXHIBITION Ottawa 1980, no. 24

NOTES
1. The preparatory drawings are discussed in detail in Vey 1962.
2. This sheet was described by Vey as a copy but was reinstated as an original of Van Dyck's by Müller Hofstede 1973, p. 156.
3. Jaffé 1966, I, p. 63.
4. Vlieghe, *Saints*, Corpus Rubenianum, 1972, I, no. 76.
5. Ibid., no. 109c.

St Catherine of Alexandria had a vision in which she was chosen as the bride of Christ. In this painting the Christ Child places a ring on the third finger of the saint's right hand. Christ is seated on the lap of the Virgin and just behind her is an angel who carries a palm, alluding to St Catherine's future martyrdom. St Catherine, who is shown in strict profile, was famed for her great beauty, which Van Dyck enhances by painting her in a white dress edged with gold thread and a richly patterned robe loosely gathered around her. Behind St Catherine stand two monks, probably also saints.

Until 1972 all the catalogues of the Prado Museum attributed the painting to Jacob Jordaens, although in 1903 Charles Ricketts wrote that the painting 'is so singularly like van Dyck's work that one hesitates in accepting the attribution to Jordaens'. Buschmann correctly attributed it to Van Dyck in 1905, an opinion confirmed by Glück (1931), who discussed the preparatory drawings as evidence of Van Dyck's authorship.

As with many of Van Dyck's early works, the evolution of this composition can be followed in a group of pen and wash drawings: no fewer than six survive.[1] The first idea seems to have been a drawing in Berlin (Vey 59) which shows the composition, already frieze-like and in three-quarter length, in reverse, with the Virgin and Child on the right. This design may well have been based on an Italian, more particularly a Venetian, prototype. The second drawing in this sequence is probably the boldly washed and extensively altered sheet formerly in Bremen (Vey 53), which is still strongly Venetian in conception. Then came a sketch on the verso of a drawing for *The Brazen Serpent* in the Courtauld Institute Galleries (Vey 44) and after that a drawing showing the Virgin and Child in the centre of the composition (Institut Néerlandais, Paris; Vey 52). Van Dyck was probably unhappy with this arrangement because the central drama – the presentation of the ring – was on the right-hand side. Then came two drawings in which the composition, having been largely established, was refined. One is freely drawn in pen with a few splashes of wash (Pierpont Morgan Library, New York; Vey 54), while the other (fig. 1) is far more precise, with delicate washes added in the shadows. There are, however, a number of important differences between these drawings and the final painting. St Joseph, who in the drawings was on the far left, has been replaced in the painting by a column, while the group of four men standing behind St Catherine in the Washington drawing has been reduced to two. Far closer to the finished painting is a drawing, last recorded on the Berlin art market in 1908, which has been said to be the *modello* for the painting (Vey 56). Although it looks as if it is by Van Dyck, the present writer has only seen a photograph of it and is uncertain of its exact status. In addition to these compositional drawings, there is a black chalk study for the Virgin (British Museum, London; Vey 57) and a sheet of pen drawings for the Christ Child in a private collection (Vey 58).[2]

The painting is an early example of Van Dyck's fascination with the art of Titian. The three-quarter length, frieze-like composition of the Virgin and Child with saints was popular in Titian's circle. The format and St Catherine's profile recall Titian's *Virgin and Child with SS. John the Baptist, Mary Magdalen, Paul and Jerome* (Gemäldegalerie, Dresden; Wethey, no. 67), and the pose of the Virgin and Child is similar to Titian's *Virgin and Child with SS. Stephen, Jerome and Maurice* (Louvre, Paris; Wethey, nos. 72, 73). There is a sketch after Titian's composition in the so-called Antwerp Sketchbook (Chatsworth), and it has been argued that this was the source of Van Dyck's composition.[3] However, in my view that sketchbook is not the work of Van Dyck but of an associate of Rubens working in the 1630s. The painting it records was presumably a copy after Titian which was in Flanders in the early 17th century and

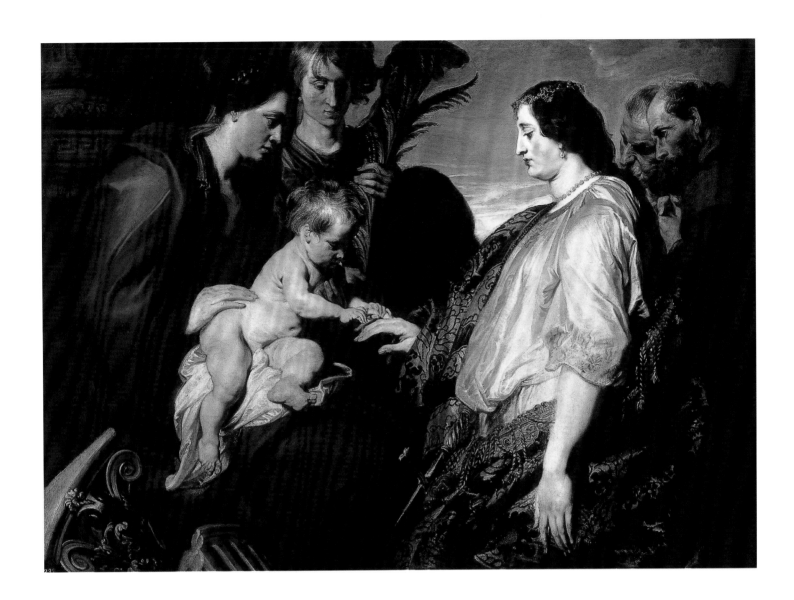

could have influenced Van Dyck's painting. The broken column and detached capital shown in the lower left-hand corner is the first use of a motif, perhaps taken from Veronese, which recurs in *The Continence of Scipio* (cat. 26). Here it represents the Old Law, which has been superseded by Christ.

Nothing is known of the circumstances of the commission of *The Mystic Marriage of St Catherine*. It has the same light tonalities and scumbled technique as *Samson and Delilah* (cat. 21), and the relatively recent cleaning of both paintings has made these similarities even more striking. Both were probably painted in the years 1618–20.

Van Dyck's composition is unlike Rubens's lost painting of about 1610 of the same subject.[4] However, Van Dyck may have modelled St Catherine on St Domitilla in Rubens's first altarpiece for the Chiesa Nuova in Rome. Rubens brought the altarpiece back to Antwerp when he returned in 1608 and placed it above the altar of the Holy Sacrament in the church of St Michael's Abbey. An oil sketch by Rubens for St Domitilla (Accademia Carrara, Bergamo) may have been Van Dyck's direct source for St Catherine.[5] CB

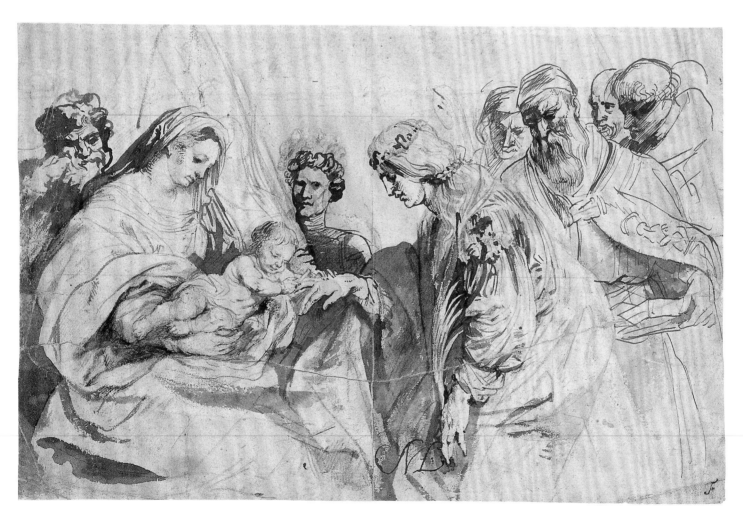

FIG 1
Anthony van Dyck, study for *The Mystic Marriage of St Catherine*, 1618–21
pen and brown ink with washes, 18.2 × 27.9 cm
National Gallery of Art, Washington, DC, Woodner Collection

13 *Portrait of a Man*
(Probably a member
of the Vinck family)
c. 1619

oil on canvas, 199 × 126 cm

Koninklijk Museum voor Schone Kunsten,
Antwerp (inv. no. 5044)

PROVENANCE 1829, collection of the art dealer
Spruyt, Brussels; 1861, sale D. van den Schrieck,
Louvain, no. 15; Fr. Schollaert, Louvain; Madame
Helleputte, Louvain; 1950, acquired by the
Museum

REFERENCES Smith 1829–42, III, p. 134,
no. 487; Schaeffer 1909, p. 146; Glück 1931,
p. 104; Antwerp 1959, no. 5044; Larsen 1988,
no. 61

14 *Portrait of a Woman*
(Probably a member
of the Vinck family)
c. 1619

oil on canvas, 202 × 127 cm

Lord Romsey, Broadlands

PROVENANCE Madame Helleputte, Louvain;
1900–30, Paul Dansette, Brussels; acquired by
Lady Louis Mountbatten

REFERENCES Schaeffer 1909, p. 147; Glück
1931, p. 105; Larsen 1988, no. 62

EXHIBITIONS Antwerp 1899, no. 84; ibid.
1930, no. 106; Bruges 1956, no. 85; London
1968a, no. 11

Traditionally this ambitious pair of portraits of a standing man and his seated wife have been said to show members of the Vinck family, a leading dynasty of Antwerp merchants. These portraits are the only pair of full-lengths painted during Van Dyck's first Antwerp period. In 1620 or 1621 he also painted a single full-length woman and child, known as *Susanna Fourment and her Daughter* (National Gallery of Art, Washington). All three use much of the portrait vocabulary that Van Dyck was to develop in Genoa. The man stands in a confident and forceful pose in front of a red curtain which is drawn aside to reveal a bale of fabric, the source of his wealth. Behind him is an armchair upholstered in decorated leather, and beyond a high wall and the open sky. His wife is seated in a more substantial chair; behind her a curtain is drawn aside to reveal a balustrade and the sky, the vista is closed on the left by a pilaster. At her feet a lively small dog looks out at the spectator. Both husband and wife are richly but soberly dressed. The man wears a high starched ruff above an embroidered black jacket with a black satin sash, black knee breeches, stockings and shoes and a black cloak. It was just at this moment that starched ruffs were being superseded by soft collars; the x-ray of the *Portrait of a Family* (cat. 15) reveals that the man originally wore a stiff ruff which was later altered to a soft collar. In cat. 14 the woman wears an ornate gold headdress and pearl drop earrings, an elaborate starched ruff above a richly embroidered bodice in gold thread with a floral pattern, ornate lace cuffs and slippers. In her left hand she holds a fan.

Both portraits are painted relatively thinly, the face of the man, for example, being built up with rapidly brushed white and red highlights rather than successive layers of glazes, which was Rubens's method of working. CB

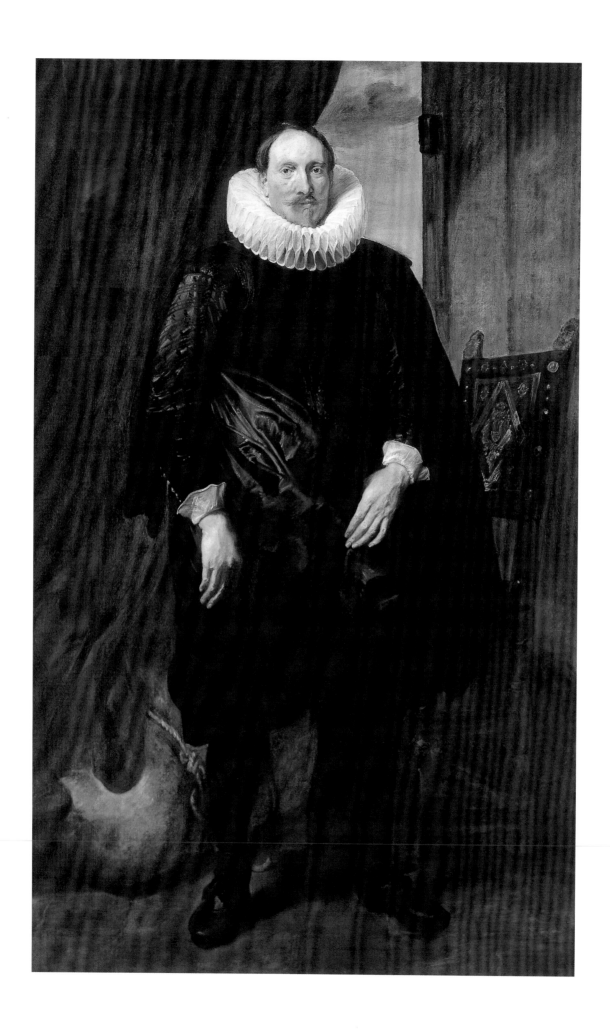

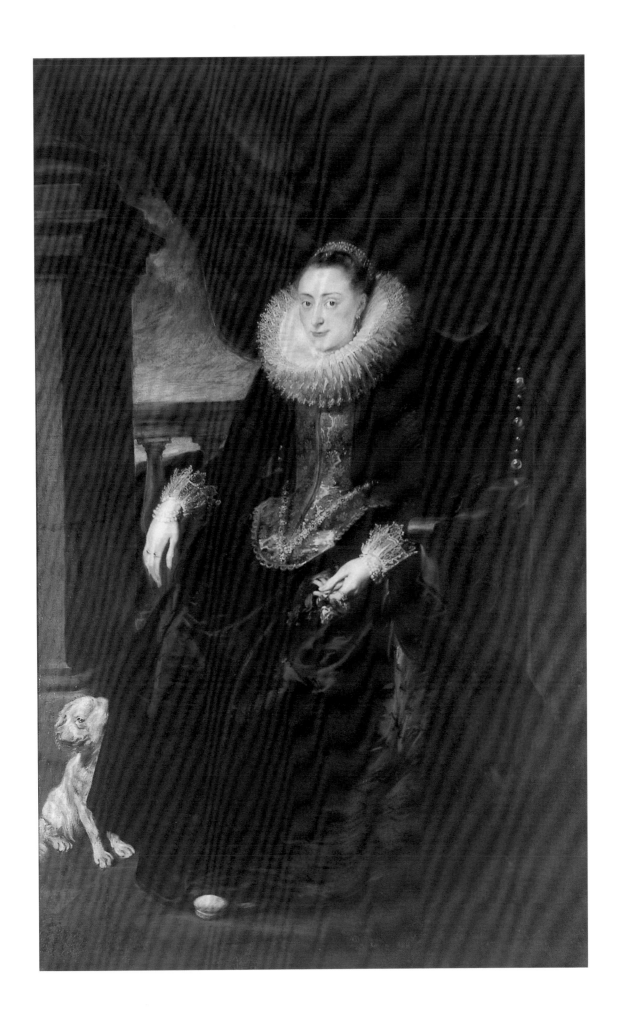

15 *Portrait of a Family*
c. 1619

oil on canvas, 113.5 × 93.5 cm

The State Hermitage Museum, St Petersburg
(inv. no. 534)

PROVENANCE 1762, collection of La Live de
Jully, Paris (said to have been bought by him in
Antwerp in that year); 2–14 March 1770, sold in
Paris; collection of Madame Groenbloedt,
Brussels; 1774, acquired from her via Golyzins by
the Empress Catherine II for the Hermitage

REFERENCES *Catalogue historique du cabinet de
peinture et sculpture françaises de M. de Lalive*, Paris
1764, p. 114ff (as 'Portrait of Frans Snyders and
his family'); Smith 1829–42, III, no. 300, IX,
no. 51; Blanc 1857, I, p. 165; Von Koehne 1863,
p. 156; Waagen 1864, p. 149; Hermitage catalogue
1870, p. 76ff, no. 627; Guiffrey 1882, p. 278,
no. 847 (as 'Snyders and his family'); Bode 1889,
46; Somof 1895, pp. 71–2; Cust 1900, p. 236,
no. 50 (as possibly 'Jan Wildens and his family';
notes copies in Stuttgart and in private collection
in England); Somof 1901, pp. 81–2, no. 627;
Rooses 1904, p. 116; Bode 1907, pp. 339–50;
Schaeffer 1909, p. 160; Rosenbaum 1928a, p. 34;
Glück 1931, p. 108; Bazin 1958, p. 152, p. 241,
no. 218; Varshavskaya 1963, pp. 100–01, no. 5;
Hermitage 1964, no. 15; Kuznetsov 1972, no. 41;
Ottawa 1980, no. 72 (not exhibited); Brown 1982,
pp. 50–51; London 1982–3, p. 12; Barnes 1986, I,
p. 122; Larsen 1988, no. 80

EXHIBITIONS Brussels 1910, no. 117;
Leningrad, State Hermitage Museum, 1938,
no. 33; *Terre des Hommes, Exposition Internationale
des Beaux-Arts/Man and his World*, International
Fine Arts Exhibition, Montreal, 1967, no. 65;
Leningrad, State Hermitage Museum, 1972,
no. 331; Washington, New York et al. 1975–6,
no. 17; Leningrad, State Hermitage Museum,
1977–8, no. 9; Vienna 1981, pp. 34–7; Rotterdam
1985, no. 32; New York and Chicago 1988, no. 37;
Washington 1990–91, no. 9; Boston and Toledo
1993–4, no. 36

It has been suggested that this charming, animated portrait shows the families of Frans Snyders (who was childless) and Jan Wildens (whose first child was born in August 1620). Both were Antwerp painters and contemporaries of Van Dyck, but neither seems to be the man represented here if compared to portraits of Snyders (Kassel; Frick Collection, New York) and of Wildens (Detroit; Vienna). Both were portrayed by Van Dyck in his *Iconography* and neither engraving resembles the man shown here. There is, however, something in the informality of the pose and the immediacy of the gestures that suggest that these sitters were well known to Van Dyck and may have been members of the tightly knit and intermarried artistic world of early 17th-century Antwerp. Van Dyck's prototype for this portrait was Rubens's portrait of *Jan Brueghel the Elder and his Family* (fig. 1).

Van Dyck's *Family Portrait* dates from about 1619, about five years after Rubens's portrait of Jan Brueghel and his family. The broadly woven canvas and sketchy application of paint distinguish this portrait from that of Rubens, which is painted on panel. The dark colours and the thick, almost dry pigments are brushed lightly onto the canvas. The spontaneity of the group is reinforced by the glance of the child towards its father who leans towards the viewer resting his right hand on the top of a chair. The coat of arms on the chair is presumably that of the family, but it is so sketchily painted that it has eluded identification. The child plays with a small flask which probably contains smelling salts belonging to its mother. X-rays of the painting show that the man originally wore a broad, stiff ruff and that Van Dyck subsequently added the soft collar with its delicate lace points, presumably responding to the sitter's wish to appear more fashionable. CB

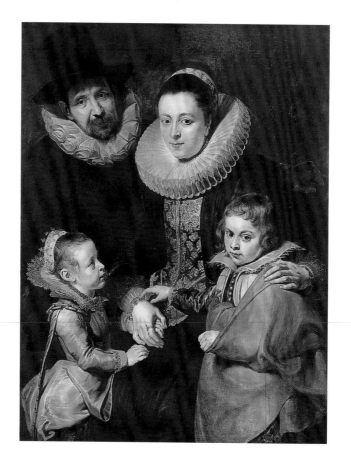

FIG 1
Peter Paul Rubens, *Jan Brueghel and his Family*,
1612–13
oil on panel, 124.5 × 94.6 cm
Seilern Collection, Courtauld Institute Galleries,
Princes Gate Collection, London

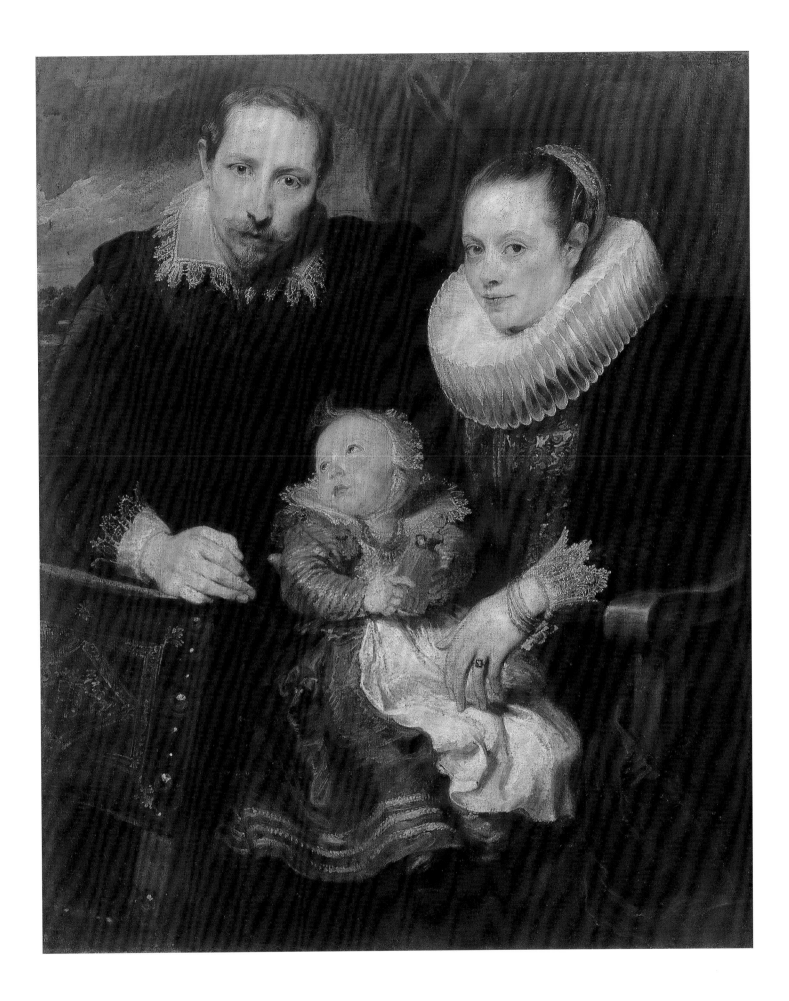

16 *St Bartholomew*, 1619–20

oil on panel, 63 × 48 cm

Private collection

17 *St James the Greater*, 1619–20

oil on panel, 63 × 51 cm

Private collection

PROVENANCE 1748, recorded in Palazzo Brignole-Sale, Genoa: *Descrizione della Galleria de quadri esistenti nel Palazzo del Serenissimo Doge Gio Francesco Brignole-Sale*, Genoa 1748; *Pitture e quadri del Palazzo Brignole-Sale ...*, Genoa 1756, p. 4; by 1763, Palazzo Rosso, Genoa: *Inventario dei quadri esistenti nel Palazzo Rosso ...*, Genoa 1763; Ratti 1766, I, p. 230; the series to which these two panels belong is presumably identical with that mentioned by Ratti 1780b, p. 152: '*Dodici mezze figure in tavola di Appostoli, opere bellissime d'Antonio Vandik*'; the entire series was bought by the Munich dealer Julius Böhler from the Cellamare collection in Naples in 1913 or 1914; 1914–20, J. Böhler, Munich; sold by him to O. Granberg, Stockholm; Karl Bergsten, Stockholm

REFERENCES Oldenbourg 1914–15, p. 227, n. 2, p. 230; Karl Madsen, *Catalogue de la collection de M. et Mme K. Bergsten: I, Peinture*, Stockholm 1925, no. 15; Glück 1927, pp. 131, 137, 141, n. 2; Rosenbaum 1928a, p. 37; Glück 1931, p. 43 (left and right); id. 1933, p. 290, n. 2; Larsen 1988, nos. 150, 153

EXHIBITION Ottawa 1980, nos. 7, 8

COPIES (of St Bartholomew) in Dresden; another formerly in the collection of F. G. Macomber, Boston (see Valentiner 1910, pp. 225–6, fig. 1)

Van Dyck made several series of paintings of Christ and his apostles early in his career. In my view there was an early series, painted *c.* 1615–16, five of which were until quite recently at Althorp House (see cat. 2, 3). The present paintings of St James and St Bartholomew belong to a second series, usually known as the Böhler series after the Munich art dealer of that name who owned them earlier this century. Yet another series of apostles was the subject of a court case (see under cat. 2, 3). For the most part the second series repeats the compositions and palette of the first but is painted in a significantly different technique. While the early series is sketchy, with bright white highlights, the Böhler apostles are more smoothly painted, the heads carefully modelled in a manner close to Rubens's technique. This may well reflect Van Dyck's close relationship with Rubens in the years 1618–20, and the series should be dated 1619–20.

St James the Greater is the only apostle in the series who looks straight out at the viewer in a manner that suggests it is a portrait. In the court hearing of 1660–61, Jan Brueghel the Younger, who was a close friend of Van Dyck and shared a studio with him in the early years, said that one of the apostles was a portrait of Brueghel's uncle, the distinguished engraver Pieter de Jode. St James the Greater does look very much like Pieter de Jode as he is shown in Van Dyck's *Iconography* (fig. 1).

The *St James the Greater* and *St Bartholomew* were both used by Cornelis van Caukerken for his engraved series of apostles after Van Dyck and both were copied by the painter of the series at Aschaffenburg. C B

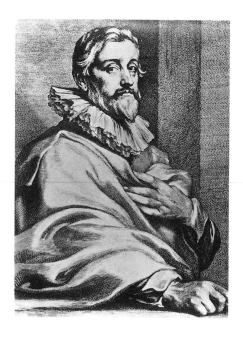

FIG 1
Anthony van Dyck, *Pieter de Jode*
engraving from the *Iconography* (Mauquoy-Hendrickx 84)

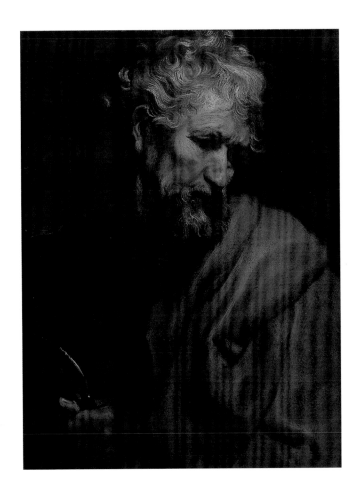
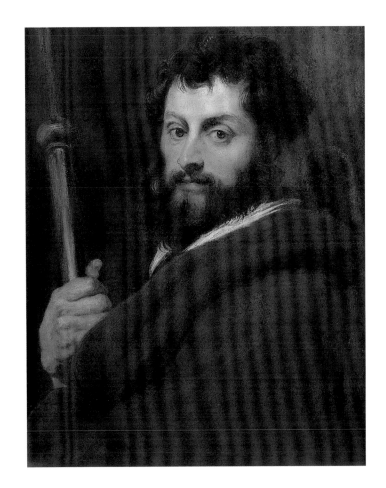

18 *St Martin dividing his Cloak*
1618–20

oil on panel, 170 × 160 cm

Kerkfabriek Sint-Martinuskerk, Zaventem

PROVENANCE Painted for St Martin's;
1806–15 on display in the Louvre, Paris

REFERENCES Descamps 1753–4, II, p. 11;
Smith 1829–42, III, p. 12, no. 34; Galesloot
1863–6, pp. 36–50, 436–50; Guiffrey 1882,
pp. 23–30, 251, no. 203; Rooses 1900, pp. 95–7;
Cust 1900, p. 40, no. 39; Schaeffer 1909, pp. 43,
497; Brussels 1910, 1912, I, p. 150; Rosenbaum
1928a, p. 53; Antwerp 1930, 1932, pp. 78–9;
Glück 1931, pp. 24, 520; Van Puyvelde 1940,
pp. 36–42; Vey 1962, pp. 88–91; Vlieghe 1973,
p. 123; Larsen 1975, pp. 32–3; Princeton 1979,
pp. 74–9; Held 1980, pp. 575–6, under no. 418;
Brown 1982, pp. 41, 43; Larsen 1988, I,
pp. 157–60; II, p. 102, no. 234

EXHIBITIONS Antwerp 1899, no. 28; Brussels
1910, no. 93; Antwerp 1930, no. 112; Amsterdam
and Rotterdam 1946, no. 26; Antwerp 1949, no. 12

The story of St Martin is told in the medieval account of the lives of the saints, *The Golden Legend*. Martin, a young officer in the army of the Emperor Julian, was a Christian convert. On a cold winter's day, as he was passing the city gate of Amiens, he saw a near-naked pauper begging, cut his cloak in two and gave half of it to the beggar. The next day, Martin had a vision in which Christ appeared to him, dressed in the piece of cloak he had given to the beggar. Van Dyck uses the established iconography for the subject, showing a young and handsome Martin on horseback, smiling as he divides his cloak. His feathered cap is an unusual attribute for a Roman officer and has a pseudo-medieval feel. He turns to the right to see two beggars, one of whom is naked. Behind him is a classical gateway in the Renaissance style, partially covered with ivy. Martin is accompanied by two other figures.

This is one of Van Dyck's most Rubensian works, painted at a time when the two artists were working in collaboration. As in the other works of these years, the figures are clearly influenced by the master. More unusual is the way Van Dyck also modelled his painting technique as closely as he could on that of Rubens. We do not find the expressive and fluid touch here that is characteristic of his earliest works (see, for instance, cat. 5). Instead the paint is applied in a smooth, opaque manner, creating an exceptionally strong plastic effect characteristic of Rubens's work between the years 1615 and 1620. The composition was derived from an earlier oil sketch by Rubens (fig. 1). The sketch is more horizontal in format, the orientation reversed from the Zaventem painting. St Martin is shown on the left and inclines towards a naked man and a beggar woman with a child; the saint's two companions appear on the right. The changes that Van Dyck made to the composition might be explained by the painting's location in the church, where it is lit from the south, that is from the right. In other words, the composition had to be reversed in order to harmonise it with the natural light source. Otherwise Rubens's sketch and Van Dyck's altarpiece are very similar, particularly in the poses of the principal figures and the horse, albeit in reverse.

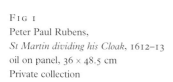

FIG 1
Peter Paul Rubens,
St Martin dividing his Cloak, 1612–13
oil on panel, 36 × 48.5 cm
Private collection

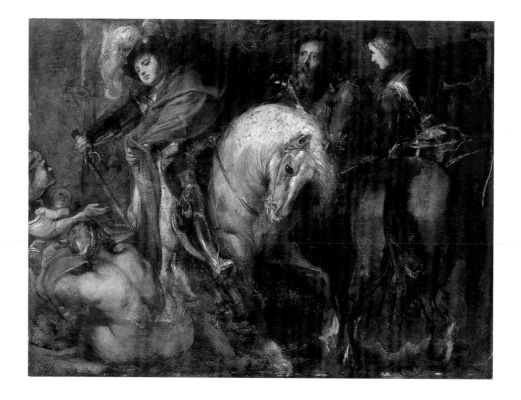

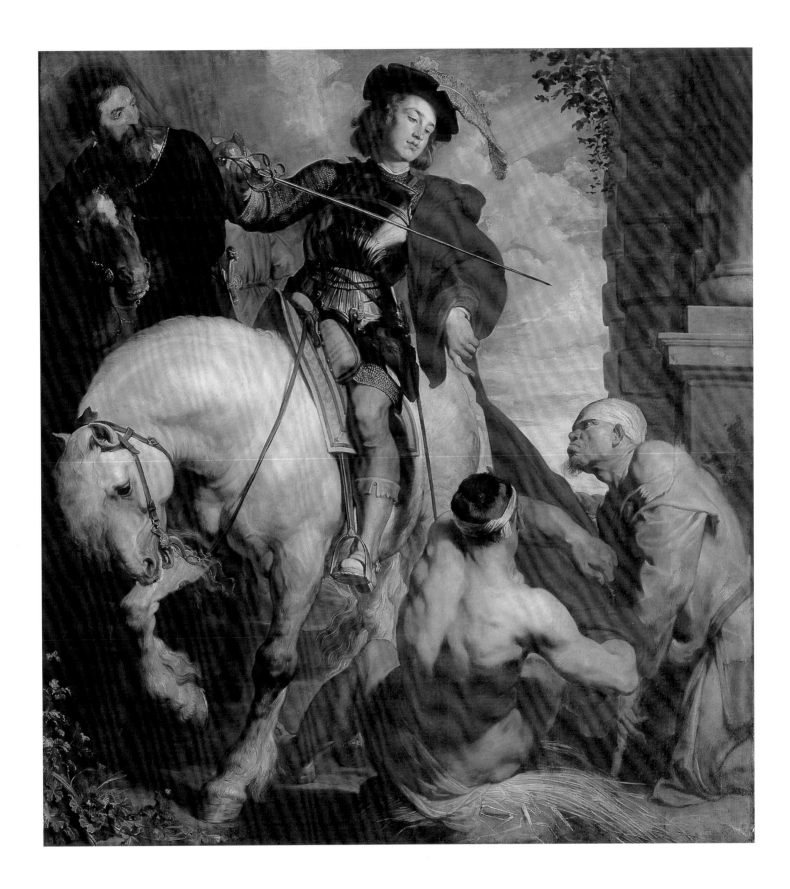

For stylistic and technical reasons Rubens's oil sketch cannot be dated later than around 1612–13. Held concluded that Rubens was originally commissioned to paint the altarpiece but eventually passed it on to Van Dyck; Held was not concerned by the long interval between the design and the finished painting. Brown, by contrast, has argued that the commission was given to Van Dyck, who sought Rubens's help and was given an old, unused design. In my opinion it seems much more likely that it was indeed Rubens who received the commission, and there is evidence that it may have come from Ferdinand de Boischot, Lord of Zaventem. The 18th-century life of Van Dyck in the Louvre states that Ferdinand de Boischot commissioned the painting to mark his accession to the Zaventem title in 1621. The de Boischot coat of arms appears on the altarpiece frame, although it dates from after Van Dyck's painting. It is plausible that Rubens handed on this assignment to his most talented pupil, given the master's increasing work load.

Van Dyck prepared his composition carefully, as witnessed by the three surviving drawings in black chalk of the beggars and the horse (figs. 2–3; cat. 19, fig. 1). Several motifs are based on examples from the Italian High Renaissance. Cust and Rooses pointed out, for instance, that the figure of St Martin is strongly reminiscent of an Egyptian horseman in Domenico delle Grecche's woodcut of Titian's *Crossing of the Red Sea*, details of which Van Dyck copied in his Italian Sketchbook. The beggar shown in profile is borrowed from Raphael's tapestry cartoon (which Rubens also copied) of *The Healing of the Lame Man* – Raphael's cartoons were in Brussels in 1619 – a fact that George Vertue also noted in his discussion of the version in the Royal Collection. HV

19 *St Martin dividing his Cloak c. 1620*

oil on canvas, 257.8 × 242.6 cm (an original
addition of 38.1 cm on the right and a later
one at the top of 34.3 cm)

Lent by Her Majesty The Queen

PROVENANCE Probably '*Un St Martin du
Chevalier van Dyck*' in the estate of Rubens
(inv. no. 234); said to be 'uppon cloth', Sainsbury
p. 242; purchased in Spain by Sir Daniel Arthur;
3 February 1729, seen by the Earl of Egmont in
the house of George Bagnall (who had married
Arthur's widow): 'two large pieces of Rubens, one,
the Legend of St Martin cutting off a piece of his
cloke to relieve the beggar ... several figures in it as
big as the life' (HMC, Egmont MSS., *Diary of the
First Earl of Egmont*, III, 1923, p. 344); 1739, seen
at Bagnall's house by Vertue (1930–55, XXVI,
1938, pp. 78, 126); before September 1747, bought
from Bagnall by Frederick, Prince of Wales, the
date of a payment for the cleaning of the picture;
framed in 1748 (payment of 28 October 1748);
1751, July, seen by Vertue at Leicester House:
Walpole Society, XVIII, 1930, p. 11; 1824, hung in
the Drawing Room at Buckingham Palace; in the
King's Closet at St James's; 1835, 10 September,
sent to Windsor

REFERENCES Vertue (1930–55), I, 1930, p. 11;
V, 1938, pp. 78, 126; Walpole *Anecdotes* (ed. 1876),
I, p. 312; Smith 1829–42, II, pp. 237–8, no. 822;
Waagen 1838, I, p. 174; id. 1854, II, p. 435;
Michiels 1882, p. 41; Rooses 1888, II, pp. 327–8
(as Van Dyck); Cust 1900, pp. 32–3; Schaeffer
1909, p. 43; Glück 1931, p. 25; Van Puyvelde 1940,
pp. 36–42; Vey 1955, pp. 61–77; Millar 1963a, I,
no. 165; Larsen 1988, no. 235

EXHIBITIONS British Institution 1821, no. 840;
ibid. 1832, no. 151; Manchester 1857, no. 569;
London 1946, no. 282; ibid. 1953–4, no. 142;
ibid. 1968b, no. 2

NOTES
1. There are a number of workshop replicas or
copies of this composition in the Kunsthistorisches
Museum, Vienna; Schloss Sanssouci, Potsdam;
Vinters' Hall, London; Pommersfelden, which was
in the Schonborn collection by 1719.
2. Once thought to be by Rubens, this painting
was correctly attributed to Van Dyck by Michiels
in 1882.
3. St Martin's companions were used by Simon
de Vos in a *Martyrdom* of 1648 (sold Christie's,
London, 27 January 1956, lot 58). A drawing by
Géricault is in Brussels (inv. no. 482).

It was quite usual for Van Dyck in his first Antwerp period to make more than one
version of his religious paintings: this appears to be a second, more elaborate version
of the Zaventem painting (cat. 18); its style suggests it was painted in about 1620.[1]
A number of second versions were in Rubens's collection, perhaps presented to him
by Van Dyck: Rubens owned versions of *Christ crowned with Thorns* and *The Taking of
Christ* (both Prado, Madrid); and he also owned a *St Martin* ('*St Martin du Chevalier
Van Dyck*' is listed in the inventory of Rubens's estate), which may well have been
this picture.[2]

Compared to the Zaventem altarpiece, Van Dyck has here treated the subject on a
more monumental scale and extended the composition on the right to accommodate
the woman and children and a dog.[3] There is a join in the canvas at this point; it is
likely that the woman and children were added at a slightly later stage since a clear
difference of style is visible between this group and the main figures, and that it was
then that the canvas was extended. The group originally included another beggar and
the rusticated wall of an archway rising behind the woman; these have been painted out
by a slightly later hand but exist in the many copies of this painting. The saint's right
hand, in which he holds the sword, is lower than in the Zaventem painting but
otherwise his pose is almost identical. The canvas is in parts very sketchily painted with
many *pentimenti* and signs of re-working, some of which show that initially this version
was closer in detail to the earlier Zaventem altarpiece, for instance, the horse's mane
was originally painted falling on the far side. CB

FIG 1
Anthony van Dyck, *A Seated Man leaning backwards*, 1618–20
black chalk, with white chalk highlights, 23.5 × 27.4 cm
Museum Boijmans Van Beuningen, Rotterdam (Vey 16)

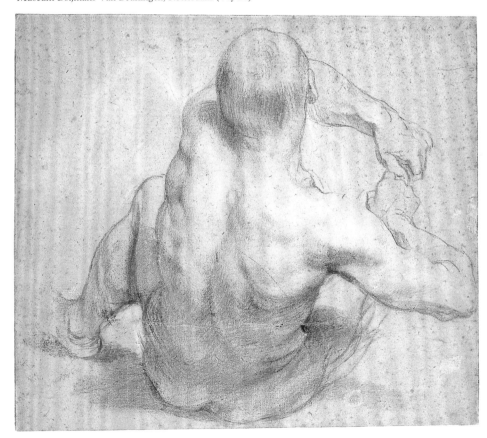

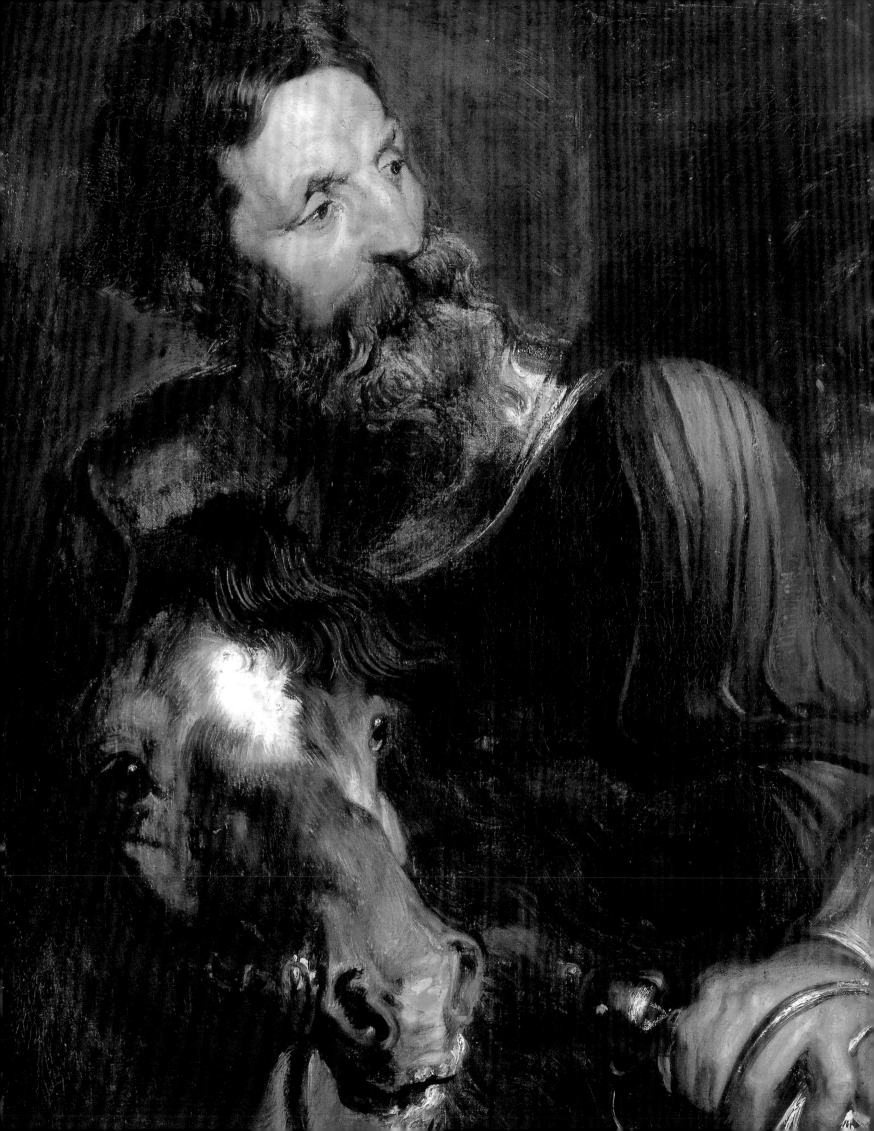

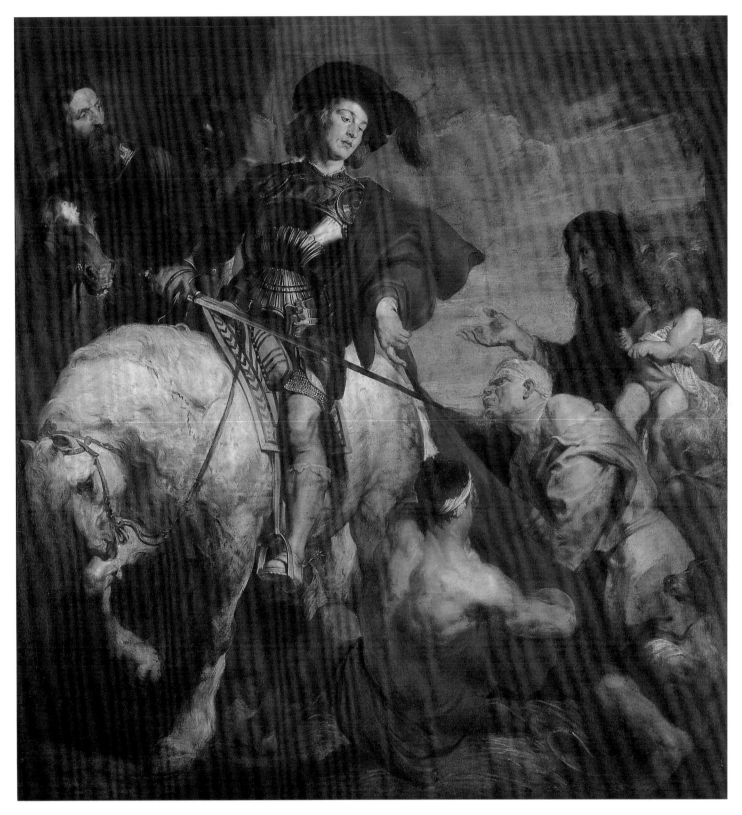

CAT 19, before restoration

CAT 19, detail, during restoration

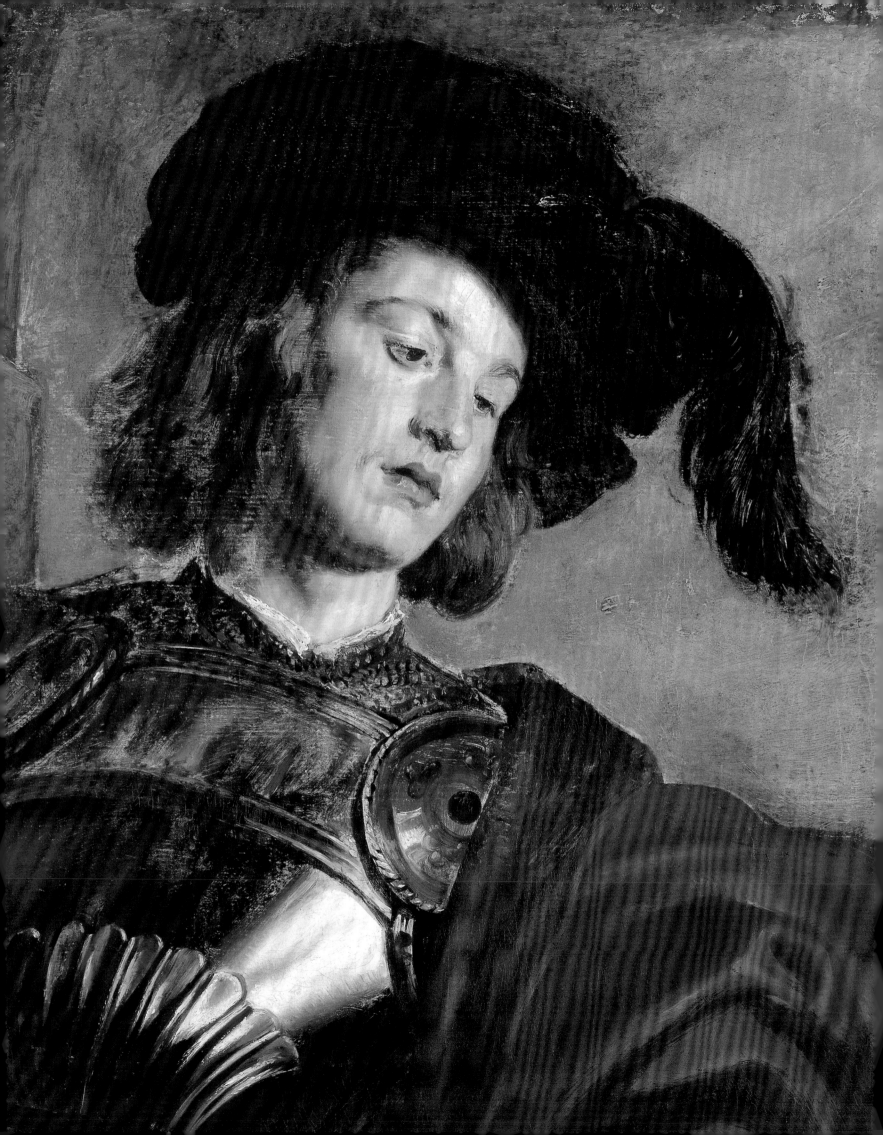

20 The Emperor Theodosius is forbidden by St Ambrose to enter Milan Cathedral 1619–20

oil on canvas, 149 × 113.2 cm

The Trustees of the National Gallery, London (inv. no. 50)

PROVENANCE Possibly in Rubens's possession: no. 233 in the 1640 inventory is '*Un S. Ambroise, du mesme* [i.e. Van Dyck], *st Ambrose by the same uppon Cloth*' (Muller 1989, pp. 134–5); possibly in the Roger Harenc sale, London (Langford), 1–3 March 1764, lot 50; Lord Scarbrough (1725–82); by 29 December 1785, bought from his heir by Hastings Elwyn (or Elwin); 1787, January, put up for sale privately, lot 17 (unsold); 13 April 1799, still in Elwyn's possession; by 1807, sold to John Julius Angerstein when lent to the British Institution for copying; 1824, purchased by the National Gallery with the Angerstein collection

REFERENCES Smith 1829–42, III, p. 76, no. 252; Passavant 1836, I, p. 44, no. 3; Waagen 1854, I, p. 223; Rooses 1886–92, II, pp. 215–16, under no. 387; Cust 1900, p. 13, p. 233, no. 10; Bode 1906, p. 269; National Gallery catalogue 1929, pp. 108–9, no. 50; Glück 1931, p. 18, 519; id. 1933, p. 281; Van Puyvelde 1941, p. 185, pl. 10; id. 1950, pp. 50–51 (as Rubens); Vey 1956, p. 174; Gerson 1960, p. 113; Martin 1970, pp. 29–34, no. 50; Vlieghe, Review of Martin 1970 in *The Burlington Magazine*, CXVI, 1974, pp. 47–8; Vienna 1977, p. 78 (entry by W. Prohaska); Ottawa 1980, pp. 15, 17, 93–5, no. 35; Brown 1982, pp. 30–31; Larsen 1988, no. 253; Muller 1989, pp. 134–5, under no. 233; E. McGrath, *Rubens's Subjects from History*, Corpus Rubenianum Ludwig Burchard XIII–1, London 1997, pp. 297–308, under no. 55

EXHIBITIONS Whitechapel Art Gallery, London, *Five Centuries of European Painting*, 1948, no. 12; Ottawa 1980, no. 35; Washington 1990–91, no. 10; Cologne, Antwerp and Vienna 1992–3, no. 34.3

CAT 19, detail, during restoration

Theodosius (*c.* 346–95), Western Emperor from 379, had ordered the massacre of a rioting mob after it had murdered one of his generals at Thessaloniki. For this act Ambrose (*c.* 340–98), Archbishop of Milan from 374, barred his entry to the Cathedral until Theodosius acknowledged his sin and performed the penance required by the Archbishop. The subject represents the triumph of the spiritual authority of the Church over the secular authority of the Emperor. This historic encounter is described in *The Golden Legend* and in greater detail in the *Annales ecclesiastici* of Cardinal Baronius.

This picture is a smaller variant of a painting on panel (fig. 1) which was designed by Rubens but largely carried out by Van Dyck in Rubens's studio under the master's direct supervision. The Vienna painting was probably painted *c.* 1617–18, given its stylistic similarities with the Decius Mus tapestry cartoons, also largely carried out by Van Dyck, which were completed by May 1618. Nothing is known of the circumstances of the commission of the Vienna painting: the subject is most unusual in Antwerp but would have been appropriate for a church in Lombardy or Liguria. Possibly it was made for the church of S. Ambrogio in Genoa, for which Rubens painted two altarpieces.

The Vienna panel was probably still in Rubens's possession in 1628 when the master went on an extended diplomatic trip to Spain and England, leaving his studio under the supervision of Willem Paneels. Paneels used the opportunity to make a series of drawings of the contents of the studio, including several studies of figures in the Vienna panel. Known as the 'Cantoor drawings', they are today in Copenhagen. On one drawing Paneels noted that it is '*naer den teodosius naer van dijck*' (after the Theodosius of Van Dyck), which makes it clear that in Rubens's studio the Vienna painting was known to be largely the work of Van Dyck.

Van Dyck made second versions of a number of his early religious compositions, including *The Crowning with Thorns*, *The Taking of Christ*, *St Martin dividing his Cloak* (cat. 18, 19); these paintings came into Rubens's possession, presumably given by the young artist to his master. Cat. 20 may be the painting of St Ambrose by Van Dyck recorded in Rubens's 1640 inventory, but it is also possible that it was commissioned from Van Dyck by Nicholas Rockox, burgomaster of Antwerp and a leading patron of the arts. A significant change from the Vienna panel is the inclusion of Rockox's portrait among the bystanders, the last but one figure from the right. Certainly Van Dyck was eager to establish his stylistic independence from Rubens, and he may have made this painting in a deliberate attempt to secure the patronage of Rockox.

Van Dyck painted the London version in his own bolder, sketchier, less three-dimensional style, making a number of significant changes: the architectural background is more prominent; Theodosius is now beardless; a spear, halberd and a dog are introduced on the left-hand side, while the baton held by the man on the left has been suppressed. X-rays of the painting show that originally it followed the Vienna picture more closely. Van Dyck changed the profile of the acolyte with the candle; emphasised the movement of the bishop's cope; extended Ambrose's hand; and substantially changed the pose and dress of the soldier on the extreme left.

A scene on St Ambrose's cope showing Christ with St Peter and a kneeling bishop, an important symbol of the legitimacy of Ambrose's authority, is visible in the Vienna panel but is omitted from the London painting. In the latter, the cope is a bravura display of Van Dyck's remarkable ability to paint rich fabrics: the bishop's bold gesture in holding back the Emperor, causes the gold thread of his cope to shimmer in the light. The architecture bears a resemblance to the three-arched screen in a banded

Tuscan order which Rubens designed for his own house in Antwerp, and bears no similarity to the Gothic Cathedral in Milan which Rubens must have seen during his stay in Italy.

The dog in the lower left is another addition. Martin suggested that it had an iconographic as well as a pictorial function. Ruffinus, the master of the Emperor's knights, remonstrated with Ambrose and (in Caxton's translation) was told by the bishop: 'Thou has no more shame than a hound.' The haughty figure on the extreme left could be Ruffinus, but given Van Dyck's lack of interest in the iconographical significance of the scene on Ambrose's cope, this seems unlikely. Martin's identification of other heads in the London painting as portraits of Paul de Vos, Lucas Vorsterman the Elder, Pieter Brueghel the Younger and Jan Brueghel the Elder has not been generally accepted, but it is important to note that Van Dyck changed the physiognomies in the London version, and these, as well as the head of Rockox, may be portraits. CB

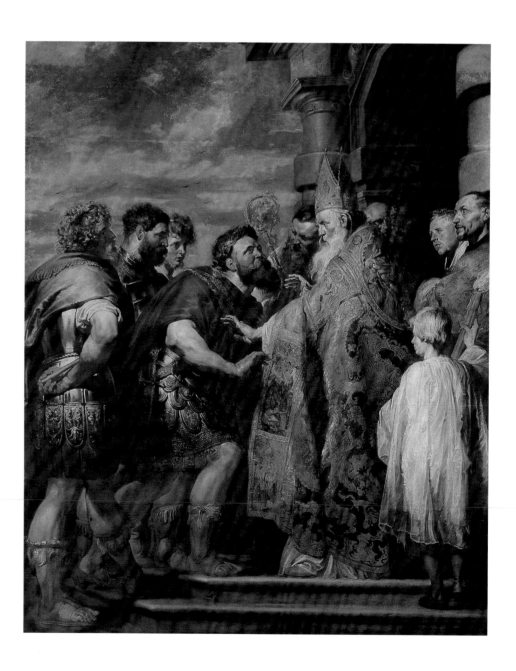

FIG 1
Peter Paul Rubens and Anthony van Dyck,
The Emperor Theodosius refused Entry into Milan Cathedral, 1617–18
oil on panel, 362 × 246 cm
Kunsthistorisches Museum, Vienna

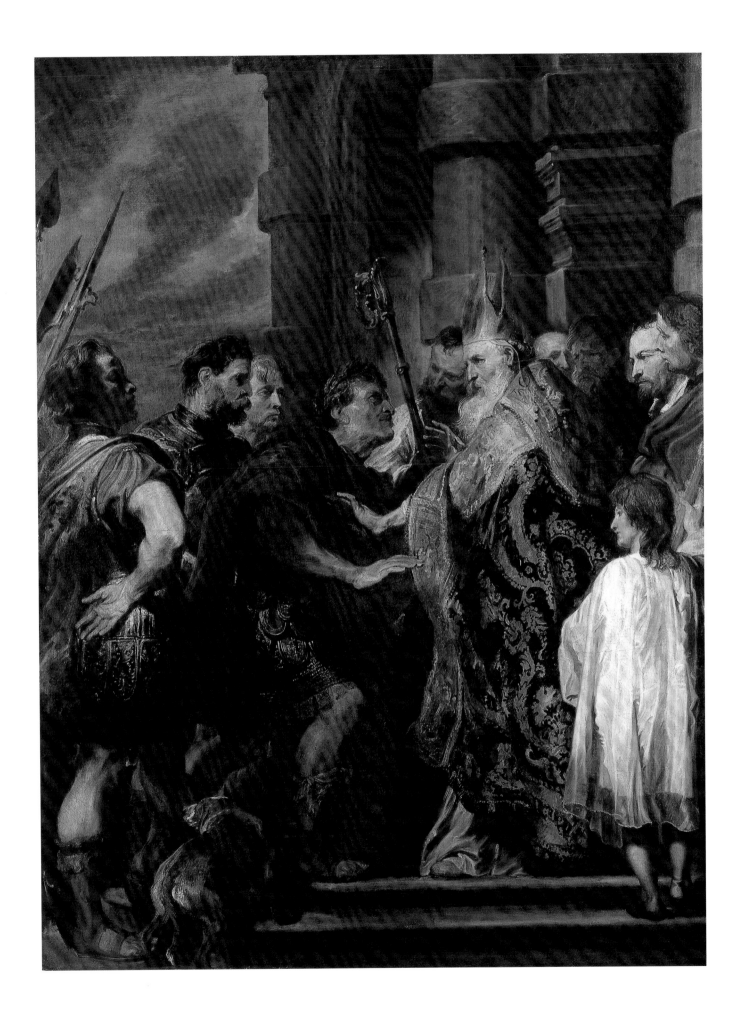

21 *Samson and Delilah*
1618–20

oil on canvas, 149 × 229.5 cm (this includes the
added strip at the top which is 12.7 cm deep)

The Trustees of Dulwich Picture Gallery, London
(inv. no. 127)

PROVENANCE 1711, David Armory, Amster-
dam; 23 June 1722, Armory sale, no. 1; before
1767, Sir Gregory Page; 26 (or 28) May 1783,
anonymous [Page] sale, Bertels, London, lot 76;
perhaps bought by Noel Desenfans; 8 April 1786,
Desenfans private sale, lot 174 (as Rubens), unsold;
1804, insurance list, no. 99 (as Rubens); 1807,
bequeathed by Desenfans to Sir Francis Bourgeois;
1811, Bourgeois bequest to Dulwich College

REFERENCES Hoet 1752, I, p. 259, no. 1;
Thomas Martyn, *The English Connoisseur*, London
1766, p. 59; Hymans 1899a, p. 228; Cust 1900,
pp. 69, 246, no. 3; Schaeffer 1909, pp. 21, 496;
Rosenbaum 1928a, p. 56; Glück 1931, XXVII,
pp. 13, 518; id. 1933, p. 282; Evers 1943, p. 165;
Vey 1958, pp. 43–60; Gerson and Ter Kuile 1960,
pp. 113–14; Kahr 1972, p. 296, n. 53; Princeton
1979, pp. 13, 57, 58; Murray 1980, pp. 53–4,
no. 127; Ottawa 1980, pp. 56, 285; Brown 1982,
pp. 32–4; London 1982–3, p. 13; Washington
1985–6a, pp. 20, 21; Stewart 1986, p. 138; Larsen
1988, no. A 38 (as an 18th-century copy); Brown
1994, pp. 49–54

EXHIBITIONS London 1938, no. 68; ibid.
1947a, no. 13; ibid. 1953–4, no. 228; Washington
1990–91, no. 11

The story of Samson and Delilah is told in Judges XVI. The Jewish hero Samson loved a woman 'in the valley of Sorek, whose name was Delilah'. The Philistine leaders bribed her with eleven hundred pieces of silver to discover the source of Samson's superhuman strength. Eventually Samson revealed to Delilah that his strength lay in his hair, which had never been cut. Van Dyck shows the moment in the story when Samson is sleeping in Delilah's lap and the Philistine barber – he has the tools of his trade in his hand and in a leather pouch on his hip – is about to cut his hair. Delilah is anxious that Samson should not wake and nervously raises her hand to admonish the barber to be stealthy. Behind her a young woman and an old woman (of a type traditionally described as a procuress) are both curious and fearful. Beside the column on the left, at a respectful distance, Philistine soldiers prepare to bind the hero and put out his eyes. The subject was often painted in the 16th and 17th centuries: it was treated as a moral example of a great man brought low by lust, although artists, and their patrons, undoubtedly enjoyed the possibilities of the subject, a heady mixture of sex, tension and violence, which involved a beautiful (and often half-naked) woman and a sleeping hero.

Around 1609, shortly after his return from an extended stay in Italy, Rubens painted a *Samson and Delilah* (fig. 1) for Nicholas Rockox, burgomaster of Antwerp, to hang over the mantelpiece in Rockox's principal room in his house in the Keizerstraat. A decade later, Van Dyck based his treatment of this subject on Rubens's painting, which he knew well. Two compositional drawings survive for Van Dyck's painting. The first (fig. 2) follows the direction of Rubens's painting, but moves the figure of Delilah to the centre, facing the viewer, while the barber crouches on the left. As in Rubens's painting, the old woman is on the left and the Philistines crowd into the doorway on the right. The second drawing (fig. 3) is carefully drawn in pen and squared up for

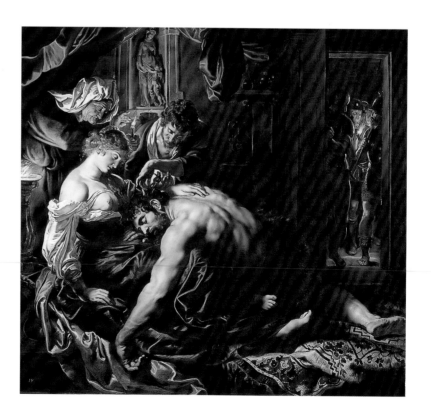

FIG 1
Peter Paul Rubens, *Samson and Delilah*, c. 1609
oil on panel, 185 × 205 cm
National Gallery, London

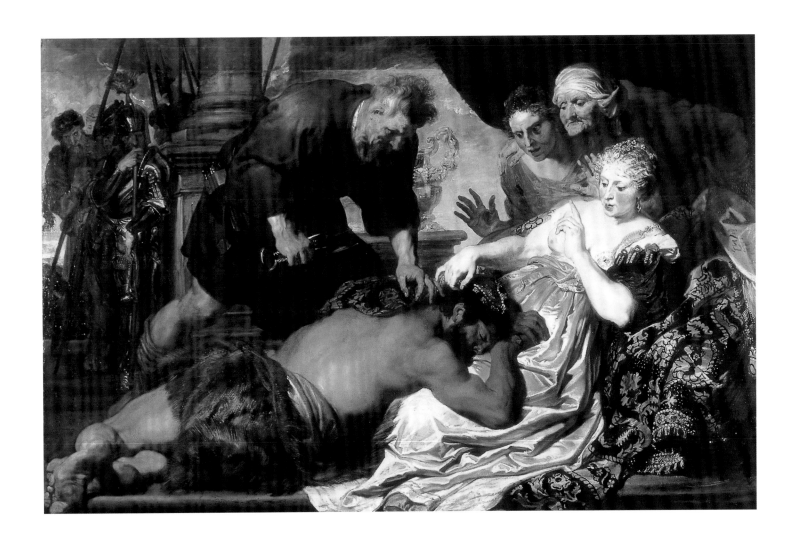

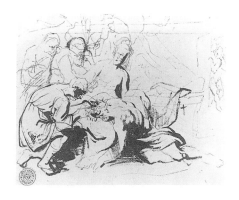

transfer to canvas. Van Dyck has reversed the composition, placing Delilah on the right, and moved the scene into the open air. This makes it similar to Jacob Matham's engraving after Rubens's painting which was made *c.* 1613, and it may be that Van Dyck had the print in front of him as he worked. Although the Berlin drawing is squared up, Van Dyck made a number of important changes when he transferred the drawing to the canvas. He added the old procuress used by Rubens; moved Delilah's hand away from her mouth; covered the corner of the bed, with its superb lion's-paw foot, with a rich brocade; placed a decorated urn (its handle appropriately decorated with a satyr in a state of arousal) prominently against the area of sky above Samson's head; and introduced a column and a group of soldiers in place of the balustrade seen on the left of the drawing. This is a striking example of the way in which Van Dyck reworked his compositions on the canvas, even after having carefully prepared them in a series of drawings.

As in many of his early paintings based on Rubens's designs, Van Dyck was determined to stamp his own creative personality on this subject. The greatest single change is that, while Rubens sets the scene in Delilah's darkened bedroom, Van Dyck places it in an open loggia, which has the effect of undermining the psychological and sexual tension of the story. In choosing an open-air setting Van Dyck was returning to a Venetian tradition exemplified by Titian's painting of *Samson and Delilah*, recorded in a woodcut by Boldrini, and Tintoretto's version of the subject (Chatsworth). Netherlandish artists of the 16th century, including Lucas van Leyden and Maarten van Heemskerck, had also represented Samson's betrayal in an outdoor setting. C B

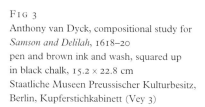

22 _Cornelis van der Geest_
1619–20

oil on panel, 37.5 × 32.5 cm; the original painting, which shows only Van der Geest's head and ruff, has been set into a larger panel on which the bust was added by a later artist; the larger panel measures 82.5 × 67 cm; the additions are concealed beneath the frame

The Trustees of the National Gallery, London (inv. no. 52)

PROVENANCE 27 February 1796, Liss (of Antwerp) sale, Christie's (2nd day), lot 99, bought by Pratbernon for 230 guineas; 26 March 1797, still in his possession; 18 May 1798, Bryan sale, Peter Coxe (2nd day), lot 51, bought by Angerstein for 340 guineas; 1824, purchased by the Gallery as part of the Angerstein collection

REFERENCES Young 1823, no. 17; Smith 1829–42, III, no. 251; Guiffrey 1882, p. 280, no. 895; Cust 1900, p. 234, no. 24; Schaeffer 1909, p. 143; Glück 1931, p. 125; Gepts 1954–60, p. 83ff; Martin 1970, pp. 34–7, no. 52; Held 1982, pp. 35–6, 55, 59; Larsen 1988, no. 45

EXHIBITIONS British Institution 1806; ibid. 1815, no. 9; Cheltenham Art Gallery and Museum, long-term loan, 1915–18; London 1939

FIG 1
Anthony van Dyck, _Cornelis van der Geest_, 1627–32 or 1634–5
black chalk, 25.5 × 18.4 cm
preparatory drawing for the portrait in the _Iconography_
Nationalmuseum, Stockholm (Vey 262)

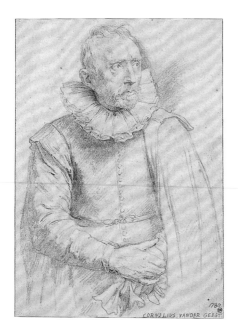

This marvellously vivacious portrait of a man in his sixties is one of the masterpieces of Van Dyck's early years. Particularly noteworthy is the painting of the glistening eyes and the way in which the artist has conveyed the sense of the structure of the skull.

The sitter can be identified from his portrait in Van Dyck's _Iconography_ as Cornelis van der Geest (1555–1638), a successful Antwerp spice merchant who served as Dean of the merchants' guild and was an important collector and patron of the arts. The portrait dates from 1619–20 when Van der Geest was 64 or 65 years old. In Willem van Haecht's painting of 1628 (cat. 49, fig. 2), which records the visit of the Archdukes Albert and Isabella to Van der Geest's house in the Mattenstraat in 1615, but at the same time illustrates his collection and social circle, both Rubens and Van Dyck are shown. Van der Geest's taste was wide-ranging: he collected works by 16th-century Antwerp masters (above all Quentin Metsys), by his contemporaries, notably Rubens, but also paintings by Elsheimer and Rottenhammer, Italian pictures and Flemish, Italian and German drawings and prints, as well as small sculptures by Petel, bronzes by Giambologna, casts of classical statuary, ancient coins, majolica, watches, armillary spheres and astrolabes. Van der Geest played an important role in the early career of Rubens: he was a churchwarden of the church of St Walburga and was responsible for Rubens receiving the commission for _The Raising of the Cross_ painted for that church (now Cathedral, Antwerp; cat. 61, fig. 1). It established Rubens's reputation as the leading history painter of the day. The artist acknowledged Van der Geest's importance in the inscription on the print made of the altarpiece in 1638, after his death: 'To Heer Cornelis van der Geest, the best of men and the oldest of friends, in whom ever since youth he [Rubens] found a constant patron, and who all his life was an admirer of painting, this souvenir of eternal friendship is dedicated, intended to be presented in his lifetime. Engraved after the picture in the church of St Walburga, the idea of which he was the first to conceive and which he supported so zealously.'

At an early date another artist extended the portrait to bust length by adding an extra panel, the joint being hidden beneath the specially constructed frame. The additional panel bears the brand of the city of Antwerp and the panelmaker's mark of Michiel Vriendt, whose date of death in 1636–7 provides an approximate _terminus ante quem_ for the addition. X-rays show that Van der Geest originally wore a high collar. Its size may have been reduced either by Van Dyck himself or at the time the addition was made. Its present format of head and shoulders corresponds with Van der Geest's portrait in Willem van Haecht's picture, as does his pose, so the addition was probably made between 1628 and about 1637 by an artist who knew that picture. Van Dyck seems to have originally shown Van der Geest's head and shoulders in a simulated oval porphyry surround, of which traces survive.

Van Dyck's drawing for the portrait of Van der Geest in the _Iconography_ (fig. 1) was made either between 1627 and 1632 or during Van Dyck's stay in Flanders in 1634–5, and was engraved by Paulus Pontius. The fourth state is inscribed: ARTIS PICTORIAE AMATOR ANTVERPIAE (Mauquoy-Hendrickx 1991, no. 48). Van der Geest is one of only four collectors in the group of portraits of artists and collectors in the _Iconography_, which numbers 52 in all. Two of the other three, Peeter Stevens (cat. 48) and Jacques de Cachiopin, are shown in Van Haecht's painting near the centre, examining a miniature. CB

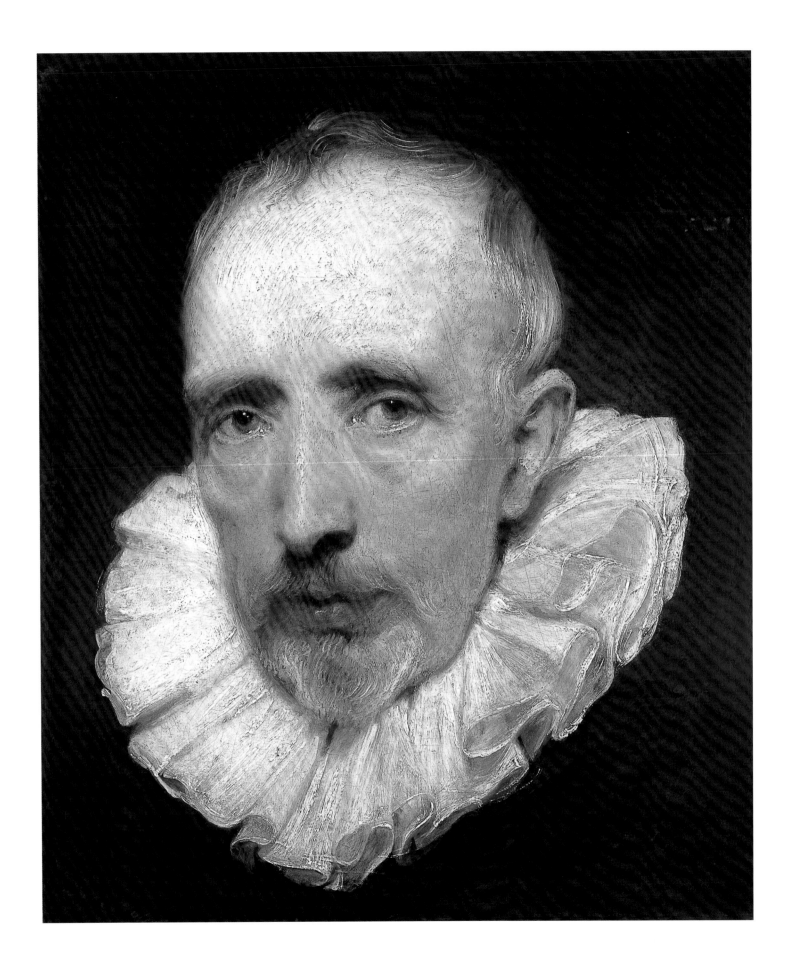

23 *Drunken Silenus, c.* 1620

oil on canvas, 107 × 91.5 cm
inscribed on the base of the jug, top centre: AVD
(in monogram)

Gemäldegalerie Alte Meister der staatlichen
Kunstsammlungen, Dresden (inv. no. 1017)

PROVENANCE Archduke Leopold Wilhelm;
bought by the painter Antoine Pesne for
Augustus III of Saxony; 1722[–28] inventory,
no. A79

REFERENCES Dresden inventory, 1722;
Gemäldegalerie Dresden 1765, p. 65, no. 335;
Smith 1829–42, III, p. 55, no. 193; Guiffrey 1882,
p. 144, p. 253, no. 267; Cust 1900, pp. 14, 44–5,
p. 233, no. 15; Woermann 1905, p. 329, no. 1017;
Bode 1906, p. 257; Schaeffer 1909, p. 54;
Valentiner 1910, p. 226; Rosenbaum 1928a, p. 55ff;
Glück 1931, pp. xxxii, 67; id. 1933, p. 286; Van
Puyvelde 1941, pp. 182–3; id. 1950, pp. 43, 47, 67,
123; Vey 1962, no. 99; Brussels 1965, under no. 58;
Brown 1982, p. 27; Roland 1984, p. 220; Dresden
1987, p. 166; Larsen 1988, no. 305

EXHIBITIONS *Masterpieces of European Painting
from the Gemäldegalerie alte Meister Dresden,*
National Museum of Western Art, Tokyo, 1974–5,
no. 38; Washington 1978–9, no. 548; Ottawa 1980,
no. 68; Washington 1990–91, no. 12

The story of the drunkenness of Silenus is told by Ovid (*Metamorphoses*, XI, 85–193; see cat. 11). Rubens was intrigued by this subject and painted it in a remarkable picture in Munich (cat. 11, fig. 1), which he began in 1617–18 as a half-length composition and expanded to a full-length composition eight or nine years later. Van Dyck's two closely related paintings of this subject were made in direct response to that picture. One version (cat. 11) was probably painted *c.* 1618–19, before this more elaborate version. Here Silenus is supported by a beautiful young woman with long hair and exposed breast whom the Phrygians, one of whom is black, observe with expressions of frank lust. One of them drains a jug of wine on the bottom of which Van Dyck painted his monogram. It probably dates from about 1620. At the same date Rubens returned to the subject (fig. 1) in a painting executed in his workshop according to his design. Van Dyck, as a leading member of Rubens's studio, painted the figures, and Frans Snyders, the still-life of grapes. This provides a fascinating example of Van Dyck's ability to vary his style in the years around 1620 depending on whether he was working independently or as a member of Rubens's studio.

In the painting from the Rubens workshop Van Dyck emphasises the solidity and three-dimensionality of the figures, whereas here he paints thinly and brilliantly with broken and scumbled highlights in a technique which is distinctly Venetian. His principal innovation in terms of subject-matter is the inclusion of the young woman on the left who supports Silenus and is the object of desire of the peasants on the right. Her presence gives an erotic tension to the scene that is lacking in Rubens's version. It is a fluent and assured performance by the young painter, and it is presumably a mark of his satisfaction with the finished painting that he added his monogram to the base of the jug. CB

FIG 1
Studio of Peter Paul Rubens, *Drunken Silenus supported by Satyrs, c.* 1620
oil on canvas, 133 × 197 cm
National Gallery, London

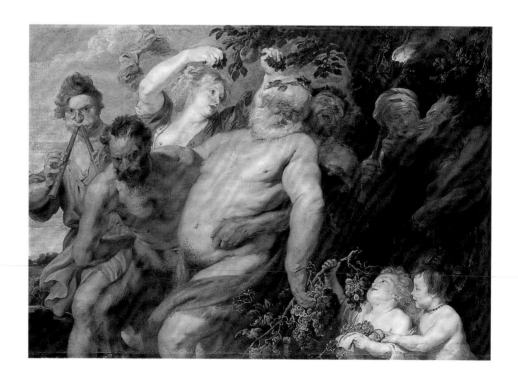

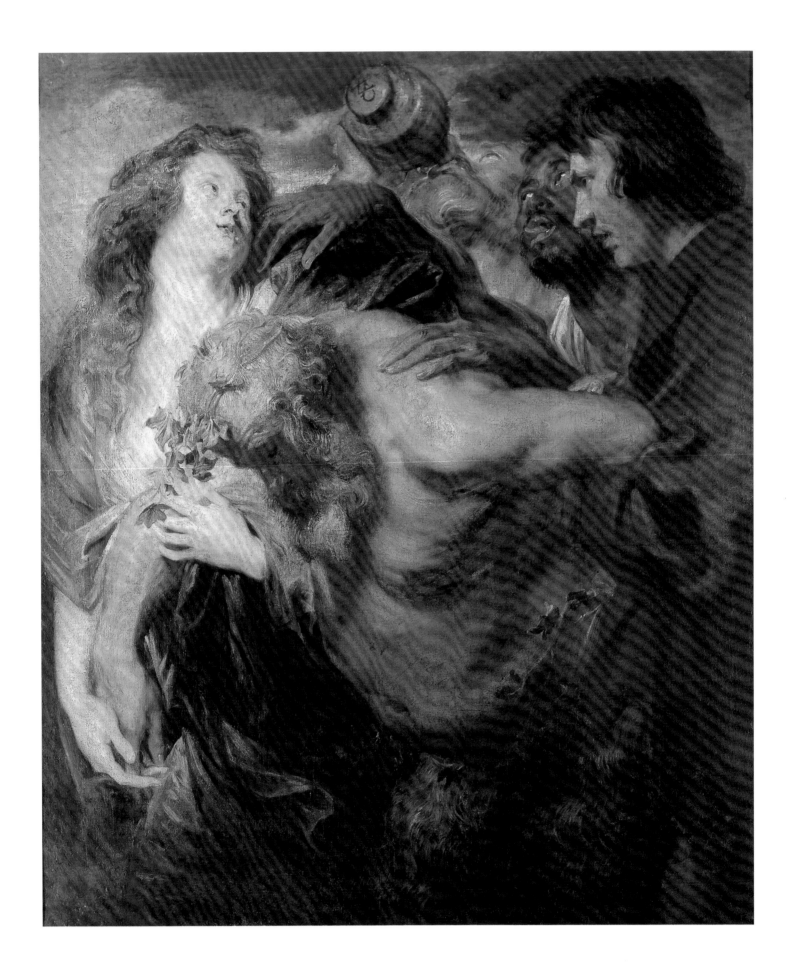

24 *The Taking of Christ*
c. 1620

oil on canvas, 274 × 222 cm

Bristol Museums and Art Gallery

PROVENANCE Possibly Alexander Voet, Antwerp: an altarpiece (*autaerstuck*) of this subject is in his 1689 inventory; 1747, purchased from George Bagnall by Sir Paul Methuen (1672–1757); 1757, inherited by his cousin and godson, Paul Methuen (1723–95), who had bought Corsham Court in 1745 and moved his paintings from Grosvenor Square, London, to Corsham *c.* 1761; by descent to the 4th Lord Methuen; 1984, on his death accepted in lieu of estate duty

REFERENCES Britton 1801, p. 289; Smith 1829–42, III, p. 5, no. 16; Waagen 1838, III, pp. 102–3; id. 1857, p. 395; Guiffrey 1882, p. 31, p. 247, no. 92B; Cust 1900, pp. 30–31, p. 247, no. 12; Bode 1906, p. 260; Schaeffer 1909, p. 38; Rosenbaum 1928a, p. 66; Glück 1931, pp. xxxii, 70, 527; Delacre 1934, p. 83; T. Borenius, *A Catalogue of the Pictures at Corsham Court*, London 1939, pp. 68–9, no. 119; Vey 1958, pp. 201–4; Antwerp and Rotterdam 1960, pp. 79–82; Princeton 1979, p. 102; Brown 1982, p. 39; *A Catalogue of the Pictures at Corsham Court*, Corsham 1986, p. viii; Larsen 1988, no. 258; Brown 1994, pp. 43–9

EXHIBITIONS British Institution 1857, no. 12; Royal Academy 1877, no. 109; ibid. 1887, no. 125; Antwerp 1899, no. 9; London 1900, no. 30; Washington 1985–6b, no. 264; ibid. 1990–91, no. 14

Van Dyck has shown in a highly dramatic fashion the moment of Christ's betrayal by Judas in the Garden of Gethsemane and his arrest by Roman soldiers. As Judas, clasping Christ's hand, bends forward to kiss him, one of his accomplices throws a rope over his head with which to bind him. The fullest account is given in John XVIII, 1–12.

Van Dyck painted three versions of this subject in about 1620 with relatively minor differences. The first version is the smallest, a broadly painted canvas (fig. 3) which has the character of a sketch yet seems too large to be one. The largest version, which is probably the third in the sequence, was purchased by Philip IV of Spain from Rubens's estate (fig. 1). With *St Martin dividing his Cloak* (cat. 18, 19) and *The Mocking of Christ* (Prado, Madrid), it was one of a group of versions of early religious paintings by Van Dyck that were owned by Rubens. They may well have been presented to him by Van Dyck himself.

There are seven surviving compositional drawings for this subject of which three are for the group of figures including St Peter cutting off the ear of the servant Malchus, which is shown in the Minneapolis and Madrid versions, but not in cat. 24; one for a group of sleeping apostles which was not used in any of the paintings; and one black chalk study for the figure of Malchus made from a model posed in the studio.

In the first drawing in Berlin (Vey 79) the principal elements of the composition are loosely sketched in pen. It shows a later moment in the story: Christ has been arrested, his hands are tied behind his back, and Judas cannot be identified in the mass of figures. This drawing is on the verso of a study for *Christ carrying the Cross* (cat. 7) of 1617–18; it is very much a first thought and may even predate the commission. The first drawing to be truly preparatory to the paintings is one of two in this series in Vienna (Vey 80). The key elements of the final composition are present: Judas's face close to Christ's but not actually kissing him; the noose held above the crowd, and the violent incident of Peter and Malchus. The format, however, is horizontal and the

FIG 1
Anthony van Dyck,
The Taking of Christ, c. 1620
oil on canvas, 344 × 249 cm
Museo Nacional del Prado, Madrid

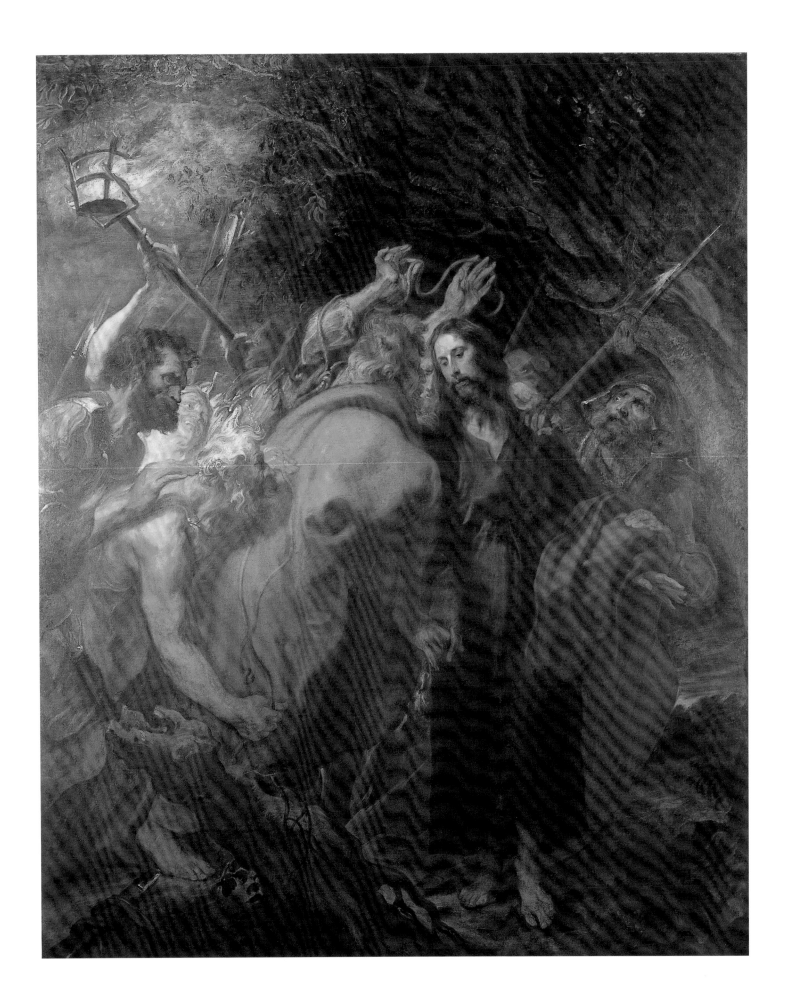

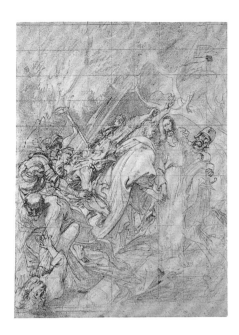

action moves from right to left. In a drawing in Berlin (Vey 81) the group including Christ and Judas has been moved to the right and St Peter and Malchus are replaced by a group of sleeping apostles. A third drawing in Berlin (Vey 88) is a remarkably free sketch in which the composition is simplified and compressed into an upright format for the first time. The next sheet, in Vienna (Vey 83), moves Judas from right to left and omits both Peter and Malchus and the sleeping apostles. It is a study of the central drama of the kiss. The drawings which follow, in Paris (Vey 84) and Hamburg (fig. 2), are both squared for enlargement and can be considered as *modelli*. They present different compositional solutions, but it was the Hamburg *modello* which was preferred: it was used by Van Dyck for the Minneapolis painting which should be regarded as a large-scale painted sketch used to try out the effectiveness of the composition before embarking on the larger canvases.

The present painting was the next stage, presumably the commissioned work itself – an altarpiece, although nothing is known of the commission. Finally Van Dyck made a version for Rubens, extending the composition at the top and on the left and reinstating Peter and Malchus. In studying this group of drawings and paintings we feel we can enter into the working of the young Van Dyck's creative intellect as he works on a project, trying out ideas, rejecting some, developing and refining others. And even after all this intensive preparation, he substantially reworked the compositions on the canvas. CB

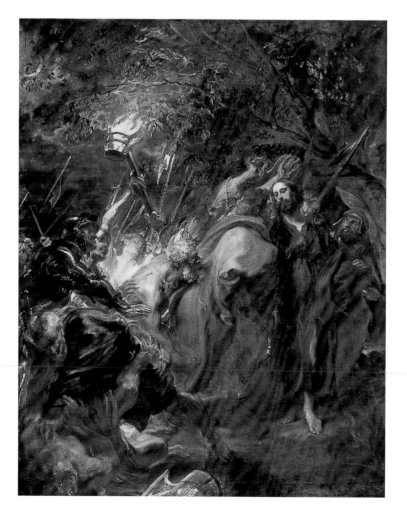

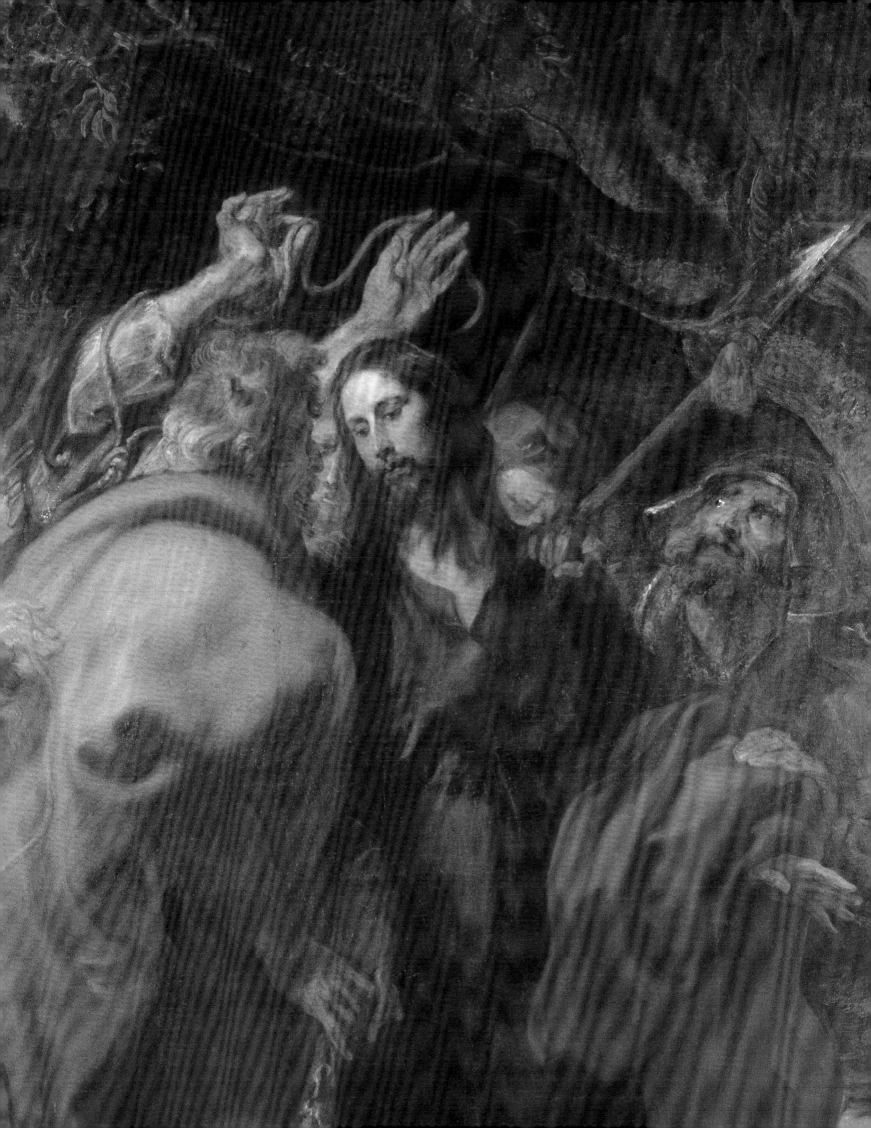

25 *Thomas Howard, 2nd Earl of Arundel* 1620–21

oil on canvas, 102.8 × 79.4 cm

The J. Paul Getty Museum, Los Angeles
(inv. no. 86.PA.532)

PROVENANCE 1727, collection of Philippe, duc d'Orléans, Regent of France; 1792, by descent to Philippe, duc d'Orléans (Philippe Egalité); 11 May 1801, Citoyen Robit sale, Paris, lot 36; 6 November 1801–31 May 1802, Michael Bryan sale, lot 92, bought by the 3rd Duke of Bridgewater; before 1913 by descent to the 1st Duke of Sutherland; Fritz Gans, Frankfurt am Main; Bachstitz collection, The Hague; by 1929, Daniel Guggenheim, New York; 1931–at least 1939, Mrs Daniel Guggenheim, New York; 1950, Robert Guggenheim, Washington; Mrs David Guggenheim, New York; 1980, Mr and Mrs Francis Lenyon, Washington; 1980, John A. Logan, Washington; 1983, 8 July, Mrs Rebecca Pollard Logan sale, Christie's, London, lot 92; Jamie Ortiz Patino, Switzerland; 1986, sold by him through Agnew's to the Museum

REFERENCES Cust 1900, pp. 23, 268, no. 1; Hervey 1921, pp. 187–8; Glück 1931, pp. 125, 533; Brown 1982, pp. 55–6; Larsen 1988, no. 38; White 1995

EXHIBITIONS British Institution 1820 (?); Royal Academy 1876, no. 262; ibid. 1890, no. 150; ibid. 1900, no. 2; Detroit 1929, no. 14; Ottawa 1980, no. 65; London 1982–3, no. 2; Malibu 1995; London 1995–6, no. 146

NOTES
1. Quoted in Howarth 1985, p. 221.
2. Quoted by Hervey 1921, p. 175. See also Howarth 1990.

Sir Edward Walker served Arundel on the occasion of his embassy to Germany in 1636 and described the Earl as follows: 'He was tall of Stature, and of Shape and proportion rather goodly than neat; his Countenance was Majestical and grave, his Visage long, his Eyes large, black and piercing; he had a hooked Nose, and some Warts or Moles on his Cheeks; his Countenance was brown, his Hair thin both on his Head and Beard; he was of stately Presence and Gate, so that any Man that saw him, though in ever so ordinary Habit, could not but conclude him to be a great Person, his Garb and Fashion drawing more Observation than did the rich Apparel of others; so that it was a common Saying of the late Earl of Carlisle, Here comes the earl of Arundel in his plain Stuff and trunk Hose, and his Beard in his Teeth, that looks more a Noble man than any of us.'[1]

Thomas Howard, 2nd Earl of Arundel (1586–1646) was a prominent member of the courts of James I and Charles I. At James's court, Arundel was a member of the cultivated and highly sophisticated circle around Henry, Prince of Wales, who died in 1612. He was artistic mentor to the Prince, whose tastes were in turn influential on those of his younger brother Charles, who ascended the throne as Charles I in 1625. In 1611 Arundel was created Knight of the Garter; in this portrait he wears the ribbon of the order and holds the jewel of the Lesser George. In 1616 he was admitted to the Privy Council and in 1621 was created Earl Marshal, an office traditionally vested in his family of which his father had been stripped, which carried with it responsibility for all court ceremonial.

Arundel formed a remarkable collection of paintings and antiquities, using his wife Aletheia's large fortune – she was the heiress of the Earl of Shrewsbury – as well as his own. When Rubens was in England in 1629, he expressed astonishment at the riches of the collection. At the houses in London and Sussex which bore his name, Arundel gathered scholars and artists around him. The philosopher and antiquarian Franciscus Junius served as his librarian and wrote his famous study of classical painting, *De Pictura Veterum* (published in 1637) while in Arundel's household. Among the artists who enjoyed Arundel's patronage were the architect Inigo Jones and the portrait painter Daniel Mytens, born in Delft c. 1590, who by 1618 had moved from The Hague to London at Arundel's request.

There can be little doubt that this portrait was painted in England during Van Dyck's short first stay in 1620–21. For the first time he had the opportunity to see significant numbers of Venetian paintings. Here he adopted the Venetian portrait formula of a rich velvet curtain draped behind the chair; up to this date his portraits had plain backgrounds. Additionally, his technique is freer and more Venetian than anything before.

Van Dyck's arrival in England is first noted in a letter of 20 October 1620 sent to William Trumbell in Brussels by Thomas Locke, in which he mentions that 'The young Painter Van Dyke is newly come to the towne…' and that he was sent for by John Villiers, Lord Purbeck, the Duke of Buckingham's elder brother.[2] Earlier in the year Lady Arundel had been in Antwerp (where she sat to Rubens in July) and her secretary Francesco Vercellini had written to Lord Arundel that 'Van Dyck is still with Signor Rubens, and his works are hardly less esteemed than those of his master'. Lady Arundel met Lord Purbeck in Spa later that summer, and it may have been she who recommended the young artist to him. During his first visit to England Van Dyck received three commissions, two from Buckingham (see cat. 26) and the third – for this portrait – presumably from Arundel himself. Arundel was involved in the formalities of arranging for Van Dyck's journey to Italy in 1621 and, shortly after his arrival in Italy, Van Dyck joined the entourage of Lady Arundel in Venice. After his return to England in 1632 Van Dyck received further commissions from Arundel (see cat. 89). CB

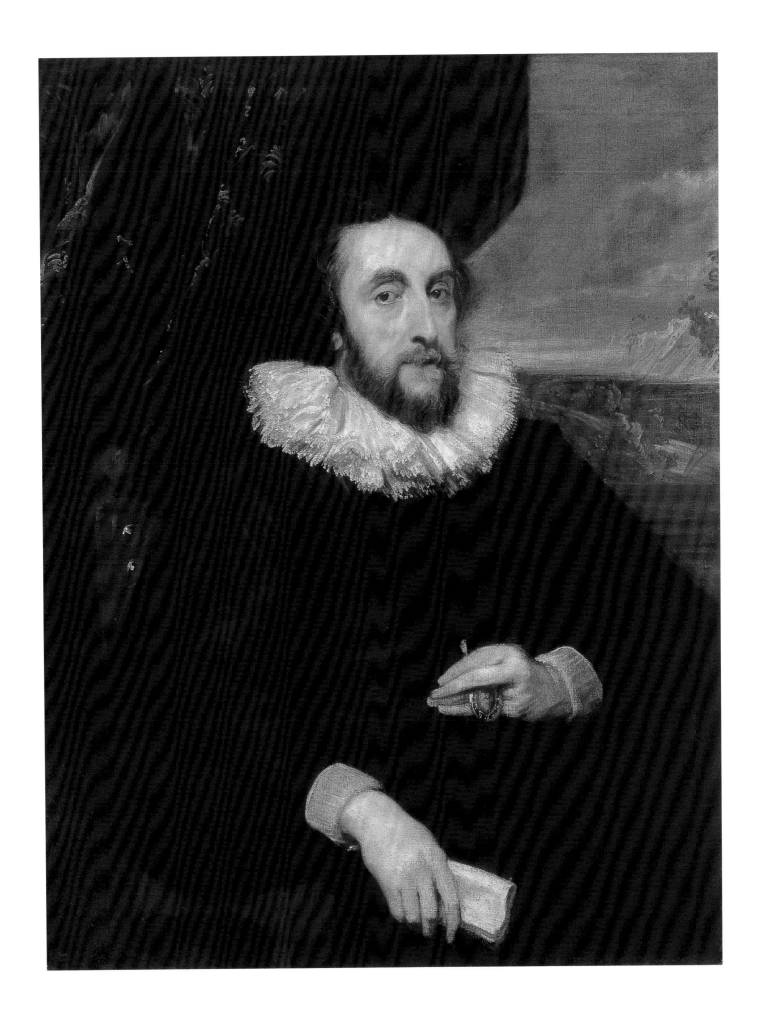

The Continence of Scipio
1620–21

oil on canvas, 183 × 232.5 cm

By permission of the Governing Body of Christ Church, Oxford

PROVENANCE Probably the painting recorded in the Duchess of Buckingham's inventory of 1635 as hanging in the hall at York House: 'Vandyke One great Peice being Scipio'; 4th Duke of Argyll (engraved by T. Miller, 1766); Lord Frederick Campbell (third son of the 4th Duke of Argyll); 1809, bequeathed to Christ Church

REFERENCES Smith 1829–42, III, no. 404 ('improperly ascribed to Van Dyck'); Christ Church catalogue 1833, no. 164 (as Van Dyck); Rooses 1866–92, IV, no. 809; Davies 1906–7, p. 379; Borenius 1916, no. 231 (as School of Rubens); Glück 1927, pp. 72–3; id. 1931, p. 140; Millar 1951, pp. 125–6; Gerson 1960, p. 113, pl. 97a; Vey 1962, no. 107; Byam Shaw 1967, pp. 125–6, no. 245; Martin 1973, pp. 56–9, pl. 62; Harris 1973, pp. 526–30; Larsen 1988, no. 295; Wood 1992, pp. 37–47; Harvie 1993, p. 224; White 1995, pp. 59–62; Meijer 1997, pp. 131–44

EXHIBITIONS London 1953–4, no. 227; Liverpool 1964, no. 16; London 1972–3, no. 10; Ottawa 1980, no. 64; London 1982–3, no. 3

NOTES
1. This suggestion was first made by Millar in London 1982–3.
2. Held 1980, no. 287.
3. Meijer argues that the drawings (notably the recto of the Bremen sheet) require that Van Dyck knew Veronese's *Family of Darius before Alexander* (National Gallery, London) which he could have seen in Venice only in 1622. He proposes that all three drawings are preparatory not to the Oxford painting but to a picture (showing Scipio on the right) formerly in the Harrington collection, now in an Italian private collection, attributed by Waagen to Theodore Boeyermans. Its attribution to Van Dyck seems unlikely judging from Meijer's illustrations.
4. Millar 1951 mentions another version formerly in the collection of Prince Dietrichstein, 161.5 × 205 cm, drawn to his attention by Burchard.

The story is told by Livy (XXV, 50). After he had captured New Carthage in 209 BC, Scipio Africanus released a beautiful female captive, restoring her to her betrothed, Allucius, and giving the couple the gifts her parents had brought to ransom their daughter. Allucius was a leading figure in his tribe and, overwhelmed by Scipio's magnanimity, praised him to his fellow tribesmen and joined his army with 1500 men. Scipio's action was often cited as an example of the virtues of generosity and continence and was praised by Machiavelli as a model of astute statecraft.

The picture dates from Van Dyck's time in England in 1620–21; it is probably the work recorded in the widowed Duchess of Buckingham's inventory of 1635 as hanging in the hall at York House in London: 'Vandyke One great Peice being Scipio'. Payment had been made to 'Vandyke the picture drawer' by Endymion Porter on behalf of the Duke; although the date and amount are unspecified, it must have been before Porter left Buckingham's service to enter that of Prince Charles in 1620–21.

George Villiers (1592–1628) was the acknowledged favourite of King James I from 1617 and subsequently of Charles I. He was created Knight of the Garter in 1616 and Duke of Buckingham in 1623. In 1625 he was appointed General of the Fleet and of the Army, but his attempt to relieve the siege of La Rochelle ended in ignominy. He was assassinated in Portsmouth in 1628. On 16 May 1620 Buckingham had married Lady Katherine Manners against the wishes of the bride's father, the Earl of Rutland. The subsequent reconciliation between the Duke and his father-in-law was effected by the King. It has been suggested that the choice of this subject refers to these events, and that the features of Allucius and his bride are those of Buckingham and his wife. It has also been argued by Wood that the elephant visible on the carpet beneath the couple's feet refers to their chastity.

Van Dyck had been brought to England in 1620 by Lord Purbeck, Buckingham's brother. Purbeck was neither patron nor collector, and he may well have been acting on Buckingham's instructions. We know of only three paintings made by Van Dyck during his first stay in England, the portrait of Arundel (cat. 25), *The Continence of Scipio* and *The Duke and Duchess of Buckingham as Venus and Adonis* (fig. 19), painted about the same date. The fact that two of these were apparently commissioned by Buckingham makes it clear that he took a strong interest in Van Dyck's career. It has been suggested that Van Dyck may have been brought to England not as a portrait painter but as a designer of tapestries:[1] while in Rubens's studio in Antwerp he was closely involved in the design of the Decius Mus tapestries and the painting of their cartoons (Liechtenstein collections; see fig. 22). Buckingham was a supporter of the Mortlake tapestry factory and if we look at *The Continence of Scipio* it is difficult not to be struck by its frieze-like composition and two-dimensionality. Both are characteristics of Van Dyck's style in Antwerp as well as in London and are especially appropriate to tapestry design. The composition is indebted to Van Dyck's study of Buckingham's collection: Veronese's influence is apparent, particularly that of his *Esther and Ahasuerus*, one of a large group of paintings by Veronese in the Duke's collection, seven of which are today in the Kunsthistorisches Museum, Vienna.

As with so many of his works of this period, Van Dyck's composition is essentially a reworking of a design by Rubens. Rubens had treated the subject *c.* 1615–17, and although the painting was destroyed in 1836, two preparatory drawings and an oil sketch survive.[2] The first of Van Dyck's preparatory drawings (fig. 2) is based on Rubens's drawing (Berlin; Mielke and Winner 1977, no. 24). Scipio is seated beneath a canopy on the right; the captive woman stands on a platform before him, holding

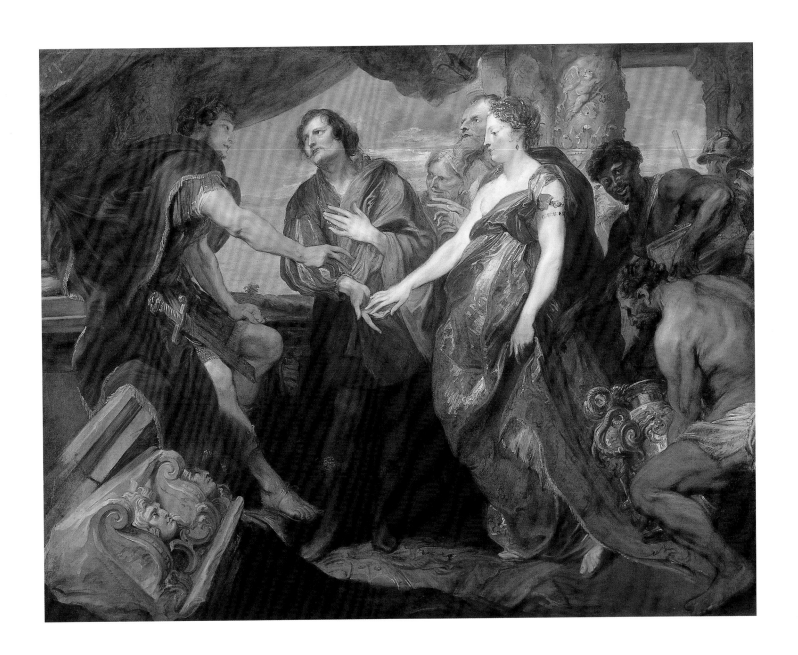

Allucius' hand while a man bends over to lift a large metal ewer. Van Dyck developed the composition in a second drawing (fig. 3), introducing the crouching man in the lower right. A third drawing, on the recto of the same sheet, reverses the composition and removes the platform, so that the figures are arranged in a frieze.[3] In the painted version Van Dyck reduced the number of figures, using his own drawings and also elements of other compositions by Rubens: the man with the urn recalls a figure in Rubens's *Abraham and Melchisedeck* (Caen) and another in Rubens's sketch for *The Adoration of the Magi* (Groningen).[4]

Buckingham was a rival to the Earl of Arundel (see cat. 25) in his passion for collecting antiquities and paintings. The frieze shown in the foreground of this picture is a provincial Roman relief of Syrian origin (fig. 1). It was excavated some years ago on the site of Arundel House in London, and it has been suggested that Arundel obtained the relief from Buckingham's collection after the Duke's assassination in 1628. CB

FIG 2
Anthony van Dyck, compositional study for
The Continence of Scipio, 1620–21
pen and brush over black chalk with brown wash,
31.4 × 45.6 cm
Musée du Louvre, Cabinet des Dessins,
Paris (Vey 106)

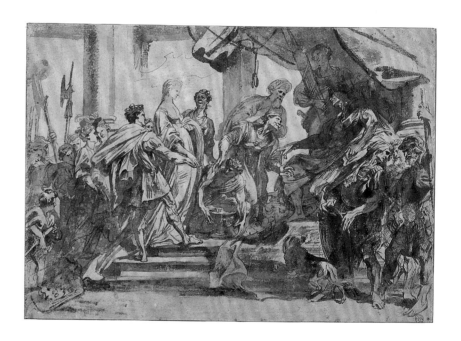

FIG 3
Anthony van Dyck, compositional study for
The Continence of Scipio, 1620–21
pen and brush on paper, 26.9 × 40 cm
formerly Kunsthalle, Bremen (Vey 107)

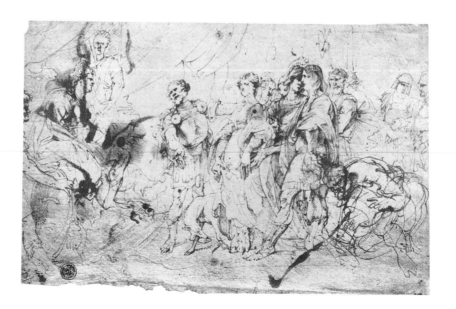

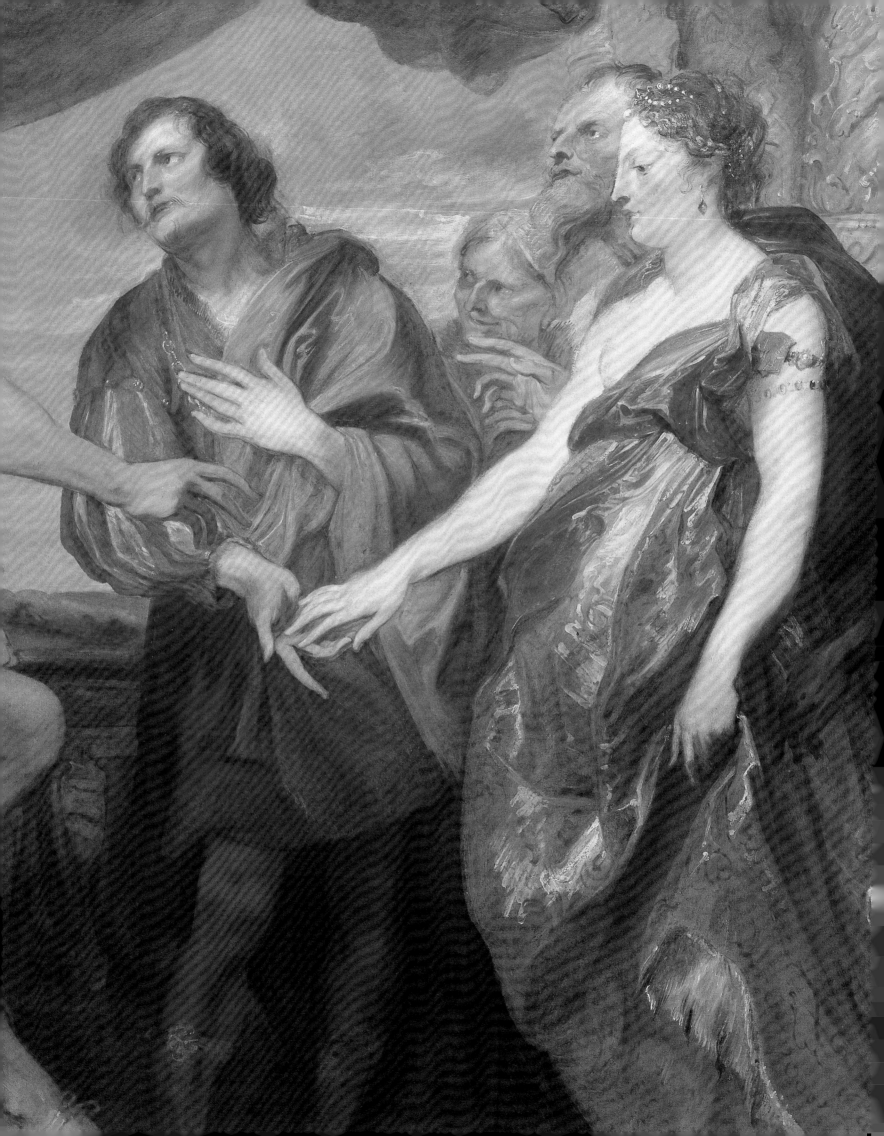

27 *Isabella Brant*

1621

oil on canvas, 153 × 120 cm

National Gallery of Art, Washington, DC,
Andrew W. Mellon Collection (1937.1.47)

PROVENANCE Pierre Crozat (1665–1740);
by descent to his nephews, Louis François Crozat,
Baron de Chatel (1691–1750), and (on his death
without a direct male heir) to Louis-Antoine
Crozat, Baron de Thiers (1700–70); 1772,
purchased by Catherine II (1729–96), Empress
of Russia, for the Imperial Hermitage Gallery,
St Petersburg, where it remained until 1932; 1937,
sold to Andrew W. Mellon; 1937, presented by
him to the Gallery

REFERENCES Probably Félibien 1666–88;
De Piles 1708; probably Houbraken 1718, I,
pp. 182–3; Crozat 1755, p. 47 (as Rubens);
Hermitage 1774, p. 101 (as Rubens); Waagen
1864, p. 140, no. 575 (as Rubens); Walpole 1876,
I, p. 317; Rooses 1886–92, IV, pp. 131, 136,
no. 900 (as Rubens); Somof 1895, II, p. 63,
no. 575 (as Van Dyck); Rooses 1895, p. 284
(as Rubens); Cust 1900, p. 24, p. 235, no. 35
(as Van Dyck); Somof 1901, II, pp. 365–6, no. 575
(as Rubens); Rooses 1905, pp. 496–7 (as Rubens);
Ricketts 1905, pp. 83–4 (as Van Dyck); Bode
1906, pp. 268–9 (as Van Dyck); Rooses 1907,
pp. 41–4, 43 (as Rubens); Schaeffer 1909, pp. 167,
502, 525; Burchard 1929, p. 322, n. 3; Glück 1931,
pp. 114, 531 (as Van Dyck); id. 1933, pp. 96, 100,
102, 144, 163 (as Van Dyck); Van Puyvelde 1937,
pp. 5–7 (as Van Dyck); id. 1940a, pp. 2–9 (as Van
Dyck); Francis 1947, p. 248 (as Rubens); Goris
and Held 1947, p. 248 (as Rubens); Larsen 1967,
pp. 4–5 (as Van Dyck); Crozat 1968, p. 104,
no. 386 (as Rubens); Ottawa 1980, pp. 12, 17, 272;
Washington 1985, p. 143, no. 1937.1.47; Barnes
1986, I, p. 75, no. 37; H. Vlieghe, *Portraits,
Antwerp, Identified Sitters*, Corpus Rubenianum
Ludwig Burchard, XIX–2, London 1987, p. 58;
Larsen 1988, no. 77; Muller 1989, p. 148

EXHIBITIONS Washington 1990–91, no. 23;
Cologne, Antwerp and Vienna 1992–3, no. 61.1

Félibien, writing in the second half of the 17th century, tells us that when Van Dyck left Antwerp to travel to Italy in 1621, he presented Rubens with a portrait of Rubens's wife, Isabella Brant. This painting has long been identified as that portrait. It is an outstanding example of Van Dyck's portraiture, showing Isabella as a vivacious and radiant young woman. Van Dyck uses the Venetian device of a draped curtain to disguise the hiatus between foreground and background, and places her before the three-arched screen that Rubens had built to link his house and studio. Between 1617 and 1621 Rubens had expanded his late-medieval house to create a residence with a studio on the opposite side of his courtyard to suit his status as the leading painter in Antwerp.

Van Dyck knew Isabella well. Since about 1618 he had worked closely with Rubens and had watched his house being transformed into an urban palace. He has wittily transposed the statue of Minerva from the screen to stand on a balustrade above Isabella's right shoulder, thereby associating her with the goddess of Wisdom. Van Dyck made a drawing of the garden screen which does not survive but is recorded in the inventory of Alexander Voet in 1689. He also made a sketch of it on the verso of a drawing of St John the Baptist in the Institut Néerlandais, Paris (Vey 50).

Isabella holds an ostrich-feather fan in her left hand and is richly dressed in a gown with the bodice embroidered with gold thread beneath her black coat. She wears gold earrings, pearls and gold chains decorated with jewels. Her eyes are bright and she has a broad smile. It has been suggested that Rubens's remarkably vivid drawing of Isabella (British Museum, London) was Van Dyck's model, but there is no reason why this should be the case: Isabella presumably sat to Van Dyck in Antwerp in the period between his return from England and his departure for Italy. These eight months were particularly fertile for Van Dyck's portraiture. He had been intensely stimulated by the experience of seeing a great quantity of Venetian painting in England, and it was at this time that he painted two of his greatest early portraits, those of Frans Snyders and his wife, Margaretha de Vos (Frick Collection, New York).

Isabella Brant was the eldest daughter of Jan Brant, who was one of the four secretaries of the city of Antwerp and a scholar of classical literature. After her death in June 1626, Rubens wrote an intensely moving account of her in a letter (15 July 1626) to his Parisian correspondent Pierre Dupuy: 'In truth I have lost an excellent companion. How to express it, one had to cherish her – with reason – because she had none of the faults of her sex: never moody, no feminine weaknesses, nothing but goodness and thoughtfulness. Her virtues made her dear to everyone during her lifetime, and have caused universal grief since her death. Such a feeling of loss as I have seems justified to me, and because the sole remedy for all such ills is time, I must doubtless look to time for my relief. But it will be difficult for me to separate the pain that her loss makes me suffer from the memory I will guard all my life of this cherished and venerated woman'. Shortly after her death Rubens himself painted a portrait of his wife (Uffizi, Florence); it was for this portrait that the British Museum drawing was used.

This painting is not recorded in the inventory of Rubens's collection made shortly after his death in 1640, because portraits of the artist and of his wives were reserved for the family. It was first mentioned in the Crozat collection in the mid-18th century as a Rubens. Since Bode attributed it to Van Dyck in 1906, it has been accepted as the portrait mentioned in Félibien's account. CB

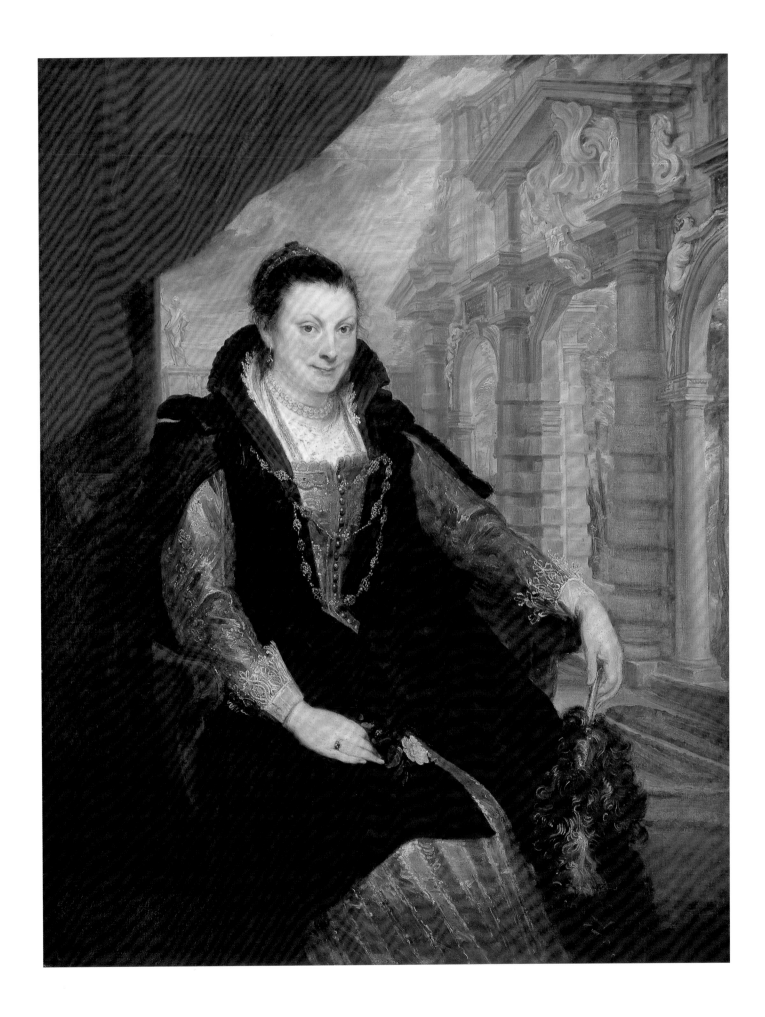

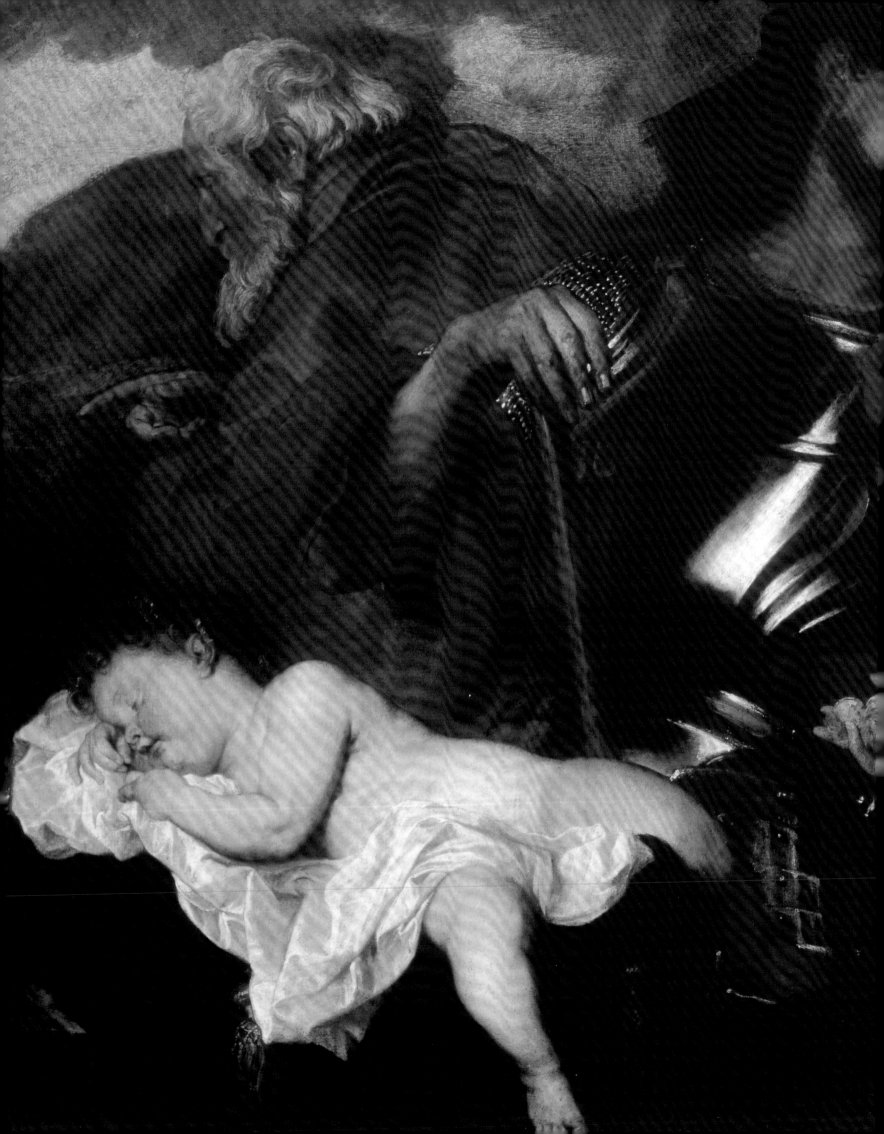

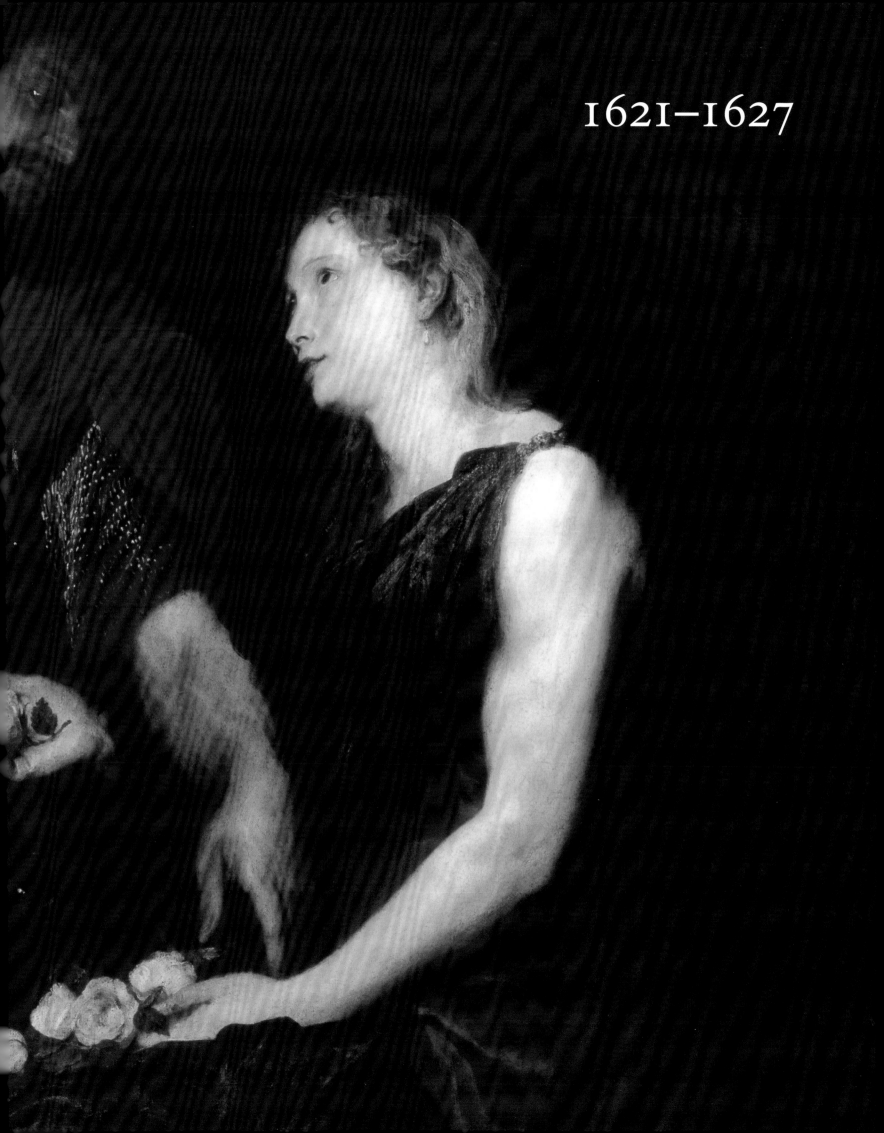

1621–1627

28 *A Woman and Child*
c. 1621

oil on canvas, 131.5 × 106.2 cm

The Trustees of the National Gallery, London
(inv. no. 3011)

PROVENANCE 1758, probably first recorded
in Palazzo S. Giacomo Balbi in the collection of
Francesco Maria Balbi (b. 1734), Genoa;[1]
collection of Francesco Maria Balbi;[2] possibly
among the ten paintings acquired by Andrew
Wilson on 13 November 1805 from the Balbi
collection;[3] by 1815, collection of Sir Abraham
Hume (1749–1838), when lent to the British
Institution; by descent to Earl Brownlow; 1914,
purchased from him by the Gallery

REFERENCES Cochin 1758, III, pp. 278, 282
and pp. 278–9, n. 1; Ratti 1780b, p. 192; Smith
1829–42, III, no. 533; Waagen 1838, II, p. 203;
id. 1854, II, p. 315; Guiffrey 1882, p. 287,
no. 1100; Cust 1900, p. 237, no. 67; Schaeffer 1909,
p. 153; Glück 1931, pp. 109, 530 note; Martin
1970, pp. 47–8, no. 3011; Larsen 1988, no. 81

EXHIBITIONS British Institution 1815,
no. 2; ibid. 1836, no. 7; ibid. 1838, no. 22;
ibid. 1843, no. 80; Royal Academy 1871, no. 125;
London 1887, no. 118; Royal Academy 1893,
no. 127; Antwerp 1899, no. 98; London 1900,
no. 11

NOTES
1. Cochin 1758, III, p. 278, n. 1, and p. 282:
'Palais del S. Giacomo Balbi, i Strada Balbi…
Le Portrait de la femme & de l'enfant de Vandick,
peint par lui-meme'.
2. Ratti 1780b, p. 192: [In Palazzo Francesco
Balbi:] *'Ritratto d'una Signora con un fanciullo in*
braccio, opera delle più ben condotte del Vandik.
Questo ritratto e volgarmente conosciuto sotto nome
della moglie del Vandik'.
3. In a letter dated 23 February 1828 to Sir Robert
Peel, Wilson claimed to have sold the picture to
Hume for £400: see Brigstocke 1982, pp. 488–9.

This is a particularly tender and animated portrait of a mother and child. The mother, richly dressed in black with a bodice embroidered in gold thread, looks directly at the viewer while the child, wriggling on its mother's knee, looks to the left, as if its attention had been caught by a sudden movement. The child is probably a boy, still dressed in his 'skirts' as was usual in the 17th century: he wears a hat, soft ruff and a dress with a purple satin skirt which is painted with brilliant highlights. Mother and child are shown three-quarter length seated against an imposing architectural backdrop. Behind the child, between the ledge and the billowing red curtain, is a view over an extensive landscape. The sitters are unidentified; in 1758 they were said to show Van Dyck's wife and a child, but the artist was unmarried in the 1620s, and the identification was refuted by Ratti as early as 1780. The child looks eagerly out of the painting to the left and raises his right hand, actions which suggest that originally there was a pendant portrait of his father, perhaps with an older child.

The dating of the painting is problematic. The fine modelling of the woman's face is similar to the portrait of *Margaretha de Vos* (Frick Collection, New York) which was painted in Antwerp probably in 1621. However, the use of a dark ground and the painting's presence in Genoa at an early date make it equally likely that it was painted shortly after Van Dyck's arrival in that city late in 1621.

There are a few very small *pentimenti*: the woman's ruff may have originally been slightly higher at the back on the left and the red curtain originally extended further to the right. CB

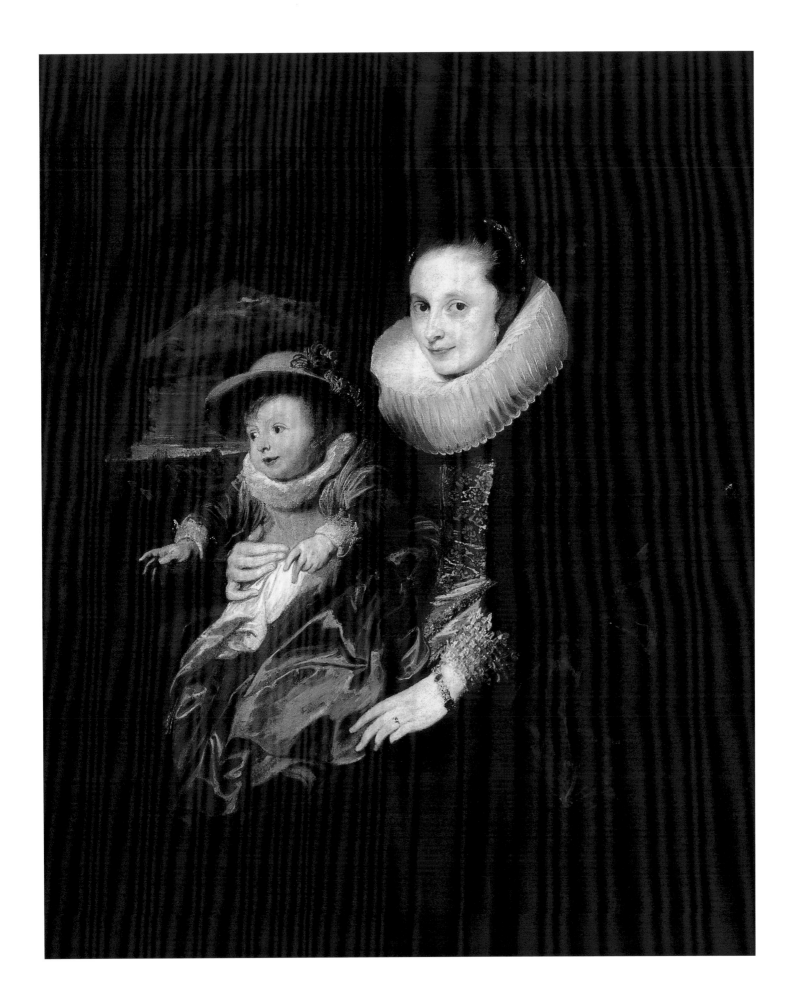

Teresia, Lady Shirley

1622

oil on canvas, 200 × 133.4 cm

Petworth House, The Egremont Collection
(The National Trust) (inv. no. 39)

30 *Sir Robert Shirley*

1622

oil on canvas, 210 × 133.5 cm
inscribed in yellow, bottom left: *Sr Robert Shirley*

Petworth House, The Egremont Collection
(The National Trust) (inv. no. 38)

PROVENANCE 1764, collection of the 2nd Earl
of Egremont (1710–63) at Petworth House;[1] by
descent to the 3rd Lord Leconfield who in 1947
gave Petworth House and park to the National
Trust; 1956, transferred in lieu of death duties to
the Treasury, which conveyed them to the
National Trust[2]

REFERENCES Bellori 1672, p. 255; Smith
1829–42, III, p. 154, nos. 544, 545; Waagen 1854,
III, p. 40, no. 10 ('too feeble in drawing and too
heavy in colour for van Dyck'); Cust 1900, p. 243,
nos. 117, 119; Collins Baker 1920, p. 28, nos. 96,
97; Vaes 1924, pp. 202–3, 223–30; Glück 1931,
p. 577, nos. 510, 511; Adriani 1940, pp. 55–7; Van
Puyvelde 1950, p. 162; Millar 1955, p. 314; Brown
1982, pp. 64–5, 67; Barnes 1986, I, pp. 245–7,
nos. 37, 38; Larsen 1988, nos. 405, 406

EXHIBITIONS British Institution 1815, no. 61
(cat. 29); London 1955, nos. 38, 39; ibid. 1968a,
nos. 17, 18; ibid. 1982–3, nos. 4, 5; Washington
1990–91, nos. 28, 29; London 1995a, no. 2 (cat. 30)

NOTES
1. There is a tradition at Petworth that the
portraits were acquired at the sale of a Shirley
house at Wiston. They could also have been
purchased by the 2nd Earl of Egremont in Italy.
2. According to George Vertue (1757, no. 18)
there was a portrait of 'The Lady Shirley in
fantastick habit [supposed to be a Persian habit]
by Vandyke' in the collection of Charles I. This is
likely to have been a different painting, as the two
portraits do not ever seem to have been separated.

FIG 1
Anthony van Dyck,
study for *Sir Robert Shirley*, 1622
pen and ink, fol. 62r of the Italian Sketchbook
British Museum, London

FIG 2
Anthony van Dyck, study for *Lady Shirley*, 1622
pen and ink, fol. 60v of the Italian Sketchbook
British Museum, London

Sir Robert Shirley (c. 1581–1628) is shown here in his official dress as an envoy of the
Shah of Persia. He had accompanied his brother Anthony (1565–1635) on a diplomatic
mission in 1598–9 to Persia, where he settled and married a Circassian Christian
noblewoman, Teresia Khan. She was a renowned beauty: Thomas Fuller noted that
she had 'more of ebony than ivory in her complexion'. In 1607–8 Robert Shirley
travelled to Europe to negotiate alliances with European rulers against the Turks on
behalf of Shah Abbas the Great. He returned to Isfahan only in 1615, later that year
embarking on a second series of missions. From 1617 until the summer of 1622 he
was in Spain. On 22 July 1622 he arrived in Rome, where he was received as Persian
ambassador by Pope Gregory XV. He remained in Rome until 29 August, as we know
from the diary of the papal official Paulo Adaleoni, and it was during this five-week
stay that he and his wife must have sat to Van Dyck. The pair moved on from Rome
to London and subsequently returned to Persia in 1627. Sir Robert died there in the
following year and his wife retired to Rome and spent the remaining 40 years of her life
in a convent attached to S. Maria della Scala, dying in 1668.

The artist's Italian Sketchbook contains a number of quick pen sketches of Shirley,
his wife and his entourage. One sketch shows Shirley in the pose he adopts in the
painting; a more detailed pen drawing (fig. 1), inscribed *'Ambasciatore di Persia in
Roma'* (Persian Ambassador in Rome), shows him full-length in profile; it is a study for
his dress with colour notes: *'drapo doro'* (gold cloth), and *'le figure et gli foliagi de colori
differenti de veluto'* (the figures and foliage in different colours to the brocade). That of
his wife (fig. 2), inscribed *'habito et maniera di Persia'* (Persian dress and style), includes
the landscape, and so can more properly be considered a preparatory study for the
painting. Shirley wears a tunic embroidered with gold and silver thread and a cloak of
cloth-of-gold, richly embroidered with oriental figures and flowers. His wife, dressed in
opulent woven and embroidered textiles, is seated outside a tent with her pet monkey.
Behind her is a Roman landscape. Despite their having been painted in Rome the
portraits are thoroughly Venetian in technique and treatment of colour, and there is
no sign that Van Dyck had studied any Roman portraiture.

Bellori's description of the portraits suggests that he had seen them and that they
were in Rome in the second half of the 17th century. CB

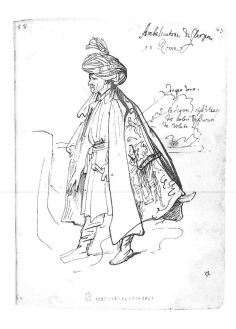
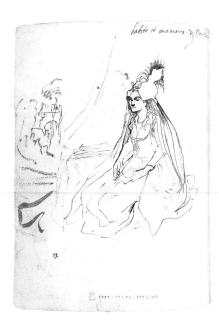

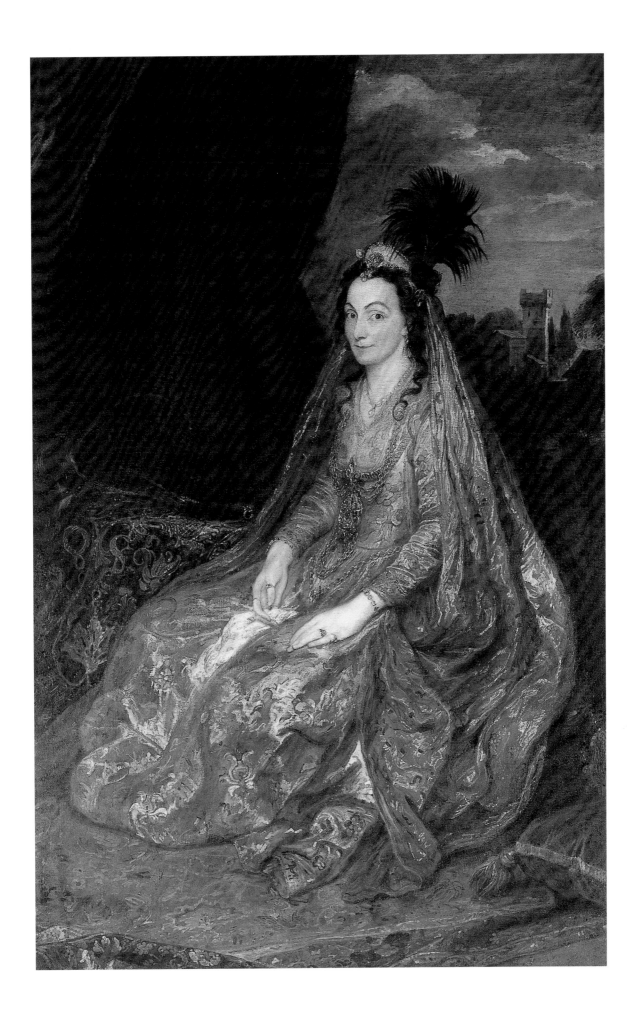

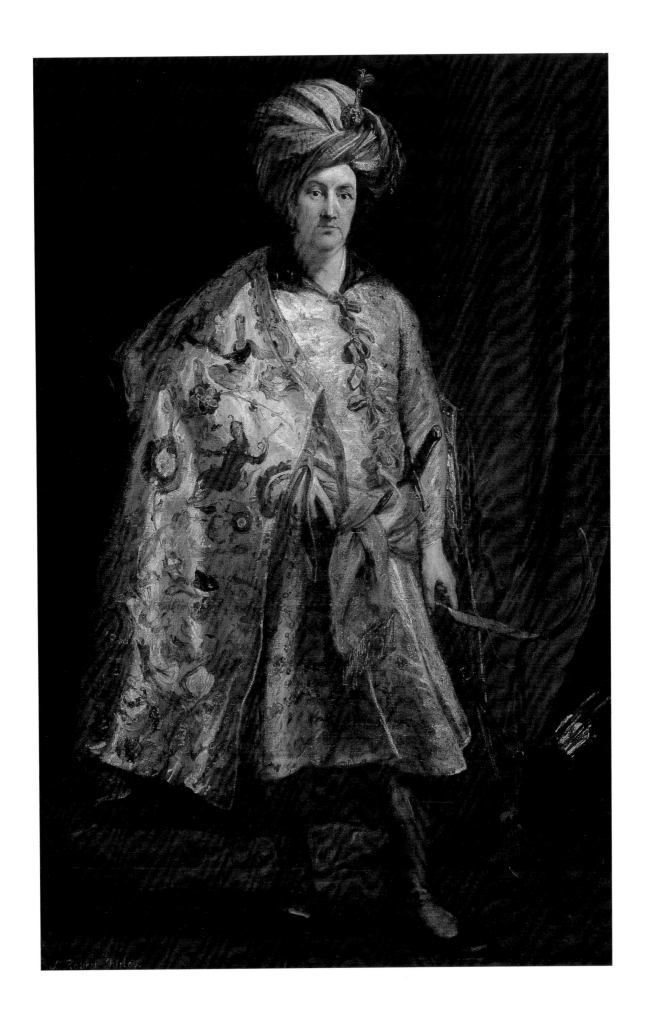

31 *Self-portrait*, 1622–3

oil on canvas, 116.5 × 93.5 cm

The State Hermitage Museum, St Petersburg
(inv. no. 548)

PROVENANCE Possibly the self-portrait of Van
Dyck mentioned in the 1691 inventory of Jan-
Baptista Anthoine; Crozat collection, Paris (Crozat
Inventory 1740, no. 69); 1772, acquired for the
Hermitage from the Crozat collection

REFERENCES Crozat 1755, p. 7 (as a self-
portrait); Smith 1829–42, IX, p. 395, no. 98;
Guiffrey 1882, p. 280, no. 905 (as a self-portrait
painted in England); Cust 1900, p. 19, p. 235,
no. 42 (first Antwerp period); Schaeffer 1909,
p. 171; Glück 1931, pp. 122, 532 (first Antwerp
period); id. 1933, p. 310; id. 1934, p. 195 (dated
after his return from Italy); Varshavskaya 1963,
no. 11 (as late 1620s–early '30s); Brown 1982,
p. 52 (as 1620 or 1621); Millar, in London 1982–3,
p. 15 (dated before departure for Italy); Liedtke
1984, p. 68; Barnes 1986, I, pp. 215–17, no. 28
(as Italian period, *c.* 1623); Larsen 1988, no. 43

EXHIBITIONS State Hermitage Museum,
Leningrad 1938, no. 36; ibid. 1972, no. 333;
Moscow 1972, pp. 51, 62; State Hermitage
Museum, Leningrad 1978, no. 12; Ottawa 1980,
no. 77 (not exhibited); Vienna 1981, pp. 38–41;
National Museum of Western Art, Tokyo 1983,
no. A; Rotterdam 1985, no. 106; New York and
Chicago 1988, no. 39; Washington 1990–91,
no. 33; *The European Fine Art Fair, Treasures
from the Hermitage, St Petersburg*, Maastricht,
12–20 March 1994, no. 28

FIG 1
Anthony van Dyck, copy after Raphael,
Portrait of an Unknown Man wearing a Cap, 1622
pen and ink, fol. 109v of the Italian Sketchbook
British Museum, London

Around 1620 Van Dyck painted three similar self-portraits which are today in New York, Munich and St Petersburg. They all show a confident and self-possessed young man dressed in a magnificent black silk costume, restrained in its extravagance. He is posed self-consciously in a manner that displays to their best advantage his elegant hands with their long tapering fingers.

The precise dating and sequence of these three self-portraits has been much discussed. The first seems to be the one in Munich (fig. 25), originally bust-length and later expanded and substantially repainted. It probably dates from about 1618. This was followed by the New York half-length (fig. 26), which Cust, and more recently Liedtke, have suggested was painted during Van Dyck's stay in England in 1620–21. This must remain speculative, but its technique of scumbled highlights applied with an almost dry brush is characteristic of that moment; it was certainly painted in about 1620. The St Petersburg portrait is the most refined and highly finished of the three. It is thinly painted in certain areas – the underpainting can clearly be seen beneath the white shirt – but it is fully worked up in the face and hair. Instead of indicating the volume of the hair with broken white highlights it is modelled carefully with delicate shadows. The self-portrait was probably painted in Rome in 1622 or 1623 when Van Dyck was 23 or 24 years old. The pose shows a familiarity with Raphael's famous portrait of a man in half-length wearing a cap (formerly in the Czartoryski collection, Cracow), then thought to be a self-portrait, which Van Dyck had seen in Rome and drawn in his Italian Sketchbook (fig. 1). The presence of a broken column, suggesting the ruins of Antiquity, also supports a Roman dating. The use of the column may well have been taken from Titian's portrait of *Benedetto Varchi* (Kunsthistorisches Museum, Vienna), to which Van Dyck devoted several pages in his Italian Sketchbook (British Museum, London). CB

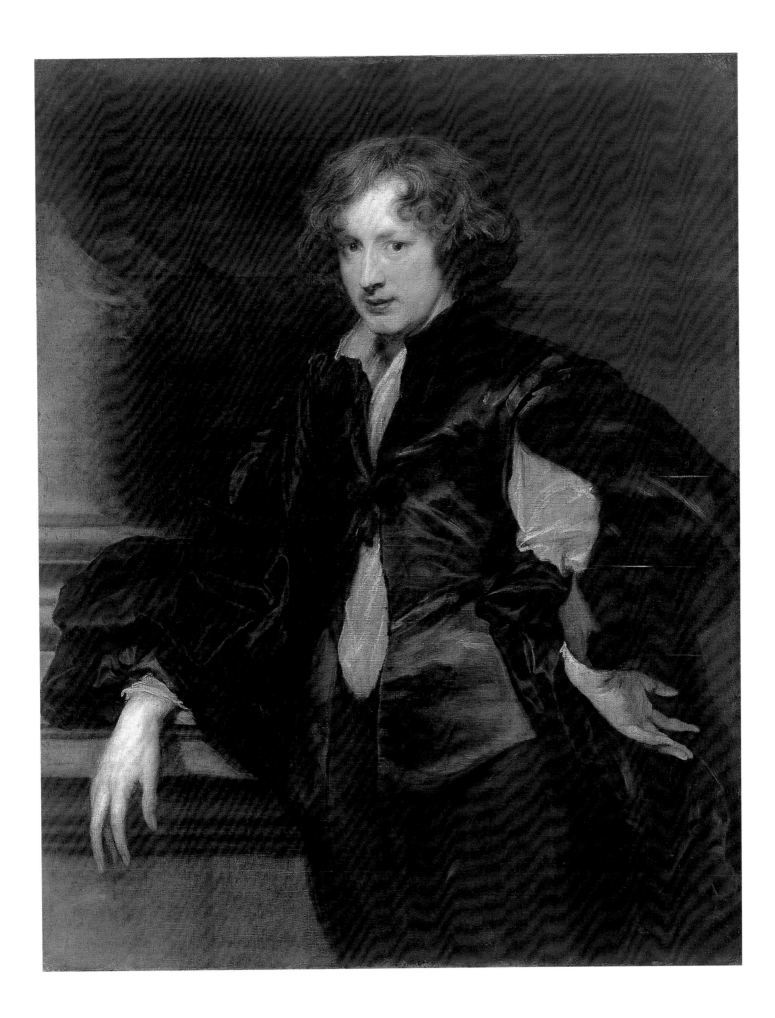

32 The Stoning of St Stephen
1622–4

oil on canvas, 178 × 150 cm

The Egerton Collection, Tatton Park
(by courtesy of The National Trust and Cheshire
County Council)

PROVENANCE Possibly painted for 'the Spanish
Chapel at Rome';[1] 1793, in the church of
S. Pascual Bailon, Madrid;[2] between 1803 and
1806, removed from the church by Don Manuel
Godoy, Chief Minister of Charles IV and 'Prince
of Peace', and hung in his palace in Madrid until
his fall in 1808; 1808, purchased in Madrid by the
painter George Augustus Wallis, acting for the art
dealer William Buchanan, and brought by Wallis
via Germany and France to England in 1813;
purchased from Buchanan by the art dealer Alexis
Delahante, apparently for more than £1000;
3 June 1814, Delahante sale, Philips, lot 77, bought
for 700 guineas (£735) by Wilbraham Egerton of
Tatton, MP (1781–1856); thence by direct descent
to the barons Egerton of Tatton, Tatton Park;
1958, left to the National Trust by Maurice,
4th and last Baron Egerton of Tatton (1874–1958)

REFERENCES Ponz 1793, V, p. 37; Buchanan
1824, II, pp. 245, 247; Smith 1829–42, III, p. 100,
no. 354; Guiffrey 1896, pp. 60–61; Cust 1900,
p. 240, no. 48; Schaeffer 1909, no. 64; Glück 1931,
p. 137; Princeton 1979, pp. 24–5; Brown 1982,
pp. 78–82; Wagner 1983, II, no. 141, pp. 121–3;
Barnes 1986, pp. 176–9, no. 15; Larsen 1988,
no. 471

EXHIBITIONS Royal Academy 1884, no. 166;
London 1900, no. 89; ibid. 1960, no. 51; ibid.
1968a, no. 19; ibid. 1995a, p. 132, no. 49 (entry
by C. Brown)

NOTES
1. According to the catalogue of Delahante's sale
in 1814, the painting 'is one of two illustrated [sic]
pictures painted at Venice by the immortal artist,
for the Spanish chapel at Rome'. It is not recorded
either in S. Giacomo degli Spagnoli or S. Maria di
Monserrato, the principal churches of the Spanish
community in Rome, or in any other church
mentioned in F. Titi, *Studio di pittura, scoltura et
architettura nelle chiese di Roma*, Rome 1674 or any
other 17th-century guidebook of the city. It is
possible that it was in the private chapel of the
Spanish ambassador, but no description of a
Spanish ambassador's residence is known before
the acquisition of the Palazzo di Spagna (formerly
Palazzo Monaldeschi) in the Piazza di Spagna, by
the Count of Onate for use as the embassy in 1647.
2. Probably presented by Don Juan Gaspar
Enríquez de Cabrera, 6th Duke of Medina de
Roseci and 10th Almirante de Castilla (1623–91),
whose father, the 9th Almirante, may have bought
the painting in Italy; he purchased paintings in
Rome (where he was ambassador) and Naples.
The 10th Almirante was an artist and collector,
founded the church of S. Pascual Bailon in 1683
and endowed it with a number of his pictures.

St Stephen's election as the first of the seven deacons chosen by the apostles and his subsequent martyrdom by stoning are described in the Acts of the Apostles, VI–VII. He was the first Christian martyr, a man 'full of faith and power, [who] did great wonders and miracles among the people'. Brought before the Jewish council, he called his listeners 'stiffnecked and uncircumcised in heart and ears, [who] … do always resist the Holy Ghost: as your fathers did'. He looked up and saw a vision: 'Behold, I see the heavens opened, and the Son of Man standing on the right hand of God.' Stephen was then taken out of Jerusalem and stoned. 'And he kneeled down, and cried with a loud voice, "Lord, lay not this sin to their charge".' Among the bystanders watching the martyrdom with approval was Saul, later to become St Paul.

Van Dyck shows the moment when Stephen, dressed in a red dalmatic (the vestments of a deacon), falls on his knees and calls to God to forgive his five murderers. Another man looks on at the far left, and in the background are two more. The foremost, excitedly pointing out the scene to his companion, is the young Saul, at whose feet, in the biblical account, 'the witnesses laid down their clothes', which can be seen beneath his left foot. Angels fly down to the saint carrying wreaths and the palm of martyrdom.

All the principal features of the composition – the kneeling saint with his eyes turned towards heaven, the muscular executioners, the figure of Saul pointing, and the angels – can be found in Rubens's great altarpiece of the same subject (Musée des Beaux-Arts, Valenciennes). Van Dyck has, however, reversed the composition. Rubens's painting is usually dated in the period 1615–20 and may well have been painted when the young Van Dyck was in his studio. In addition to this evident dependence on Rubens's composition, Van Dyck may well also have returned to Rubens's own source, Cigoli's altarpiece for the church of the Montedomini convent in Florence. There are also echoes of Titian's *Martyrdom of St Peter Martyr* (destroyed 1867), which Van Dyck had seen in the church of SS. Giovanni e Paolo in Venice.

Stylistically the painting can be dated early in Van Dyck's Italian stay. Its scale and composition, and the powerful half-naked figures of the saint's murderers recall such large-scale religious paintings as *The Taking of Christ* (cat. 24) and *The Brazen Serpent* (Prado, Madrid), painted a year or two before he travelled from Antwerp to Italy late in 1621. The head of the saint, his eyes raised to heaven, is strikingly similar to the heads of St Rosalia, the patron saint of Palermo, whom van Dyck painted a number of times during and after his stay in Sicily in 1624–5. The angels are handled in the same manner as those who crown St Rosalia as she is borne up to heaven (Menil Collection, Houston; Apsley House, London). The painting should therefore be dated to 1622–4, when Van Dyck was travelling around Italy before settling in Genoa. At this time he was absorbing diverse Italian influences: his study of the work of the Carracci in Bologna is revealed in the composition (which is more open than that of Rubens) and in the saint's upturned face, while the broad and vigorous technique is distinctly Venetian.

It was claimed in 1814 that the painting was made for a Spanish chapel in Rome: while there is no real supporting evidence for this (apart from its early Spanish provenance), it could have been painted during Van Dyck's stay in Rome during the summer of 1622, when he also painted Sir Robert and Lady Shirley (cat. 29, 30). CB

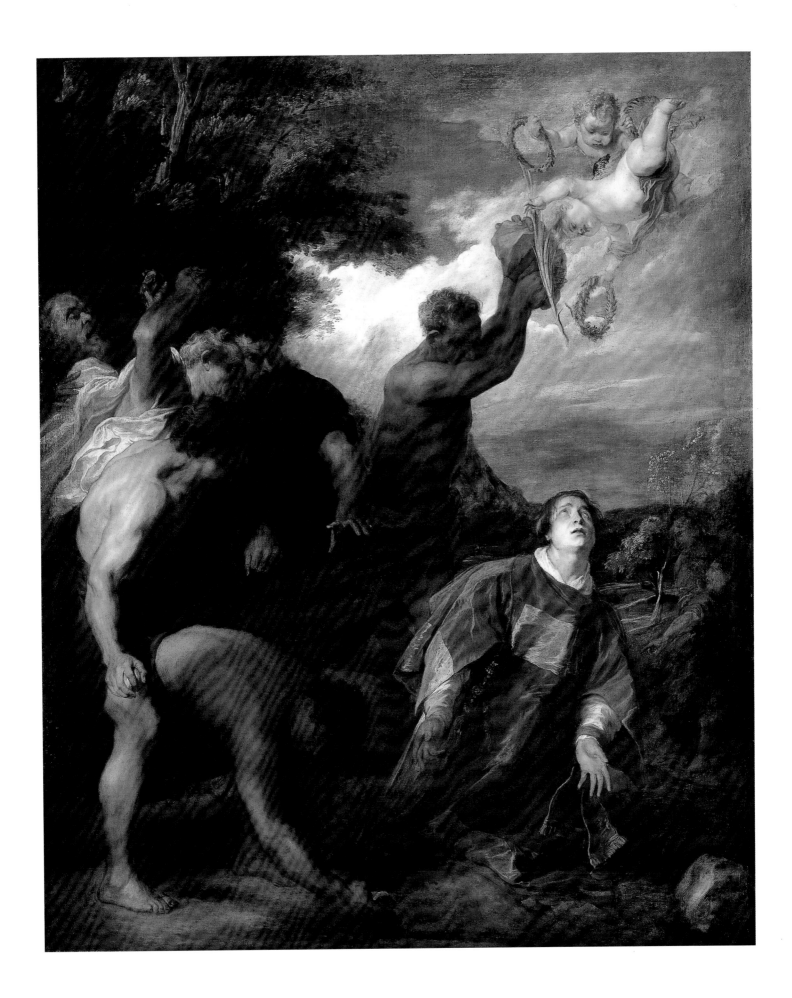

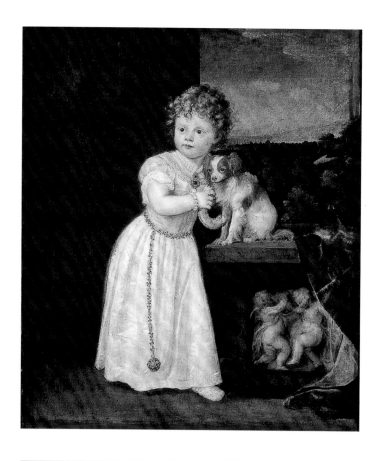

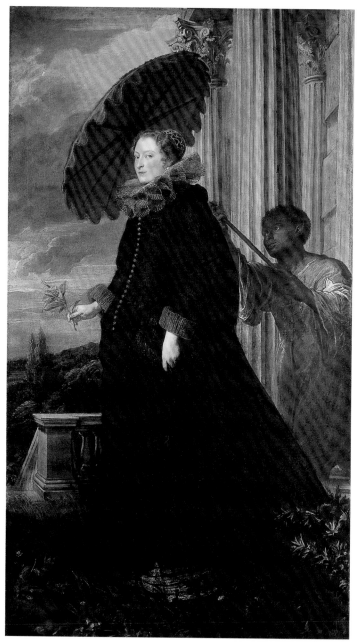

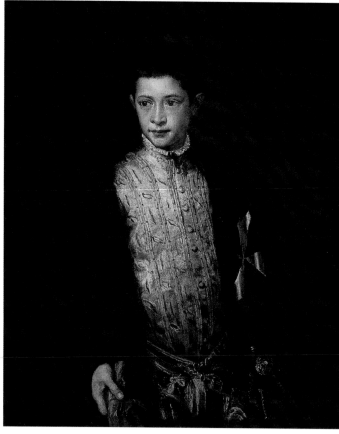

Fig 1
Titian, *Clarice Strozzi*, 1542
oil on canvas, 115 × 98 cm
Staatliche Museen zu Berlin, Preussischer Kulturbesitz, Gemäldegalerie

Fig 2
Anthony van Dyck, *Elena Grimaldi Cattaneo with a Black Page*, 1623
oil on canvas, 246 × 172 cm
National Gallery of Art, Washington, DC, Widener Collection

Fig 3
Titian, *Ranuccio Farnese as a Knight of Malta*, 1542
oil on canvas, 89.7 × 73.6 cm
National Gallery of Art, Washington, DC, Samuel H. Kress Collection

33 *Filippo Cattaneo*, 1623

oil on canvas, 122 × 84 cm
inscribed on pilaster on the left: *Aº 1623 Aet·4·7*

National Gallery of Art, Washington, DC,
Widener Collection (1942.9.93)

34 *Maddalena Cattaneo (formerly known as Clelia Cattaneo)*, 1623

oil on canvas, 122 × 84 cm
inscribed on pillar on the left: *1623 Aet 2·8*

National Gallery of Art, Washington, DC,
Widener Collection (1942.9.94)

PROVENANCE By 17 July 1692, collection of
Giovanni Giacomo Cattaneo (1628–1712), Genoa;
by 1828, Nicola Cattaneo, Genoa;[1] until 1907,
Cattaneo della Volta collection, Genoa; P. & D.
Colnaghi Ltd., London; M. Knoedler & Co. to
P. A. B. Widener, 1908; by descent to Joseph
Widener; 1942, presented to the Gallery

REFERENCES Cunningham 1843, II, pp. 494–5
(cat. 34); Cust 1900, p. 242; Valentiner 1914,
pp. 208–9, p. 239, nos. 13, 14; Glück 1931, pp. 188,
189, 540; Vey 1962, I, p. 62; Brown 1982,
pp. 93–5; Barnes 1986, I, pp. 131–4, 210–14,
nos. 26, 27; Larsen 1988, nos. 342, 343; Boccardo,
in Genoa 1997, pp. 53–8

EXHIBITIONS New York 1909, nos. 3, 5;
Washington 1990–91, nos. 34, 35

NOTES
1. See Cunningham 1843, II, pp. 494–5: letter to
Robert Peel, 28 January 1828: 'I was taken to the
Palace of Nicola Cataneo.... On the left of his
picture [of Elena Grimaldi] is a full-length of a
Girl about seven years old, in white satin, with
yellow curling locks about her face: this picture is
beautifully painted. The companion to this is the
full-length of a Boy, equally good...'
2. '*tre quadri d'Antonio Vandich cioe in uno il ritratto
della suddetta quondam Magnifica Elena e la figura
d'un schiavo nero, nel secondo il ritratto del quondam
magnifico Filippo quando era fanciullo in eta di anni
quattro in circa, e nel terzo il ritratto della quondam
magnifica Madalena sorella di esso quondam magnifico
Filippo e del sudetto magnifico Gio. Giacomo quando
era fanciulla in etta d'anni due in circa...*'.
3. Filippo Cattaneo, the son of Giacomo Cattaneo
and Elena Grimaldi, was inscribed in the *Libro
d'oro* of the Genoese aristocracy on 5 December
1640 at the age of 23. This would have made him
five or six in 1623, not four years and seven
months as in the inscription. One or other date
must be incorrect.

FIG 4
Anthony van Dyck, copies of four portraits
including *Ranuccio Farnese as a Knight of Malta*
after Titian, pen and ink, fol. 108r of the Italian
Sketchbook, British Museum, London

Van Dyck possessed very special qualities as a painter of children's portraits. This is already apparent in the *Portrait of a Family* (cat. 15), painted while he was still in Antwerp, in which the vivacious little girl twists round on her mother's lap to look up at her father. It was the ability of children to disrupt the formality of a commissioned portrait with their unpredictable behaviour that Van Dyck especially enjoyed. In *The Balbi Children* (cat. 40), the three boys, dressed in their best clothes, embody the dynastic hopes of the family, yet their playful glances and the youngest boy's grasp of his pet bird undermine any sense of stifling formality.

Van Dyck painted relatively few portraits of children on their own, rather than in a group. These charming portraits of a Genoese brother and sister were painted in 1623, not long after the artist's arrival in Italy. He adopted the high viewpoint of an adult, which has the effect of enlarging the children's heads and so giving a particularly intimate character to their portraits. In later portraits of children painted in Genoa, such as those of *The Balbi Children* or the so-called *Boy in White* (Palazzo Durazzo Pallavicini, Genoa), Van Dyck used a lower viewpoint, which creates a greater sense of distance from the sitter. The high viewpoint was a device he had brought with him from Antwerp. He also put his experience of studying portraits by Titian to good use. The portrait of the boy is markedly similar to Titian's portrait of *Ranuccio Farnese* which Van Dyck had sketched while in Rome (figs. 3, 4), and that of his sister displays an even more powerful dependence on Titian's portrait of *Clarice Strozzi* (fig. 1) which Van Dyck saw in Palazzo Strozzi in Rome.

Until purchased by Colnaghi's in Genoa in 1906 – with the magnificent full-length of their mother Elena Grimaldi accompanied by a black servant (fig. 2) – these paintings were in the collections of the Cattaneo family. Traditionally they had been said to show Filippo and Clelia Cattaneo, the children of a certain Alessandro Cattaneo and Elena Grimaldi. However, Piero Boccardo (Genoa 1997) has recently published a notarial document of 17 July 1692, a list of the goods of Giovanni Giacomo Cattaneo (1628–1712), the third son of Giacomo Cattaneo and Elena Grimaldi, in which the paintings of the children and their mother are described:[2] 'the portrait of the late Filippo when he was a child aged about four and ... the portrait of the late Madalena, sister of Filippo ... when she was a child of about two years old...'. Consequently, we

can confidently confirm the identity of the boy as Filippo Cattaneo who, according to the inscription on the portrait, was born in 1619,[3] and rechristen the girl Maddalena, born in 1621.

The Cattaneo family had strong trading links with Antwerp; indeed, several members of the family lived there. It is quite likely that Van Dyck arrived in Genoa with an introduction to the family, which would explain their patronage of the young Flemish painter almost immediately after his arrival in that city. CB

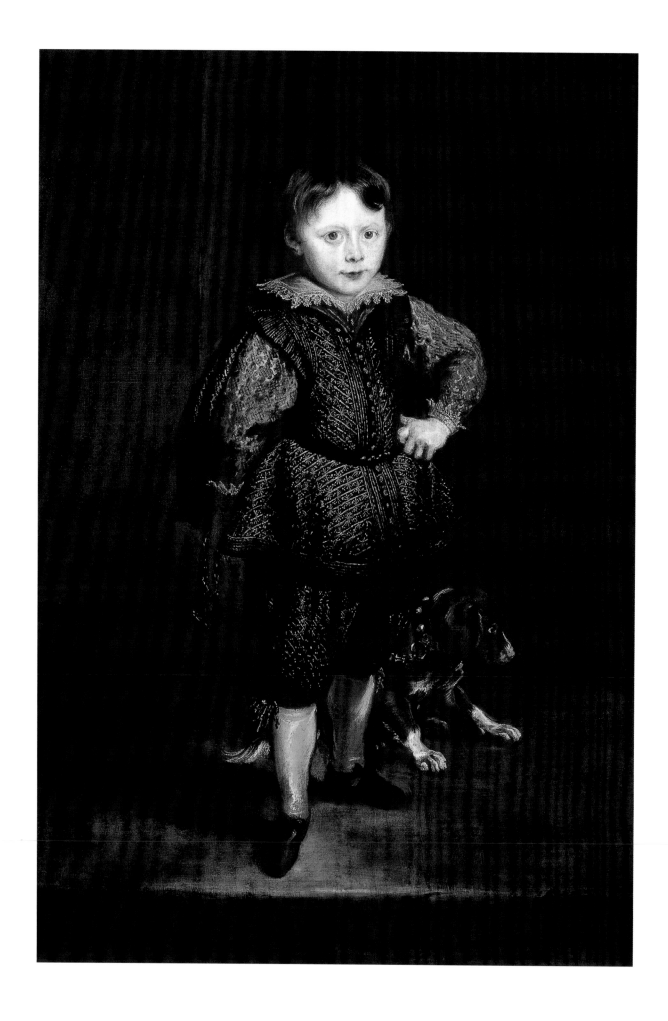

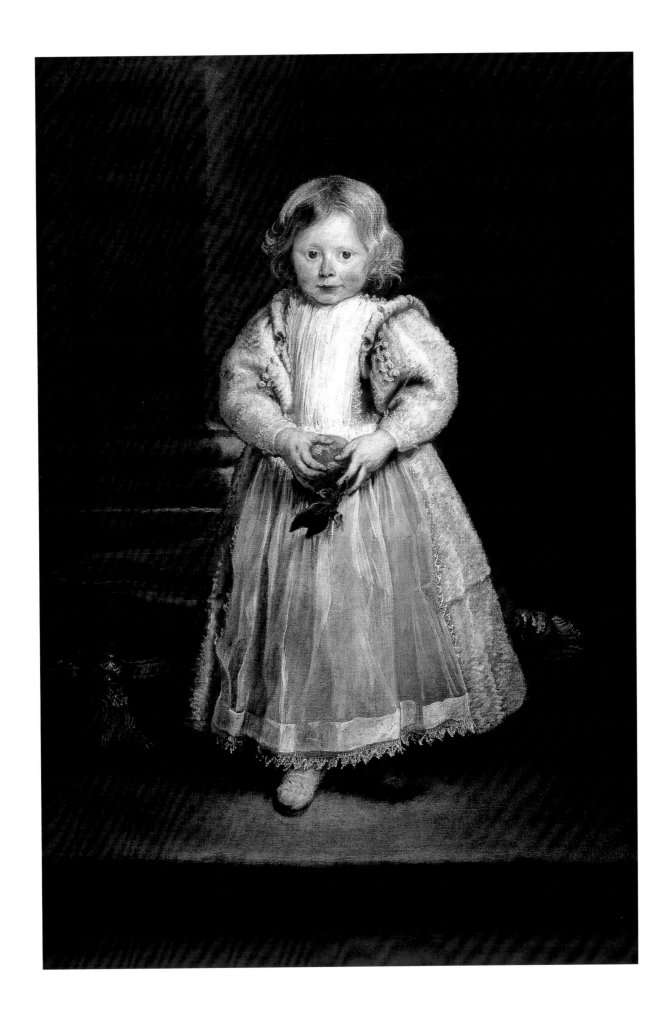

35 *Emanuele Filiberto of Savoy*
1624

oil on canvas, 126 × 99.6 cm

The Trustees of the Dulwich Picture Gallery, London (inv. no. 173)

PROVENANCE 29 May 1793, V. Donjeux sale, Paris, lot 132, bought by Desmarets; 1811, Bourgeois Bequest to Dulwich College (1813 inventory as Duke d'Alva)

REFERENCES Bellori 1672, p. 257; Smith 1829–42, III, p. 197, no. 682, p. 232, no. 831; Waagen 1854, II, p. 342, no. 3 ('The portrait of a General in rich armour, here called the Archduke Albert'); Guiffrey 1882, p. 284, no. 986; Schaeffer 1909, p. 436; Van de Put 1912, pp. 310–14; id. 1914, p. 59; Vaes 1924, p. 217; Glück 1931, pp. 171, 538; Murray 1980, no. 173; Brown 1982, p. 82; Barnes 1986, I, p. 14, pp. 240–41, no. 36; Larsen 1988, no. 368; Beresford 1998, no. 173

EXHIBITIONS British Institution 1828, no. 113; London 1947, no. 12; ibid. 1953–4, no. 153; Washington 1985–6, no. 6; ibid. 1990–91, no. 38

NOTES
1. *Excquias del serenissimo principe Emanuel Filiberto*, Madrid 1626.
2. *'chi non l'amava era cattivo e chi non lo riveriva era uomo vitioso'*; see Van de Put 1912, p. 313.

Van Dyck travelled to Sicily in the spring of 1624; he may have gone to Palermo at the request of the Viceroy, Emanuele Filiberto, or on his own initiative, as his friend Jan Brueghel the Younger had done in the previous year. Plague broke out in the city in mid-May and many thousands died, including the Viceroy himself.

Van Dyck painted this portrait in Palermo that summer. Emanuele Filiberto (1588–1624) was the third son of Duke Carlo Emanuele I of Savoy and of Catherine, daughter of Philip II of Spain. He spent his life in the service of the Spanish Crown. A Knight of Malta, he was appointed Capitan General de la Mar in 1612. His father created him Prince of Oneglia in 1620 and in the following year he was appointed Viceroy of Sicily by Philip IV of Spain. He died on 3 August 1624.

In a treaty of 16 May 1624 Emanuele Filiberto was betrothed to Maria Gonzaga, daughter of Francesco, Duke of Mantua, and it is possible that this portrait was commissioned with the intention of sending it to Mantua in exchange for a portrait of Maria which had been sent to him. Emanuele does not wear the eight-pointed star of the Order of St John of which he was a Prior, but this is not entirely surprising as he was about to renounce his membership of the Order (which required celibacy of its members) in order to marry. In the posthumous life of the Viceroy, written by his doctor Gianfrancesco Fiochetto, a portrait painted to be sent to Mantua is mentioned. Fiochetto says that one day, on his return from Mass, the Viceroy found the portrait face down on the ground which he took to be an omen of his imminent death.

Van Dyck lavished particular attention on the armour – which bears the palm and crown motifs of the House of Savoy – and the lace collar and cuffs, as well as the plumed helmet. The prototype for the portrait is Titian's half-length of Emanuele Filiberto's great-grandfather, *Charles V in Armour*, known through Rubens's copy and Vorsterman's engraving of that copy.

Roales[1] described the Viceroy at the time of his death aged 36 as of more than medium stature, well built, of worshipful countenance (*'de gran veneración el semblante'*), his face extremely handsome, not fleshy, of a proper length, forehead spacious, eyes blue, the pallor of his cheeks slightly tinged with red, beard and hair ruddy, but not deeply so, the nose well proportioned and slightly curved, the lip full. In another pen-picture Castagnini gave the prince's eyes as black and vivacious, beneath a wide brow and wavy hair, and added: 'only the wicked did not love him and only the corrupt did not revere him'.[2] There is a marble bust of Emanuele Filiberto in the Galleria Sabauda, Turin. CB

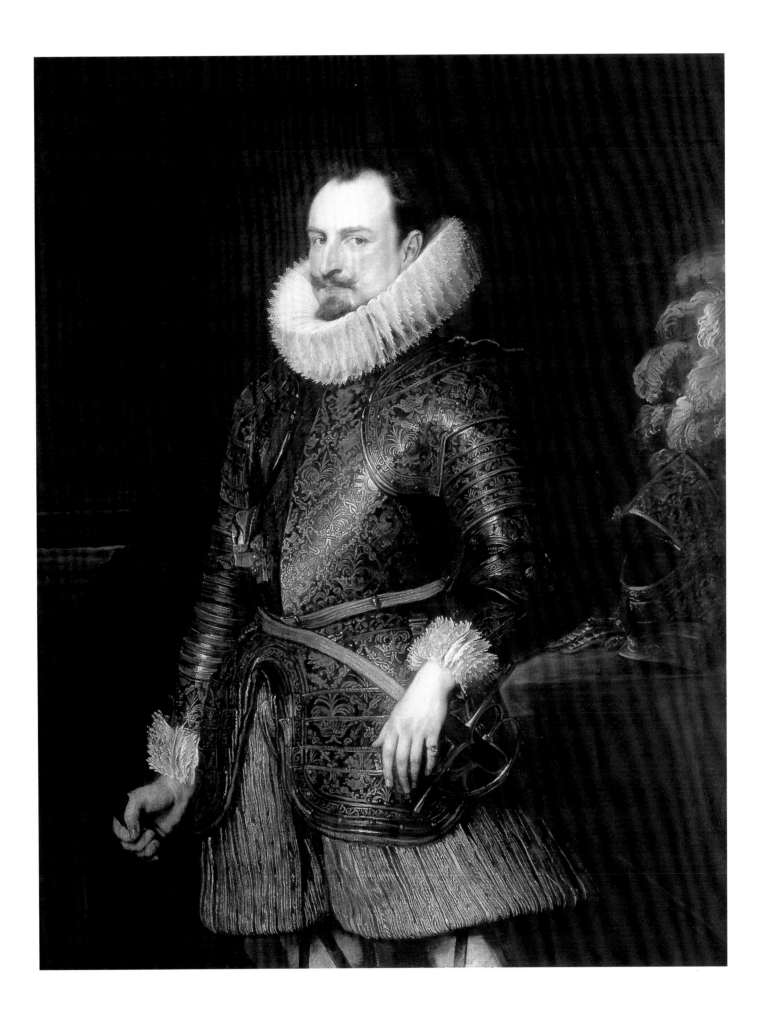

The Ages of Man
c. 1625

oil on canvas, 118 × 164 cm

Museo Civico d'Arte e Storia, Vicenza
(inv. no. A 228)

PROVENANCE 10 November 1665, inventory of
the collection of Carlo II Gonzaga, 9th Duke of
Mantua (1629–65) (called *'le quattro età'*); 1711,
Gonzaga inventory for sale, 'another picture of van
Dyck representing an armed man, a sleeping child
and a young girl holding some roses and an old
man' (English trans.); 1826, bequest of Paolina
Porto Godi to the Museum

REFERENCES Schaeffer 1909, p. 58; Glück 1931,
pp. 146, 535; id. 1933, p. 286; Millar 1955, p. 314;
Brown 1982, p. 97; Barnes 1986, pp. 184–5, no. 18;
Limentani Virdis 1986, pp. 172–4; Larsen 1988,
no. 475; Joannides 1991, p. 377, n. 13

EXHIBITIONS Venice 1946, no. 227; Genoa
1955, no. 49; Padua 1990, no. 78; Washington
1990–91, no. 41; Boston and Toledo 1993, no. 40;
Genoa 1997, no. 64

This is the only allegorical painting known from Van Dyck's Italian years. The subject of the successive stages of a man's life – infancy, youth, maturity and old age – was treated by Venetian painters of the early 16th century, notably Giorgione and Titian. Titian's early painting, the *Three Ages of Man* (fig. 1), which Van Dyck saw in Rome in the Aldobrandini collection in 1622 or 1623, treats the subject in a different way, although Van Dyck borrowed the sleeping *putto* which he had already copied in his Italian Sketchbook. Van Dyck's prototype may be Giorgione's lost painting of the *Vita Humana* recorded by Ridolfi in the Cassinelli collection in Genoa. According to Ridolfi's description, Giorgione's multi-figured composition illustrated the four ages, with an infant at a nurse's breast, a young man in conversation with scholars, a powerful man in armour and a stooped elderly one, contemplating a skull. Whether or not Van Dyck's painting is based on Giorgione's, it certainly underlines his absorption of the world of Venetian early 16th-century painting.

It is not known when the painting came to Mantua. After the sale of the Gonzaga collection to Charles I of England in 1627–8, Carlo II, Duke of Mantua, started making a new collection using as agents, among others, the brothers Salvatore and Giovanni Benedetto Castiglione, who were resident in Genoa. He bought, for example, the collection of Giovanni Vincenzo Imperiale. Among the paintings acquired for Carlo II by the Castiglione brothers were a number of Van Dycks and this may have been among them. CB

FIG 1
Titian, *The Three Ages of Man*, c. 1509
oil on canvas, 106 × 182 cm
Duke of Sutherland Collection, on loan to the
National Gallery of Scotland, Edinburgh

A Genoese Noblewoman and her Son

c. 1625

oil on canvas, 189 × 139 cm

National Gallery of Art, Washington, DC, Widener Collection (1942.9.91)

PROVENANCE Before 1802, probably by 1787, George Greville, 2nd Earl of Warwick (1746–1816), Warwick Castle; by descent to the 5th Earl of Warwick; 1909, sold to M. Knoedler & Co., Paris; sold to P. A. B. Widener; 1942, presented by him to the Gallery

REFERENCES Smith 1829–42, III, p. 179, no. 617; Waagen 1838, III, p. 213; id. 1854, III, p. 213; Guiffrey 1882, p. 259, no. 412; Cust 1900, pp. 40, 200, pp. 241–2, no. 72; Schaeffer 1909, p. 503, under no. 177; Glück 1931, pp. 181, 540; Brown 1982, p. 88; Millar, in London 1982–3, p. 15; Washington 1985, p. 145; Barnes 1986, pp. 128–9, 334–5, no. 83; Larsen 1988, no. 323; Christensen, Palmer and Swicklik, in Washington 1990–91, pp. 48–51

EXHIBITIONS British Institution 1862, no. 36; London 1871, no. 155; Royal Academy 1878, no. 158; ibid. 1887, no. 18; New York 1909, no. 2; London, *Grafton Gallery, National Loan Exhibition of Old Masters*, 1910, no. 55; Washington 1990–91, no. 43 (with full bibliography)

The lady, holding the hand of her young son, is seated on a terrace at the back of one of the grand palaces on the Strada Nuova in Genoa which command views over the bay. The setting is not sufficiently precise to permit its identification. She is dressed in black and presented in a hieratic profile and so may well be a widow. This would explain the importance given to the joined hands of mother and son, which are at the very centre of the composition. The boy appears very mature for his age of about seven or eight. His patterned velvet suit and assertive pose suggest a self-confidence that may come with his position as head of the family. The leaping dog – which first appeared in Van Dyck's *Venus and Adonis* (*c.* 1616–17; Larsen 1988, no. 310) animates what otherwise would be a rather solemn portrait. The dog was picked up by Reynolds in his portrait of *Mrs Mathews* of 1777 (Museum of Fine Arts, Houston).

The woman assumed a number of identities in the 19th and 20th centuries. When the painting hung at Warwick Castle she was thought to be a Lady Brooke; later she became the Countess of Brignole; and in 1900 she was identified as Paolina Adorno, Marchesa Brignole-Sale, an identification that was accepted until recently. However, a documented portrait of Paolina Adorno painted in 1627 (cat. 47) shows a different, younger woman. Furthermore, Paolina and her husband, Anton Giulio Brignole-Sale, could not have had a child the age of this boy before Van Dyck's departure from Italy. Unfortunately there is no record of the painting before it arrived at Warwick Castle, and it seems to have been sold before Ratti wrote his guidebook to the treasures of Genoa. CB

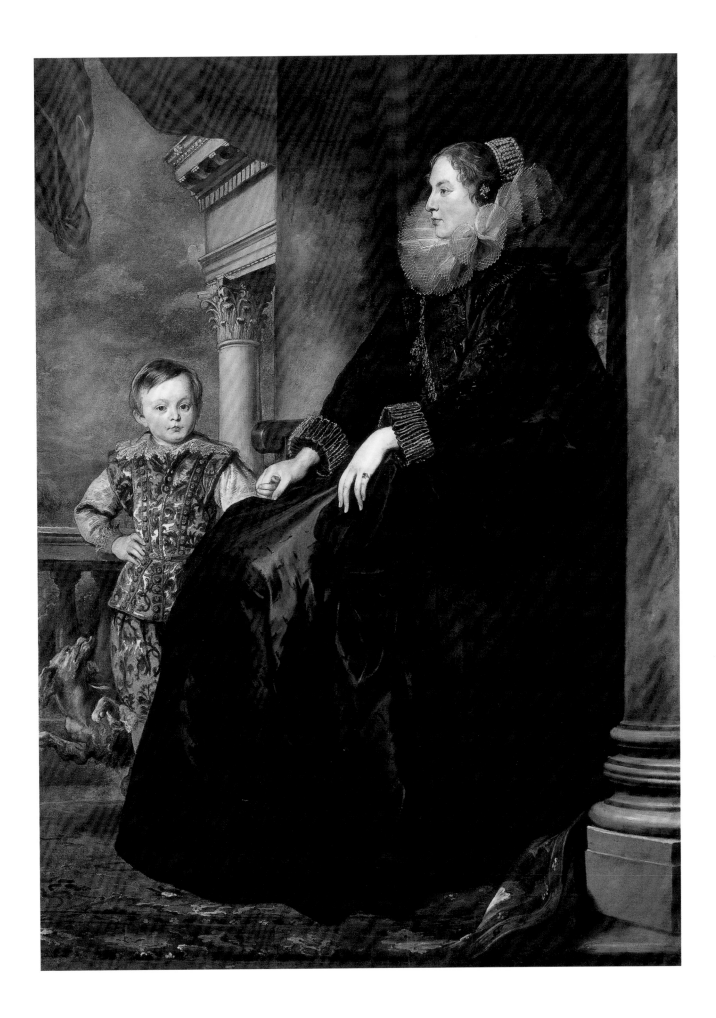

38 *The Tribute Money*
c. 1625

oil on canvas, 142 × 119.5 cm

Galleria di Palazzo Bianco, Genoa
(inv. no. PB 191)

PROVENANCE By 1748, Brignole-Sale
collection, Genoa (in inventory of that year);
by descent to Maria De Ferrari Brignole-Sale,
Duchess of Galliera; 1874, bequeathed by her to
the city of Genoa

REFERENCES Cochin 1758, p. 258; Ratti 1766,
p. 233; id. 1780b, p. 257; Buchanan 1824, II,
p. 132; Smith 1829–42, III, pp. 50–51, no. 172;
Cunningham 1843, II, p. 447; Guiffrey 1882,
p. 45, p. 246, no. 83; Cust 1900, p. 46, p. 237, no. 1;
Schaeffer 1909, p. 61; Glück 1931, p. 142; Van
Puyvelde 1950, pp. 60, 136; Millar 1955, p. 314;
Ottawa 1980, pp. 18–19; Barnes 1986, pp. 39,
158–9, no. 9; Larsen 1988, no. 474

EXHIBITIONS Palais de la Présidence du Corps
Législatif, Paris 1873; Genoa 1892, no. 60; ibid.
1955, no. 24; Washington 1990–91, no. 40; Genoa
1991, no. 10; ibid. 1997, no. 69

Van Dyck's constant source of inspiration from his earliest Antwerp years was Titian. It was a very special relationship: Van Dyck absorbed the style and technique of the Venetian master to a truly remarkable extent. In this painting he reinterprets a late composition by Titian of the same subject (fig. 1) which was painted for Philip II of Spain and seems to have been in Spain when Van Dyck was in Italy. Van Dyck may only have known it in the form of a painted copy, such as the one now in Modena, or the engraving after it by Martin Rota. Van Dyck's *Tribute Money* is painted more tightly than Titian's version.

This incident in the life of Christ is described in Matthew XXII, 15–22. The Pharisees, hoping to ensnare Christ into denying the political authority of the Romans, showed him a coin bearing Caesar's head and asked him 'is it lawful to give tribute unto Caesar, or not?'. He replied: 'Render unto Caesar that which is Caesar's and unto God the things that are God's'. CB

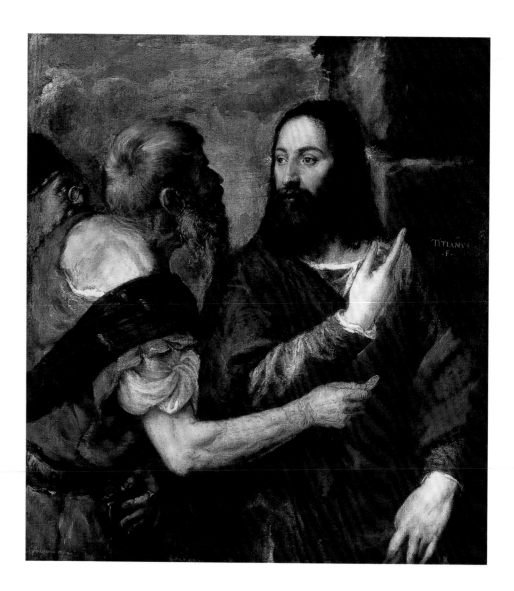

FIG 1
Titian, *The Tribute Money*, 1568
oil on canvas, 109 × 101.5 cm
National Gallery, London

39 *Ecce Homo,* 1625–6

oil on canvas, 101.5 × 78.5 cm

The Trustees of the Barber Institute of Fine Arts, The University of Birmingham

PROVENANCE 1701, Francesco Maria Balbi, Genoa; 13 November 1805, acquired by Andrew Wilson; 6 May 1807, Coxe, London, lot 32; 28 May 1810, Coxe, London, lot 10; 1825, sold by Mr Berry of Glasgow to Sir Alexander Hope through Andrew Wilson; by descent to Earls of Hopetoun, the Marquess of Linlithgow; 18 June 1954, sold Christie's, London, lot 38; purchased for the Institute

REFERENCES Ratti 1780b, p. 188; Smith 1831, p. 96, no. 331; Cunningham 1843, III, p. 23; Waagen 1854, III, p. 310; Cust 1900, p. 238, no. 7; Glück 1931, p. 542, no. 215; Millar 1968, p. 712; Martin 1977, pp. 230–32; Brown 1982, p. 121; Brigstocke 1982, pp. 8, 20, 241, 455, 486; Barnes 1986, pp. 162–3, no. 10; Larsen 1988, no. 697 (as painted shortly after Van Dyck's return to Flanders)

EXHIBITIONS Royal Academy 1883, no. 172; ibid. 1938, no. 73; ibid. 1953–4, no. 200; Bruges 1956, no. 86; London 1962, no. 133; ibid. 1968b, no. 22; Princeton 1979, no. 3; Genoa 1997, no. 67

FIG 1
Anthony van Dyck, copy after Titian,
The Mocking of Christ
pen and ink, fol. 20v of the Italian Sketchbook
British Museum, London

FIG 2
Anthony van Dyck,
The Mocking of Christ, 1622–5
oil on paper, 71 × 54 cm
Courtauld Institute Galleries, Princes Gate Collection, London

Van Dyck illustrates the moment in the Passion of Christ described in the Gospel of St John, XIX, 5. Christ is led out to be shown to the people and Pilate says: *'Ecce Homo!'* ('Behold the Man'). Christ is naked to the waist and wears the crown of thorns. His hands are bound, his head turned to the left, while a grinning soldier, with ironic solicitude, places a robe around his shoulders. The focus of the painting is Christ's carefully modelled torso which stands out from the shadowy background.

Van Dyck had painted the related subject of *The Mocking of Christ* with full-length figures during his early Antwerp years (one version formerly in Berlin, destroyed; another Prado, Madrid). His decision to concentrate on a 'close-up' of the figure of Christ was, however, a result of his careful study of Titian's treatments of the subject while he was in Italy. He copied a number of such compositions in his Italian Sketchbook (fols. 20v–21v; see fig. 1). He also owned a Titian of *The Mocking of Christ.* His first painted treatment of the subject in a Titianesque manner (fig. 2), in oil on paper and like a sketch in its handling, is on the reverse of a *St Sebastian* probably painted shortly before he left Antwerp. He probably carried the *St Sebastian* with him to Italy and painted the *Ecce Homo* shortly after his arrival. That work is not strictly a *modello* for this one, but certainly represents an early idea for this composition. In Florence Van Dyck would also have seen Cigoli's treatment of this subject (Galleria Palatina, Florence) which was greatly admired by contemporaries, but the primary inspiration – as so often with Van Dyck – is Titian.

After his return to Antwerp in 1627, Van Dyck etched the subject of *The Mocking of Christ.* The three-quarter-length format and the pose of Christ are similar to this painting, but Van Dyck replaces the grinning soldier with two figures – a soldier in breastplate and helmet (who drapes a robe around Christ's shoulders) and a stooping, bearded man who offers Christ a reed in mocking reference to the royal sceptre of the 'King of the Jews'. The composition of the etching closely follows Van Dyck's

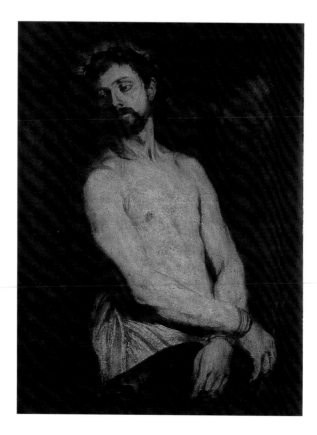

painting now in the Princeton Art Museum, which was painted shortly after his return to Antwerp. While cat. 39 was in the Balbi collection in Genoa, it was much admired, and a large number of copies survive. Particularly noteworthy is the copy by Piola in Palazzo Bianco in Genoa.
CB

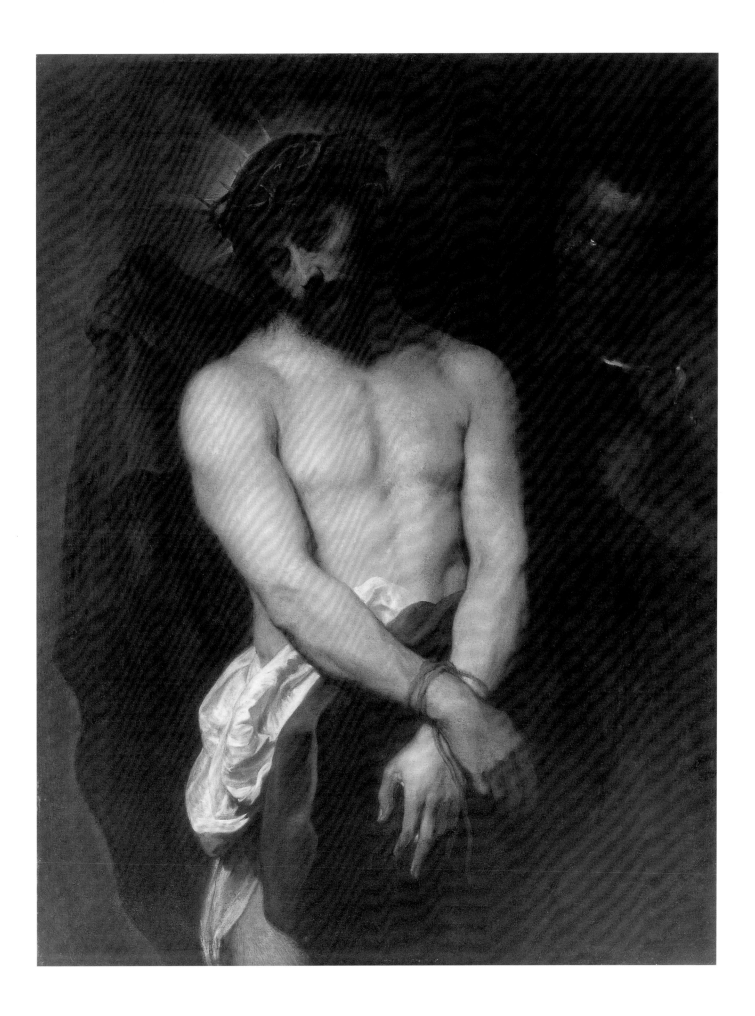

40 *The Balbi Children*
1625–7

oil on canvas, 219 × 151 cm

The Trustees of the National Gallery, London
(inv. no. 6502)

PROVENANCE 1724, collection of Costantino
Balbi, Genoa; 1740–1823, Palazzo Giacomo Balbi;
1823, Marchesa Violantina Spinola, Palazzo
Spinola; purchased by 'Monsieur Hill'; by 1824 or
1825, William, 2nd Baron Berwick (1770–1832),
Attingham House, Shropshire; 1842, sold through
the dealer Samuel Woodburn to Thomas Philip,
2nd Earl de Grey; by marriage to the collection of
the Earls Cowper at Panshanger; by descent to
Lady Lucas; 1985, purchased from her by the
Gallery

REFERENCES Cochin 1758, III, p. 271; Ratti
1766, p. 171; id. 1780b, p. 195; Waagen 1854, II,
p. 84; Guiffrey 1882, p. 287, no. 1079; Cust 1900,
p. 241, no. 66; Schaeffer 1909, p. 504; Glück 1931,
pp. xxxviii, 541; Van Puyvelde 1950, pp. 106,
146–7; Barnes 1986, I, no. 86, pp. 343–4; Boccardo
1987, pp. 62–86 (especially pp. 76–9 and nn. 41
and 42); Larsen 1988, no. 329; Boccardo 1994,
p. 98; Jaffé 1994, p. 140

EXHIBITIONS Manchester 1857, no. 620
(provisional catalogue), no. 660 (definitive
catalogue); London 1871, no. 148; London 1887,
no. 29; London 1986–7, no. 16; Genoa 1997, no. 61
(as 'Three Children of the De Franchi Family')

The boys stand on the steps in front of two columns of a portico draped with a green velvet curtain. Behind them is a tree and an extensive landscape. The eldest, on the left, wears a millstone ruff and a doublet decorated with gold thread, and carries a black hat. With his left hand he gestures towards two pet choughs on the steps. The second boy, in the centre, wears a soft collar and a black doublet with gold frogging; his left arm is around the shoulders of his younger brother who is wearing a full-length velvet robe. The youngest boy, still in the 'skirts' of babyhood, holds a bird in his right hand.

The portrait shows three sons of an aristocratic Genoese family. Traditionally it has been entitled 'The Balbi Children' because of its provenance from Palazzo Giacomo Balbi in Genoa, but the boys have never been convincingly identified as particular members of that extensive family. Recently it has been proposed that they are members of quite a different Genoese family, and are Cesare, Giovanni Benedetto and Angelo De Franchi on the grounds that the black birds have a heraldic significance: one of the quarterings of the De Franchi arms has a black crow on a gold ground. These boys were the sons of Gerolamo De Franchi, whose brother, Federico, was elected Doge of Genoa for a two-year term on 25 June 1623; it is argued that the painting should be dated to late 1623, a high point in the fortunes of the De Franchi family. This attractive idea has, however, been undermined by the fact that the Genoese *Libro d'oro* reveals that the ages of the boys do not fit those in the painting (Giovanni Benedetto was only two when Van Dyck left Genoa). The only De Franchi whose ages would fit are Vincenzo and Nicolò di Francesco, born respectively in 1614 and 1618. In addition, it is clear that the birds are choughs, well-known on the Genoese coast, and not crows; and the possibility (or likelihood) remains that these birds are simply domestic pets. In view of this uncertainty, it has been thought best to retain the traditional identification of the sitters. Recently a late dating of the painting – to Van Dyck's last months in Genoa in 1627 – has been proposed; in my view, dating the Genoese portraits is a very speculative enterprise and about 1625–7 is probably as specific as it is possible to be for this painting without documentary evidence.

The portrait is first mentioned in the 1740 inventory of the paintings inherited by Giacomo Balbi from his father Costantino Balbi, who had been Doge of Genoa from 1738 to 1740. This inventory is, in fact, a copy of an earlier inventory of 1724, so the painting was in Costantino's possession already in 1724. This was a highly important collection and included, for example, Luca Giordano's *Perseus turning Phineus and his Followers to Stone*, and two paintings by Rubens: *Autumn Landscape with a View of Het Steen* and *Roman Triumph* (all in the National Gallery, London). The Van Dyck was given the very high valuation of 4000 lire (the Giordano is valued at 3000 and Rubens's *Het Steen* at 2500). The use of the generic term *fanciulli*, boys, rather than specific names or other identifications, such as '*mio zio*', '*mio avo*' (my uncle, my grandfather), as appears elsewhere in the inventory, makes it unlikely that the sitters were directly related to Giacomo or Costantino Balbi. Costantino was a voracious collector, and he may well have purchased the picture from another aristocratic family in Genoa or from one of the many other branches of his own family. As well as the De Franchi family, mentioned above, the Balbi were related to the Spinola family. It has also been suggested that this portrait may be part of a large group of paintings acquired by Costantino in 1706 from Alessandro Saluzzo and his brothers for a total of at least 33,000 lire.

In 1766 Carlo Ratti saw the portrait in Palazzo Giacomo Balbi: '*Una tela con tre ritratti di fanciulli in piedi, quadro dei piu belli del Vandik*' (a canvas with three portraits

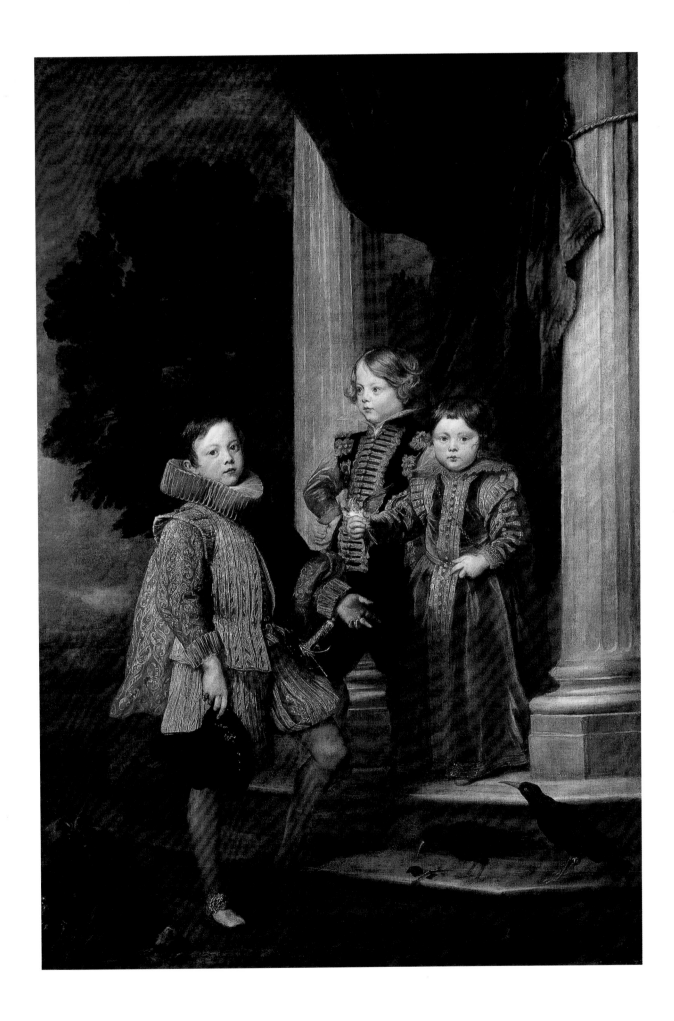

of standing boys, one of Van Dyck's most beautiful paintings). On the death of Costantino Balbi the Younger on 1 January 1823, the painting passed to Valentina Balbi, wife of Giacomo Spinola, and entered the collection at Palazzo Spinola. In April 1823, when the painter Santino Tagliafichi valued the paintings Valentina had inherited from Costantino Balbi, Van Dyck's portrait was valued at 5000 lire, the second highest valuation on the list. On 23 June that year it was sold, together with a portrait by Sebastiano del Piombo, to a 'Monsieur Hill' for a total of 18,800 lire. By 1824 or 1825 it was in the collection of William, 2nd Baron Berwick at Attingham House in Shropshire.

There is some wear in the landscape and the architecture, both of which were thinly painted. The sky, tree and curtain have discoloured, but, with the exception of the hands, hat and legs of the left-hand boy, the figures are well preserved. CB

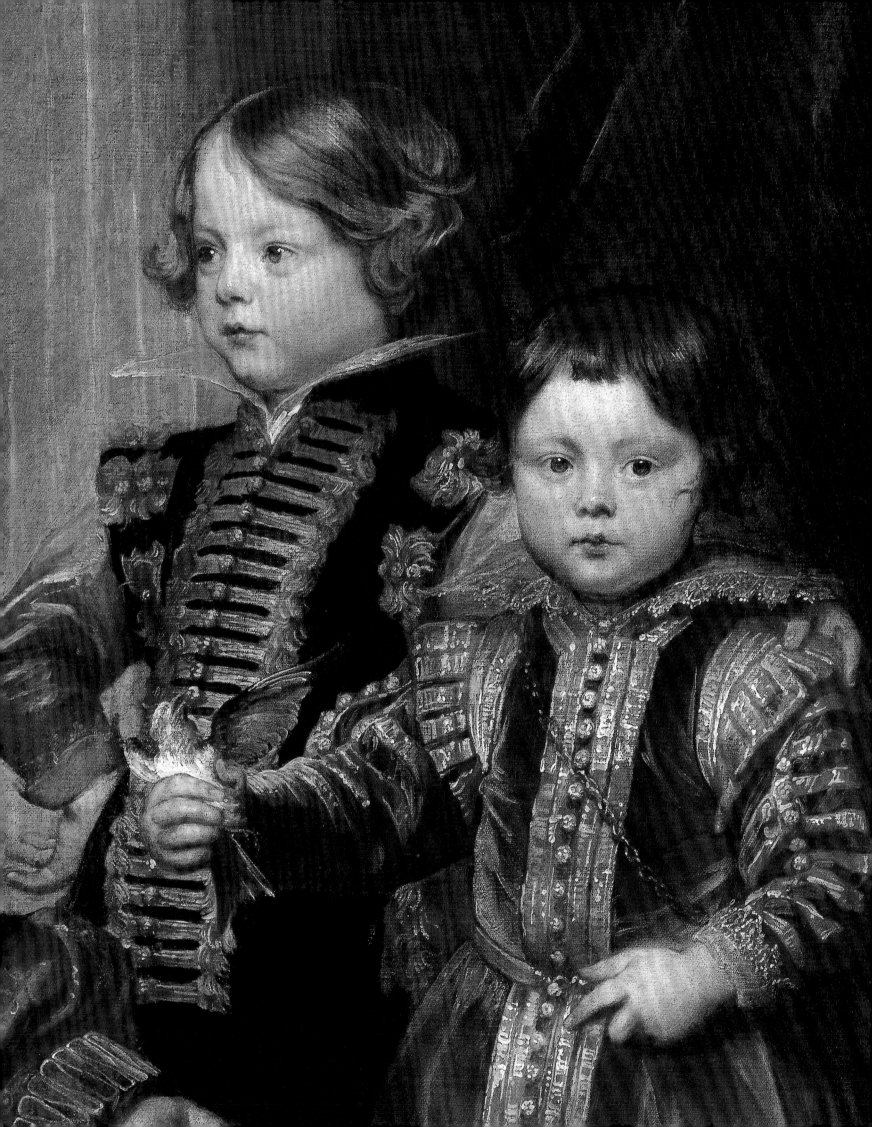

41 The Lomellini Family
1625–7

oil on canvas, 269.6 × 252.7 cm

National Galleries of Scotland, Edinburgh
(inv. no. 120)

PROVENANCE 1766, collection of Agostino
Lomellini; by descent to Luigi Lomellini; 1830,
bought from him by Andrew Wilson for the
Edinburgh Royal Institution; transferred to
the Gallery

REFERENCES Ratti 1766, p. 136; id. 1780b,
p. 162; Cunningham 1843, pp. 421, 429, 448;
id., III, pp. 23–4; Waagen 1854, III, p. 268;
Guiffrey 1882, p. 270; Cust 1900, pp. 43, 243;
Schaeffer 1909, p. 433; Glück 1931, p. 194;
*National Gallery of Scotland: Catalogue of Paintings
and Sculpture*, Edinburgh 1957, p. 77, no. 120;
Brown 1982, p. 89; London 1982, p. 15; Barnes
1986, I, no. 84, pp. 127, 337–9; Larsen 1988,
no. 362; Boccardo, in Genoa 1997, pp. 278–81

EXHIBITION Genoa 1997, no. 53

This is the most ambitious and complex family portrait Van Dyck painted during his Italian years. It looks forward to family groups such as those of *John of Nassau-Siegen and his Family* (cat. 76), the 'Great Peece' of Charles I and his family (fig. 15) and even the monumental group portrait of *The Earl of Pembroke and his Family* (fig. 62). It is an unusual group portrait, including as it does two men, the elder in armour and holding a broken staff, a seated woman and two children. It was clearly a very special commission that can only be accounted for in terms of the personal history of the sitters, and recently a highly plausible explanation has been proposed by Piero Boccardo.

The portrait was seen and sketched by David Wilkie in 1827 'fitted into the wall' of a room in the *palazzo* of Luigi Lomellini (1805–84), the great-grandson of Agostino Lomellini in whose palace Ratti (1766 and 1780) had noted *'una tela entro a cui sono di … Vandik molti ritratti intieri uniti insieme'* (a painting containing many full-length portraits by … Van Dyck). During Van Dyck's years in Genoa the head of the family was Giacomo Lomellini (1570–1652), who was then in his mid-50s, and so older than either of the men shown in the painting. Giacomo was elected Doge of Genoa on 16 June 1625 and served the usual two-year term, retiring from the post on 25 June 1627. There was a Genoese convention that the Doge was not painted while in office, as the Republic was very sensitive to the possibility that individuals and their families might become too powerful. Giacomo had two sons by his first marriage, Nicolò (b. 1590) and Giovanni Francesco (b. 1601), who could well be of the same age as the men in the portrait. Giacomo's second wife was Barbara Spinola and they had two children: a daughter, Vittoria, whose date of birth has not been discovered but who married in 1637 and so could have been born in about 1620, and a son, Agostino, born in 1622. If the portrait was painted during Giacomo's term as Doge, Vittoria would have been six or seven and Agostino about four or five, which could be the ages of the children in the painting. We may then be looking at a portrait of the family of Doge Giacomo Lomellini: his two sons Nicolò and Giovanni Francesco, his second wife Barbara and her children, Vittoria and Agostino.

If this idea is correct, what is the significance of the martial stance of the elder brother who holds a broken staff? The great concern of Giacomo's term of office was the defence of the Republic against its war-like neighbour, the Duchy of Savoy, and it was he who on 7 December 1626 laid the first stone of the new defensive wall of the city. It may be this state of military preparedness against the threat from Savoy that the dress and pose of the elder man alludes to.

The theme of the painting could be both the defence of the city and the Republic and the defence of domestic life. The woman and her children are shown beneath a statue of *Venus Pudica* – just visible on the right of the painting, and the man in armour is framed by a triumphal arch. This would seem an appropriate theme for a commission by the Doge, the paterfamilias who was leading the city's defence. CB

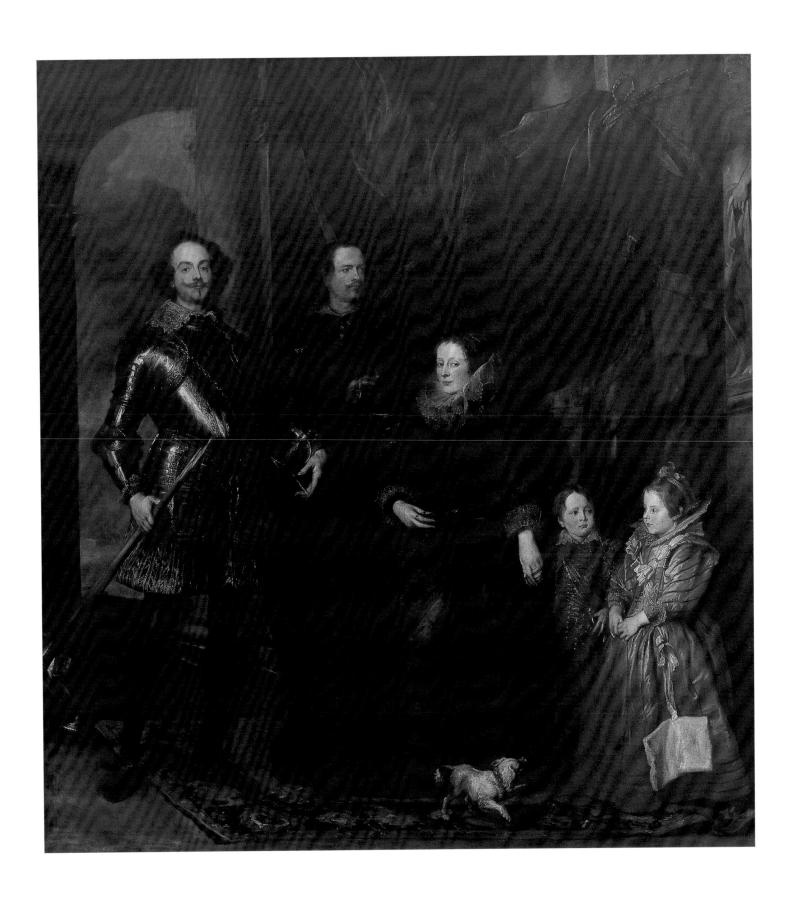

A Genoese Nobleman with Two Children

1625–7

oil on canvas, 223.5 × 148.5 cm

Trustees of the Abercorn Heirlooms Settlement

PROVENANCE 1780, possibly in the collection of Ambrogio Doria, Genoa; since 1875, in the collection of the Dukes of Abercorn

REFERENCES Ratti 1780b, p. 313; Cust 1900, p. 242, no. 81; Hill 1963, pp. 13, 16–17

EXHIBITIONS Royal Academy 1875, no. 219; Belfast 1961, no. 14 (as 'The Doria Family'); Genoa 1997, no. 56

NOTE

1. Ratti 1780b, p. 313: *'diversi ritratti di Signori di questa famiglia, e singolare tra tutti e quello di un non so qual personaggio in compagnia di due fanciulle del Vandik'*.

The sitters, probably a widower and his two daughters, have not been identified. The child dressed in black standing on the left is certainly a girl; the other child, dressed in white and holding the man's hand, may be a girl, but could be a boy dressed in the skirts of childhood. In the Abercorn collection, the painting has been entitled 'The Doria Family' because it was said to have been bought from Palazzo Doria in the 19th century. In the palace of Ambrogio Doria, Ratti saw 'various portraits of members of this family, among them one of who knows which member of the family accompanied by two girls by Van Dyck'.[1]

It is unusual to show a man with his children in this way. In the 17th century it was common for children to be shown with their mother. Portraits of seated men are also unusual: most of Van Dyck's Genoese portraits of men are shown standing, whether half- or full-length. Only when shown in their official robes, like Agostino Pallavicino (Getty Museum, Los Angeles) or Cardinal Bentivoglio (fig. 6), are they seated. The reason for the unconventional arrangement in this portrait was, presumably, the death of the children's mother: the sombre costumes and atmosphere support the idea that the sitters are in mourning for a recently deceased wife and mother. Although adults are often shown in grave mood in Van Dyck's Genoese portraits, children are usually represented with lively gestures and expressions. Here the children look intensely serious. The father gazes out of the painting, the elder girl looks anxiously across at him while the younger looks into space.

The portrait was probably painted *c.* 1625–7. It has been restored for this exhibition. Previously it was covered by discoloured varnish but cleaning reveals it to be thinly and broadly painted. In the central pilaster and on the right individual brushstrokes can be made out. In the background Van Dyck leaves the dark brown *imprimatura* layer clearly visible. The picture appears to have been extended during the course of painting by using the tacking margin. CB

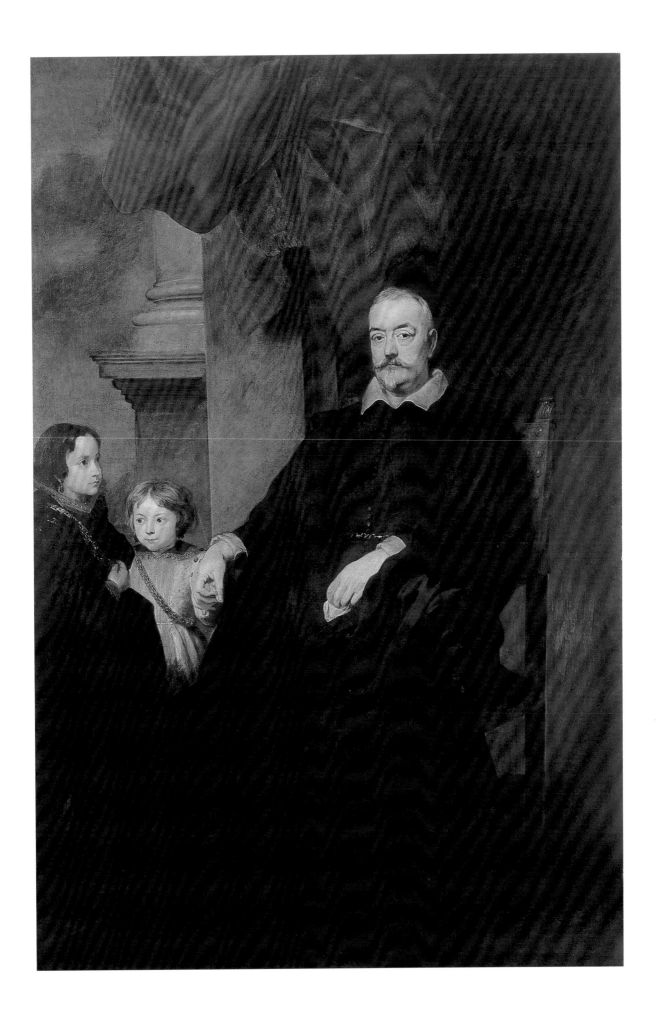

43 *A Man in Armour*
1625–7

oil on canvas, 137.2 × 121.3 cm

Cincinnati Art Museum, Cincinnati,
Gift of Mary M. Emery (inv. no. 1927.393)

PROVENANCE 1672, Francesco Maria Balbi;
1701 and 1766, recorded in Balbi inventories;
1807, Andrew Wilson, London; purchased from
him by Admiral Lord Radstock; 12–13 May 1826,
Radstock sale, Christie's, London, lot 49
(as 'Portrait of Ambrogio Spinola'); 1831–1900,
Alexander Baring, 1st Lord Ashburton (as 'John,
Count of Nassau'); Agnew's, London; Scott &
Fowles, New York; 1909, purchased by Mrs Mary
M. Emery, Cincinnati; 1927, given by her to the
Museum

REFERENCES Bellori 1672, p. 256; Ratti 1780b,
p. 185 ('*Ritratto d'un Generale vestito d'armadura,
del Vandik*' – at Palazzo Balbi); Smith 1829–42,
III, p. 106, no. 374; Waagen 1854, II, p. 103;
Guiffrey 1882, p. 295, no. 716; Cust 1900, p. 244,
no. 121 (as 'Ambrogio Spinola?'); Glück 1931,
pp. 179, 539; Van Puyvelde 1950, pp. 107, 139,
213, n. 3; Rogers 1980, pp. 32–3; Brigstocke 1982,
p. 487; Barnes 1986, pp. 265–7, no. 46; Scott 1987,
no. 18 (with full bibliography); Larsen 1988,
no. 327

EXHIBITIONS London 1822, no. 62; ibid. 1871,
no. 106; ibid. 1890, no. 51; ibid. 1900, no. 57; ibid.
1927, no. 143; Detroit 1929, no. 27; New York
1939, no. 110; San Francisco 1939–40; Cincinnati
1941, no. 16; St Louis 1947, no. 13; Genoa 1997,
no. 51 (with full bibliography)

NOTES
1. Bellori 1672, p. 256: '*Un vecchio armato d'armi
bianche, col bastone di Generale nella destra, e la
sinistra posata su'l pomo della spada, e questo si tiene
essere il Marchese Spinola chiarissimo Capitano
volgendosi generoso, e vivo nel colore non meno che
nell'istessa natura…*'.
2. H. Vlieghe, *Rubens Portraits*, Corpus Rubenia-
num Ludwig Burchard, XIX–2, London 1987,
pp. 183–9.

This is the only known portrait from Van Dyck's Genoese years showing an elderly man in armour. In his life of Van Dyck, which is by far the most important early source for the painter's biography, Bellori describes a portrait by Van Dyck in the collection of Francesco Maria Balbi in Genoa: 'An old man dressed in silver armour, with a general's baton in his right hand, and his left hand resting on the pommel of a sword; this is said to be Marchese Spinola, a most renowned soldier, showing himself as good natured and alive in paint as he was in life.'[1]

Bellori is a reliable early source and so this may well show a member of the Spinola family. The family's most famous soldier was Ambrogio (1569–1630), and all martial portraits in the Spinola family were thought to be of him. This portrait, however, bears no resemblance to Ambrogio, as seen, for example, in his friend Rubens's portrait of him.[2] Glück noted an inscription giving the man's age as 48: that is no longer visible. Perhaps the sitter was a commander of the Genoese troops sent to fight against Savoy in the years 1625–7. He is alert and on guard, and holds a commander's baton.

He wears a fine suit of north Italian armour of *c.* 1590–1600: the breastplate, pauldrons (shoulder sections) and tassets (thigh sections) are decorated with scale-work enclosing flower patterns and set off with red straps. If the straps are velvet, as they appear to be, the armour is ceremonial rather than functional. CB

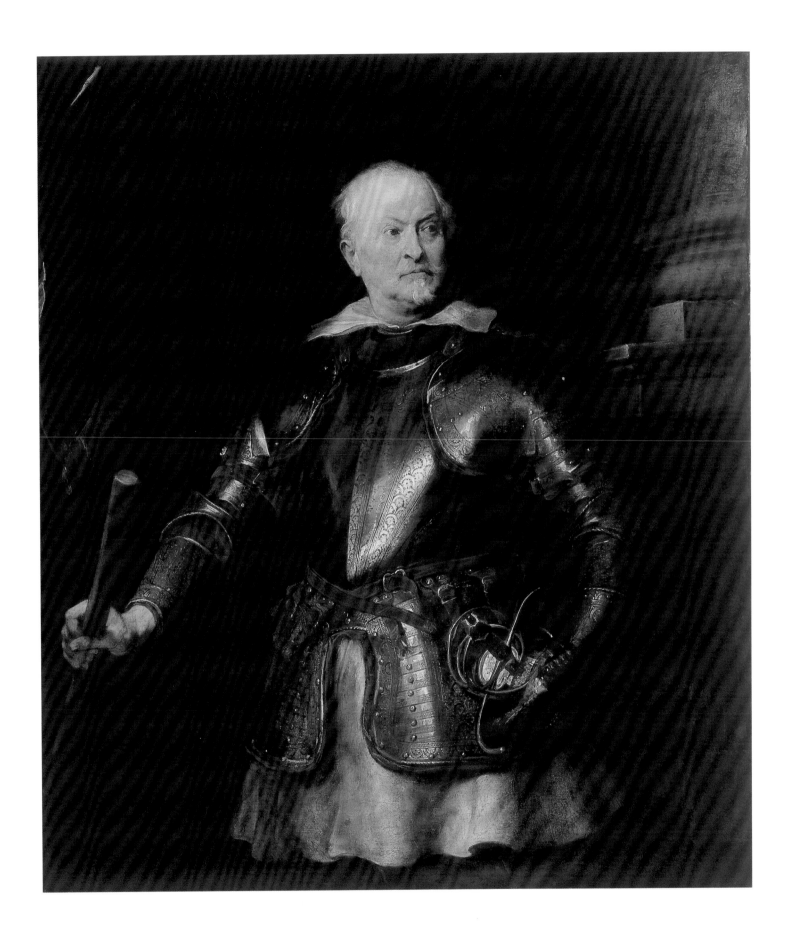

Porzia Imperiale and her Daughter

1625–7

oil on canvas, 184.5 × 134 cm

Musées Royaux des Beaux-Arts de Belgique, Brussels (inv. no. 6115)

PROVENANCE 1672, David Imperiale, Naples; before 1886, by descent to Maria Caterina Imperiale; Palazzo Cambiaso, Genoa; 1922, sold by the Marchese Cambiaso; 1931, Paul Bottenweiser, Berlin; 1937 or 1938, Tomás Harris, London; 1938, purchased by the Museum

REFERENCES Glück 1931, p. 538; Van Puyvelde 1950, p. 140; Barnes 1986, pp. 330–31, no. 81; Larsen 1988, no. 390

EXHIBITIONS Berlin 1909 (?); Amsterdam and Rotterdam 1946, no. 24; Antwerp 1949, no. 28; Bruges, Venice and Rome 1951, no. 68; Genoa 1955, no. 44; Brussels 1961, no. 26; ibid. 1965, no. 73; Genoa 1997, no. 55

NOTE
1. 'Uno quadro del Vandich alto palmi nove, largo otto della felice memoria della Signora Portia Imperiale, et signora Maria Francesca sua figlia ancora figliola col cembalo'.

Porzia Imperiale was a member of a distinguished Genoese family. The daughter of Andrea Imperiale, she married Bartolomeo Imperiale, presumably a distant cousin, in 1610 when she was 24 and her husband only 17. This portrait was painted in about 1626 when she was 40. The painting can be identified in an inventory taken in Naples on 20 June 1672 of the possessions of Porzia's brother, David Imperiale, after his death: 'A painting by Van Dyck, nine by eight *palmi* [225 × 200 cm], of Signora Portia Imperiale of happy memory and Signora Maria Francesca, her daughter, still a girl, with a clavichord'.[1] This refers almost certainly to this painting but suggests that it has been reduced in size. David Imperiale's possessions passed to another sister, Maria Caterina, but nothing is known of the painting's subsequent fate until it is recorded with the art dealer Bottenweiser in Berlin.

Maria Francesca's date of birth is unknown but she appears to be about twelve in this portrait. She plays a clavichord with the motto VIRTUTE GAUDET (she rejoices in virtue). With the lively turn of her head Van Dyck suggests that she has been interrupted at her music by the spectator.

Rubens's Genoese portraits were a source of constant inspiration to Van Dyck. In this case he was clearly influenced by the double portrait of a woman and her daughter (Staatsgalerie, Stuttgart).

The painting has been restored for this exhibition. It was formerly covered by a heavy, discoloured varnish; now not only is the detail of Porzia's dress legible, but the subtle spatial relationships between mother and daughter and between the figure group and the architecture can be understood. CB

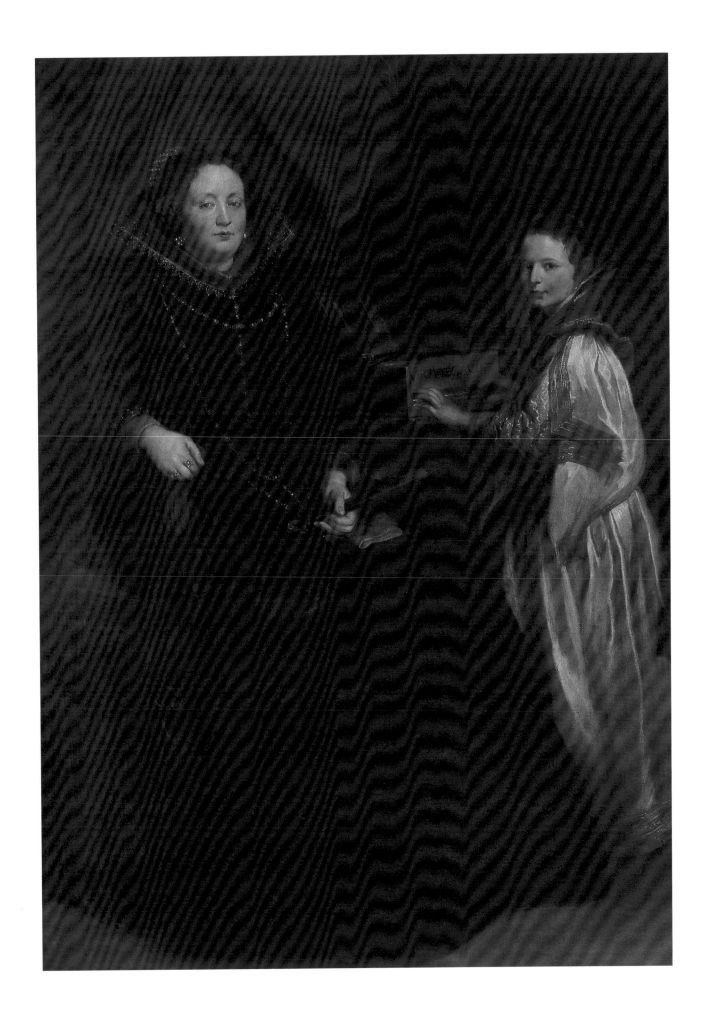

45 *Lucas and Cornelis de Wael*
c. 1627

oil on canvas, 120 × 101 cm

Pinacoteca Capitolina, Rome (inv. no. 71)

PROVENANCE From 1627, De Wael family collection, Antwerp; by 1691, J.-B. Anthoine (inventory of 27 March 1691: *'Twee contrefeytsels van Cornelis ende Lucas de Wael, op eenen doeck, van van Dyck gl. 600'*); 21 July 1738, Count de Fraula sale, Brussels; 21 March 1822, Vincenzo Nelli, Rome, by whom conceded to the Camera Apostolica; 1824, in the Pinacoteca

REFERENCES Soprani 1674, p. 327; Hoet and Terwesten 1752–70, I, p. 541; Smith 1829–42, III, p. 85; Guiffrey 1882, pp. 42–3, 56, 282; Cust 1900, p. 53, 244; Schaeffer 1909, pp. 217, 504; Rooses 1911, pp. 42–3; Vaes 1924, p. 230; id. 1925, pp. 22–3; Glück 1931, pp. 157, 537; id. 1933, p. 312; Van Puyvelde 1950, pp. 137, 162, 168; Jaffé 1965, p. 43; Brown 1982, p. 61; Barnes 1986, I, pp. 259–61, no. 43; Larsen 1988, no. 347

EXHIBITIONS Brussels 1910; Genoa 1955, no. 62; Rome 1966, p. 22; Genoa 1987, no. 25; Washington 1990–91, no. 42; Frankfurt 1992, no. 13; Genoa 1997, no. 63 (with full bibliography)

NOTES

1. Soprani 1674, p. 327: *'tanto generoso che la sua casa era sempre aperta a tutti e massime a suoi nationali'*.
2. *'Avant de partir il donna un beau témoignage de la reconnaissance qu'il devait à l'amitié des frères De Wael. Il les peignit l'un et l'autre sur la même toile…'*.
3. There is a second version of the painting in Kassel, on panel (27.2 × 23.1 cm; inv. no. 772). It is a reduced grisaille copy which is incised, and may have been used for Hollar's etching. It is first recorded as having been bought from the collection of Valerius Rover in Delft in 1750. See B. Schnackenburg, *Gemäldegalerie alte Meister Gesamtkatalog*, Kassel 1996, I, p. 112.

The seated man in the foreground is Cornelis de Wael (1592–1667), son of the painter Jan de Wael (see cat. 53). He had grown up in Antwerp, receiving his training in the studios of his father and of Jan Brueghel the Elder. He moved to Genoa in about 1620 and spent the rest of his life in Italy painting battle scenes, marine pictures and moralising genre cycles. He was also active as a dealer in Flemish paintings. The man standing on the left in a silver and white waistcoat and striking a nonchalant pose is Lucas (1591–1661), Cornelis's elder brother.

Cornelis was the focal point of the community of Flemish artists in Genoa which included Jan Roos, Vincent Malò, Jan Hovaert and, of course, his family friend from Antwerp, Van Dyck. Soprani wrote of Cornelis that he was 'so generous that his house was always open to all comers, especially to his fellow-countrymen'.[1] His brother Lucas, also a painter, joined him in Genoa, and they shared a studio. The houses of the De Waels – the first by Porta S. Caterina all'Acquasola and the second near the Convent of S. Brigida, in the parish of S. Tommaso – became Van Dyck's base in Italy, and his decision to visit Genoa first and to work there between 1625 and 1627 was no doubt at least in part a consequence of his close friendship with the De Wael brothers. Cornelis corresponded with Lucas van Uffel, a native of Antwerp resident in Venice, a close friend, and his business partner. In these letters Van Dyck's travels in Italy are described and, although the correspondence is now lost, it was the source for a life of Van Dyck written in French in the early 18th century, the manuscript of which is today in the Bibliothèque du Louvre.

According to that manuscript Van Dyck portrayed the two brothers 'on the same canvas', 'in token of his gratitude'.[2] This double portrait has been identified as that gift, painted in recognition of the De Waels' hospitality to Van Dyck during his years in Italy and the introductions with which they no doubt provided him to many of his Genoese sitters. In 1625–6 the brothers went to Rome, where in 1627 they separated, Lucas returning to Antwerp and Cornelis to Genoa. Cornelis moved back to Rome in 1657, where he died in 1667.

This is the first example of a type of portrait that Van Dyck later developed: a double portrait of men who are relatives or friends seen in an informal and relaxed pose. The circumstances of the creation of this painting and its presentation to the De Wael brothers account for its remarkable character. It was etched by Wenceslaus Hollar in 1646 with an inscription which identifies the sitters.[3]

The painting is first mentioned in the inventory of a collector, Jan-Baptista Anthoine, who died in Antwerp in March 1691. It seems likely that it was taken back to Flanders by Lucas. The painting was in Brussels in 1738, but subsequently found its way back to Italy and was given to the Vatican in 1822 with other paintings, in settlement of a debt. CB

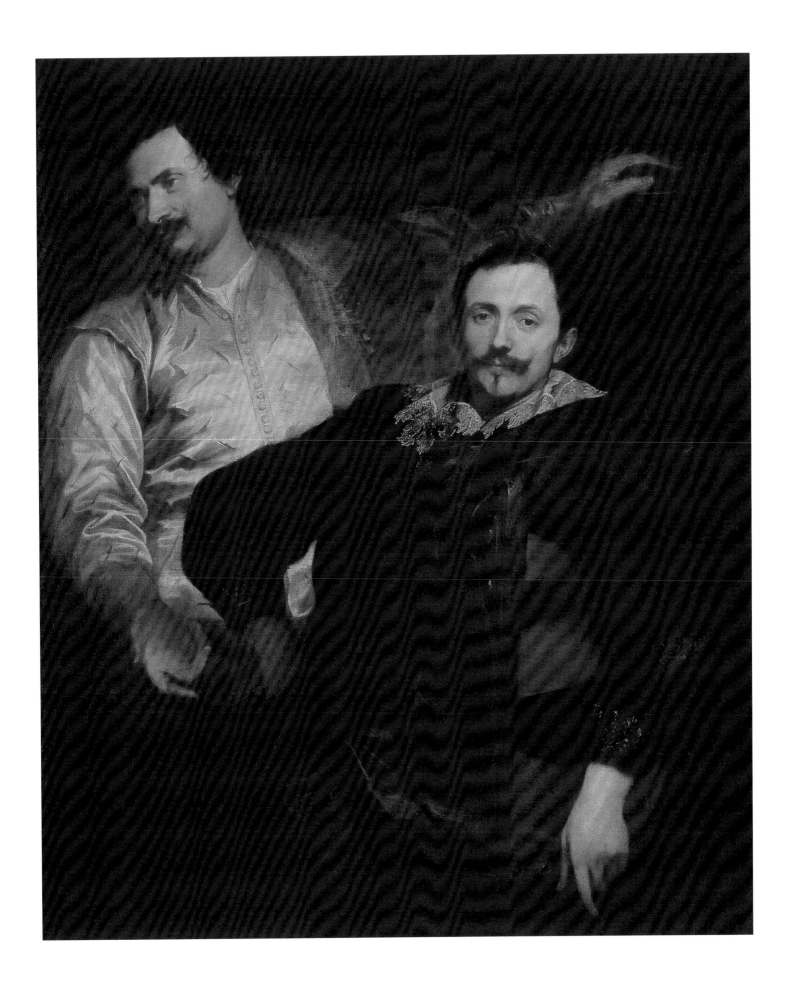

46 *Marchese Anton Giulio Brignole-Sale on Horseback* 1627

oil on canvas, 282 × 199 cm

Galleria di Palazzo Rosso, Genoa (inv. no. PR 48)

PROVENANCE 1627, Giovanni Francesco Brignole, Genoa; by descent to Paola Brignole-Sale; 1687, acquired from her by Giovanni Francesco I Brignole-Sale (Brignole-Sale archives, 21 March 1687, a payment of 4700 lire made by Gian Francesco Brignole to his niece Paola in settlement of this painting and that of Paolina Adorno on the occasion of the division of the estate of Ridolfo Maria); by descent to Maria Brignole-Sale De Ferrari, Duchess of Galliera; 1874, presented by her to the city of Genoa

REFERENCES Bellori 1672, p. 256; De Brosses 1739, p. 78; Cochin 1758, p. 261; Ratti 1766, p. 230; Ratti 1780a, p. 253; Smith 1831, III, p. 49; Cunningham 1843, II, pp. 421, 447; Carpenter 1845, p. 18; Michiels 1881, p. 78; Guiffrey 1882, pp. 44, 259; Bode 1899; Cust 1900, pp. 38–40, 73, 241; Rooses 1900, p. 22; Schaeffer 1909, p. 503; Rooses 1914, p. 227; Burchard 1929, p. 344; Glück 1931, p. xxxviii; Van Puyvelde 1950, pp. 141, 143, 145; Millar 1955, p. 314; Van Puyvelde 1955b, pp. 99–100; Brown 1982, pp. 88, 105, 166; Millar 1982, p. 15; Barnes 1986, I, no. 24, pp. 204–7 (with full bibliography); Larsen 1988, no. 331; Tagliaferro 1995, pp. 22, 57, 137, 143

EXHIBITIONS Genoa 1955, no. 42; ibid. 1997, no. 59 (with full bibliography)

NOTES
1. 'Dipinse ... il Marchese Giulio Brignole celebre poeta disposto a cavallo e colori l'altro ritratto della Signora Marchesa sua consorte in cui si obbligo la natura perpetuando la sua bellezza.'
2. 'E per tre quadri grandi con ritratti di Anton Giulio e Paola in due, e nel 3° Geronima e Maria Aurelia, contanti ad Antonio fiamengo come alla note 38 ... £747.'
3. Cunningham 1843, II, p. 447.

The young Genoese aristocrat Marchese Anton Giulio Brignole-Sale rides a magnificent grey horse with a long white mane and tail; with his gloved left hand he holds the reins and with his right doffs his plumed hat. He wears a black costume enlivened with gold thread and a soft lace collar in the Spanish fashion; his hair is short and he wears a moustache; he gazes directly at the viewer. Behind him is the colonnaded portico of a country house and an extensive landscape. A dog scampers along at the horse's feet, looking up at the rider. This type of commanding pose had previously only been used in royal portraits. A similar pose was used later for the so-called portrait of *Cornelis de Wael* (Koninklijk Museum voor Schone Kunsten, Antwerp). It is the first of a long series of equestrian portraits by Van Dyck which culminates in those of Charles I.

Anton Giulio (1605–65) was the only son of Giovanni Francesco Brignole – who was to serve as Doge of Genoa from 1635 to 1637 – to survive into adulthood. He inherited the title of Marchese di Groppoli from his mother, Geronima Sale. On 9 December 1625 he married Paolina Adorno (cat. 47) and made his official entry into the Genoese nobility on 26 November 1626. He achieved literary fame with the publication of his oration for Doge Giovanni Stefano Doria and his eulogy for Emilia Adorno Raggi in 1634, being elected to various literary academies in Italy, including the Umoristi in Rome, the Addoramenti in Genoa and the Incogniti in Venice. As a member of the last he was portrayed in the publication, *Le Glorie de gli Incogniti* (Venice 1647), the head, engraved by G. B. Castiglione, being after the present painting. Anton Giulio was sent by the Republic of Genoa as Ambassador Extraordinary to Spain (1644–6) and on his return held various public offices, culminating in his election as Senator in July 1648. His wife died in that year and, after only six months as a Senator, he resigned to study for holy orders. In 1652 he joined the Jesuits, leaving his estate to his sons. Bellori described the portraits of Anton Guilio and his wife in 1672: 'He painted ... the Marchese Giulio Brignole, the celebrated poet, on horseback and also portrayed the Marchesa, his wife, serving Nature by preserving her beauty in perpetuity.'[1]

In the account book of Giovanni Francesco Brignole, father of the sitter, for 18 December 1627 is the entry: 'and for three large paintings, two with portraits of Anton Giulio and Paola, and the third of Geronima and Maria Aurelia, paid to Anthony the Fleming as in note 38 ... 747 lire'.[2] The three paintings are this equestrian portrait, its companion (cat. 47) and a double portrait of Anton Giulio's mother, Geronima Sale, with her daughter Aurelia (Palazzo Rosso, Genoa). If the portrait was painted and paid for in the same year, which seems likely, Anton Giulio is shown aged 22.

The portrait is broadly and thinly painted and has suffered from several restorations: the painter Carbone was paid on 31 July 1679 *'per gionta al quadro del Sig. Anton Guilio'* ('also for the painting of Sig. Anton Giulio'); other payments for cleaning and restoration followed in 1857 and 1864, and the Scottish painter Sir David Wilkie described the painting as rubbed.[3] It looks almost sketch-like and unfinished in some areas, particularly the lower part of the painting including the horse's legs. It has been suggested (by Barnes) that it was executed with the aid of assistants; however, the recent restoration has rediscovered the portrait's great strengths, notably the sensitive features of Anton Giulio and the breathtakingly fluent treatment of the horse's head, mane and forequarters. There is an oil sketch for the horse (cat. 47, fig. 1). CB

47 *Marchesa Paolina Adorno Brignole-Sale*

1627

oil on canvas, 288.5 × 199 cm

Galleria di Palazzo Rosso, Genoa (inv. no. P R 51)

PROVENANCE As cat. 46

REFERENCES As cat. 46

EXHIBITIONS Genoa 1955, no. 43; ibid. 1997, no. 60 (with full bibliography)

While her husband rides through the countryside near Genoa (cat. 46), Paolina is shown standing in their Genoese palace before an imposing giant order of columns and, on the left, an arch and a balustrade overlooking a terraced garden. She wears a deep blue velvet dress richly embroidered in gold thread, a high starched ruff and starched lace at her wrists. Her hair is gathered under a cap decorated with rows of pearls and ostrich feathers. She holds a red rose in her right hand. A pet parrot perches on the arm of a chair upholstered in red velvet with carved finials.

Paolina's date of birth is not known, but she married Anton Giulio Brignole-Sale on 9 December 1625. In this portrait, paid for and probably also painted in 1627, she looks about twenty years old. The couple's first child was born in 1631. Paolina was to die relatively young in 1648. It has been argued (Genoa 1997) that the parrot was painted by Van Dyck's Flemish contemporary Jan Roos, a specialist in animal and still-life painting who lived and worked in Genoa and collaborated with Van Dyck: the *Portrait of a Young Boy in White* (private collection, Genoa) is their collaborative work. This may be the case, although Van Dyck was perfectly capable of painting a lively parrot himself, as he was to show in his portrait of *The Earl of Denbigh* (fig. 68).

The condition of the painting is better than that of its companion: the figure of Paolina is well preserved, although there is some wearing in the architecture. C B

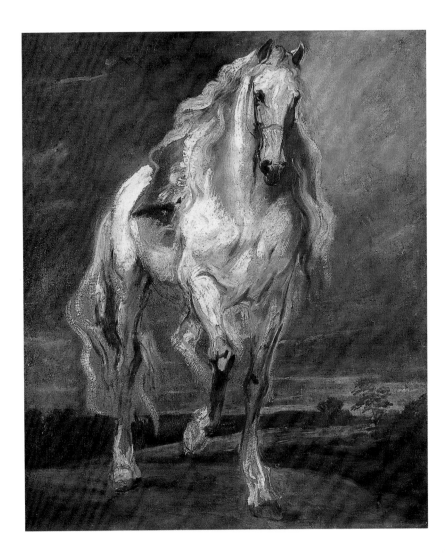

FIG 1

Anthony van Dyck, *Study of a Horse*, 1627
oil on canvas, 80.6 × 67.5 cm
Private collection

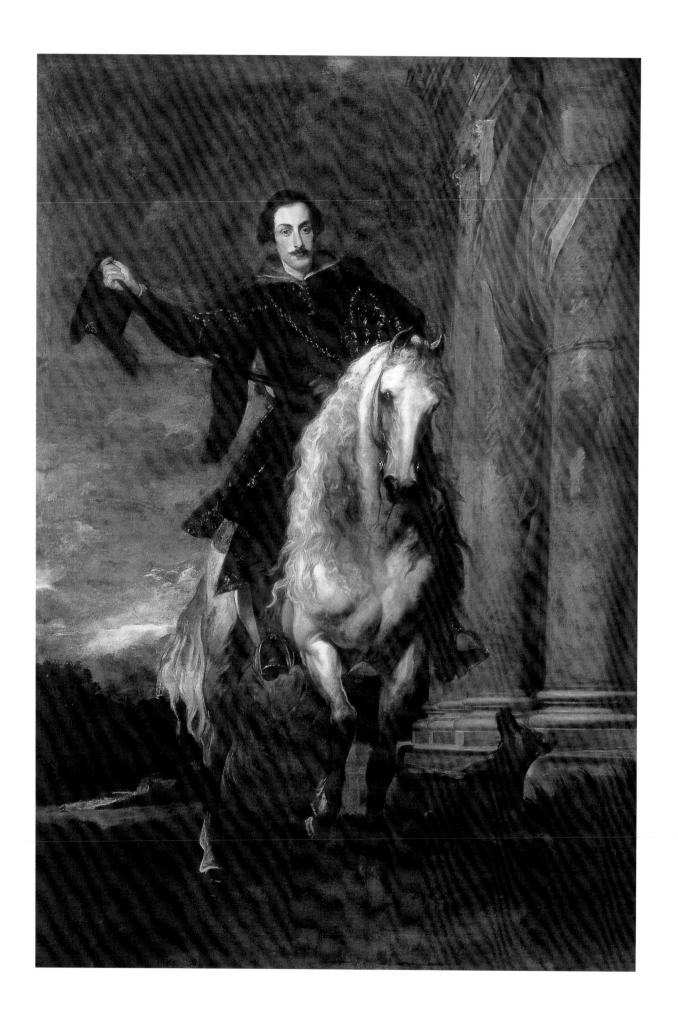

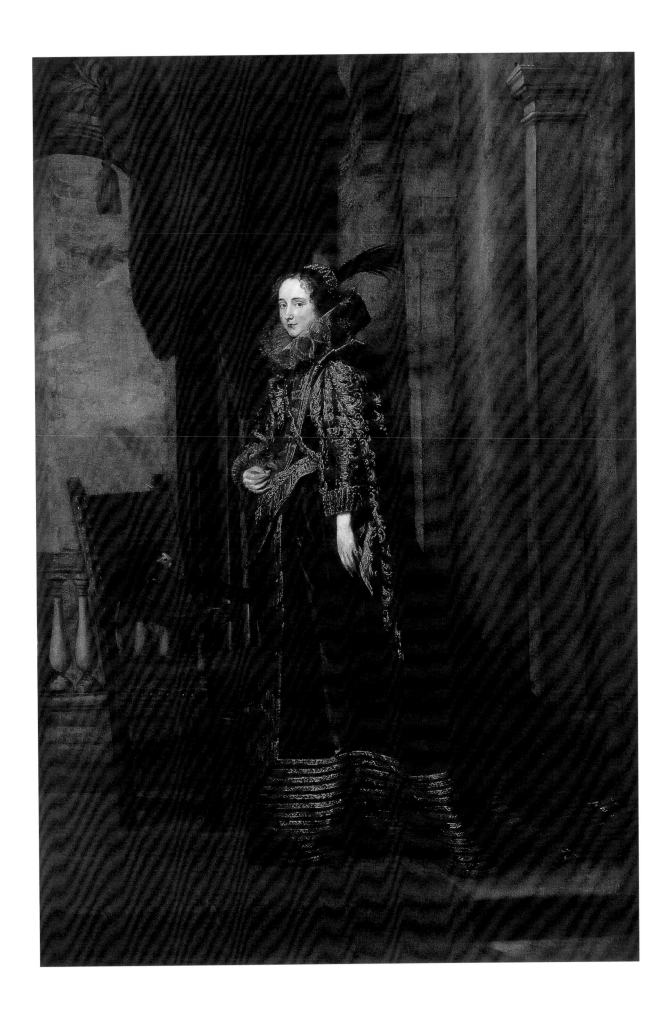

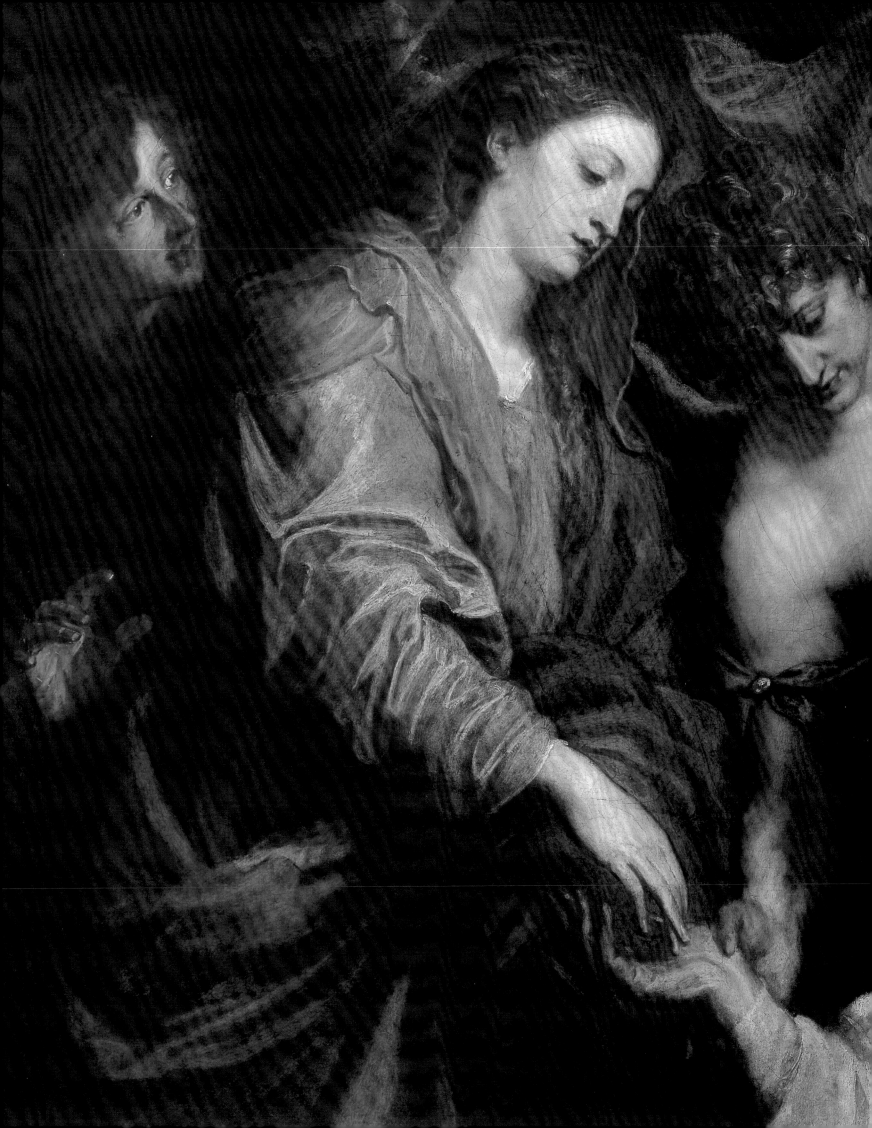

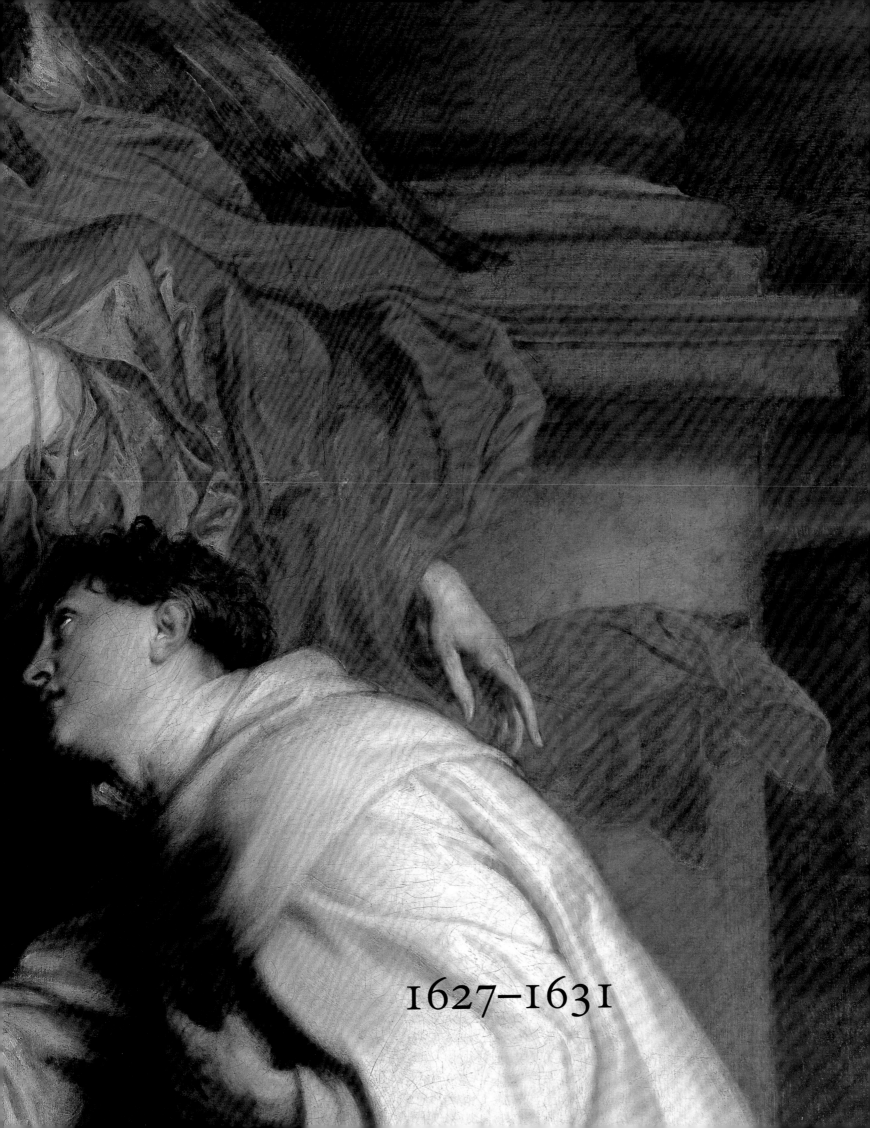

1627–1631

48 *Peeter Stevens, 1627*

oil on canvas, 113 × 98 cm
inscribed left, on the base of the pilaster:
AET · SVAE *37 · 1627 · | Antº. van Dijck · fecit*

Koninklijk Kabinet van Schilderijen 'Mauritshuis',
The Hague (inv. no. 239)

PROVENANCE 1628–68, Peeter Stevens,
Antwerp; 1752–68, Govert van Slingelandt,
The Hague; 1768–95, William V, The Hague;
1795–1815, transferred to the Louvre, Paris;
1815, transferred to the Koninklijk Kabinet van
Schilderijen, The Hague

REFERENCES Hoet and Terwesten 1752–70, II,
p. 404; III, p. 694; Smith 1829–42, III, p. 38,
no. 134; Guiffrey 1882, pp. 91–2, 277, no. 836;
Cust 1900, pp. 57–8, 259–60, no. 180; Schaeffer
1909, pp. 224, 504–5; Leveson Gower 1910,
pp. 73–6; Brussels 1912, I, p. 162; Hofstede de
Groot 1916, p. 68; Glück 1931, p. 285; Martin
1935, pp. 82–4, no. 239; Speth-Holterhoff 1957,
pp. 14–19; Van Gelder 1959, pp. 47–8; Drossaers
and Lunsingh Scheurleer 1974–6, III, p. 208,
no. 24; Brenninkmeyer and de Rooij 1976,
pp. 162–3, no. 24; Mauritshuis 1977, p. 81;
Briels 1980, pp. 138, 165; Smith 1982, pp. 87–8;
Mauritshuis 1985, p. 360; Broos 1987, pp. 121–4,
under no. 21; Larsen 1988, I, pp. 244–5;
II, pp. 250–51, no. 617; Mauritshuis 1993,
p. 55, no. 239

EXHIBITIONS Brussels 1910, no. 98; Antwerp
1949, no. 46; Washington 1990–91, pp. 196–200,
no. 45 (entry by A. K. Wheelock)

FIG 1
Lucas Vorsterman
after Anthony van Dyck, *Peeter Stevens*
etching and engraving from the *Iconography*
(Mauquoy-Hendrickx 93)

Peeter Stevens is shown three-quarter length, turned to the left and pointing in the same direction with his left hand. A soft lace collar provides the only contrast with his dark clothes. On the left is a pilaster with a coat of arms, a signature and date. The arms are those of Stevens, a wealthy cloth merchant who was born in Antwerp in 1590 and died there in 1668 (Leveson Gower 1910). He was responsible for a variety of charitable duties in the city, where he served for many years as the Municipal Almoner. He is best known, however, for the magnificent collection of paintings he assembled (see Briels 1980).

Van Dyck painted a second portrait of Stevens in a somewhat different pose, of which Lucas Vorsterman the Elder produced a print for Van Dyck's *Iconography* (fig. 1). Stevens also appears among the *cognoscenti* in Willem van Haecht's painting of the picture gallery of Cornelis van der Geest in 1615 (1628; see cat. 49, fig. 2).

This portrait and the one of Stevens's wife Anna Wake (cat. 49) have always been recognised to be pendants. Ludwig Burchard (notes at the Rubenianum Antwerp, Van Dyck documentation) has pointed out, however, that Stevens's portrait was initially made as an independent painting. He is standing on the 'wrong' side – the heraldic left in relation to his wife, although this 'heraldic correctness' was gradually growing less important, as is evident from other portraits by Van Dyck painted shortly afterwards (especially Louvre, Paris, inv. nos. 1242, 1243; and Staatsgalerie, Schleiß-heim, inv. nos. 201, 995, the Godines–van den Berghe couple). More important evidence in support of Burchard's argument is the fact that Anna Wake's portrait was made a year after that of her husband, in 1628, when the couple were married. Presumably Peeter Stevens commissioned the portrait of his bride around the time of their wedding, asking Van Dyck to make it a pendant to his own.

Wheelock has argued (see Washington 1990–91) that the two portraits were conceived as a pair from the beginning. He interprets Stevens's gesture as an expression of affection towards Anna Wake, but it is rather a refinement by Van Dyck of a rhetorical pose and gesture that Rubens had used in single portraits, such as that of Michiel Ophovius (*c.* 1618; Mauritshuis, The Hague). Its origins may be traced to early 16th-century Netherlandish portraits, especially by Jan Gossaert and Jan Vermeyen. Van Dyck has, however, refined the motif in this painting, as he had already done in his Italian portraits. The portrait of Stevens seems to be the first after his return to the Low Countries in which Van Dyck applied this sense of carefully calculated nonchalance, known as *sprezzatura*, that was such an important element of Venetian High Renaissance portraiture; it is not surprising that it was appreciated by a connoisseur of Stevens's sensibilities. In using such an innovative pose Van Dyck also illustrated changes that had been taking place in the lifestyle of the rich in Antwerp since the 1620s, away from the austere code of conduct still apparent in the portraits he painted during his early Antwerp years (see cat. 9).

These pendant portraits were probably among the *'Quatre Portraits… d'Antoine Van Dyck, Chevalier'*, listed in 1668 in the inventory of Stevens's estate. The other two portraits referred to in the document were of Stevens's parents, Adriaen Stevens and Maria Bosschaerts (Pushkin Museum, Moscow, on loan from the Hermitage, St Petersburg). HV

49 *Anna Wake,* 1628

oil on canvas, 112.5 × 99.5 cm
inscribed left, on the foot of the pilaster:
AET · SVAE 22 · AN · 1628 ·/*Antº. van Dyck fecit*

Koninklijk Kabinet van Schilderijen 'Mauritshuis',
The Hague (inv.no. 240)

PROVENANCE 1628–68, Peeter Stevens,
Antwerp; 1752–68, Govert van Slingelandt,
The Hague; 1768–95, William V, The Hague;
1795–1815, transferred to the Louvre, Paris;
1815, transferred to the Koninklijk Kabinet van
Schilderijen, The Hague

REFERENCES Hoet and Terwesten 1752–70, II,
p. 404; III, p. 694; Smith 1829–42, III, p. 38,
no. 135; Guiffrey 1882, p. 282, no. 943; Cust 1900,
pp. 58, 261, no. 126; Schaeffer 1909, pp. 225,
504–5; Leveson Gower 1910, pp. 74–6; Glück
1931, pp. 284, 550; Martin 1935, p. 84, no. 240;
Speth-Holterhoff 1957, pp. 15, 197; Van Gelder
1959, pp. 47–8; Drossaers and Lunsingh
Scheurleer 1974–6, III, p. 107, no. 23;
Brenninkmeyer-de Rooij 1976, p. 162, no. 23;
Mauritshuis 1977, p. 81, no. 240; Smith 1982,
pp. 87–8; Mauritshuis 1985, pp. 174–5, 360, no. 28;
Broos 1987, pp. 119–24, no. 21; Larsen 1988, I,
pp. 244–5; II, p. 251, no. 618; Mauritshuis 1993,
p. 55, no. 240

EXHIBITIONS Brussels 1910, no. 99; Antwerp
1949, no. 47; Washington 1990–91, pp. 196–200,
no. 44 (entry by A. K. Wheelock)

ENGRAVING by Pieter Clouwet

Anna Wake was born in 1606. She was the eldest daughter of Lionel Wake, an English Catholic who acted as intermediary in Rubens's dealings with Sir Dudley Carleton. Wake moved to Antwerp in 1607, and played a prominent role in the city's commercial life. Like her husband, Anna Wake is shown three-quarter length, she turns to the right and looks towards the spectator. She wears a satin dress, trimmed with a starched fan-shaped collar made of lace, like her cuffs. Her dress is worn over a bodice and skirt, its black fabric decorated with braid; the sleeves, tied at the elbow with ribbons, are split to reveal white undersleeves. The costume typifies the French fashion that, from the late 1630s, increasingly came into vogue, replacing the traditional Hispano-Flemish costume, a reflection of the more relaxed and elegant lifestyle of Antwerp's upper classes at that date. Anna wears two strings of pearls around her neck, with a gold chain and crucifix beneath. In her left hand she holds a large ostrich-feather fan. As in the pendant portrait of her husband, the background is plain apart from a pilaster to her left on which is painted her coat of arms, a signature and date.

This portrait was probably commissioned to mark the wedding in 1628 of Anna Wake and Peeter Stevens (see cat. 48). Anna Wake's portrait was engraved by Pieter Clouwet (fig. 1) and appears in Van Dyck's *Iconography*, as does its pendant. The name of the sitter has never been in doubt, although she was once confused with another Anna Wake, the wife of Lord Sheffield.

Despite her modern French costume, Anna Wake's appearance in this portrait is rather reserved, especially when compared with her husband's more lively pose. Her presentation is still very much in keeping with the Netherlandish tradition that sought to emphasise the modesty and reserve of the wife's role in matched portraits of bourgeois couples. HV

FIG 1
Pieter Clouwet after
Anthony van Dyck, *Anna Wake*
engraving from the *Iconography*
(Mauquoy-Hendrickx 171)

FIG 2
Willem van Haecht, *The Visit of the Archdukes Albert and Isabella to Van der Geest's House in the Mattenstraat in 1615*, 1628
oil on panel, 104 × 139 cm
Rubenshuis, Antwerp

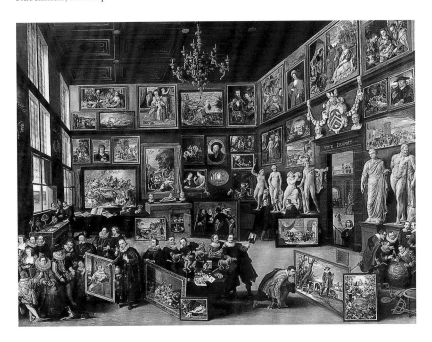

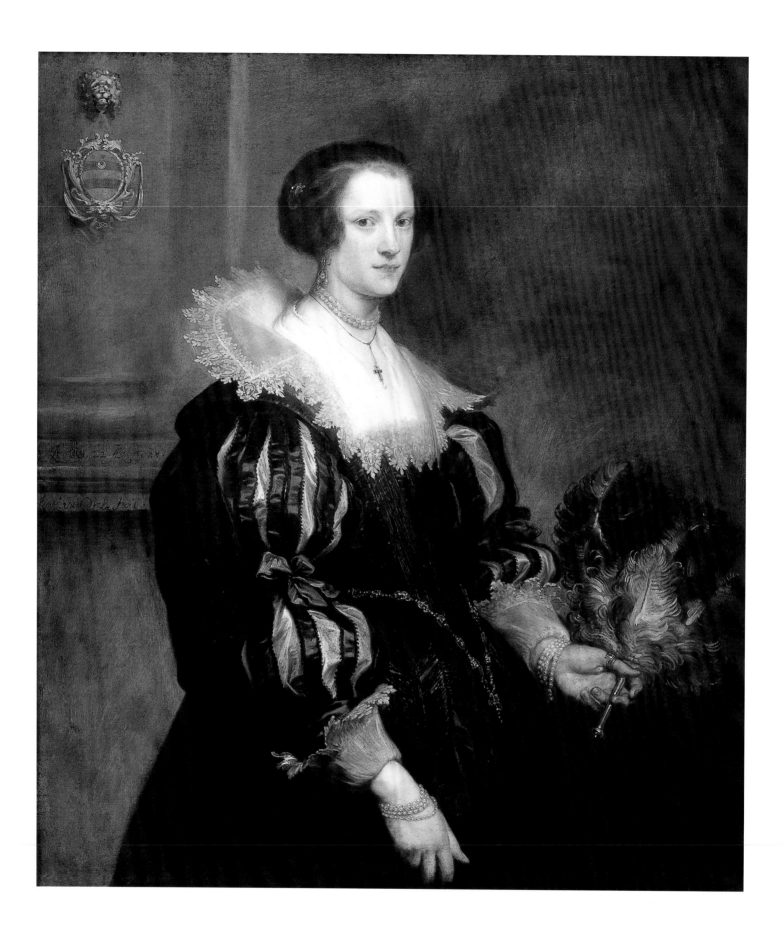

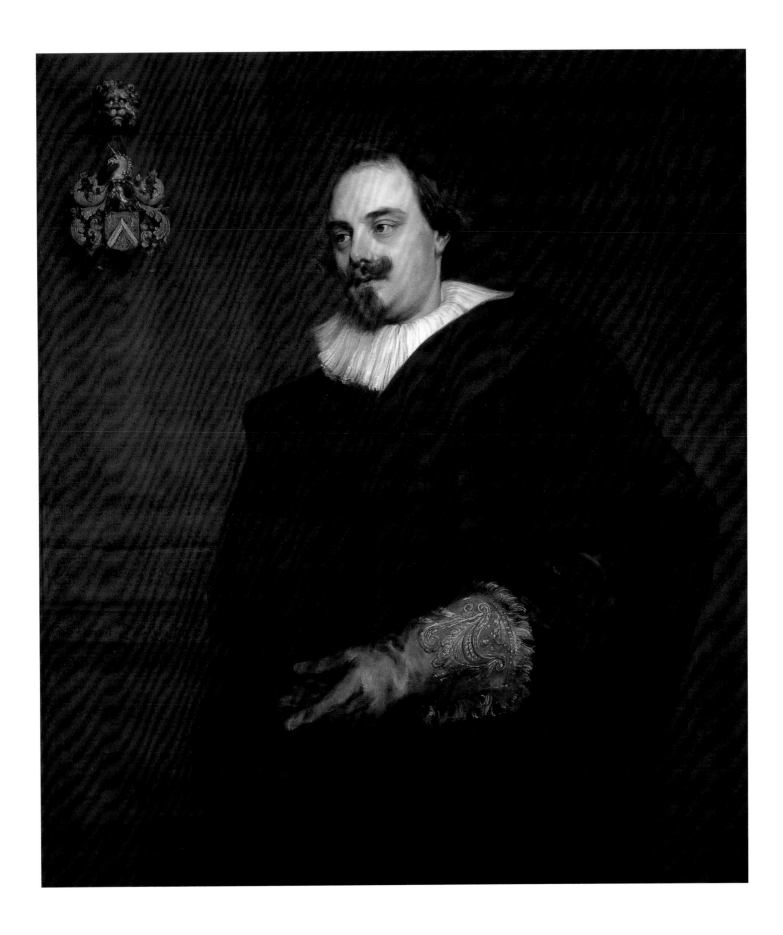

50 *Nicholas Lanier*, 1628

oil on canvas, 111.5 × 87.6 cm

Kunsthistorisches Museum, Gemäldegalerie, Vienna (inv. no. 501)

PROVENANCE Charles I of England; 2 November 1649, acquired by Lanier at the dispersal of the royal collection; 1720 at the Stallburg, Vienna; thereafter in the Habsburg Imperial collections

REFERENCES Vertue 1757, p. 90, no. 34; Mechel 1783, p. 109, no. 21; Smith 1829–42, III, p. 233, no. 834; Engerth 1884, p. 123, no. 809; Phillips 1896, p. 36; Cust 1900, pp. 52–3, 86, 259, no. 96; Schaeffer 1909, p. 201; Glück 1931, pp. 349, 557; id. 1936, pp. 148–53; de Hevesy 1936, p. 153; Gaunt 1980, pp. 92, 93; Brown 1982, p. 137; De Poorter, in Vienna 1987, pp. 194–5, no. 82; Larsen 1988, II, p. 351, no. 898; Gritsai 1996, p. 113

EXHIBITIONS Antwerp 1930, no. 99; Amsterdam 1947, no. 52; Brussels 1947, no. 34; London 1972–3, no. 74; ibid. 1982–3, no. 6; Washington 1990–91, pp. 207–9, no. 48 (entry by A. K. Wheelock)

FIG 1

Anthony van Dyck, study for *Nicholas Lanier*, 1628 black chalk with white highlights on blue paper, 39.2 × 28.5 cm
National Gallery of Scotland, Edinburgh (Vey 203)

Nicholas Lanier (1588–1666) was born in London to a French father. He was appointed Master of the King's Music in 1625 and, as Charles I's agent, played an important part in the acquisition of paintings for the royal collection. It was Lanier, accompanied by Daniel Nys, who successfully negotiated the purchase of the legendary Gonzaga collection in Mantua. The acquisition of paintings by Mantegna, Raphael, Giulio Romano, Andrea del Sarto, Correggio, Titian, Tintoretto and Caravaggio transformed the English court at a stroke into one of Europe's most brilliant artistic centres, with a collection to rival those of the Habsburg and Medici.

Lanier visited Antwerp in 1628 *en route* from Mantua to England, as recorded by Rubens, who wrote to Pierre Dupuy in Paris on 15 June 1628: 'The English gentleman who is taking the Mantua collection to England is in town.' He added that most of the paintings were due to arrive in Antwerp soon. Van Dyck must have painted this portrait of Lanier during that visit. He evidently considered its quality exceptional, as we learn from the reported comments of his successor as court painter, Sir Peter Lely. According to Walpole, Lanier told Lely that he had had to pose for Van Dyck for seven full days and had been forbidden from viewing the work in progress until the artist was entirely satisfied with it.

The identification of the sitter as Lanier is based on his similarity to a print by Lucas Vorsterman the Elder after a lost portrait of Lanier by Lievens (Glück 1936); earlier it had been suggested that he was either Charles I or Count Rhodokanakis. It is evident from the composition and pose that Van Dyck wished to emphasise Lanier's status as a courtier. Lanier gazes at the viewer slightly ironically, with an expression that combines melancholy and hauteur. His seemingly nonchalant pose, with his right hand on his hip and the left resting on his dagger, expresses the courtly ideal of *sprezzatura* that was cultivated so assiduously at the Stuart court. Titian was the source for the informal pose, the colourful red and white costume, which contrasts magnificently with the black cape, thrown carelessly over his shoulder, and the background of an elegiac, Arcadian landscape at twilight. There can be little doubt that patron and artist were in complete accord in their desire to re-create a Venetian atmosphere. Van Dyck's careful preparation for the portrait is apparent from his precise preliminary study (fig. 1) which shows Lanier looking more to the left. His direct gaze in the final painting adds considerably to Lanier's aristocratic air.

There is evidence that Lanier and Van Dyck were friends some time before this commission. It is possible that the Earl of Arundel introduced the two men during Van Dyck's first visit to England in 1620–21, or they may have met in Genoa. Their friendship may also explain how Van Dyck came to lodge with Lanier's brother-in-law, Edward Norgate, when he returned to England in 1632.

Lanier's demeanour and pose have much in common with Rubens's most aristocratic self-portrait (Kunsthistorisches Museum, Vienna) in which he presents himself in the guise of artist and courtier. It is tempting to conclude that Rubens was enchanted by the courtly grace of Van Dyck's portrait of Lanier, which was painted several years earlier. Certainly it is striking how, in the final years of his life, Rubens introduced an air of studied elegance into several portraits of Hélène Fourment, including *The Walk in the Garden* (Metropolitan Museum, New York) and *Hélène Fourment* (Louvre, Paris) that came closer in spirit to Van Dyck's portrait style than any of his other works. H V

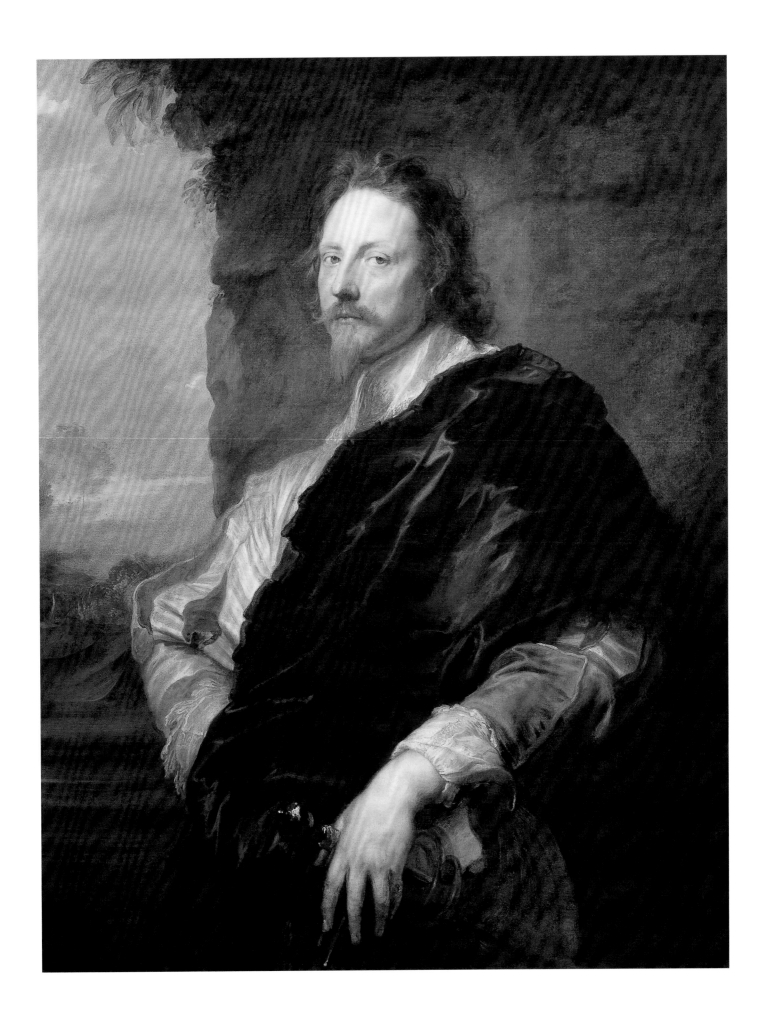

51 *St Augustine in Ecstasy*, 1628

oil on canvas, 389 × 227 cm

Koninklijk Museum voor Schone Kunsten,
Antwerp, on loan from the Augustijnenkerk

PROVENANCE Commissioned by the Antwerp
Augustinians as an altarpiece for their church;
1795 (?), transferred to the Louvre, Paris;
1815, returned to the Augustijnenkerk

REFERENCES Bellori 1672, p. 258; Houbraken
1718–21, I, p. 184; Sanderus 1727, II, p. 216;
De Wit c. 1748, p. 83; Descamps 1753–4, II, p. 16;
Mensaert 1763, I, pp. 182–3; Descamps 1769,
p. 175; Berbie 1774, p. 56; Smith 1829–42, III,
pp. 3–4, no. 5; Guiffrey 1882, pp. 93–6, 250, no. 167;
Cust 1900, pp. 60, 61, 181, 209, 249, no. 56;
Schaeffer 1909, pp. 89, 499; Buschmann 1916,
pp. 47–8; Peeters 1930, pp. 136–48; Glück 1931,
pp. 237, 544; Millar 1954, p. 42; Vey 1956, p. 176;
d'Hulst and Vey, in Antwerp and Rotterdam 1960,
pp. 156–8, under no. 124; Larsen 1975, pp. 66–8;
Van de Velde 1977, pp. 221–34; Brown 1979, p. 145;
Princeton 1979, pp. 136–9; Brown 1982, pp. 114–16;
Larsen 1988, I, pp. 242, 244; II, pp. 204–5, no. 658;
Moir 1994, p. 26; Vlieghe 1994, p. 218, n. 7

EXHIBITIONS Antwerp 1899, no. 26; id. 1949,
no. 14; London 1953–4, no. 132; Washington 1990–
91, pp. 201–3, no. 46 (entry by A. K. Wheelock)

NOTE
1. '*Hoc anno procurata est pictura admodum elegans
St. Augustini in extasi contemplantis divina attributa
a Domino Van Dyck depicta constitit 600 florenis.*'

FIG 1
Peter Paul Rubens, *The Vision of St Gregory*, 1606–7
oil on canvas, 475 × 287 cm
Musée de Peinture et de Sculpture, Grenoble

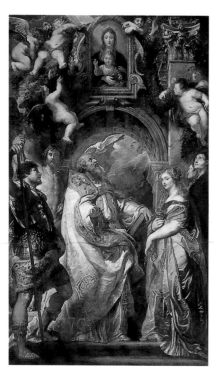

St Augustine gazes up at a heavenly vision of the Holy Trinity supported by clouds and *putti* holding symbols of the omnipotence, unity and eternity of the Trinity. Bellori (1672) explained that the sceptre surmounted with an eye symbolises divine providence; the olive branch, peace; the snake biting its tail, eternity; and the sun, justice. Augustine is supported by two angels, one of whom points to the vision with his right forefinger, drawing it to the attention of the donor, Father Marinus Jansenius, kneeling on the right. According to the 18th-century 'Louvre Biography', Van Dyck portrayed the monk in the guise of St Nicholas of Tolentino, one of the Augustinians' most popular saints. I find this improbable, however, as the saint would be out of place in this context. No attributes support such an identification, and additionally Nicholas of Tolentino is customarily portrayed with a beard.

St Augustine's mother, St Monica, in widow's garb, appears on the left. She too gazes with awe at the vision above her. Her presence may indicate that the theme of the painting was prompted by a passage from Augustine's *Confessions* (IX, 10) in which the saint and his mother, at Ostia, discuss the mystery of eternity, thereby bringing themselves to such a state of ecstasy that they lost all awareness of their bodily selves. Total submission to God was favoured by Counter-Reformation theologians, and was linked to St Francis receiving the Stigmata during a similar moment of submission (Princeton 1979). The upper part of the painting focuses on the Holy Trinity, on which Augustine meditated in his *De Trinitate*.

The style of the painting shows Van Dyck's familiarity with Italian art of the High Renaissance and early Baroque periods, which he had studied and assimilated during his time in Italy. In this composition Van Dyck incorporated elements from the work of Raphael and Titian, Annibale Carracci and Guido Reni (Wheelock, in Washington 1990–91). Nevertheless, the most direct example was Rubens's *Vision of St Gregory* (fig. 1), an altarpiece painted in Rome in 1606–7 and installed by the artist over his mother's tomb in the church of St Michael on his return to Antwerp in 1608. It is hard to imagine that Van Dyck did not have that work in mind when painting this altarpiece. He had already taken it as his point of departure for the *Madonna of the Rosary* painted in 1624–7 for the Oratorio del Rosario in Palermo (fig. 40).

The Augustinians of Antwerp commissioned Van Dyck to paint *St Augustine* in 1628 for the altar in the left aisle of their church, as we learn from records of the city's Augustinian monastery for the year 1628.[1] Simultaneously Rubens was commissioned to paint *The Mystic Marriage of St Catherine* (cat. 52, fig. 1) for the high altar, while Jacob Jordaens was asked to paint *The Martyrdom of St Apollonia* for the altar in the right aisle. These prestigious commissions may have been intended to commemorate the meeting of the provincial chapter held by the Augustinians at the Antwerp monastery in May 1628. It was, presumably, the first commission for a large altarpiece that Van Dyck received on his return from Italy – a view supported by Houbraken.

I think it probable that originally Rubens was offered the commission to supply all three altarpieces, but was obliged by pressure of time – his visit to Spain in the autumn of 1628 – to delegate part of the assignment to his two most talented former collaborators. No doubt the Augustinians set firm guidelines as to the iconographic programme of Van Dyck's altarpiece, but it was paid for by Father Marinus Jansenius, a member of the order's Antwerp community. The sum of 600 guilders that Van Dyck received for his work was average for an altarpiece of this scale, although it was less than the 3000 guilders Rubens was paid for his. Pieter de Jode the Younger made an engraving of the composition dedicated to Van Dyck's sister Susanna, an Antwerp Beguine. HV

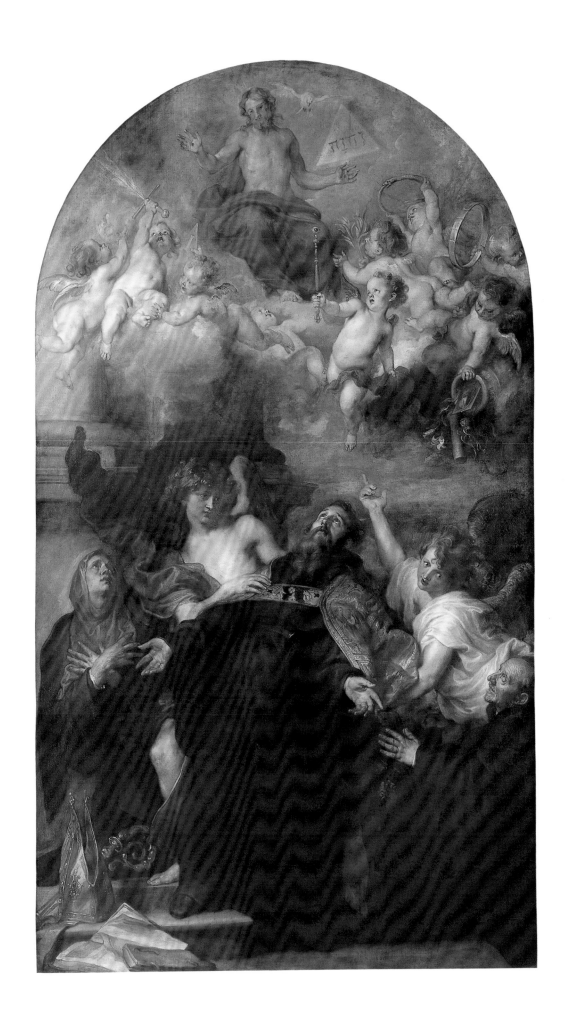

52 *St Augustine in Ecstasy,* 1628

oil on panel, 44.5 × 28 cm

Koninklijk Museum voor Schone Kunsten, Antwerp

PROVENANCE Frederick Mont, New York; private collection, The Hague; 10 July 1998, sale Christie's, London ('the property of a nobleman'), no. 17

REFERENCES Princeton 1979, pp. 140–42, no. 37; Brown 1982, p. 116; Larsen 1988, I, pp. 242, 470; II, p. 258, no. 661

EXHIBITIONS Princeton 1979, no. 37; Washington 1990–91, pp. 342–4, no. 93 (entry by J. S. Held)

FIG 1
Peter Paul Rubens,
The Mystic Marriage of St Catherine, 1628
oil on canvas, 564 × 401 cm
Koninklijk Museum voor Schone Kunsten, Antwerp

FIG 2
Anthony van Dyck, *St Augustine in Ecstasy*
oil on panel, 49.8 × 30.5 cm
Yale University Art Gallery, New Haven,
Gift of Hanah D. and Louis M. Rabinowitz

This monochrome oil sketch, with its rapid, sure touch and vivid white highlights, was first identified as the *modello* of Van Dyck's 1628 altarpiece (cat. 51) for St Augustine's, Antwerp, by Martin and Feigenbaum (in Princeton 1979); an opinion that subsequently won support from Brown and Held. Previously another version (Ashmolean Museum, Oxford) was considered to be the preliminary design, despite being notably weaker than this version. Larsen still maintains that the Oxford copy is superior in quality to the Antwerp sketch, writing: 'if this painting is autograph, which is not above doubt, it might rather be a first attempt later discarded by the master'.

The composition of the altarpiece is more or less fixed in this oil sketch, although a number of significant changes were made subsequently. St Augustine dominates the picture plane more emphatically in the altarpiece than he does in the sketch, while St Monica, shown in profile, is more prominent in the sketch, and is in a state of greater ecstasy than in the final canvas. These adjustments were probably prompted by considerations of decorum.

Martin and Feigenbaum, supported by Held, have suggested that this work may be identified as the grisaille sketch mentioned in the inventory of Alexander Voet's estate on 18 February 1689 (*'Een schetse van Sint Augustinus, wit en swert, van van Dyck'* – 'A sketch of St Augustine, black and white, by Van Dyck'; Denucé 1932, p. 311). While this is possible, the 1689 document may also be linked to a grisaille design (fig. 2) for the print Pieter de Jode engraved after the composition. H V

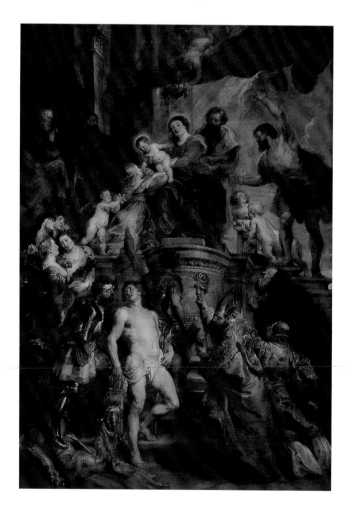

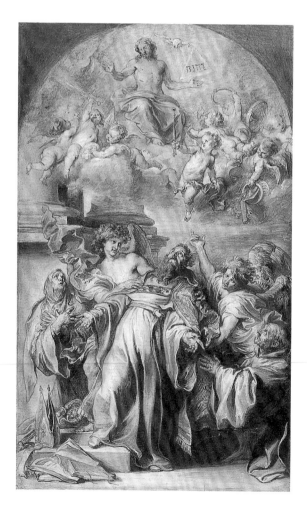

53 The Painter Jan de Wael and his Wife Gertrude de Jode 1629

oil on canvas, 125.3 × 139.7 cm; a 3.5 cm strip has been added at the top and another measuring 4 cm at the bottom

Bayerische Staatsgemäldesammlungen, Alte Pinakothek, Munich (inv. no. 596)

PROVENANCE Gisbert van Colen, Antwerp; 1698, sold by him to Max Emmanuel, Elector of Bavaria; 1781, transferred from Schloss Schleissheim to the Hofgartengalerie, Munich; since 1836, displayed at the Alte Pinakothek

REFERENCES Smith 1829–42, III, pp. 22–3, no. 72; IX, p. 369, no. 6; Guiffrey 1882, p. 282, no. 938; Cust 1900, pp. 16, 235, no. 45; Schaeffer 1909, pp. 163, 502; Glück 1931, pp. 304, 552; Vey 1962, p. 315, under no. 248; London 1968, p. 40; Krempel 1976, pp. 223, 230; Krempel, in Munich 1983, pp. 185–6, no. 596; Larsen 1988, II, p. 211, no. 525; Moir 1994, pp. 31–2

EXHIBITIONS Amsterdam 1948, no. 47; London 1949, no. 4; Washington 1990–91, pp. 214–15, no. 51 (entry by A. K. Wheelock)

The identification of the couple in this painting relies on the portrait of Jan de Wael that Van Dyck himself etched for his *Iconography*. The print features the same composition in reverse, accompanied by the inscription 'IOANNES DE WAEL ANTVERPIAE PICTOR HVMANARVM FIGVRARVM'. A painted copy of the man, recorded on the Prague art market in the 1930s, was inscribed 'AETAT SVAE 71, 1629', which suggests that Van Dyck painted this portrait of De Wael and his wife in 1629.

The painter Jan de Wael (1558–1633) trained under Frans Francken the Elder and spent some time in France. He appears to have produced religious scenes, but none has survived. Returning to Antwerp, he served as the dean of the archery guild 'De Oude Voetboog', which suggests he enjoyed a degree of social prestige. Like so many of his contemporaries, he was well established in the familial network that characterised Antwerp's artistic milieu: in 1588, he married Gertrude de Jode (died 1641), sister of Pieter de Jode the Elder and aunt of Pieter the Younger, both of whom were celebrated engravers. The couple's sons were Cornelis and Lucas de Wael, who played a leading role in the colony of Netherlandish artists in Genoa (see cat. 45).

The elderly De Waels are shown three-quarter length against a grey-brown background with a large pilaster to the left and a red cloth-of-honour behind Gertrude de Jode. Husband and wife are both turned three-quarters to the viewer. Jan de Wael stands gazing resolutely ahead, from the painting, his authoritative pose emphasising his role as head of the family. With his left hand he makes a gesture that harks back to earlier Netherlandish portraits and to Titian. In his right hand he holds a pair of gloves, a motif denoting a degree of social standing which Van Dyck had used in his earliest portraits, and which also derives from 16th-century Netherlandish and Venetian painting. Gertrude de Jode sits, which makes her subservient to her husband. This, together with her position on the heraldic left, reflects the subordination and resignation traditionally expected of women. Unlike her husband, she is not looking outwards but gazing dreamily into the distance.

The De Waels are shown in sober, black clothes enlivened only by their white lace collars and cuffs. Jan de Wael has a pleated ruff of the type called *'fraise à confusion'* over his dark tunic, while his wife wears a starched millstone ruff. On his right sleeve, Jan ostentatiously displays the insignia of the archery guild of which he was once dean.

The couple's dress and pose create a stern and conservative impression. The effect is reinforced by the fact that, unlike Van Dyck's Italian group portraits, the two sitters do not form an integrated composition, but rather give the impression that the artist painted two single portraits on one support rather than a group portrait. Jan de Wael's portrait was, in fact, prepared in an independent drawing (Louvre, Cabinet des Dessins, Paris; Vey 248). It is reasonable to assume that the composition and the sober costumes express the tastes of an older generation. The painting is in striking contrast to the flamboyant portrait of De Wael's two sons (cat. 45).

A later artist reproduced the couple as they appear here as separate donor figures in the wings of their memorial painting in Antwerp Cathedral. The author of the little triptych has not been identified, although it is likely to have been painted in or around 1633, the year in which Jan de Wael died. Perhaps the De Waels would have preferred Van Dyck to do the second painting as well, but they could not give him the commission as he had by that date moved to England. HV

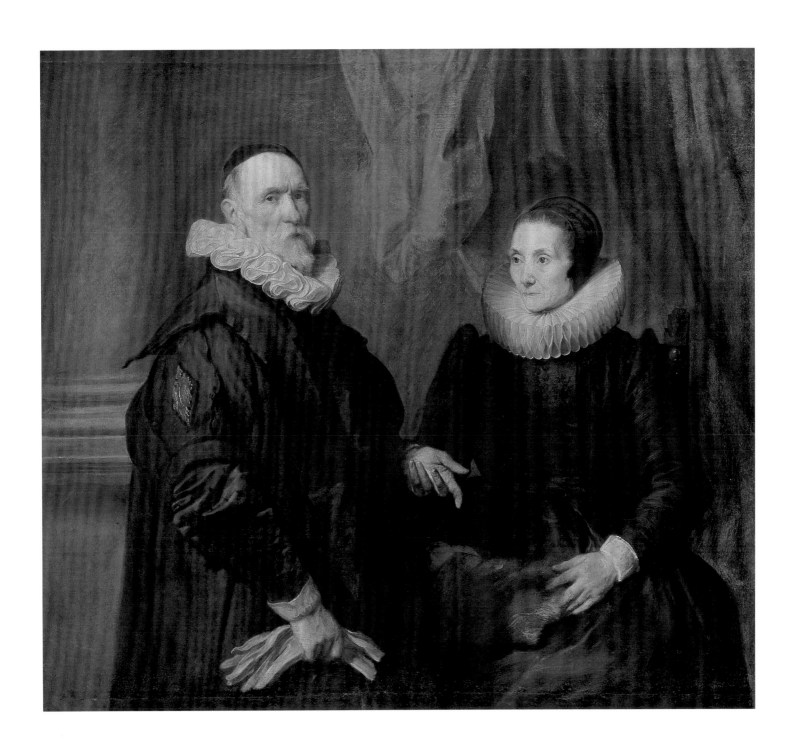

54 *Jean-Charles della Faille*
1629

oil on canvas, 130.8 × 118.5 cm
inscribed upper right (a later addition):
A° 1629·Ætatis Sue 32

Musées Royaux des Beaux-Arts de Belgique,
Brussels (inv. no. 6254)

PROVENANCE Della Faille de Leverghem
family; 1942, donated to the Museum by Count
Georges della Faille de Leverghem

REFERENCES Smith 1829–42, III, p. 207,
no. 731; Guiffrey 1882, p. 264, no. 515; Cust 1900,
pp. 79, 254, no. 32; Brussels 1912, I, p. 170,
pl. LXXVIII; id. 1930, I, p. 81, pl. XLIV; Glück
1931, pp. 352, 557; Devigne 1944, pp. 21–2, pl. XI;
Brussels 1984, p. 95; Larsen 1988, I, pp. 284–5;
II, pp. 204–05, no. 509

EXHIBITIONS Antwerp 1899, no. 138; Brussels
1910, no. 140; Antwerp 1930, no. 113; Genoa
1955, no. 72; Brussels 1965, no. 65

Jean-Charles della Faille (Antwerp 1599–1652 Barcelona) entered the Jesuit convent at Mechelen (Malines) as a novice in 1613. He completed his training at the Order's house in Antwerp. Della Faille devoted himself to the study of mathematics, partly prompted by his celebrated fellow Jesuit, Franciscus Aguilonius, and later taught the subject at the Jesuit College in Louvain. He left the Netherlands on 23 March 1620 to take the Chair of Mathematics at the Emperor Charles V's college in Madrid. Della Faille became an important adviser to the King of Spain in the field of military engineering.

He is shown seated, turned three-quarters to the right. He wears the black robe of his Order and a biretta, and looks at the viewer somewhat quizzically. His right hand, in which he holds a pair of dividers, rests on a table on which are placed other astronomical and geometrical instruments, including a globe and a set square: the attributes of a scholar.

The date 1629 and the sitter's age have been added by a later hand. Judging from della Faille's appearance and the style of the painting, the date seems to be correct. In 1629 della Faille left the Netherlands for good to settle in Spain. It is plausible that his family commissioned the portrait from Van Dyck to remind them of their expatriate Jesuit relative.

The diagonal pose, viewed slightly from beneath, is reminiscent – albeit in reverse – of Rubens's portrait of the Antwerp theologian and parish priest of the church of St George, Hendrick van Thulden, painted around 1617 (fig. 1). H V

FIG I
Peter Paul Rubens, *Hendrick van Thulden*, c. 1617
oil on panel, 123.6 × 105.1 cm
Alte Pinakothek, Munich

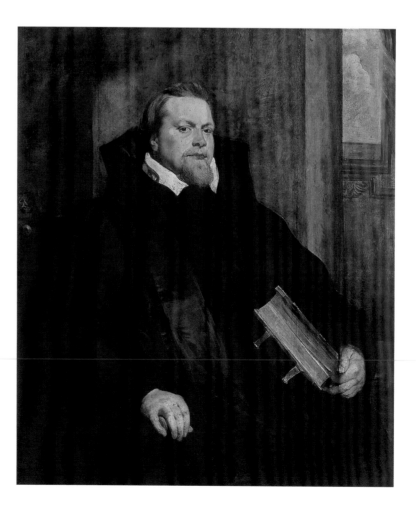

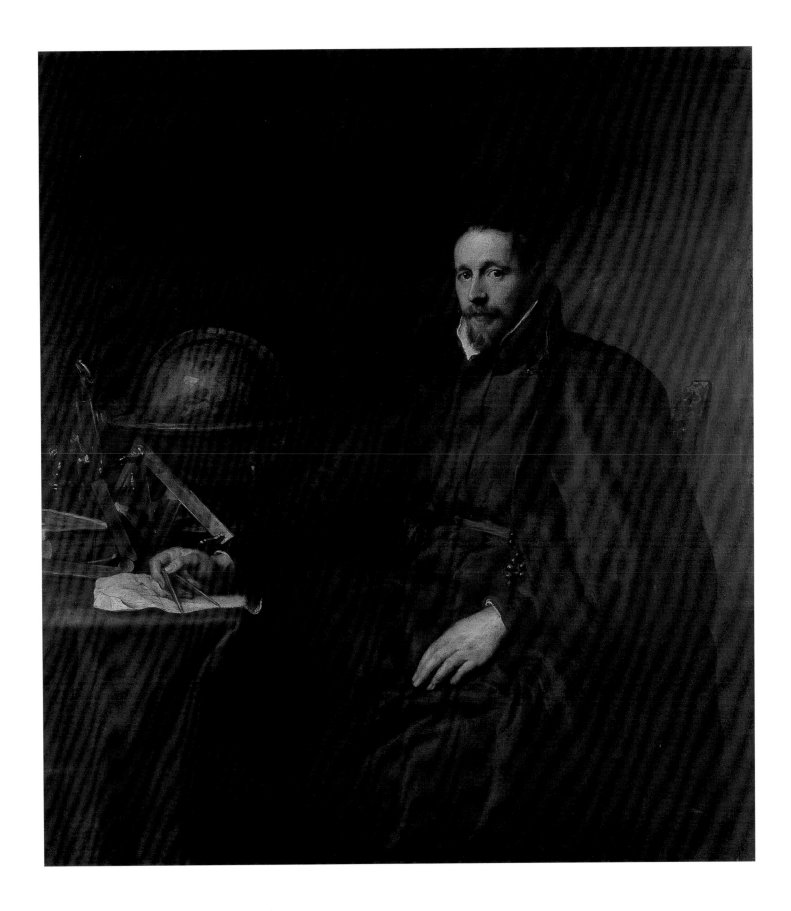

55 *Maria Louisa de Tassis*
c. 1629

oil on canvas, 128.2 × 99.5 cm

Collections of the Prince of Liechtenstein, Vaduz
Castle (inv. no. 58)

PROVENANCE 1710, bought by Prince Johann
Adam of Liechtenstein from the Antwerp painter
and dealer Jan-Pieter van Bredael

REFERENCES Fanti 1767, p. 75, no. 374;
Dallinger 1780, no. 650; Smith 1829–42, III, p. 33,
no. 113; Waagen 1866, I, p. 272; Falke 1873,
no. 115; Bode 1889, p. 48; Cust 1900, pp. 75–7,
260, no. 118; Schaeffer 1909, p. 294; Wilhelm
1911, p. 102; Kronfeld 1927, p. 21, no. 58; Glück
1931, pp. XLI, 333, 556; Strohmer 1943, p. 98;
Baldass 1957, pp. 265, 267–8; Wilhelm 1976, p. 72;
Baumstark 1980, pp. 159–60, no. 65; Brown 1982,
p. 106; Lorandi 1984, pp. 91, 124; Larsen 1988, I,
pp. 281, 284; II, p. 209, no. 521

EXHIBITIONS Lucerne 1948, no. 122; Bregenz
1965, no. 32; New York 1985–6, pp. 314–16,
no. 200 (entry by R. Baumstark); Washington
1990–91, no. 52 (entry by A. K. Wheelock);
Cologne and Vienna 1992–3, pp. 398, 400–01,
no. 61.5 (entry by C. Brown); Antwerp 1992–3,
no. 55 (entry by C. Brown)

Maria Louisa de Tassis (1611–38) was the only daughter of Antonio de Tassis, a
member of the famous northern Italian family that played an essential role in
organising Europe's international postal network. Antonio de Tassis pursued a career
in the army, during which he saw action in the Revolt of the Netherlands (Eighty
Years' War) fighting on the Spanish side. In the 1620s he served several terms as
alderman on the City Council of Antwerp and was knighted in 1627. His wife had died
in 1613. Antonio de Tassis was ordained in 1629, becoming a canon at Antwerp
Cathedral. He also commissioned a portrait of himself from Van Dyck, in which he is
shown in his canon's regalia (fig. 1). Its provenance matches that of this painting and
the two portraits are approximately the same size. It is quite possible that de Tassis
commissioned them both at the time of his ordination. Antonio de Tassis was a
discerning connoisseur, as witnessed by the magnificent collection of paintings he left
on his death in 1651. His taste is also recorded in the inscription beneath the engraved
portrait that Jacob Neeffs had made after the one in Vaduz for Van Dyck's
Iconography: 'PICTURAE, STATUARIAE, NEC NON OMNIS ELEGANTIAE
AMATOR ET ADMIRATOR' (Lover and admirer of paintings, sculpture and all
things elegant).

Maria Louisa de Tassis poses three-quarters to the left and is dressed in the latest
French fashion. Her white satin dress, elegantly decorated with ribbons, is picked out
in gold, the sleeves visible through dark over-sleeves. Her sophisticated appearance is
further accentuated by the wide, flat lace collar, the ostrich feather in her right hand
and her jewels: a small coral necklace with a pendant crucifix and a larger pearl
necklace with a heavy crucifix, set with diamonds.

Baumstark has rightly noted that the composition is a virtual mirror-image of Van
Dyck's *Portrait of Anna Wake* (cat. 49), but in this painting the drapery is painted more
fluently and there is a softer transition between the head and neck. HV

FIG 1
Anthony van Dyck,
Canon Antonio de Tassis, 1626–32
oil on canvas, 126 × 90 cm
Collections of the Prince of Liechtenstein,
Vaduz Castle

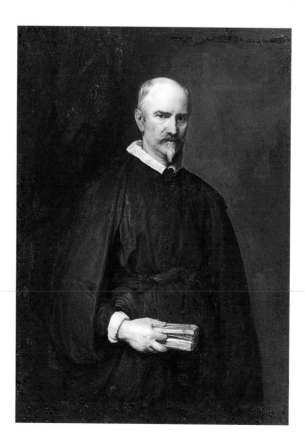

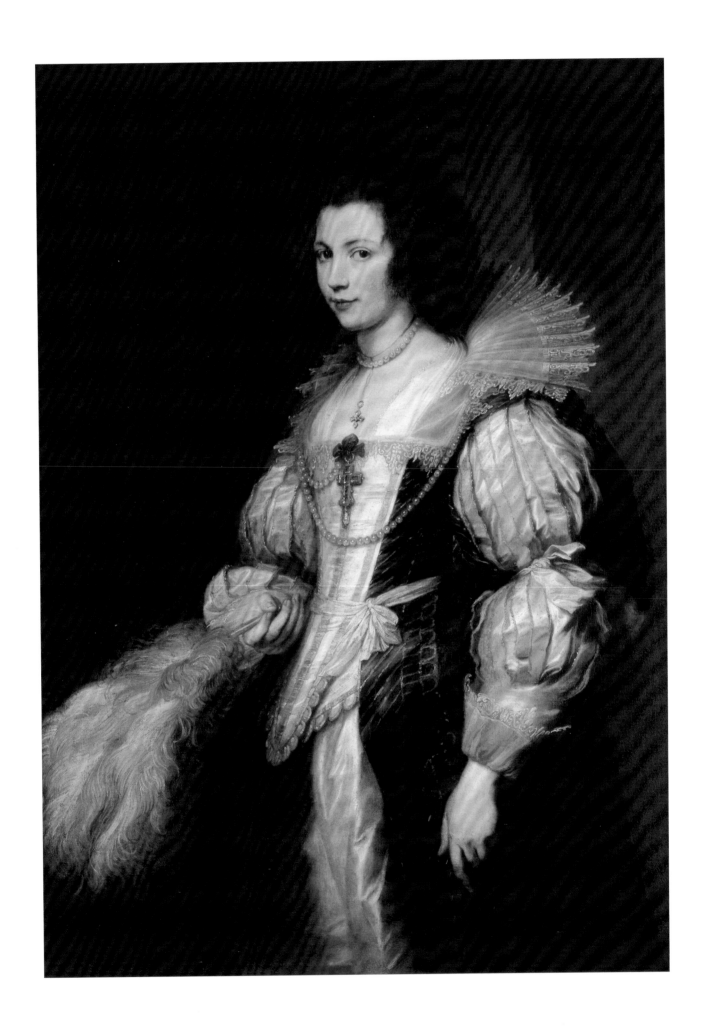

The Vision of the Blessed Herman Joseph

1630

oil on canvas, 160 × 128 cm

Kunsthistorisches Museum, Gemäldegalerie, Vienna (inv. no. 488)

PROVENANCE Jesuits' convent, Confraternity of Bachelors, Antwerp; 1776, acquired for the Imperial collections, Vienna, from the sequestered goods of the Jesuit Order

REFERENCES Tessin 1687, p. 82; Papebrochius c. 1700, IV, p. 431; De Wit c. 1748, p. 71; Mensaert 1763, I, p. 221; Descamps 1769, p. 189; Berbie 1774, p. 72; Mechel 1783, p. 110, no. 26; Smith 1829–42, III, p. 8, no. 24; p. 31, no. 107; Piot 1878, p. 147; Guiffrey 1882, pp. 100–01, 251, no. 186; Engerth 1884, pp. 112–13, no. 794; Cust 1900, p. 250, no. 64; Schaeffer 1909, pp. 113, 500; Glück 1931, pp. 243, 545; Vey 1962, p. 197; W. Prohaska, in Kunsthistorisches Museum 1987, pp. 190–91, no. 80; Larsen 1988, I, pp. 260, 262; II, p. 280, no. 696; Scheelen 1988, pp. 279, 282

EXHIBITIONS Brussels 1947, no. 33; Amsterdam 1947, no. 51; London 1949, no. 56

ENGRAVING by Paulus Pontius

NOTE
1. Noted by Prohaska.

Herman Joseph was a pious Norbertine monk who lived at Steinfeld Abbey, in the Eifel region, around 1200. He was famous for his devotion to the Virgin Mary, who appeared to him in a vision, accompanied by two angels, and entered into a 'mystic marriage' with him.

Van Dyck made this painting in 1630 for the altar of the Bachelors' Confraternity – which was dedicated to the Virgin – in the Jesuit convent in Antwerp. He was paid 150 guilders for the work; this relatively low sum may have reflected the fact that Van Dyck himself had been a member of the Confraternity since 1628. In 1629 he had painted a larger work – *The Coronation of St Rosalia* (fig. 44) – for the same institution, for which he also received a modest fee of 300 guilders. Both paintings emphasise chastity as the ideal for unmarried people, who were meant to devote themselves to the Virgin Mary. The choice of the Blessed Herman Joseph, who was not a Jesuit, as the model for the celibate bachelor is, however, surprising. Papebrochius, evidently basing himself on earlier sources, states in his *Annales Antverpienses*, compiled around 1700, that the choice of subject reflected the fact that the Confraternity was headed at the time by Father Herman Spruyt.

Van Dyck depicts the moment when the Virgin appears to the monk. The intensity of the miraculous event is conveyed in Herman Joseph's expression of devotion and submission, as Mary gently touches him and speaks to him. The supernatural atmosphere is further heightened by the delicate shifting light effects, which imbue the colours – for the most part pinkish-red, blue, orange and white – with an unearthly glow. Van Dyck's point of departure for this painting[1] may have been *The Ecstasy of St Theresa* painted by Rubens in 1614–15 for the church of the Discalced Carmelites (formerly Asscher & Welker, London; destroyed). The *contrapposto* arrangement of the figures is largely the same, though reversed. Rubens, however, placed less emphasis on the intensity of the monk's mystical surrender than Van Dyck; spiritually Herman Joseph is much closer to Bernini's version of *The Ecstasy of St Theresa*, sculpted between 1645 and 1652 (S. Maria della Vittoria, Rome). Bernini belonged to the same generation as Van Dyck and displayed a similar sensibility in more than one respect. A more direct source for Van Dyck's painting was Gerard Seghers's *Vision of St Francis Xavier*, also painted for the Jesuit church in Antwerp, of which Paulus Pontius engraved a print in 1629 (see fig. 55). Seghers's religious work, with its emotional rendering of mystic exultation in the manner of the Italian 17th-century masters, had a marked influence on Van Dyck. Moreover, it is likely that the Jesuits themselves drew Van Dyck's attention to *The Vision of St Francis Xavier*, which Seghers had painted for their church. HV

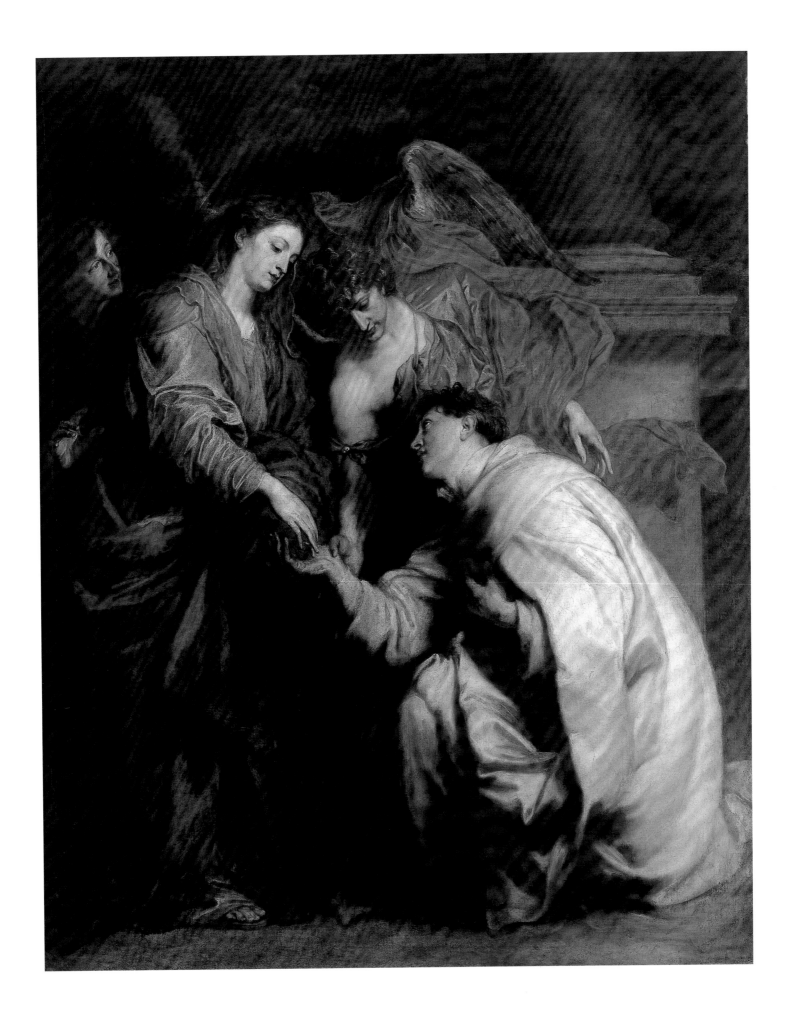

57 *The Virgin and Child with Two Donors*

c. 1630

oil on canvas, 250 × 191 cm; 57 cm strip added
at the top after 1709

Musée du Louvre, Département des Peintures,
Paris (inv. no. 1231)

PROVENANCE 1668, bequest of Canon
Guilielmus van Hamme, Antwerp(?); 1685,
acquired by the painter Gabriel Blanchard for
the collection of Louis XIV

REFERENCES Smith 1829–42, III, no. 149;
Villot 1852, II, no. 137; Michiels 1881, pp. 264–6;
Guiffrey 1882, pp. 107, 109, 246, no. 70; Engerand
1899, pp. 252–3; Cust 1900, p. 249, no. 45;
Schaeffer 1909, pp. 83, 499; Demonts 1922, p. 30;
Glück 1931, pp. 245, 545; Bouchot-Saupique
1947, pp. 66–7; Vey 1962, p. 202; Constans 1976,
pp. 162, 172; Brejon de Lavergnée, Foucart and
Reynaud 1979, p. 51; Brejon de Lavergnée 1987,
pp. 459–60, no. 482; Larsen 1988, I, pp. 160, 262;
II, p. 263, no. 645

EXHIBITION Antwerp 1949, no. 17

The Virgin and Child sit beneath a canopy hanging from the branches of a tree.
A middle-aged couple kneels to the right. They wear sober, dark clothes, enlivened
by white ruffs. Two small angels hover above them.

The identity of the donors is unknown. The painting must have been moved from
its original location at an early date, since it was in the collection of Louis XIV in 1685.
It may be the 'large painting by Sir Anthony van Dyck, comprising an image of the
Madonna with two portraits, on canvas...' recorded on 24 May 1668 in the estate of
Canon Guilielmus van Hamme of Antwerp (Denucé 1932, p. 246).

The donors participate in the supernatural event in a way that recalls Titian's votive
paintings. The composition is similar to an Adoration of the Magi. The work originally
appears to have had a commemorative function, perhaps decorating the couple's tomb.
Devotion to the Christ Child and appeals for the Virgin's intercession were traditional
for such paintings, as they were in 17th-century funerary art, in both sculpture and
painting – see, for instance, Jerome Duquesnoy's tomb of Antonius Triest (1652–4;
St Bavo Cathedral, Ghent) and Rubens's *Votive Painting of Alexander Goubau and his
Wife* (*c.* 1615; fig. 1). HV

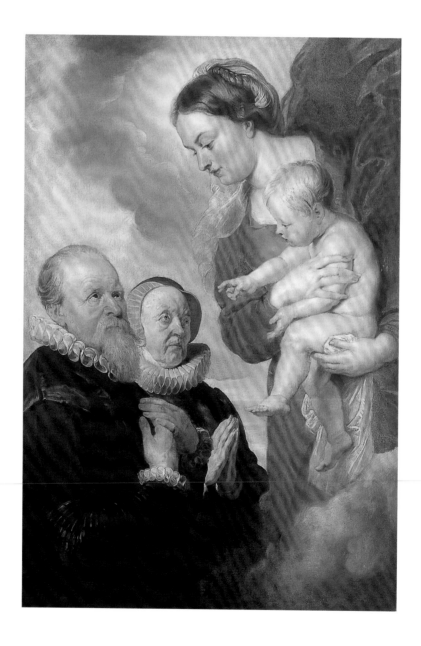

FIG 1
Peter Paul Rubens, *Votive Painting of Alexander
Goubau and his Wife*, *c.* 1615
oil on panel, 124 × 84 cm
Musée des Beaux-Arts, Tours

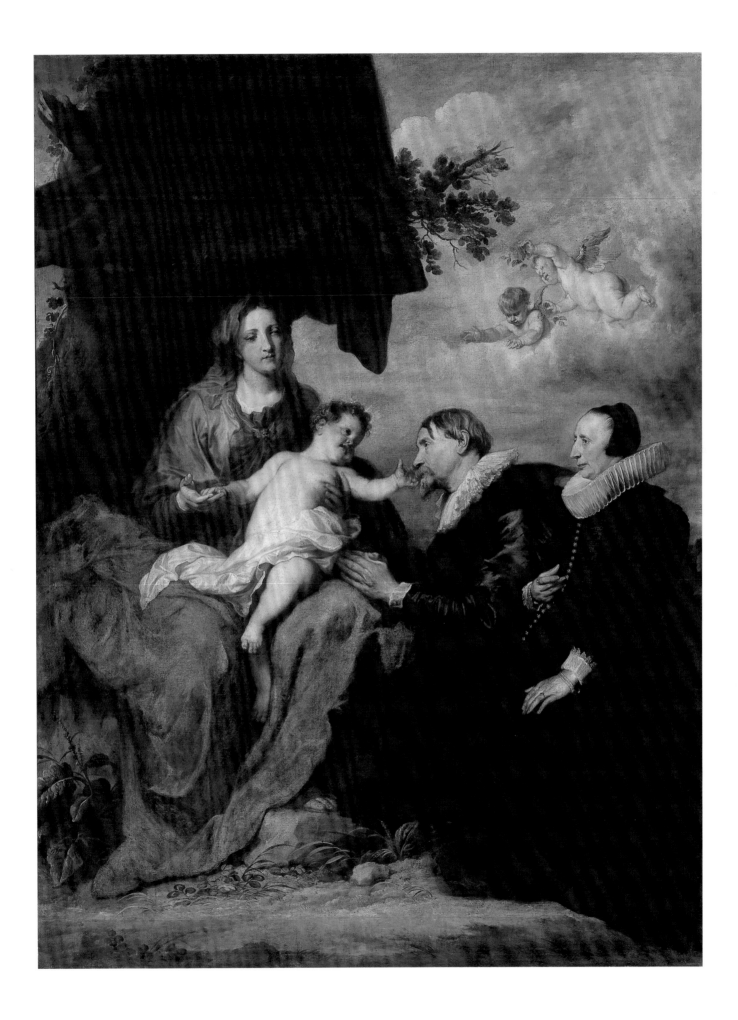

58 Samson and Delilah

c. 1630

oil on canvas, 146 × 254 cm; heavily trimmed at the top in the 18th or 19th century

Kunsthistorisches Museum, Gemäldegalerie, Vienna (inv. no. 512)

PROVENANCE 1659, Archduke Leopold Wilhelm, Brussels and Vienna; Imperial Collections, Vienna

REFERENCES Bellori 1672, p. 262; Mechel 1783, p. 102, no. 1; Smith 1829–42, 111, p. 32, no. 110, p. 91, no. 314; Guiffrey 1882, pp. 144, 243, no. 4; Berger 1883, p. CXXI, no. 112; Engerth 1884, pp. 114–15, no. 797; Cust 1900, p. 69; Schaeffer 1909, pp. 20, 496; Glück 1931, pp. 262, 547; Tietze-Conrat 1932, pp. 246–7; Evers 1943, pp. 164, 165; Vey 1962, p. 204; Garas 1968, p. 112; Kahr 1972, p. 296, n. 53; Larsen 1975, p. 144; Prohaska, in Vienna 1987, pp. 184–5, no. 77; Larsen 1988, pp. 269, 271, no. 252; 11, p. 295, no. 745; Balis 1994, pp. 177–80; Gritsai 1996, p. 103

EXHIBITIONS Zurich 1946, no. 388; Brussels 1947, no. 30; Amsterdam 1947, no. 49; London 1949, no. 54

ENGRAVING by Hendrik Snyers

NOTE
1. Pointed out by Balis 1994.

FIG 1
Niccolò Boldrini after Titian,
Samson and Delilah, 1540–45
woodcut, 30.1 × 49.2 cm

Samson had fallen asleep with his head in Delilah's lap; Delilah has already betrayed Samson, and the Philistine soldiers rush into the room to bind him and gouge out his eyes (Judges XVI, 20–21). Van Dyck had painted the same subject around 1619–20, basing his work on Rubens's *Samson and Delilah* of 1609 (see cat. 21, fig. 1). Once again, Van Dyck took his cue from Rubens, this time from an oil sketch (Art Institute of Chicago), and a painting produced in Rubens's workshop in the early 1620s (Alte Pinakothek, Munich).

Rubens emphasised the furious, if hopeless, resistance Samson mounted against his captors, and stressed Delilah's allure, to which Samson had fallen prey, showing her in the nude with a sultry and sensual expression – especially in the Chicago sketch – turning away from Samson, thereby emphasising her betrayal. Van Dyck's figures assume the same poses and positions as Rubens's, but the brutal physical and erotic violence of the earlier painting is replaced by a very different interpretation, conveying the inherent tragedy of the drama in a much more penetrating way than Rubens. Samson, who appears to have given up the struggle, gazes at his treacherous lover for the last time with sorrow and longing. Van Dyck also drew inspiration from the best known of all antique images of pathos, the dying Laocoön. Moreover, Delilah is no longer portrayed as a heartless *femme fatale*, as she was by Rubens, but rather is shown to be prey to powerfully conflicting emotions. Her sad gaze falls on Samson, and she caresses him one last time with her left hand, apparently responding to Samson, who stretches out his hand towards her.

The rich colouring and melancholic atmosphere of the painting reveal Van Dyck's familiarity with the work of Titian. Van Dyck looked back to a composition of the same subject by Titian, reproduced in a woodcut by Niccolò Boldrini (fig. 1), from which he took the detail of Samson touching Delilah's thigh.

The painting was first recorded in a 1659 inventory of the collection of Archduke Leopold Wilhelm of Austria, who served as Philip IV's Governor of the Southern Netherlands between 1647 and 1656. Bellori recorded that the Archduke had acquired the work from 'Signor Van Woonsel', possibly the merchant Marcus van Woonsel, who was also involved in Van Dyck's commission to paint *The Raising of the Cross* in Kortrijk (cat. 61). The melodramatic facial expressions of the male protagonists are close to those in *The Raising of the Cross*. It therefore seems plausible to date Van Dyck's *Samson and Delilah* to c. 1630.

The facial expressions were worked out in preliminary drawings. A sheet of studies has a black chalk drawing of the torso of the Samson and the heads of two of the soldiers (Institut Néerlandais, Fondation Custodia, Paris). These differ in that the bearded soldier standing behind Samson in the painting is positioned to the hero's right in the drawing. His place is taken by a young, clean-shaven man, who appears in the painting in profile on the far right.

The composition was engraved around 1642 by Hendrik Snyers on behalf of Abraham van Diepenbeeck, who also painted the grisaille intended to serve as the *modello* for the engraving (Musée Pescatore, Luxembourg).[1] HV

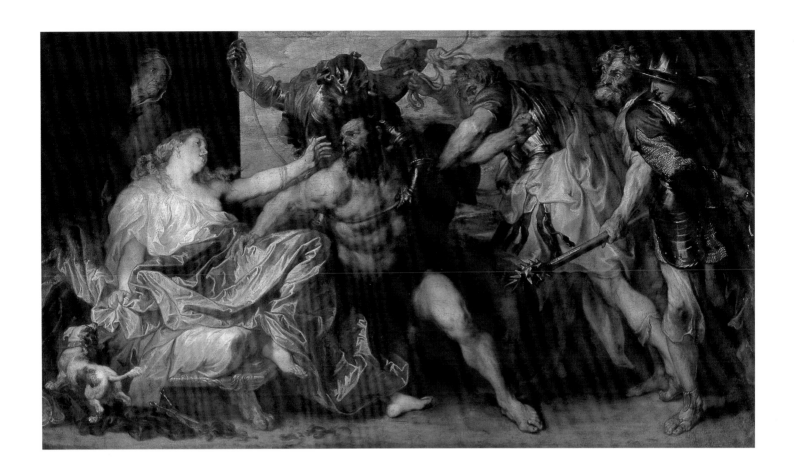

59 *The Assumption of the Virgin c. 1630*

oil on panel, two planks, 59.5 × 42 cm; strips
measuring 2.5 cm added to the left and right

Gemäldegalerie der Akademie der bildenden
Künste, Vienna (inv. no. 643)

PROVENANCE Collection Count Anton
Lamberg-Sprinzenstein, Vienna; donated in 1822

REFERENCES Schwemminger 1866, p. 435,
no. 486; Lützow 1889, p. 242, no. 643; Frimmel
1892–1901, IV, p. 162; Cust 1900, p. 249, no. 52;
Eigenberger 1924, pp. 37–9; id. 1927, pp. 117–18;
Glück 1931, pp. 253, 546; Vey 1956, pp. 189–94;
Kurz 1957, pp. 179–82; d'Hulst and Vey 1960,
pp. 160–61, no. 127; Vey 1962, p. 139, under
no. 70; Poch-Kalous 1972, p. 99, no. 171;
Lahrkamp 1982, pp. 44–5; Larsen 1988, I, pp. 473,
474; II, p. 279, no. 692; Trnek 1989, p. 68

EXHIBITIONS Antwerp and Rotterdam 1960,
no. 127; Princeton 1979, no. 49; Washington
1990–91, pp. 349–50, no. 96 (entry by J. S. Held);
Cologne and Vienna 1992–3, pp. 320–21, no. 34.4
(entry by C. Brown); Antwerp 1992–3, p. 84,
no. 21 (entry by C. Brown)

NOTES
1. Pointed out by Julius Held.
2. Pointed out by Otto Kurz.
3. Known from an engraving by C. Warren, who
attributed the work to Jan Boeckhorst.
4. Auctioned at Christie's in London on 21 July
1972, no. 117. It measures 62.5 × 39.4 cm. One of
these copies may have been the 'Assumption of
Our Lady, after Van Dyck, on panel, framed',
mentioned on 24–6 October 1652 in the estate
inventory of the painter and art dealer Victor
Wolfvoet (Denucé 1932, p. 147).

The primary source for the subject of the Assumption of the Virgin was the apocryphal texts popularised in *The Golden Legend*. The composition is divided into a heavenly zone, in which Mary is raised to heaven, and an earthly one, in which the amazed apostles stand around her empty tomb, staring after her.

The composition derives from the *Assumption* painted by Titian in 1516–18 for the high altar of Santa Maria Gloriosa dei Frari in Venice, but Van Dyck was also influenced by more contemporary interpretations of the subject, in particular those of Rubens. It is not surprising that Van Dyck should have taken Rubens's painting of 1626 for the high altar of Antwerp Cathedral as his model, as it had been finished only recently when he began work on his own interpretation.[1] In that painting Rubens expressed pathos more explicitly than in his earlier work, by means of dramatic staging, vehement gestures and swirling contours. The expansive gestures of the Virgin and the apostles derive from Rubens, as does the configuration around the empty tomb. In fact, Van Dyck seems to have borrowed more from the *modello* (fig. 1) than from Rubens's altarpiece. The apostle who flings his arms in the air is borrowed from Rubens's St John.

Guido Reni's *Assumption* of 1617 in S. Ambrogio, Genoa, also appears to have left its mark on Van Dyck's composition (fig. 2).[2] It is a work with which Van Dyck was undoubtedly familiar, as is borne out by an iconographical detail noted by Held. Whereas in Rubens's versions of the Assumption a number of women are present, Reni – following Titian's example – omitted the female bystanders, as did Van Dyck.

The commission for which this oil sketch was made has not been identified. Unlike most of Van Dyck's sketches, this one has touches of colour, which has prompted Christopher Brown to conclude that the colouring must have been added later.

As with so many of Van Dyck's oil sketches, this *modello* appears to have been copied at an early date. (This happened with the oil sketch for *St Augustine in Ecstasy*; see cat. 52.) The attribution of a copy in the Bridgewater collection in the 19th century[3] to Boeckhorst prompted Christopher Brown to wonder if cat. 59 might not have been by that master. I do not detect any compelling reason to doubt the attribution of the sketch to Van Dyck, since it has much in common with other oil sketches firmly ascribed to him. Nevertheless, it might be interesting to consider whether the colouring that Brown thought might have been added later could be Boeckhorst's work. We know that he retouched other paintings by Van Dyck, and the colour range is similar to that of Boeckhorst. A second, inferior copy[4] is rounded at the top, which suggests that the altarpiece was to be that shape too. HV

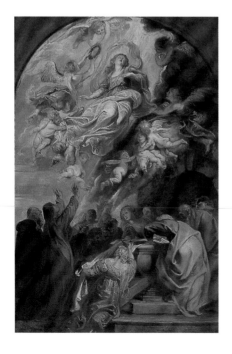

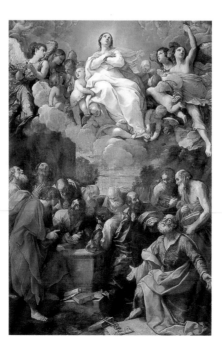

FIG 1
Peter Paul Rubens, *The Assumption
of the Virgin*, 1620–25
oil on panel, 90 × 61 cm
Koninklijk Kabinet van Schilderijen 'Mauritshuis',
The Hague, Stichting Vrienden van het Mauritshuis

FIG 2
Guido Reni, *The Assumption of the Virgin*, 1617
oil on canvas, 442 × 287 cm
S. Ambrogio, Genoa

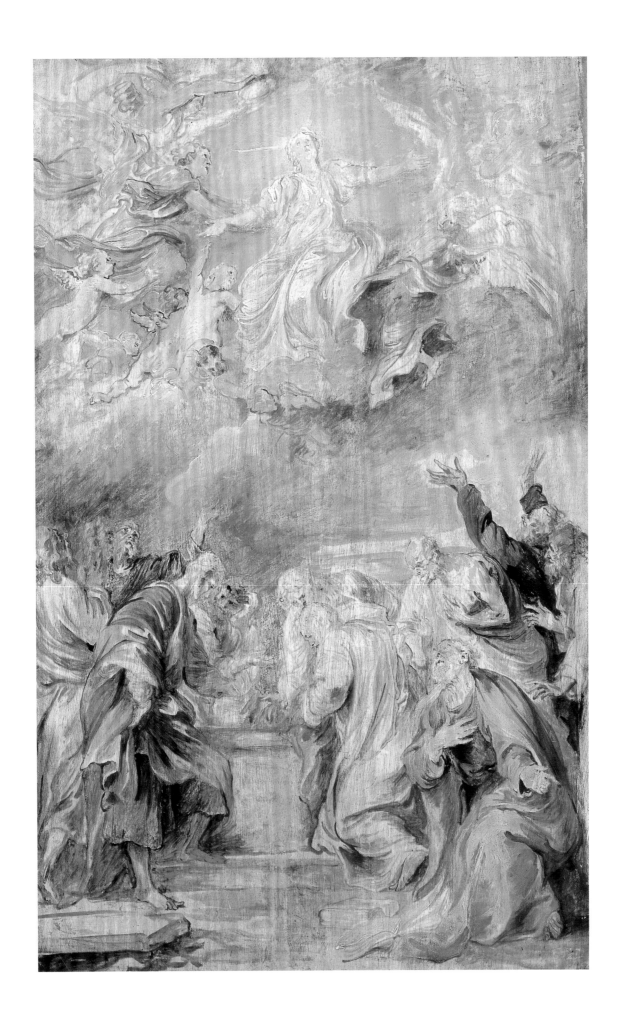

60 *The Rest on the Flight into Egypt, c. 1630*

oil on canvas, 134.7 × 114.8 cm; approx. 20 cm
strip added to the top

Bayerische Staatsgemäldesammlungen,
Alte Pinakothek, Munich (inv. no. 555)

PROVENANCE Acquired by Elector Max
Emmanuel of Bavaria; Schloss Schleissheim;
in 1781 transferred to the Hofgartengalerie,
Munich; since 1836 on display at the Alte
Pinakothek

REFERENCES Smith 1829–42, III, p. 17, no. 48;
Guiffrey 1882, p. 244, no. 21; Cust 1900, p. 246,
no. 8; Schaeffer 1909, pp. 82, 499; Glück 1931,
pp. 228, 543; Back-Vega 1953, p. 31; Vey 1961,
p. 22; id. 1962, p. 202; Princeton 1979, p. 144;
Brown 1982, pp. 123–5, 126; Krempel, in Munich
1983, p. 185, no. 555; Larsen 1988, 1, pp. 260, 263;
11, p. 290, no. 729; Moir 1994, pp. 90–91

EXHIBITIONS Brussels 1948, no. 104; London
1949, no. 40; Berne 1949–50, no. 84

ENGRAVING by Schelte à Bolswert

Since the early 16th century *The Rest on the Flight into Egypt* had been a popular religious subject for personal devotion for both clergy and laity. Like other miraculous events that supposedly occurred during the flight of the Holy Family into Egypt, the subject was taken from the apocryphal texts, especially that of the Pseudo-Matthew.

The painting places particular emphasis on Mary and Joseph's love for the sleeping child. All anecdote is eliminated, and only the trees in the background indicate that this is a scene from the Flight into Egypt. As with similar themes that were made chiefly for private devotion, the Holy Family is shown as the prototype of the Christian family. In interpreting the subject in this way, Van Dyck was subscribing to the widespread contemporary view, stressed by Counter-Reformation theologians, of the importance of the Holy Family as a guiding light for a society inspired by Catholic principles.

This painting was probably made as an *Andachtsbild* for use in private worship. A 'Flight into Egypt' is mentioned in the inventory of Theodoor van Dyck's possessions drawn up between 1640 and 1668. Theodoor, the painter's brother, was a Norbertine canon who took the name of Waltman. He lived for some time at the Abbey of St Michael in Antwerp, and served as a parish priest at Minderhout. No further details of his painting are given, so we cannot be certain that it was this one. It is, however, plausible, because Van Dyck dedicated Schelte à Bolswert's engraving after the Munich composition to his brother.

The work is particularly harmonious thanks to the triangular composition of the figures, the soft colouring, and the balance between figures and landscape: it is one of the most Titianesque of Van Dyck's works dating from his second Antwerp period. Despite its gentle, even sentimental, character and the interplay of facial expressions and gestures, the figures retain a plasticity characteristic of other religious works of the period, in particular *The Vision of the Blessed Herman Joseph* (1630; cat. 56). In terms of the figures' types and their relationship both with one another and with their surroundings, the work also shares similarities with *The Mystic Marriage of St Catherine* (fig. 1), painted around 1630. It therefore seems plausible to date the *Rest on the Flight* about or a little before 1630. A drawing (Hermitage, St Petersburg) is a study for the Virgin and the sleeping Christ Child. HV

FIG 1
Anthony van Dyck, *The Mystic Marriage of St Catherine, c. 1630*
oil on canvas, 126.4 × 119.4 cm
Her Majesty The Queen

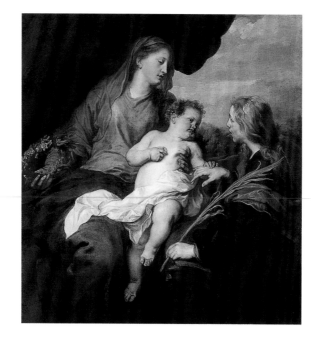

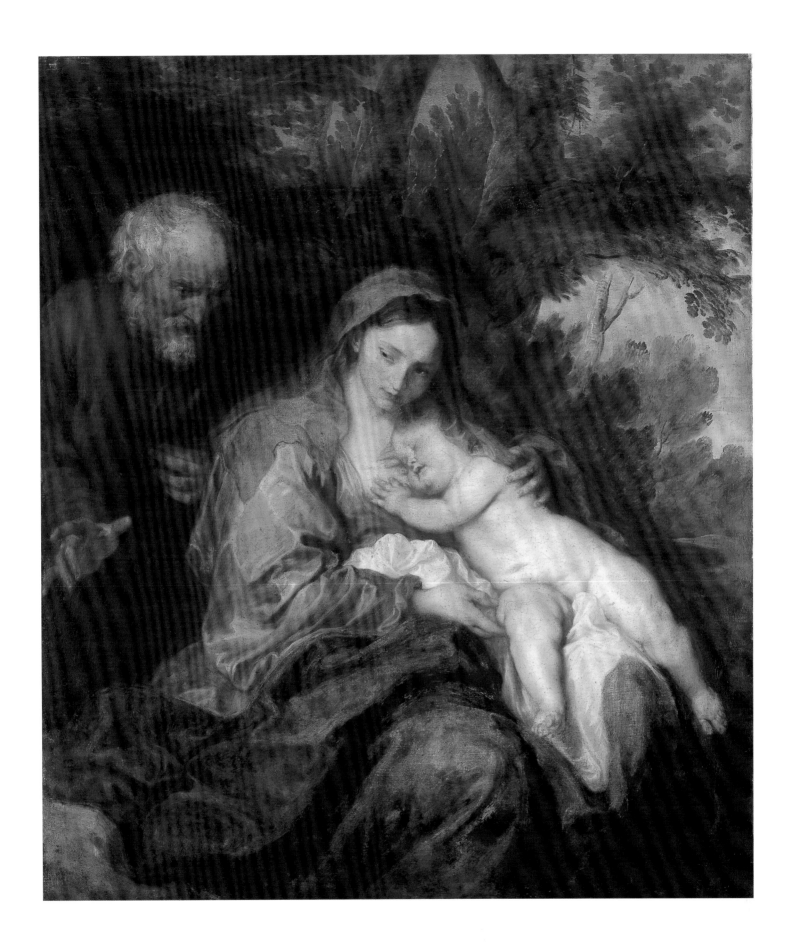

The Raising of the Cross
1630–31

oil on canvas, 345 × 280 cm

Kerkfabriek Onze-Lieve-Vrouw, Kortrijk

PROVENANCE 1631, painted for Onze-Lieve-
Vrouwekerk; 1794, transferred to Paris, where it
was exhibited in the Louvre; 1802, made over by
the French government to the Brussels museum
where it was exhibited until 1817; 1817, returned
to Onze-Lieve-Vrouwekerk

REFERENCES Descamps 1753–4, II, pp. 14–15;
Mensaert 1763, pp. 66–7; Descamps 1769,
pp. 261–2; Smith 1829–42, III, pp. 11–12, no. 33;
Guiffrey 1882, pp. 134–42, 247, no. 102; Van den
Branden 1883, pp. 718–20; Piot 1883, pp. 36,
276–7, 334, 434, 436; Rooses 1900, pp. 48–9;
Cust 1900, pp. 64–5, 247, no. 16; Schaeffer 1909,
pp. 114, 500; Caullet 1912–13, pp. 64–101, 343–8;
Decoen 1925, pp. 1–16; Glück 1931, pp. 249, 545;
Van Molle 1953, pp. 145–59; Billiet 1960,
pp. 226–9; Devliegher 1965, pp. 9, 77–8;
Debrabandere 1966, pp. 135–53; Vlieghe 1972,
no. 10; Larsen 1975, pp. 21–3, 69–72; De Man
1980a, pp. 53–154; De Man 1980b, pp. 251–9;
Brown 1982, p. 118; Larsen 1988, I, pp. 252–5,
258; II, pp. 283–4, no. 705

EXHIBITIONS Antwerp 1899, no. 12; Brussels
1910, no. 103; Antwerp 1949, no. 17

ENGRAVING by Schelte à Bolswert

On 8 November 1630 Van Dyck wrote to Rogier Braye, an elderly canon at the church of Our Lady in Kortrijk, stating his willingness to paint a Crucifixion. He also indicated that he had already produced an oil sketch for the patron's approval, but that he considered the price proposed by Braye's nephew, the Antwerp merchant Marcus van Woonsel, to be too low. A fair price for the painting, Van Dyck suggested, would be 800 guilders, but he remained open to negotiation and wished to start work quickly. Braye's answer was delivered via Marcus van Woonsel in the form of a humorous poem: the canon replied that Van Dyck would be ill-advised to refuse the offered price of 600 guilders.

We do not have the artist's reply, but evidently he did not attempt to drive too hard a bargain. In 1631, Braye paid for a new altar for the chapel of St Blaise and St Nicholas in the church of Our Lady, Kortrijk, specifying that Van Dyck's *Raising of the Cross* was to be installed there. Van Woonsel wrote to Braye on 8 May 1631 that the canvas had been dispatched from Antwerp by cart and was due to arrive the following day. The canvas was to remain rolled up until the frame was ready. Braye wrote to Van Dyck on 13 May 1631 to congratulate him on the finished work. Van Dyck in turn wrote to thank his patron on 20 May 1631. Two days earlier, the artist had presented Van Woonsel with a receipt, from which we learn that he had after all agreed to accept the sum of 600 guilders. His letter to Braye on 20 May tells us that he also received a bonus of a dozen Kortrijk waffles. Unusually, Van Dyck gave the preparatory oil sketch

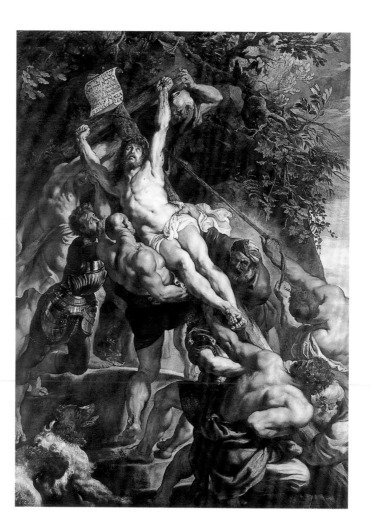

FIG 1
Peter Paul Rubens,
The Raising of the Cross, 1610–11
oil on panel, 462 × 150 cm
Cathedral, Antwerp

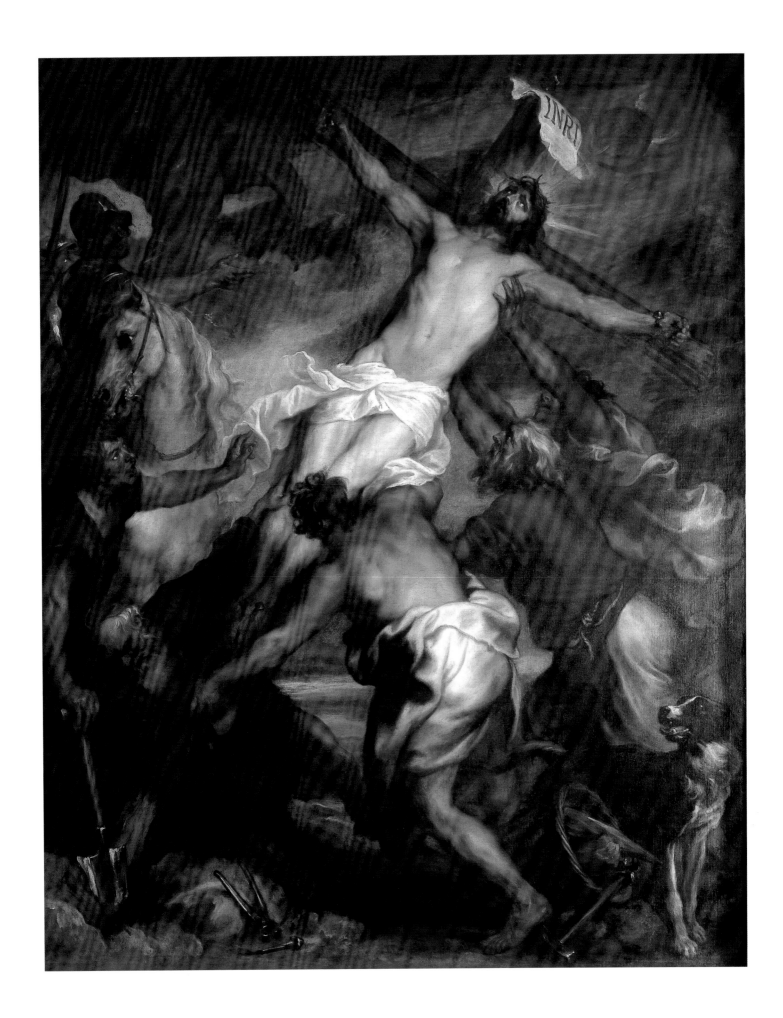

to Van Woonsel, evidently wishing to please his patron, Braye. The latter died on 27 October 1632, and was interred in front of Van Dyck's altarpiece. This suggests that the canon had wished to have the painting as his memorial – the theme of salvation through the Cross would have been eminently suitable in this context. Braye's choice of subject also reflected his own, highly personal devotion: the theme of the Crucified Christ recurs frequently in his religious poetry.

Rubens's *Raising of the Cross* of 1610–11 (fig. 1) was clearly Van Dyck's prototype. The central part of Van Dyck's altarpiece refers, albeit in reverse, to Rubens's painting for St Walburga, Antwerp (now in the Cathedral). Van Dyck, however, transformed the monumental and heroic character of Rubens's work into a much more introspective interpretation in which the characters express their inward emotional turmoil. His composition differs from that of Rubens in that the figures are set further back from the picture plane and more elongated. This emotionally charged rendering of devotional subjects was introduced into Flemish baroque art by Gerard Seghers (1591–1651) in his *Raising of the Cross* (fig. 3) for the high altar of the Jesuit church in Antwerp. The connection with Seghers is even closer in Van Dyck's oil sketch (fig. 2). H V

FIG 2
Anthony van Dyck,
The Raising of the Cross, 1630–31
oil on panel, 26 × 21.5 cm
Musée Bonnat, Bayonne

FIG 3
Gerard Seghers,
The Raising of the Cross, 1624–5
oil on canvas, 535 × 395 cm
St Carolus Borromeus, Antwerp

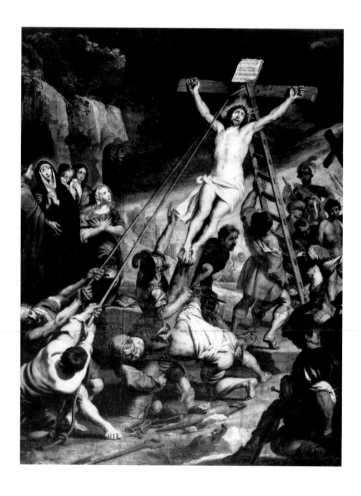

62 *Amaryllis and Mirtillo*
1631–2

oil on canvas, 120 × 135 cm

Graf von Schönborn Collection, Pommersfelden
(inv. no. 44)

PROVENANCE 1632–47, Frederik Hendrik of
Orange-Nassau, Stadhouderlijk Kwartier, The
Hague; 1647–50, William II of Orange-Nassau,
The Hague; 1650–1702, William III, The Hague;
from 1694–5, Het Loo, Apeldoorn; 1702–11, Johan
Willem Friso, Het Loo, Apeldoorn; 1711–13, heirs
Johan Willem Friso, Het Loo, Apeldoorn, where it
was appraised in 1712; sale Amsterdam, 26 July
1713, no. 5; purchased by the painter Jan Joost de
Cossiau for 3600 guilders on behalf of Elector
Lothar Franz von Schönborn, for the latter's
Schloss Weissenstein, Pommersfelden; since 1719,
catalogued at Pommersfelden

REFERENCES Bellori 1672, p. 314; Nordenfalk
1938, p. 36; Van Gelder 1959, pp. 53, 57–8; Damm
1966, p. 67; Drossaers and Lunsingh Scheurleer
1974–6, I, pp. 183 (no. 25), 677 (no. 828), 698
(no. 75); Larsen 1975, pp. 90–91; Van Gelder
1978, pp. 237, 243–6; Brown 1982, pp. 128, 130;
Kettering 1983, pp. 12, 109, 182, 193; Lohse
Belkin 1987, pp. 143–52; Brown 1987, p. 164;
Larsen 1988, I, pp. 247–9; II, pp. 292–3, no. 735;
Van den Brink 1993, pp. 19–21

EXHIBITIONS Washington 1990–91,
pp. 239–42, no. 60 (entry by A. K. Wheelock);
The Hague 1998, pp. 37, 114–17, no. 5 (entry
by P. van der Ploeg)

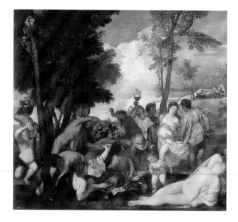

FIG 1
Titian, *Bacchanal (The Andrians)*, 1518–19
oil on canvas, 175 × 193 cm
Museo Nacional del Prado, Madrid

The nymph Amaryllis sits beneath a gold brocade awning suspended from the branches of a tree, waiting to be crowned by her lover, Mirtillo. Some of her smiling companions point towards the couple as if to emphasise Mirtillo's amorous gesture, while others embrace. The *putti* who hover above the couple further accentuate the tenderness of the moment. The scene is taken from the famous late 16th-century pastoral drama *Il Pastor Fido* by Giovanni Battista Guarini, which sparked a revival in pastoral and epic poetry and had an immense impact, not only in Italy, but also in France, Britain and the Netherlands. The idyll of a carefree life in Arcadia, in perfect harmony with nature, was quickly adopted in drama, music and the visual arts.

The moment depicted here is one of the climaxes of Guarini's narrative. Amaryllis organised a kissing contest for her nymphs, prompting Mirtillo, who was in love with her, to disguise himself as a woman and enter the competition. He was declared the winner and Amaryllis awarded him a floral crown, which he promptly placed on her head. The couple were later to marry, thereby fulfilling an oracle that said that the land would be ravaged by plague until a nymph and shepherd, both offspring of the gods, should marry. Thereafter their land was protected from all disasters.

The painting is first recorded in the 1632 inventory of Frederik Hendrik of Orange-Nassau, Stadtholder of the United Provinces, when it hung in his residence in The Hague. Van Dyck may have painted the work during his visit to the Dutch city in 1631–2. Frederik Hendrik's secretary, the humanist and poet Constantijn Huygens, may have acted as adviser for the commission, as he was a great admirer of Flemish baroque art and negotiated other commissions that Van Dyck received from the House of Orange. Pastoral love poetry also formed an important part of his own literary work.

The Stadtholder also owned Van Dyck's *Achilles and the Daughters of Lycomedes* (cat. 63, fig. 1), a work of similar size, which makes it reasonable to suppose that the two works were commissioned at the same time. Their subjects are also related, since both Mirtillo and Achilles disguised themselves as women to achieve their goals. The Stadtholder was fond of the pastoral genre. He also owned Van Dyck's *Rinaldo and Armida* (Louvre, Paris) and similar 'Arcadian' works by Dutch painters like Honthorst and Poelenburgh.

Two other versions of this composition (Galleria Sabauda, Turin, and Gothenburg Museum) have also been proposed as Frederik Hendrik's Van Dycks, but the execution of the Pommersfelden painting is superior and its provenance matches that of its pendant, *Achilles and the Daughters of Lycomedes*.

Together with his two interpretations of *Rinaldo and Armida* (a painting of 1629 is in the Baltimore Museum of Art, fig. 59; another painted before 1632 is in the Louvre), this is one of Van Dyck's most original contributions to the pastoral genre. It is also one of the works in which he most clearly emulates Titian, taking as his model his *Bacchanal (The Andrians)* (fig. 1), which he saw in the Ludovisi collection when he was in Rome and copied in his Italian Sketchbook (British Museum, London). This influence is evident in the harmonious mood between the carefree lovers and the luxuriant landscape, and is further heightened by the warm colouring, also derived from Titian. Nevertheless, Van Dyck stamps his own, very personal sensitivity on this Venetian-inspired composition, imbuing the graceful play of the nymphs with a more 'musical' feel than we find in Titian's great work. HV

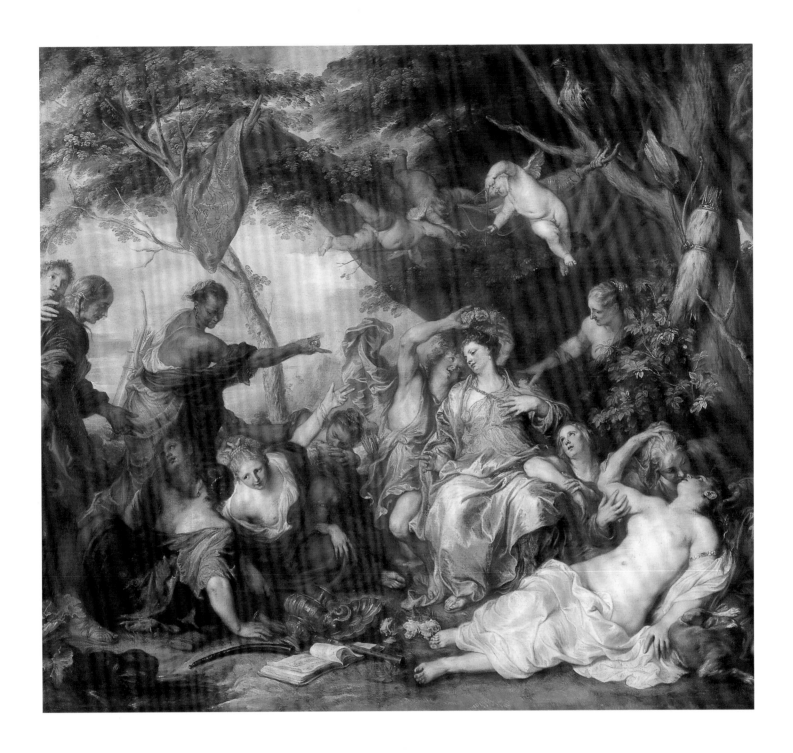

63 *Amaryllis and Mirtillo*

1631–2

oil on panel, 23.1 × 35.3 cm

Ecole Nationale Supérieure des Beaux-Arts, Paris
(inv. no. 11704)

PROVENANCE J.C. Robinson (1824–1913),
London; 7–8 May 1868, sale Drouot, Paris, no. 23;
A. Armand (1805–88), Paris; P. Valton, Paris;
1908, bequeathed to the Ecole Nationale
by Mme Valton

REFERENCES Guiffrey 1882, p. 39; Glück 1919,
pp. 38–40; Rouchès 1924, p. 97; Glück 1933,
pp. 340–41 (as Simon de Vos); Burchard 1933,
p. 415; Nordenfalk 1938, pp. 36–48; Van den
Wijngaert 1943, p. 137; d'Arschot 1949, p. 270;
Vey 1956, p. 181; Van Gelder 1959, p. 58, n. 12;
d'Hulst and Vey 1960, pp. 165–6, no. 132; Vey
1962, p. 137, under no. 69; Larsen 1988, I,
pp. 247, 249; II, p. 293, no. 736; Washington
1990–91, p. 242, under no. 60 (entry by A.K.
Wheelock); The Hague 1998, pp. 37, 114, 116,
under no. 5 (entry by P. van der Ploeg)

EXHIBITIONS Paris 1879, no. 317; ibid. 1947,
no. 1; Antwerp 1949, no. 21; London 1953–4,
no. 548; Ghent 1960, no. 55; Antwerp and
Rotterdam 1960, no. 132; Paris 1977–8, pp. 79–81,
no. 41 (entry by F. Heilbrun)

This is the detailed grisaille *modello* for the *Amaryllis and Mirtillo* (cat. 62). It differs from the final work in a number of respects, chiefly in its greater width. The painting is squarer in shape, allowing the painter to focus on the main drama, which is also emphasised by the addition of the three *putti* floating above the two main figures, one of which, the winged Cupid, fires his arrows at the couple. This motif is absent in the grisaille. The number of nymphs in the final painting was reduced, which additionally enabled the artist to focus on the lovers.

Van Dyck's chief source of inspiration was Titian's *Bacchanal (The Andrians)* (cat. 62, fig. 1). The ratio of width to height, for instance, is nearer to that of Titian's work. In particular, the pose of the nude nymph reclining in the bottom right corner who, in the oil sketch, embraces her lover, is shown in the final painting with her left arm stretched out by her side, just as she appears in Titian's *Bacchanal*. HV

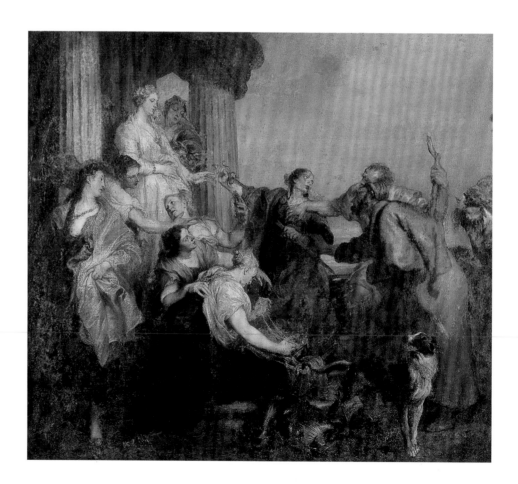

FIG 1
Anthony van Dyck, *Achilles and the Daughters of Lycomedes*, 1631–2
oil on canvas, 123 × 137.5 cm
Graf von Schönborn Collection, Pommersfelden

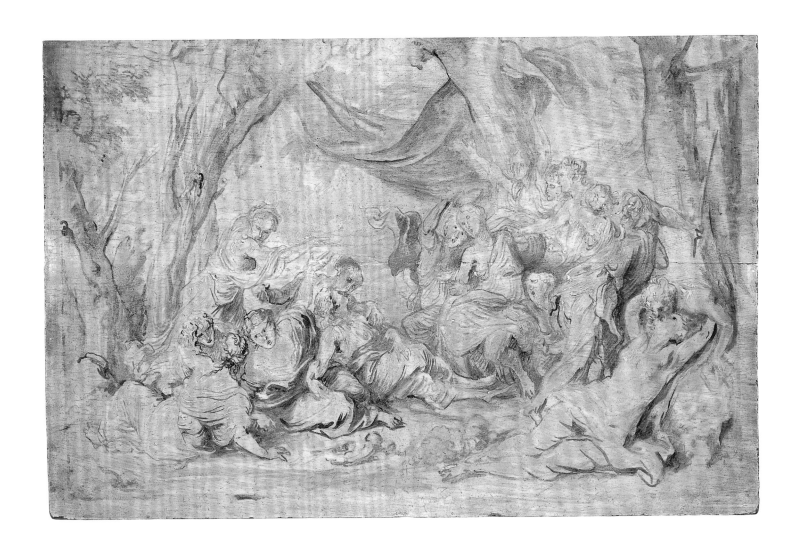

64 *Prince Rupert of the Palatinate*

1631–2

oil on canvas, 175 × 95.5 cm

Kunsthistorisches Museum, Gemäldegalerie, Vienna (inv. no. 484)

PROVENANCE 1730, first mentioned in the Imperial collections, Vienna

REFERENCES Mechel 1783, p. 105, no. 7; Smith 1829–42, III, p. 30, no. 102; Engerth 1884, pp. 116–17, no. 800; Cust 1900, p. 259, no. 100; Schaeffer 1909, pp. 238, 505; Glück 1931, pp. 334, 556; Brown 1982, pp. 130, 133; Prohaska, in Vienna 1987, pp. 196–7, no. 83; Larsen 1988, I, pp. 280–81; II, p. 226, no. 561; Moir 1994, pp. 30, 96–7, pl. 25; Gritsai 1996

EXHIBITIONS Zurich 1946, no. 391; Brussels 1947, no. 35; Amsterdam 1947, no. 55; London 1949, no. 58

FIG I
Anthony van Dyck, *Prince Charles Louis of the Palatinate*, 1631–2
oil on canvas, 176 × 96 cm
Kunsthistorisches Museum, Vienna

Prince Rupert of the Palatinate (1619–82), known in England as Rupert of the Rhine, was the third son of the Calvinist Elector Palatine, Frederick V, and his wife, Elizabeth Stuart, daughter of King James I of England and sister of the future King Charles I. Frederick's accession to the throne of Bohemia in 1619 marked the beginning of the Thirty Years' War. He was defeated by the armies of the Emperor Ferdinand II at the Battle of the White Mountain near Prague in 1620, bringing his reign to a premature end after a single winter, which earned Frederick his nickname of 'The Winter King'. He was stripped of his status as elector in 1623 and fled with his family to The Hague, where he was received by Maurits and Frederik Hendrik of Orange-Nassau.

The Winter King must have approached Van Dyck during the artist's visit to The Hague in the winter of 1631–2 to paint portraits of Rupert and his older brother, Charles Louis. Van Dyck undoubtedly owed this prestigious commission to the favourable reputation he enjoyed with the House of Orange.

The twelve-year-old prince is shown in a relaxed *contrapposto* stance, leaning against a column in a dreamy, melancholy fashion. His dark clothes are offset by his gold chain and dagger, and by his starched white collar and cuffs. The column and the curtain are rather theatrical props, designed to accentuate the sitter's royal status; they contrast with the boy's relaxed pose. His wistful gaze conveys something of the turmoil of adolescence, which is echoed in the stormy, autumnal landscape behind him.

A dog gazes up at his master: dogs, like dwarves and jesters, were well established as the companions of royalty and aristocrats, but the animal could also symbolise the prince's filial piety and ability to model his behaviour on that of his parents.

The informality of this portrait contrasts sharply with that of Rupert's brother Charles Louis (fig. 1), his senior by two years, who is portrayed in a more severe and authoritarian manner. HV

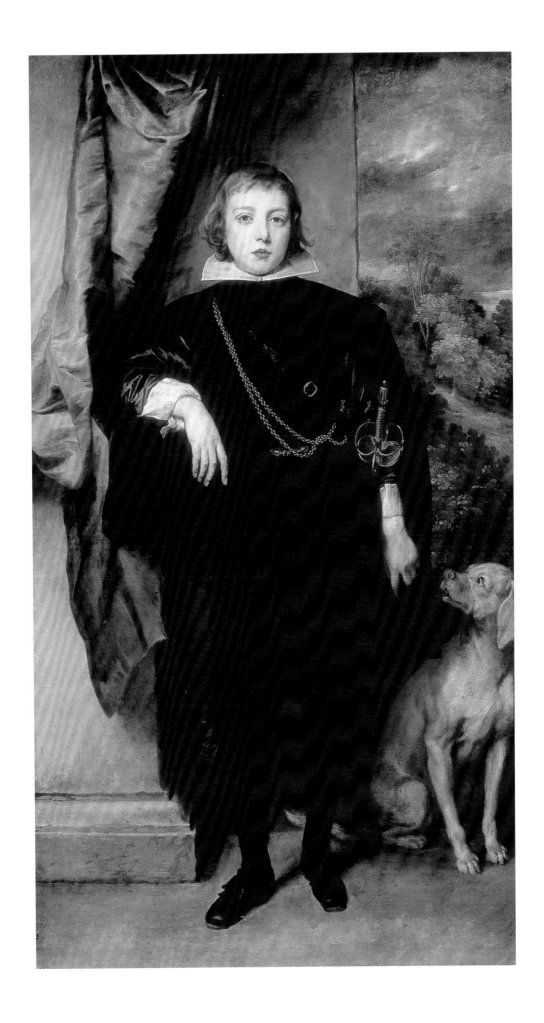

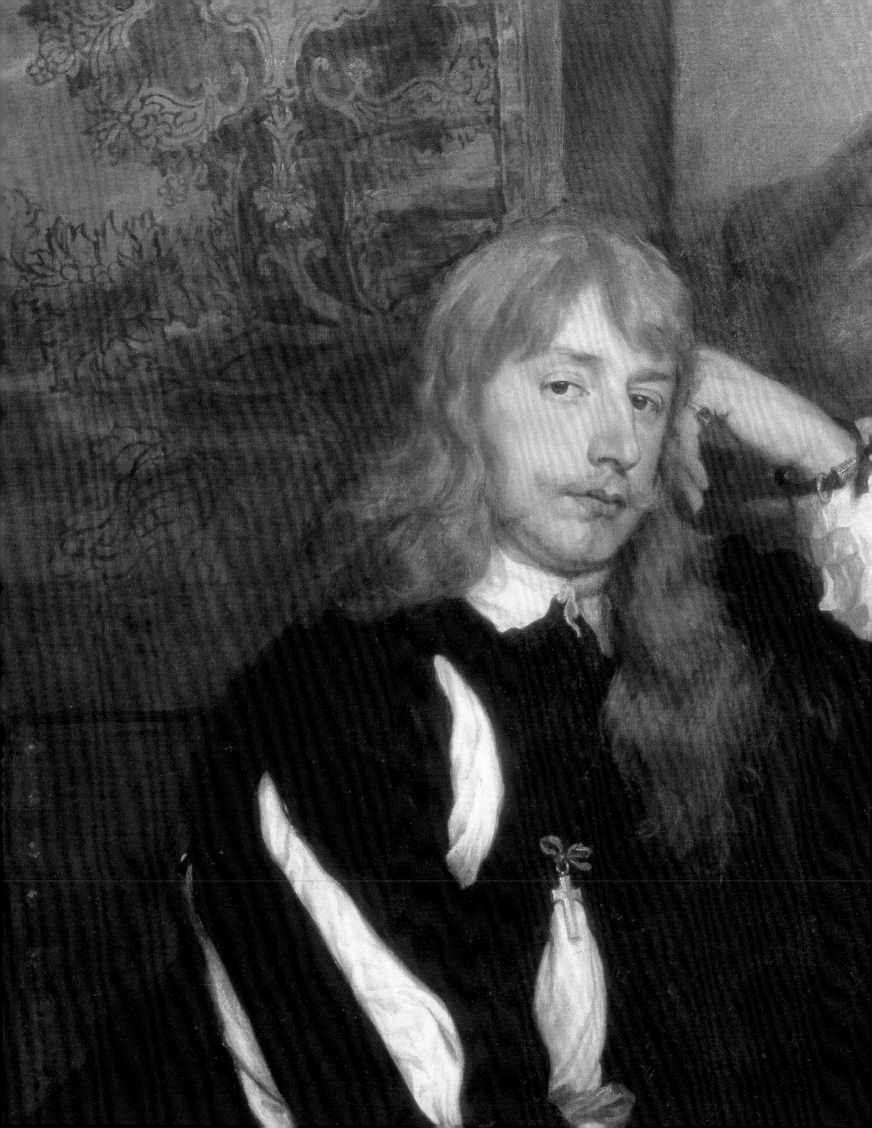

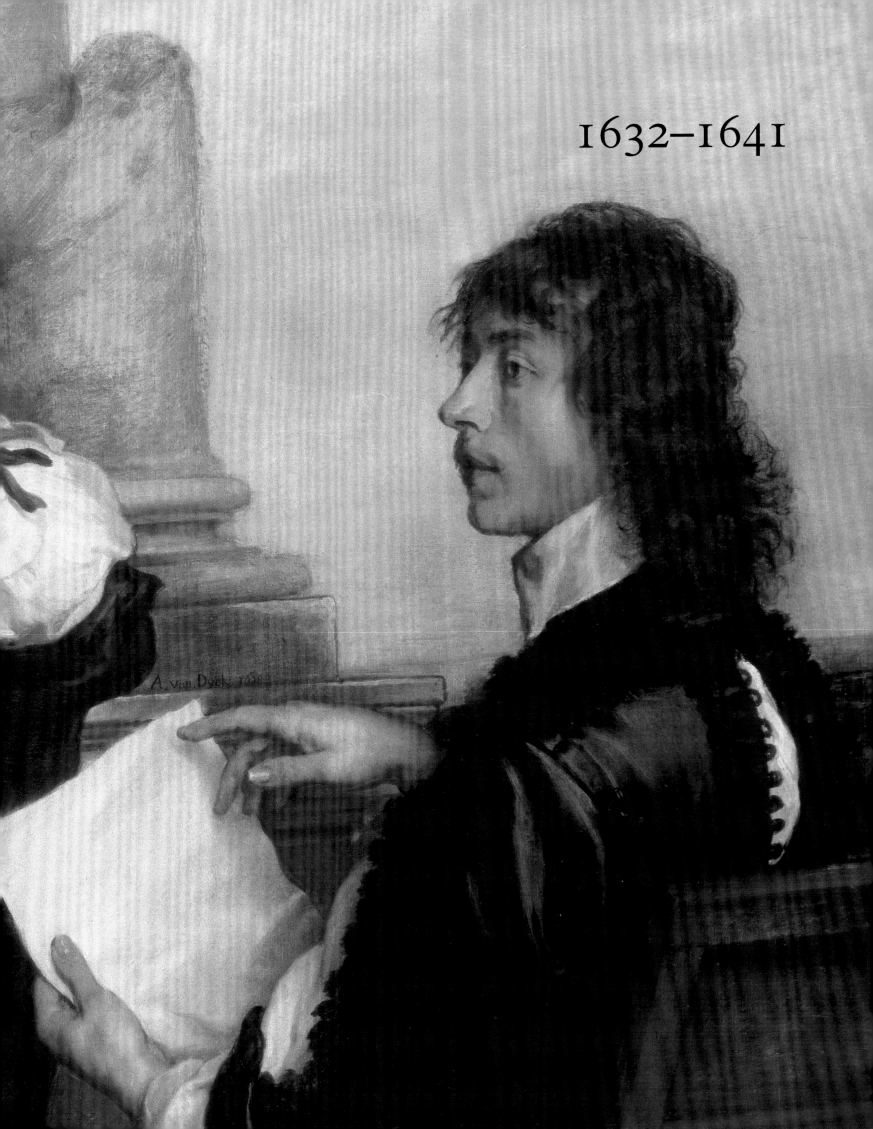

1632–1641

Charles I and
Henrietta Maria
1632

oil on canvas, 113.5 × 163 cm
CR painted on the back, presumably in imitation
of a CR brand on the back of the canvas

Archiepiscopal Castle and Gardens, Kroměříž,
Czech Republic (inv. no. 406)

PROVENANCE Commissioned by Charles I
to replace a double portrait by Daniel Mytens
at Somerset House; 1649, offered in the
Commonwealth sale of 'the King's Goods',
as 'The King & Queene wᵗʰ a lawrell leafe,
by Vandyke', valued at £60; (?) 23 October 1651,
accepted in part payment of debts by John
Jackson, acting for a 'Dividend' (syndicate)
of royal creditors; apparently allotted by the
syndicate, with other royal goods, to Jasper and
James Duart (or Du Aults), court jewellers (but
from Jasper Duart's petition to Charles II in 1672,
seemingly never in their possession); probably
passing through various hands until acquired by
Franz and Bernhard von Imstenrad, Cologne,
dealers and nephews of the dealer Everhard
Jabach;[1] 1673, among 260 pictures purchased from
the Imstenrad brothers by Karl von Liechtenstein,
Bishop of Olomouc; 1691, among the collection of
pictures bequeathed by him to the Bishop's Palace
at Olomouc; 1948, ownership transferred from the
Bishopric of Olomouc to the National Gallery in
Prague; 1959, ownership transferred to the
Museum of Kroměříž

REFERENCES Bellori 1672, p. 260; Millar 1962,
pp. 326–30; Uměleckohistorické Muzeum: Obrazárna
Kroměřížského Zámku, Kroměříž 1964, p. 55;
Millar 1972, p. 317, no. 354; Parry 1981, p. 220;
Larsen 1988, no. 806

EXHIBITION Washington 1990–91, no. 62

VERSION Studio version, Collection Duke of
Grafton, Euston Hall; Cust 1900 p. 265, no. 22,
as Van Dyck: Charles I and Henrietta Maria with
a Myrtle-wreath, exh. as by Van Dyck, London
1887, Antwerp 1889, London 1900; Glück 1931,
p. 374

NOTES
1. See Jonathan Brown, Kings and Connoisseurs,
New Haven and London 1995, p. 66.
2. Levey 1971, p. 128.
3. A copy at Welbeck (repr. Millar 1963, fig. 12)
gives some idea of the original picture.
4. Collection of the Duke of Northumberland;
repr. John Murdoch et al., The English Miniature,
New Haven and London 1981, p. 100.

Elated by Charles I's invitation to work at his court, Van Dyck was painting in London by 1 April 1632. His first royal commissions, completed within four months (paid for on 8 August 1632), included a 'great peece of oʳ royall selfe, Consort and children', now known as Charles I and Henrietta Maria with their Two Eldest Children (fig. 15), and a single three-quarter-length portrait of Henrietta Maria (fig. 3). Both pictures, in their different ways, revealed Van Dyck's ability (in Michael Levey's words) to 'throw an aura of glamorous instinctive nobility around a royal person'.[2] The 'Great Peece' (for which Van Dyck received £100), hung in the Long Gallery at Whitehall Palace, demonstrated to courtiers and foreign visitors alike that Van Dyck had transformed the art of court portraiture in England.

The portrait of Henrietta Maria (for which Van Dyck was paid £20) was placed in the King's Bedchamber in Whitehall Palace. When he painted it, Van Dyck may have been unaware that not long before his arrival in London, Daniel Mytens had been commissioned to paint a double portrait of the King and Queen. Mytens had worked at the English court since 1624, appointed by Charles 'one of our picture-drawers' for life, but never accorded the title of 'Principall Paynter' so speedily bestowed on Van Dyck (with a knighthood) in July 1632. Competent but unimaginative, Mytens was chiefly employed on official royal portraits for presentation; Millar notes that Charles I does not appear to have retained any of Mytens's official portraits of himself and his Queen. Perhaps the comparative liveliness of Mytens's Charles I and Henrietta Maria departing for the Chase (fig. 58) of c. 1630–32 encouraged Charles to commission a smaller double portrait, to be set over the fireplace in the Drawing Room or 'Great Cabinet' at Somerset House.

Mytens's Charles I and Henrietta Maria (fig. 1) remains in the Royal Collection, though not as he originally painted it.[3] With Van Dyck's exquisite single portrait of Henrietta Maria (fig. 3) in front of him, the King found Mytens's stolid image of her unacceptable. Mytens was requested to repaint her figure in the style of Van Dyck's portrait. The unhappy result is seen all too clearly in fig. 1. It pleased nobody. Briefly hung, Mytens's picture was taken down, and Van Dyck was commissioned to paint a new double portrait to replace it. Humiliated (though this can hardly have been what Van Dyck himself intended), Mytens left England for ever in 1634.

Van Dyck was charged with the task of reinterpreting his predecessor's composition, in the light of the fact that Charles liked and wished him to retain Mytens's basic conceit, which was that the royal couple should be portrayed holding between them a symbolic wreath of evergreen leaves. Van Dyck adapted the Queen's figure from his single portrait of her. Charles evidently gave Van Dyck a fresh sitting for his own portrait, which differs notably not only from Mytens's awkwardly sober figure but also from the more consciously regal figure in the 'Great Peece'. Here, perhaps for the first time and perhaps with Van Dyck's encouragement, Charles has discarded the unflattering ruff for the broad lace collar which became him far more and was thereafter preferred; his hair falls softly over it, with a hint of a lovelock curling over the collar. Usually he chose to be portrayed in darker colours. Here the orange-pink of his costume (termed 'carnation' by Van der Doort), its colour echoed in the ribbons, bows and bracelet worn by Henrietta Maria, contributes to the sense that this is an informal, semi-private portrait of the royal couple. The King was sufficiently pleased with Van Dyck's version of the subject to commission a miniature replica from John Hoskins.[4] Cataloguing it, Van der Doort described the subject as 'yoʳ Maᵗⁱᵉ in Carnacon and yᵉ Queene in a white habbitt shee presenting yoʳ Maᵗⁱᵉ with her right hand a Garland of

5. *Hall's Dictionary of Subjects and Symbols in Art*, revised ed. 1989, p. 219.

6. See Cecil Gould, *National Gallery Catalogues: The Sixteenth-century Italian Schools*, London 1975, pp. 326–30.

7. See Antony Griffiths, *The Print in Stuart Britain: 1603–1689*, exh. cat. British Museum, London 1998, no. 42, p. 86. The inscription reads: '*Filius Sic Magna est Jacobi, haec filia Magni Henrici, soboles dic misi qualis Erit?*' The choice of the word *soboles* in the context of Van Dyck's picture suggests a visual pun: it can mean 'branch or spray', as in the evergreen leaves, or 'offspring'.

Lawrell, and in her left hand, holding an Ollive Braunch… Coppied … after Sʳ Anthony Vandikes picture'.

The symbolism of the evergreen leaves seemed to Millar (1962) obvious: 'The Queen, as the daughter of a famous warrior-king, Henri IV of France, hands her husband a wreath of laurel; he, in return, hands her the olive branch which represents the peace-making activities of his own father [James I]'. That may have been Mytens's original concept, but Van Dyck, familiar with a more erotically allusive Italian tradition, was aware that a wreath of evergreen leaves held between a couple would be construed as a wreath of myrtle, the evergreen shrub sacred in Antiquity to Venus and, in particular, to conjugal fidelity.[5] Ten years earlier, in Venice, Van Dyck had studied Veronese's paintings (or studio versions of them) of the *Allegory of Love*, a series of four decorative paintings perhaps commissioned in the 1570s by the Emperor Rudolph II (now in the National Gallery, London),[6] making sketches of two of them in his Italian Sketchbook. He did not draw the fourth of Veronese's series, *The Happy Union*, in which a Venus-figure holds a crown (supposedly of myrtle) over a couple who jointly hold an olive branch symbolising their peaceful union; but it is unlikely that he would forget the imagery if he once saw it.

In Van Dyck's version of *Charles I and Henrietta Maria*, symbolic reference to the royal couple's progenitors has become secondary to the tenderness with which he portrays the royal couple themselves. The King turns towards his Queen in a beautifully restrained pose, which remains ceremonial while clearly affectionate.

FIG I
Daniel Mytens, *Charles I and Henrietta Maria*, 1632
oil on canvas, 95.3 × 175 cm
Her Majesty The Queen

Henrietta Maria holds the wreath lightly in her right hand above Charles's outstretched hand; with her left hand she holds a sprig against the lower part of her body. Van Dyck was perhaps less interested in clarifying the symbolism of the leaves (or in depicting them identifiably as laurel and olive or myrtle) than in the chance to paint the royal couple's delicately poised hands, which seem – reticently yet tellingly – to express their loving relationship.

A Latin inscription which Robert van Voerst added to his engraving of Van Dyck's picture, published in 1634 (fig. 2),[7] adroitly combines both senses of the symbolism to ask the rhetorical question (here roughly translated): 'This is the son of the great James, this the daughter of the great Henri: tell me what will their offspring be?' It was probably after seeing Van Voerst's engraving (or possibly the painting itself, then on the European art market) that Bellori in 1672 recorded that the royal pair held between them a branch of myrtle ('un ramo di mirto'). Van Dyck may himself have believed that the evergreen wreath carried the symbolic associations of myrtle. JE

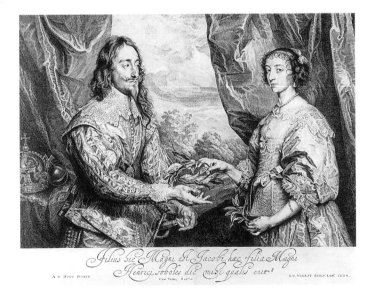

FIG 2
Robert van Voerst (1597–1636) after Anthony van Dyck,
Charles I and Henrietta Maria, 1634
engraving, 40.7 × 54.7 cm
Department of Prints and Drawings,
British Museum, London, Cracherode Bequest

FIG 3
Anthony van Dyck, *Henrietta Maria*, 1632
oil on canvas, 108.6 × 86 cm
Her Majesty The Queen

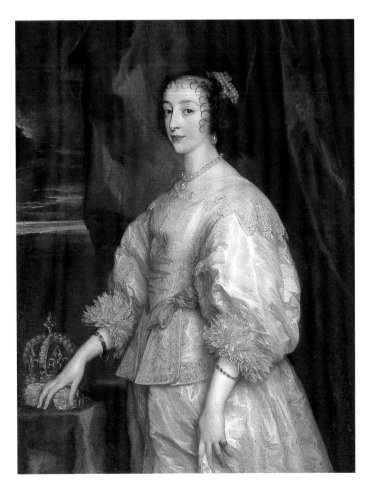

Self-portrait with a Sunflower
1632–3?

oil on canvas, 60.3 × 73 cm

By kind permission of His Grace The Duke of
Westminster OBE TD DL

PROVENANCE Early provenance unknown,
then by descent

REFERENCES Cust 1900, p. 140, pp. 284–5,
no. 208; Glück 1931, p. 496; Vertue II (XX), 1932,
p. 107; R. R. Wark, 'A Note on Van Dyck's Self
Portrait with a Sunflower', *The Burlington
Magazine*, XCVIII, 1956, pp. 53–4; J. Bruyn and
J. A. Emmens, 'That Sunflower Again', *The Bur-
lington Magazine*, XCIX, 1957, pp. 96–7; Levey
1971, pp. 125–6; Brown 1982, pp. 147–50; Liedtke
1984–5, p. 20; Larsen 1988, no. 727; J. Douglas
Stewart, in Washington 1990–91, pp. 70–71; Paul
Taylor, *Dutch Flower Painting 1600–1720*, New
Haven and London 1995, pp. 66–8, 209, n. 122

EXHIBITIONS Antwerp 1899; London 1900,
no. 35; ibid. 1995–6, no. 3; *Face to Face: Three
Centuries of Artists' Self Portraiture*, Walker Art
Gallery, Liverpool, 1994, no. 4; London 1995–6,
no. 3

VERSIONS OR COPIES Noted by Cust 1900,
pp. 284–5, under no. 208

NOTE
1. For the symbolism of sunflowers, see Wark
1956; Bruyn and Emmens 1957.

Against a summer sky, the painter portrays himself in a confident mood, dressed in dazzling crimson silk; with one hand he draws attention to the massive gold chain worn over his right shoulder, with the other he points to a sunflower, double-petalled and brilliantly coloured. Van Dyck turns his head as if to invite the spectator to witness his association with the great golden flower. Achievement, status and pride are (as Michael Levey notes) all apparent in his demeanour.

That the sunflower is symbolic is evident: but precisely what it symbolises (and whether the gold chain is also symbolic) has been much debated.[1] It would seem unwise to insist upon a single meaning. Ovid used the sunflower as an image of the lover devoted to his beloved. Later, the sunflower was used as an emblem of the devout soul following God, and occasionally of the devotion of the Virgin to Christ, as Van Dyck himself used it in the *Rest on the Flight into Egypt* of *c.* 1630 (Hermitage, St Petersburg). In 17th-century emblem books (in both Holland and England), the contemplation of a sunflower seems chiefly to have been used as a symbol of the relationship of a faithful subject to his king or prince; but it could also symbolise the God-given beauty of nature, to which the painter devotes his art. It is not known whether Van Dyck painted his *Self-portrait with a Sunflower* for a patron (royal or noble), for a friend, for a lover or for himself. This is a highly sophisticated image in which the painter is primarily interested in himself. His rich dress, his valuable gold chain and his confident expression all proclaim him to be enjoying success: he basks in the presence of the glorious sunflower, which may well have a multiple meaning, symbolising royal favour, his art and his fame.

It is perhaps gratitude (rather than devotion) to the King that is uppermost in his mind. Charles I had brought him to England, knighted him on 5 July 1632, appointed him 'principalle Paynter in ordinary to their Majesties', and was to present him with 'a chain and gold medal of One Hundred and Ten Pounds value', for which the Lord Chamberlain issued a warrant on 20 April 1633. It has been suggested that Van Dyck portrayed himself wearing this chain as a mark of devotion to the King; but if the gold medal was attached to it, it is not even glimpsed here. Van Dyck wears his chain slung over one shoulder in the current fashion (observable in the portraits of *Prince Rupert of the Palatinate*, cat. 64, and of Mainwaring in *The Earl of Strafford with Sir Philip Mainwaring*, cat. 102). To wear a gold chain (preferably heavy) was to display wealth. Van Dyck loved wearing 'chains of gold across his chest', as Bellori notes; he wears one in the early *Self-portrait* of *c.* 1617–18 (fig. 25), and accumulated others, for instance from the Duke of Mantua in 1622. The gesture in this *Self-portrait*, which seems to link the gold chain to the sunflower, is perhaps more likely to be a recollection of Ripa's personification of *Pittura* as a beautiful woman wearing a chain symbolising the continuity of the art of painting, each artist learning from previous masters.

Wark relates that, during the Civil War, the *Self-portrait with a Sunflower*, known through copies and through Wenceslaus Hollar's etching of 1644, became 'a veritable symbol of the royalist cause'. Yet Hollar's publisher dedicated the etching to John Evelyn as a patron of painting: '*Artis Picturae Amatori & Admiratori Maximo*'. Then as now, the picture's meaning has been variously interpreted.

Van Dyck introduced a less flamboyant sunflower into his portrait of *Sir Kenelm Digby in Mourning with a Sunflower* of *c.* 1635 (private collection), for a different purpose: Digby appears as a black-clad widower, hand on heart. The sunflower in that portrait has been variously interpreted as symbolising his loyalty to the King, his return to the Catholic faith or his retreat from earthly beauty after his wife's death. JE

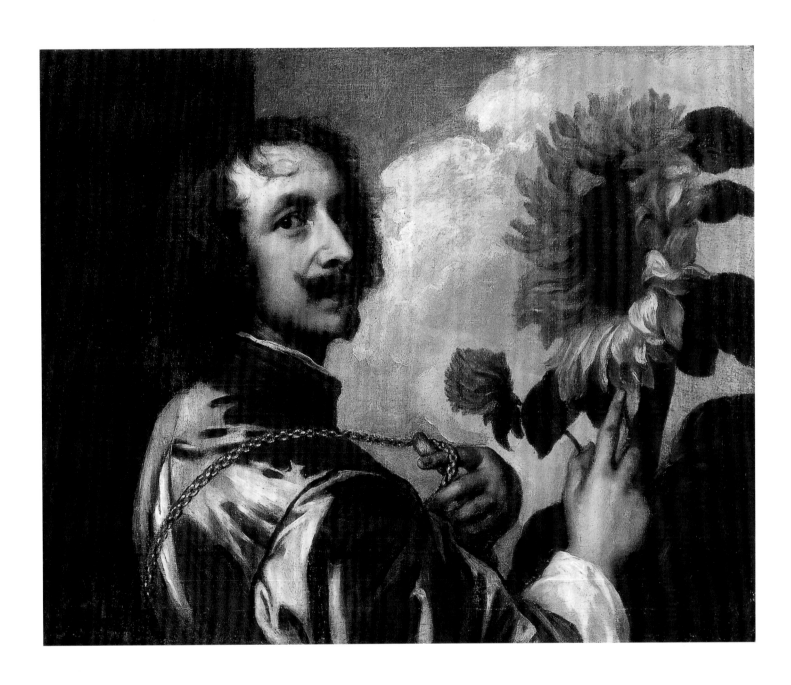

67 *Queen Henrietta Maria with Jeffrey Hudson and an Ape* 1633

oil on canvas, 219.1 × 134.8 cm

National Gallery of Art, Washington, DC, Samuel H. Kress Collection (1952.5.39)

PROVENANCE Passed among the related families of the Earls of Bradford, Earls of Mountrath, and Earls of Dorchester to Henry Dawson, later 3rd Earl of Portarlington (see Eisler 1977); 1881, acquired from him by exchange by Francis George Baring, 2nd Earl of Northbrook; 1927, sold by him to Joseph (later Lord) Duveen; sold by him to William Randolph Hearst; M. Knoedler & Co., New York, from whom purchased by Samuel Kress; 1952, presented by him to the Gallery

REFERENCES Cust 1900, pp.108, 265, no.24; Schaeffer 1909, p.307; ed. W.R. Valentiner with Ludwig Burchard and Alfred Scarf, *Unknown Masterpieces in Public and Private Collections*, New York 1930, I, p.47; Glück 1931, p.44; Van Puyvelde 1950, p.172; Vey 1962, p.280, no.206; Jaffé 1965, pp.43, 46; Eisler 1977, p.116, no. K1911; Brown 1982, p.180; Washington 1985, p.147; Larsen 1988, no.864

EXHIBITIONS Royal Academy 1878, no.166; London 1887; Detroit 1929, no.42; *Masters of Portraiture*, Century Club, New York, 1938, no.10; *Masterworks of Five Centuries*, San Francisco 1939, no.92; *Loan Exhibition of Allied Art for Allied Aid*, M. Knoedler & Co., New York, 1940, no.3; *Objects from the William Randolph Hearst Collection*, Hammer Galleries, New York, 1941, no.29; Diamond Jubilee, Philadelphia Museum of Art, 1951, no.31; *Bilder vom Menschen in der Kunst des Abendlandes*, Staatliche Museen, Berlin, 1980, p.216, no.9; Washington 1990–91, no.67; London 1992–3, no.1

COPY A very fine version of the painting, for which Van Dyck was paid in October 1633, was presented by Charles I to Lord Wentworth, later Earl of Strafford; collection of Lady Juliet Tadgell

NOTES
1. Charles I's height has been reckoned from his armour in the Tower of London; see Brown 1982, p.164.
2. See Vertue I, p.78.
3. For Hudson (often erroneously styled 'Sir') see Vertue v, pp.25, 78–9; DNB; Millar 1963, under nos.120, 125, 314.
4. See Eisler 1977; Washington 1990–91, no.67.

FIG I
Anthony van Dyck, *Study for Henrietta Maria's Dress*, 1633
black chalk with white highlights on blue paper, 41.9 × 25 cm
Ecole Nationale Supérieure des Beaux-Arts, Paris (Vey 206)

Probably painted in 1633, this is one of Van Dyck's earliest portraits of Queen Henrietta Maria. In 1633 she would have been 24 years old. Small in stature – the top of her head reached only her husband's shoulder, his own modest height being probably 5 ft 4 in (162 cm)[1] – she is portrayed here in the comparative informality of a blue hunting-dress; but she is, nevertheless, projected as regal. The crown on a ledge beside her reinforces (but unostentatiously) the sense of royal presence; the stone platform on which she stands contributes to the illusion that she commands the picture space. Vertue noted (over a century later) that 'it is observable that Vandyke in several pictures of this Queen which he has done at len[gth] he contrivd secretly to show the Queen rather taller than shee was'.[2] The attendance of the dwarf Jeffrey Hudson, with whom she evidently liked to be portrayed, serves to add several cubits to her stature.

A preliminary chalk study for the Queen's dress and pose (fig. 1), for which one of her ladies-in-waiting may have 'stood in' (the head is merely suggested) pays particular attention to the play of light upon the sumptuous hunting-dress, noting with deft heightening in white chalk how the light falls upon its satin folds.

Jeffrey Hudson (1619–82) is portrayed at the age of about fourteen.[3] Reputedly he was only 18 inches (45 cm) tall by the age of thirty. Aged seven or eight he had entered the entourage of the Duke of Buckingham; and as part of the entertainment provided by Buckingham when King Charles, Henrietta Maria and their court visited his country house, Hudson was 'served up to the table in a Cold pye'. Buckingham 'gave' Hudson to the Queen as a present. He remained in her service until, after killing a man in a duel (fought on horseback, with pistols) he was imprisoned and later banished. Hudson was twice portrayed by Daniel Mytens, Van Dyck's predecessor as most 'favoured Court portraitist': full length (*c.* 1630; Royal Collection, see Millar 1963a, no.125), and as a tiny figure on the left in *Charles I and Henrietta Maria departing for the Chase* (*c.* 1630–32; see fig. 58), seemingly restraining hounds which, compared with him, can hardly be more than 8 inches (20 cm) high. Not the least of the qualities that made Van Dyck an infinitely more subtle artist than Mytens was his ability to 'adjust' matters of scale without sacrificing truthfulness.

The ape perched on Hudson's arm was, like the dwarf himself, one of the exotica with which Henrietta Maria liked to surround herself. The age-old fondness of monarchs and their consorts for exotic animals (many presented as gifts from foreign courts) is well known; but more recondite explanations for the ape's presence have

been propounded, such as that the Queen's gentle pressure on the ape's body symbolises her instinctive control of erotic passion.[4] The orange tree flourishing in a stone pot behind the Queen is probably one of those she had sent over from France to adorn her palaces and to cultivate in her gardens; her father, Henri IV, had built the first orangery in his palace of the Tuileries. The orange was regarded not only as a thing of beauty (especially in a cold climate), but also as symbolic of the fruits of Paradise, of purity, chastity and the transience of worldly pleasure. JE

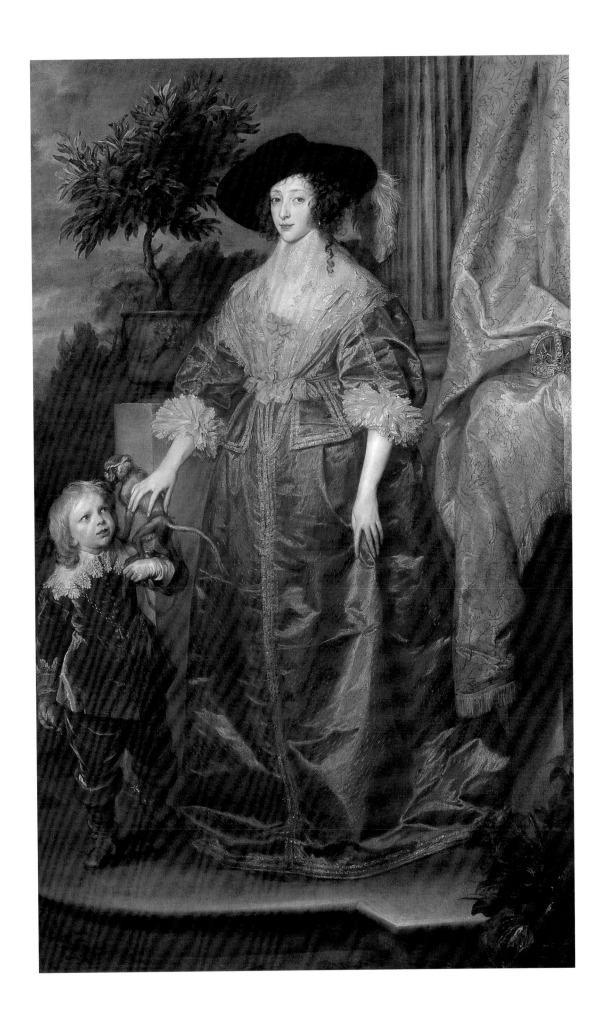

68 *Thomas Wentworth,*
1st Earl of Strafford
1632–3

oil on canvas, 213.2 × 138.2 cm

Lent by the Trustees of the Rt. Hon. Olive,
Countess Fitzwilliam's Chattels Settlement,
by permission of Lady Juliet Tadgell

PROVENANCE Commissioned by the sitter,
Thomas Wentworth, created Baron Wentworth
of Wentworth Woodhouse, July 1628, Viscount
Wentworth, December 1628, Baron of Raby and
Earl of Strafford, 1640 (beheaded 1641); his son,
2nd Earl of Strafford (the forfeiture of his father's
honours in 1641 being reversed in 1662 after the
Restoration), d.s.p. 1695; the latter's nephew and
heir Hon. Thomas Watson-Wentworth (third son
of the 2nd Earl of Strafford's eldest sister, Lady
Anne Wentworth); his son Thomas, 6th Baron
Rockingham, created, in 1746, 1st Marquess
of Rockingham (d. 1750); his son Charles, 2nd
Marquess of Rockingham (d.s.p. 1782); his
nephew and heir, William Wentworth-Fitzwilliam,
4th Earl Fitzwilliam; then by descent to the 10th
Earl Fitzwilliam (d.s.p. 1979)

REFERENCES Arthur Young, *A Six Months Tour
through the North of England...*, 1770, 1, pp. 291–2;
MS Inventory of works at Wentworth Woodhouse
in the collection of the late 2nd Marquess of
Rockingham, 1782 (Wentworth Woodhouse
Muniments, Sheffield Archives, A/1204, p. 16v);
Cust 1900, pp. 130, 283, no. 195; Glück 1931,
p. 437; Brown 1982, pp. 207–8; Millar 1986,
pp. 109–23; Larsen 1988, no. 1001

EXHIBITIONS London 1875; ibid. 1900, no. 63;
ibid. 1982–3, no. 15; ibid. 1992–3, no. 15

NOTES
1. Lord Macaulay, *Critical and Historical Essays*
[1834], ed. F. C. Montague, 3 vols, London 1903:
quotations are from 1, pp. 138, 420.
2. C. V. Wedgwood, *Thomas Wentworth, First Earl
of Strafford*, London 1961, p. 389.
3. Sir Philip Warwick, *Memoires of the Reign of
King Charles I*, London 1701, pp. 112 (and,
quoting Richelieu), 162.

Of all Van Dyck's English sitters, it is Strafford who looms largest in political events leading up to the Civil War. Born in 1593, he began as plain Thomas Wentworth: a commoner, but one born into a wealthy family with vast estates centring on Wentworth Woodhouse. He studied law. In 1614 he entered the House of Commons as Member of Parliament for his native Yorkshire. Over the next fourteen years, he strongly opposed royal attempts to raise funds independently of Parliament. The Parliament of 1628 placed him in a dilemma. At first he led the Commons in trying to bring Charles I to some reasonable compromise over forced loans and imprisonment without cause shown, offending the King by insisting that supplies voted by Parliament for specific purposes should be safeguarded from appropriation by the Crown; then, when the King proved obstinate, he backed down, passively accepting the Petition of Right as a substitution for his own more radical proposals. Given the disharmony between King and Parliament, he had come to believe that the monarchy – if it could be well advised – should rule. As his political ally Sir George Radcliffe MP wrote: 'His experience taught him that it was far safer that the King should increase in power, than that the people should gain advantage on the King.'

From the time of Wentworth's about-face in 1628, Charles showed him increasing favour, in the same year creating him Baron and Viscount Wentworth (thus deftly removing him from the arena of the House of Commons) and President of the Council of the North; Privy Councillor in 1629; Lord Deputy of Ireland in 1632; Baron Raby and Earl of Strafford (the title by which he is now best known) in 1640. In the language of the times, Strafford had moved during 1628 from 'country' to 'court'. Macaulay was to write of his acceptance of a peerage as 'a baptism into the communion of corruption', and of Strafford himself as 'the lost Archangel, the Satan of the Apostasy'.[1]

During the final years of the King's personal rule, 1629–40, Strafford became Charles I's chief unofficial adviser. A potentially effective relationship which might have ensured judicious exercise of the King's prerogative failed because of faults in both men. As a ruler, Charles I was 'too weak to enforce his will and too obstinate to deny it'.[2] Strafford, though chiefly driven by a sense of duty to the King, was not above self-interest, self-righteousness and some grave errors of judgement. The end, when it came, came quickly. The King needed money to suppress a revolt in Scotland. In the hope of getting a vote of supplies, Strafford advised the King to call the first Parliament since 1629 (the 'Short Parliament'). In November 1640, what was to be known as the Long Parliament met.

On Charles's personal guarantee of his safety ('upon the Word of a King, you shall not suffer in Lyfe, Honour or Fortune'), Strafford attended it. He was impeached by the House of Commons on charges of high treason ('traitorously endeavouring to subvert the fundamental laws and government of the realm...') – in effect, for supporting the King's prerogative against the people's elected representatives – and sent to the Tower. His trial opened in March 1641, with old taunts of 'apostate' loud in the air (figs. 1, 2). A bill of attainder against him, passed by the Commons on 21 April and by the Lords on 8 May, was sent two days later to Charles for signature. Against a background of a violent mob clamouring in Whitehall for his execution, Strafford himself urged Charles to sign it; reluctantly, and with lasting remorse, he did so.

On 12 May 1641, Strafford was beheaded on Tower Hill. Richelieu is said to have remarked: 'The English Nation were so foolish, that they would not let the wisest head among them stand on its own shoulders.'

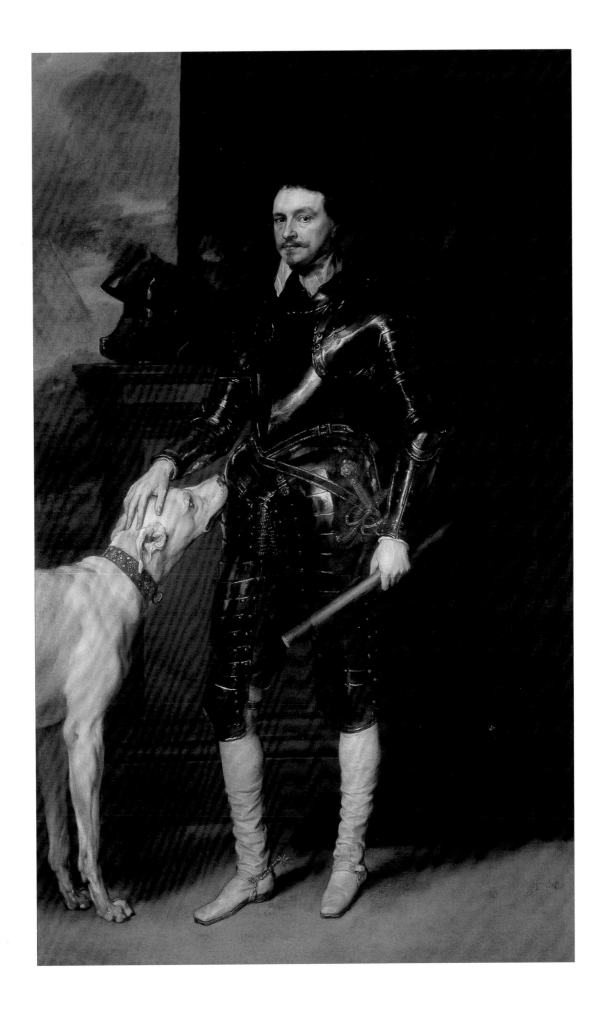

No portraits painted by Van Dyck in England more brilliantly demonstrate his penetrating powers of perception than those of Charles I and Thomas Wentworth, Earl of Strafford, two sharply contrasting personalities. This is probably the first of his portraits of Strafford (others are noted under cat. 102). Millar (1986) suggests that it should probably be dated between January 1632, when Strafford was appointed Lord Deputy of Ireland, and his departure for Dublin in July 1633. He also notes that the King had granted Strafford vice-regal powers which had not been exercised by any of his predecessors in Ireland. Van Dyck's portrait was inspired by Titian's full-length of Charles V with 'a bigg white Irish dog', then in Charles I's collection, hanging in the Bear Gallery in Whitehall (now in the Prado, Madrid). Strafford rests his hand on an Irish wolfhound. The portrait was destined for Wentworth Woodhouse, but was still in London in 1636.

The decision to sit to Van Dyck in armour is likely to have been Strafford's own. Strafford was a tall man and, though certainly no Puritan, wore his hair short, ignored court fashions and dressed relatively plainly, consciously projecting the image of a strong character. 'His countenance was cloudy, whilst he moved, or sat thinking', noted Strafford's contemporary Sir Philip Warwick MP, adding that he 'stooped much in the neck'.[3] Van Dyck rose repeatedly to the challenge of portraying this resolute but deeply troubled man, catching always the clouded countenance, and producing, with no attempt at ingratiation, portraits of Strafford which are unforgettable, even haunting. It was to those portraits that Macaulay turned when, almost two centuries after Strafford's death, he wrote of 'this great, brave, bad man', and described his appearance: 'those harsh, dark features, ennobled by their expression into more than the majesty of an antique Jupiter … that fixed look, so full of severity, of mournful anxiety, of deep thought, of dauntless resolution, which seems at once to forebode and to defy a terrible fate, as it lowers on us from the living canvass of Vandyke'. J E

69 Venetia, Lady Digby, on her Deathbed

1633

oil on canvas, 74.3 × 81.8 cm

The Trustees of Dulwich Picture Gallery, London
(inv. no. 194)

PROVENANCE Commissioned by Sir Kenelm
Digby, and presumably taken with him to the
Continent in 1641; possibly the picture entitled
'A Memento Mori', sold from Alexis Livernet's
collection, Christie's, 28 May 1806, buyer's name
unrecorded; collection of Sir Francis Bourgeois
RA; 1811, bequeathed to the Gallery

REFERENCES Sir Kenelm Digby, *Loose Fantasies*
[first published as *Private Memoirs*, London 1827],
ed. G. Gabrieli, Rome 1968, p. 241; John Aubrey,
*Brief Lives … set down … between the Years 1669
and 1696*, ed. Andrew Clark, Oxford 1898, 1,
pp. 230–32; Brown 1982, p. 145; Larsen 1988,
no. 854; Nigel Llewellyn, *The Art of Death*, London
1991, p. 31; G. Parry, in ed. Barnes and Wheelock
1994, pp. 258–9; Beresford 1997, no. 194

EXHIBITIONS Washington and Los Angeles
1985–6, no. 7; London 1995–6, no. 31

COPIES A copy in miniature by Peter Oliver
(private collection); a full-scale copy at Althorp
(Garlick 1976, no. 167); a copy seen by John
Aubrey in the 1670s 'at Mr Rose's' (the Covent
Garden jeweller), perhaps a small-scale copy by
Rose's wife, the miniaturist Susan Penelope Rose,
untraced

NOTES
1. Habington's lines are from *To Castara, upon the
Death of a Lady*, ed. Kenneth Allott, *The Poems of
William Habington, 1605–54*, Liverpool and
London 1948, p. 65.
2. The literature is voluminous, beginning with
Digby's own writings; see London 1995–6,
pp. 134–9.

In 1626 the courtier, diplomat and intermittent Catholic Sir Kenelm Digby married Venetia Stanley. From his copious and sometimes fevered writings (particularly *Loose Fantasies*, unpublished in his lifetime), it is clear that Digby knew before he married her that Venetia had been notoriously promiscuous (and had borne the Earl of Oxford two illegitimate children). It is also clear that he loved her passionately and was determined that she should be remembered as a blameless wife. John Aubrey, the chief source for scandal about Venetia (though he was only seven years old when she died), quotes Kenelm Digby as saying that 'a wise man, and lusty, could make an honest woman out of a brothell-house'.

Venetia Digby 'dyed in her bed suddenly' (Aubrey's phrase) at the age of 33. According to Kenelm Digby, she died during the night of 1 May 1633, her maid finding her the next morning, lying 'in the same posture' as when she had gone to sleep the night before. 'There appeared not to have bin the least struggling; no part of the very linen or clothes were disordered or untucked about her, but lay close to her bodie and thrust under her as her maid had putt them; even her hand, she observed, lay just as she left it; no bodie would have thought other than that she had bin fast a sleepe: and with the same sweetness of lookes she continued till the surgeons and women ordered her bodie for her cold and long bed'.

Before 'the surgeons and women' arrived, Sir Kenelm Digby asked Van Dyck to paint her on her deathbed. Digby states that Van Dyck began the deathbed scene 'the second day after she was dead'. Whether Venetia in fact died peacefully cannot now be determined. What is certain is that Van Dyck's picture cannot faithfully represent what she looked like by 'the second day after she was dead', since it denies the remorseless changes which death quickly brings as *rigor mortis* sets in and features contract. The tender, near life-like fantasy which Van Dyck produced is very different from authentic deathbed portraits of unmistakably lifeless 'sitters' (for near-contemporary examples, see London 1995–6).

If Van Dyck actually attended Venetia's deathbed 'the second day after she was dead', he must have been presented with a carefully stage-managed scene. Digby recounts that Venetia's waiting-women 'brought a little seeming color into her pale cheekes' by 'rubbing her face'; since there was no circulation of blood, this can only mean that rouge was applied. A two-day-old corpse could not sustain that elegant pose without being propped up; and since Digby had plaster casts made of her face, hands and feet (and cut off some of her hair for mourning relics), there must have been some disarrangement of the body. Venetia is hardly likely to have gone to bed in her pearls; Van Dyck presumably added these – also adding what Digby himself describes as 'a rose lying upon the hemme of the sheet, whose leaves … seeming to wither apace, even whiles you looke upon it, is a fitt Embleme to express the state her bodie then was in'.

Altogether, the picture is designed not as a truthful document but as an elegy; and it prompts the question of whether, having painted Venetia recently from life (fig. 1), Van Dyck may not have conjured up this memorial image to please Digby, his friend as well as his patron. His picture – thinly painted, and by no means highly finished, was delivered by 19 June to Digby, who pronounced it to be 'the Master peece of all the excellent ones that ever Sir Anthony Vandike made'. He wrote to his brother: 'This is the onely constant companion I now have. It standeth all day over against my chaire and table … and all night when I goe into my chamber I sett it close by my beddside, and by the faint light of candle, me thinkes I see her dead indeed'. The painting in turn inspired verses by the young Catholic poet William Habington,[1] Digby's protégé:

Van Dyck's seeming witness to Venetia's death in the tranquillity of sleep may in fact have been requested to counter rumours that Digby himself caused her sudden (and still unexplained) death – either inadvertently, through a concoction of viper's blood to preserve the beauty of her complexion (he was an amateur chemist), or deliberately, because he was 'jealous of her that she would steale a leape'. Charles I is said to have ordered an autopsy; if this was carried out, it would probably have been by the King's much respected physician, Sir Theodore de Mayerne, but no report appears to have survived. Venetia was buried by night in Christ's Church Greyfriars, Newgate Street, where, a year later, Digby preached a sermon on her virtue and his desolation. Digby may have been innocent of Venetia's death; but his ambivalent writings, his extravagant parade of grief and his flair for manipulating truth, amply demonstrated in his programme for *Venetia Digby as Prudence* (cat. 70), make it difficult to be sure.[2] J E

FIG 1
Anthony van Dyck, *Sir Kenelm and Lady Digby with their Two Eldest Sons*, 1632
oil on canvas, 137 × 212 cm
Private collection

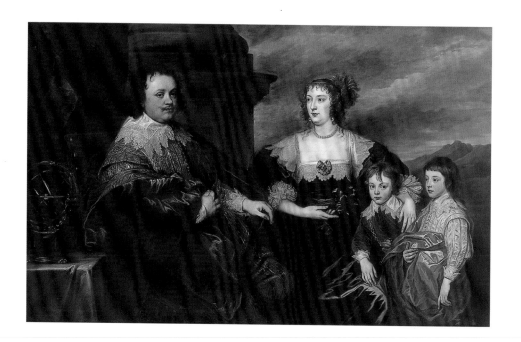

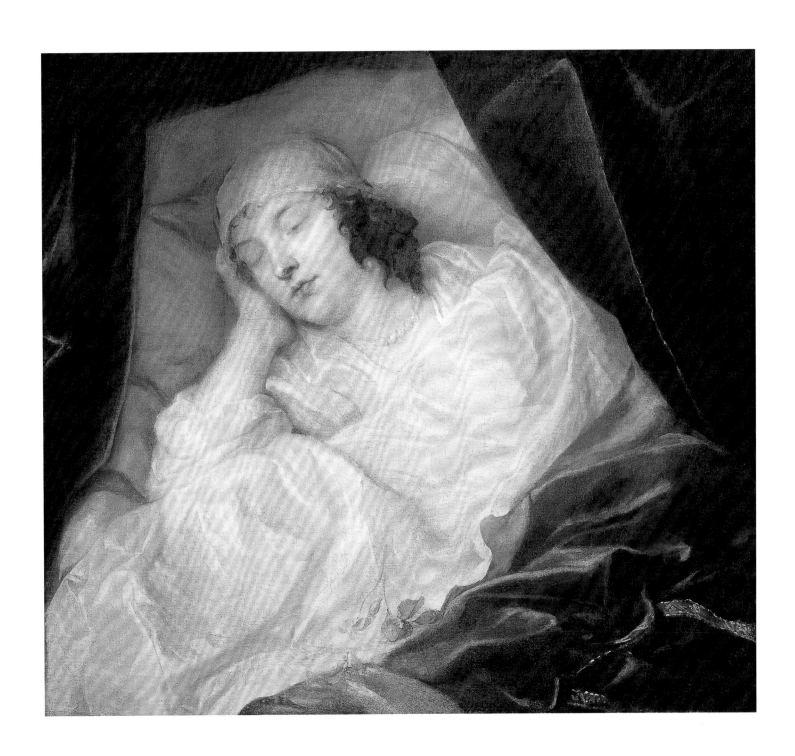

Venetia, Lady Digby, as Prudence

1633–4

oil on canvas, 101.1 × 80.2 cm

National Portrait Gallery, London (inv. no. 5727)

PROVENANCE Painted for Sir Kenelm Digby:
1641, either this work or an earlier, larger version
(or both) taken by him to the Continent; probably
the picture acquired by Cardinal Mazarin
(no. 1235 in his inventory, 1661, measuring
36 × 29″ [i.e. 2.7 cm]); by 1748, Thomas Walker,
London (when seen by George Vertue), by whom
bequeathed with the rest of his collection to his
nephew, Stephen Skinner; by descent through
Emma Harvey (née Skinner) to Admiral Sir Eliab
Harvey KCB, MP (d. 1830, in whose collection at
Rolls Park, Essex it was observed by J.P. Neale in
1826); thence to Mrs B. Gibbs, by whom offered
at Christie's 29 June 1962, lot 69 (bought in);
1964, purchased from Mrs B. Gibbs by Agnew's,
by whom sold later in 1964 to H.A.L. Dawes;
thence by descent; 1984, sold through Agnew's to
the Gallery

REFERENCES Bellori 1672, p. 261; Vertue 1922,
III, p. 141; Comte de Cosnac, *Les Richesses du
Palais Mazarin*, Paris 1884, pp. 337–8; Glück
1931, p. 563; Millar 1963a, pp. 107–8, under
no. 179; Brown 1982, pp. 145–7; National Portrait
Gallery *Report* 1984, London 1985, p. 11; Larsen
1988, no. A 219/4

EXHIBITIONS King's Lynn, 1963; London
1968a, no. 43; ibid. 1972–3, no. 107; ibid. 1982–3,
no. 9; Washington 1990–91, no. 64; London
1992–3, no. 2; ibid. 1995–6, no. 39

NOTES
1. When sold in 1962, the catalogue stated that it
was 'inscribed *Omne Numen Adest*', but no
inscription is now visible.
2. Ripa, *Iconologia*... ed. Venice 1645, p. 509
(*Prudenza*) and p. 87 (*Castita*); this edition post-
dates Van Dyck's death, but the woodcuts appear
in earlier editions.
3. See *Private Memoirs of Sir Kenelm Digby*,
ed. anon., London 1827, p. 98.

Sir Kenelm Digby asked Van Dyck to paint his wife Venetia on her deathbed (cat. 69) within hours of her sudden death on 1 May 1633. Whether he conceived the idea that she should be portrayed as Prudence during her lifetime, or whether it sprang from the turbulent emotions into which he was plunged by her death, remains uncertain. In this allegorical portrait, there seem (at least at first sight) to be no overt allusions to her death; her portrait seems to be a repetition of her image as Van Dyck had painted her in the family group (see cat. 69, fig. 1).

It was Digby who was chiefly responsible for the elaborate allegorical programme of this picture. Van Dyck, not himself often given to symbolism, was content to follow that programme because, as Vertue notes, Sir Kenelm Digby 'always was his most generous friend & protector'. He may or may not have realised how important it was for his patron to protest that his wife did not (or, by the time he married her, did not) deserve the reputation for promiscuity which still attaches to her name. Digby's programme for this picture was specific: his wife must be represented as chaste, blameless, and steadfastly treading down temptation.

Vertue, studying this picture in Thomas Walker's house in 1748, noted that Venetia's face was 'lively & brilliant ... her hands delightfull & genteel, the right having a serpent twined about her arm – the left hand on 2 of the whitest innocent doves ... over her h^d in the air are disposed various angells with a reath of flowers or Laurels, besides her, is overthrown, falsehood with the double face of Janus. and under feet lust is represented thrown down, by a Cupid with his flaming torch &c....'[1]

Van Dyck also painted a larger version of this picture (probably fig. 2). Kenelm Digby may have taken both versions with him when he left England in 1641. In Rome, it seems that he showed, or described, to Bellori a version which included an even larger cast of figures symbolising Venetia's 'victory and triumph over the vices'. As well as 'Deceit wth two faces', Cupid crushed beneath her heel, and 'a glory of singing angels' over her head, Bellori noted 'Anger with furious countenance', 'meagre Envy with her snaky locks' and a second, blindfolded Cupid with broken bow and scattered arrows. The Milan picture (like the studio version of it; Royal Collection) includes some of this additional imagery; but Bellori's account may reflect all the ideas Digby poured out to him rather than those which Van Dyck actually translated onto the canvas.

To fulfil Digby's programme for this picture, Van Dyck probably consulted Cesare Ripa's *Iconologia*, a well-known mine for artists.[2] Illustrated editions (the first published in Rome in 1603) included a woodcut image of *Prudenza* with a serpent encircling her arm: Bellori, no doubt recalling the image of Venetia as Prudence which Digby had discussed with him, reproduced it to introduce his life of Van Dyck. The illustrated *Iconologia* also included an image of *Castità* (Chastity), with a conquered Cupid at her feet; its text relates that the turtle-dove could also be used as a symbol of matrimonial chastity. The two-faced male figure is, in Ripa, an emblem of Deceit, but there were precedents for combining it with Prudence. Bellori used a figure of Prudence to introduce his life of Van Dyck (fig. 1).

Digby evidently hoped that those who saw *Venetia Digby as Prudence* would realise that her white shift alludes to her purity, the snake encircling her right arm to her wisdom, the turtle-doves under her left hand to her fidelity to the marriage-bed and the Cupid crushed under her heel to her blameless married life, while the two-faced figure of Deceit personifies what Digby himself called 'that monster which was begot of some fiend in hell' to put a 'false construction' on Venetia's character.[3] In Van Dyck's

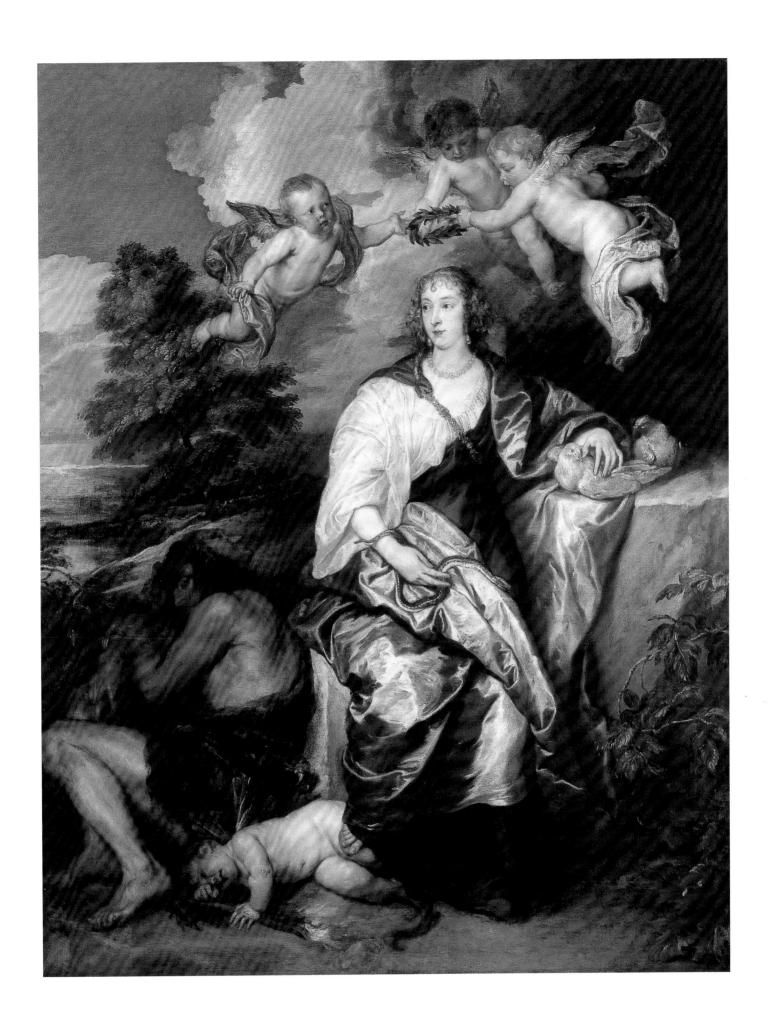

ANTONIO VANDYCK

FIG 1
Vignette of *Prudence* illustrating the life of
Van Dyck in G. P. Bellori, *Le Vite de' Pittori,
scultori et architetti moderni*, Rome 1672, p. 353

obliging allegory, Deceit is seen to be spurned, rejected and crushed to the ground.

One last detail should be noted. Because Venetia's crimson mantle immediately takes the eye, we do not at once register the fact that beneath it, the tunic-like drapery over her white shift is, apart from its jewelled fastening, unrelievedly black. Her draperies are not, of course, what the well-dressed woman would wear around 1633, resembling rather those adorning such classical or romantic heroines as Armida (fig. 59) or Amaryllis (cat. 62). Perhaps, after all, the black alludes to the fact that, whenever the picture was commissioned, Venetia Digby died before it was completed. JE

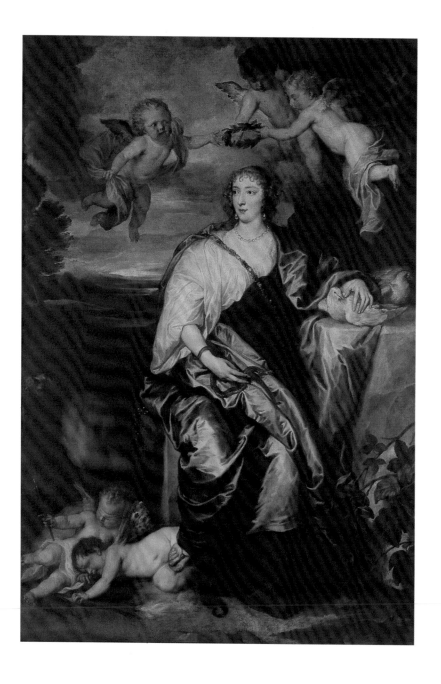

FIG 2
Anthony van Dyck,
Venetia Digby as Prudence, 1633–4
oil on canvas, 242 × 155 cm
Palazzo Reale, Milan

James Stuart, 4th Duke of Lennox and 1st Duke of Richmond

1633–4

oil on canvas, 215.9 × 127.6 cm

The Metropolitan Museum of Art, New York, Marquand Collection, Gift of Henry G. Marquand, 1889 (inv. no. 89.15.16)

PROVENANCE Sir Paul Methuen (d. 1757); his cousin and godson, Paul Methuen, of Corsham Court, Wiltshire (d. 1795); then by descent to Frederick Henry Paul Methuen, 2nd Baron Methuen of Corsham, until 1886, when acquired by Henry G. Marquand of New York; 1889, presented by him to the Museum

REFERENCES Cust 1900, pp. 117–18, p. 278, no. 123; Glück 1931, pp. 411, 564–5; Vey 1962, p. 288, nos. 214, 215; Brown 1982, pp. 191–2; Liedtke 1984, pp. 50–54; Larsen 1988, no. 968

EXHIBITIONS British Institution 1835, no. 15; ibid. 1857, no. 1; Royal Academy 1877, no. 138; Washington 1990–91, no. 66; Boston and Toledo 1993–4, no. 41

VERSIONS Noted by Cust 1900, p. 278, under no. 123

NOTES
1. C. V. Wedgwood, *The King's Peace*, London 1955, p. 148.
2. *Calendar of State Papers Venetian*, XXV, p. 54.
3. Quoted in GEC, X, p. 833.

This is a portrait of one of Charles I's closest relatives and most loyal supporters. When James Stuart (1612–55) inherited the Scottish title of Duke of Lennox in 1624 at the age of twelve, the ageing King James I, as his nearest male relative, became his guardian. Charles I, succeeding to the throne the following year, continued to regard his cousin with special affection. Known as the Duke of Lennox for most of Charles I's reign, he was raised (additionally) to the English peerage as 1st Duke of Richmond in 1641.

On 18 April 1633, Charles nominated Lennox for the Order of the Garter, England's highest order of chivalry, perhaps timing this to coincide with Lennox's coming of age (he was baptised in Whitehall Chapel on 25 April 1612). This portrait was probably completed soon after Lennox's installation as a Knight of the Garter on 6 November 1633. The ribbon and badge of the Garter hang below the lace collar, the Garter itself (blue velvet, with the motto *'Honi soit qui mal y pense'* embroidered in gold) is visible below his left knee and the Garter star with its aureole of silver rays is conspicuous upon his cloak; but unlike *Henry Danvers, Earl of Danby* (cat. 73), this is not a portrait of a Garter Knight in full robes.

The presence of Lennox's greyhound contributes to its informality. Van Dyck's two studies of the hound (fig. 2), made from life, then combined in the final, painted pose, have more immediacy than his study of Lennox himself (Vey 214). The inclusion of a large devoted hound in portraits of great men has precedents which go back at least a century, to Titian's *Charles V with a Hound* of 1533, then in Charles I's collection (Prado, Madrid). But Lennox's greyhound is no mere symbol of loyalty. It is as much an individual as his master, and equally well-bred. Its colouring – 'red fallow, with a black muzzle' – had been the most highly prized for the breed since the Duke of York's treatise *On the Chase* in 1471. The same or a similar hound appears in Van Dyck's half-length portrait of Lennox of *c.* 1634 (fig. 1), prompting anecdotes that it once saved its master's life. C. V. Wedgwood wrote that 'The character of Lennox can be read from Anthony van Dyck's different versions of his fair, aristocratic, equine features: he was a good young man, loyal, sweet-natured and simple-hearted, but not clever':[1] an example of the large responsibility which Van Dyck's portraits bear for our supposed insights into his sitters' characters.

Lennox's career, as the Scottish-born, near-royal cousin and devoted supporter of a King who aroused increasing mistrust and finally rebellion, was doomed to failure, for he was caught from the start in religious and political cross-fire. The entire Stuart family, from the King downwards, was suspected of Roman Catholicism. Ludovic Stuart, one of Lennox's younger brothers, became a priest (and was elected Cardinal shortly before his death). Lennox himself was suspected of being a secret Catholic. The complexities of Lennox's position can only briefly be suggested here. He was Heritable High Chamberlain of Scotland, but his fellow-Scots mistrusted him (especially on the point of their objections to the Book of Common Prayer), while in England, his appointment as Lord Warden of the Cinque Ports in 1640 prompted the 'disgust of the English lords, who do not think it decent or safe to hand over all the gates of England to a Scot of such eminence'.[2]

On a lighter note, Lennox performed between 1635 and 1640 in the extravagantly beautiful court masques designed for Charles by Inigo Jones: as 'a masquer' in *Coelum Britannicum*, *Britannia Triumphans* and *Salmacida Spolia*, as 'a noble Persian youth' in *The Temple of Love*, and as 'a mariner' in *Luminalia: The Queen's Festival of Light*. *Salmacida Spolia*, performed in January 1640, was the most splendid of all the court masques; but it was to be the last of them. By the summer of 1642, the Civil War had begun.

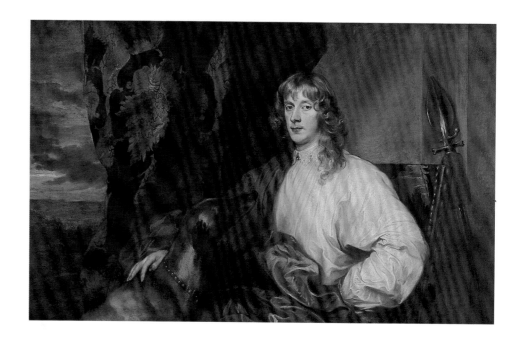

FIG 1
Anthony van Dyck, *James Stuart,*
Duke of Richmond and Lennox, c. 1634
oil on canvas, 99.7 × 160 cm
Iveagh Bequest, Kenwood House

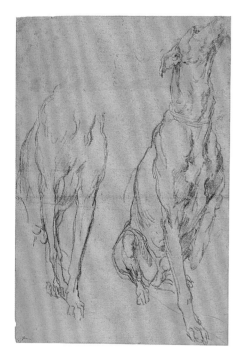

FIG 2
Anthony van Dyck, *Studies of*
a Greyhound, 1633–4
black chalk with white highlights
on light brown paper, 47 × 32.8 cm
Department of Prints and Drawings,
British Museum, London (Vey 215)

Clarendon described Lennox as 'a man of honour and fidelity in all places'.[3] His loyalty to the King was absolute. He lent the King vast sums of money (totalling £96,000) both before and after the outbreak of the Civil War. Throughout that war, in which three of his brothers were to die 'for God and King Charles', Lennox remained supportive, though more clear-eyed than many of the cavaliers; he appears to have realised at an early stage that the King would eventually have to capitulate to Parliament. One of the King's Commissioners for Peace in 1647, he was subsequently one of the five peers who offered themselves to Parliament for 'punishment' (i.e. execution) instead of the King – to no avail. After the King's execution, Lennox was one of the four peers who oversaw his burial in the Royal Chapel at Windsor.

As well as other portraits of Lennox, Van Dyck painted his wife, formerly Lady Mary Villiers, only daughter of Charles's favourite, the murdered Duke of Buckingham (Royal Collection) and several of his younger brothers, including *George Stuart, 9th Seigneur d'Aubigny* (National Portrait Gallery) and, most memorably, *Lord John and Lord Bernard Stuart* (cat. 97). Not the least aspect of Van Dyck's genius is his ability to catch differences of character among brothers, while retaining a family likeness. JE

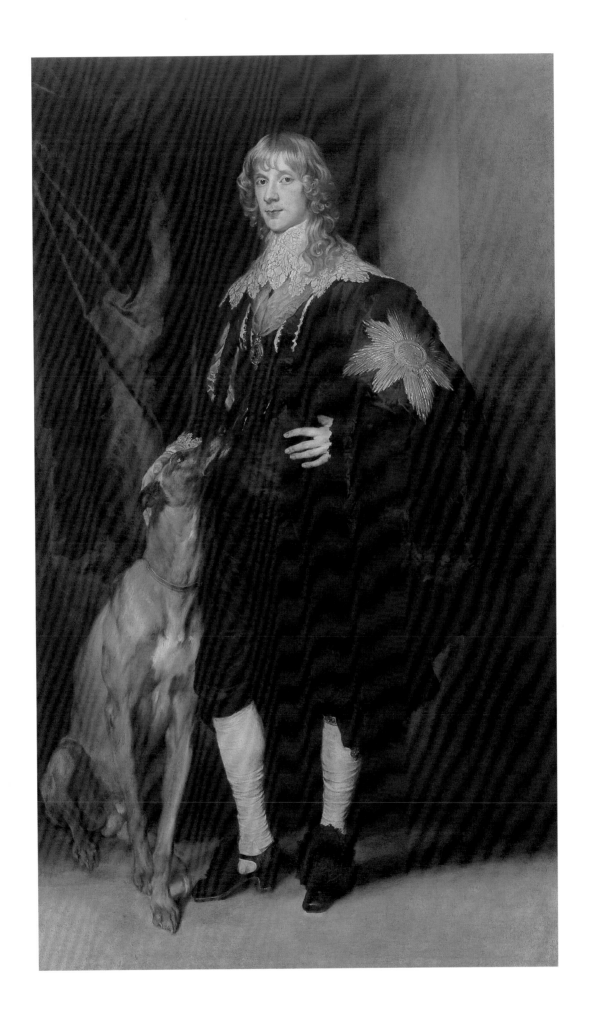

Robert Rich, 2nd Earl of Warwick

c. 1634

oil on canvas, 208 × 128 cm

The Metropolitan Museum of Art, New York, The Jules Bache Collection, 1949 (inv. no. 49.7.26)

PROVENANCE Presumably commissioned by the sitter; by descent to his sons, respectively 3rd and 4th Earls of Warwick; inherited by their cousin, Robert Rich (son of Henry Rich, 1st Earl Holland), 5th Earl of Warwick and 2nd Earl Holland (d. 1675), and by his sister Mary, first wife of the 1st Earl of Breadalbane (d. 1717); by descent to the 5th Earl of Breadalbane (d. 1862); inherited by his sister, Lady Elizabeth Pringle, and by her daughter, the Hon. Mrs Baillie-Hamilton, passing to her great-nephew the Hon. Thomas George Breadalbane Morgan-Grenville-Gavin; offered at Christie's, 6 July 1917, lot 68, bought in; Duveen Brothers, New York, from whom purchased by 1921 by Jules S. Bache, New York; 1949, bequeathed by him to the Museum

REFERENCES Cust 1900, pp. 127, 285, no. 220; Glück 1931, no. 395; Brown 1982, pp. 204, 206; Liedtke 1984, I, pp. 72–4; Larsen 1988, no. 1028

EXHIBITIONS London 1877, no. 209; ibid. 1893, no. 126; Detroit 1921, no. 41; Detroit, Institute of Arts, *British Paintings of the late Eighteenth and Early Nineteenth Centuries*, 1926, no. 50; New York, World's Fair, *Masterpieces of Art*, 1939, no. 106; London 1972–3, no. 99; Washington 1990–91, no. 68

NOTE

1. Quotations are from GEC, XII, ii, pp. 407–11.

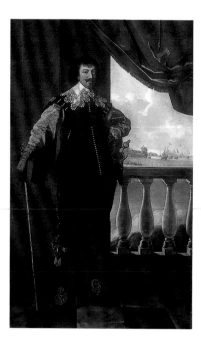

Unlike most of the English sitters in this exhibition, Robert Rich, 2nd Earl of Warwick (1587–1658) was not a courtier. A near-contemporary wrote that 'His Spirit aimed at more publick Adventures, planting Colonies in the *Western* World, rather than himself in the King's Favour'.

Van Dyck depicts a man of formidable energy. That energy was directed during the first half of his life to maritime adventure, not without 'a bit of Elizabethan piracy', and motivated more by profit-seeking than by any patriotic urge towards empire-building. Between 1615 and 1630, Warwick was actively involved on councils for the Colony of Virginia and for the plantation of New England; he had interests in the Bermudas, Guinea, Amazon River and Bahamas Companies. In 1628 he was made a Free Brother of the East India Company, having married (three years earlier, as his second wife) Susan, widow of Alderman William Halliday, sometime Sheriff of London and a Governor of the East India Company: she was a rich woman, though her status as a 'citizen' was regarded low.

In middle age, Warwick was readier to serve at home. Upon reports in the autumn of 1625 that the Spanish would attempt a landing in England, he was appointed (with the Earl of Sussex) Joint Lord Lieutenant of Essex, sharing that office until 1642, combined with that of Vice-Admiral of Essex – but the Spaniards did not come. In 1627 Warwick received a privateering commission against the Spaniards. His squadron attempted, but failed, to intercept a silver fleet from Brazil. Warwick himself narrowly missed capture when his ship passed through the Spanish fleet near the Rock of Gibraltar on 2 July. By 14 August he was back in England, and kissed the King's hand at Windsor; it was reported that he 'was never sick one hour at sea, and would as nimbly climb up to the top and yard as any common mariner in the ship; and all the time of the fight was as active, and as open to danger, as any man there'.[1]

Extrovert, ebullient and, in Clarendon's phrase, 'a man of universal jollity', Warwick is unlikely to have kept his various exploits to himself. Possibly the blazing naval skirmish in the background of Van Dyck's portrait commemorates his narrow escape from capture off Gibraltar in 1627, but since Van Dyck makes no attempt to represent the Rock, the background may more generally allude to Warwick's career as a man of action. Millar (in London 1972–3) observes that Van Dyck's introduction of movement and allusion into this portrait anticipates the design and spirit of Reynolds's *Commodore Augustus Keppel* of 1752–4 (National Maritime Museum, Greenwich).

By 1640, Warwick had become an active Parliamentarian. Although no Puritan (Clarendon described Warwick's way of life as 'very licentious and unconformable to their professed rigour'), Warwick strongly opposed the policies of the crown. This opposition divided him from his own brother, Henry, Earl Holland, whose execution was to follow not long after the King's. When the Civil War began, Warwick was aged 55, but had lost none of his energy. As Admiral of the Fleet and later Lord High Admiral (his chief offices during the War, though there were others, including Lord Warden of the Cinque Ports, Lord High Admiral in the West Indies and Governor of Guernsey), he held the command of the seas for Parliament throughout the war. Warwick died in 1658, aged 71. JE

FIG 1

Daniel Mytens, *Robert Rich, 2nd Earl of Warwick*, 1632
oil on canvas, 221 × 139.7 cm
National Maritime Museum, Greenwich

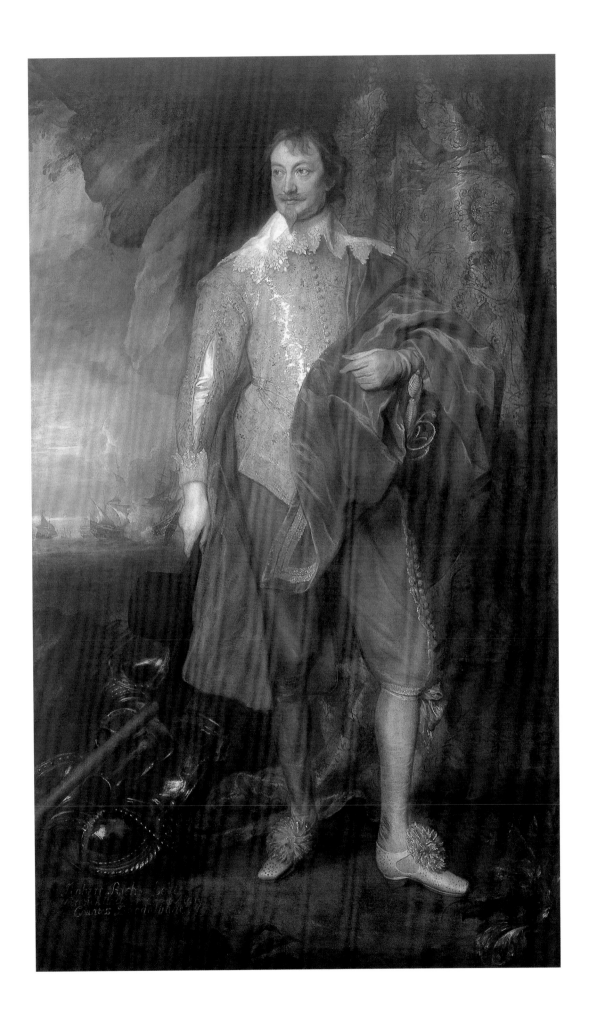

73 *Henry Danvers, Earl of Danby*
1633–5

oil on canvas, 223 × 130.6 cm

The State Hermitage Museum, St Petersburg
(inv. no. 545)

PROVENANCE Commissioned by the sitter,
who bequeathed it to his nephew, John Danvers;
presented by the latter's son Sir Joseph Danvers
to Sir Robert Walpole (later 1st Earl of Orford),
Houghton Hall; by descent to his grandson,
3rd Earl of Orford, who sold it in 1779, as part of
the Walpole Collection, to Empress Catherine II
('Catherine the Great') of Russia; State Hermitage
Museum

REFERENCES Cust 1900, p. 124, no. 61;
Varshavskaya 1963, p. 127, no. 24; Larsen 1988,
no. 934; Gritsai 1996, p. 124

EXHIBITIONS London 1982, no. 20; New
Haven, Toledo, St Louis and St Petersburg
1996–7, no. 3

NOTES
1. For an outline of Danby's career, see GEC, LV,
pp. 48–9.
2. Danby's scar is also evident in a much earlier
portrait (Larsen, no. 819).
3. See John Aubrey, *Brief Lives*, ed. Clark 1898,
p. 194.
4. Jennifer Sherwood, *Oxfordshire*, Harmonds-
worth 1974, p. 553.

FIG 1
Peter Paul Rubens, *Self-portrait*, 1623–4
oil on panel, 86 × 62 cm
Her Majesty The Queen

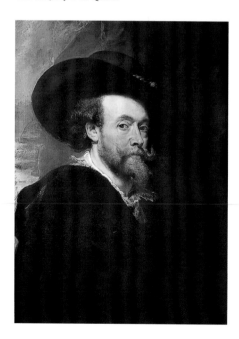

By the time Van Dyck painted him, Henry Danvers, 1st (and only) Earl of Danby (1573–1644),[1] was one of the most venerable members of Charles I's court, having served under both Elizabeth I and James I. The second son of Sir John Danvers and his second wife, Elizabeth Nevill, he began his career as a page to Sir Philip Sidney. As a soldier, he fought in the Low Countries under Prince Maurits of Orange, in the armies of Henri IV of France (there, perhaps, gaining the abiding scar near his left eye which Van Dyck depicts) and in Ireland under the Earl of Essex. One crime marred an otherwise distinguished career: for the murder of Henry Long at Corsham Castle in 1594, he and his brother were banished (but pardoned four years later). By 1602 he held the rank of Sergeant Major-General of the Army.

In middle age, and at the court of James I, Danvers became a connoisseur of pictures and an admirer of Rubens, from whom he commissioned a *Self-portrait* in 1623 (fig. 1); this he presented to the Prince of Wales, later Charles I. Thereafter, honours (and perquisites) came thick and fast. In 1626, he was created 1st Earl of Danby; two years later, he was made a Privy Councillor. In November 1633, Danby was installed as a Knight of the Order of the Garter, thus becoming one of the small company of 'persons of the highest honour' selected by the King for the highest order of chivalry in England. It is this honour that Van Dyck's portrait celebrates, and celebrates supremely. A preliminary chalk drawing (Vey 212) shows Danby at three-quarter length; but it was decided that this august figure must be portrayed full length. The result is the only full-length of a Garter Knight in full robes that Van Dyck painted. But Danby himself succeeds in dominating the white, gold and red splendour of his costume. Sixty years old by the time of his installation, Danby is evidently still a man of action, his figure lean and energetic, the battle-scar inflicted four decades earlier still (under a black patch) in evidence,[2] the commanding gesture with which he points (if here only to the tablecloth, rather than to a plan of campaign) seemingly one of lifelong habit.

Aubrey gives a pen-portrait of Danby which both reflects and complements Van Dyck's painted image: 'tall and spare; temperate; sedate and solid; lived mostly at Cornbury; a great improver of his estate … a great oeconomist. All his servants sober and wise'.[3] In 1617 he had been granted the Rangership of Cornbury Park in the royal forest of Wychwood; and there, in 1632–3, he employed the sculptor and master mason Nicholas Stone to transform a former hunting lodge into Cornbury House, in 'one of the earliest attempts to design a classical house front in England'.[4]

In Oxford, in 1621, Danby founded and endowed the first Physic Garden in England, for the study of 'simples', or plants with medicinal qualities. He employed Nicholas Stone to build (and probably design) three stone gateways to this garden, which was ready for occupation in 1642. Unable to secure the services of John Tradescant, gardener to Charles I, Danby appointed Jacob Brobart, a former Brunswick soldier, as its keeper. The first catalogue of the Oxford Botanic Garden (as it became known) was published in 1648; it listed some 600 native plants and 1200 plants from abroad, all by then established there.

Danby died at home in Cornbury in 1644, unmarried and in his seventy-first year. JE

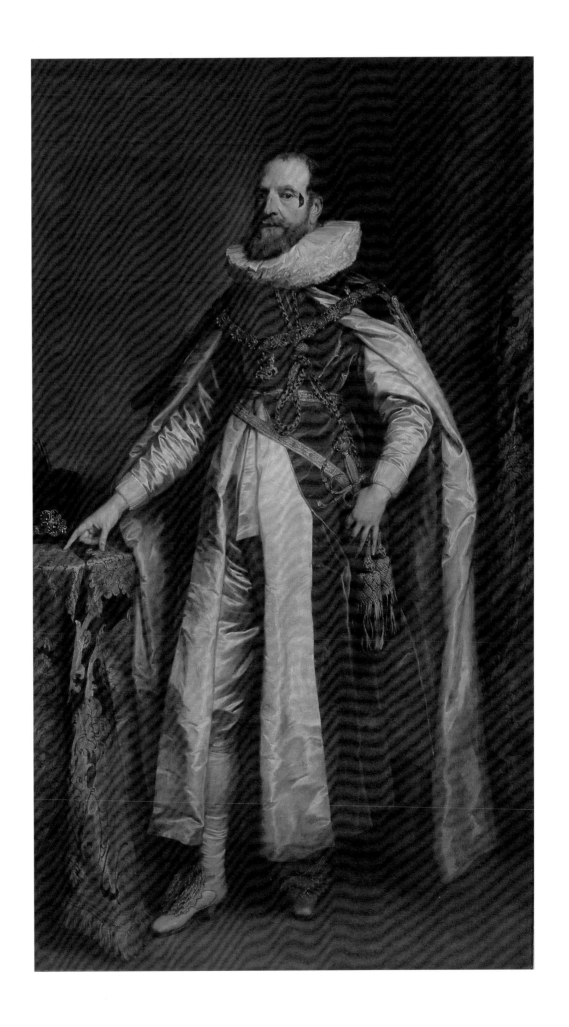

74 *Princess Henrietta of Lorraine attended by a Page* 1634

oil on canvas, 213.4 × 127 cm
inscribed bottom left, as if on a piece of paper: *Henrietta Lotharinga / Princeps de Phalsburg, 1634* and, bottom right: *Ant. van Dyck Eques Fecit*

English Heritage (The Iveagh Bequest, Kenwood) (inv. no. 88028826)

PROVENANCE 1634, painted for the sitter, by whom entrusted to Endymion Porter; 1634-5, brought by him from Brussels and given to Charles I; offered in the Commonwealth sale, sold to Col. Webb 27 October 1649 for £30; Cardinal Mazarin, Paris; 1722, bought by Philippe, duc d'Orléans; among pictures in the Orléans collection brought to England in 1792; bought *c.* 1793-5 by Benjamin Vandergucht; 11-12 March 1796, his sale, Christie's, lot 70; by 1831, Earl of Carlisle; by 1842, 10th Duke of Hamilton, and by descent to 12th Duke of Hamilton, by whom sold in the Hamilton Palace sale, 17 June 1882, lot 18, bought by Davies; 5th Earl of Rosebery, from whom bought by Agnew's; 1888, sold to Sir Edward Cecil Guinness, later 1st Earl of Iveagh

REFERENCES *Description des Tableaux du Palais Royal ... Dediée a Monseigneur Le Duc d'Orléans...,* Paris 1727, p. 73; Vertue 1757, p. 88, no. 24; Smith 1829-42, III, pp. 94-5, no. 327; IX, pp. 383-4, no. 54; Cust 1900, pp. 91-2, p. 219, no. 59, p. 255, no. 49; Stryienski, Orléans coll. 1913, pp. 118, 190, no. 502; Glück 1931, pp. 431, 567; Kenwood 1953, pp. 4, 8-9, no. 47; Antwerp 1960, p. 142, under no. 107; London 1970, p. 11; Millar 1972, p. 69; Larsen 1988, no. 903; Cifani and Monetti 1992, pp. 511-12 and 514, n. 55

EXHIBITIONS *Orléans Collection,* Pall Mall, London 1793, no. 52; Royal Academy 1873, no. 132; ibid. 1892, no. 130; London 1900, no. 59; *Old Masters presented to the Nation by the late Earl of Iveagh,* Manchester 1928, no. 10; *Works by Late Members of the Royal Academy and of the Iveagh Bequest of Works by Old Masters (Kenwood Collection),* Royal Academy, London, 1928, no. 192; *Meisterwerke flämischer Malerei,* Museum zu Allerheiligen, Schaffhausen, 1955, no. 28; Washington 1990-91, no. 72

NOTE
1. For the Abbé Scaglia's bequest to Henrietta of Lorraine, and for the suggestion that she may have been the model for the Virgin in *The Abbé Scaglia adoring the Virgin and Child,* see Cifani and Monetti 1992.

By 1634, when Van Dyck painted her, Henrietta of Lorraine (?1605-60), Princess of Phalsbourg, was a widow; in 1621 she had married Louis de Guise, Prince of Lixin and Phalsbourg, who died soon afterwards. She was later to remarry three times, each time unhappily. The elder daughter of Count François de Vaudemont, she was a member of the ducal house of Lorraine of which her brother Charles was 4th Duke. Relations between the dukes of Lorraine and the kings of France had long been uneasy; in this period, Cardinal Richelieu tried strenuously to control the duchy of Lorraine and the fortunes of its house. By 1634, when Van Dyck was working in Brussels, Charles, Duke of Lorraine, Henrietta and her younger sister Margaret had all taken refuge at the court of Brussels; also in residence there was Marie de' Medici, Richelieu's bitterest enemy, and mother of Henrietta Maria of England.

In Brussels, and in a manner befitting their rank, Van Dyck painted separate portraits of Charles, Duke of Lorraine, and both his sisters, Henrietta and Margaret; more beguilingly, he painted *Béatrice de Cusance, Princesse de Cantecroix* (Royal Collection), whom Charles married for love after repudiating his first marriage. In great secrecy, Margaret married Gaston, duc d'Orléans, Marie de' Medici's younger son, disaffected brother of Louis XIII of France and of Henrietta Maria of England. This marriage, also for love, brought down the fury of Richelieu, who had planned that Gaston should marry his own niece. Henrietta escaped arrest by Richelieu's troops at Nancy by disguising herself as a man and fleeing to Brussels.

A preliminary drawing (Vey 195) preceded Henrietta's portrait. Her pose is essentially a repetition of that which Van Dyck used the previous year in *Henrietta Maria with Jeffrey Hudson and an Ape* (cat. 67), and was to repeat in his portrait of Henrietta's sister Margaret (Uffizi, Florence). Faced with Henrietta's unyielding features, Van Dyck ennobles her portrait by extending the length of her legs, and enlivens it by adding a Moorish page, who offers the *grande dame* roses on a silver salver, gazing up at her towering presence with a devotion which (given her glacial expression) may get him nowhere. The page's pose echoes that of the respectful child in Van Dyck's portrait known as *A Man with his Son* (*c.* 1628-9; Louvre, Paris). Lely was to borrow the motif for his portrait of *Elizabeth Murray, Countess of Dysart* (Victoria and Albert Museum, London).

Henrietta had less than a year in which to contemplate Van Dyck's portrait. Worsening relations between France and Spain prompted hostility to the French in Brussels, and both Henrietta and Margaret of Lorraine moved (as did Marie de' Medici) to Antwerp. Before leaving Brussels, Henrietta entrusted her portrait to Endymion Porter (cat. 88); he brought it to England in the winter of 1634-5 and presented it to Charles I, who hung it in Whitehall Palace: his grandmother, Mary, Queen of Scots, was the daughter of Mary of Lorraine.

There were to be bitter episodes in Henrietta's life, but she was able to live in some style in Antwerp and to extend patronage to painters and writers. She formed one memorable friendship, with the Abbé Scaglia (cat. 78), who bequeathed her Van Dyck's *The Abbé Scaglia adoring the Virgin and Child* (cat. 78, fig. 3),[1] together with a painting by the Antwerp painter Daniel Seghers of 'a festoon of roses'. JE

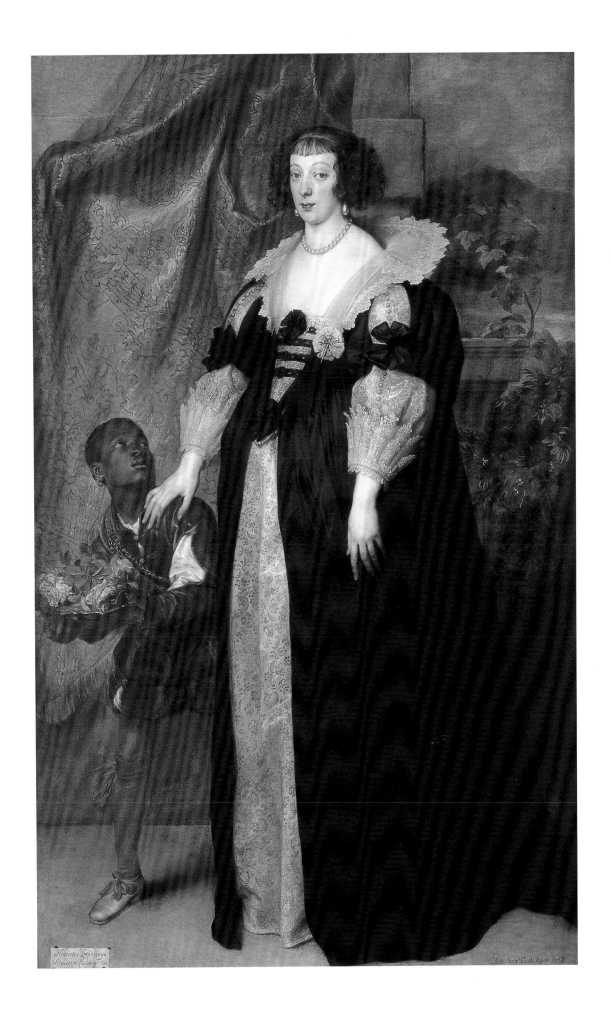

75 *Philip Herbert, 4th Earl of Pembroke, c. 1634*

oil on canvas, 105.4 × 83.8 cm

National Gallery of Victoria, Melbourne, Felton Bequest, 1937 (inv. no. 457–4)

PROVENANCE Presumably commissioned by the sitter; at an unknown date, entered the Pytts collection (? acquired by Sir James Pytts MP, d. 1752; Edmund Pytts, d. 1781; or his brother Jonathan Pytts, d.s.p. 1807) at Kyre Park, Worcestershire; passed with Kyre Park and its contents to Catherine Pytts's grandson William Lacon Childe; in the Childe (later styled Baldwyn-Childe) family; inherited *c.* 1929 from Prebendary Baldwyn-Childe, Rector of Kyre, by Charles Edward Childe-Freeman; 1930, sold to George H. Heath with the entire Kyre Park estate; by 1931, Colnaghi's [on approval to Garabed Bishirgan, in whose name lent to the Paris exhibition of 1936, but not purchased by him]; 1937, purchased from Colnaghi's for the Felton Bequest by the Gallery

REFERENCES Glück 1931, p. 564; Brown 1982, p. 201; Larsen 1988, no. 937; Brown, in Washington 1990–91, pp. 37–44; Ursula Hoff, *European Paintings before Eighteen Hundred: National Gallery of Victoria*, Melbourne 1995, pp. 94–5 (with full bibliography)

EXHIBITIONS *Worcestershire Exhibition*, Worcester 1882 (ex-cat.; exhibition label on lining canvas); Paris 1936, no. 32 (misprinted in catalogue as 17); London 1972–3, no. 104; Moscow and Leningrad 1979, no. 8; London 1982–3, no. 12

NOTES
1. John Aubrey, ed. Clark 1898.
2. The quotation from Lady Anne Clifford is from the Roxburghe Club edition of her *Lives*, 1916, p. 55.
3. Noted in GEC, V, 1945, p. 417.

Such lasting fame as Philip Herbert and his elder brother William enjoy is chiefly due to the fact that their names are associated with the publication of *Mr William Shakespeare's Comedies, Histories and Tragedies*, better known as the First Folio, in 1623, seven years after Shakespeare's death. In a dedicatory address, William and Philip Herbert are styled 'the Most Noble and Incomparable Pair of Brethren'. That William Herbert at the time held the office of Lord Chamberlain, which included the licensing of theatres and plays, no doubt influenced this dedication.

William (1580–1630) and Philip Herbert (1584–1650) were the sons of the 2nd Earl of Pembroke, of Wilton House, Wiltshire. William succeeded his father as 3rd Earl in 1601; Philip was to succeed his brother as 4th Earl in 1630. Both were prominent at the courts of both James I and Charles I; each had interests in New World colonising enterprises; and each used the rewards of court life and commercial enterprise for the glorification of the Pembroke family and for the embellishment of Wilton House.

This portrait shows Philip Herbert, by then Earl of Pembroke and Montgomery, at the age of about 50. He was appointed Lord Chamberlain in 1626 (in his brother's place), and as such was the principal officer of the royal household. Van Dyck portrays him wearing the Garter ribbon and badge, and holding his wand of office, a white staff. He looks grave, dignified and dependable. In fact, he appears to have been overbearing and quarrelsome ('intolerable, cholerick and offensive', according to Dorothy Osborne). He had begun his career at court as one of the chief favourites of James I, catching the kingly eye in manly sports, yet displaying bad temper even on the royal tennis court. James made him a Gentleman of the Bedchamber, created him 1st Earl of Montgomery (1605) and paid his debts. After the accession of Charles I, Philip was one of the peers who escorted the King's bride, Henrietta Maria, from Paris to England in May 1625. He enjoyed royal favour for a further fifteen years, his immense power chiefly deriving from his position as Lord Chamberlain of the Household, with authority over courtiers, ceremonies, procedures and entertainments.

Pembroke is seen to better advantage on his home ground, Wilton, described by Aubrey as 'an Arcadian place and a paradise'.[1] Though not scholarly, like his brother-in-law the Earl of Arundel (cat. 89), Pembroke used his wealth and position to rebuild Wilton, adorn it with paintings and sculpture, and lay out its gardens. His collection of paintings included some which he exchanged with the King: most notably, he gave the King Raphael's *St George and the Dragon* (Royal Collection) in return for Holbein's 'great booke' of portrait drawings, which he then gave to the Earl of Arundel. He was closely involved with the redecoration of the royal palaces as well as with every aspect of the staging of court masques. Van Dyck's vast painting *The 4th Earl of Pembroke and his Family* (fig. 62) was commissioned to hang at Wilton in the Double Cube Room designed for Pembroke by Inigo Jones. Van Dyck's full-length (1635–8; The Earl of Pembroke, Wilton House) portrays Pembroke as he must often have appeared in his role as Lord Chamberlain, peremptorily exiting with his wand of office. His expression seems to echo the comment of his second wife, Lady Anne Clifford, that although 'extremely cholerick by nature', Pembroke was 'very crafty withal'.[2]

By 1641, foreseeing the failure of the King's attempts at personal rule, Pembroke sided with Parliament against the Court, and was one of the Commissioners who received the King when he was surrendered by the Scots in January 1647. It should be noted of this famously bad-tempered man that he was the only one to visit the King's children 'to receive their small errands to their Father'.[3] Pembroke's generosity to the playwright Philip Massinger and the poet Sir John Denham should also be recalled. J E

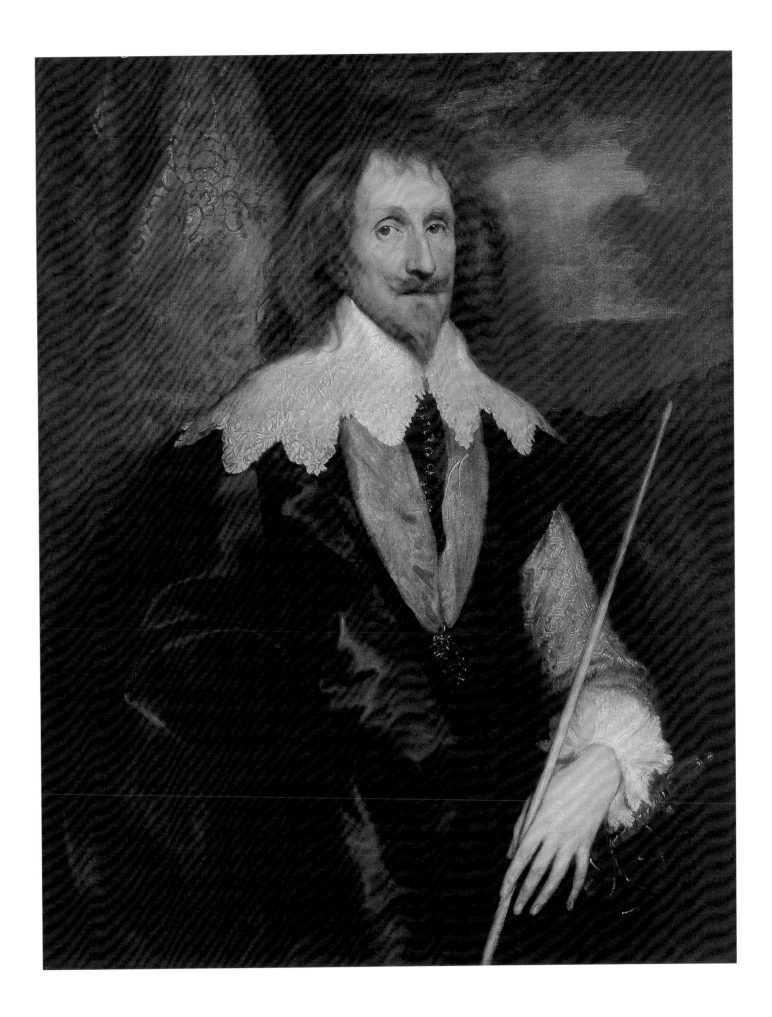

76 *John, Count of Nassau-Siegen, and his Family* 1634

oil on canvas, 292.5 × 265 cm
A lengthy inscription on the pillar gives the sitters' names and the date *1634*

Trustees of Firle Estate Settlement Trust

PROVENANCE Commissioned by the principal sitter, and by descent, until 1741 (?), when purchased by Van Swieten, The Hague; Earl Cowper, Panshanger, Hertfordshire, and thence by descent

REFERENCES Waagen 1853, III, pp. 16–17; Cust 1900, p. 92, p. 258, no. 90; Glück 1931, p. 567, note to no. 428; Brown 1982, pp. 153, 157; Larsen 1988, no. 915

EXHIBITIONS Royal Academy 1881 (?); *The Firle Van Dyck*, National Gallery, London (no catalogue)

Van Dyck returned to Antwerp for a visit to his family in the spring of 1634, in time to purchase on 28 March 1634 property on the estate of Het Steen, whose house and manor were to be purchased by Rubens a year later. By the middle of April 1634, Van Dyck was summoned to the Court at Brussels. There the ceremonial entry of the new Regent of the Netherlands, the Cardinal-Infante Ferdinand, brother of Philip IV of Spain, was awaited. When the Cardinal-Infante finally arrived (he was officially proclaimed Governor of the Netherlands on 4 November), Van Dyck was to paint several portraits of him; meanwhile, he received abundant commissions to portray members of the Court.

The group portrait of John, Count of Nassau-Siegen, his wife Ernestine de Ligne and their four children is one of the most ambitious – and one of the largest – of Van Dyck's Brussels court portraits. It was preceded by preliminary chalk studies of the Count and of the Countess and her son (Vey 199, 200). The pictorial device of a rounded stone platform (used the previous year for the portrait of Henrietta Maria and Jeffrey Hudson, cat. 67) is here deployed as an almost ceremonial dais, on which the Count and Countess are seated, and their young son Johan Frans is, as heir, privileged to stand. His eldest sister Ernestine is permitted to place one foot upon the dais, in a pose which seems to echo (in reverse) Lady Mary Villiers' pose in the grandest and largest of all Van Dyck's non-royal portraits, *Philip Herbert, 4th Earl of Pembroke, and his Family* (fig. 62); his other two sisters, Claire-Marie and Lamberta Alberta, stand meekly below it. The Pembroke group, perhaps completed before Van Dyck's departure for Antwerp, is on a vast scale, covering one whole wall at Wilton House. The concept of the Nassau-Siegen group is also undeniably grand, yet its sitters, confronting Van Dyck in Brussels, do not evoke from him the same response with which he painted the aristocratic and supremely elegant Pembroke family in England. In this portrayal of the stolid reliability of John, Count of Nassau-Siegen, and his dutiful family one can detect almost a whiff of homesickness for the moodier and more elegant vagaries of the English Court.

The Count of Nassau-Siegen (1585–1638), a member of the Catholic branch of the Nassau family, was a commander and eventually Field-Marshal in the Spanish army in the Netherlands. Philip IV of Spain admitted him to the Order of the Golden Fleece, one of the most ancient and prestigious of all chivalric orders. In Van Dyck's portrait, the gold collar and badge of the Order are prominently displayed. Van Dyck also painted a full-length portrait of the Count in armour, holding his field-marshal's baton; this is of more conventional size (202 × 122 cm, Liechtenstein coll., Vaduz). JE

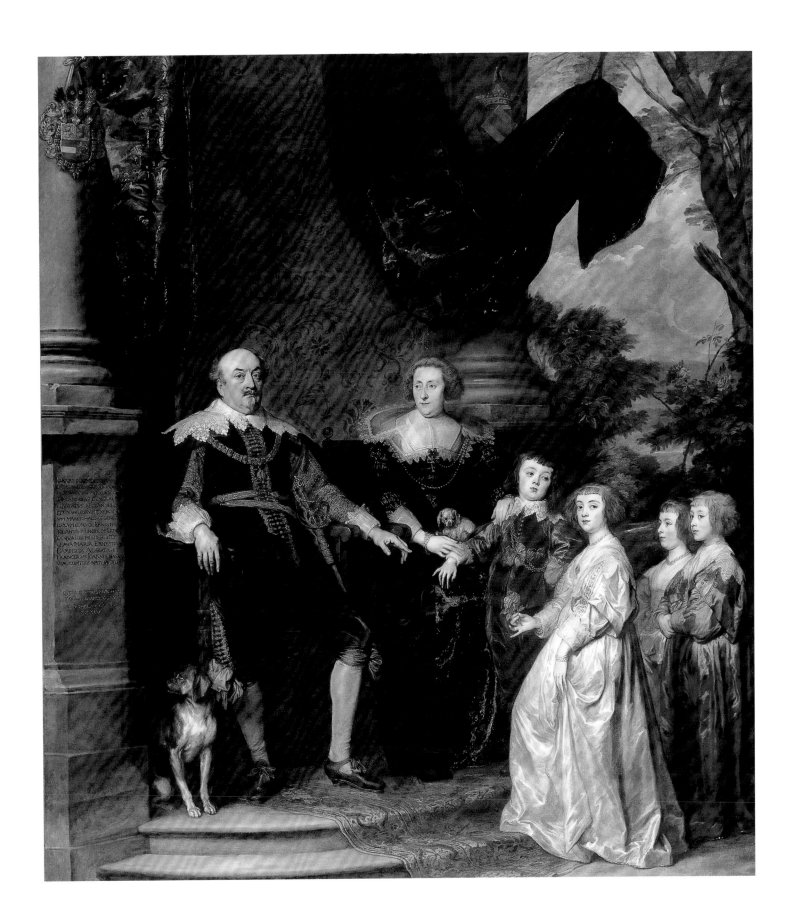

77 *Portrait of an Elderly Woman*
1634

oil on canvas, 117 × 93 cm
inscribed bottom left: A VAN DYCK / A° 1634

Kunsthistorisches Museum, Gemäldegalerie,
Vienna (inv. no. 500)

REFERENCES Mechel 1783, p. 109, no. 23; Smith
1829–42, III, p. 29, no. 100; Guiffrey 1882, p. 288,
no. 1121; Engerth 1884, pp. 122–3, no. 808; Cust
1900, p. 262, no. 162; Schaeffer 1909, p. 330;
Glück 1931, pp. 418, 565; Vienna 1987, p. 232;
Larsen 1988, I, p. 352; II, p. 378, no. 963

The elderly woman, shown three-quarter length, wears a simple dark dress relieved only by a flat lace collar and lace cuffs. She stands before a curtain drawn back to reveal a large rock and a hilly landscape with trees beyond. It seems likely that the painting once had a pendant portrait of her husband. The monumental rock may have been intended as an emblem of constancy.

The work was painted during Van Dyck's brief sojourn in the Netherlands between the autumn of 1634 and the spring of 1635. It is somewhat old-fashioned in appearance, not merely because of the lady's outmoded costume; the simple pose, with the one arm held at her side and the other across her waist, is also traditional. For that reason, the portrait is reminiscent of certain works dating from Van Dyck's earliest Antwerp years, such as the 1618 *Portrait of a Woman* (cat. 10), and is compositionally very different to the graceful and alluring female portraits in which he captured the self-image of a younger generation. H V

Cesare Alessandro Scaglia di Verrua, Abbé of Staffarda and Mandanici

1634–5

oil on canvas, 204.5 × 124.5 cm

Accepted by Her Majesty's Government in lieu of Inheritance Tax in 1999. Awaiting permanent allocation

PROVENANCE Painted for the sitter (d. 1641); Delacourt van der Voort, Leiden; his son Allard de la Court, by whose widow, Catharina Backer, sold Leiden, 8–9 September 1766, no. 3; by 1815, Sir Thomas Baring, Bt.; 1843, among 13 paintings sold to Robert Stayner Holford, MP (d. 1892); his son Sir George Lindsay Holford (d. 1926), by whose executors sold Christie's, 17 May 1928, no. 61, bought William Ewert Berry, created 1st Baron Camrose 1929 and 1st Viscount Camrose 1941 (d. 1954); by descent; 1999, accepted by HM Government in lieu of Inheritance Tax

REFERENCES Cust 1900, pp. 93–4, p. 259, no. 104; Glück 1931, pp. xlii, 159, 161; Schlugleit 1937, pp. 153–4; Brown 1982, pp. 159, 161; Larsen 1988, 11, no. 989; Cifani and Monetti 1992, pp. 506–14

EXHIBITIONS London 1815, no. 11; British Institution 1815, no. 6; ibid. 1839, no. 3; London 1862, no. 2; ibid. 1887, no. 54; Antwerp 1899, no. 73; London 1922, no. 37; ibid. 1927, no. 133; Antwerp 1930, no. 82; Paris 1932, no. 83; ibid. 1936, no. 20; London 1938, no. 86; Antwerp 1949, no. 49; London 1953–4, no. 155; ibid. 1982–3, no. 17; Washington 1990–91, no. 70

VERSIONS Koninklijk Museum voor Schone Kunsten, Antwerp, 189 × 110 cm; see fig. 1. Other versions or copies noted by Cifani and Monetti 1992, p. 511

NOTES
1. For Scaglia's involvement with the Greenwich commission, see White 1987, pp. 182–3. For further information about Scaglia, see Martin 1970, pp. 48–50.
2. See Cifani and Monetti 1992, pp. 511–12.
3. For later artists' adaptation of the pose, made familiar through Van den Enden's engraving in the *Iconography*, see Millar, in London 1982–3, p. 58.
4. Cifani and Monetti 1992, p. 513.
5. Noted by Millar, in London 1982–3, p. 58.

The Abbé Scaglia (1592–1641), second son of Filiberto, Count of Verrua and Marquess of Calussi, was principally engaged for most of his life in diplomacy (like his father before him), serving the Dukes of Savoy as ambassador to Rome (1614–23), Paris (1625–7) and London (1631–2), and travelling extensively around the courts of Europe. Scaglia was strongly pro-Spanish; Philip IV of Spain, whose interests he served on his embassy to London, rewarded him in 1631 with the rich revenues of the abbey of Mandanici in Sicily. Cifani and Monetti note that Scaglia was referred to in the coded letters of contemporary espionage as agent '2x': mistrusted by many, but admired by most for his intelligence and sound judgement.

By the time Van Dyck revisited the Spanish Netherlands in 1634–5, the Abbé Scaglia was officially in retirement, though never wholly detached from foreign affairs; at first based in Brussels, he settled in Antwerp in 1639. Cifani and Monetti describe him (p. 508) as 'Sceptical, cynical, ironic and intelligent … not indifferent to female charm, luxury and good living, despite the sincerity and intensity of his religious beliefs'. Scaglia knew all the leading Flemish painters, including Rubens – who might have been expected to paint him, but did not, perhaps because the two men were, through their diplomatic involvements, slightly wary of each other. Scaglia was later to be involved (with Rubens and Balthasar Gerbier) in Charles I's commission to Jordaens for decorative paintings for the Queen's House at Greenwich (see cat. 100).[1] Scaglia was to own at least seven paintings by Van Dyck,[2] including *The Abbé Scaglia adoring the Virgin and Child* (fig. 3), which he was to bequeath to Henrietta of Lorraine (see cat. 74).

Van Dyck, who may first have met Scaglia as early as 1623 in Turin, is likely to have found this urbane and civilised man very congenial; Scaglia's luxurious way of life – his house in Antwerp with its gold clocks, chinoiseries, silk hangings and state beds – no doubt also appealed to him. Van Dyck's four chalk studies of the Abbé Scaglia, made c. 1634–5 with portraits in mind, are almost conversational in spirit, as if he were enjoying the encounter (fig. 2; repr. Cifani and Monetti 1992).

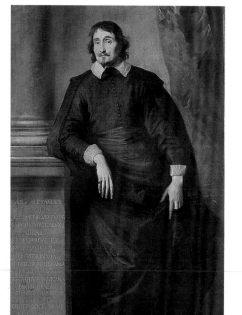

Scaglia presumably commissioned this full-length for himself, and was rewarded with a portrait which is monumental yet understated, deeply perceptive yet entirely uningratiating. Scaglia was no longer in good health when he posed for this portrait; probably with this in mind, Van Dyck used a variation of the Titianesque pose in which he had portrayed *Prince Rupert of the Palatinate* (cat. 64), leaning against a column.[3] This allowed Scaglia some support, without detracting from the

FIG 1
Anthony van Dyck, *Abbé Cesare Alessandro Scaglia*, 1639–40
oil on canvas, 189 × 110 cm
Koninklijk Museum voor Schone Kunsten, Antwerp

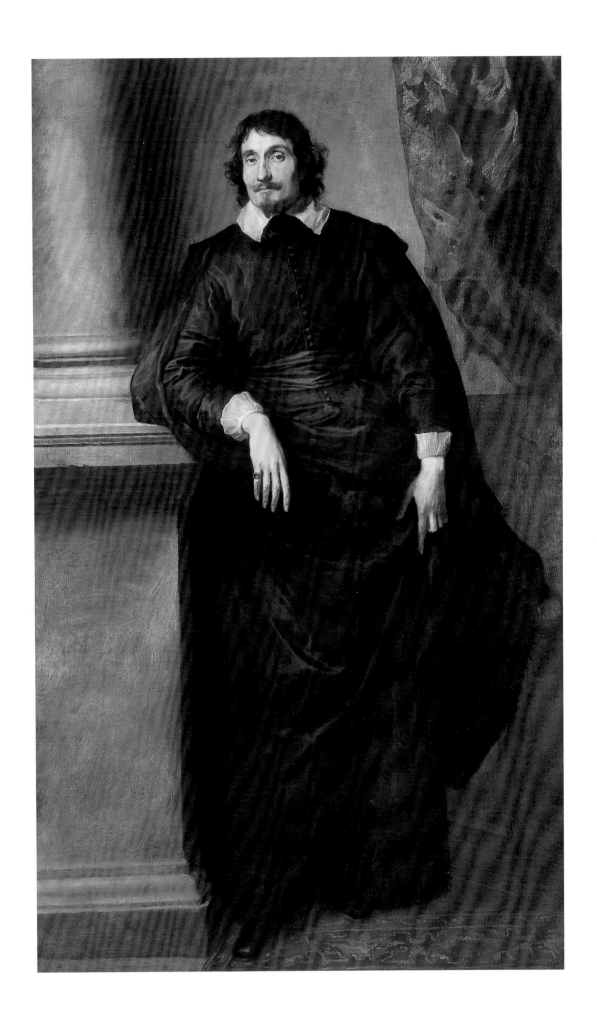

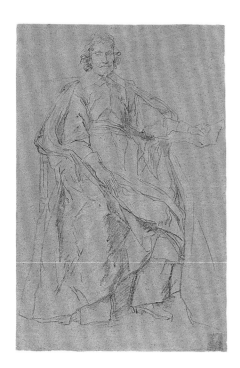

FIG 2
Anthony van Dyck, *Abbé Cesare
Alessandro Scaglia*, 1634–5
black and white chalk on
brown paper, 48.4 × 32.3 cm
Collection Frits Lugt, Institut Néerlandais,
Paris (Vey 192)

strength either of his figure or of his character; the leaning pose adds, rather, to the impression of a man who, having achieved much in this world, is now in reflective mood. The amber colours of the column, curtain, chair and carpet, subtly differentiated, contribute warmth to what might otherwise have been an austere portrait.

Scaglia intended to spend his last years in the Franciscan monastery of the Recollects in Antwerp. Having paid for the erection of an altar there, he commissioned Van Dyck to paint the *Lamentation* (cat. 85) as its predella. At some point (in 1634–5?), Scaglia also commissioned Van Dyck to paint a second version of the full-length portrait of himself (fig. 1). This was long assumed to be a copy, but Cifani and Monetti have established through the evidence of Scaglia's will that it is an authentic work by Van Dyck, presented by Scaglia to the monastery church of the Recollects; it was lettered on the plinth of the column after his death to that effect.[4] It appears to have been cut at the top and bottom, and is at present in less good condition. The quality of cat. 78 is finer, and its primacy is further indicated by the aura around the head,[5] which marks the area on which Van Dyck worked when painting the head. Scaglia died in his house in Antwerp on 21 May 1641, aged 49. The altarpiece in the monastery church of the Recollects was not erected until after his death; it was later taken to pieces. JE

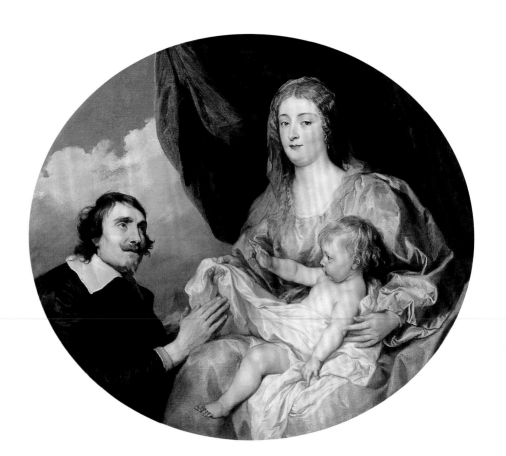

FIG 3
Anthony van Dyck, *The Abbé Scaglia
adoring the Virgin and Child*, 1634–5
oil on canvas, 106 × 120 cm
National Gallery, London

Prince Tommaso Francesco of Savoy-Carignano

1634

oil on canvas, 315 × 236 cm

Soprintendenza per i Beni Artistici e Storici del Piemonte, Galleria Sabauda, Turin (inv. no. 743)

PROVENANCE Commissioned by the sitter, and paid for in January 1635; Prince Vittore Amedeo II of Carignano, by whom presented to his cousin (the sitter's grandson), Prince Eugène of Savoy (d. 1732), and in his collection in Vienna; 1742, having been inherited by his niece, Marie Anne-Victoire of Savoy-Carignano (Princesse of Saxe-Hildbourghausen), sold by her to Carlo Emanuele III of Savoy, King of Sardinia, and returned to Turin; by descent to Charles Albert, King of Sardinia; 1832, among pictures from the Savoyard collection made available by him to the public as the Royal Gallery of Turin; 1860, in the Royal Gallery collection given by his son King Vittorio Emanuele II to the Italian state and, in 1932, renamed the Galleria Sabauda

REFERENCES Vesme 1885, pp. 27–41; *Catalogo della Regia Pinacoteca di Torino*, Turin 1899, no. 17; Cust 1900, p. 91, p. 259, no. 102; Marziano Bernardi, *The Sabauda Gallery of Turin*, Turin 1968, pp. 90, 94–6; Franco Mazzini, *Turin: The Sabauda Gallery*, Turin 1969, p. 15; Brown 1982, p. 153; Millar, in London 1982–3, pp. 33–4; Larsen 1988, no. 986

EXHIBITIONS *Diana Trionfatrice: Arte di Corte nel Piemonte del Seicento*, Turin 1989, no. 24; Washington 1990–91, no. 71

NOTES
1. The original, sold in the Commonwealth sale, is now in the Gemäldegalerie, Berlin (repr. Washington 1990–91, p. 275, fig. 1). See Millar 1963, under no. 184, a good contemporary copy which remains in the Royal Collection.
2. Vesme 1885, p. 28: '*offrit ... son épée au roi catholique*'.
3. Ibid. For a more detailed account of his career and campaigns, see *Biographie Universelle*, ed. Michaud, VI, Paris 1843, p. 675.
4. '*la remuante ambition ... a procuré beaucoup plus de mal que de bien à sa patrie*'.

This magnificent equestrian portrait was painted at the highest point of Prince Tommaso Francesco's career, during the short period in which he served King Philip II of Spain (in circumstances outlined below) as acting Regent of the Southern Netherlands. It was at that point, in 1634, that he commissioned two portraits of himself from Van Dyck, both paid for in January 1635. Van Dyck's receipt for the sum of five hundred *pattaconi* for two portraits of '*signore Principe Tomaso ... fatti di mia mano, l'uno a cavallo, et l'altro di meza postura*', signed and dated at Brussels, 3 January 1635, is reproduced in facsimile by Vesme 1885 (frontispiece). One of the two was the equestrian portrait; the other, the three-quarter length presumably presented by Prince Tommaso Francesco to Charles I and his sister-in-law Henrietta Maria.[1]

The Prince is depicted in the great tradition of equestrian portraiture which seeks to persuade us that he who can expertly control a rearing horse must, by analogy, be well fitted to rule subjects, or command battalions. That tradition, fully explored and illustrated by Walter Liedtke in *The Royal Horse and Rider* (New York 1989), includes works by Rubens which Van Dyck probably knew, such as *Giovanni Carlo Doria on Horseback*, of 1606–7 (fig. 35), and the sketchier but very glamorous *Equestrian Portrait of George Villiers, Duke of Buckingham*, of late 1625 (Kimbell Art Museum, Fort Worth), which Van Dyck undoubtedly knew and was influenced by in his own portrait of Prince Tommaso Francesco. Velázquez's *Equestrian Portrait of the Count-Duke Olivares* (fig. 1), probably painted two years after Van Dyck's picture, depicts a less showy but more credible man of action.

Prince Tommaso Francesco is portrayed wearing the ribbon and badge of the Order of the Annonciade conferred on him by his father in 1616; but this now appears to be his only link with the small principality of Savoy. His armour appears to be of Spanish workmanship. His horse must derive from Spain; like the horses supplied to the Spanish Riding School in Vienna, and to the finest stables in Europe (including the Duke of Buckingham's), it is of the prized Andalusian breed. Its luxuriant silken mane has been allowed (or encouraged, by some equine hairdresser) to reach as far as Prince Tommaso's spurs; more cruel is the long curved bit, capable of breaking the jaw of a disobedient horse. The portrait is resplendent; but it is by too perceptive an artist to leave us convinced that the sitter is truly a great man. The eyes alone seem to reveal that the Prince's ambition outsoared his intelligence. For all its energy and flamboyance, the picture resorts to a formula, and thus lacks the credibility of Van Dyck's greatest (and more quietly composed) equestrian portraits, such as *Anton Giulio Brignole-Sale* (cat. 46), painted in Genoa in the mid-1620s, or *Charles I on Horseback with Monsieur de St Antoine* (fig. 64), painted in 1633, a year before this picture.

Tommaso Francesco of Savoy-Carignano (1596–1656) was for the greater part of his life an active military commander. The youngest son of Carlo Emanuele I, Duke of Savoy (d. 1630) and his wife Catherine, daughter of King Philip II of Spain, he was related by birth or family marriages to some of the most powerful rulers of his day. Philip II's younger daughter Isabella (Tommaso's aunt) married the Archduke Albert and ruled jointly with him as Regents of the King of Spain in the Spanish Netherlands, until Albert's death in 1621, after which Isabella was sole Regent. Tommaso's eldest brother, Vittore Amedeo I, who succeeded as Duke of Savoy in 1630, married Christina, daughter of Henri IV of France and Marie de' Medici (and younger sister of Queen Henrietta Maria of England), and formed a French alliance; after his death in 1638, his widow Christina ('*Madame Royale*') ruled as Regent in Savoy. Tommaso Francesco's second brother Emanuele Filiberto, Viceroy of Sicily, portrayed by

Van Dyck in 1624 (cat. 35), was by contrast firmly committed to the service of the Spanish crown. Such conflicting alliances were to complicate Prince Tommaso Francesco's career; but the Turin scholar Baudi di Vesme (1885, p. 29) suggests that the chief key to his character was his own 'restless ambition'.

Tommaso Francesco's military career began at the age of sixteen, in the army of his father Carlo Emanuele, Duke of Savoy. In 1626 he was given the rank of Lieutenant-General and appointed Governor of Savoy. After Vittore Amedeo's succession as Duke of Savoy in 1630, Tommaso Francesco became increasingly mistrustful of his brother's pro-French policies and of Richelieu's evident wish to bring Piedmont and Savoy under French control. In 1634, deserting his brother, Tommaso Francesco 'offered his sword' to King Philip II of Spain and moved to Brussels.[2] The moment proved opportune. The Archduchess Isabella, Regent of the Netherlands (and Tommaso Francesco's aunt), had died on 1 December 1633. King Philip II of Spain appointed his younger brother Cardinal-Infante Ferdinand as the new Regent, but circumstances delayed his arrival in Brussels until November 1634. In the interim, Tommaso Francesco was appointed as acting Regent; he was also appointed commander of the Spanish forces in the Netherlands.

This is the point at which the Prince asked Van Dyck to portray him. Over the next five years he fought under the Spanish flag in the Netherlands against French and Dutch forces, sometimes victoriously, sometimes not ('*tantôt vainqueur, tantôt vaincu*').[3] His determination to share in the guardianship of his young nephew Carlo Emanuele II, Duke of Savoy, was resisted by the boy's mother, Duchess Christina. Three years of bitter warfare followed, after which Tommaso Francesco again changed sides. Deserting Savoy, he joined the French army with the rank of Marshal. His later campaigns were disastrously unsuccessful. He died, mortified, in 1656. Vesme, who (as noted earlier) singled out 'restless ambition' as the key to Prince Tommaso Francesco's career, suggests that 'he did more harm than good to his own country'.[4]

The picture was copied (with a different background) by Gonzales Coques in the 1650s for his *Equestrian Portrait of Thomas, 3rd Baron Fairfax*, the Parliamentary general who defeated Charles I at the battle of Naseby in 1645 (repr. Liedtke 1989, fig. 141). JE

FIG 1
Diego Velázquez, *The Count-Duke Olivares on Horseback, c.* 1636
oil on canvas, 314 × 240 cm
Museo Nacional del Prado, Madrid

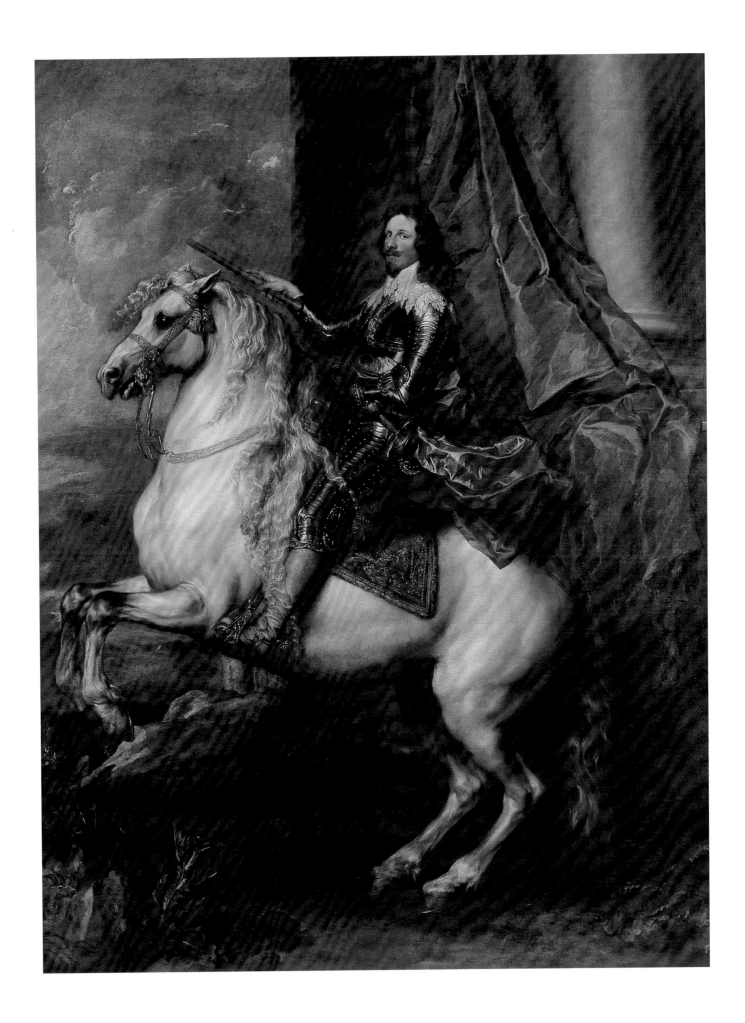

80 *Study for an Equestrian Portrait*

1634-5

oil on a thinly primed panel, 31.7 × 22.9 cm

The Earl of Pembroke

PROVENANCE 1774, first recorded at Wilton; possibly acquired by Philip, 4th Earl of Pembroke (d. 1650), or by Thomas, 10th Earl of Pembroke (d. 1794); then by descent

REFERENCES *Aedes Pembrochianae: A New Account and Description of the Statues, Bustos, Relievos, Paintings, Medals and Other Antiquities and Curiosities, in Wilton-House...*, ed. Jonathan Richardson, Junior, Wilton House and Salisbury 1774 (as 'The Duke of Epernon, on horseback; by Vandyke', by then hanging in the New Dining-Room); Smith 1829-42, III, p. 196, no. 697; Waagen 1854, III, p. 154; Glück 1931, pp. 380, 560-61; Vey 1956, pp. 201, 207 n. 47; Sidney, 16th Earl of Pembroke, *Catalogue of the Paintings and Drawings at Wilton House*, London and New York 1968, p. 66, no. 171; Martin 1970, pp. 43, 45, n. 20; Larsen 1988, no. 832

EXHIBITION Washington 1990-91, no. 97 (as 'Equestrian Portrait of Thomas-Francis, Prince of Savoy-Carignan')

NOTE
1. See Brown 1982, pl. 124.

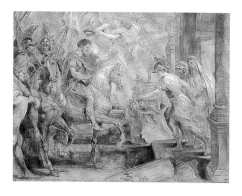

FIG 1
Peter Paul Rubens, *The Triumphal Entry of Constantine into Rome*, 1622
oil on panel, 48.3 × 63.5 cm
Indianapolis Museum of Art,
The Clowes Fund Collection

This sketch was swiftly executed in brown oil paint heightened with white. So far as is known, it was not developed into a commissioned portrait. We are left with a brilliant sketch of an unidentified military commander riding at an exalted processional pace onto the public stage, symbolically crowned by Fame, whose almost notional figure hovers overhead with a coronet, with a slightly less sketchy figure of Victory bearing a palm beside him. The concept is in the same tradition as Rubens's *Triumphal Entry of Constantine into Rome* (fig. 1).

Almost certainly the sketch was made around 1634-5, and probably in Brussels. There can be little doubt that it is a portrait study of a specific individual, who appears to have been a man aged between 35 and 45, of average height and fairly sturdy build, who was entitled to be portrayed with the baton proper to those of high military rank. While various candidates have been proposed, no conclusive identification has yet been made. From its earliest record at Wilton in 1774 until Glück's catalogue of 1931, the sitter was identified as 'The Duc d'Epernon'. He could hardly be Jean Louis de Nogaret, one of the favourites of Henri III of France, who was created 1st Duke of Epernon in 1581, since Nogaret's active career was over well before the 1630s. Possibly there was some confusion with his second son Bernard (1592-1661), who served under Richelieu as Colonel-General of the infantry and Governor of Guienne, succeeded his father as 2nd Duke of Epernon and was awarded the Order of the Garter in 1661, the year he died. However, one of Richelieu's colonels is unlikely to have been fêted in pro-Spanish Brussels around 1634-5.

Glück called this oil sketch simply 'Sketch for an Equestrian Portrait', but suggested (despite the rider's very different appearance) that it might have been related to an equestrian portrait of Charles I. In 1970 Gregory Martin suggested that the sitter in the oil sketch 'bears some resemblance to Prince Thomas of Savoy': that is, to Tommaso Francesco, Prince of Savoy-Carignano, of whom Van Dyck painted two portraits while he was in Brussels in 1634-5. Martin suggested that the oil sketch may have been 'a rejected *modello* for this commission'. But even if some resemblance between the heads in cat. 79 and in the oil sketch could be detected, there is little similarity between Tommaso's tall, lean figure and the shorter, sturdier figure in the sketch. A portraitist with an eye for body language as well as for faces – and, acutely, Van Dyck had such an eye – does not, when painting an equestrian portrait, lapse into the convention of painting 'a rider', but observes the different manners in which riders sit in the saddle, choose a stirrup length and hold the reins. By this test, there is little similarity between *Tommaso Francesco, Prince of Savoy-Carignano* (cat. 79) and this study of an unidentified hero.

Not many equestrian portraits by Van Dyck of this period are known. That of the Spanish commander *Marqués Francisco de Moncada* (Louvre, Paris) depicts an older, more sedate sitter. Several half-length portraits of military commanders with batons were engraved for the *Iconography*, including *Prince Frederik Hendrik of Orange*; conceivably, he might be worth investigating as a candidate for this study. Van Dyck painted him in armour, holding a baton (Prado, Madrid).[1] JE

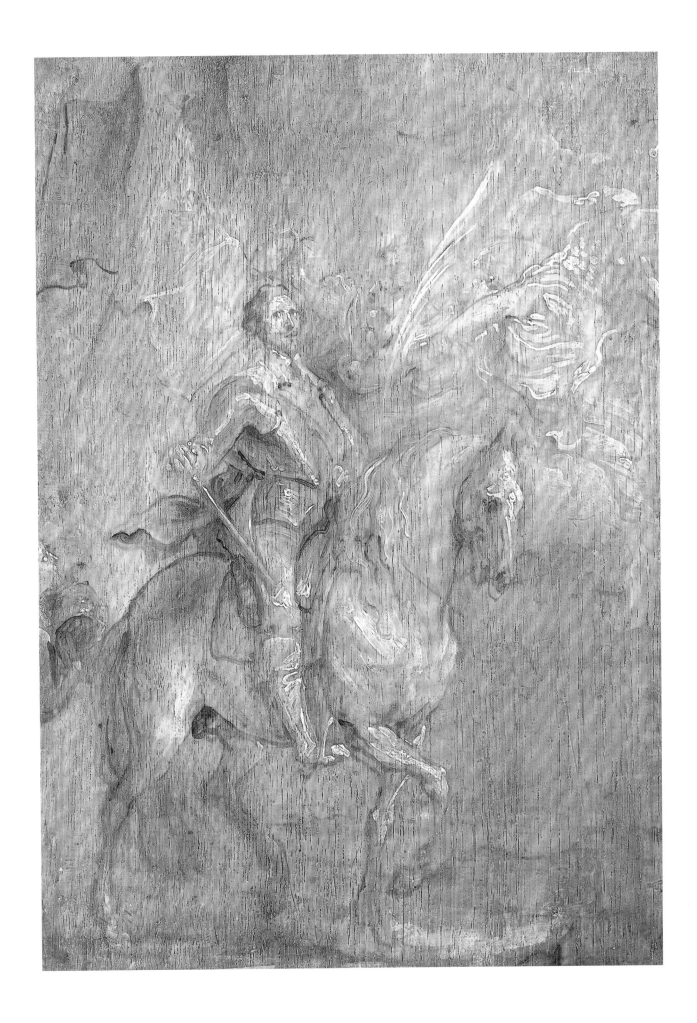

81 *Justus van Meerstraeten*
1634–5

oil on canvas, 119.3 × 109.5 cm

Staatliche Museen, Gemäldegalerie, Kassel
(inv.no. GK 126)

PROVENANCE Probably before 1731, collection
of the Elector Landgrave Wilhelm VIII of Hessen-
Kassel; 1806, transferred to Paris on Napoleon's
orders; 1814, returned to Kassel

REFERENCES Smith 1829–42, III, p.45,
no.155; Guiffrey 1882, p.281, no.916; Eisenmann
1888, pp.78–9, no.116; Cust 1900, p.257, no.77;
Voll 1904, pl.28; Schaeffer 1909, pp.314, 510;
Glück 1931, pp.416, 565; Van den Wijngaert
1943, p.142; Vogel 1958, p.55, no.126; Gerson
and ter Kuile 1960, p.124; Vey 1962, p.274, under
no.202; Schnackenburg 1985, pp.36–7; Larsen
1988, I, pp.347, 351; II, p.397, no.1015; Brown
1991, p.246, under no.77

EXHIBITION Antwerp 1949, no.51

ENGRAVING by J.L. Leonart

FIG 1
Anthony van Dyck,
Justus van Meerstraeten, 1634–5
black chalk with white highlights
on grey-green paper, 36.5 × 22.5 cm
Christ Church, Oxford (Vey 202)

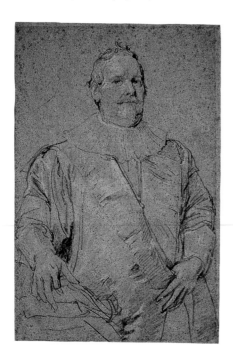

Justus van Meerstraeten (d. 1639) was a jurist and a prominent member of the Brussels magistracy. His identity is established by a print of this portrait engraved by J.L. Leonart (1633–after 1680) some time before 1660. Since it entered the Hessen-Kassel collection, it has been paired with a female portrait, which can be identified as that of his wife, Isabella van Assche. It, too, was engraved by Leonart. Isabella van Assche's portrait is smaller than that of her husband, which prompted Eisenmann in 1888 to cast doubt on the idea that the two portraits were conceived as pendants. Whatever the case, Van Dyck's authorship is proved by a deed drawn up on 27 July 1662 by the notary Gerardi, in which the two portraits, said to be the work of Van Dyck, passed to Carolus van Meerstraeten, Justus's son.

Van Meerstraeten is shown to the right of the centre in a relaxed pose; with his right hand he casually leafs through a large folio volume open on a table, to which a strip of paper is attached bearing the text DIGESTV[M]. This refers to a volume of the *Corpus Juris Civilis*, the Emperor Justinian's renowned codex of Roman law. There are several other books and a plaster cast of the famous antique bust believed at the time to be a portrait of Seneca. A marble copy of this bust was in Rubens's possession and appears in his *Four Philosophers* (Galleria Palatina, Florence) which shows Rubens, his brother Philip, and Johannes Woverius listening to Justus Lipsius, their mentor. The presence of a plaster cast after this famous portrait suggests that Van Meerstraeten, like most contemporary intellectuals in the Southern Netherlands, was a follower of Justus Lipsius' brand of neo-Stoicism, based in part on the writings of Seneca. The window on the right looks out onto a landscape. The pose and background are stylistically related to Van Dyck's portrait of the Brussels painter Quentin Simons of 1634–5 (cat.82). A similar date is likely for this portrait of Justus van Meerstraeten, who, like Simons, was a prominent citizen of Brussels. Van Dyck is known to have spent some time in Brussels in 1634–5, when he painted leading members of the Brussels magistracy, nobles and prominent civil servants.

A preparatory drawing for this painting shows the sitter without the attributes of his profession and intellectual interests (fig. 1). HV

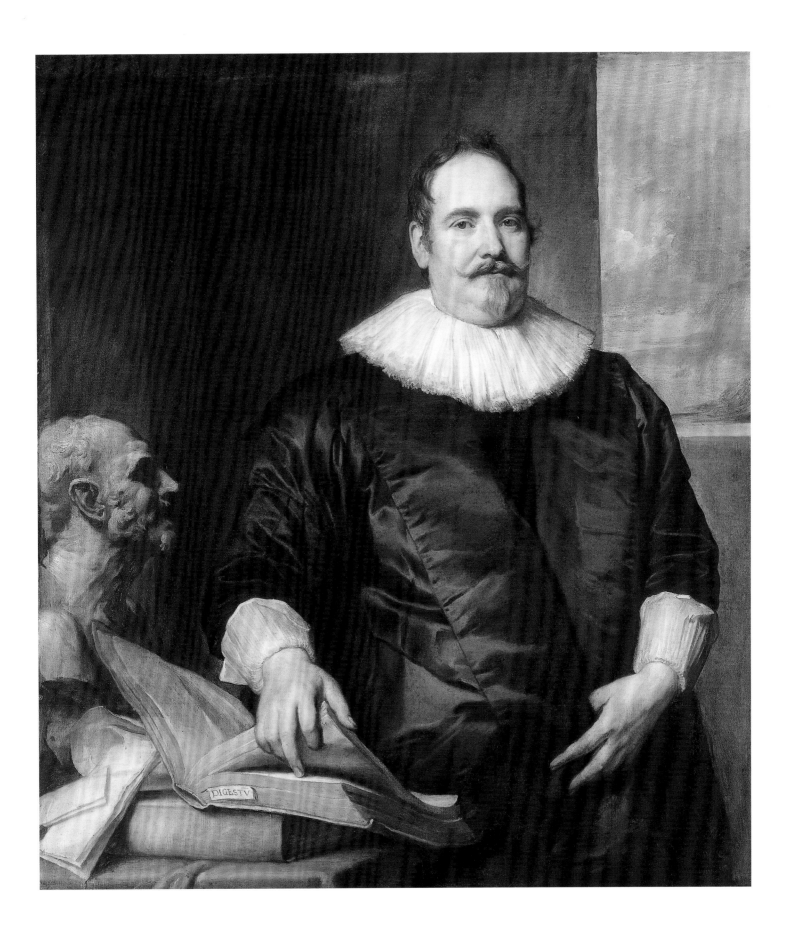

Quentin Simons
1634–5

oil on canvas, 98 × 84 cm

Koninklijk Kabinet van Schilderijen 'Mauritshuis', The Hague (inv. no. 242)

PROVENANCE 1752–68, Govert van Slingelandt, The Hague; 1768–95, William V, The Hague

REFERENCES Hoet and Terwesten 1752–70, II, p. 404; Reynolds 1781, ed. 1852, pp. 192–3; Smith 1829–42, III, p. 38, no. 136; Guiffrey 1882, p. 277, no. 840; Cust 1900, p. 260, no. 109; Schaeffer 1909, p. 248; Glück 1931, p. 343; Martin 1935, p. 85, no. 242; Vey 1962, I, p. 272, under no. 200; Gerson 1967, no. 48; Drossaers and Lunsingh Scheurleer 1974–6, III, p. 208, no. 25; Mauritshuis 1977, p. 81; Brown 1982, pp. 153, 229; Mauritshuis 1985, p. 360; Larsen 1988, II, pp. 248–9, no. 611; Mauritshuis 1993, p. 55, no. 242

EXHIBITION Antwerp 1949, no. 50

ENGRAVING by Pieter de Jode the Younger

Quentin Simons is shown three-quarter length, standing a little right of centre, with his body turned slightly to the right and his face to the left. He wears a large lace collar; his left hand hangs loosely, while his right hand is half concealed beneath his cape. On the left we glimpse a landscape with trees and clouds.

The sitter's identity is based on the inscription beneath Pieter de Jode's engraving after the portrait in Van Dyck's *Iconography* (fig. 2) which describes Quentin Simons as *'Bruxellensis pictor historiarum'* (a history painter from Brussels). He was born in 1592 and enrolled as a master in the Brussels painters' guild in 1614. He married in 1628, which may suggest he spent some time travelling. His work is entirely unknown, although the inscription on the print states that he produced history paintings. It seems likely that Van Dyck painted his portrait during a brief trip to Brussels some time between April 1634 and February 1635. This is supported by the fact that on the reverse of the preliminary drawing for the portrait (fig. 1) is a study for a portrait of Countess Ernestina of Nassau-Siegen, who was also painted by Van Dyck at that time (see cat. 76).

The calculated nonchalance Van Dyck conveys in this painting also appears in portraits of other artists painted during his later sojourns in the Low Countries, such as those of *Gaspar de Crayer* (Liechtenstein coll., Vaduz) and *Theodoor Rombouts* (Alte Pinakothek, Munich). The painters clearly wished to assert the prestige of their profession by adopting dignified poses, rather than by being portrayed with the traditional attributes of their craft, such as paintbrushes, palettes and maulsticks. Van Dyck's self-portraits set a precedent, and Rubens also expressed his social standing through the manner he depicted himself, particularly in his late *Self-portrait* (Kunsthistorisches Museum, Vienna). The high social standing of the profession is also implied in the artists' portraits included in Van Dyck's *Iconography*, which he began to assemble in 1634. H V

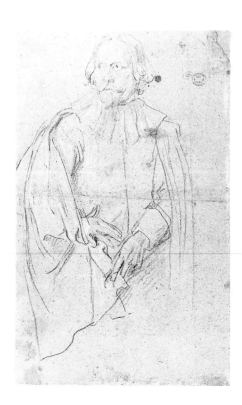

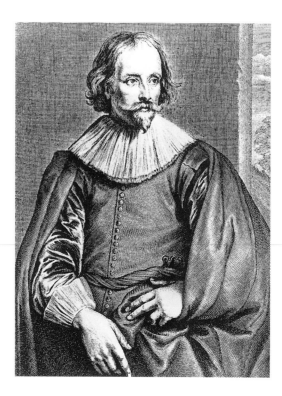

FIG 1
Anthony van Dyck,
Quentin Simons, 1634
black chalk with white highlights,
44.3 × 28 cm
Department of Prints and Drawings,
British Museum, London (Vey 200)

FIG 2
Pieter de Jode after Anthony van Dyck, *Quentin Simons*
engraving from the *Iconography*
(Mauquoy-Hendrickx 174)

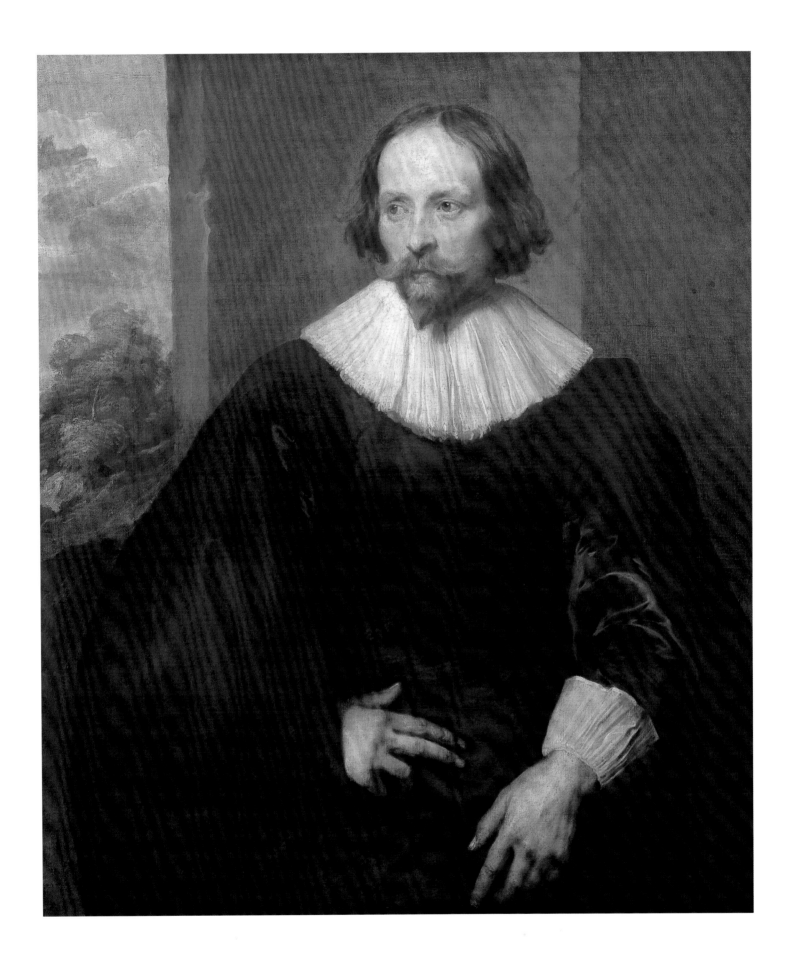

François Langlois as a Savoyard
1634–7?

oil on canvas, 103.6 × 84.1 cm

The National Gallery, London, and the Barber Institute of Fine Arts, the University of Birmingham, supported by the National Lottery through the Heritage Lottery Fund

PROVENANCE Painted for the sitter; 1647, inventory of his collection at his death; according to Mariette, successively owned by M. le Président de Maisons, 1730, Marquise de Ruffec, M. Dutrévoux, M. de Lautrec and Chevalier de la Ferrière; Prince de Conti, at whose sale in 1777 acquired by the Duc de Praslin (d. 1793), chief minister of Louis XV; intermediate provenance hitherto given is unreliable, and is currently being researched by Burton Fredericksen; by 1887, owned by William Garnett, Quernmore Park; April 1919, bought from him by Agnew's and sold the following month to 2nd Viscount Cowdray; Trustees of the Cowdray Estate, 1997, jointly purchased from the Estate by the Trustees of the Barber Institute of Fine Arts, University of Birmingham, and the Trustees of the National Gallery, London

REFERENCES Smith 1829–42, III, p. 89; *Abecedario de P. J. Mariette et autres notes inédites...*, ed. P. de Chennevières and A. de Montaiglon, Paris 1851–60, II, p. 204; VI, pp. 329–30; M. Faucheux, 'François Langlois, dit de Chartres', *Revue Universelle des Arts*, VI, 1857, pp. 314–30; Cust 1900, pp. 51–2, 201, no. 40, p. 222, no. 122, p. 242, no. 92 (as 'painted at Genoa'); Glück 1931, p. 160; id. 1936, p. 148; Van Hasselt, in Ghent and Ledeberg 1972, pp. 41–4, under no. 31, the chalk study for the painting; Brown 1982, pp. 111–12; Frote-Langlois 1983, pp. 119–20; Larsen 1988, no. 538

EXHIBITIONS London 1887, no. 40; ibid. 1900, no. 122; ibid. 1938, no. 85; ibid. 1953–4, no. 158; Genoa 1955, no. 29; Manchester 1957, no. 76; London 1968, no. 52; ibid. 1982–3, no. 10; Washington 1990–91, no. 81

NOTES
1. See Wethey 1971, II, p. 103, no. 40.
2. In Washington 1990–91, it is variously dated 'c. 1636' on p. 256, and 'c. 1637' on p. 306.
3. See ed. Mary Woodall, *The Letters of Thomas Gainsborough*, London 1961, p. 115.

FIG 1
Anthony van Dyck, study for *François Langlois*, 1634–7
black and white chalk, 39.2 × 28.2 cm
Collection Frits Lugt, Institut Néerlandais, Paris (Vey 169)

This is an affectionate portrait of a friend who became eminent as an art dealer and bookseller, but was well content to be portrayed – by Van Dyck and by other friends, including Claude Vignon – in his private role as a lover of music who performed expertly on several instruments. Here he is dressed as a 'Savoyard', or rural musician, and plays the *musette*, a small type of bagpipe. Some twenty years earlier, Vignon had portrayed him in contemporary dress playing a *sourdeline*, another type of bagpipe (Wellesley College Museum); in another portrait of *c.* 1620, engraved by Charles David, Langlois is depicted playing the lute.

Born in Chartres in 1588 (and nicknamed 'Ciartres' after his birthplace), Langlois is recorded by Mariette as *'un ami de Van Dyck'*. The two men may have met in Italy in the 1620s, where Langlois became a friend of Nicholas Lanier (cat. 50), painter, musician and kindred spirit; each combined a flair for art-dealing with a love of music. Van Dyck and Langlois are likely to have encountered each other again many times, in different places. Langlois first visited London in 1625, supplying paintings for Charles I and for the Duke of Buckingham. By 1634 he had settled in Paris as a dealer in books and prints, with a shop in the rue St Jacques 'Aux Colonnes d'Hercule'; the business he established, carried on after his death in 1647, first by his widow alone, then with her second husband Pierre II Mariette, was to achieve its greatest renown under Langlois's grandson Pierre-Jean Mariette (1694–1774). A different, more conventional portrait of Langlois by Van Dyck (original untraced) was engraved by Nicolas Poilly around 1635. Langlois is known to have made further visits to London in 1637, and again in November 1641, when he may have acted as agent in the sale of Titian's so-called 'Ariosto' (National Gallery, London)[1] to Van Dyck; and Van Dyck twice visited Paris in 1641, in the last months of his life.

The painting was preceded by a preliminary chalk study (fig. 1), undoubtedly drawn from life. Various dates in the 1630s and up to 1641 have been proposed for both. The drawing could have been made at any point in the 1630s: the present writer supports Van Hasselt in thinking that its probable date is around 1632–4. There may have been

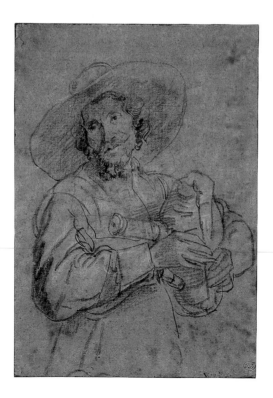

some lapse of time before the portrait was painted on canvas. Portraits of friends (like self-portraits) may often have to be fitted in between commissions. When the 1630s began, Langlois was aged 42. In the painting, he might be any age between 40 and 50. The date proposed for the painting by Wheelock (in Washington 1990–91, p. 306) is 1637, when Langlois (who would then have been aged 49) is known to have been in London. This is possible, but his supporting argument that the dog's heads in this painting and in the portrait of *James Stuart, Duke of Lennox* (cat. 71, fig. 1) are 'virtually identical' is weak, partly because

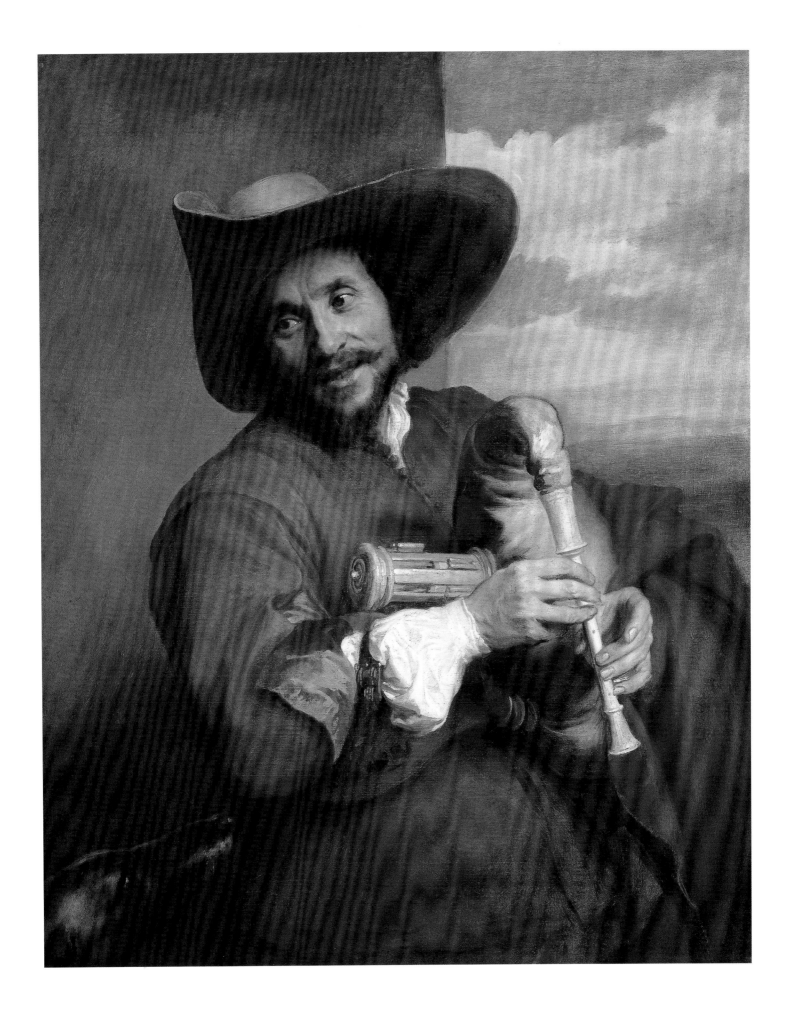

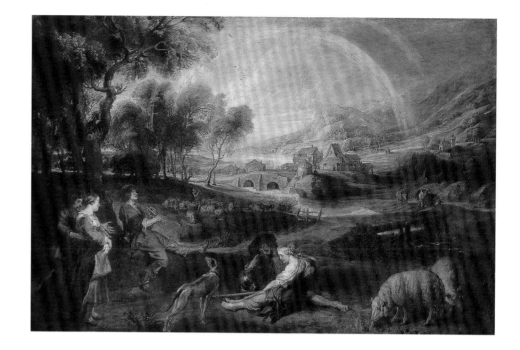

Fig 2
Peter Paul Rubens, *Pastoral Landscape
with Rainbow*, 1615–18
oil on canvas, 81 × 129 cm
The State Hermitage Museum, St Petersburg

James Stuart's portrait is not dated,[2] but primarily because Van Dyck was a continually inventive painter of dogs, not needing to cast his mind back to a dog's head in one portrait to paint a dog's head in another (nor are the two heads identical in pose or in colouring).

Van Dyck himself loved music. Bellori records that in his years of affluence in London, he employed 'musicians and singers' to entertain his guests and soothe his sitters. He had portrayed Nicholas Lanier as 'David, playing his harp before Saul', according to Bellori (now lost). The chance to portray Langlois as a Savoyard may have come as a welcome diversion after endless commissions to portray English courtiers. He imbued Langlois with the expressiveness of music-making, so that the figure seems to respond with every fibre to the music he plays, his open lips perhaps singing *sotto voce*, his expression wistful, the eyes painted with such feeling as to suggest that the painter as well as his friend well understand what solace the changing moods of music can bring. Both the expression of the sitter and the mood of the painter exude that longing for a simpler life which sometimes sweeps over the most successful of men. The mood is akin to Gainsborough's when, some 150 years later, and at the peak of success, he wrote of his longing 'to take my Viol da Gamba and walk off to some sweet Village when I can paint landskips and enjoy the fag End of Life in quietness and ease'.[3]

Ellis Waterhouse (1938) judged the portrait to be redolent of Titian. But in his broad-brimmed hat and peasant dress, playing his pipes, Langlois is surely well content to be portrayed by his friend as the heir to the recurring image of a peasant playing a pipe in Rubens's images of Arcadia: for instance, in the *Pastoral Landscape with Rainbow* (fig. 2). JE

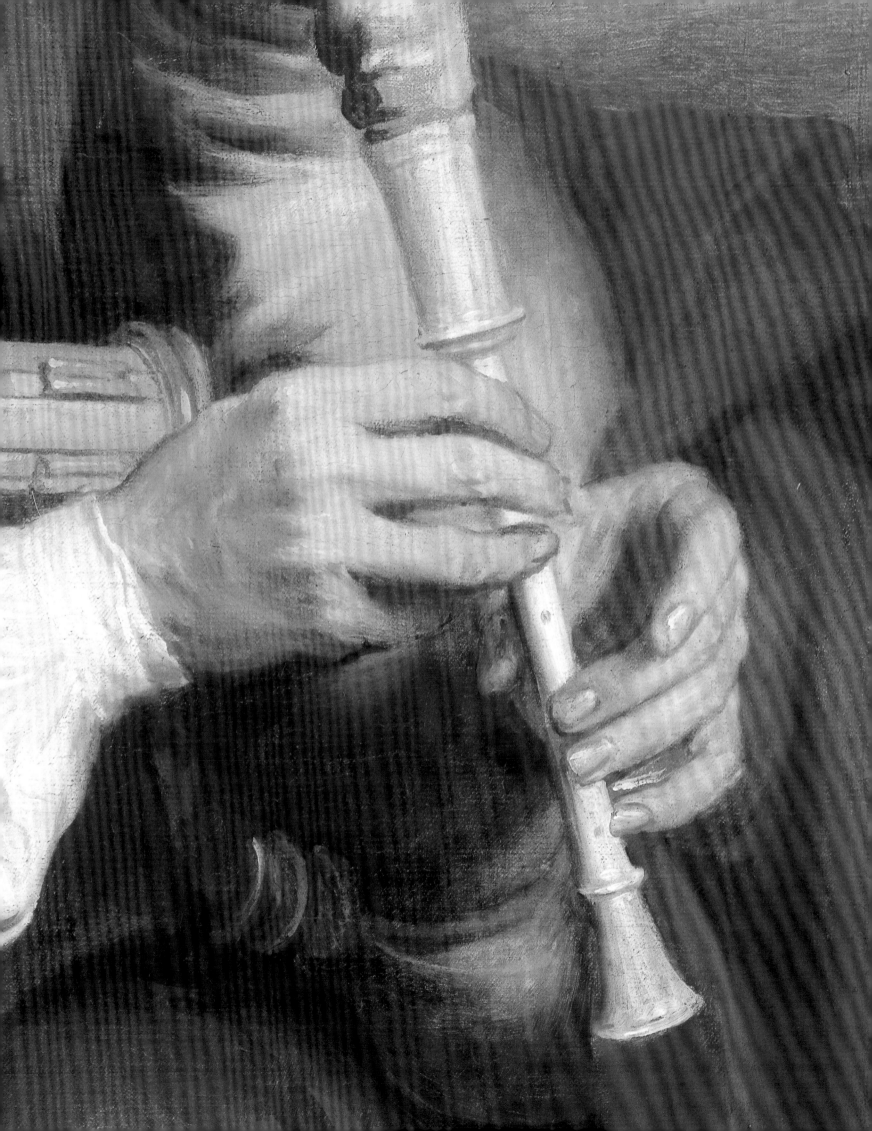

84 *The Aldermen of Brussels*
1634–5

oil on panel, 26 × 58 cm

Ecole Nationale Supérieure des Beaux-Arts, Paris
(inv. no. 11705)

PROVENANCE A. Armand (d. 1888); P. Valton,
by whom bequeathed in 1908 to the Ecole
Nationale

REFERENCES Bellori 1672, quoted in Brown
1991, p. 19; Cust 1900, p. 94; Glück 1939b, pp. 1–4
(including quotations from Isaac Bullart, *Académie
des Sciences et des Arts...*, Paris 1682); Vey 1956,
p. 198; Brown 1982, p. 161; Larsen 1988, no. 578;
Brown, in Washington 1990–91, p. 38

EXHIBITIONS Antwerp and Rotterdam 1960,
no. 133; Brussels 1965, no. 76; Paris 1977–8,
no. 44; Boston and Toledo 1993–4, no. 43

NOTES
1. White notes that two oil studies of heads in the
Ashmolean Museum, Oxford, are generally
identified as studies for the figures on the left and
right of Justice; the poses are similar, but not the
likenesses, suggesting that Van Dyck was chiefly
concerned in the oil sketch with the arrangement
of the figures. See Christopher White, *Dutch,
Flemish and German Paintings before 1900 in the
Ashmolean Museum, Oxford* (forthcoming): text
kindly made available by the author.
2. For other paintings destroyed in the fire of
1695, see Lorne Campbell, *Van der Weyden*,
London 1979, pp. 5–6; Elizabeth McGrath,
Rubens, Subjects from History, Corpus
Rubenianum, XIII–2, 1997, p. 42.

Shortly before returning to England in spring 1635, Van Dyck completed the most important commission he received in Brussels: a life-size group portrait of the aldermen who, together with the burgomaster, governed that city. With this commission, the city of Brussels bestowed its own official approval on the painter who had been made Honorary Dean of the Guild of St Luke in Antwerp some months earlier. To invite an artist of such renown to paint a group portrait of local dignitaries was something of a novelty in the southern Netherlands. In Holland, artists of the stature of Frans Hals and Bartholomeus van der Helst had accepted commissions for group portraits of civic dignitaries, and Rembrandt (in 1662) was to depict *The Sampling-Officials of the Cloth-Makers' Guild at Amsterdam* (Rijksmuseum, Amsterdam); but in Flanders such commissions previously had been given only to minor artists such as Peter Meert and Peter van Lint.

Van Dyck's very large picture of the city aldermen was to hang in the Court Room of the Town Hall of Brussels. On one wall of that room there already hung four large panels by Rogier van der Weyden, who (almost two centuries earlier, until his death in 1464) had been official painter to the city of Brussels. His panels represented *The Justice of Trajan* and *The Justice of Herkinbaldt*, and were intended as a perpetual reminder to magistrates of their duty to dispense impartial justice. The blindfolded figure of Justice in the centre of Van Dyck's sketch serves the same purpose.

When Van Dyck's finished picture hung *in situ* in the Town Hall, it was described by various visitors to the city. In 1663 M. de Monconys noted it contained portraits of 24 or 25 aldermen, and also saw there a second life-size group portrait by Van Dyck of *'une dizaine d'Officiers de guerre'*. Isaac Bullart, a French visitor to Flanders in 1675, noted that the group of aldermen included 23 life-size figures, and observed that the picture was hung to such good effect 'that you seemed at first to see this illustrious senate actually discussing and deliberating the affairs of the republic'. The oil sketch suggests a rather static composition; but Bullart, standing in front of the finished painting, was struck not only by its 'grandeur', but also by 'the gleams of brightness in the eyes of these grave senators, and the fresh, lively colouring of their faces'.[1]

The painting was destroyed by fire in 1695, during the French bombardment of Brussels under Maréchal de Villeroi. The flames which ravaged the Town Hall destroyed not only Van Dyck's group portrait but also Van der Weyden's Justice panels, Rubens's *Judgement of Cambyses* and, probably, also Rubens's *Judgement of Solomon* and *Last Judgement*.[2]

All that survives of Van Dyck's painting is this oil sketch, swiftly executed in thin brown paint, and some related drawings and sketches (listed in Antwerp 1960, under no. 133). Since Bullart specifies that the finished work included 23 life-size figures, it seems likely that this sketch of seven men and the figure of Justice is for the central part of the picture. It may have been painted at an early stage of the commission, to give the aldermen some idea of that key area. JE

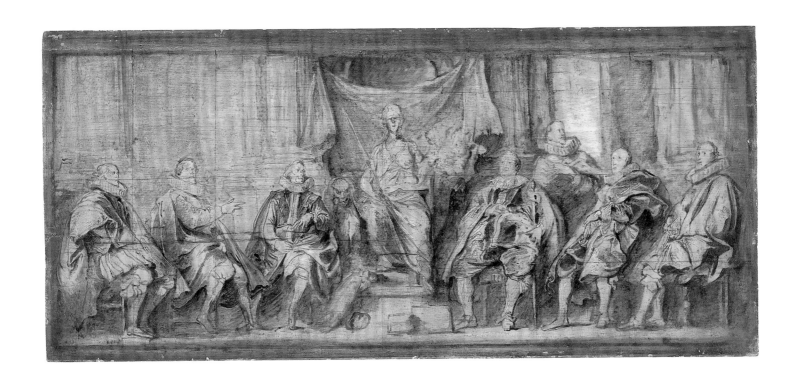

85 The Lamentation over the Dead Christ 1635

oil on canvas, 115 × 208 cm

Koninklijk Museum voor Schone Kunsten, Antwerp (inv. no. 404)

PROVENANCE Commissioned by the Abbé Scaglia for the church of the monastery of the Recollects in Antwerp, and hung there; after Scaglia's death in 1641, replaced by the Recollects with a copy, and sold; 1794, taken by the French to Paris; 1815, returned to Antwerp, transferred to the Museum

REFERENCES Cust 1900, p. 248, no. 33; Glück 1931, 367; Vey 1962, no. 141; Monballieu 1973, pp. 263–4; Brown 1982, pp. 159–61; Larsen 1988, no. 1041; Brown 1991, pp. 252–3

EXHIBITIONS Antwerp 1899, no. 25; ibid. 1949, no. 7; Genoa 1955, no. 83; *Space in European Art*, The National Museum of Western Art, Tokyo 1987, no. 83; Antwerp 1988, no. 404; Washington 1990–91, no. 79

FIG 1
Anthony van Dyck, *The Lamentation over the Dead Christ*, 1634
oil on panel, 108.7 × 149.3 cm
Alte Pinakothek, Munich

FIG 2
Anthony van Dyck, *Study for the Dead Christ*, 1635
black chalk with white highlights on grey-blue paper, 27.5 × 39.3 cm
Pierpont Morgan Library, New York (Vey 141)

This *Lamentation* was commissioned by the Abbé Scaglia (see cat. 78) as part of the altarpiece – given its proportions, probably the predella – of the chapel of Our Lady of the Seven Sorrows in the church of the monastery of the Recollects in Antwerp. It seems likely that he commissioned it in 1635, when suffering from an illness he did not expect to survive, and that Van Dyck completed the painting while he was in Antwerp. Scaglia retired to the monastery of the Recollects in September 1637; the altarpiece was not installed until after his death there in 1641.

For any artist during the age of faith, representation of the moment when those closest to Christ in life see that the body, taken down from the cross, is dead was a supreme test of emotional sincerity. Lamentation preceded the miracle of Resurrection, and upon that Resurrection all Christian faith depends. Van Dyck had treated the subject several times after returning from Italy to work in Antwerp (1629–32). Now, again in Antwerp in 1634–5, he returned to the subject, in an Italian (particularly Bolognese) manner. The *Lamentation* now in Munich (fig. 1) is dated 1634; yet another variation on the theme, also horizontal in format like Scaglia's painting, is known in several versions; one in a private collection, Rome (repr. Brown 1991, p. 250, fig. 2).

In each, Christ and his mother are seen in variations of the traditional *pietà*, with the dead Christ in his mother's lap; but the more horizontal shape dictated by Scaglia's commission – evidently for a predella below another picture in the Recollects' chapel altarpiece – necessitated a shallower design than that for the Munich picture. Van Dyck's solution was to lower both figures nearer to the ground, and to extend the length of Christ's supine body. This practical solution serves, in Van Dyck's hands, to intensify the drama, enabling him to use the Virgin's outspread arms not only to close the left-hand side of the picture, but also convincingly to invoke the presence of two angels on the right. St John gently raises Christ's left arm to show the grieving angels the wound made by the nail. A chalk study for this picture (fig. 2), probably made from a model in Van Dyck's studio in Antwerp, reveals that Van Dyck considered three different levels to which that arm should be raised, before settling on the lowest, most natural position. JE

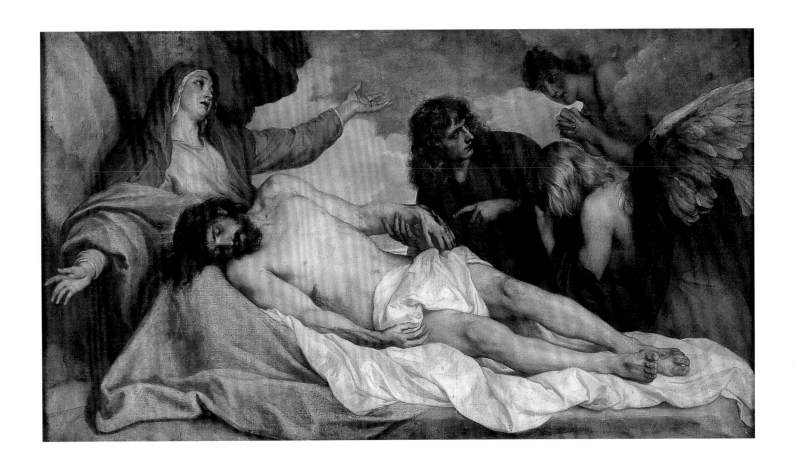

Triple Portrait of Charles I
1635

oil on canvas, 84.5 × 99.7 cm

Lent by Her Majesty The Queen

PROVENANCE Commissioned by Charles I; probably in autumn 1635, sent to Bernini in Rome; remained with Bernini and his descendants until 1802, when purchased from Palazzo Bernini by James Irvine on behalf of the dealer William Buchanan, and sent back to England; 12 May 1804, sold at Christie's, London, lot 9, bought by Stewart, thereafter changing hands among members of Buchanan's syndicate until sold to Walsh Porter, one of the Prince Regent's advisers on works of art; by 1809, sold by Porter's son to the artist William Wells of Redleaf, who in 1814 declined Lord Yarborough's offer of 700 guineas for it; negotiations for its purchase by the Prince Regent opened in May 1819 through Joseph Farington, who was asked to offer Wells 500 guineas, which he declined; purchased from Wells by the Prince Regent in July 1819 for 1000 guineas, and thereafter in the Royal Collection

REFERENCES Bellori 1672, quoted in Brown 1991, p.20; Cust 1900, pp.106–7, p.211, no.50; p.264, no.19; Glück 1931, no.389; Millar 1963a, no.146; Lightbown 1981, pp.439–52; Larsen 1988, no.797

EXHIBITIONS London 1819, no.116; ibid. 1826, no.113; ibid. 1827, no.178; Leeds 1868, no.785; London 1870, no.66; Antwerp 1899, no.50; London 1946–7, no.30; ibid. 1953–4, no.138; ibid. 1968b, no.11; ibid. 1972–3, no.86; ibid. 1982–3, no.22; ibid. 1988–9, no.11; Washington 1990–91, no.75; London 1999, no.5

NOTES
1. Lightbown 1981, p.451.
2. The central head Van Dyck was to repeat in a three-quarter-length portrait of the King in armour: Glück 1931, p.392.
3. Then hanging in Whitehall with an attribution to Titian; now Kunsthistorisches Museum, Vienna.
4. For the commission and payment for Bernini's bust, and the casts made after it, see Gudrun Raatschen, 'Plaster Casts of Bernini's bust of Charles I', *The Burlington Magazine*, CXXXVIII, 1996, pp.813–16, figs.44, 46a–c; and Charles Avery, *Bernini*, London 1997, pp.225–8.

This portrait of Charles I from three different angles was requested by the King to provide the great sculptor Gianlorenzo Bernini with an accurate likeness from which he could carve a marble bust. Bernini was Pope Urban VIII's official sculptor, and could not undertake such a commission without licence from the Pope. Charles I reigned as a Protestant and was thus, in papal eyes, a heretic; it was not possible for him to ask such a favour from the Pope. But Queen Henrietta Maria, a Catholic, was under no such constraint. Indeed, a condition of her marriage to Charles I was that she was to be allowed free exercise of her religion.

Lightbown (1981) shows that it can only have been Henrietta Maria, acting as a cover for Charles and working through her own agents at the Papal court, who obtained the Pope's permission to commission the bust: 'it was she who commissioned it, she to whom it was sent, and she who paid for it. In this way, neither the Papal court nor the King was exposed to criticism, the one for granting favors to heretics, the other for receiving them from Rome'.[1]

Reports that the Pope had agreed to her request must have reached Henrietta Maria and Charles by 17 March 1635. On that date, Charles I wrote to Bernini requesting him to carve a bust 'after a painting which we shall send you'. A reply from Bernini expressing his willingness to do so presumably followed. Having returned from Antwerp in the spring of 1635, Van Dyck lost no time in painting the triple portrait. It was about this time that a causeway and 'a new pair of stairs' were specially constructed leading from the Thames waterside to the garden of Van Dyck's house at Blackfriars so that the King could more easily go ashore from the royal barge. Charles is known to have visited the studio in June and July, and it may have been on these visits that he sat for the triple portrait.[2] Quickly completed, and dispatched to Rome reputedly in the care of Thomas Baker, the portrait appears to have reached Bernini during the autumn of 1635.

The King is portrayed from three different angles and, although the lace collar and Garter ribbon recur in each portrait, in three different costumes, perhaps so that neither black nor scarlet nor carnation should influence the *persona* in which he might appear to Bernini. The idea of a portrait from three angles was probably partly inspired by Lorenzo Lotto's *Portrait of a Goldsmith in Three Positions*, then in Charles's collection.[3] In 1642 (seven years after Van Dyck's triple portrait of Charles I), Philippe de Champaigne was to supply a *Triple Portrait of Cardinal Richelieu* (fig. 1), also for Bernini's use.

Bernini's bust of Charles I was exhibited to acclaim in Rome before being dispatched to England. Scrupulously careful arrangements for the bust's transport to England were made by Cardinal Francesco Barberini. It arrived in its packing-case at Oatlands Palace on 27 June 1637, and was opened in the presence of the King and Queen. Such was the habit of fulsome compliment among Charles's courtiers that one remarked that the bust was a miracle 'as soon as the first plank of the case was raised'. Both the King and Queen were delighted with the bust. As the papal agent George Con reported on 31 July, both of them 'profess that this is a grace conferred by Your Eminence on the Queen'. As for Bernini himself, he added, he has instantaneously 'acquired a glorious name in these shores'.

Payment to Bernini took longer. In June 1638, Con reported that the Queen had selected for Bernini 'a most beautiful diamond'; but such was her capacity for procrastination that it was not until late in September 1639 that the diamond, set in a ring, and valued at £1000 (4000 *scudi*), was eventually presented to Bernini. Though

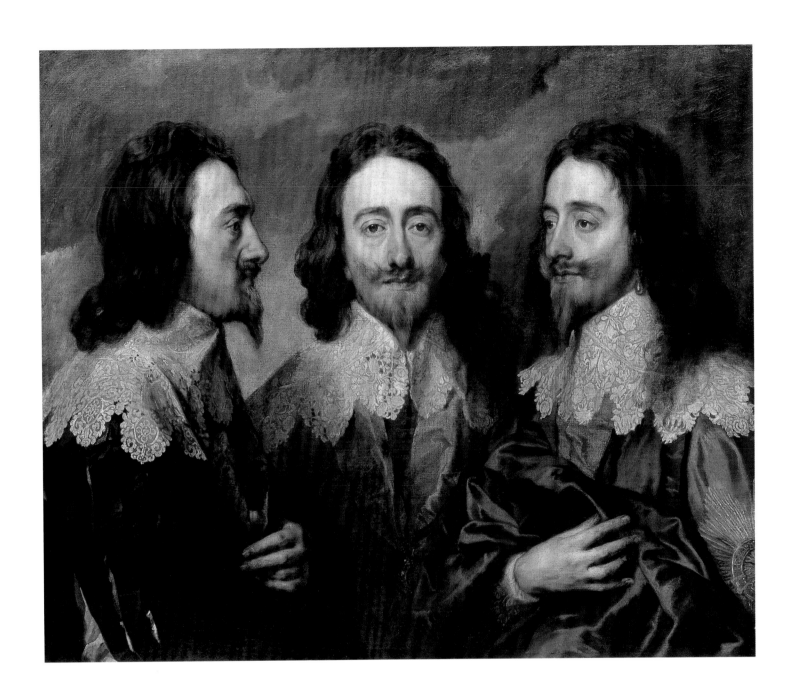

late, this was remuneration on a truly royal scale. Plaster casts of the bust made in England include the recently discovered cast of the face alone (fig. 2).[4] The bust itself disappeared in the fire which destroyed Whitehall in 1698. JE

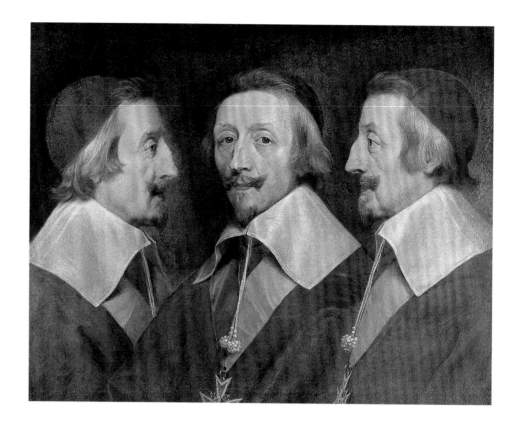

FIG 1
Philippe de Champaigne,
Triple Portrait of Cardinal Richelieu, 1642
oil on canvas, 58.4 × 72.4 cm
National Gallery, London

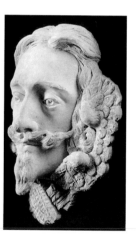

FIG 2
Three views of a plaster cast after
Bernini's *Bust of Charles I*
Collection R. J. G. Berkeley Esq, Berkeley Castle

The Three Eldest Children of Charles I

1635

oil on canvas, 153.7 × 156.8 cm

Soprintendenza per i Beni Artistici e Storici del Piemonte, Galleria Sabauda, Turin (inv. no. 264)

PROVENANCE 1635, commissioned by Queen Henrietta Maria to be sent to her elder sister, Christina, Duchess of Savoy; by descent; 1799, seized by the French occupying forces and taken to the Louvre; 1815, returned to the Royal Gallery in Turin, renamed, 1832, the Galleria Sabauda

REFERENCES *Lettres de Henriette-Marie de France, Reine d'Angleterre, à sa sœur Christine Duchesse de Savoie*, ed H. Ferrero, Turin 1881, pp. 40, 43; Vesme 1885, pp. 54–7; Sabauda 1899, no. 264; Cust 1900, pp. 110, 118, p. 266, no. 41; Glück 1931, p. 375; *Ventiquattro Capolavori della Galleria Sabauda di Torino*, Turin 1951, p. 60; Millar 1963, under no. 151; Franco Mazzini, *Turin: The Sabauda Gallery,* Turin 1969, pl. XV; Tardito Amerio 1982, p. 12, no. 74; Brown 1982, pp. 181–2; Millar, in London 1982–3, as no. 18, but not available for that exhibition; Larsen 1988, no. 807; Katharine Gibson, 'Best Belov'd of Kings: the Iconography of King Charles II', Ph.D. thesis, Courtauld Institute, London, 1997, unpublished, and kindly made available by the author

EXHIBITIONS Antwerp 1930, no. 98; Turin 1951, no. 74; Turin, Palazzo Madama, *La Moda in Cinque Secoli di Pittura,* 1951, no. 22; Genoa 1955, no. 91; Washington 1990–91, no. 74

NOTES
1. '*Ma fille n'a jamais voulu avoir la pasiance de les leser achever. Tel qu'il est, je le vous envoye; j'an feray faire une autre pour elle, qui sera mieux.*'
2. Charles I was born 29 May 1630, Mary on 4 November 1631 and James on 14 October 1633.
3. See Washington 1990–91, p. 286 (reproducing the Titian, p. 259, fig. 3).
4. John Rowlands, *Holbein: The Paintings of Hans Holbein the Younger,* Oxford 1985, p. 146, no. 70, colour plate 32.
5. See Gibson 1997, op. cit., p. 10.
6. '*le Roy estoit faché contre le peintre Vandec po' ne leur avoir mis leur Tablié, comme on accoustume aux petits enfans, et qu'elle enscriproit à Madame sa soeur, pour le leur faire mettre*'. Vesme (1885) notes that the Duchess of Savoy wisely requested no alteration in the picture.
7. See Michael Jaffé, 'Van Dyck', in *The Dictionary of Art,* London 1996.
8. Gibson (1997, op. cit., p. 8 and n. 28) notes that an inventory of the Royal Collection in 1688 lists a portrait by Paul van Somer of 'Charles I at length in Coats, with hatt and Feather' (untraced); possibly Charles I disliked that portrait of himself and did not want his eldest son so portrayed.

Justly, Sir Oliver Millar describes this picture as 'one of Van Dyck's most ravishing compositions and possibly the most enchanting study of childhood in his career' (in London 1982–3, p. 61). Van Dyck was probably commissioned to paint it early in the summer of 1635, not long after his return from Brussels. Queen Henrietta Maria wished to send her sister, Christina, Duchess of Savoy ('*Madame Royale*'), a triple portrait of the children so far born to her, in exchange for a portrait of her sister's children. In an undated letter, probably written in July 1635, Henrietta Maria informed her sister that '*dans une semaine*' ('in a week's time'), she would send her '*les pourtraicts de mes enfans*'; she added that her daughter's impatience in sitting had held up the picture's completion and produced a less than satisfactory result.[1] Several months passed, during which Henrietta Maria received portraits of her sister's two children. Thanking her sister in an undated letter evidently written in the autumn of 1635, Henrietta Maria again promised that the 'portraits' of her own children would be sent '*dans une semaine*'. The picture was probably despatched to Turin in October or November. In a letter of 29 November 1635 (paraphrased by Ferrero, op. cit., pp. 42–3, n. 4), Benoît Cize, the ambassador of Savoy to London, reported that the Queen had shown him the portraits sent by her sister, and spoken of the picture which had by then been sent in exchange.

The three royal children are Prince Charles (later Charles II), born in 1630; Princess Mary, born the following year, and James, designated Duke of York on the day of his birth in 1633 (later James II). They were thus (respectively) about five, four and two years old when they sat for this portrait.[2] Van Dyck does not let their royal status inhibit his perception of the nature of childhood. Charles, as heir to the throne, stands a little apart from the two younger children, who turn in his direction. The young Prince faces us, one hand resting on the head of a large, well-behaved spaniel; that gesture has been recognised as a possible echo from Titian's great portrait *Charles V with a Hound*,[3] but it is also close to the more natural manner in which the young Prince's cousin, Lord James Stuart, gently restrains and communes with his own hound (cat. 71 and cat. 71, fig. 1). The royal family's fondness for dogs is revealed in many of Van Dyck's portraits.

Differences in the children's ages and characters are subtly observed. The composure of the two year-old Duke of York is reminiscent of Holbein's portrait of Edward, Prince of Wales, Henry VIII's son, painted at much the same age in 1539 or 1540;[4] that portrait was probably in the collection of the Earl of Arundel when Van Dyck painted Charles I's three children, but the King owned a miniature copy by Peter Oliver. Edward holds a rattle made by a goldsmith; James holds an apple, perhaps a symbol of fruitfulness. Millar (1982–3, op. cit.) suggests that the roses strewn on the carpet below him allude to the *Poet's Good Wishes* addressed by Robert Herrick to 'his pretty Duke-ship', which include the lines:

May his soft foot, where it treads,
Gardens thence produce, and Meads:
And those Meddowes full be set
With the Rose, and Violet.

The roses, the rose-bush in the background and the rose-red of Charles's dress echo the sentiment of *Corona Minervae*, a masque performed before the children in London on 27 February 1635,[5] in which they were addressed as 'Three Royall Blossomes … Whose lookes and sweetnesse, make eternall spring'.

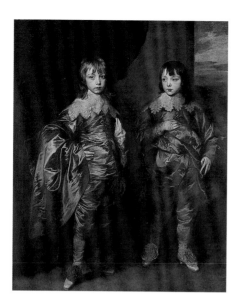

A chalk study for Charles's figure (Binion 1904, IV, p. 277, no. 38) shows him in the pose and in the costume followed in the finished painting. Millar (op. cit., p. 61) notes the 'delicate touch' and 'exquisite, almost Watteau-like, range of colour' sustained right across the canvas, drawing attention in particular to such passages as the lace on the Prince's dress, the pattern on the Princess's dress and the floating of the filmy, lace-edged aprons over the two younger children's skirts.

Despite its beauty, the picture did not please Charles I. Cize, the Savoy ambassador, reported that the Queen told him that the King was angry with Van Dyck for not having dressed them in the *tabliers* which little children customarily wear, and that she had written to Madame her sister to have them 'put on [? painted in]'.[6] Cize's report of this conversation is puzzling; perhaps, since at that time he had not seen the picture (apparently already on its way to Turin), he did not grasp what the Queen recounted about the King's displeasure. Van Dyck had painted the two younger children wearing near-transparent *tabliers* (better translated as 'smocks' than 'aprons'),[7] such as they might have worn informally in the nursery. The King may have disliked the childishness of the *tabliers*; but he was probably more gravely displeased by the fact that Van Dyck had depicted the Prince of Wales in the 'coats' then worn by boys until they were promoted (usually at the age of seven) to breeches.[8]

Later in 1635, Van Dyck was requested to paint a second portrait of the three royal children (fig. 2). Differences between the two portraits suggest the King's insistence that his son and heir should be portrayed not as a child but as a prince. In the second portrait, Prince Charles is dressed in adult fashion, in jacket and breeches, in much the same style as *George Villiers, 2nd Duke of Buckingham, and his Brother Lord Francis Villiers*, in a double portrait also painted for the King in 1635 (fig. 1), in which the two boys are respectively seven and six years old. Gibson (1997) notes that by 1635, the five year-old Prince Charles was already undertaking small ceremonial duties such as escorting ambassadors into the King's presence. At the age of eight, he was created Prince of Wales and installed as a Knight of the Garter; he was also given his own all-male Household, and was never thereafter portrayed with his siblings. The second portrait of the royal children also gave Van Dyck the chance to paint a more pleasing likeness of Princess Mary than her 'impatience' had allowed in the first triple portrait. Van Dyck portrays her as the young bride of Prince William of Orange in cat. 105. JE

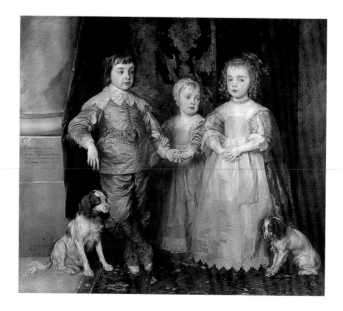

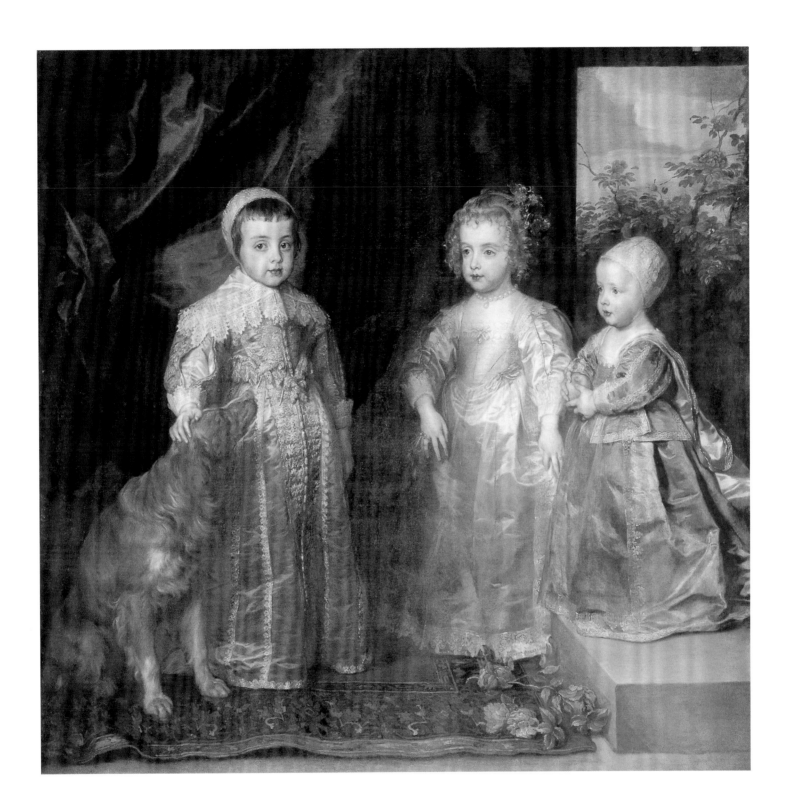

88 *Endymion Porter with the Artist* *c.* 1635

oil on canvas, 110 × 114 cm (oval)

Museo Nacional del Prado, Madrid (inv. no. 1489)

PROVENANCE Presumably painted for Porter; possibly taken with him in 1645 to the Continent, and there sold because of his poverty; possibly the painting in Diego Duarte's sale, 1668, purchased by Cosimo de' Medici; acquired from Isabella Farnese's collection for the Palace of San Ildefonso, La Granja; by 1794, Palace of Aranjuez; by 1814, Palace of Madrid

REFERENCES Cust 1900, pp. 138, 140, p. 285, no. 211 (as probably John, 1st Earl of Bristol, with the artist); Glück 1931, pp. 440, 568; William Vaughan, *Endymion Porter & William Dobson*, London 1970, p. 10; Brown 1982, pp. 152–3; Larsen 1988, no. 1020; Balis 1989, pp. 206–7

EXHIBITION Washington 1990–91, no. 73

NOTE
1. See Millar 1960.

FIG 1
William Dobson, *Endymion Porter*, 1642–5
oil on canvas, 150 × 127 cm
Tate Gallery, London

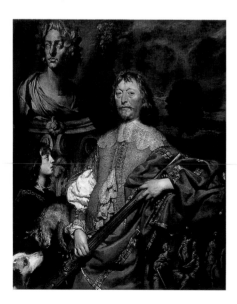

This is the only work in which Van Dyck includes a self-portrait with that of another person. The fact that he does so suggests that he recognises a kindred spirit in Porter, the age difference of some thirteen years between them mattering little.

Endymion Porter (1587–1649) was a cultivated, cosmopolitan man with a gift for languages and particular connections with Spain (through his Spanish grandfather). He had been one of the Duke of Buckingham's entourage, particularly assisting with his collection of works of art. He first met Van Dyck in 1620, during the artist's brief visit to London, during which Buckingham purchased *The Continence of Scipio* (cat. 26). He accompanied Buckingham and the future Charles I on their secret, mildly farcical and unsuccessful attempt to win the Spanish Infanta as Charles's bride. Porter also helped Charles I to acquire works of art: most notably in 1627, when he was involved, in a more subsidiary way than Nicholas Lanier (cat. 50) and the dealer Daniel Nys, in the negotiations for the King's purchase of the spectacular collection of the Dukes of Mantua.

Porter formed a collection of his own (seemingly never listed). Van der Doort's catalogue of Charles's collection records payments to Porter, who may have been a *marchand-amateur* as well as an agent.[1] It was on behalf of the King that Porter commissioned Van Dyck to paint *Rinaldo and Armida* (fig. 59), probably the first of the artist's works to enter the royal collection; Porter paid Van Dyck £78 for it in 1629, and was reimbursed the following year. Reputedly, it was this picture which inspired Charles I to invite Van Dyck to work at his court; if so, the commission must have set the seal on Van Dyck's and Porter's friendship.

Endymion Porter was appointed a Gentleman of the Bedchamber. He maintained a lavish household in the Strand; he was the patron of the poet Robert Herrick and the playwrights Thomas Dekker and William D'Avenant, while among artists he counted Rubens and Orazio Gentileschi among his friends, as well as Van Dyck. He was closely involved with Charles I's commissions to Rubens for the ceiling decorations for the Banqueting House in Whitehall. The antiquarian Anthony Wood recalled Endymion Porter as 'beloved by two kings, James I for his admirable wit and Charles I (to whom … he was a servant) for his general learning, brave stile, sweet temper, great experience, travels and modern languages'.

The double portrait was probably painted in 1635; Porter would then have been aged about 47, and Van Dyck about 35. There is an unusual diffidence about the painter's pose and expression, as if he were acknowledging some debt to the friendship of the older man, or aware that this sort of self-intrusion is irregular, to be undertaken only in the cause of friendship. Porter's own more extrovert geniality is even more evident in Van Dyck's group portrait *Endymion and Olivia Porter with their Three Eldest Sons* (private collection, England), perhaps painted soon after Van Dyck arrived in the spring of 1632, to work at Charles's court.

When war broke out, Porter, too old for active service, joined the King's court at Oxford. There, *c.* 1642–5, he sat to William Dobson, for one of that artist's finest portraits (fig. 1). In July 1645, entrusted with messages for Henrietta Maria, he left for France, where his wife later joined him, and where they lived in great poverty. Porter returned to England early in 1649, to find his King under sentence of execution and his own possessions confiscated; he himself died in August 1649. It may have been during his years of exile that Porter had to part with the portrait which commemorates the friendship of this genial, intelligent man with the most prodigiously talented painter of his day. JE

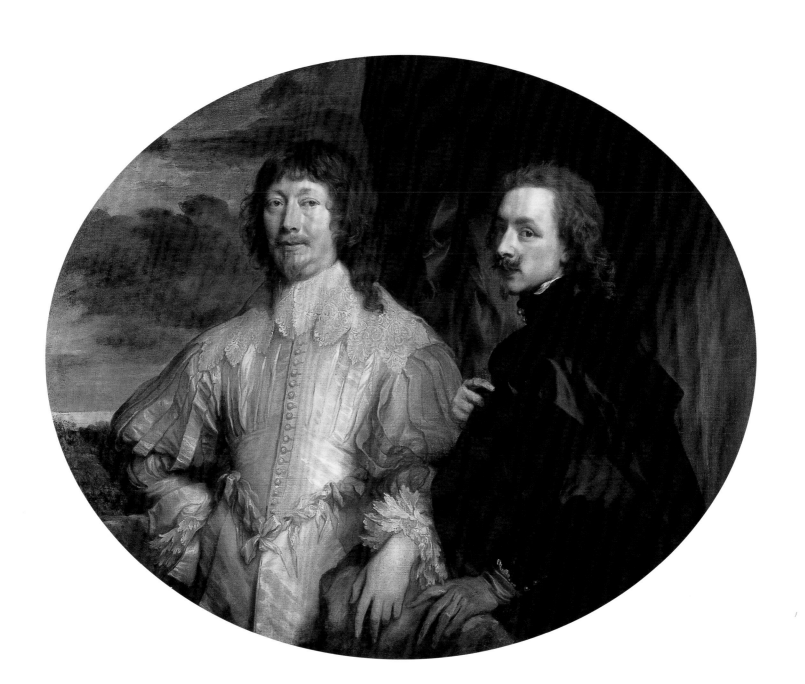

Thomas Howard,
2nd Earl of Arundel,
with his Grandson Thomas,
later 5th Duke of Norfolk
1635–6

oil on canvas, 143 × 120 cm

By kind permission of His Grace The Duke of Norfolk KG

PROVENANCE By descent

REFERENCES MS 'Inventory of pictures in the possession of Aletheia, Countess of Arundel, at the time of her death in Amsterdam in 1654' (published by Mary Cox, *The Burlington Magazine*, XLX, 1911, ii, p. 323), as *'Van Dick. ritratto del Sigr conte d'Arundel con suo Nipote'*; Vertue V, XXVI (1938), pp. 53–4; Smith 1829–42, III, pp. 183–4, no. 629; Cust 1900, pp. 131–2, p. 268, no. 3; Glück 1931, p. 473; Brown 1982, p. 208; John Martin Robinson, *The Dukes of Norfolk: A Quincentennial History*, Oxford and New York 1982, pp. 112–14; Howarth 1985, pp. 161–4; White 1995, p. 71

EXHIBITIONS London 1880, no. 57; ibid. 1887, no. 8; Antwerp 1899, no. 41; London 1900, no. 58; Antwerp 1949, no. 57; London 1953–4, no. 136; ibid. 1968a, no. 45; ibid. 1982–3, no. 31; Oxford 1985–6, no. 6; Washington 1990–91, no. 76

Arundel's 'majestical and grave' countenance, 'large, black and piercing eyes' and 'stately Presence', noted by Sir Edward Walker, can be observed in all Van Dyck's portraits of him, including that of *c.* 1620–21 (cat. 25) and the double portrait of the Earl with his Countess of 1639 (fig. 1), known as the 'Madagascar' portrait since the Earl points on a globe to that island as ripe for colonisation. Vertue singled out the portrait of Arundel with his grandson to support his belief that the best of Van Dyck's English portraits 'are superior to any done by any other Painter': he called it 'a most excellent Masterly peice … wherein he has Imitated the stile of Titian in his colouring … the Armor is painted with great force & skill…'.

A swift preliminary study for Arundel's head and shoulders (Vey 229) concentrates on his features, inevitably changed (chiefly, broadened) in the fifteen years or so since he sat to Van Dyck for cat. 25. The plain, wide collar and Garter ribbon are indicated in the study, seemingly over a conventional doublet. The decision to be painted in armour may largely have been Arundel's. Arundel was not a military man (Clarendon observed that there was 'nothing martial about him but his presence and his looks'), but to be shown in armour evoked associations with age-old nobility and chivalry which well became his resolute campaign to restore the dignity of his line. Van Dyck no doubt welcomed the chance to rise to the challenge of Rubens's portrait of Arundel in armour, painted in London in 1629–30 (fig. 2), and did so, with passages of sheer painterly virtuosity. Millar (in London 1982–3) justly praises Van Dyck's 'glowing baroque handling' of the gold-brown armour, noting the reflection of the boy's pink jacket in the gleaming metal of his father's breastplate. In 1638, some two years after this portrait, Charles I appointed Arundel (by then aged 53) Captain-General of the army against the Scots, a role which, as things turned out, did not involve active service.

Of greater personal significance than the armour is the detail noted by Vertue, that Arundel is portrayed 'with the Earl Marshals Staf in his hand'. The office of Earl Marshal (eighth among the great offices of state, and including responsibility for the College of Arms and for all state ceremonials) had long been held by Arundel's ancestors. The staff, or baton, of that office is prominent in Holbein's portrait of Arundel's great-great-grandfather, *Thomas Howard, 3rd Duke of Norfolk* (Royal

FIG 1
Anthony van Dyck, *Thomas Howard, 2nd Earl of Arundel, with Aletheia, Countess of Arundel ('The Madagascar Portrait')*, 1639
oil on canvas, 135 × 206.8 cm
His Grace The Duke of Norfolk KG, Arundel Castle

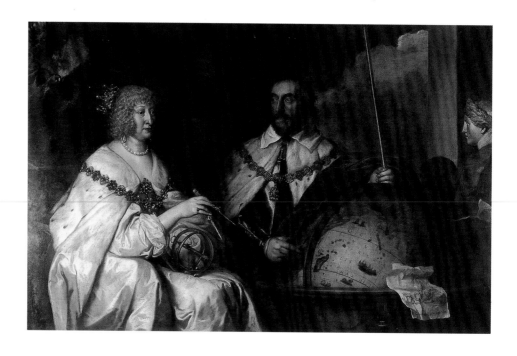

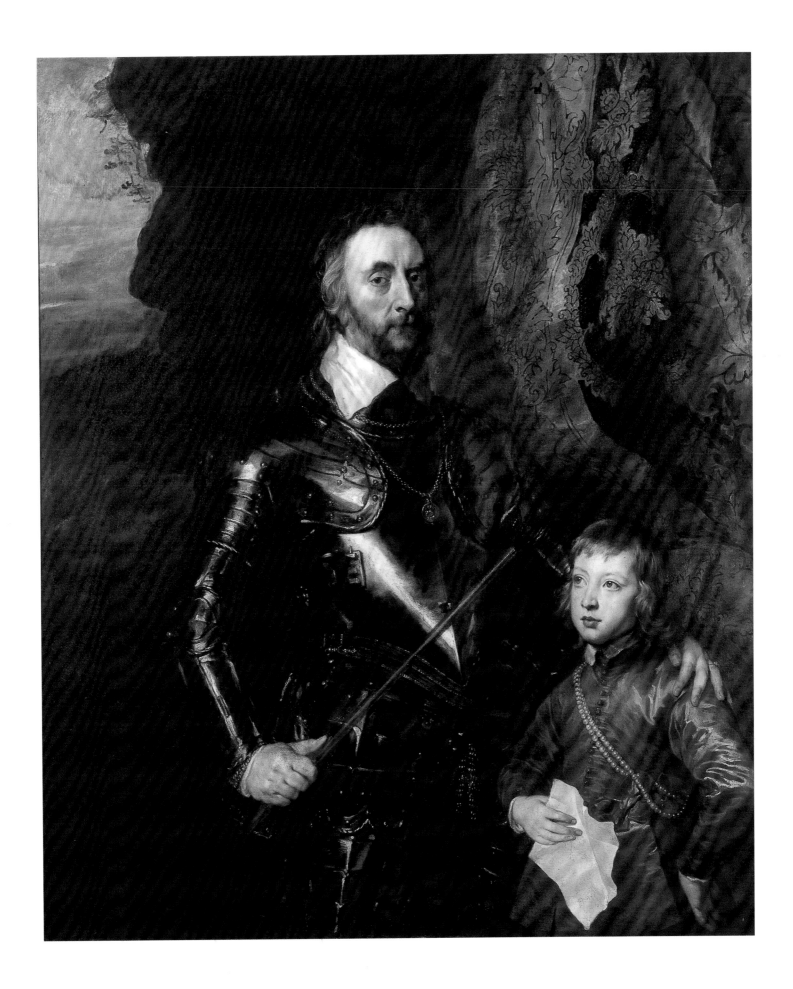

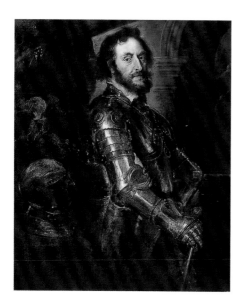

Collection). Forfeited by Arundel's disgraced father, the Earl Marshalship was later shared by Arundel with five others. Its restoration to Arundel alone, in 1621, after he conformed to Protestantism, represented a significant victory. Arundel himself must have asked Van Dyck to include the baton: it is painted directly over the armour (Millar op. cit.). Arundel also wears the 'Lesser George', the badge of the Order of the Garter.

There is much in this portrait to counter Clarendon's judgement that Arundel was 'a man supercilious and proud, who lived always within himself'. If the right hand clasps the baton tenaciously, the left arm is protective, suggesting a degree of tenderness towards his grandson, Thomas Maltravers (1627–77), which those outside his immediate circle never saw. Arundel himself identifies the boy as 'little Tom' in a letter of November 1636 to his friend and agent William Petty in Italy: he writes that he is sending out 'a Picture of my owne and my little Tom bye me', in the hope (unfulfilled) that an Italian sculptor – perhaps Bernini – 'might doe another of the [sam]e' in marble. Howarth reasonably suggests that for this project (surely impractical, and not carried out), Arundel might have sent a replica of this great double portrait rather than the original.

Arundel's crusade to restore his family's dignity, honours and possessions slowly succeeded. He was the King's ambassador to the widowed Queen of Bohemia in 1632, to Holland in 1636, and was appointed Lord Steward of the Household in 1640. As Lord High Steward, he presided over Strafford's trial in March 1641 (see cat. 68). Charles created him Earl of Norfolk in 1644; but not until 1660, fourteen years after his death, was the Dukedom of Norfolk restored. John Evelyn, who saw Arundel shortly before his death in Padua on 4 October 1646, found 'that great and excellent man in teares on some private discourse of crosses that had befallen his illustrious family... and the misery of his country now embroiled in Civil War'. One of those 'crosses' was that his grandson Thomas Maltravers, 'little Tom' in this double portrait, contracted a fever in Padua which caused brain disorder. It was to him that the Dukedom of Norfolk was restored in 1660, but by then he was incurably mad. JE

90 *Charles I in Robes of State*
1636

oil on canvas, 253.4 × 153.6 cm
inscribed below the King's crown on the right:
Anto⁰ van dijck Eques Fecit; dated 1636 under
initials C R below a crown; on back of canvas:
C R brand (visible from the front)

Lent by Her Majesty The Queen

PROVENANCE Painted for the King, perhaps
for the royal portrait gallery at Somerset House;
inspected there by the Trustees for the Sale of the
King's Goods and, with a companion portrait of
the Queen, valued at £60 and sold to Colonel
Webb, 29 October 1649; acquired by Henry
Browne in his capacity as Keeper of Somerset
House, and declared by him to the Committee of
the House of Lords at the Restoration; thereafter
in the Royal Collection

REFERENCES Cust 1900, pp. 105, 263, no. 8;
Vertue IV, XXIV (1936), pp. 73, 74; Walpole
1762–71, ed. 1888, I, p. 320; Glück 1931, p. 382;
Collins Baker 1937, p. 75; Millar 1963a, no. 145;
Brown 1982, p. 143

EXHIBITIONS British Institution 1818; London
1946–7, no. 45; ibid. 1953–4, no. 131; ibid. 1982–3,
no. 30

FIG I
Anthony van Dyck, *King Charles I, c.* 1633
black chalk, 47.9 × 36.5 cm
Rijksprentenkabinet, Rijksmuseum, Amsterdam
(Vey, under no. 204)

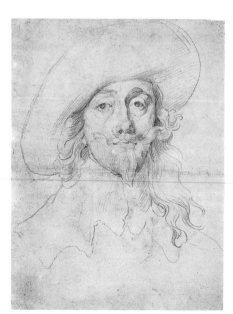

This image of majesty, on a canvas over nine feet high (2.5 metres), was designed as an official state portrait, from which copies painted by the ablest of Van Dyck's assistants could be dispatched through the diplomatic network to other European rulers, or presented as a mark of high favour to eminent courtiers. Many copies were made, of dimensions which varied according to the importance of the recipients. Sometimes a copy was accompanied by a companion portrait of the Queen.

For Van Dyck, this form of state portraiture, necessarily constrained, can hardly have been as stimulating as the portraits of Charles to which he had already brought all his inventiveness of pose, all his empathetic powers of characterisation and all his ability to give as much movement and life to a monarch as to a lesser man. Those earlier portraits had included two canvases on which Van Dyck secured for ever his vision of the man of fastidious taste who combined instinctive nobility with regal authority: *Charles I on Horseback with Monsieur de St Antoine* (fig. 64) and *Le Roi à la Chasse* (fig. 17).

Van Dyck would have been well aware that this state portrait would become the most widely known image of the King, both at home and abroad. A state portrait should show the King virtually full-face, motionless and composed, in the full panoply of ermine-trimmed regal robes, with orb and crown conspicuously in evidence. Van Dyck, however, surpasses convention, successfully combining an image of royalty with a sympathetic impression of the man within the royal robes.

The right arm, akimbo, plays a large part in saving the state portrait from being a static icon of majesty. The pose with a hand on his hip may have been habitual with Charles; it recurs in *Le Roi à la Chasse* painted the previous year, allowing Van Dyck the chance to paint a dazzlingly foreshortened left arm akimbo. Here the bend of the King's right arm gives the painter the chance to break through the sombre weight of the robes with a shimmering right angle of white silk, opulent, yet so fine that its every fold over the royal arm can be lovingly rendered – unlike the hand itself, evidently turned backwards at the wrist – in an informal gesture now difficult to read.

The ever-present problem with Charles I was that he was a small man (like Van Dyck himself). The vantage point here, looking upwards, increases the illusion of his height. J E

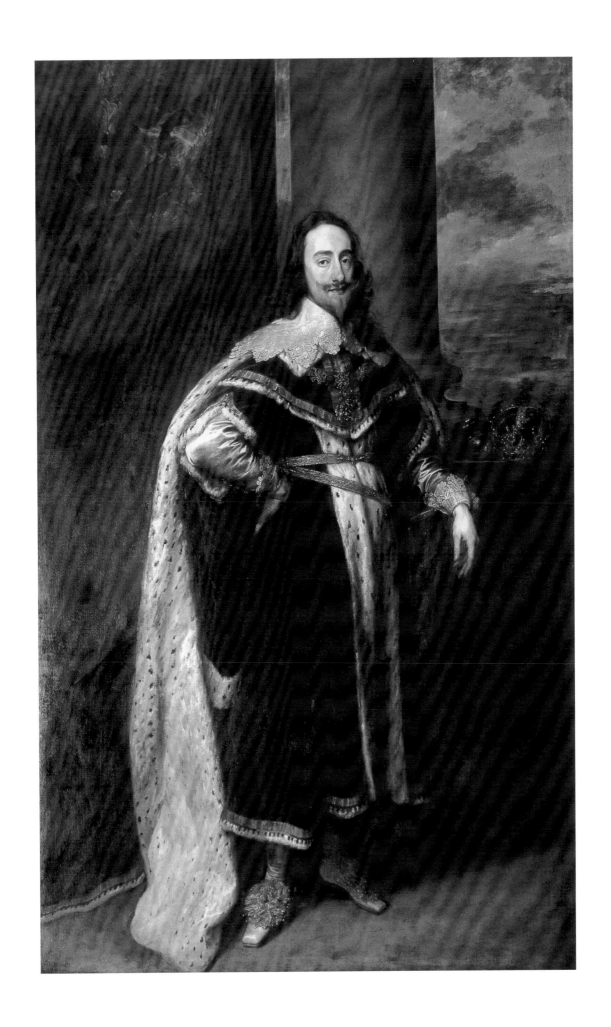

91 *Princess Elizabeth and Princess Anne*

1637

oil on canvas, 29.8 × 41.9 cm
inscribed (not by the artist): *The Princesse/ Elizabeth* and (erroneously) *Henry Duke of Gloucester*

The Scottish National Portrait Gallery, Edinburgh (inv. no. PG 3010)

PROVENANCE By 1879, Lord Chesham; by descent; 1977, sold through Agnew's to the British Rail Pension Fund; 1996, purchased through Hazlitt, Gooden & Fox by the Trustees of the National Galleries of Scotland, with assistance from the National Art Collections Fund and the Wolfson Foundation

REFERENCES Glück 1931, p. 384; Millar 1963a, p. 99, under no. 152; Brown 1982, pp. 184–5; Larsen 1988, no. 810; National Art Collections Fund, *1996 Review*, 1997, pp. 170–71

EXHIBITIONS Royal Academy 1879, no. 131; London 1922, no. 2; ibid. 1953–4, no. 317; *European Pictures from an English County (Hampshire)*, Agnew's, London 1957, no. 13; London 1968a, no. 49; ibid. 1972–3, no. 106; *Children through the Ages*, Fermoy Art Centre, King's Lynn 1977, no. 5; London 1982–3, no. 27; *Sir Geoffrey Agnew 1908–1986, Dealer and Connoisseur: Old Master ... Pictures lent by his Friends*, Agnew's, London 1988, no. 8; Washington 1990–91, no. 101

This oil sketch depicts the two younger children in the large group portrait *The Five Eldest Children of Charles I* (fig. 63). That group includes the three elder children – Charles, Prince of Wales; Mary, Princess Royal; and James, Duke of York – and is dated 1637. At that date, Princess Elizabeth (born 28 December 1635) was under two years old and Princess Anne (born 17 March 1637) hardly six months old. The artist himself establishes Princess Anne's presence in that group; including it in his bill for pictures painted for the King, he identifies the youngest child as 'Pr Anna'.

As Millar (in London 1982–3) notes, this is the only surviving sketch of its kind from Van Dyck's English period. The confidence with which the heads of the children are defined and modelled is complete. Although it is generally assumed that this is a preliminary study for the large group portrait of the royal children, its very assurance leaves open the possibility that the heads of the two youngest children were abstracted from the group portrait and repeated on this small canvas, perhaps as a personal gift to the Queen or to one or other of the children's high-born governesses.

Van Dyck's response to the natural liveliness of children is very evident. The baby reaches out towards the family dog; gently, her sister saves her from toppling over. Van Dyck's portrayal of both infants as somewhat older than their tender years may have been inspired by a wish to endow each of them with as much personality as the other three children in the group portrait, but whereas they have been schooled to decorum, the younger two are seen to behave far more naturally.

Princess Anne died in 1640, aged three. Whoever identified her infant head as that of 'Henry, Duke of Gloucester' must have forgotten her brief existence and assumed that the baby was the next in the royal family, Prince Henry (born 1639). Princess Elizabeth was aged seven when the Civil War began. During the War her movements were controlled by Parliament. Repeatedly, she asked to be allowed to join her sister Mary, Princess of Orange, in Holland, but instead was kept under house arrest, moving from one place to another, finally to Carisbrooke Castle, where her father the King had been held prisoner. She never recovered from the news of his execution, and died there on 8 September 1650, aged fifteen. By all accounts, she was a gentle and studious child. JE

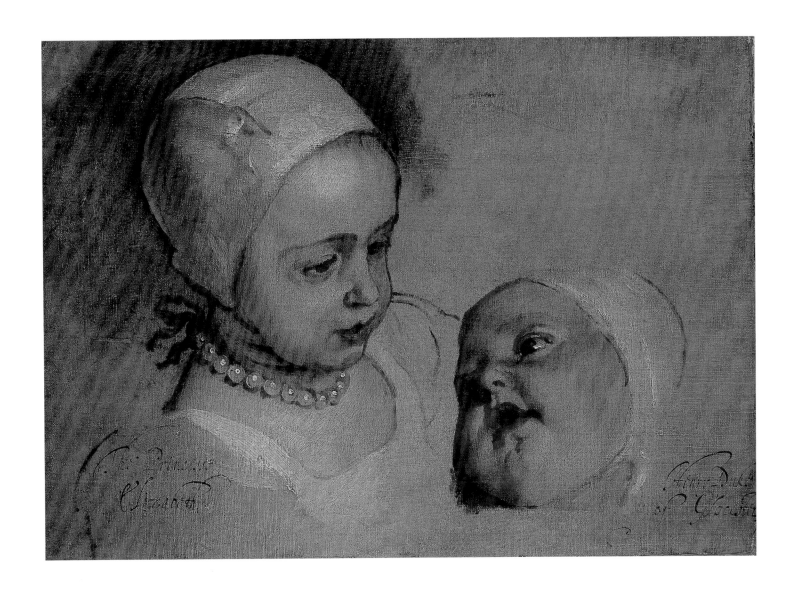

92 *Henrietta Maria in Profile, facing right,* 1638

oil on canvas, 64.1 × 48.3 cm

Memphis Brooks Museum of Art, Memphis, TN;
Memphis Park Commission Purchase 43.30

PROVENANCE Commissioned by Queen
Henrietta Maria (perhaps 'La Reyne en petite
forme...£20' in Van Dyck's *Mémoire pour sa Mag^tie
Le Roy*, listed 2 below those for *Mons^r Barnino*);
Carpenter 1844, p. 67: probably presented by
Charles I or Henrietta Maria to James Hamilton,
3rd Marquess and later 1st Duke of Hamilton
(inventoried in his collection as 'One peice of the
queene to the waste syde faced of S^r Anthonye
Vandyke': Millar 1982, p. 94), d. 1649; by descent
to the 12th Duke of Hamilton until sold in the
Hamilton Palace sale, Christie's, 17 June 1882,
lot 75; J.E. Reiss, sold 6 February 1914, lot 114,
bought Agnew's, by whom sold to Mr Bevan,
London, 1927; Kings Galleries, London; 1943,
Warner S. McCalle, St Louis, Missouri

REFERENCES Glück 1931, no. 387; Lightbown
1981, pp. 439–52; Brown 1982, p. 177; *Painting
and Sculpture Collection, Memphis Brooks Museum
of Art*, Memphis 1984, p. 57; Larsen 1988, no. 875

EXHIBITIONS London 1982–3, no. 54;
Washington 1990–91, no. 82

NOTES
1. Millar 1963, nos. 148, 149.
2. Filippo Baldinucci, *The Life of Bernini*,
trans. C. Enggas, 1966.
3. See Washington 1990–91, pp. 307–8, presenting
evidence from technical examination which shows
that this portrait was painted over an unfinished
frontal image, suggesting that it was not painted at
the same time as the other two, and may have be-
longed to a larger composition which was cut down.
4. Carpenter 1844, pp. 67–8.
5. Danish Royal Collection, Rosenborg Castle,
Copenhagen.

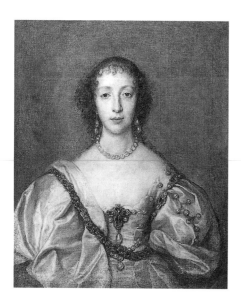

Bernini's marble bust of Charles I, sculpted in Rome from Van Dyck's *Triple Portrait of Charles I*, was officially commissioned by Henrietta Maria (see cat. 86). When it reached England in July 1637, the Queen, like the King and his court, was delighted, and expressed the wish that Bernini would execute a companion bust of herself. The following month, her wish was relayed to the papal court in Rome, where Bernini was working. There were delays, mostly of the Queen's making. Having requested Van Dyck to paint a portrait of her for Bernini to work from, she procrastinated for almost a year before finally sitting to him at Greenwich Palace in the summer of 1638. She hoped a single portrait might suffice, but that proved impossible, and instead Van Dyck caught her image on three separate small canvases (see fig. 1).[1] These were displayed at court on 27 August 1638, where they were seen by the Queen's papal agent, George Con. Almost a year passed before the Queen wrote to Bernini, expressing her admiration for the bust of her husband and adding: 'to make my satisfaction complete I would like a similar one of myself made by your hand from portraits that will be given to you'.[2] Bernini had no wish to undertake any other 'picture in marble after a painting', but was saved by the fact that Van Dyck's portraits of Henrietta Maria were never dispatched to him, presumably because of the troubles looming over the English court.

This sensitive and sympathetic portrait seems to catch the Queen in untroubled mood, attentive and almost conversational. It is also a supremely delicate rendering of the nuances of muted colour, from the warm opalescence of the Queen's pearls to her filigree lace collar, then through the pale silver-blue ribbon bow to the dove-like featheriness of her filmy cinnamon-coloured shawl and a glimpse of her ivory satin gown. No painter until Gainsborough could render stuffs with such sensitivity.

Some puzzles surround the execution of this portrait. It has been suggested that it was not painted at the same time as the frontal and profile portraits (fig. 1) destined for Bernini.[3] The bill Van Dyck presented for payment for work done for the King and Queen includes only two portraits painted *'pour Mons^r Barnino'* (i.e. Bernini), each priced at £20 (the King marked them down to £15 each).[4] For the purpose of the proposed bust, another profile portrait was not wholly necessary, though the Queen may have believed that because Bernini had been provided with three views of her husband, he should receive three of herself. The Memphis portrait is different in kind – freer, more characterful and more animated – than the profile portrait facing left painted for Bernini. Whether Van Dyck painted the Memphis portrait after the other two, whether he painted it for the Queen herself, whether she gave it to Lord Hamilton, or whether it was commissioned by Lord Hamilton is unclear.

The small portraits of the Queen destined for Bernini did, in the end, provide the basis for a marble bust, sculpted by the Flemish-born François Dieussart who worked in England. His bust of Henrietta Maria was completed in 1640.[5] JE

FIG 1
Anthony van Dyck, *Queen Henrietta Maria, facing front*, 1638
oil on canvas, 78.7 × 65.7 cm
Her Majesty The Queen

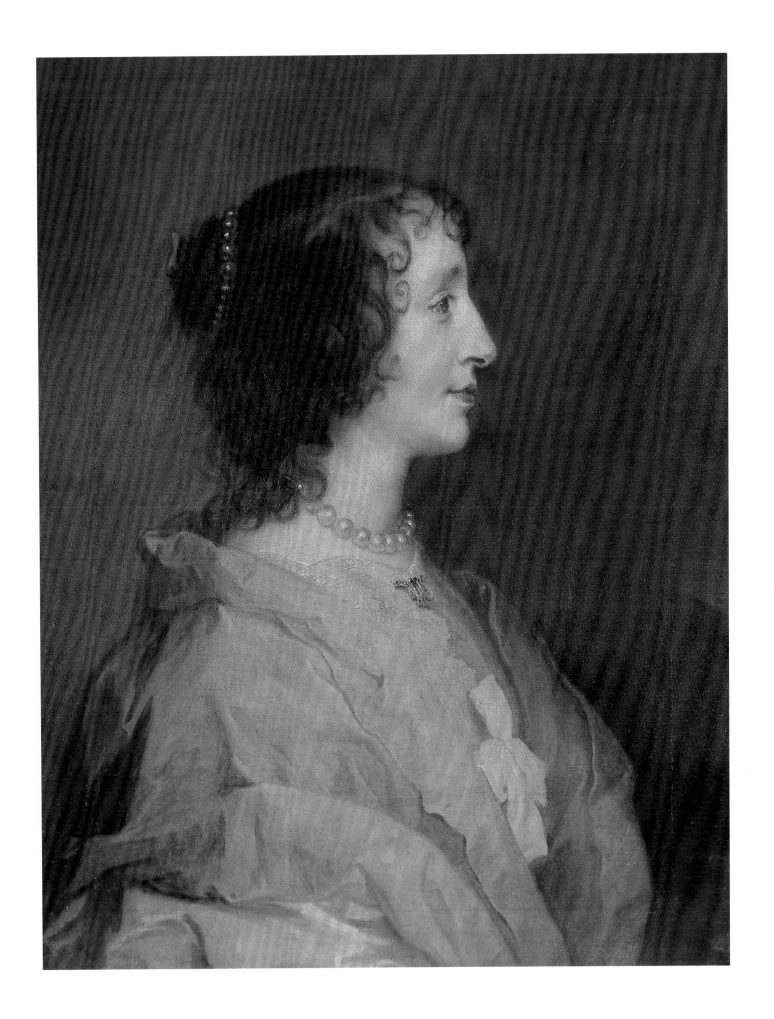

93 *George, Lord Digby, and William, Lord Russell* c. 1637, or earlier

oil on canvas, 250 × 157 cm
inscribed lower right: *Ant van Dyck Eques P¹*

The Collection at Althorp Park

PROVENANCE Evidently commissioned by
George, Lord Digby, later 2nd Earl of Bristol
(d. 1677); by descent through his daughter,
Lady Anne Digby, who married Robert Spencer,
2nd Earl of Sunderland, of Althorp, to the
present owner

REFERENCES Vertue IV (1936), pp. 38, 40, 49;
Cust 1900, pp. 124, 269–70, no. 24; Garlick 1976,
no. 146; Brown 1982, p. 197; Larsen 1988, no. 778

EXHIBITIONS London 1856, no. 18;
Manchester 1857 (British Portraits section),
no. 123; London 1866, no. 728; Leeds 1868,
no. 597; London 1887, no. 112; ibid. 1894, no. 72;
Antwerp 1899, no. 52; London 1900, no. 56; ibid.
1922, no. 16; ibid. 1927, no. 135; ibid. 1953–4,
no. 145; Manchester 1957, no. 78; London 1968a,
no. 42; ibid. 1972–3, no. 100

COPIES AND VERSIONS Noted by Garlick
1976, under no. 146

NOTES
1. Quoted in Richard Ollard, *Clarendon and his
Friends*, London 1987, p. 65ff.
2. See Orgel and Strong 1978, pp. 599, 661, 705,
707, 729.

In dignity, design and brilliant colour, this double portrait is as magnificent as the grandest of Van Dyck's Genoese portraits; yet there is an air of informality about it which makes it unmistakably English. The two young men portrayed here had hardly begun to make their names when they sat to Van Dyck c. 1637: Digby was then aged about 25, and Russell about 21. The casual litter of props – an armillary sphere, well-thumbed books and papers hinting at Digby's studious interests, a helmet and breast-plate suggesting that Russell is more extrovert – indicate what Van Dyck has been able to glean about them from, perhaps, a few sittings (or, perhaps, from learning that Digby had been at Oxford, Russell had not). Both men were to achieve renown, in different ways; but in about 1637, neither was celebrated. Van Dyck's thrilling response is, rather, to their instinctive elegance, their virility and the contrast which the two friends offer to his eye. They were 'graceful and beautiful persons' (to borrow a phrase from Clarendon, quoted below): and as such he responded to them.

George Digby (1612–77), a remote cousin of Sir Kenelm Digby (see cat. 69), was to succeed his father as 2nd Earl of Bristol in 1653; William Russell (1616–1700) succeeded his father as 5th Earl of Bedford in 1641 and was later created 1st Duke of Bedford. By the time this portrait was painted, they were brothers-in-law, Digby having married Russell's sister Anne in 1632. Both were at court in the 1630s, both, for instance, taking part as masquers in Carew's *Coelum Britannicum*, performed at Whitehall in 1634.

Of the two men, Digby is the more complex character; Van Dyck's half-length portrait of him in Dulwich Picture Gallery hints at this. Clarendon wrote that Digby was 'a graceful and beautiful person', with qualities suited to great affairs, but because of his vanity, 'the unfittest man alive' to conduct them,[1] while Horace Walpole was to remark that Digby was 'a singular person whose life was one contradiction. He wrote against Popery, and embraced it'.[2] Both men sat in the House of Commons in 1640–41. Russell, by then opposed to the policies of the Court, was one of the 24 Commoners who conferred with the Lords over presenting the King with a petition of grievances, but had to leave the Commons on succeeding in 1641 to his father's peerage. Digby, pro-Court and pro-Catholic, defended Strafford (see cat. 68, 102) in Parliament, earning the hatred of the mob and subsequent impeachment himself for treason. On the outbreak of Civil War, Russell accepted a commission as General of the Horse in the Parliamentary army (though one might have supposed Van Dyck's image of him in scarlet, with boots and spurs, predicted a quintessential Cavalier); as such he fought at Edgehill, and as such he found himself besieging Sherborne Castle, against Digby and his own sister. Later Russell joined the King's forces. If this account is bewildering, it reflects the conflicting loyalties which Englishmen, and particularly erstwhile courtiers, experienced during the Civil War. Russell was to find private happiness in his marriage to Anne Carr (cat. 98). JE

FIG I
Anthony van Dyck, *George, Lord Digby*, c. 1637
black chalk with white highlights on green-grey paper, 34.9 × 16.8 cm
Department of Prints and Drawings, British Museum, London (Binyon 1907, no. 52)

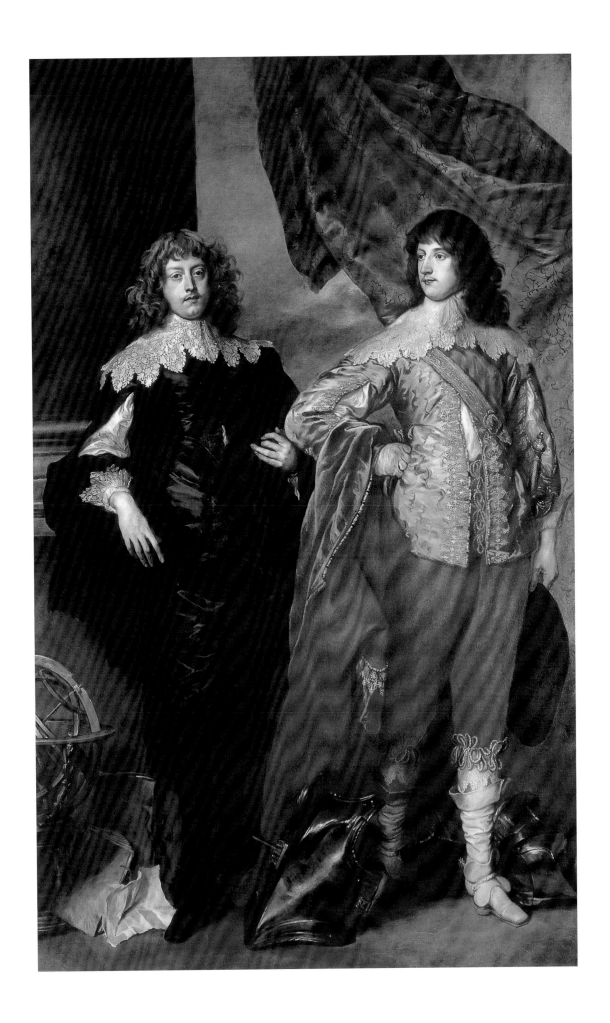

Prince Charles Louis, Elector Palatine, and his Brother, Prince Rupert of the Palatinate

1637

oil on canvas, 132 × 152 cm

inscribed: CAROLUS PRENCEPS ELECTOR PALATINVS/CVM FRATRE ROBERTO/1637

Musée du Louvre, Département des Peintures, Paris (inv. no. 1238)

PROVENANCE Painted for Charles I, and hung in the Privy Gallery at Whitehall;[1] offered in the Commonwealth sale, valued at £40; 22 March 1650, sold to (or accepted by, in part payment of debts) the former royal jeweller Jasper Duart; sold by him to Everhard Jabach; 1671, purchased from Jabach by Louis XIV; thence to the Louvre

REFERENCES Cust 1900, p. 267, no. 50; Glück 1931, no. 441; Musée du Louvre, *Catalogue sommaire illustré des peintures…: Ecoles flamande et hollandaise*, I, 1979, p. 52; Millar 1960, pp. 26, 230; id. 1972, p. 274; Larsen 1988, no. 936

EXHIBITION London 1982–3, no. 30

COPIES See Millar, in London 1982–3, p. 75

NOTES

1. '… The Kings nephewe Princ Charles Elector Pallatine togeether with his Brother Princ Robert both painted in Armoure in one peece in an adorned with Marshiall weapons carved whited and guilded frame Soe bigg as the life halfe figures'; Van der Doort catalogue, ed. Millar 1960, p. 26, no. 20.

2. See Rosalind K. Marshall, *The Life of Elizabeth of Bohemia 1596–1662*, exh. cat., Scottish National Portrait Gallery, Edinburgh 1998, passim (and bibliography pp. 110–11), for a fuller account than can be attempted here.

3. Ed. Rhodes Dunlap, *The Poems of Thomas Carew*, Oxford 1949, p. 77.

4. For his service during the Civil War, see C. V. Wedgwood, *The King's War 1641–1647*, London 1958, passim; for his character, see pp. 158–9.

5. See Richard Godfrey, *Printmaking in Britain*, Oxford 1978, pp. 27–8; plate 22 reproduces Prince Rupert's *Head of the Executioner* (from a picture of the school of Ribera), 1662, signed with Rupert's royal monogram.

Prince Charles Louis (1617–80) and Prince Rupert (1619–82), nephews of Charles I, were the eldest surviving sons of Frederick V, Elector Palatine and briefly King of Bohemia, and of King Charles's only sister, Elizabeth of Bohemia. Their parents' political fortunes were dogged by disaster. Having accepted the crown of Bohemia in 1619, Frederick lost it, and with it the Palatinate, two years later during the German wars; thereafter he and Queen Elizabeth ('the Winter Queen') lived in exile. On Frederick V's death in 1632, Prince Charles Louis considered himself to be the rightful heir to the role of Elector Palatine, or premier Elector of the Holy Roman Emperor, in whose realm the Rhineland principality of the Palatinate lay.[2]

Prince Charles Louis came to London in November 1635, hoping to enlist King Charles I's support for his attempt to regain his father's forfeited lands in the Rhineland. Prince Rupert joined him three months later, and the brothers remained in London until 26 June 1637. Van Dyck had painted single portraits of them in 1631–2 (see cat. 64). In this double portrait, Van Dyck depicts them both in armour. Charles Louis, on the left, wears the Lesser George from a chain round his neck; he had been made a Knight of the Garter in 1633. He is said to have been reserved, even 'chilly' in London; preoccupied by his own grave problems, he may rather have been impatient at the comparative frivolity of Charles's court, summed up by the poet Thomas Carew:

Tourneys, masques, theatres better become
Our halcyon days; what though the German drum
Bellow for freedom and revenge, the noise
Concerns us not, nor should divert our joys…[3]

Charles I, who had no wish to become involved in the European war against the Spanish–Austrian alliance, gave his nephew small help. Disillusioned, Charles Louis cultivated the friendship of the King's prominent Protestant critics. In the event, the Peace of Westphalia, which ended the Thirty Years' War in 1648, gave Charles Louis the Lower Palatinate (but not the Upper, nor the Electoral title). During the Civil War in England, he openly supported Parliament.

Prince Rupert, his younger brother, by contrast enjoyed his visit to the English court, mixing in artistic circles and becoming devoted to his uncle, the King of England. Loyally, he fought in Charles Louis's unsuccessful attempt to invade the Lower Palatinate (1638), but was captured and suffered three years' imprisonment. In the English Civil War he offered his services to Charles I, and as one of his cavalry commanders, became popularly known as 'Rupert of the Rhine', with a reputation for fearlessness.[4] After the Royalist defeat, and in retirement at Frankfurt, he experimented with the technique of mezzotint, producing a superb plate known as *The Great Executioner*.[5] JE

95 Thomas Killigrew and a Man 'not known certainly' 1638

oil on canvas, 132.7 × 143.5 cm
inscribed, probably by the artist, on the base of the
broken column, between Killigrew's elbow and his
companion's right hand: *A·van·Dyck·1638*

Lent by Her Majesty The Queen

PROVENANCE Perhaps taken by Thomas
Killigrew in 1649 to the Continent; acquired
(in Madrid, *c.* 1716?) by Daniel Arthur, an Irish
merchant; inherited by his widow, who married
(secondly) George Bagnall; 1729, probably among
paintings from Arthur's collection (including
cat. 19, and other works by Van Dyck) seen in
Bagnall's London house by the Earl of Egmont;
1748, purchased from Bagnall by Frederick, Prince
of Wales; then by royal descent

REFERENCES Vertue XVIII (1930), I, p. I; IV,
p. 125; Walpole 1762–71, ed. 1888, I, pp. 326–7;
E. Law, *Pictures by Van Dyck at Windsor Castle*,
London 1899, p. 77; Cust 1900, pp. 134–5, p. 276,
no. 107; Glück 1931, p. 451; Millar 1963b, no. 156;
Brown 1982, p. 212; Rogers 1993, pp. 224–6

EXHIBITIONS British Institution 1820, no. 91;
ibid. 1834, no. 2; Manchester 1857 (not exhibited);
London 1866, no. 754; ibid. 1871; ibid. 1887,
no. 109; Antwerp 1899, no. 61; London 1900,
no. 65; ibid. 1946–7, no. 36; ibid. 1953–4, no. 164;
ibid. 1968b, no. 14; ibid. 1988–9, no. 9;
Washington 1990–91, no. 84

NOTES
1. E.g. in A. E. Popham, *Catalogue of the Drawings
of Parmigianino*, New Haven and London 1971, II,
pl. 97ff.
2. In correspondence with the author.
3. Rogers (1993) suggests that the paper is
deliberately blank, 'reminding Killigrew of his loss,
that it might be the more keenly felt'.
4. Alastair Laing later pointed out that the only
member of the Crofts family of eligible age would
have been Lord Crofts's nephew of whom no
likeness is so far known.

The sitter who faces us is the courtier and playwright Thomas Killigrew (1612–83), portrayed at the age of 26. He is shown in mourning for his wife Cecilia Crofts, one of the Queen's ladies-in-waiting, who had died on 1 January 1638, only eighteen months after their marriage. Attached to his sleeve is a small gold and silver cross engraved with her intertwined initials ℭℭ; her wedding ring hangs from a black band around his left wrist, and there are two rings (perhaps a wedding and a mourning ring) on his fingers. Dejectedly, he holds a crumpled paper depicting two antique female figures, each on a carved pedestal, one with a child at her side. Perhaps a funerary design, it is reminiscent of drawings by Parmigianino in the Earl of Arundel's collection.[1] The figure clasping a child may represent Cecilia Killigrew with her six-month-old son; the other may represent her sister Anne, Countess of Cleveland, who had died just two weeks after Cecilia. Black and white dominate the picture, but some warmth is added behind Killigrew by tawny-coloured drapery. Michael Levey suggests[2] that the broken column against which Killigrew leans his arm is introduced as a symbol of Fortitude. He notes that in Moroni's *Portrait of a Gentleman* (Poldi Pezzoli, Milan), a man leans against a broken column whose plinth is inscribed *Impavidum ferient ruinae* (from Horace: '[If the world should break and fall on him,] its ruins would strike him unafraid'). He also observes that the broken column which Van Dyck introduces into his own *Self-portrait* (cat. 31) is probably also a symbol of Fortitude. In this double portrait, the meaning is likely to be that Killigrew is trying to bear his sorrows 'like a man', perhaps encouraged by the advice (or example?) of his friend.

Van Dyck gives the predominant role in the picture to Killigrew, leaving small doubt that he is the principal mourner. His identity is securely established by Van Dyck's single portrait of him, also painted in 1638, with Killigrew's name and family crest 'engraved' on his dog's collar (Weston Park Foundation, repr. Rogers 1993, p. 227, fig. 59). But who is the second man, holding a blank sheet of paper?[3] A writing or drawing instrument in his hand might have suggested a poet, an artist, or the designer of a monument; but there is no such clue.

By the 1730s to 1740s, when the double portrait was offered for sale by George Bagnall (see Provenance), the identity of the second man had been lost. Vertue, who as a portrait engraver and collector was keenly interested in questions of identity and had studied the likenesses of most celebrated English sitters, noted that 'the other person is not known certainly'. Trying to establish his identity, Vertue was first informed that the second man was the poet Sir John Denham (1615–69), and later that he was the poet Thomas Carew (1594/5–1640). Neither suggestion was based on a likeness (and no portraits of either Denham or Carew, engraved or otherwise, appear to be known). Both suggestions appear to have been attempts to suggest 'plausible candidates', or men within Killigrew's known circle who could be assumed to be sufficiently close to him to explain companionship in such an emotional double portrait.

The proposal of Thomas Carew as the second man was accepted without question by Horace Walpole. Carew, the more senior of the two and the court's chief lyricist, was Cupbearer to Charles I; his *Coelum Britannicum*, a masque, was performed in the Banqueting House at Whitehall on 18 February 1633. Carew also knew Cecilia Crofts, and celebrated her wedding to Thomas Killigrew in his poem *On the Marriage of T. K. and C. C. the morning stormie*. Carew continued to be identified (at least tentatively) as the second man in Van Dyck's double portrait until Law (1899) pointed out that the portrait is dated 1638, when Carew would have been aged 42 or 43, surely too old to be Killigrew's companion, who seems much the same age as himself.

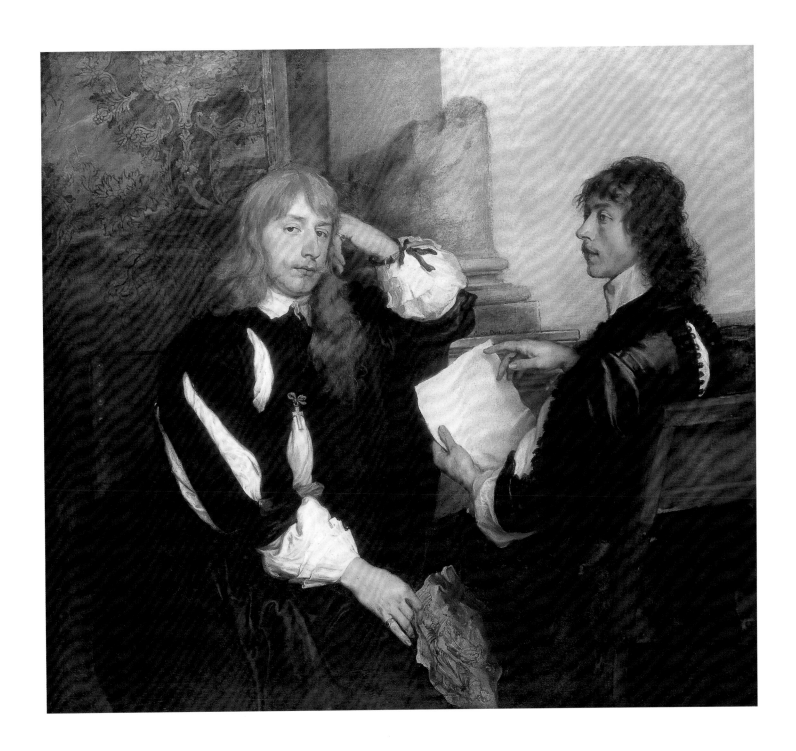

Millar (1963), noting that 'the identity of Killigrew's companion has never been satisfactorily established', suggested 'a more plausible candidate': Killigrew's brother-in-law, William Crofts, later 1st Lord Crofts (*c.* 1611–77), his inclusion in this mourning picture seeming likely because death had robbed him of two sisters, Cecilia (Killigrew's wife) and Anne (Countess of Cleveland). Tentatively, Millar retitled the picture 'Thomas Killigrew and William, Lord Crofts (?)'.[4]

If further 'plausible candidates' are to be sought, they might include the poet Francis Quarles (1592–1644), as suggested by Arthur K. Wheelock (in Washington 1990–91), whose elegy *Sighes At the Contemporary Deaths of Those Incomparable Sisters, the Countesse of Cleaveland and Mistrisse Cicily Kiligrew* was published in 1640, though he (like Carew) seems too old to be the second man portrayed in 1638. Another possible candidate (at least on paper) might be the Hon. Walter Montagu (?1603–77), with whom Killigrew had recently travelled abroad, returning shortly before his marriage in June 1636. Montagu wrote *The Shepherds' Paradise,* a play performed at court in 1633 by the Queen and her ladies-in-waiting, including Cecilia Crofts.

The difficulty with all the 'plausible candidates' is that no reliable comparative portraits are now known. We are back with Vertue's problem in establishing identity. If 'likeness' were to be accepted as a starting-point, then Sir Thomas Hanmer should be considered as a candidate for the second man. Van Dyck's portrait of him (cat. 96) was painted in the same year as this double portrait. The dark eyes, vestigial moustache and dark, tangled, curling hair, which Van Dyck clearly delighted in painting in both portraits, seem very similar, as does the quick, alert expression. Hanmer, born the same year as Killigrew, is likely often to have encountered Killigrew at Court: both men were Pages of Honour to Charles I (Hanmer being promoted to Cupbearer), and both married ladies-in-waiting to Henrietta Maria. No evidence of a particular friendship has been found; but outside the pages of Anthony Powell (or Proust), which of us fully knows the ramifications of present friendships, let alone those of over three centuries ago? The presence of Hanmer's portrait in this exhibition should offer a chance to consider the possibility that Hanmer is the second man in the double portrait.

Killigrew's later career seemingly surmounted grieving. His plays grew bawdier as the years went by. Under Charles II, he was appointed Master of the Revels, and became known as 'the King's jester'; he also managed Drury Lane Theatre. Yet he evidently never forgot his Cecilia. Her wedding ring still hangs, with his, from a black band around his left wrist in his portrait of 1650 by William Sheppard (fig. 1). JE

96 Sir Thomas Hanmer
c. 1638

oil on canvas, 117.5 × 85.7 cm

The Weston Park Foundation (inv.no. 101.0090)

PROVENANCE Presumably painted for the sitter
(d. 1678); by 1683, in the collection of Viscount
Newport (Comptroller and Treasurer of the Royal
Household), created 1st Earl of Bradford, 1694
(d. 1708), by descent; thence to the Foundation

REFERENCES Millar 1958, p. 249; Brown 1982,
pp. 211–12; Larsen 1988, no. 859

EXHIBITIONS Nottingham 1960, no. 20;
London 1960–61, no. 5; King's Lynn 1963, no. 21;
London 1968a, no. 54; ibid. 1972–3, no. 103;
ibid. 1982–3, no. 37; Washington 1985–6, no. 63

NOTES
1. *The Garden Book of Sir Thomas Hanmer*, ed. Ivy
Elstob, introduction by E. S. Rohde, London 1933.
It includes (pp. 144–51) the earliest gardening
calendar in the English language.
2. See Edward Norgate, *Miniatura or the Art of
Limning*, ed. J. M. Muller and J. Murrell, New
Haven and London 1997, pp. 16, 152 note 128,
220 and 222: Appendix 1, no. 15, describing
Hanmer's transcript (now collection Aberystwyth,
National Library of Wales, MS 21753B, 89–116v).

FIG 1
Cornelius Johnson, *Sir Thomas Hanmer*, 1631
oil on canvas, 77.5 × 62.2 cm
National Museum of Wales

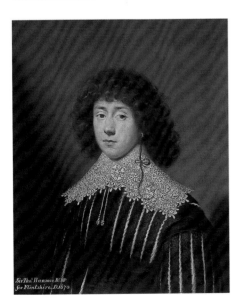

Born in 1612, Thomas Hanmer was the son of Sir John Hanmer, 1st Baronet of
Hanmer, County Flint, Member of Parliament for Flintshire, and his wife, Dorothy
Trevor. He succeeded his father as 2nd Baronet in 1624, at the age of twelve. Hanmer
served as page and subsequently Cupbearer to Charles I; while serving at court, he fell
in love with and, before he came of age, married Elizabeth Baker, one of Henrietta
Maria's maids of honour, and sister of the Thomas Baker, whose chief claim to fame
is that in 1636 he sat to Bernini for a bust (Victoria and Albert Museum, London).

Hanmer had been portrayed by Cornelius Johnson in 1631 (fig. 1), in a gentle,
unenthralled manner very different from that of Van Dyck's portrait, which may have
been painted in 1638, shortly before Hanmer and his younger brother John received
(on 30 September 1638) passports to travel for three years. Millar 1958 describes
Sir Thomas Hanmer as 'one of Van Dyck's most delicately poised and brilliantly
sustained English portraits, steeped in his recollections of Titian and foreshadowing
Gainsborough in the following century'. The area of the hands is particularly fine, with
the right wrist emerging from a black slashed sleeve to rest akimbo, while the left hand,
clenched within one pale chablis-coloured glove, holds the other empty, limp and
sensuously soft. When, after Hanmer's death, Evelyn saw this portrait in the collection
of Lord Newport, he noted in his diary: '… some excelent pictures, especialy that of
Sir Tho: Hanmers of V: Dyke, one of the best he ever painted'.

When Civil War broke out, both Thomas Hanmer and his brother raised troops for
the Royalist army, Thomas in Flintshire and John in Suffolk. Their father had been a
leader of the Puritan party in Parliament; the divided loyalties which perturbed many
families affected both his sons. In 1644 Thomas Hanmer went abroad for some two
years, during which time his wife died. On his return, having remarried, he retired to
Bettisfield, near Whitchurch, in his native Flintshire.

'As soon as peace hath introduced plenty and wealth into a country men quickly
apply themselves to pleasures', Hanmer was to observe. He found his own chief
pleasure in cultivating his garden at Bettisfield. Those hands which Van Dyck had
painted so exquisitely were chiefly engaged, for the rest of his life, in planting and
propagation. Hanmer became one of the most distinguished plantsmen of his day.
He kept a manuscript 'garden book' which shows little concern with garden design or
ornament but instead concentrates on 'choice plants … with short directions for their
preservation and increase'. Hanmer shared the period's fascination with tulips
('tulipomania'), importing from Holland a bulb that he developed, eponymously and
to great renown, as the *Agate Hanmer*. Impartially, he sent 'mother-rootes' of it both
to John Lambert, a former Parliamentary general, and to John Rose, Charles II's head
gardener.[1] The nursery gardener John Rea (d. 1681) dedicated his book *Flora, Ceres
and Pomona* (1665) to Hanmer, who had given him 'many noble and new Varieties'
from his 'incomparable Collection'. Hanmer corresponded with John Evelyn, sending
him seeds and 'rootes of severall sortes' for his new flower garden. In 1664, he also
made a transcript of Edward Norgate's treatise *Miniatura or the Art of Limning*.[2]

Hanmer should perhaps be considered as a candidate for the unidentified 'second
man' in *Thomas Killigrew and a Man 'not known certainly'*, painted about the same time
(see cat. 95). JE

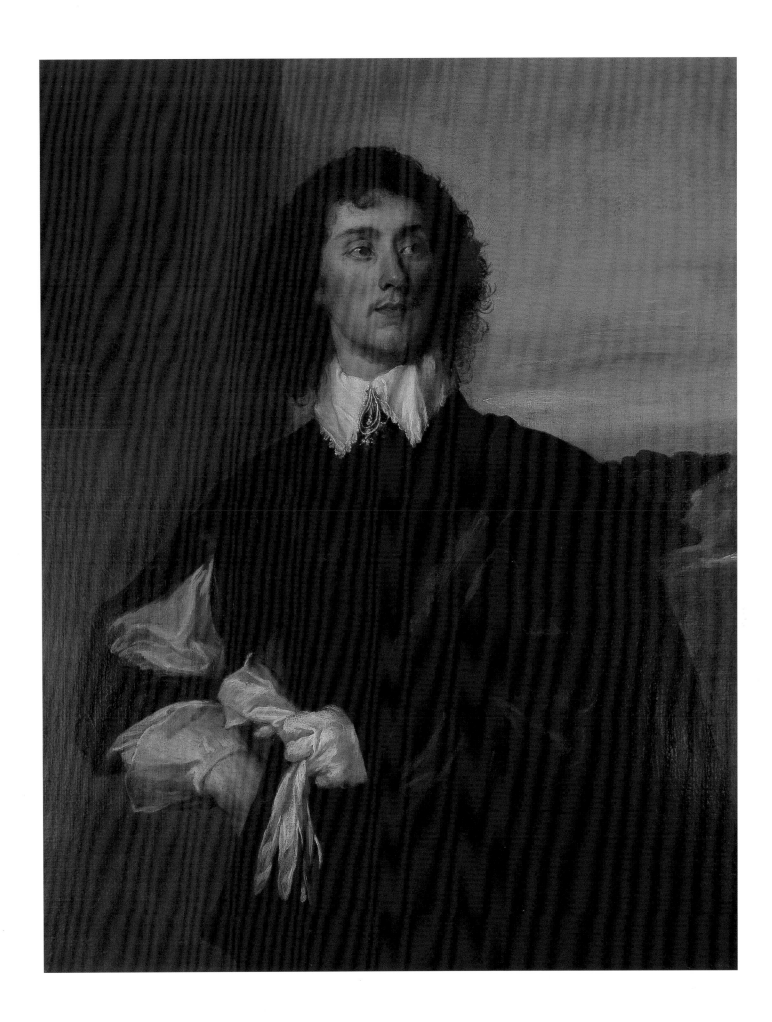

97 *Lord John Stuart and his Brother, Lord Bernard Stuart*
c. 1638

oil on canvas, 237.5 × 146.1 cm

The Trustees of the National Gallery, London
(inv. no. 6518)

PROVENANCE Probably commissioned by the
sitters' elder brother James Stuart, 1st Duke of
Richmond and 4th Duke of Lennox; his eldest son
and successor (d. 1672); inherited by his widow,
then by descent through her granddaughter,
1st Countess of Darnley, to the Earls of Darnley;
Sir George Donaldson; Sir Ernest Cassel;
Countess Mountbatten of Burma, by descent to
Lady Pamela Hicks, from whom purchased by the
National Gallery through Sotheby's, with the aid
of the J. Paul Getty Endowment Fund, 1988

REFERENCES Cust 1900, p. 283, no. 189; Glück
1931, p. 459; Brown 1982, p. 192; Larsen 1988,
no. 1009; National Gallery *Report* 1988–9, London
1989, pp. 10–12

EXHIBITIONS British Institution 1815; Royal
Academy 1882, no. 54; London 1887, no. 105;
Antwerp 1899, no. 78; London 1900, no. 54; ibid.
1904, no. 76; ibid. 1927, no. 137; Antwerp 1930,
no. 105; London 1938, no. 70; Antwerp 1949,
no. 59; Paris 1952, no. 15a; London 1953–4,
no. 139; ibid. 1982–3, no. 44

NOTES
1. For Van Dyck's borrowing from Correggio, see
David Ekserdjian, *Correggio*, London 1997, p. 191
(and pl. 205).
2. Lord Bernard Stuart's account of the battle of
Edgehill is published by Godfrey Davies, 'The
Battle of Edgehill', *English Historical Review*,
XXXVI, 1921, pp. 38–9.

Of all Van Dyck's images of Charles I's courtiers, this double portrait of two of the
King's confident young Stuart cousins, each of whom was to die fighting for his cause,
seems – with hindsight – most poignantly to evoke the transitory glamour of his court.

Lords John and Bernard Stuart were respectively the sixth and seventh younger
brothers of James Stuart, 4th Duke of Lennox and later 1st Duke of Richmond
(cat. 71). In this double portrait, painted about 1638, they are hardly more than boys.
John, in a golden doublet, on the left, born on 23 October 1621, is portrayed at the age
of about seventeen; Bernard, born in 1622 or 1623, in blue cloak and breeches laced
with silver (and not only booted but spurred), may not yet be sixteen. Van Dyck
observes a convention that a younger brother should be posed at a level slightly lower
than that of an elder; so Lord Bernard is seen as if ascending to the step on which Lord
John is standing. For Bernard's pose, Van Dyck borrows from Correggio's *Madonna of
St George* (Gemäldegalerie, Dresden), in which St George, with his left leg treading
down his conquered dragon, looks over his shoulder towards the spectator, hand on
hip. Lord Bernard's pose closely echoes St George's; but St George is clad in the tunic
and buskins of an early Christian warrior, while Lord Bernard wears turquoise satin
breeches.[1] Van Dyck's preliminary study (fig. 1) concentrates on the way in which the
satin must fold and crease as his right leg bears the chief weight of his pose.

The double portrait was probably commissioned shortly before the Stuart brothers
set off for three years' travel abroad, for which they received royal licence early in 1639.
The Civil War in which both were to lose their lives broke out soon after their return.
In the summer of 1642, Bernard, by then aged 20 or 21, requested and received
permission to serve under Prince Rupert in the King's lifeguard. In this role, and in
command of an extravagantly well turned-out troop of horse (popularly known as 'the
Show Troop'), Lord Bernard took part in the first decisive battle of the Civil War, at
Edgehill on 23 October 1642. His sobering account of that battle,[2] confusedly fought
among the lanes and hedges of Warwickshire, and of the blunderings of Englishmen
unused to war (overheard, the Royalist password 'For God and King Charles' allowed
enemy captives to escape) was written before learning that another brother, Lord
George Stuart, had been killed in the battle. Lord John was fatally wounded during the
battle of Alresford, 29 March 1644. Lord Bernard died at Rowton Heath, 24 Septem-
ber 1645, during the siege of Chester, with the King himself watching the rout of his
cavalry from its walls.

In 1785, nearly a century and a half after Van Dyck's death, Gainsborough saw this
picture in the collection of the 4th Earl of Darnley, and admired it so greatly that he
painted a full-scale copy (St Louis Art Museum) and a particularly sensitive study
of Lord Bernard's head and shoulders (Gainsborough's House, Sudbury). Gains-
borough's lifelong admiration for Van Dyck reputedly inspired his last words: 'We are
all going to heaven, and Van Dyck is of the company.' JE

FIG 1
Anthony van Dyck, study for *Lord Bernard Stuart*, *c.* 1638
black chalk on green-grey paper, 43.2 × 28.7 cm
Department of Prints and Drawings, British Museum, London (Vey 231)

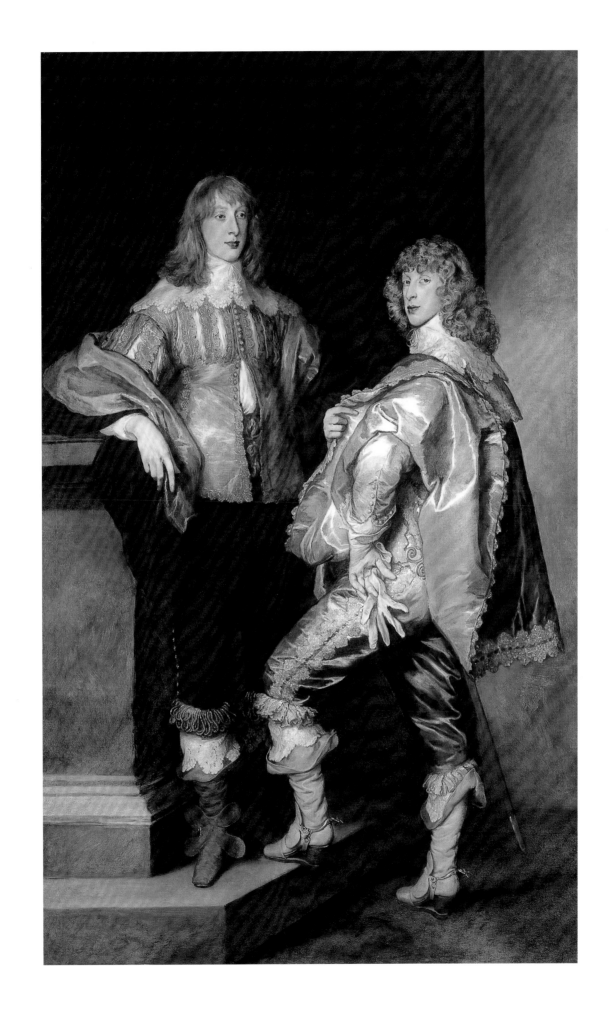

98 *Lady Anne Carr, Countess of Bedford*
c. 1638

oil on canvas, 136.2 × 109.9 cm

Lord Egremont

PROVENANCE Presumed to have been commissioned by Algernon Percy, 10th Earl of Northumberland (d. 1668); by descent through Elizabeth, 6th Duchess of Somerset (and heiress of Percy estates including Petworth House), to her grandson, 2nd Earl of Egremont, and thence by descent

REFERENCES Cust 1900, p. 270, no. 28; Collins Baker 1920, p. 20, no. 218; Glück 1931, p. 467; Larsen 1988, no. 768; Wood 1994, pp. 290, 303

EXHIBITIONS British Institution 1820, no. 63; London 1887, no. 140; ibid. 1953–4, no. 442; ibid. 1982–3, no. 41; Washington 1985–6, no. 64

NOTES
1. For other female portraits by Van Dyck at Petworth, see Collins Baker 1920.
2. The quotation from Haydon is from his diary, 15 November 1826, ed. W. B. Pope, *The Diary of Benjamin Robert Haydon*, London 1963, III, p. 167.
3. Chamberlain to Carleton, 6 April 1616. Quotations from John Chamberlain are from ed. N. E. McClure, *The Letters of John Chamberlain*, Philadelphia 1939, I, pp. 458, 619. See Beatrice White, *Cast of Ravens: The Strange Case of Sir Thomas Overbury*, London 1965, *passim*, with bibl. pp. 245–52.

This is the finest of a group of portraits of female relatives and friends commissioned from Van Dyck by the 10th Earl of Northumberland – after the King, the artist's most constant English patron.[1] It was to be greatly admired by artists welcomed at Petworth by the 3rd Earl of Egremont (d. 1837). On his visit in 1826, Benjamin Haydon recorded: 'I dine with the finest Vandyke in the world – the Lady Anne Carr, Countess of Bedford. It is beyond everything'.[2] J. M. W. Turner, a frequent visitor, painted a free version of it in about 1830 (now known as *A Lady in Van Dyck Costume*, Tate Gallery, London). Millar (in London 1982–3) described *Anne Carr* as 'one of Van Dyck's most magical portraits: the subtle sense of movement as the sitter moves imperceptibly forward is enhanced by the momentarily frozen movement in the hands, by the flutter of the scarf … the stirring of the curtain and the trembling of the rose-bush'.

Anne Carr is portrayed at the age of about 23, in a gown almost the colour of ripening black grapes, achieved by indigo glazes over blue and violet underpainting, with grape-like pearl clusters at her ears. A preliminary drawing (fig. 1) had established the pose; none of that sense of 'momentarily frozen movement' was lost in the translation to canvas. Her face is touchingly plump, with a double chin already in evidence; this was not a period that favoured thin women. Dangling a glove, she seems less than wholly confident.

Anne Carr deserved all the sympathetic handling which Van Dyck gave her, though he can have known only by hearsay of the black shadows cast over her childhood. Born on 9 December 1615, she was the daughter of James I's Scottish favourite, Robert Carr, created Earl of Somerset in 1613, and his infamous wife, Frances Howard, younger daughter of the Earl of Suffolk. Together, they were responsible for the murder of the poet Sir Thomas Overbury, Carr's friend, who had advised against the marriage because of Frances Howard's notorious promiscuity. For this she took a dreadful revenge. Overbury was taken to the Tower, and there slowly poisoned by the Countess of Somerset's agents. Somerset was committed to the Tower a month after the birth of his daughter Anne. His Countess was allowed time for lying-in, then she too was sent to the Tower, 'upon [such] short warning that she had scant leysure to shed a few tears over her little daughter at the parting'.[3]

While the Countess's agents were tried for murder, found guilty and hanged, the Earl and Countess were tried, found guilty, sentenced to be hanged but quickly pardoned by James I. Confined to the Tower, they were soon barely on speaking terms; they were released from the Tower in January 1622 to live for years under house arrest in relatives' houses. They moved to Chiswick, where the Countess died (reputedly of venereal disease) in 1632. Anne Carr appears to have been brought up by her maternal aunt, Lettice Knollys, and is said to have known nothing of her parents' past until after her mother's death, fainting from shock when it was disclosed to her.

Thereafter, her life brightened. Lord William Russell, later 5th Earl and then Duke of Bedford (portrayed in cat. 93), fell in love with her. Russell's father, the 4th Earl, who had been present at the Countess of Somerset's trial, bitterly opposed the marriage, urging his son to 'choose a wife out of any family than that', but Charles I and Henrietta Maria interceded for the lovers, and the marriage took place on 11 July 1637. JE

FIG 1
Anthony van Dyck, *Lady Anne Carr, Countess of Bedford*, 1635–40
black chalk on light brown paper, 42 × 24.2 cm
Department of Prints and Drawings, British Museum, London (Vey 241)

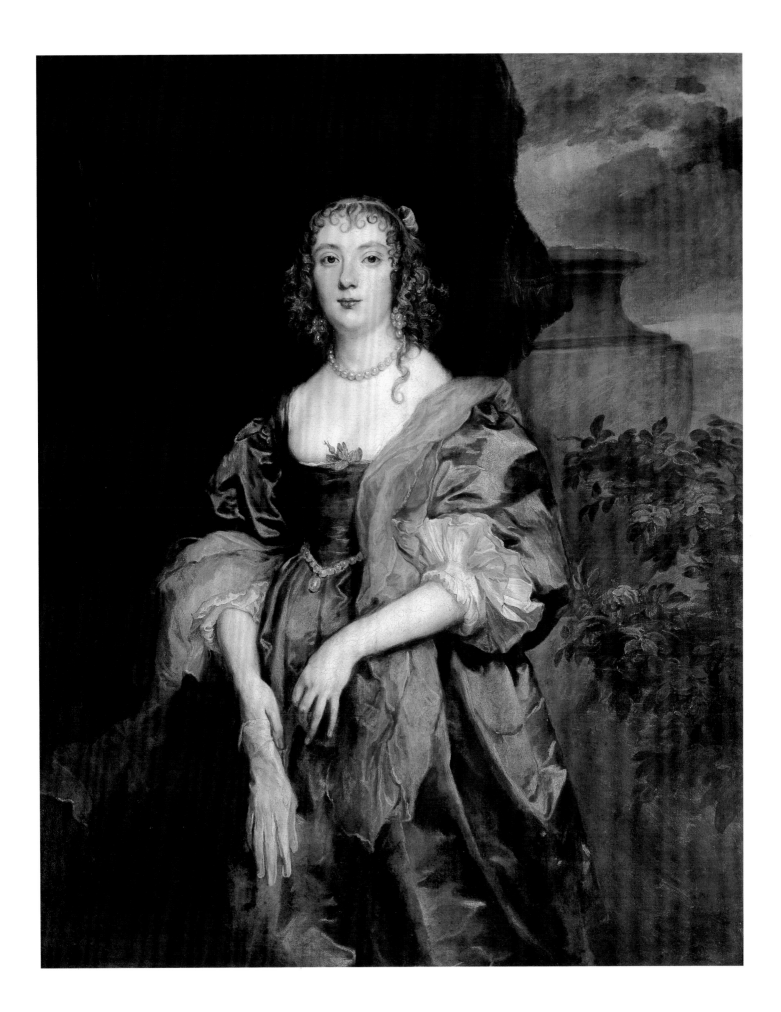

99 *Anne Killigrew with an Unidentified Lady*
c. 1638

oil on canvas, 131.5 × 150.6 cm

The State Hermitage Museum, St Petersburg
(inv. no. 540)

PROVENANCE Unknown until, at some date
between 1763 and 1774, it was acquired by
Empress Catherine II of Russia, from an unknown
source, as 'Portrait of Charles I's Consort,
Henrietta Maria and his Sister, Elizabeth of
Bohemia'; State Hermitage Museum

REFERENCES Cust 1900, p. 137, p. 277, no. 113;
Varshavskaya 1963, pp. 127–9 (correcting the
erroneous statement in earlier Hermitage
catalogues that the portrait entered the collection
with the Walpole Collection); Larsen 1988,
no. 894; Gritsai 1996, p. 128

NOTES
1. For *The Queen's Pastoral* (and the quotation
from the Venetian Ambassador), see Orgel and
Strong, 11, 1973, p. 505ff.
2. *Calendar of State Papers Domestic, Charles I*,
XVIII, p. 48.
3. Glapthorne's verses, in the form of two long
elegies, were appended to his *Whitehall, A poem*,
published in 1643.
4. For Van Dyck's 'friendship portraits', see Zirka
Zaremba Filipczak, 'Reflections on Motifs in Van
Dyck's Portraits', Washington 1990–91, pp. 63–4,
p. 67 n. 38.
5. Comment made by the Countess of Warwick,
quoted in Harbage 1930, p. 22.

FIG 1
Anthony van Dyck, *Elizabeth Villiers,
Lady Dalkeith, and Cecilia Killigrew, c.* 1638
oil on canvas, 127.5 × 147.5 cm
Collection of the Earl of Pembroke,
Wilton House, Salisbury

This entered Catherine the Great's collection as a portrait of Charles I's Queen, Henrietta Maria, with his sister, Elizabeth of Bohemia. By 1900, the lady on the right was securely identified as Anne Kirke through Van Dyck's beautiful full-length of her in yellow satin, *c.* 1638 (Huntington Art Gallery, San Marino). The eldest daughter of Sir Robert Killigrew and his wife Mary Woodhouse, she was born in 1607, five years before her brother, the playwright Thomas Killigrew (cat. 95). She spent most of her life at court (like most of her family), in waiting upon Queen Henrietta Maria, beginning as a Maid of Honour. In 1627 she married George Kirke, Gentleman of the King's Wardrobe, herself becoming a Dresser to the Queen.

The role of a lady-in-waiting was not without privileges; but waiting upon a highly-strung, famously unpunctual and frequently pregnant Queen such as Henrietta Maria involved long hours and uncertain rewards. The court was constantly on the move between the palaces of Whitehall, Oatlands, Nonesuch, Richmond, Greenwich, Hampton Court and Windsor, as well as on progresses; each move involved packing and unpacking exquisite gowns and robes. Masques and plays, those elaborate (and costly) court entertainments, involved much extra work for those in the Wardrobe. Anne Kirke herself played 'Camena' in Walter Montagu's *The Shepherd's Paradise*, a 'courtly pastoral' performed at Somerset House on 9 January 1633 by the Queen and her ladies-in-waiting. The Queen played the principal role of 'Bellesa, alias Saphira, Princess of Navarre'; as the Venetian ambassador noted, 'the Queen likes the King to see her perform in public with the other ladies, each one in her part'.[1]

Anne Kirke's life was cut short by disaster. On 6 July 1641, she was travelling in the Queen's barge when, after shooting London Bridge, it struck a piece of timber and capsized. Anne Kirke was drowned. The Queen, it was reported, 'has taken very heavily the news and, they say, shed tears for her'.[2] Anne Kirke was buried in Westminster Abbey. Henry Glapthorne's elegy on *… the timelesse death of Mrs. Anne Kirk…, drowned unfortunately passing London Bridge, July 6, 1641* includes the lines:

> *See how the Matrons lay their tires aside,*
> *And only in their sorrow take a pride,*
> *Their sorrow which now beautifully weares,*
> *Instead of diamonds, carcanets of teares.*[3]

The identity of the lady on the left remains unknown. In most of Van Dyck's so-called 'friendship portraits'[4] of women, the sitters are either relatives, or of much the same age; examples include *Elizabeth Villiers, Lady Dalkeith, and Cecilia Killigrew* (fig. 1) and *Dorothy Savage, Viscountess Andover, and her Sister Elizabeth, Lady Thimbleby* (fig. 67). Anne Kirke's companion is evidently older than herself. She wears sumptuous court dress and a massively assured necklace of gold-linked semi-precious stones, a fashion favoured by Henrietta Maria. Possibly she is Anne Kirke's mother, Lady Stafford. After Sir Robert Killigrew's death in 1633, she had married Sir Thomas Stafford, one of the Queen's gentlemen-ushers, and was herself in attendance at court; a relative described her as 'a cunning old woman … long versed in amours'.[5] Or she may be a senior lady-in-waiting, such as the (unnamed) 'Mother of the Maids of Honour' who played 'Votorio, the High Priest' in the Queen's pastoral in 1633. Cust (1900) identified her as Lady Dalkeith (later Lady Morton, famous in Stuart history for escaping to France with the infant Princess Henrietta, born while Charles was in captivity); but portraits of her suggest that she is too young, too nubile and too lively to be the quite sharp-featured and surely middle-aged lady portrayed with Anne Kirke. JE

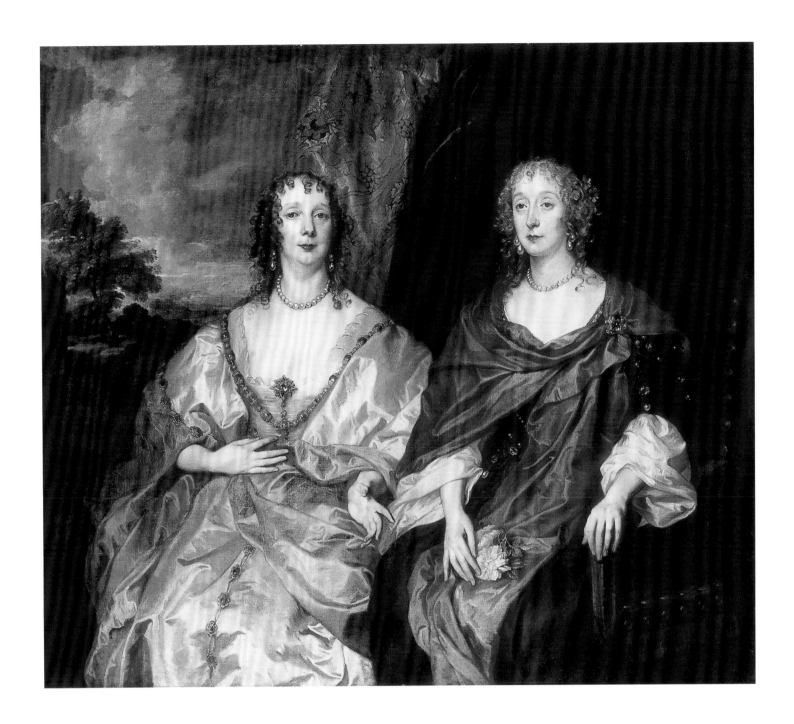

100 *Cupid and Psyche*
1638–40

oil on canvas, 199.4 × 191.8 cm, including small
early additions at upper and lower edge;
in Charles I's inventory, measurements given as
'74 × 77' (188 × 195.6 cm)

Lent by Her Majesty The Queen

PROVENANCE Commissioned by Charles I,
perhaps intended for Greenwich Palace; valued at
£110 by the Commonwealth Trustees for the sale
of 'the King's goods'; 8 October 1651, sold to
Robert Houghton, 'Gentleman and Brewer to the
late King'; 1654, considered as a possible purchase
by Cardinal Mazarin, but rejected as too
expensive; later in the possession of Peter Lely;
18 May 1660, following the Restoration of
Charles II, duly declared by Lely to a House
of Lords Committee; 3 August 1661, returned
to the Royal Collection

REFERENCES Waagen 1854, II, p. 360; Cust
1900, pp. 112–13, 251, no. 87; Glück 1931, p. 362;
Collins Baker 1929, p. 40; Oppé 1941, pp. 186–91;
Millar 1963a, pp. 166–7, no. 166; Brown 1982,
pp. 186–8; Larsen 1988, no. 143

EXHIBITIONS Manchester 1857, no. 599;
London 1946–7, no. 293; London 1953–4, no. 282;
Manchester 1957, no. 136; London 1968, no. 15;
ibid. 1972–3, no. 109; ibid. 1982–3, no. 58;
Washington 1990–91, no. 85; London 1991, no. 31;
ibid. 1998, no. 31

The scene is from the legend of Cupid and Psyche, as related by Apuleius in the 2nd century AD. Psyche's beauty inspired the jealous Venus to punish her with a series of seemingly impossible tasks. Ordered to assist in punishing Psyche, Cupid instead fell in love with her.

Psyche's final task was to fetch from the underworld a casket holding the secrets of Proserpine's beauty. We see the casket beside her; but disobeying Venus' orders, Psyche has opened it. Instantly, she falls insensate under Venus' spell. Oppé notes that the attitude in which Van Dyck depicts her is entirely faithful to his source, for Apuleius wrote that she lay there *'nihil aliud quam dormiens cadaver'* ('like nothing so much as a sleeping corpse'). Two trees behind Psyche – one in full leaf, one blighted – echo her precarious state, midway between sleep and death. Van Dyck would have known Titian's reclining nudes, but there is nothing of their confident beauty here; instead, there is much pathos in Psyche's utter vulnerability.

In the nick of time, Cupid touches down: that is the nearest one can get to the weightless manner in which he alights upon the earth, his wings still fluttering, his exquisite draperies still buoyant. Van Dyck's Cupid is the pictorial embodiment of Plato's definition of ideal love: 'Love is Desire aroused by Beauty'. But his Cupid also has work to do. He must rescue Psyche from the spell, and does so by pricking her with one of his darts. In the sequel, Cupid carries Psyche to Olympus and there, with Jupiter's sanction, marries her. Love triumphs, and Psyche becomes immortal.

Renaissance writers developed the legend of Cupid and Psyche into an allegory of the search of the soul (Psyche) for union with Desire (Eros), enduring suffering before finding fulfilment. The story would have been well known in the neo-Platonic culture of Charles I's court. In 1637, some two years before Van Dyck's painting, Shackerley Marmion's *Cupid and Psyche, An Epic Poem* was presented at court during the visit of the King's nephew, Prince Charles Louis, the Elector Palatine. This was a recital, not a masque; yet something of the stagecraft of Caroline masques seems to haunt Van Dyck's scene, as if his roseate sky might at a cue reveal a cloud-machine to waft Cupid and Psyche to Olympus. But chiefly, Van Dyck represents his scene directly and tenderly, as a private trial of love in a wood. The scene has a lyricism quite unlike the near-operatic drama of *Rinaldo and Armida* (fig. 59), painted some ten years earlier. Instead of contributing to the growing respect for morally elevating history painting, *Cupid and Psyche* recalls rather the tender pagan mythologies of Dosso Dossi, a century earlier (fig. 2). Less wantonly erotic than Titian's Bacchus (fig. 1), though similarly impelled by desire, Van Dyck's Cupid is depicted with all the delicate sweetness proper to the fantasies of the Caroline court. Bellori records that Van Dyck painted various mythological subjects for Charles I, including the Muses dancing on Parnassus, and 'Cupids dancing … while Venus and Adonis sleep', but this is the only such painting known to survive.

The King desired that a series of paintings from the story of Cupid and Psyche should decorate the Queen's House at Greenwich. By now short of funds, he could not afford to employ Van Dyck on this project, and instead (after negotiations involving Rubens, Balthasar Gerbier and the Abbé Scaglia) the commission was given to the Flemish painter Jacob Jordaens. Charles had stipulated that the faces of the women were to be as beautiful as possible and 'yᵉ figures gracious and svelta'. Eight paintings duly arrived, but were not installed (they are now untraced, though Jordaens later painted versions for his own house). Probably Jordaens's rumbustious manner displeased both Charles and Henrietta Maria. Van Dyck's *Cupid and Psyche* depicts

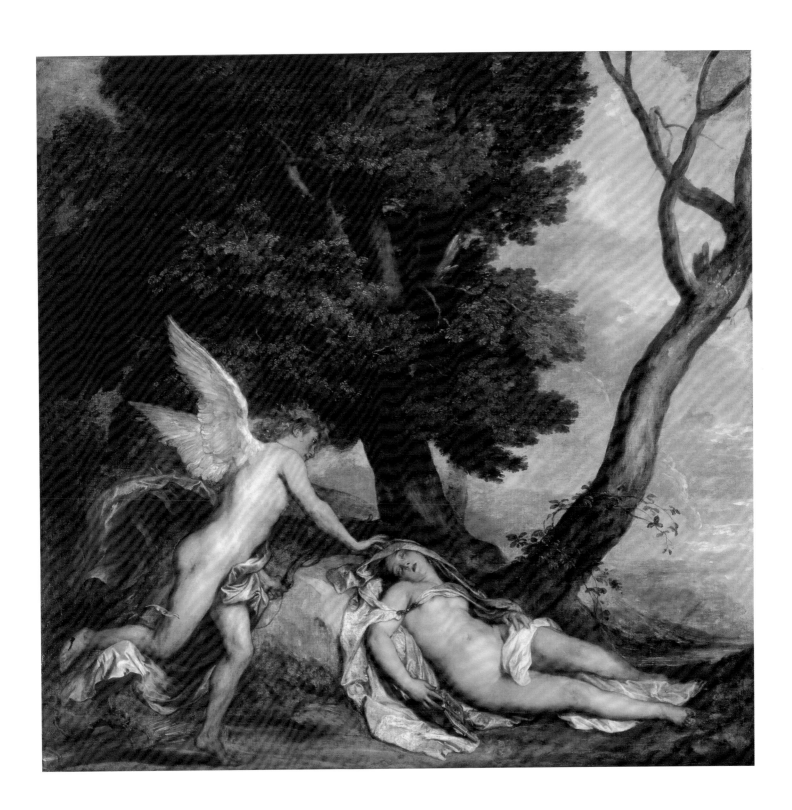

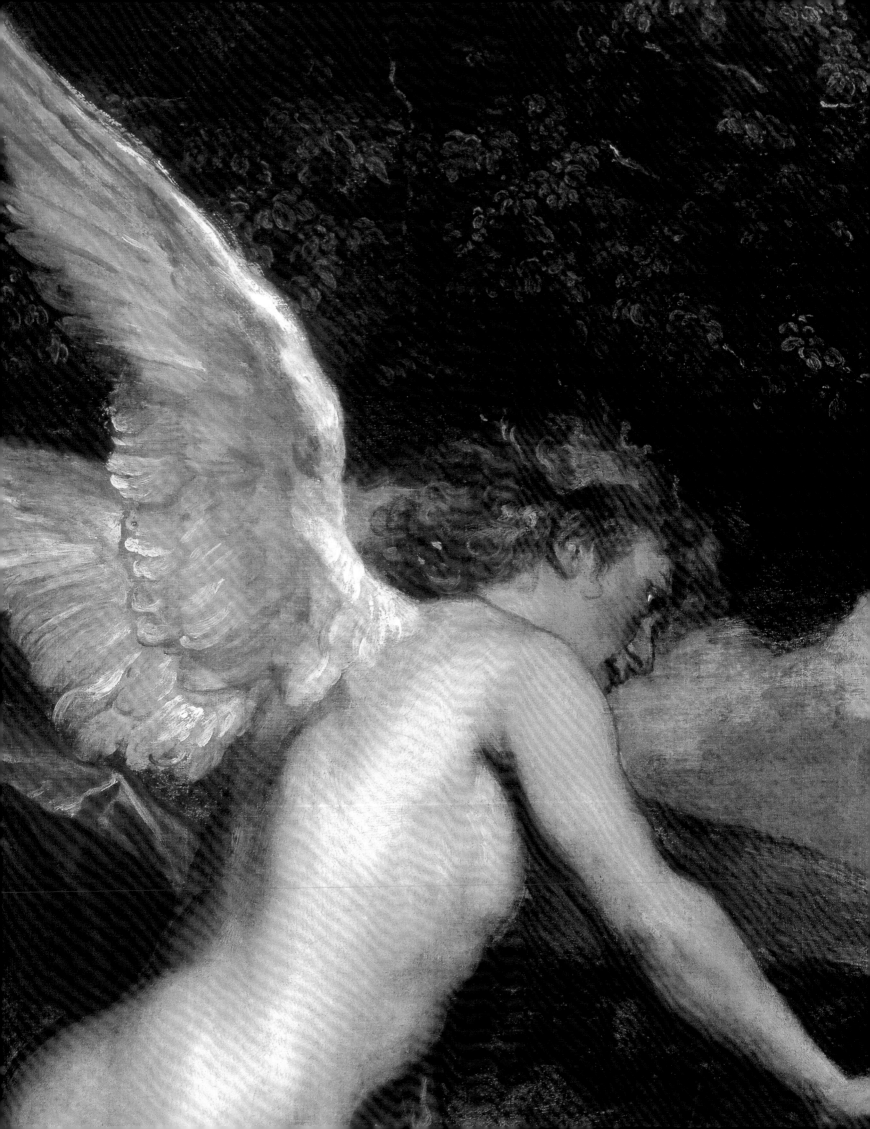

one of the scenes commissioned from Jordaens, on a canvas of about the same proportions; perhaps requested as a substitute, it may be the picture listed in Van Dyck's bill to the King in 1638 as *'Une pièce pour la Maison a Grunwitz* [Greenwich]', but never hung. An entry for it was inserted in Van der Doort's draft catalogue of the King's collection, as in the Long Gallery in Whitehall Palace, apparently unframed. JE

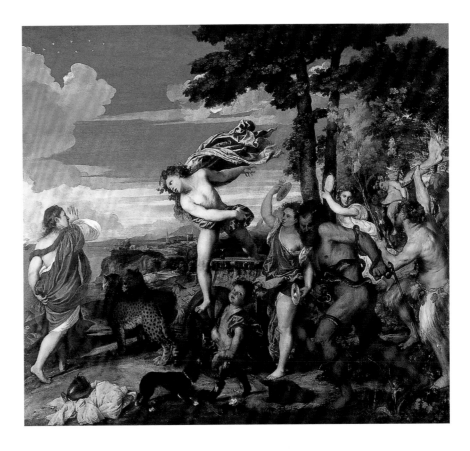

FIG 1
Titian, *Bacchus and Ariadne*, 1520–23
oil on canvas, 175 × 190 cm
National Gallery, London

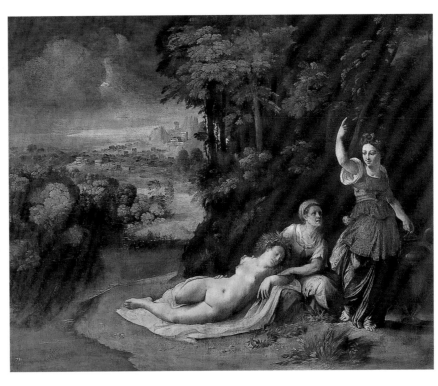

FIG 2
Dosso Dossi, *Callisto*, 1529–30
oil on canvas, 134 × 163.5 cm
Galleria Borghese, Rome

Arthur Goodwin

1639

oil on canvas, 218.4 × 130.8 cm
lettered by a later hand, bottom right: *p. S^r Ant:
Vandike. Arthur Goodwin father of Jane/his sole
daughter and heyre/2^d wife of Philip now L^d
Wharton/1639 about y^e age of 40*

The Duke of Devonshire and Chatsworth House
Trust (inv. no. 169)

PROVENANCE Commissioned by the sitter's
father-in-law, Philip Wharton, 4th Baron Wharton
(d. 1696); by descent to his grandson Philip, 6th
Baron Wharton (created 1st Duke of Wharton
1718), by whom sold c. 1725 to Sir Robert
Walpole, Houghton Hall; before 1736, given by Sir
Robert Walpole to William Cavendish, 3rd Duke
of Devonshire; thence by descent

REFERENCES Cust 1900, pp. 123, 274, no. 83;
Brown 1982, pp. 202–3; Larsen 1988, no. 849;
Millar 1994, pp. 523, 526, checklist, no. 12

EXHIBITIONS London 1956–7, no. 72; ibid.
1972–3, no. 94; ibid. 1982–3, p. 95, no. 55 (entry
by O. Millar)

FIG I
Anthony van Dyck, *Mrs Arthur Goodwin*, 1639
oil on canvas, 132.5 × 106 cm
The State Hermitage Museum, St Petersburg

Arthur Goodwin (?1593–1643), a man of considerable property, was the only surviving
son of Sir Francis Goodwin of Upper Winchendon, knight of the shire for Bucking-
hamshire, and his wife Elizabeth, daughter of Earl Grey de Wilton. He is chiefly
remembered now for his long friendship with John Hampden (1594–1643), the most
effective and respected leader of the Parliamentary opposition to the King.

Goodwin's friendship with Hampden, his almost exact contemporary, began when
they were boys at Thame Grammar School. It ripened as they studied (and versified)
together at Magdalen College, Oxford, and in the Inner Temple, and was strengthened
by Goodwin's support for Hampden in Parliament. Goodwin was Member of
Parliament for Chipping Wycombe in the Parliaments of 1620–21 and 1623–4, and
for Aylesbury in 1625–6; in 1640, with Hampden, he represented the county of
Buckinghamshire. Their friendship endured through active service in the Parliamentary
army in the Civil War, ending only when Hampden, mortally wounded in a skirmish
at Chalgrove Field after the first battle of Newbury (20 September 1643), was
carried off the battlefield by Goodwin. Writing a few days later to his daughter Jane,
Goodwin lamented the death of his friend: 'a gallant man, an honest man, an able
man, and take all, I know nott to any man liveinge second...'. Goodwin himself died
a few months later.

Van Dyck's characterisation of Goodwin conveys the idea of an utterly dependable
man – 'gallant, honest and able', to borrow the adjectives Goodwin was to use of
Hampden – who is himself indifferent to the limelight. Goodwin was aged about 45
when he sat to Van Dyck. There is little element of swagger in this portrait, and the
colouring, particularly of the amber-coloured doublet and cape, is restrained in range
throughout.

This is one of a series of family portraits commissioned from Van Dyck in 1637–9
by Philip Wharton, 4th Baron Wharton, who married in 1637 Jane Goodwin, Arthur
Goodwin's only child and heir; she brought him the manors of Winchendon and
Wooburn in Buckinghamshire. As a young man, Wharton had himself sat to Van
Dyck, for one of the earliest and most romantic of Van Dyck's English portraits
(fig. 65). At Winchendon he created a long gallery, reputedly 120 feet long, to be hung
with royal portraits, family portraits and some portraits of contemporaries; for it he
commissioned numerous pictures from Van Dyck ('twelve whole lengths and six half
lengths', according to Vertue) and, after Van Dyck's death, from Lely (see Millar
1994). From the uneven quality of the portraits commissioned from Van Dyck, Millar
observes that the patron evidently did not insist that all the portraits should be wholly
by Van Dyck's hand.

Van Dyck's portrait of *Mrs Arthur Goodwin* (fig. 1), also commissioned by Lord
Wharton, is a three-quarter length, and thus not designed as a pendant to her
husband's portrait; nor is it of the same quality as his. Stout and middle-aged, she
holds a single tulip, not so much symbolically but as if she had grown it herself (which,
given the current fashion for tulip-growing, she may well have done). Van Dyck's
portrait of Goodwin's daughter, Jane, Lady Wharton, gathering roses, is a full length,
like her father's (Pennington-Miller-Munthe Trust). JE

Arthur Goodwin father of Jane
his sole daughter and heyre
2 wife Philip now L: Wharton
1639 about y age of 40,

P. S. Ant: Vandike

Thomas Wentworth, Earl of Strafford, with Sir Philip Mainwaring, 1639–40

oil on canvas, 123.2 × 139.7 cm

Lent by the Trustees of the Rt. Hon. Olive, Countess Fitzwilliam's Chattels Settlement, by permission of Lady Juliet Tadgell

PROVENANCE Commissioned by the sitter, Thomas Wentworth, created Baron Wentworth of Wentworth Woodhouse, July 1628, Viscount Wentworth, December 1628, Baron of Raby and Earl of Strafford, 1640 (beheaded 1641); his son, 2nd Earl of Strafford (the forfeiture of his father's honours in 1641 being reversed in 1662 after the Restoration), d.s.p. 1695; the latter's nephew and heir Hon. Thomas Watson-Wentworth (third son of the 2nd Earl of Strafford's eldest sister, Lady Anne Wentworth); his son Thomas, 6th Baron Rockingham, created, in 1746, 1st Marquess of Rockingham (d. 1750); his son Charles, 2nd Marquess of Rockingham (d.s.p. 1782); his nephew and heir, William Wentworth-Fitzwilliam, 4th Earl Fitzwilliam; then by descent to the 10th Earl Fitzwilliam

REFERENCES MS Inventory of works at Wentworth Woodhouse in the collection of the late 2nd Marquess of Rockingham, 1782 (Wentworth Woodhouse Muniments, Sheffield Archives, A/1204, p. 16v); Walpole, ed. 1888, I, p. 327; Cust 1900, p. 130, p. 284, no. 201; Glück 1931, p. 483; Michael Jaffé, 'The Picture of the Secretary of Titian', *The Burlington Magazine*, CVIII, 1966, pp. 114–26; Brown 1982, p. 207; Millar 1986, pp. 120–21

EXHIBITIONS British Institution 1815; London 1900, no. 82; ibid. 1982–3, no. 57; Washington 1990–91, no. 86

NOTES
1. Jaffé, op. cit.
2. Walpole 1762–71, ed. 1888, II, p. 210.

At the King's request, Strafford returned from service as Lord Deputy of Ireland in September 1639. This double portrait was presumably painted between that date and 12 September 1640, when he was awarded the Order of the Garter (whose ribbon and badge he is evidently not yet entitled to wear here). As Van Dyck portrays him, Strafford is gravely yet unflinchingly aware of the weight of his responsibility as principal but unofficial adviser to the King in his attempt to continue personal rule. His demeanour is that of a great man, more concerned with momentous matters than Charles himself is ever shown to be; that clutch of the hand upon the arm of his chair recalls the portraiture of many a pope. Beside him, ready to transmit urgent orders, sits Sir Philip Mainwaring MP (*c.* 1589–1661): often described merely as 'his secretary', he was in fact Strafford's Secretary of State for Ireland (knighted 1634). Strafford was able to maintain his role for less than two years. His attainder, his trial and his execution in May 1641 are noted under cat. 68.

Michael Jaffé in 1966 showed that Van Dyck borrowed the poses of Strafford and Mainwaring from a double portrait by Titian (fig. 1).[1] That picture, acquired by the Duke of Buckingham (assassinated in 1628), was once thought to have been in Van Dyck's own collection, but it remained in Buckingham's young son's possession at York House in London, where Van Dyck was able to study it, and passed into the collection of the 10th Duke of Northumberland during the Civil War. Jaffé traced the poses in the Titian (painted *c.* 1540) back to Sebastiano del Piombo's portrait of *Cardinal Carondelet and Two Companions*, painted some 30 years earlier and then in the collection of the Earl of Arundel (now Museo Thyssen-Bornemisza, Madrid).

Van Dyck's interpretation of Titian's double portrait in turn inspired a tradition of English portraiture of great men with their secretaries which includes John Shackleton's Henry Pelham, as 1st Lord of the Treasury, with John Roberts, and Sir Joshua Reynolds's more inspired unfinished portrait of Strafford's descendant, *The 2nd Marquess of Rockingham, with his Parliamentary Secretary Edmund Burke* (Fitzwilliam Museum, Cambridge). The 2nd Marquess (twice Prime Minister) for many years hung Van Dyck's double portrait of Strafford and Mainwaring in the antechamber to his bedroom, among works of special importance to him, but later felt obliged to hang it more publicly in the dining room, where Horace Walpole saw it – and never forgot it. Discussing paintings by Van Dyck in various English collections, Walpole 'reserved to the last, the mention of the finest picture, in my opinion, of this master. It is of the Earl of Strafford and his secretary, at the Marquis of Rockingham's … I can forgive him [Van Dyck] any insipid portraits of perhaps insipid people, when he showed himself capable of conceiving and transmitting the idea of the greatest man of the age'.[2] JE

FIG 1
Titian, *Georges d'Armagnac, Bishop of Rodi, with Guillaume Philandrier*, 1540
oil on canvas, 104 × 224.3 cm
The Duke of Northumberland, Alnwick Castle

Philadelphia and Elizabeth Wharton
1640

oil on canvas, 162 × 130 cm
inscribed (not by Van Dyck), bottom right:
P: Sʳ Ant·Vandike; bottom left: *Philadelphia
Wharton and Elizabeth / Wharton yᵉ onely daughters
of Philip / now Lord Wharton by Elizabeth his / first
wife, / 1640 about yᵉ age of 4 & 5*

The State Hermitage Museum, St Petersburg
(inv. no. 533)

PROVENANCE Commissioned by Philip
Wharton, 4th Baron Wharton (d. 1696); by
descent to his grandson Philip, 6th Baron Wharton
(created 1st Duke of Wharton 1718), by whom
sold in or about 1725, with other family portraits,
to Sir Robert Walpole (later 1st Earl Orford), of
Houghton Hall (d. 1745); by descent (through his
son Robert, 2nd Earl of Orford, d. 1751), to his
grandson George, 3rd Earl of Orford; 1779, sold
by him, among many paintings from Houghton
Hall, to the Empress Catherine the Great of
Russia; State Hermitage Museum

REFERENCES Cust 1900, pp. 123–4, 272, no. 48
(as 'Philadelphia and Elizabeth Cary'); Glück
1931, pl. 486; Varshavskaya 1963, pp. 1, 24–5,
no. 19; Larsen 1988, no. 1032; Millar 1994, p. 527,
checklist, no. 14; Gritsai 1996, p. 137

EXHIBITIONS London 1982–3, no. 56; New
Haven et al. 1996–7

NOTE
1. See George Lipscomb, *History and Antiquities of
the County of Buckingham*, London 1831, 1, p. 544;
*Lives of Lady Anne Clifford, Countess of Dorset,
Pembroke and Montgomery (1590–1676) and of her
Parents, summarized by herself,* (Roxburghe Club)
1916, p. 64.

The lettering records, clearly and unambiguously, that the sitters are Elizabeth and Philadelphia Wharton, only daughters of Philip, Lord Wharton, by his first wife Elizabeth, portrayed in 1640 aged about four and five. Elizabeth is the five year-old, in white; Philadelphia the four year-old, in blue. The picture was one of many family portraits commissioned by the 4th Lord Wharton for his portrait gallery at Winchendon, including *Arthur Goodwin* (cat. 101); for Van Dyck's earlier (and exquisite) portrait of Wharton himself, see fig. 65. The lettering conforms in style to that of other identifying inscriptions in Wharton's gallery, and was evidently added during his lifetime ('Philip *now* Lord Wharton') and according to his instructions.

Lettering on portraits cannot always be trusted ('bought' pictures in particular often carrying claims to bogus ancestry); but doubts which have long clouded the identity of these two children seem unreasonable. In 1900, Cust (who may never have seen the identifying inscription) heard that the sitters were said to be the 4th Lord Wharton's sisters. He consulted Burke's *Peerage*, finding that Wharton had no sisters of the right age. He further found (in that not infallible source) that only one daughter by Wharton's first marriage (to Elizabeth Wandresford) was recorded – Elizabeth, born about 1635. Philadelphia, born about 1636, seemingly did not exist. Cust concluded that these children must be Lord Wharton's first cousins, Philadelphia and Elizabeth Cary (although they, born according to Cust in 1631 and 1632, would surely have been too old to be Van Dyck's sitters in 1640). The double portrait thereafter became known as *Elizabeth and Philadelphia Cary*, with or without a question mark – except by Millar (1994), who wisely retains the inscribed title.

Which should we rely on, the lettering added to the picture within the lifetime of the children's father (and later followed in Pieter van Gunst's engraving), or modern historians' mistrust of it because of their own failure to find supporting evidence of the younger child's existence? A child named Philadelphia is unlikely to be a figment of the imagination. In fact that was the name of the 4th Lord Wharton's mother, Philadelphia Cary, and was passed on to later generations. It was to be given again in 1655 to one of the 4th Lord Wharton's daughters by his second marriage. The probability (as Brian Allen suggests in New Haven et al. 1996–7) is that the Philadelphia who sat to Van Dyck in 1640 had meanwhile died. Neither her baptism nor her burial has so far been traced. She is not recorded in Lipscomb's notes on the Whartons in *History ... of the County of Buckingham* (1831: perhaps Burke's source);[1] but Lord Wharton acquired his Buckinghamshire estates only upon his second marriage. Philadelphia may have been born in London, where her father was attached to the court, or in Westmorland, where he still maintained Wharton Hall, and where her mother died *c.* 1635.

Philadelphia, aged four, in her shimmering blue dress, meanwhile seems to live only through this portrait and its inscription. Only one other hint that she existed has so far been found. In August 1653 Lady Anne Clifford recorded that she was expecting a visit from her cousin, Philip, Lord Wharton, *en route* to Wharton Hall in Westmorland, with his second wife 'and his eldest daughter by his first wife'. An 'eldest daughter' presupposes at least one younger one, though Philadelphia may have died by 1653. Elizabeth, the 'eldest daughter', married (as his second wife) Robert Bertie, 3rd Earl of Lindsey, and is thus securely recorded. She died on or about 1 July 1669.

The delicately painted heads are undoubtedly by Van Dyck. The hands are less sensitively drawn; the background, with its lumpish curtain and perfunctory tree, is harsh and unimaginative. The uneven quality of the work indicates studio assistance. JE

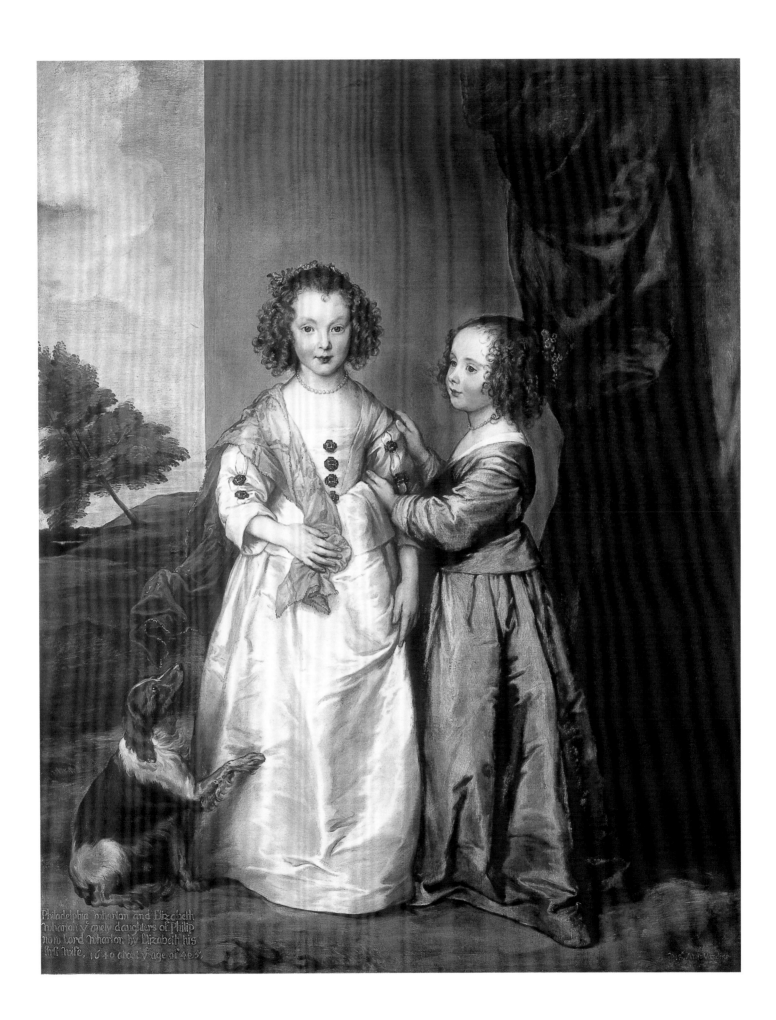

Philadelphia Wharton and Elizabeth
Wharton ye onely daughters of Philip
now Lord Wharton by Elizabeth his
first wife, 1640 about ye age of 4 & 3.

A. VAN DYCK

104 Rachel de Ruvigny, Countess of Southampton, as Fortune c. 1640

oil on canvas, sight size 223.2 × 131.8 cm
inscribed lower right (in a later hand): *Rachel·
1ˢᵗ Countess of/Southampton*

National Gallery of Victoria, Melbourne,
The Felton Bequest, 1937

PROVENANCE Probably commissioned by the
sitter's husband, Thomas Wriothesley, 4th Earl of
Southampton (1606–67); inherited by his third
wife and widow Frances (d. 1681) (née Frances
Seymour, formerly wife of 2nd Viscount
Molyneux), who married thirdly Conyers Darcy,
Lord Darcy and Baron Conyers, later Earl of
Holdernesse; sold by Lord Darcy in 1683 to
Anthony Grey, 11th Earl of Kent (d. 1702), who
married (1663) Mary Lucas, created Baroness
Lucas of Crudwell, with remainder of that dignity
to her issue male by that husband, or failing that
by special remainder to issue female by descent to
their son, Henry Grey, Earl of Kent, Baron Lucas
of Crudwell and 1st Duke of Kent, who died
without male heirs in 1740; his granddaughter,
Lady Jemima Campbell, later Baroness Lucas and
Marchioness de Grey, who married (1720) Philip,
Lord Royston, later 2nd Earl of Hardwicke; their
daughter Amabel, Lady Lucas, Countess de Grey;
her nephew, Thomas, Earl de Grey (d. 1859); his
elder daughter Anne Florence, from 1859,
Baroness Lucas of Crudwell in her own right: she
married (1833) 6th Earl Cowper, of Panshanger
(d. 1880); 7th Earl Cowper (d. 1905); his nephew,
Lord Lucas (d. 1916); his sister, Lady Lucas
(d. 1959); 1922, acquired from her by the Gallery
after an extended loan (1909–22) to the National
Gallery, London

REFERENCES *Catalogue of Pictures belonging to
Thomas Philip, Earl de Grey*, 1834, no. 68; Mary
Louisa Boyle, *Biographical Catalogue of the
Portraits at Panshanger, the Seat of Earl Cowper,
K.G.*, London 1885, p. 391, no. 9; Cust 1900,
pp. 125, 174, 282, no. 184; R. W. Goulding,
'Wriothesley Portraits', *Walpole Society*, VIII,
Oxford 1920, pp. 76–7; Jaffé 1984, pp. 603–11;
Larsen 1988, no. 994; Ursula Hoff, *European
Paintings before 1800 in the National Gallery of
Victoria*, Melbourne 1995, pp. 96–8

EXHIBITIONS London 1815, no. 87; ibid. 1852,
no. 62; Manchester 1857, no. 119; London 1873,
no. 111; ibid. 1887, no. 42

Rachel de Ruvigny was born in Paris around 1602, the daughter of Daniel de Massue, Seigneur de Ruvigny; she married first Elysée de Beaujeu, and secondly, in 1633, after several years of virtuous widowhood, Thomas Wriothesley, 4th Earl of Southampton, who is said to have gone to France after heavy losses at Newmarket. When he returned to London with his French wife in November 1634, Lord Conway described her as 'very merry and very discreet, very handsome, and very religious, she was called in France, *La belle & vertueuse Huguenotte*, and to my Lord Southampton's great joy, she is with Child'. Of five children of this marriage, only two daughters survived infancy. Rachel herself died in childbirth in February 1640, aged 37.

The picture combines a portrait of the Countess with her personification as Fortune. There are two principal versions: this picture, and the version inherited by the Countess's daughter, taken with her to Althorp upon her marriage, and now in the Fitzwilliam Museum, Cambridge. Following his usual practice, Van Dyck began with a study of the Countess's head *ad vivam* (finer in the Fitzwilliam version). Neither picture may have been completed before the Countess's death in February 1640. Both were probably painted at much the same time, with studio assistance, as Van Dyck himself died in December 1641. The question of which picture is the prime version has been debated (see Jaffé 1984; Hoff 1995), so far inconclusively. Each has different excellences, and each has suffered similar losses and retouchings over the years, particularly in the blue drapery. Technical examination of the Melbourne picture reveals that glazes of azurite were applied over the darker, indigo blues, and that much of the azurite (which has poor bonding properties) was subsequently lost.

Van Dyck rarely invented allegorical subjects. For his portrait of *Venetia Digby as Prudence* (cat. 70), Kenelm Digby specified imagery to redeem his wife's reputation from slander. No programme is known for Lady Southampton, painted some seven years later. Garbed in heavenly blue, the Countess sits in the clouds with an air of detachment proper to Fortune. Her left arm rests on a globe which mirrors worldly matters; if she chooses to intervene, she can favour or frustrate such matters by wielding the phoenix-headed sceptre. The globe and sceptre are customary attributes of Fortune, well known through Ripa's *Iconologia*. In the Melbourne picture, the sceptre is now missing. Residues of paint suggest that it was scraped off at an early stage, necessitating the repainting of the right hand and forearm. Changes were also made to make Fortune's globe more transparent and ethereal, less clouded by mundane matters. Recent cleaning reveals a dramatic sunburst behind the Countess, its glow reflected in the globe. Both versions include a *memento mori* which has less to do with Fortune than with the fact that Lady Southampton died comparatively young. She is depicted as treading down a human skull, as if triumphing over death. In the Fitzwilliam picture her foot is sandalled; in the Melbourne version, it is concealed by her blue drapery, so that its contact with the skull is concealed. JE

CAT 104, during restoration

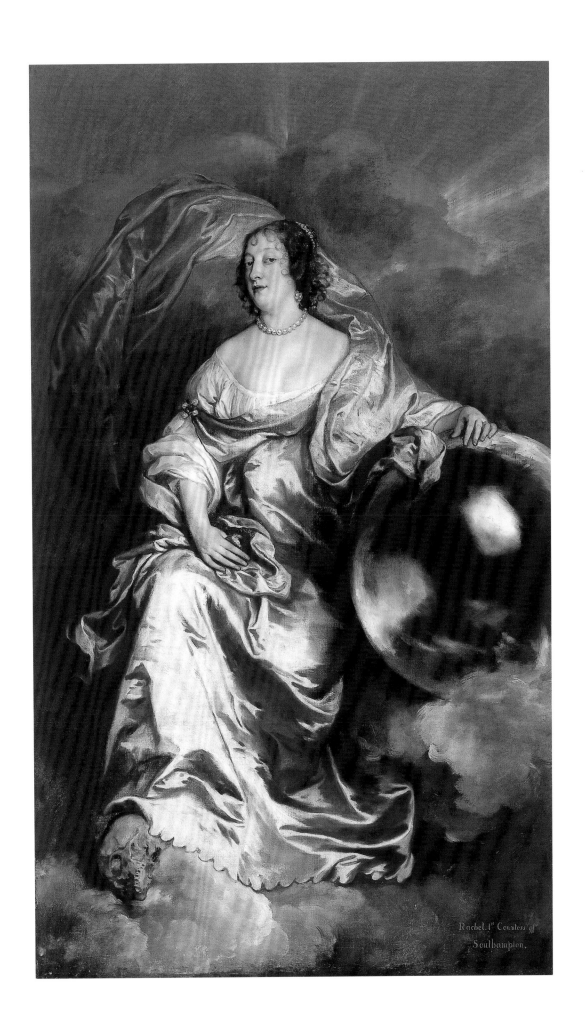

Rachel. 1.st Countess of
Southampton.

105 *William II, Prince of Orange, and his Bride, Mary, Princess Royal of England*

1641

oil on canvas, 182.5 × 142 cm

Rijksmuseum, Amsterdam (inv. no. SK–A–102)

PROVENANCE Commissioned by the bridegroom's parents, Prince Frederik Hendrik of Orange and his wife, Amalia van Solms; 1645, recorded in an inventory as hanging in the Huis ten Bosch, their palace in The Hague; inherited by the Frisian branch of the Nassaus; by 1808, in the Koninklijk Kabinet van Schilderijen in The Hague, and transferred with its collections to the Rijksmuseum

REFERENCES Cust 1900, pp. 144, 145, p. 267, no. 48; *Catalogue of Paintings, Rijksmuseum, 1960* (English edition), no. 857; Brown 1982, p. 215

EXHIBITIONS London 1964, no. 12; ibid. 1982–3, no. 62; *Paintings from England,* Mauritshuis, The Hague 1988, no. 25

Before our eyes, a dynastic marriage is enacted. The bridegroom is the fifteen year-old William, Prince of Orange (grandson of 'William the Silent'), who was to succeed as William II, Stadtholder of the principality of Orange in the Northern Netherlands. The bride, not yet ten years old, was born on 3 November 1631, the eldest daughter of Charles I and Henrietta Maria. The marriage, arranged after two years of negotiation, was finally solemnised in the Chapel Royal at Whitehall on 12 May 1641. This marriage portrait was commissioned by the young bridegroom's parents, Prince Frederik Hendrik of Orange and his wife, Amalia van Solms, already patrons of Van Dyck. He had portrayed them several times, and they owned many paintings other than portraits by him; but the commission for this double portrait was chiefly a political bid to advertise the prestige of the House of Orange through matrimonial union with the royal family of England.

The conjoined hands state the chief message of this picture. The child bride wears a wedding ring. She, dressed in cloth of silver-gold, also wears the large diamond brooch which her young husband presented to her the day after their marriage. The Prince of Orange wears a pale crimson costume made for him in London by David Juwery (paid for, with a speed rarely experienced by suppliers to any royal house, four days after the marriage). He had arrived in London in April 1641 and departed on 3 June, leaving the Princess Mary to travel to The Hague with her mother, the following February.

Nine years earlier, Princess Mary had been portrayed by Van Dyck as a baby in her mother's arms, with her two year-old brother Charles (later Charles II) standing beside the King; this very large picture, known as the 'Greate Peece', dominated the Long Gallery in the Palace of Whitehall (fig. 15). Van Dyck portrayed her at the age of about four, with the future Charles II and the infant James, Duke of York, in *The Three Eldest Children of Charles I* (1635; cat. 87), and again with more siblings in *The Five Eldest Children of Charles I,* painted in 1637; in this she is depicted as a miniature court beauty, in pearls and white satin, though still in leading-strings (fig. 63).

The House of Orange pressed for further portraits of their new Princess in her wedding dress, but soon after Prince William's return to Holland in May, Van Dyck became ill. He now had to drive himself to complete commissions. He made a brief visit to Antwerp in October, going on to Paris to discuss a commission to portray Cardinal Richelieu. He returned to London gravely ill, and died on 9 December 1641.

This is among the last of Van Dyck's works. Suggestions that this picture may be (at least in part) a product of Van Dyck's studio are discussed (but not concurred with) by Millar (1982), who concludes that it is 'a fine example of the painter's manner in the last months of his life: extremely competent, if rather cold and hard and lacking the precision and delicacy of his best English portraits'.

William II of Orange died at the age of 24 in 1650, at the gates of Amsterdam, in a momentous failure to force that independent city to surrender. Princess Mary died in 1660, aged 29, in the year of the restoration of her brother Charles II to the English throne. William III, the son born to this young couple in 1650, was to succeed – with his consort, another Mary – to the throne of England in 1688. JE

CAT 105, before restoration

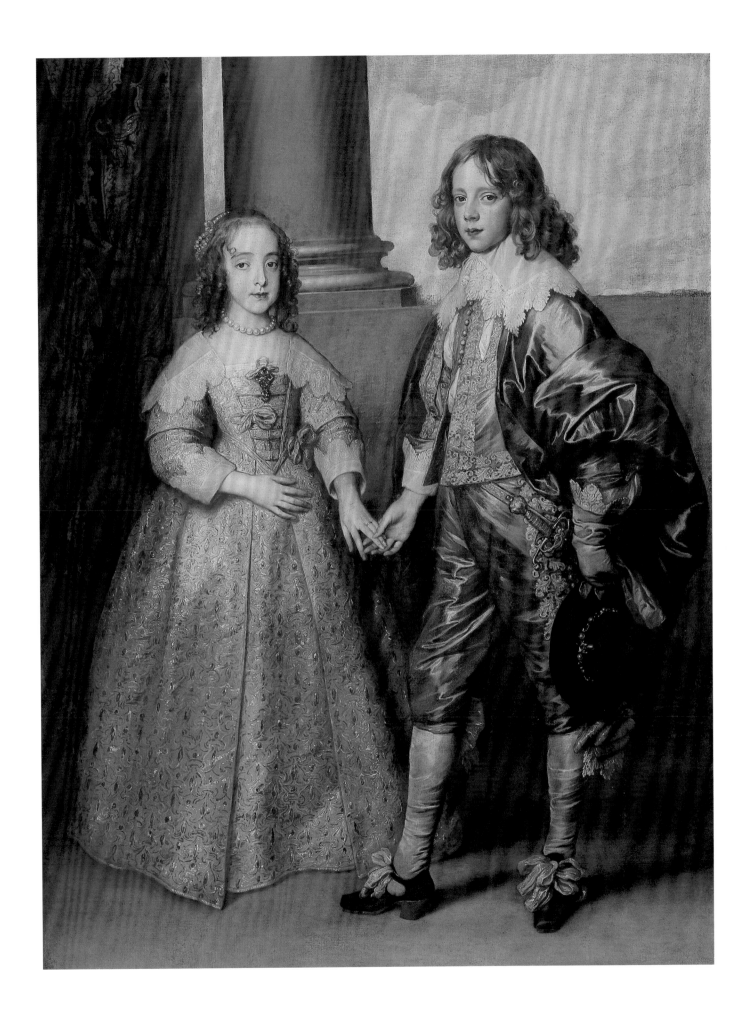

Chronology

Political and Artistic Events and the Life of Sir Anthony van Dyck

HANS VLIEGHE, KATLIJNE VAN DER STIGHELEN AND KATHARINE GIBSON

1528

Andrea Doria draws up the Constitution of Genoa. The aristocratic republic he founds remains independent until the end of the 18th century.

1534

Act of Supremacy declares Henry VIII supreme head of the Church of England, independent of the Church in Rome.

1548

An Order for the removal of images from churches and other religious buildings results in violent iconoclasm in England.

1553

Accession of Mary Tudor who determines to reintroduce Catholicism.

1554

Mary Tudor marries Philip, son of Charles V, King of Spain, Duke of Burgundy and Holy Roman Emperor. Charles V relinquishes control of the Netherlands and the Kingdom of Naples to Philip.

1555

Charles V's brother, Ferdinand I, is elected Holy Roman Emperor and rules from Prague.

1556

Philip II succeeds to the Spanish throne. His power extends over Spain, Burgundy and the Netherlands, much of Italy (including Naples and Sicily, Milan, Genoa and Savoy), with colonies in North and South America, the East Indies and Africa.

1558

Death of Charles V.

Emanuele Filiberto I, Duke of Savoy, created Governor of the Netherlands.

Death of Mary Tudor and accession of Elizabeth I who reigns as a Protestant.

1559

Emanuele Filiberto of Savoy marries Marguerite de Valois, daughter of Henri II of France and Catherine de' Medici. He makes Turin his chief residence.

1563

30 September: Anthony van Dyck the Elder, Van Dyck's grandfather, 'who also has been a painter', testifies for Jan van Cleve in Antwerp.

December: The last session of the Council of Trent lays down guidelines for the representation of religious subjects in art.

1566

Rioters attack churches and religious houses in Antwerp, Ghent and Amsterdam and elsewhere in the Netherlands.

1567

Philip II appoints the Duke of Alva as Regent of the Netherlands with an army of 20,000 Spaniards. The Inquisition introduced and heavy taxation imposed. The Revolt of the Netherlands (the Eighty Years' War) begins. Antwerp suffers further riots and iconoclasm.

1568

4 September: Anthony van Dyck the Elder, a merchant 'dealing in silk and fancy goods', pleads lack of space in order to be relieved of his duty to lodge soldiers.

1573

Birth of Inigo Jones, son of a Catholic clothworker, in London.

1576

Pacification of Ghent: all the provinces of the Netherlands unite against the Spanish.

November: Mutinous Spanish mercenaries sack Antwerp ('the Spanish Fury'), burning a third of the city and killing thousands.

Death of Titian in Venice.

1577

Birth of Peter Paul Rubens in Siegen, Westphalia.

1578

Emanuele Filiberto transfers the Holy Shroud from Chambéry to Turin.

1579

30 December: Anthony the Elder buys the house 'Den Berendans', close to the 'new City Hall' in Antwerp.

Union of Utrecht formed by the northern provinces of Holland, Zeeland and Utrecht (the United Provinces) to resist the Spanish.

1580

3 March: Death of Anthony the Elder. His widow, Cornelia Pruystinck, continues their business.

Carlo Emanuele I succeeds to the Dukedom of Savoy. Subsequently he marries the daughter of Philip II of Spain, Catalina Micaela. His fifty years as Duke saw an ever-changing pattern of conflicts throughout the strategic areas of the southern Alps. He left the state of Savoy in ruin.

Death of Andrea Palladio in Venice.

1581–3

William the Silent declares the sovereignty of the United Provinces of the Netherlands, and renounces the authority of the Spanish King. Antwerp is governed by William, and a Calvinist city council removes Antwerp's few surviving works of art.

1582–3

Baptism of Frans Hals in Antwerp.

1584

William the Silent assassinated in Delft. Maurits of Nassau, his son, succeeds as Stadtholder.

1585

17 August: After a fourteen-month siege, Antwerp recaptured by the Spanish Governor, Alessandro Farnese, Duke of Parma. Subsequently some 35,000 Protestants leave the Southern Netherlands. The United Provinces blockade the river Scheldt, and Antwerp enters a period of economic decline.

1587

4 October: Franchois van Dyck, son of Anthony the Elder, marries Maria Comperis in Antwerp.

1588

27 January: Cornelia van Dyck-Pruystinck signs a business agreement with Franchois and her son-in-law Sebastiaen de Smidt. The widow pays in 6000 guilders, while the other partners contribute 4800 guilders.

31 July–8 August: The English navy defeats the Spanish Armada.

1589

25 July: Death of Maria Comperis.

1590

6 February: Franchois marries Maria Cuypers.

18 October: Baptism of Anthony's sister Catharina van Dyck.

Birth of Daniel Mytens in Delft.

1592

30 October: Baptism of Anthony's sister Maria van Dyck.

1593

The Huguenot, King Henri of Navarre, converts to Catholicism and becomes King Henri IV of France.

1594

29 October: Baptism of Anthony's brother Franchois van Dyck the Younger.

Birth of Nicolas Poussin in Normandy.

1596

Archduke Albert of Austria appointed Regent of the Netherlands. He resides in Brussels, there to be joined in 1599 by his bride, the Archduchess Isabella Clara Eugenia, daughter of Philip II of Spain. Antwerp begins a programme of renewal which draws artists, printers and scholars to the city.

1598

4 January: Baptism of Anthony's sister Cornelia van Dyck.

The Edict of Nantes ends the French Civil War and gives Huguenots freedom to worship in France.

Death of Philip II of Spain; succeeded by Philip III.

Birth of Gianlorenzo Bernini in Naples.

1599

22 March: Anthony van Dyck is born in the house 'Den Berendans' on the Grote Markt in Antwerp, the seventh child of Franchois van Dyck the Elder and Maria Cuypers. Peeter Peeterssone and Joanna de Meester act as witnesses at his baptism on 23 March.

25 December: The family moves to 'Het Kasteel van Rijsel' in the Korte Nieuwstraat, the house that Franchois had bought on 17 February 1599.

Birth of Oliver Cromwell in Huntingdon.

Birth of Diego Velázquez in Seville.

1600

Birth of Charles (later Charles I), second son of James VI of Scotland and Anne of Denmark, at Dunfermline in Scotland.

15 September: Baptism of Anthony's sister Susanna van Dyck.

Rubens travels to Italy and is appointed Court Painter to Vincenzo Gonzaga, Duke of Mantua.

1601

9 December: Baptism of Anthony's sister Anna van Dyck.

1603

Death of Elizabeth I. James VI of Scotland inherits the English throne to become James I of England.

1605

7 April: Baptism of Anthony's brother Theodoor van Dyck.

5 November: The Gunpowder Plot, a Catholic conspiracy to blow up James I at the opening of Parliament, is foiled.

1606

2 October: Baptism of Anthony's sister Elisabeth van Dyck.

Rubens in Genoa.

Birth of Rembrandt in Leyden.

1607

7 March: Franchois van Dyck and Maria Cuypers buy the buildings adjacent to their home in the Korte Nieuwstraat, including the dwelling 'De Stadt van Ghendt'.

16 April: Before the notary Adriaen de Witte, Franchois and Maria vow to give each of their surviving children 150 Flemish pounds on the death of one of the parents.

17 April: Death of Maria van Dyck-Cuypers, Anthony's mother.

1608

Rubens returns to the Netherlands as Court Painter to Archduke Albert, with special dispensation to live in Antwerp although the court was in Brussels.

1609–10

Anthony van Dyck begins his apprenticeship with Hendrick van Balen.

1609–21

A Truce is concluded by Archduke Albert between Spain and its dominions (including the Southern Netherlands) and the Northern Netherlands. It lasts twelve years.

1610

2 May: Catharina, Anthony's eldest sister, marries the notary Adriaen Diericx.

15 December: Jacobmyne de Kueck is banished from Antwerp for slandering Franchois van Dyck and threatening to kill him.

Assassination of Henri IV in Paris. Marie de' Medici acts as Regent for her son, Louis XIII.

1611

Birth of William Dobson in London.

1613

Aged fourteen Anthony van Dyck paints the portrait of a 70 year-old man (fig. 20).

James I's daughter, Elizabeth, marries the Elector Palatine, Frederick V, and is escorted to Heidelberg by the Earl of Arundel.

1614

Maria, Anthony's second sister, marries the merchant Lancelot Lancelots.

1615

6 June: Acting as guardians to the under-age children of Franchois van Dyck and Maria Cuypers, Anthony's brothers-in-law, Adriaen Diericx and Lancelot Lancelots, try to keep the estates of their mother and grandmother out of the hands of their parents' creditors.

17 July: Diericx and Lancelots refer to 'the disgrace that has befallen Franchois van Dyck' [i.e. his financial difficulties]. They request the City Council's permission 'immediately to sell nine of the best paintings left by the children's grandmother', in order to safeguard at least part of the grandmother's inheritance. The proceeds of the sale are to be distributed among the children on their coming of age at 25.

24 July: Diericx and Lancelots bring a lawsuit against Franchois in order that the children's inheritance, amounting to 6600 Flemish pounds, be restored. Franchois's assets are inventoried and sold.

On his return to London after three years in Italy, Inigo Jones becomes Surveyor of the King's Works, and begins to design the Queen's House, Greenwich.

1616

8 February: Franchois the Younger marries Catelijn Kanewers.

3 December: Anthony van Dyck declares before the aldermen that his brothers-in-law are not administering the estate of his grandmother properly, and requests that they render account for their actions before a commissioner in the presence of himself and 'one of his good friends'.

December: Franchois the Younger rents the house 'De Cleyn Sonne', near St James's church, Antwerp, from Balthasar Mertens.

Death of William Shakespeare.

Paul van Somer arrives in London to stay until his death in 1622. He becomes the favourite painter of James I's wife, Anne of Denmark.

1616–18

Anthony van Dyck sets up his own studio in 'Den Dom van Ceulen' in the Lange Minderbroedersstraat (now Mutsaertstraat). Herman Servaes and Justus van Egmont become his assistants.

1617

14 February: Franchois the Younger is accused by Balthasar Mertens of breaking his tenancy agreement.

15 July: Diericx and Lancelots state that they are auctioning off Franchois's assets on Antwerp's Vrijdagmarkt (Friday Market) to recoup their inheritance. They buy in several valuables which are loaned to Anthony's elder brother Franchois the Younger who is running the tavern 'De Goublomme'. Franchois is also in financial trouble and when his belongings are confiscated on behalf of his creditors, the guardians lodge an objection.

13 September: Anthony van Dyck appeals to the aldermen to restore his possessions and to protect those of his younger brothers and sisters from their guardians.

Commission for the cycle of paintings of the Mysteries of the Rosary for St Paul's church in Antwerp. Van Dyck is paid 150 guilders for his *Christ carrying the Cross* (cat. 7). Rubens and Jordaens receive the same fee.

1618

11 February: Van Dyck is enrolled as a master in the Guild of St Luke, Antwerp.

16 February: Van Dyck receives an annuity of 'two old *groats* or Brabant *stuyvers*', the proceeds of the mortgage taken out by his father on 'De Stadt van Ghendt', and officially attains his majority with his father's assent.

28 April: Rubens offers Sir Dudley Carleton a painting of *Achilles among the Daughters of*

Lycomedes (fig. 21). He describes it as 'done by my best pupil' – Van Dyck – and retouched by himself.

26 May: Van Dyck works on the tapestry cartoons of the *History of Decius Mus*. Rubens writes to Sir Dudley Carleton that the cartoons have arrived at the Brussels tapestry workshops. Gonzales Coques, Jan Carlo de Witte and Jan Baptist van Eyck state (16 February 1661) that Van Dyck made the cartoons after designs by Rubens.

The crown of Bohemia is offered to the Elector Palatine Frederick V. Emperor Ferdinand II objects and Frederick and Elizabeth, later known as the Winter King and Queen, are driven into exile in The Hague. The Battle of the White Mountain marks the start of the Thirty Years' War, which will eventually involve most European countries. The Low Countries will see the worst of the destruction.

Vittorio Amedeo, heir to the Dukedom of Savoy, marries Christine of France, daughter of Henri IV and Marie de' Medici, and sister of Louis XIII and Henrietta Maria.

Daniel Mytens comes to London and stays until 1633.

1619–22

Inigo Jones designs the Banqueting House, Whitehall.

1620

6 March: After the death of his wife, Maria van Dyck, Lancelot Lancelots asks the aldermen to supervise the administration of her estate. He considers it advisable to appoint a commissioner, 'because the heirs are likely to quarrel'.

29 March: Rubens signs a contract for 39 ceiling paintings for the Jesuit church (now St Carolus Borromeus) in Antwerp: Rubens will supply the designs, which will be executed by 'Van Dyck and certain other of his pupils'.

30 May: By judicial decision of 6 June 1615 and at the guardians' request the house 'De Stadt van Ghendt' is sold, and the pictures, furnishings and fixtures auctioned 'on successive Fridays at this city's Friday Market'.

17 July: Francesco Vercellini, Italian secretary to the Earl of Arundel, writes to his master that the 21 year-old '*Van Deick sta tutavia con il Sr Ribins*' ('Van Dyck is still with Signor Rubens').

20 October: Letter from Thomas Locke in London to William Trumbull, English agent in Brussels. 'The yong painter Van Dyke is newly come to towne and brought me l[ette]rs from Sgr Rubens; ... I am tould my Lo[rd] of Purbeck sent for him hither'.

25 November: Letter from Toby Matthew in Antwerp to Sir Dudley Carleton. 'Van Dyck, his [Rubens's] famous *allievo* [student] is gone into England, and ... the King has given him a pension of £100 per annum'.

The pilgrims set sail from Plymouth in 'The Mayflower' to establish a colony in New England.

1621

16/26 February: 'To Anthony Vandike the some of one hundred pounds by way of reward for speciall service by him p[er]formed for his Matie [James I]...'.

28 February: 'A passe for Anthonie van Dyck gent his Maties Servaunt to travaile for 8 moneths he having obtayned his Maties leave in that behalf as was sygnified by the E[arl] of Arundell'.

March: Van Dyck returns to Antwerp.

31 March: Death of Philip III of Spain. Philip IV rules with the help of Count-Duke Olivares.

16 July: Death of Archduke Albert. Archduchess Isabella rules the Spanish Netherlands alone until her death in 1633. The Twelve Year Truce expires.

October: Van Dyck leaves for Italy.

Late November: Arrives in Genoa, at the house of Lucas and Cornelis de Wael.

December 1621–January 1622: Van Dyck paints the portrait of *Agostino Pallavicino* (Getty Museum, Los Angeles).

Simon Vouet (1590–1649) in Genoa.

1622

Famine in Genoa.

February–August: Van Dyck in Rome. He paints the portraits of *Sir Robert Shirley* and *Teresia, Lady Shirley* (cat. 29, 30) between 22 July and 29 August.

August/September: In Venice, where he probably meets the Countess of Arundel. He visits several collections in Venice and Padua.

October–early 1623: Van Dyck probably accompanies the Countess of Arundel to Turin via Mantua and Milan and may also have visited Genoa, Florence and Bologna *en route* for Rome.

1 December: His father dies in Antwerp.

Rubens painting the Marie de' Medici cycle for the Luxembourg Palace in Paris.

1623

Van Dyck returns to Genoa.

February: Charles, Prince of Wales, and the Duke of Buckingham travel to Madrid to promote the betrothal of the Prince to the Infanta Maria of Spain. Their mission is unsuccessful and they return in October.

March–October/November: Van Dyck in Rome.

6 August: Urban VIII (Maffeo Barberini) elected Pope.

October: *Velázquez appointed Painter to Philip IV of Spain.*

Orazio Gentileschi, in Genoa, sends his painting of The Annunciation *to Duke Carlo Emanuele in Turin.*

Autumn 1623–Spring 1624: Van Dyck in Genoa.

1624

Spring: Van Dyck in Palermo, probably at the invitation of Emanuele Filiberto of Savoy. In May the city is visited by plague. The cult of St Rosalia spreads as her purported remains are discovered on Monte Pellegrino on 14 July. Van Dyck paints *Emanuele Filiberto* (cat. 35), shortly before the Viceroy dies of the plague on 3 August.

12 July: He visits the aged painter Sofonisba Anguissola. The portrait he draws of her in his Sketchbook is accompanied by notes of their conversation (fig. 9).

21 November: 'Anthony van Dyck, the Flemish painter who is living in Palermo these days', acts as guarantor for Jan Brueghel the Younger when he declares that he has received on 29 July through a bill of exchange from his father, Jan Brueghel the Elder, the sum of 19 *onze* from Hendrik Dych, Consul-General of Flanders and of the German community in Sicily.

27 November: His brother-in-law declares to the Antwerp magistracy that Van Dyck lives abroad.

December: Van Dyck is paid for the portraits of *Marcello Durazzo* (Ca' d'Oro, Venice) and his wife, *Caterina Balbi Durazzo* (Palazzo Reale, Genoa), and *Battina Balbi Durazzo* (private collection).

Cardinal Richelieu appointed Chief Minister of France.

Prince Charles betrothed to Henrietta Maria, daughter of Henri IV of France. King James pledges toleration for English Catholics.

Nicolas Poussin travels to Rome.

1625

27 March: Death of James I and accession of Charles I.

Savoy troops invade Genoa and are repulsed.

6 April: Van Dyck, 'the Flemish painter who is living in Palermo', declares that he has received a payment of 36 *onze* and 12 *tari*, for which sum he sent a bill of exchange to Cornelis de Wael in Genoa.

Van Dyck has made paintings for Hendrik Dych in return 'for all the food he [Dych] had given him at his home'.

7 May: Van Dyck declares that he has received four *onze* from Clemente Pilo for painting a *Crucifixion* for Hendrik Dych. Another six *onze* were added to this sum for another *Crucifixion*, also painted for Dych 'and delivered at an earlier date'.

May: Charles I is married by proxy in Paris to Henrietta Maria, and in June she arrives in Kent.

18 August: Van Dyck declares that he has received from Jacopo and Giovanni Battista Brignone the sum of ten *onze*, through a bill of exchange from Giovanni Battista Cattaneo issued in Genoa on 23 May. This is probably a payment for one of the portraits painted in Genoa, *Elena Grimaldi Cattaneo* (National Gallery, Washington) and of her children, *Filippo Cattaneo* and *Maddalena Cattaneo* (cat. 33, 34).

22 August: Van Dyck commissioned to paint a large altarpiece of the Madonna of the Rosary for the Oratory of the Compagnia del Rosario in Palermo. The agreed price is 260 Neapolitan ducats.

3 December: Power of attorney granted by Van Dyck to the Flemish artist Hieronymus Gerardi (or Gerards) in Palermo, which enables Gerardi to repossess from Domenico Martinetto, Van Dyck's servant in Palermo, various paintings of heads, on canvas and on paper.

12 December: Van Dyck's brothers and sisters declare to the Antwerp magistracy that he lives abroad.

Breda falls to the Spanish commander, Spinola, in a temporary victory for the Spanish (immortalised by Velázquez and Callot). The Northern Provinces, under Frederik Hendrik of Orange, attempt to repulse the Spanish.

Daniel Mytens appointed 'Picture-drawer' to Charles I.

Simon Vouet returns to France.

1626

Orazio Gentileschi (1563–1639) settles in London after working in Paris for Marie de' Medici for the previous two years.

1627

18 September: Van Dyck's sister Cornelia dies in Antwerp. Van Dyck returns to Antwerp. He paints *Peeter Stevens* (cat. 48).

December: Payment is made in Genoa by Giovanni Francesco Brignole-Sale to '*Antonio fiamengo*' for portraits of his son *Anton Giulio Brignole-Sale* (cat. 46), Anton Giulio's wife, *Paolina Brignole-Sale* (cat. 47), and Francesco's mother, *Geronima Sale Brignole with her Daughter Maria Aurelia* (Palazzo Rosso, Genoa).

The bankers of Genoa, Antwerp and Amsterdam are affected by Spain's near-bankruptcy. The Genoese bear the brunt of the debts.

1628

6 March: Van Dyck makes his will in Antwerp. He wishes to be buried in the choir of the Beguinage church in Antwerp.

8 April: The Compagnia del Rosario in Palermo makes payment for the *Madonna of the Rosary*, '*novamente fatto nella città di Genova*' (recently painted in Genoa), to Van Dyck's representative, Antonio della Torre.

May: Van Dyck joins the Jesuit Confraternity of Bachelors in Antwerp. To combat a severe bout of the plague, the Confraternity imports relics of St Rosalia from Sicily.

27 May: The Earl of Carlisle writes from Brussels to the Duke of Buckingham that he has met Rubens at 'Monsr Van-digs'.

Van Dyck makes his first visit to The Hague (Houbraken 1718–21); he paints the portraits of Frederik Hendrik of Orange and Amalia van Solms.

In Antwerp he paints *Anna Wake* (cat. 49) and *St Augustine in Ecstasy* (cat. 51).

The City accounts of Brussels refer to a portrait of the City Council for which Van Dyck was to be paid 2400 guilders. This portrait did not survive but in 1634–5 Van Dyck painted a group portrait of the aldermen only (see cat. 84).

Summer 1628–April 1629: Rubens on diplomatic errands: he visits Madrid and meets Velázquez.

June: Nicholas Lanier, Master of the King's Music, *en route* from Mantua to London, is painted by Van Dyck (cat. 50).

23 August: Assassination of the Duke of Buckingham, favourite of Charles I and patron of Van Dyck, in Portsmouth.

December: Van Dyck receives a gold chain, worth 750 guilders, for a portrait of the Archduchess Isabella.

The Gonzaga collection acquired from Mantua by Charles I, through the agency of Daniel Nys and Nicholas Lanier. Payment of £11,500 made on 23 November 1629.

Philippe de Champaigne appointed Painter to the French Queen Mother, Marie de' Medici.

1629

Van Dyck paints *The Coronation of St Rosalia* (fig. 44) for the Jesuit Confraternity of Bachelors in Antwerp, for which he is paid 300 guilders, and *The Crucified Christ with St Dominic and St Catherine of Siena* (fig. 46) for the convent of Dominican nuns in Antwerp.

Charles I dissolves Parliament and begins eleven years of personal rule.

June–March 1630: Peter Paul Rubens is in London as an envoy from the Archduchess Isabella, Regent of the Netherlands, and the King of Spain.

5 December: Van Dyck writes in Spanish to Endymion Porter about a painting worth £72 which he has handed to Porter's agent (presumably *Rinaldo and Armida*; fig. 59).

1630

Van Dyck paints *The Vision of the Blessed Herman Joseph* (cat. 56) for the Confraternity of Bachelors of the Jesuit Convent in Antwerp, for 150 guilders.

He is paid 800 guilders for the *Crucifixion* (fig. 52) painted for the Brotherhood of the Sacred Cross at St Michael's church, Ghent.

3 March: Rubens knighted by King Charles I, and given the commission for the Banqueting House ceiling before he returns to Antwerp.

20 March: Payment via Endymion Porter 'by his Ma^ts Appointmt' of £78 to Van Dyck 'for one picture of ... Reynaldo and Armyda'.

20 March: The city of Antwerp raises a loan of 100,000 guilders; Van Dyck subscribes 4800 guilders.

27 May: Van Dyck calls himself 'painter to Her Highness', the Archduchess Isabella, in a power of attorney given to the painter Pieter Snayers. He receives an annual salary of 250 guilders as painter to the court at

Brussels, although he continues to live in Antwerp.

29 May: Birth of Charles, heir to the British throne, later Charles II.

26 July: Vittorio Amedeo I succeeds to the Dukedom of Savoy.

December: Peace declared between England and Spain after negotiations conducted by Rubens.

December: The Antwerp restorer J.-B. Bruno mentions Van Dyck's exquisite collection of pictures.

1630–31

Van Dyck paints three altarpieces for the Minorites of Mechelen: a *Crucifixion* for their high altar (fig. 47), and *St Bonaventure* (Musée des Beaux-Arts, Caen) and *St Anthony* (fig. 48) for the side altars. Chevalier Jan van der Laen, Lord of Schriek and Grootloo, pays Van Dyck 2000 guilders.

1631

10 May: Van Dyck stands as godfather to Antonia, daughter of the engraver Lucas Vorsterman.

4 September–16 October: Marie de' Medici is in Antwerp, with her son Gaston, Duc d'Orléans. Van Dyck paints their portraits. Puget de la Serre, secretary to the Queen Mother, admires Van Dyck's '*Cabinet de Titien*'.

16 December: Letter from Balthasar Gerbier to Lord Treasurer Weston forwarding 'a very beautiful *Virgin and St Catherine* by the hand of Van Dyck ... [which] ... I think will afford great pleasure to the King [Charles I]'.

Winter: Van Dyck travels to The Hague to work at the court of Frederik Hendrik and Amalia van Solms, Prince and Princess of Orange, and at the Bohemian court in exile.

1631–2

Van Dyck is paid 500 guilders for an *Adoration of the Shepherds* (fig. 51) for the altar of the Confraternity of Our Lady at Our Lady's church, Dendermonde.

1632

28 January: In The Hague Van Dyck paints the portrait of Constantijn Huygens, who writes in his diary, '*Pingor a Van Dyckio...*'. Huygens supplies three mottos for Van Dyck's *Iconography*. Meets Frans Hals.

Sir Thomas Wentworth, later Earl of Strafford, appointed Lord Deputy of Ireland (see cat. 68).

13 March: Letter from Balthasar Gerbier in Brussels to King Charles I: 'Van Dyck is here, and says he is resolved to go over into England'.

By 1 April: Van Dyck has arrived in London and initially lives with Edward Norgate who receives 15 shillings a day 'for ye diet and lodging of Signor Antonio van Dike and his servants'. Norgate was Illuminator of Royal Patents, Windsor Herald, and Clerk of the Signet. He was Nicholas Lanier's brother-in-law, and wrote *Miniatura, or The Art of Limning*.

Towards the end of May, Sir Francis Windebank, Secretary of State, with the help of Inigo Jones, finds Van Dyck a house with a garden near the Thames at Blackfriars, where he is outside the jurisdiction of the City of London Painter–Stainers' Company. His rent is paid by the Crown, and he is given a residence in the summer palace at Eltham in Kent. Vertue tells us that 'at … Eltham … on pannels are several Sketches in two colours said to be done by Vandyke … Stories of Ovid. This house Vandyke ('tis reported) use to pass his Time at his leasure in the Summer season'. Nothing remains of the lesser rooms of Eltham Palace.

5 July: As 'principalle Paynter in ordinary to their Majesties', Van Dyck is knighted by Charles I at St James's Palace.

3 August: Signet Warrant for payment to Van Dyck of £280, signed in 'St Andrewes'.

8 August: Privy Seal Warrant signed in Westminster. The King agrees to purchase the following portraits that Van Dyck has brought from Flanders: of 'Monsieur the french Kings Brother [Gaston, Duc d'Orléans]', of the Archduchess Isabella, of Stadtholder Frederik Hendrik, and the Princess of Orange (Amalia van Solms), and 'their sonne at half length' (Prince William). Van Dyck had also painted 'The Greate Peece' (fig. 15), a group portrait of Charles I, Henrietta Maria, Prince Charles and Princess Mary as a baby, as well as separate pictures of the King and the Queen. Van Dyck was paid for 'mendinge' the *Emperor Galbus* by Titian, and painting a new *Vitellius* to replace Titian's picture which had been irreparably damaged in transit from Mantua.

1633

William Laud (Bishop of London 1628–33) made Archbishop of Canterbury. He attempts to impose uniformity upon the Church of England, while ignoring the diversity of Puritan opinions. He reintroduces music and permits paintings, sculpture, and other decoration in churches. Laud is painted (c. 1638) by Van Dyck.

4 February: Warrant for payment of £200 to 'Philip Burlamachi, merchant, which some he had paid by severall commands unto Sir Antony van Dyck'.

20 April: Van Dyck is given a gold chain worth £110 by Charles I.

2 May: Paints Sir Kenelm Digby's wife, Venetia, on her deathbed (cat. 69).

7 May: Warrant for payment to Van Dyck of £444 for 'nine pictures of the Kings and Queenes Ma^ts royall'.

17 May: 'A penson of 200^l p.ann. [£200 per annum] graunted unto Sir Anthony Vandike … to continue during his Ma^ts pleasure'. Confirmed by Privy Seal Warrant at Westminster on 17 October.

24 May: The Earl of Pembroke, the Lord Chamberlain, issues a warrant for payment to Van Dyck for a portrait of the Queen for himself.

18 June: Charles I crowned in Scotland in a lavish episcopal ceremony. His jewels and plate lost when

the ferry, Blessing of Burntisland, founders in the Firth of Forth.

26 August: The Queen writes to invite Van Dyck's brother, Theodoor, a Premonstratensian, or Norbertine, priest in Antwerp, to join her service as a chaplain.

27 August: Van Dyck dates a watercolour sketch of the Sussex town of Rye (Pierpont Morgan Library, New York; Vey 288).

21 October: Order for payment to Van Dyck of £40 for a 'Picture of O^r dearest Consort the Queene … delivered unto … the Lord Viscount Wentworth'.

1 December: Death of Archduchess Isabella in Brussels. Her nephew, Prince Tommaso Francesco of Savoy-Carignano (cat. 79), is named as the temporary Regent of the Spanish Netherlands.

Van Dyck paints *Charles I on Horseback with Monsieur de St Antoine* (fig. 64).

Misères de la Guerre engravings published by Jacques Callot, reflecting the devastations of the Thirty Years' War.

Daniel Mytens, painter to Charles I, returns to Holland. Last reference to him dated May 1633.

1634

March: Van Dyck buys an interest in the estate Het Steen, later bought by Rubens.

By 28 March: Van Dyck in Antwerp. He dedicates to George Gage an engraving by Lucas Vorsterman of his *Lamentation* (Munich).

14 April: In Brussels Van Dyck authorises his sister Susanna to administer his property in Antwerp.

4 November: The new Regent of the Spanish Netherlands, Cardinal-Infante Ferdinand, arrives in Brussels.

16 December: Van Dyck is said to be living in ''t Paradijs', a house near the City Hall in Brussels. He had recently painted the Cardinal-Infante.

William Prynne publishes *Histriomastix*, a censure of contemporary theatre which criticises morals at court and the royal love of masques.

1635

3 January: Van Dyck acknowledges receipt of the sum of 500 *pattacons* for two portraits of Prince Tommaso Francesco of Savoy, including an equestrian portrait (cat. 79).

Rubens orchestrates the triumphal entry into Antwerp of the new Spanish Regent, Cardinal-Infante Ferdinand, brother of the King of Spain. His paintings for the Banqueting House ceiling dispatched to London. Payment authorised 1637.

Philippe de Champaigne's first major portrait of Louis XIII painted for the Galerie des Hommes Illustres in Richelieu's Palais Cardinal in Paris.

By the spring Van Dyck is back in London, bringing with him his collection of paintings. At a cost of £26, 'a new Cawsey way [ten foot broad] and a new paire of Staires [leading up] into the Garden' are constructed 'for the King's Majesty to land to goe to S^r Anthony

Vandike's house there to see his Paintings in the moneths of Iune and Iuly…'.

Before November: Van Dyck paints *The Three Eldest Children of Charles I* (cat. 87) for the Queen to send to her sister, Christine, Duchess of Savoy.

Certificate of 'strangers born beyond the seas, who dwell … in the precinct of Blackfriars' includes 'Sir Anthony Vandyke, 2 years, 6 servants'.

1636

Van Dyck writes to Franciscus Junius, the Earl of Arundel's librarian and the author of *De Pictura Veterum*, for a motto for the engraving of his portrait of Sir Kenelm Digby.

February 1636–January 1637: Letters written by an English Benedictine friar in London, David Codner, and Gregory Law in Perugia, reveal that Van Dyck is dealing in Italian art. The painter warns of the sophistication of English tastes, and although not prepared to risk any money himself, will try to sell paintings at Court.

Gian Lorenzo Bernini is commissioned to carve a bust of Charles I, based upon the triple portrait by Van Dyck (cat. 86). *In order to work upon a non-papal task, Bernini had to obtain dispensation from Pope Urban VIII. Bernini pasted the Queen's letter of 26 June 1639 to the back of Van Dyck's painting.*

June–November: Viscount Wentworth requires two portraits of himself painted by Van Dyck at the same sittings at Eltham Palace (cat. 102). Wentworth wanted to be sure Van Dyck himself painted both portraits, and that he would not be palmed off with one original and one studio copy: 'minde Sr. Anthonye that he will take good paines upon the perfecting of this [the full length] picture w^th his owne pensell'.

November: The Earl of Arundel sends Van Dyck's portrait of himself with his grandson Thomas (cat. 89) to his agent, William Petty, in Rome, to have a '*basso relievo*' made by 'a yonge sculptor'.

Van Dyck paints *Charles I in Robes of State* (cat. 90).

1637

2 January: George Con, the Papal Minister, excuses his delay in returning to Rome from England by saying that he was 'waiting for a portrait of the Queen to present to the Pope in her name…' (see cat. 92).

February: The Earl of Newcastle writes to Van Dyck saying he enjoys Van Dyck's company and conversation, and signing himself 'Pationatly Your Moste Humble Servant.'

23 February: Payment of £1200 from Charles I to Van Dyck for 'certaine pictures by him delivered for our use'.

April: Bernini's bust of Charles I dispatched from Rome as a present from the Pope to the Queen.

16 November: After the problem had arisen again, of foreigners practising in rivalry to London artists, Van Dyck attends a peace-

making dinner at the Painter–Stainers' Company, together with John de Critz and his wife, Inigo Jones, Matthew Wren, uncle to Christopher Wren, and Edward Norgate.

Van Dyck paints *The Five Eldest Children of Charles I* (fig. 63), for which the King pays £100.

1638

March: Denization granted to 'Sr. Arthur Van Dycke Knight'.

September: Marie de' Medici makes an unwelcome three-year visit to her daughter in London. Puget de la Serre remarks on the portrait of *Charles I on Horseback with Monsieur de St Antoine* (fig. 64) which was hanging in St James's Palace Gallery.

October: Birth of the Dauphin, later Louis XIV, to Louis XIII and Anne of Austria.

Van Dyck sends an undated memoir to the King with a list of 25 paintings commissioned by the King and Queen, for which he has not been paid. These include '*Le roy alla ciasse*' (fig. 17), *The Five Eldest Children of Charles I* (fig. 63), and portraits of the Queen for Bernini (see cat. 92). Van Dyck also states that he has not received his annual pension of £200 for the past five years. The King annotates the list, reducing the price of fourteen paintings which he had commissioned, and indicating that the Queen must do the same for hers. The King rates his at £528, plus £75 for 'the pictures wch Sr Arthur Hopton had into Spaine'. With £1000 owing on his pension, Van Dyck was owed £1603. (See payment below, December 1638.) The King marked down, from £30 to £25 each, Van Dyck's replicas of his royal portraits for Spain, and indeed, the Spanish rejected them as they 'were discovered to be no originalls'.

13 December: Order for payment to Van Dyck of £603 'for divers Pictures by him made and sold to his Maty', and a further £1000 for his pension.

December 1638–January 1639: Abraham Van der Doort draws up lists of the King's pictures in Whitehall Palace. Thirteen of these are by Van Dyck, plus one preparatory drawing for *Charles I on Horseback with Monsieur de St Antoine* which the King kept in a special book of outstanding drawings, including some by Leonardo and Michelangelo.

1639

25 February: Order for payment to Van Dyck of £305 'for pictures for his Maties use'.

By signing the National Covenant the previous year, the Scots had abolished episcopacy and rebelled against the imposition of English liturgy. In May Charles I invades Scotland. The 'First Bishops' War' ends in an ignominious climb-down by the King, with the Peace of Berwick in June.

26 June: Henrietta Maria writes to Bernini asking if he will carve her likeness and promises to send portraits of herself (see cat. 92).

September: Viscount Wentworth, later Earl of Strafford (cat. 102), becomes chief adviser to the King.

Jacob Jordaens commissioned to paint 22 pictures of the Story of Psyche for the Queen's House at Greenwich in a scheme which came to nothing. Rubens was considered too expensive.

Van Dyck marries Mary Ruthven, lady-in-waiting to the Queen and granddaughter to the 1st Earl of Gowrie.

1640

January: The last court masque of Charles I's reign, *Salmacida Spolia* by William D'Avenant with decor by Inigo Jones, performed in Whitehall.

January: The Countess of Sussex is critical of Van Dyck's portrait of her which is 'to rich in ihuels [jewels] ..., but it tis no great mater for another age to thinke me richer then I was'. It also made her too fat in the face: 'It lokes lyke on[e] of the windes poffinge – but truly I thinke it is lyke the originale. If ever i com to London before Sr Vandicke goo, i will get him to mende my pictuer'. Van Dyck was clearly planning to leave England.

5 and 13 February: First and Second Readings in the House of Commons of the Bill against Superstition and Idolatry.

April: Short Parliament called by the King to raise funds for a second invasion of Scotland. Strafford placed at head of royalist troops at York. The Scots march south to Durham.

25 May: William Laud, Archbishop of Canterbury, takes refuge in Whitehall Palace after his Croydon residence is ransacked. Lord Arundel has to defend his London house during the apprentices' riots.

30 May: *Death of Peter Paul Rubens in Antwerp.*

August: Cardinal Barberini apologises for the 'lascivious' *Bacchus and Ariadne* by Guido Reni, ordered for Henrietta Maria: 'I hesitate to send it for fear of further scandalising these Heretics'. Prynne later attacks the Papal Nuncio for attempting to 'seduce the King ... with Pictures, Antiquities, Images & other vanities brought from Rome'.

September: The Earl of Arundel obtains a passport for Van Dyck and his new wife to travel to Antwerp.

The first edition of Van Dyck's *Iconography* is published in Antwerp, printed by Martin van Enden. It comprises 80 engravings of princes, statesmen and philosophers, and artists and amateurs.

23 September: Letter from Cardinal-Infante Ferdinand to King Philip IV mentions that Van Dyck is expected to attend the St Luke's Day Feast at the Guild of St Luke in Antwerp.

18 October: Van Dyck attends the Feast of St Luke in Antwerp and is nominated honorary Dean of the Guild of St Luke, an honour previously awarded only to Rubens.

3 November: Long Parliament meets without royal permission in London. Strafford and Laud impeached for high treason and committed to the Tower.

10 November: The Cardinal-Infante writing again to Philip IV states that Van Dyck is not prepared to complete unfinished paintings by Rubens, but is willing to undertake new commissions.

Late December: Van Dyck visits Paris in an attempt to gain the commission for the decoration of the Grande Galerie in the Louvre. *This is given to Poussin who stays in Paris for only 18 months before returning to Rome.*

1640–41

Van Dyck is commissioned to paint *The Martyrdom of St George* (fig. 56) for the altar of the Archers' Guild in Antwerp Cathedral. The Guild offered him 2200 guilders; the painting was unfinished at his death.

1641

January: Letter from Claude Vignon to François Langlois mentioning that Van Dyck is at present in Paris.

March and April: Six-week trial of Strafford in London.

2 May: Marriage of Princess Mary to Prince William (later William III of Orange) at Whitehall Palace (cat. 105).

8 and 9 May: Riots and mob violence in London.

12 May: Strafford executed on Tower Hill.

The Earl of Arundel accompanies Marie de' Medici to Cologne.

August: Charles I goes to Scotland seeking support against the Covenanters.

9 August: Van Dyck in London. The Prince of Wales visits him in Blackfriars on a 'barge wth 12 ores wch carryed his highnes ... to Sr Anthony Vandickes'.

13 August: The Countess of Roxburghe, Governess to Princess Mary, writes from Richmond Palace to Baron van Brederode in The Hague that Van Dyck has been ill ever since painting the picture of the Prince of Orange, but is now recovered and intends to travel to Holland in ten or twelve days' time, bringing with him the picture, and another made for '*Madame la Princesse d'Auranges*'.

October: Van Dyck is in Antwerp.

October: While the King is still in the north, John Pym, Leader of the House of Commons, draws up the Grand Remonstrance, a bitter indictment of the King's policies and the Court's Catholic inclinations.

16 November: Van Dyck travels to Paris but, because of illness, has to refuse a commission to paint the portrait of 'the Cardinal' (either Richelieu or Mazarin). He asks for a passport to return to London.

25 November: The King returns to London.

1 December: Birth of Van Dyck's daughter, Justiniana.

4 December: Sir Anthony van Dyck makes a new will, leaving his Antwerp property to his sister Susanna who should take care of his younger sister Isabella, and also of his illegitimate daughter, Maria Theresia. He leaves the rest of his estate, including the contents of his studio and the debts owed to him by the King of England, to his wife and new-born daughter. And he bequeaths £3 'to the poore of the parish of Blackfriars'.

9 December: Baptism of Justiniana. The same day Van Dyck dies at Blackfriars. He is buried

two days later, as requested in his will, in the choir of St Paul's Cathedral. The King sets up a monument representing Van Dyck as the Genius of Painting (destroyed in 1666).

Charles I cannot hold the metropolis against the combined antagonism of the House of Lords, the Commons and the mob. By 26–8 December London is on the brink of anarchy.

1642

10 January: The King and Queen leave London.

February: The King goes north. The Queen, escorted by the Earl and Countess of Arundel, accompanies her daughter Mary to Holland. Arundel takes up residence in Antwerp.

16 February: Gabriel Franciscus Essers, son of Gabriel Essers and Maria Theresia van Dyck, natural daughter of the painter, is baptised in the church of St Gommarus, Lier.

August: Charles raises his standard at Nottingham, and later sets up headquarters in Oxford.

William Dobson becomes painter to the Court in Oxford.

The poet Abraham Cowley writes 'On the Death of Sir A. VanDyck the famous Painter'.

Upon the death of Richelieu, Cardinal Mazarin becomes Chief Minister of France. He will be responsible in 1651 for acquiring a number of Van Dyck's paintings from Charles I's collection for the French Crown.

1644

Royalists routed at Marston Moor by Cromwell's New Model Army.

June: Robert Harley 'reforms [the Long Gallery at Whitehall Palace] of all such pictures as displeased his eye' (report by the royalist journal, *Mercurius Aulicus*).

Rome's Master-Peece or The Grand Conspiracy of the Pope… by William Prynne, published with the authority of Parliament, names many leading Catholics, including the Earl and Countess of Arundel, 'Master Porter of the Kings Bedchamber and … his wife, Secretary Windebanke, Sʳ Digby, Sʳ Winter, Master Mountague the younger, Lord Sterling, and the Duchess of Buckingham are all part of the Jesuit design'. Also Lord Gage, deceased, who 'had a Palace adorned with lasivious pictures, which counterfeited prophaneness…'.

1645

William Laud, Archbishop of Canterbury, executed.

Defeat of the King at the battle of Naseby.

Death of Mary Ruthven, previously Lady Van Dyck, now married to Sir Richard Price. Her relative, Patrick Ruthven, petitions Parliament on behalf of Justiniana claiming that the paintings which had remained in Van Dyck's studio after his death had been taken by one Richard Andrewes in payment of debts owed him by Price. Price's relatives from the Wittewrong and Middleton families continue to haggle over the paintings until 1650.

1646

May: Charles I surrenders to the Scots at Newark.

24 September: Death of Arundel in Padua.

1648

The Treaty of Westphalia, signed in Münster, ends the Thirty Years' War and officially recognises the independence of the United Provinces (the Protestant Northern Netherlands).

Charles persuades the Scots to march on London in his support, thus starting the Second Civil War. They are defeated at Preston in August. The Commons ('the Rump') set up a special High Court of Justice to try, and condemn, the King.

1649

30 January: King Charles I executed on a scaffold erected outside the Banqueting House in Whitehall.

1649–51

'The sale of the late King's goods' – the dispersal of the royal collection of works of art – at the command of Parliament. Richard Symonds writes that 'ye things of Vandyke were bought up by the Flemings at any rate wᶜʰ were the Kings'.

1653

Justiniana van Dyck married, aged twelve, to Sir John Stepney.

1656

Oliver Cromwell appointed Lord Protector.

1658

September: Death of Oliver Cromwell.

1660

29 May: Charles II re-enters London in triumph. Monarchy restored. Many pictures returned to the King, including a number of Van Dyck's paintings.

5 September: Jan Brueghel the Younger states that 'he has known the celebrated painter Van Dyck very well from childhood', and that he has seen how 'before he left for Italy', he painted 'the Twelve Apostles and Our Lord'. Guilliam Verhagen states that he commissioned the apostle series '44 to 45 years ago' from Van Dyck.

1661

30 October: *Peter Lely granted an annual pension of £200 p.a. 'as formerly to Sir Vandyke'.*

1662

March: Justiniana, now a Catholic, petitions Charles II for 'the place of dresser to the Queen [Catherine of Braganza], or some order for her livelihood. His Majesty was pleased … to promise her … 1,500ˡ [£1500] due to her father by the late King'. He granted her an annual pension of £200.

1664

Justiniana petitions for the continuance of her pension of £200 'stopped a year ago, … having nothing else to subsist upon'. Payments noted between 1669 and 1675.

1666

1 September: *Frans Hals is burried in Haarlem.*

September: The Great Fire of London destroys much of the City; Old St Paul's Cathedral gutted, and Van Dyck's tomb destroyed.

1668

12 December: The 70 year-old painter Herman Servaes claims that he was Van Dyck's assistant during the Twelve Year Truce, and that he watched Van Dyck paint a *Drunken Silenus*.

1669

4 October: *Rembrandt dies in Amsterdam.*

Bibliography

ADRIANI 1940 G. Adriani, *Anton van Dyck: Italienisches Skizzenbuch*, Vienna 1940

AMSTERDAM 1947 *Kunstschatten uit Wenen, Meesterwerken uit Oostenrijk*, exh. cat., Rijksmuseum, Amsterdam, 1947

AMSTERDAM 1948 *Meesterwerken uit de Oude Pinacotheek te München*, exh. cat., Rijksmuseum, Amsterdam, 1948

AMSTERDAM AND ROTTERDAM 1946 *Van Jan van Eyck tot Rubens. Meesterwerken uit de Belgische musea*, exh. cat., Rijksmuseum, Amsterdam; Museum Boijmans Van Beuningen, Rotterdam, 1946

ANTWERP 1899 *Exposition Van Dyck à l'occasion du 300ᵉ anniversaire de la naissance du maître/Van Dijck tentoonstelling ter gelegenheid der 300e verjaring van de geboorte van den meester*, exh. cat., Koninklijk Museum voor Schone Kunsten, Antwerp, 1899

ANTWERP 1930, 1932 *Trésor de l'art flamand: Mémorial de l'exposition d'art flamand ancien à Anvers, 1930*, Brussels 1932

ANTWERP 1949 *Van Dyck Tentoonstelling*, exh. cat., Koninklijk Museum voor Schone Kunsten, Antwerp 1949

ANTWERP 1959 *Koninklijk Museum voor Schone Kunsten te Antwerpen, Oude Meesters*, Brussels 1959

ANTWERP 1988 *Catalogus Schilderkunst Oude Meesters, Koninklijk Museum voor Schone Kunsten Antwerpen*, Antwerp 1988

ANTWERP 1992–3 *Van Bruegel tot Rubens: De Antwerpse schilderschool, 1550–1650*, exh. cat., Koninklijk Museum voor Schone Kunsten, Antwerp, 1992–3

ANTWERP AND ROTTERDAM 1960 *Antoon van Dyck; tekeningen en olieverfschetsen*, exh. cat., ed. R.-A. d'Hulst and H. Vey, Rubenshuis, Antwerp; Museum Boijmans Van Beuningen, Rotterdam, 1960

D'ARSCHOT 1949 Comte d'Arschot, 'Réflexions sur l'exposition Van Dyck (Anvers 1949)', *Les Arts plastiques*, 1949, pp. 261–74

BACK-VEGA 1953 E. Back-Vega, 'Van Dycks Ruhe auf der Flucht', *Weltkunst*, XXIII-4, 1953, pp. 3–4

BAD HOMBURG AND WUPPERTAL 1995 *Rembrandt, Rubens, Van Dyck: Italien-Sehnsucht nordischer Barockmaler. Meisterwerke aus dem Museum der bildenden Künste Budapest*, exh. cat., ed. I. Ember and M. Chiarini, Bad Homburg and Wuppertal 1995

BAKER 1920 C.H. Collins Baker, *Catalogue of the Petworth Collection of Pictures...*, London 1920

BAKER 1937 C.H. Collins Baker, *Catalogue of the Principal Pictures at Hampton Court*, London 1937

BALDASS 1957 Ludwig Baldass, 'Some Notes on the Development of Van Dyck's Portrait Style', *Gazette des Beaux-Arts*, 6th series, L, 1957, pp. 251–70

BALIS 1989 A. Balis et al., *Flandria Extra Muros, De Vlaamse schilderkunst in het Prado*, Antwerp 1989

BALIS 1994 A. Balis, 'Van Dyck: Some Problems of Attribution', in Barnes and Wheelock 1994, pp. 177–96

BARNES 1986 S.J. Barnes, *Van Dyck in Italy*, Ph.D. diss. New York University, 2 vols, 1986

BARNES AND WHEELOCK 1994 S.J. Barnes and A.K. Wheelock, Jr., (ed.), *Van Dyck 350* (Studies in the History of Art, 46), Washington 1994

BAUDOUIN 1994 F. Baudouin, 'Van Dyck's Last Religious Commission: an Altarpiece for Antwerp Cathedral', *Journal of the Warburg and Courtauld Institutes*, LVII, 1994, pp. 175–90

BAUMSTARK 1980 R. Baumstark, *Meisterwerke der Sammlungen des Fürsten von Liechtenstein*, Zurich 1980

BAZIN 1958 G. Bazin, *Musée de l'Ermitage: Les grands Maîtres de la Peinture*, Paris 1958

BELFAST 1961 *Pictures from Ulster Houses*, exh. cat., Belfast Museum and Art Gallery, 1961

BELLORI 1672, 1976 G.P. Bellori, *Le vite de' pittori, scultori e architetti moderni*, Rome 1672; another edition ed. E. Borea, Turin 1976

BENESCH 1938 O. Benesch, 'Zur Frage der frühen Zeichnungen Van Dycks', *Die graphischen Künste*, III, 1938, pp. 19–31

BERBIE 1774 G. Berbie, *Description des principaux ouvrages de peinture et de sculpture actuellement existans dans les églises, couvens et lieux publics de la ville d'Anvers*, Antwerp 1774

BERESFORD 1998 R. Beresford, *Dulwich Picture Gallery: A Complete Illustrated Catalogue*, London 1998

BERGER 1883 A. Berger (ed.), 'Inventar der Kunstsammlung des Erzherzogs Leopold Wilhelm von Österreich nach der Originalhandschrift im Fürstl. Schwarzenberg'schen Centralarchive (14 VII 1659)', *Jahrbuch der kunsthistorischen Sammlungen des Allerhöchsten Kaiserhauses*, I, 1883, pp. lxxix–cxci

BERNE 1949–50 *Kunstwerke der Münchner Museen*, exh. cat., Kunstmuseum, Berne, 1949–50

BILLIET 1960 G. Billiet, 'Aantekeningen over vier schilderijen tijdens de Franse Overheersing (1794) te Kortrijk ontvoerd', *De Leiegouw*, II, 1960, pp. 221–36

BINYON 1907 Laurence Binyon, *Catalogue of Drawings by British Artists and Artists of Foreign Origin ... in the Department of Prints and Drawings in the British Museum*, 4 vols, London 1907

BLANC 1857 Charles Blanc, *Le Trésor de la Curiosité tiré des Catalogues de Vente*, 2 vols, Paris 1857

BOCCARDO 1987 P. Boccardo, 'Per la Storia della Quadreria di Palazzo Spinola', in 'Palazzo Spinola a Pellicceria: Due musei in una dimora storica', *Quaderni della Galleria Nazionale di Palazzo Spinola*, X, 1987, pp. 63–86

BOCCARDO 1994 P. Boccardo, 'Ritratti di Genovesi di Rubens e di Van Dyck: Contesto ed identificazioni', Barnes and Wheelock 1994, pp. 79–102

BODE 1889 Wilhelm von Bode, 'Anton van Dyck [in der Liechtenstein Galerie]', *Die graphischen Künste*, XII, 1889, pp. 39–52

BODE 1906 Wilhelm von Bode, 'Anton van Dyck als Mitarbeiter des Peter P. Rubens', *Rembrandt und seine Zeitgenossen*, Leipzig 1906, pp. 255–82

BODE 1909 Wilhelm von Bode, *Great Masters of Dutch and Flemish Painting*, London 1909

BODE 1914 Wilhelm von Bode, 'Ein neu-aufgefundenes Bildnis von Rubens' erster Gattin Isabella Brant', *Jahrbuch der Königlich Preußischen Kunstsammlungen*, IV, 1914, pp. 221–3

BORENIUS 1916 Tancred Borenius, *Pictures by the Old Masters ... in the Library of Christ Church, Oxford*, Oxford 1916

BOSTON AND TOLEDO 1993–4 *The Age of Rubens*, exh. cat., ed. P. Sutton, Museum of Fine Arts, Boston; Toledo Museum of Art, Toledo, 1993–4

BOUCHOT-SAUPIQUE 1947 J. Bouchot-Saupique, *La peinture flamande du XVIIᵉ siècle au Musée du Louvre*, Brussels 1947

VAN DEN BRANDEN 1883 F.J. Van den Branden, *Geschiedenis der Antwerpsche schilderschool*, Antwerp 1883

BREGENZ 1965 *Meisterwerke der Malerei aus Privatsammlungen im Bodenseegebiet*, Künstlerhaus Palais Thurn und Taxis, Bregenz, 1965

BREJON DE LAVERGNÉE 1987 A. Brejon de Lavergnée, *L'Inventaire Le Brun de 1683. La collection des tableaux de Louis XIV*, Paris 1987

BREJON DE LAVERGNÉE, FOUCART AND REYNAUD 1979 A. Brejon de Lavergnée, J. Foucart and N. Reynaud, *Catalogue sommaire illustré des peintures du Musée du Louvre. I. Ecoles flamande et hollandaise*, Paris 1979

BRENNINKMEYER-DE ROOIJ 1976 B. Brenninkmeyer-de Rooij, 'De schilderijenverzameling van Prins Willem V op het Buitenhof te Den Haag (2)', *Antiek*, 11, 1976, pp. 138–76

BRIELS 1980 J. Briels, 'Amator Pictoriae Artis. De Antwerpse kunstverzamelaar Pieter Stevens en zijn Constkamer', *Jaarboek Koninklijk Museum voor Schone Kunsten Antwerpen*, 1980, pp. 137–226

BRIGSTOCKE 1982 H. Brigstocke, *William Buchanan and the 19th Century Art Trade. 100 Letters to His Agents in London and Italy*, New Haven 1982

VAN DEN BRINK 1993 P.J. van den Brink, 'Het gedroomde land – Inleiding', in *Het Gedroomde Land*, exh. cat., Utrecht 1993, pp. 9–22

BRITTON 1801 John Britton, *The Beauties of Wiltshire, Displayed in Statistical Historical and Descriptive Sketches: Interspersed with Anecdotes of the Arts*, 2 vols, London 1801

BROOS 1987 B. Broos, *Meesterwerken in het Mauritshuis*, The Hague 1987

DE BROSSES 1739 C. de Brosses, *Viaggio in Italia*, Paris 1739

BROWN 1974 C. Brown, *Anthony van Dyck. The Abbé Scaglia Adoring the Virgin and Child*, Painting in Focus 2, National Gallery, London 1974

BROWN 1979 C. Brown, 'Van Dyck at Princeton', *Apollo*, CX, 1979, p. 145

BROWN 1982 C. Brown, *Van Dyck*, Oxford 1982

BROWN 1983 C. Brown, 'Van Dyck's Collection: A Document Rediscovered', in *Essays on Van Dyck*, Ottawa 1983, pp. 69–72

BROWN 1984 C. Brown, 'Allegory and Symbol in the Work of Anthony Van Dyck', in H. Vekeman and J. Müller Hofstede (ed.), *Wort und Bild in der niederländischen Kunst und Literatur des 16. und 17. Jahrhunderts*, Erftstadt 1984, pp. 123–35

BROWN 1987 C. Brown, 'Van Dyck and Titian', in G. Cavalli-Björkman (ed.), *Bacchanals by Titian and Rubens*, Stockholm 1987, pp. 153–64

BROWN 1990 C. Brown, 'Van Dyck's Pembroke Family Portrait: An Enquiry into its Italian Sources', in Washington 1990–91, p. 38

BROWN 1991 C. Brown, *Van Dyck Drawings*, London 1991

BROWN 1994 C. Brown, 'Anthony van Dyck at work: "The Taking of Christ" and "Samson and Delilah" ', *Wallraf-Richartz Jahrbuch*, LV, 1994 (Festschrift für Prof. Dr. Justus Müller Hofstede), pp. 43–54

BROWN AND RAMSAY 1990 C. Brown and N. Ramsay, 'Van Dyck's Collection: Some new Documents', *The Burlington Magazine*, CXXXII, 1990, pp. 704–9

BRUGES 1956 *L'Art Flamand dans les collections Britanniques*, exh. cat., Musée Communal Groeninge, Bruges, 1956

BRUGES, VENICE AND ROME 1951 *I Fiamminghi e gli Italiani: Pittori italiani e fiamminghi dal XV al XVIII secolo*, exh. cat., Musée Communal, Bruges; Palazzo Ducale, Venice; Palazzo Barberini, Rome, 1951

BRUSSELS 1910, 1912 *Trésors de l'Art Belge au XVIIᵉ Siècle, Mémorial de l'Exposition d'Art Ancien à Bruxelles en 1910*, 2 vols, Brussels and Paris 1912

BRUSSELS 1947 *Meesterwerken der Musea van Weenen/Les Relations Artistiques Austro-Belges Illustrées par les Chefs-d'Œuvre des Musées de Vienne*, exh. cat., Paleis voor Schone Kunsten/Palais des Beaux-Arts, Brussels, 1947

BRUSSELS 1948 *De meesterwerken van de Pinacotheek van München*, Paleis voor Schone Kunsten, Brussels, 1948

BRUSSELS 1961 *Les plus Beaux Portraits de nos musées*, exh. cat., Musées Royaux des Beaux-Arts de Belgique, Brussels, 1961

BRUSSELS 1965 *De eeuw van Rubens/Le Siècle de Rubens*, Koninklijke Musea voor Schone Kunsten van België/Musées Royaux des Beaux-Arts de Belgique, Brussels, 1965

BRUSSELS 1984 *Koninklijke Musea voor Schone Kunsten van België. Departement Oude Kunst. Inventariscatalogus van de oude schilderkunst*, Brussels 1984

BUCHANAN 1824 W. Buchanan, *Memoirs of Paintings*, London 1824

BURCHARD 1929 Ludwig Buchard, 'Genuesische Frauenbildnisse von Rubens', *Jahrbuch der Preußischen Kunstsammlungen*, L, 1929, pp. 319–49

BURCHARD 1932 Ludwig Burchard, 'Rubensähnliche Van Dyck-Zeichnungen', *Sitzungsberichte der Kunstgeschichtlichen Gesellschaft Berlin*, 1932, pp. 8–12

BURCHARD 1933 Ludwig Burchard, 'Nachträge', in Glück 1933, pp. 371–419

BURCHARD 1938 Ludwig Burchard, ' "Christ Blessing the Children" by Anthony Van Dyck', *The Burlington Magazine*, LXXII, 1938, pp. 25–30

BUSCHMANN 1905 P. Buschmann, *Jacob Jordaens: een Studie*, Brussels 1905

BUSCHMANN 1916 P. Buschmann, 'Rubens en Van Dyck in het Ashmolean Museum Oxford', *Onze Kunst*, XXIX, 1916, pp. 1–24, 41–51

BYAM SHAW 1967 J. Byam Shaw, *Paintings by Old Masters at Christ Church, Oxford*, London 1967

BYAM SHAW 1976 J. Byam Shaw, *Drawings by Old Masters at Christ Church, Oxford*, 2 vols, Oxford 1976

CARPENTER 1844 W.H. Carpenter, *Pictorial Notices, Consisting of a Memoir of Sir Anthony Van Dyck...*, London 1844

CARPENTER 1845 W.H. Carpenter, *Mémoires et documents inédits sur Antoine van Dyck, P.P. Rubens, et autres artistes contemporains...*, trans. L. Hymans, Antwerp 1845

CAULLET 1912–13 G. Caullet, 'Le Van Dyck de Courtrai d'après la correspondance originale du maître et les écrits du XVIII^me siècle', *Bulletin du Cercle Historique et Archéologique de Courtrai*, X, 1912–13, pp. 64–101, 343–8

CHICAGO 1954 *Masterpieces of Religious Art*, exh. cat., The Art Institute of Chicago, 1954

CIFANI AND MONETTI 1992 A. Cifani and F. Monetti, 'New Light on the Abbé Scaglia and Van Dyck', *The Burlington Magazine*, CXXXIV, 1992, pp. 506–14

CINCINNATI 1941 *Masterpieces of Art*, exh. cat., Cincinnati 1941

CLARIJS 1947 Petra Clarijs, *Anton van Dyck* (Palet Serie), Amsterdam 1947

COCHIN 1758 Charles-Nicolas Cochin, *Voyage d'Italie*, Paris 1758

COLOGNE, ANTWERP AND VIENNA 1992–3 *Von Bruegel bis Rubens. Das goldene Jahrhundert der flämischen Malerei*, exh. cat., ed. E. Mai and H. Vlieghe, Wallraf-Richartz-Museum, Cologne; Koninklijk Museum voor Schone Kunsten, Antwerp; Kunsthistorisches Museum, Vienna, 1992–3

CONSTANS 1976 C. Constans, 'Les tableaux du Grand Appartement du Roi', *La Revue du Louvre et des Musées de France*, III, 1976, pp. 157–73

CUNNINGHAM 1843 A. Cunningham, *The Life of Sir David Wilkie*, London 1843

CUST 1900 L. Cust, *Anthony Van Dyck. An Historical Study of His Life and Works*, London 1900

CUST 1905 L. Cust, *Anthony van Dyck*, London 1905

CUST 1911a L. Cust, 'Notes on Pictures in the Royal Collections 20 – The Equestrian Portraits of Charles I by Van Dyck 2', *The Burlington Magazine*, XVIII, 1911, pp. 202–9

CUST 1911b L. Cust, *Van Dyck, a Further Study*, London and New York 1911

DALLINGER 1780 J. Dallinger, *Description des tableaux et des pièces de sculpture que renferme la galerie de son Altesse François Joseph Chef et Prince Régnant de la Maison de Liechtenstein*, Vienna 1780

DAMM 1966 Margaret Minn Damm, *Van Dyck's Mythological Paintings*, Ph.D. diss. University of Michigan, 1966

DAVIES 1907 R. Davies, 'An inventory of the Duke of Buckingham's Pictures, etc., at York House in 1635', *The Burlington Magazine*, X, 1907, pp. 376–9

DEBRABANDERE 1966 P. Debrabandere, 'Schilderijen van de Kortrijkse Lievevrouwekerk', *De Leiegouw*, VIII, 1966, pp. 135–53

DECOEN 1925 J. Decoen, *Où est passé le tableau que Van Dyck peignit pour la collégiale de Courtrai?*, Brussels 1925

DELACRE 1934 M. Delacre, *Le dessin dans l'œuvre de Van Dyck*, Brussels 1934

DELFT 1964 *De Schilder in zijn Wereld*, exh. cat., Delft 1964

DEMONTS 1922 L. Demonts, *Musée National du Louvre. Catalogue des peintures. Ecoles du Nord*, Paris 1922

DENUCÉ 1932 Jan Denucé, *The Antwerp Art-Galleries, Inventories of the Art-Collections in Antwerp in the 16th and 17th Centuries*, The Hague 1932

DESCAMPS 1753–4 J.B. Descamps, *La vie des peintres flamands, allemands et hollandais*, 4 vols, Paris 1753–4

DESCAMPS 1769 J.B. Descamps, *Voyage pittoresque de la Flandre et du Brabant*, Paris 1769

DETROIT 1921 *Fifty Paintings by Anthony van Dyck*, exh. cat., The Detroit Institute of Arts, 1921

DETROIT 1929 *Eighth Loan Exhibition of Old Masters, Paintings by Anthony van Dyck*, exh. cat., The Detroit Institute of Arts, 1929

DEVIGNE 1944 M. Devigne, *Koninklijke Musea voor Schoone Kunsten van België. Verzameling della Faille de Leverghem*, Brussels 1944

DEVLIEGHER 1965 L. Devliegher, *De Onze-Lieve-Vrouwekerk te Kortrijk* (Kunstpatrimonium van West-Vlaanderen, 6), Tielt and Utrecht 1965

DÍAZ PADRÓN 1975 Matias Díaz Padrón, *Escuela flamenca, siglo XVII, Museo del Prado*, Madrid 1975

DRESDEN 1765 *Catalogue des tableaux de la Galerie Electorale à Dresde*, Dresden 1765

DRESDEN 1905 Karl Woermann, *Staatliche Kunstsammlungen zu Dresden, Gemäldegalerie Alte Meister Dresden, Katalog der ausgestellten Werke*, Dresden 1905

DRESDEN 1987 Staatliche Kunstsammlungen Dresden, *Gemäldegalerie Alte Meister Dresden, Katalog der ausgestellten Werke*, Dresden 1987

DROSSAERS AND LUNSINGH SCHEURLEER 1974–6 S.W.A. Drossaers and T.H. Lunsingh Scheurleer, *Inventarissen van de inboedels in de verblijven van de Oranjes en daarmede gelijk te stellen stukken 1567–1795*, 3 vols, The Hague 1974–6

DUMONT-WILDEN 1910 L. Dumont-Wilden, 'Exposition de l'Art belge au XVII^e siècle à Bruxelles', *Les Arts*, CVI, 1910, pp. 2–27

EIGENBERGER 1924 R. Eigenberger, 'Ergänzungen zum Lebenswerke des Rubens und Van Dyck in der akademischen Gemäldegalerie in Wien', *Belvedere*, V, 1924, pp. 1–39

EIGENBERGER 1927 R. Eigenberger, *Die Gemäldegalerie der Akademie der bildenden Künste in Wien*, 2 vols, Vienna and Leipzig 1927

EISENMANN 1888 O. Eisenmann, *Katalog der Königlichen Gemälde-Galerie zu Cassel*, Kassel 1888

EISLER 1977 Colin Eisler, *Paintings from the Samuel H. Kress Collection: European Schools Excluding Italian*, Oxford 1977

ENGERAND 1899 F. Engerand, *Inventaire des tableaux du Roy rédigé en 1709 et 1710 par Nicolas Bailly*, Paris 1899

ENGERTH 1884 E.R. von Engerth, *Kunsthistorische Sammlungen des Allerhöchsten Kaiserhauses. Gemälde. Beschreibendes Verzeichnis*, II, Vienna 1884

EVERS 1943 H.G. Evers, *Rubens und sein Werk. Neue Forschungen*, Brussels 1943

FALKE 1873, 1885 J. Falke, *Katalog der Fürstlich Liechtensteinischen Bilder-Galerie im Gartenpalais der Rossau zu Wien*, Vienna 1873; another edition, Vienna 1885

FANTI 1767 Fanti, *Descrizione completa di tutto cio che ritrovasi nella galleria di pittura e scultura di Sua Altezza Giuseppe Wenceslao del S.R.I. Principe regnante della casa di Lichtenstein*, Vienna 1767

FÉLIBIEN 1666–88 André Félibien, *Entretiens sur les Vies et sur les Ouvrages des Plus Excellens Peintres Anciens et Modernes*, 3 vols, Trévoux 1666–88

FIERENS-GEVAERT AND LAES 1927 H. Fierens-Gevaert and A. Laes, *Musées Royaux des Beaux-Arts de Belgique, Catalogue de la peinture ancienne*, Brussels 1927

FLEISCHER 1910 U. Fleischer, *Furst Karl Eusebius von Lichtenstein als Bauherr und Kunstsammler (1611–1684)*, Vienna and Leipzig 1910

FRANCIS 1947 H.S. Francis, ' "Portrait of Isabella Brant" by Peter Paul Rubens', *The Bulletin of the Cleveland Museum of Art*, XXXIV, 1947, p. 248

FRANKFURT 1992 *Kunst in der Republik Genua 1528–1815*, exh. cat., ed. Mary Newcome Schleier, Frankfurt am Main 1992

FRIMMEL 1892–1901 T. von Frimmel, *Kleine Galeriestudien. Geschichte der Wiener Gemäldesammlungen*, 5 vols, Berlin 1892–1901

FROMENTIN 1876 Eugène Fromentin, *Les Maîtres d'Autrefois*, Paris 1876

FROTE-LANGLOIS 1983 M. Frote-Langlois, 'Iconographie de François Langlois dit Chartres', *Gazette des Beaux-Arts*, CII, 1983, pp. 119–20

GALESLOOT 1863–6 L. Galesloot, 'Renseignements concernant l'amie d'Antoine Van Dyck à Saventhem', *Annales de l'Académie Royale d'Archéologie de Belgique*, XX, 1863, pp. 36–50; XXVII, 1866, pp. 436–50

GALESLOOT 1868 L. Galesloot, 'Un procès pour une vente de tableaux attribués à Van Dyck', *Annales de l'Académie Royale d'Archéologie de Belgique*, XXIV, 1868, pp. 561–606

GARAS 1955 C. Garas, 'Ein unbekanntes Porträt der Familie Rubens auf einem Gemälde van Dycks', *Acta Historiae Artium Academiae Scientiarum Hungaricae*, II, 1955, pp. 189–200

GARAS 1968 C. Garas, 'Das Schicksal der Sammlung des Erzherzogs Leopold Wilhelm', *Jahrbuch der kunsthistorischen Sammlungen in Wien*, LXIII, 1967, pp. 181–278

GARLICK 1976 K. Garlick, 'A Catalogue of Pictures at Althorp', *Walpole Society*, XLV, 1976

GAUNT 1980 W. Gaunt, *Court Painting in England from Tudor to Victorian Times*, London 1980

VAN GELDER 1959 J.G. van Gelder, 'Anthonie Van Dyck in Holland in de Zeventiende Eeuw', *Bulletin des Musées Royaux des Beaux-Arts de Belgique*, VIII, 1959, pp. 43–86

VAN GELDER 1961 J.G. van Gelder, 'Van Dycks Kruisdraging in de St. Paulus kerk te Antwerpen', *Bulletin des Musées Royaux des Beaux-Arts de Belgique*, X, 1–2, 1961, pp. 43–86

VAN GELDER 1978 J.G. van Gelder, 'Pastor Fido-voorstellingen in de Nederlandse kunst van de zeventiende eeuw', *Oud Holland*, XCII, 1978, pp. 227–63

GENOA 1892 *Mostra d'arte antica aperta nelle sale del Palazzo Bianco*, exh. cat., Palazzo Bianco, Genoa, 1892

GENOA 1955 *100 Opere di Van Dyck*, exh. cat., Palazzo dell'Accademia, Genoa, 1955

GENOA 1987 *Il Tempo di Rubens: Da Anversa a Genova. Opere del Seicento fiammingo*, exh. cat., Genoa 1987

GENOA 1991 *Il Passato Presente: I Musei del Comune di Genova*, Genoa 1991

GENOA 1997 *Van Dyck a Genova: Grande pittura e collezionismo*, exh. cat., ed. S.J. Barnes, P. Boccardo, C. Di Fabio and L. Tagliaferro, Palazzo Ducale, Genoa, 1997

GEPTS 1954–60 G. Gepts, 'Tafereelmaker Michiel Vriendt, leverancier van Rubens', *Jaarboek Koninklijk Museum voor Schone Kunsten Antwerpen*, 1954–60, pp. 83ff

GERSON 1967 H. Gerson, 'Antonie van Dyck (1599–1641), Portret van Quintijn Simons, Mauritshuis, 's Gravenhage', *Openbaar Kunstbezit*, XI, 1967, no. 48

GERSON AND TER KUILE 1960 H. Gerson and E.H. ter Kuile, *Art and Architecture in Belgium 1600–1800* (The Pelican History of Art), Harmondsworth 1960

GHENT 1960 *Bloem en tuin in de Vlaamse kunst/Fleurs et Jardins dans l'art flamand*, exh. cat., Museum voor Schone Kunsten, Musée d'Art et d'Histoire, Ghent, 1960

GHENT 1972 C. van Hasselt, *Flemish Drawings of the Seventeenth Century*, exh. cat., Ghent 1972

GLEN 1983 T.L. Glen, 'Observations on van Dyck as a Religious Painter', in *Essays on Van Dyck*, Ottawa 1983, pp. 45–52

GLÜCK 1919 G. Glück, 'Eine Zeichnung von Cornelis de Vos', *Die graphischen Künste*, 1919, pp. 38–40

GLÜCK 1925–6 G. Glück, 'Van Dycks Anfänge: der heilige Sebastian im Louvre zu Paris', *Zeitschrift für bildende Kunst*, LIX, 1925–6, pp. 257–64

GLÜCK 1927 G. Glück, 'Van Dyck's Apostelfolge', in *Festschrift für Max J. Friedlaender*, Leipzig 1927

GLÜCK 1931 G. Glück, *Van Dyck, des Meisters Gemälde* (Klassiker der Kunst, XIII), Stuttgart and Berlin 1931

GLÜCK 1933 G. Glück, *Rubens, Van Dyck und ihr Kreis*, Vienna 1933

GLÜCK 1934 G. Glück, 'Self-Portraits by Van Dyck and Jordaens', *The Burlington Magazine*, LXV, 1934, pp. 194–201

GLÜCK 1936 G. Glück, 'Some Portraits of Musicians by Van Dyck', *The Burlington Magazine*, LXIX, 1936, pp. 147–53

GLÜCK 1939 G. Glück, 'Van Dyck's Burnt Paintings of the Brussels City-Council', *Old Master Drawings*, LIII, 1939, pp. 1–4

VAN GOOL 1750–51 ED. 1971 Jan van Gool, *De nieuwe schouburg der Nederlantsche kunstschilders en schilderessen. …* The Hague 1750–51, repr. Soest 1971

GORDON 1983 P. Gordon, 'The Duke of Buckingham and van Dyck's "Continence of Scipio"', in *Essays on Van Dyck*, Ottawa 1983, pp. 53–6

GORIS AND HELD 1947 J.A. Goris and J. Held, *Rubens in America*, New York 1947

GRITSAI 1996 N. Gritsai, *Anthony van Dyck*, Bournemouth and St Petersburg 1996

GUIFFREY 1882, 1896 J. Guiffrey, *Antoine van Dyck: sa vie et son œuvre*, Paris 1882; English trans., *Sir Anthony van Dyck: His Life and Work*, London 1896

HARRIS 1973 J. Harris, 'The Link between a Roman Second-Century Sculptor, Van Dyck, Inigo Jones and Queen Henrietta Maria', *The Burlington Magazine*, XCV, 1973, pp. 526–30

HARVIE 1993 R. Harvie, 'A Present from "Dear Dad"? Van Dyck's "The Continence of Scipio"', *Apollo*, CXXXVIII, 1993, p. 224

VAN HASSELT 1972, see Ghent 1972

HELD 1958, 1982 J.S. Held, 'Le Roi à la Ciasse', *The Art Bulletin*, XL, 1958, pp. 139–49; reprinted with additions, in J. S. Held, *Rubens and his Circle*, Princeton 1982, pp. 65–79

HELD 1980 J.S. Held, *The Oil Sketches of Peter Paul Rubens: A Critical Catalogue*, 2 vols, Princeton 1980

HELD 1982 J.S. Held, 'Rubens and Titian', in *Titian: His World and His Legacy*, ed. David Rosand, New York 1982, pp. 283–339

HELD 1990 J.S. Held, 'Van Dyck's Oil Sketches', in Washington 1990–91, pp. 327–9

HELD 1994 J.S. Held, 'Van Dyck's Relationship to Rubens', in Barnes and Wheelock 1994, pp. 63–76

HERMITAGE 1774 *Catalogue des Tableaux qui se trouvent dans les Galeries et dans les Cabinets du Palais Impérial de Saint Pétersbourg*, St Petersburg 1774

HERMITAGE 1964 *The Hermitage: Dutch and Flemish Masters*, Leningrad 1964

HERVEY 1921 M. Hervey, *The Life, Correspondence and Collections of Thomas Howard, Earl of Arundel*, Cambridge 1921

DE HEVESY 1936 A. de Hevesy, 'Rembrandt and Nicholas Lanier', *The Burlington Magazine*, LXIX, 1936, pp. 153–4

HILL 1963 D. Hill, 'Barons Court', *Apollo*, LXXVIII, 1963, pp. 12–17

HIND 1915 A.M. Hind, 'Van Dyck: His Original Etchings and His Iconography', *Print Collector's Quarterly*, V, 1915, pp. 2–37, 220–52

HOET 1752–70 AND TERWESTEN Gerard Hoet, *Catalogus of Naamlyst van Schilderyen, met derzelver pryzen*, ed. Terwesten, 3 vols, The Hague; reprint Soest 1976

HOFSTEDE DE GROOT 1916 C. Hofstede de Groot, 'Het portret van Stevens door A. van Dijck in het Mauritshuis', *Oud Holland*, XXXIV, 1916, pp. 34–68

HOUBRAKEN 1718–21 Arnold Houbraken, *De groote schouburgh der Nederlantsche konstschilders en schilderessen*, 3 vols, Amsterdam 1718–21

HOWARTH 1985 D. Howarth, *Lord Arundel and his Circle*, New Haven and London 1985

HOWARTH 1990 D. Howarth, 'The Arrival of Van Dyck in England', *The Burlington Magazine*, CXXXII, 1990, pp. 709–10

HOWARTH 1993 D. Howarth (ed.), *Art and Patronage in the Caroline Courts: Essays in Honour of Sir Oliver Millar*, Cambridge 1993

D'HULST 1964 R.-A. d'Hulst, *The Royal Museum, Brussels*, London 1964

HYMANS 1899 H. Hymans, 'Quelques notes sur Antoine van Dyck', *Bulletin de l'Académie Royale d'Archéologie de Belgique*, 5th series, VII, 1899, pp. 400–20

HYMANS 1899a H. Hymans, 'Antoine van Dyck et l'exposition de ses œuvres à Anvers à l'occasion du troisième centenaire de sa naissance', *Gazette des Beaux-Arts*, 3rd series, XXII, 1899, pp. 226–40, 320–32

HYMANS 1899b H. Hymans, 'Ausstellungen und Versteigerungen: Anvers Exposition Van Dyck', *Repertorium für Kunstwissenschaft*, XXII, 1899, pp. 418–22

HYMANS 1920 H. Hymans, *Œuvre*, 2 vols, Brussels 1920

JAFFÉ 1965 M. Jaffé, 'Van Dyck Portraits in the De Young Museum and Elsewhere', *Art Quarterly*, XXVIII, 1965, pp. 41–55

JAFFÉ 1966 M. Jaffé, *Van Dyck's Antwerp Sketchbook*, 2 vols, London 1966

JAFFÉ 1977 M. Jaffé, 'Rubens in Italy: A Self-Portrait', *The Burlington Magazine*, CXIX, 1977, pp. 605–8

JAFFÉ 1984 M. Jaffé, 'Van Dyck Studies II: "La belle et vertueuse Huguenotte"', *The Burlington Magazine*, CXXVI, 1984, pp. 603–11

JAFFÉ 1990 M. Jaffé, 'Van Dyck's "Venus and Adonis"', *The Burlington Magazine*, CXXXII, 1990, pp. 696–703

JAFFÉ 1994 M. Jaffé, 'On Some Portraits Painted by Van Dyck in Italy, Mainly in Genoa', in Barnes and Wheelock 1994, pp. 133–50

JOANNIDES 1991 P. Joannides, 'Titian's Daphnis and Chloë. A search for the Subject of a familiar Masterpiece', *Apollo*, CXXXIII, 1991, pp. 374–82

JOHNS 1988 C.M.S. Johns, 'Politics, Nationalism and Friendship in Van Dyck's "Le Roi à la Ciasse"', *Zeitschrift für bildende Kunst*, LI, 1988, pp. 243–63

KAHR 1972 M. Milner Kahr, 'Delilah', *Art Bulletin*, LIV, 1972, pp. 282–315

KENWOOD 1953 *The Iveagh Bequest, Kenwood, Catalogue of Paintings*, London 1953

KETTERING 1983 A. McNeil Kettering, *The Dutch Arcadia. Pastoral Art and its Audience in the Golden Age*, Montclair 1983

KING'S LYNN 1963 *Exhibition of Pictures by Sir Anthony van Dyck, 1599–1641*, exh. cat., The Fermoy Art Gallery, King's Lynn, 1963

KOEHNE 1863 B. von Koehne, *Ermitage impérial. Catalogue de la Galerie des tableaux*, St Petersburg 1863

KREMPEL 1976 U. Krempel, 'Max Emanuel als Gemäldesammler', in *Kurfürst Max Emanuel. Bayern und Europa*, exh. cat., Schleißheim 1976, I, pp. 221–38

KRONFELD 1931 A. Kronfeld, *Führer durch die Fürstlich Liechtensteinsche Gemälde Galerie in Wien*, Vienna 1931

KURZ 1957 O. Kurz, 'Van Dyck and Reni', in *Miscellanea Prof. Dr. D. Roggen*, Antwerp 1957, pp. 179–82

LAHRKAMP 1982 H. Lahrkamp, 'Der "Lange Jan", Leben und Werk des Barockmalers Johann Bockhorst', *Westfalen*, XL, 1982

LARSEN 1975 E. Larsen (ed.), *La vie, les ouvrages et les élèves de Van Dyck. Manuscrit inédit des Archives du Louvre. Par un auteur anonyme* (Académie Royale de Belgique: Mémoires de la Classe des Beaux-Arts, 2nd series, XIV–2), Brussels 1975

LARSEN 1980 E. Larsen, *L'Opera completa di Van Dyck, 1626–1641*, 2 vols, Milan 1980

LARSEN 1988 E. Larsen, *The Paintings of Anthony van Dyck*, 2 vols, Freren 1988

LEEDS 1868 *National Exhibition of works of art at Leeds*, exh. cat., Leeds Infirmary, 1868

LENINGRAD 1972 *The State Hermitage, The Art of Portraiture*, exh. cat., The State Hermitage, Leningrad, 1972

LEVESON GOWER 1910 A. Leveson Gower, 'The (so-called) Sheffield-Portrait by van Dyck in the Royal Picture Gallery at the Mauritshuis in The Hague', *Oud Holland*, XXVIII, pp. 73–6

LEVEY 1971 M. Levey, *Painting at Court*, London 1971

LIECHTENSTEIN 1885 J. Falke, *Katalog der Fürstlich Liechtensteinischen Bilder-Galerie im Gartenpalais der Rossau zu Wien*, Vienna 1885

LIEDTKE 1984 W.A. Liedtke, *Flemish Paintings in the Metropolitan Museum of Art*, 2 vols, New York 1984

LIEDTKE 1984–5 W.A. Liedtke, 'Anthony van Dyck', *Metropolitan Museum of Art Bulletin*, XLII, Winter 1984–5, pp. 1–48

LIGHTBOWN 1981 R. Lightbown, 'Bernini's Busts of English Patrons', in *Art, The Ape of Nature: Studies in Honor of H. W. Janson*, New York 1981, pp. 439–52

LIMENTANI VIRDIS 1986 C. Limentani Virdis, '"Le Quattro Eta dell'Uomo" di Van Dyck: Qualche Precisazione', *Arte Veneta*, XL, 1986, pp. 172–4

LIVERPOOL 1964 *Fifty Drawings from Christ Church*, exh. cat., Walker Art Gallery, Liverpool, 1964

LOHSE BELKIN 1987 K. Lohse Belkin, 'Titian, Rubens and Van Dyck: a New Look at Old Evidence', in G. Cavalli-Björkman (ed.), *Bacchanals by Titian and Rubens*, Stockholm 1987, pp. 143–52

LONDON 1822 *Pictures of the Italian, Spanish, Flemish and Dutch Schools*, exh. cat., London 1822

LONDON 1866 *Catalogue of the first special exhibition of national portraits: Ending with the reign of King James the Second*, exh. cat., South Kensington Museum, London, 1866

LONDON 1871 *Exhibition of the Works of Old Masters…*, exh. cat., Royal Academy, London, 1871

LONDON 1887 *Exhibition of the Works of Sir Anthony van Dyck*, exh. cat., Grosvenor Gallery, London, 1887

LONDON 1900 *Exhibition of Works by Van Dyck*, exh. cat., Royal Academy, London, 1900

LONDON 1922 *Loan Exhibition of Pictures by Old Masters: on behalf of Lord Haig's appeal for ex-servicemen*, exh. cat., Thomas Agnew & Sons, London, 1922

LONDON 1927 *Catalogue of the Loan Exhibition of Flemish and Belgian Art, a Memorial Volume*, ed. Martin Conway, Royal Academy, London, 1927

LONDON 1938 *17th-century Art in Europe, An Illustrated Souvenir of the Exhibition of 17th-century Art in Europe at the Royal Academy of Arts*, exh. cat., Royal Academy, London, 1938

LONDON 1939 *Exhibition of Portraits*, exh. cat., National Gallery, London, 1939

LONDON 1946–7 *Catalogue of the Exhibition of the King's Pictures* (text); *The King's Pictures, an Illustrated Souvenir of the Exhibition at the Royal Academy of Arts* (plates), Royal Academy, London, 1946–7

LONDON 1947a *Some Pictures from the Dulwich Gallery*, exh. cat., National Gallery, London, 1947

LONDON 1947b *Pictures from Althorp*, exh. cat., Thomas Agnew & Sons, London, 1947

LONDON 1949 *Masterpieces from the Alte Pinakothek at Munich*, exh. cat., National Gallery, London, 1949

LONDON 1953–4 *Flemish Art 1300–1700*, exh. cat., Royal Academy, London, 1953–4

LONDON 1955 *Artists in 17th Century Rome*, exh. cat., Wildenstein, London, 1955

LONDON 1956–7 *British Portraits*, exh. cat., Royal Academy, London, 1956–7

LONDON 1960 *Italian Art and Britain*, exh. cat., Royal Academy, London, 1960

LONDON 1962 *Primitives to Picasso*, exh. cat., Royal Academy, London, 1962

LONDON 1964 *The Orange and the Rose: Holland and Britain in the Age of Observation, 1600–1750*, exh. cat., Victoria and Albert Museum, London, 1964

LONDON 1968a *Sir Anthony van Dyck, a Loan Exhibition of Pictures and Sketches Principally from Private Collections in Aid of the National Trust Neptune Appeal and the King's Lynn Festival Fund*, Thomas Agnew & Sons, Ltd, London, 1968

LONDON 1968b *Van Dyck, Wenceslaus Hollar and the Miniature-Painters at the Court of the Early Stuarts*, The Queen's Gallery, Buckingham Palace, London, 1968

LONDON 1972–3 *The Age of Charles I. Painting in England 1620–1649*, exh. cat. by Oliver Millar, Tate Gallery, London, 1972–3

LONDON 1982–3 *Van Dyck in England*, exh. cat. by Oliver Millar, National Portrait Gallery, London, 1982–3

LONDON 1984 *Art, Commerce, Scholarship: A Window onto the Art World. Colnaghi 1760–1984*, exh. cat., P. and D. Colnaghi, 1984

LONDON 1986–7 *Director's Choice: Selected Acquisitions, 1973–86. An Exhibition to mark the retirement of Sir Michael Levey…*, exh. cat., National Gallery, London, 1986–7

LONDON 1988–9 *Treasures from the Royal Collection*, exh. cat. by Oliver Millar, The Queen's Gallery, Buckingham Palace, London, 1988–9

LONDON 1991 *The Queen's Pictures*, exh. cat., National Gallery, London, 1991

LONDON 1992–3 *The Swagger Portrait*, exh. cat., Tate Gallery, London, 1992–3

LONDON 1995a *In Trust for the Nation: Paintings from National Trust Houses*, exh. cat., National Gallery, London, 1995

LONDON 1995b *Dynasties: Painting in Tudor and Jacobean England: 1530–1630*, exh. cat., Tate Gallery, London, 1995

LONDON 1995–6a *Death, Passion and Politics: Van Dyck's Portraits of Venetia Stanley and George Digby*, exh. cat., ed. Ann Sumner, Dulwich Picture Gallery, London 1995–6

LONDON ET AL. 1972 *Flemish Drawings of the Seventeenth Century from the Collection of Frits Lugt*, Victoria and Albert Museum, London; Institut Néerlandais, Fondation Custodia, Paris; Kunstmuseum, Berne; Royal Library, Brussels, 1972

LORANDI 1984 M. Lorandi, 'Le pose, le armi, gli onori, i Tasso e la committenza artistica. Internazionalità del potere, internazionalità dell'arte', in *Le poste dei Tasso, un'impresa in Europa*, exh. cat., Bergamo 1984

LUCERNE 1948 *Meisterwerke aus den Sammlungen des Fürsten von Liechtenstein*, exh. cat., Kunstmuseum, Lucerne, 1948

LÜTZOW 1889 C. von Lützow, *Catalog der Gemäldegalerie der Akademie der bildenden Künste*, Vienna 1889

DE MADRAZO 1913 Don Pedro de Madrazo, *Catalogue des tableaux du Musée du Prado*, Madrid 1913

MAGURN 1955 R. S. Magurn, ed. and trans., *The Letters of Peter Paul Rubens*, Cambridge MA 1955

MALIBU 1985, see White 1985

DE MAN 1979 R. De Man, 'Kanunnik Rogier Braye (1550–1632), schenker van de "Kruisoprichting" door Antoon van Dyck', *Handelingen van de Koninklijke Geschied- en Oudheidkundige Kring te Kortrijk*, XLVI, 1979, pp. 39–94

DE MAN 1980a R. De Man, 'Het schilderij "De Kruisoprichting" door Antoon van Dyck in Onze-Lieve-Vrouw te Kortrijk', *Handelingen van de Koninklijke Geschied- en Oudheidkundige Kring te Kortrijk*, XLVII, 1980, pp. 53–154

DE MAN 1980b R. De Man, 'Documenten over het mecenaat van R. Braye (ca. 1550–1632) te Kortrijk en de schilderijen van G. de Crayer en A. Van Dijck', *Jaarboek Koninklijk Museum voor Schone Kunsten Antwerpen*, 1980, pp. 233–59

MANCHESTER 1857 *Art Treasures of the United Kingdom*, exh. cat., Manchester 1857

MARTIN 1935 W. Martin, *Musée royal de tableaux Mauritshuis à La Haye. Catalogue raisonné des tableaux et sculptures*, The Hague 1935

MARTIN 1970 G. Martin, *The Flemish Schools, circa 1600–circa 1900*, National Gallery, London 1970

MARTIN 1973 G. Martin, '"The Age of Charles I" at the Tate', *The Burlington Magazine*, CXV, 1973, pp. 56–9

MARTIN 1977 J.R. Martin, 'Van Dyck as History Painter: "The Mocking of Christ"', *Proceedings of the American Philosophical Society*, Philadelphia, CXXI, 1977, pp. 227–34

MARTIN 1981 J.R. Martin, 'Van Dyck's Early Paintings of St. Sebastian', *Art, the Ape of Nature, Studies in Honor of H. W. Janson*, New York 1981, pp. 393–400

MARTIN 1983 J.R. Martin, 'The Young van Dyck and Rubens', in *Essays on Van Dyck*, Ottawa 1983, pp. 37–44; reprinted in *Revue d'Art Canadienne/Canadian Art Review (RACAR)*, X, 1983, pp. 37–43

MARTIN AND FEIGENBAUM 1979, see Princeton 1979

MAUQUOY-HENDRICKX 1956, 1991 M. Mauquoy-Hendrickx, *L'Iconographie d'Antoine van Dyck*, 2 vols, Brussels 1956; 2nd ed. Brussels 1991

MAURITSHUIS 1977 *Mauritshuis. The Royal Cabinet of Paintings. Illustrated General Catalogue*, The Hague 1977

MAURITSHUIS 1985 *The Royal Picture Gallery Mauritshuis*, ed. H. R. Hoetink, Amsterdam, The Hague, and New York 1985

MAURITSHUIS 1993 *Mauritshuis Illustrated General Catalogue*, The Hague 1993

MAYER 1922 A.L. Mayer, *Meisterwerke der Gemäldesammlung des Prado in Madrid*, Munich 1922

MAYER 1923 A.L. Mayer, *Anthonis van Dyck*, Munich 1923

MECHEL 1783 C. von Mechel, *Verzeichniss der Gemälde der kaiserlich-königlichen Bilder Galerie in Wien*, Vienna 1783

MEIJER 1990 B.W. Meijer, 'Rubens, Van Dyck e la "Continenza di Scipione"', in *Rubens dall'Italia all'Europa: Atti del convegno internazionale di studi*, Padua 1990, ed. C.L. Virdis and F. Bottacin, Vicenza 1997, pp. 131–44

MENOTTI 1897 M. Menotti, 'Van Dyck a Genova', *Archivio storico dell'arte*, III, 1897, pp. 281–308, 360–97, 432–70

MENSAERT 1763 G.P. Mensaert, *Le peintre amateur et curieux*, 2 vols, Brussels 1763

MICHIELS 1881 A. Michiels, *Van Dyck et ses élèves*, Paris 1881

MIELKE AND WINNER 1977 H. Mielke and M. Winner, *Peter Paul Rubens: Kritischer Katalog der Zeichnungen*, Munich 1977

MILLAR 1951 O. Millar, 'Van Dyck's Continence of Scipio at Christ Church', *The Burlington Magazine*, XCIII, 1951, pp. 125–27

MILLAR 1954 O. Millar, 'Charles I, Honthorst, and Van Dyck', *The Burlington Magazine*, XCVI, 1954, pp. 36–42

MILLAR 1955 O. Millar, 'Van Dyck at Genoa', *The Burlington Magazine*, XCVII, 1955, pp. 312–15

MILLAR 1958 O. Millar, 'Van Dyck and Sir Thomas Hanmer', *The Burlington Magazine*, C, 1958, p. 249

MILLAR 1960 O. Millar (ed.), 'Abraham van der Doort's Catalogue of the Collection of Charles I', *Walpole Society*, XXXVII, 1960

MILLAR 1962 O. Millar, 'Some Painters and Charles I', *The Burlington Magazine*, CIV, 1962, pp. 324–30

MILLAR 1963a O. Millar, *The Tudor, Stuart and Early Georgian Pictures in the Collection of H.M. The Queen*, London 1963

MILLAR 1963b O. Millar, 'Van Dyck and Thomas Killigrew', *The Burlington Magazine*, CV, 1963, p. 409

MILLAR 1968 O. Millar, 'Van Dyck in London', *The Burlington Magazine*, CX, 1968, pp. 306–11

MILLAR 1972 O. Millar (ed.), 'The Inventories and Valuations of the King's Goods, 1649–51', *Walpole Society*, XLIII, 1972

MILLAR 1986 O. Millar, 'Strafford and Van Dyck', in *For Veronica Wedgwood These: Studies in Seventeenth-Century History*, ed. R. Ollard and P. Tudor-Craig, London 1986, pp. 109–23

MILLAR 1994 O. Millar, 'Philip, Lord Wharton, and his Collection of Portraits', *The Burlington Magazine*, CXXXVI, 1994, pp. 517–30

MOIR 1994 A. Moir, *Anthony Van Dyck*, New York 1994

VAN MOLLE 1953 F. Van Molle, 'De Kruisoprichting in de O.-L.-Vrouwekerk te Kortrijk. Een onderschuiving weerlegd', *Annales de la Fédération historique et archéologique de Belgique*, 1953 (1961), pp. 145–59

MONBALLIEU 1973 A. Monballieu, 'Cesare Alessandro Scaglia en de "Bewening van Christus" door A. Van Dijck', *Jaarboek Koninklijk Museum voor Schone Kunsten Antwerpen*, 1973, pp. 247–68

MOSCOW 1972 *Portret v evropeiskoi zhivopisi xv nachala xx veka [The Portrait in European Painting from the 15th to the Early 20th Century]*, exh. cat., Moscow 1972

MOSCOW AND LENINGRAD 1979 *Australian and European Masterpieces from Australian National Galleries*, Pushkin Museum, Moscow; Hermitage, Leningrad, 1979–80

MULLER 1989 J.M. Muller, *Rubens: The Artist as Collector*, Princeton 1989

MÜLLER HOFSTEDE 1987–8 Justus Müller Hofstede, 'Neue Beiträge zum Oeuvre Anton van Dycks', *Wallraf-Richartz-Jahrbuch*, XLVIII–XLIX, 1987–8, pp. 123–86

MÜLLER-ROSTOCK 1922 J. Müller-Rostock, 'Ein Verzeichnis von Bildern aus dem Besitze des Van Dyck', *Zeitschrift für bildende Kunst*, XXXIII, 1922, pp. 22–4

MUNICH 1983 *Alte Pinakothek München*, Munich 1983

MUÑOZ 1941 A. Muñoz, *Van Dyck*, Novara 1941

MUNZ 1955 L. Munz, *Katalog und Führer der Gemäldegalerie, Akademie der bildenden Künste in Wien*, Vienna 1955

MURRAY 1980 P. Murray, *Dulwich Picture Gallery: A Catalogue*, London 1980

NATIONAL GALLERY OF CANADA 1987 *Catalogue of the National Gallery of Canada: European and American Painting, Sculpture and Decorative Arts*, 2 vols, Ottawa 1987

NEW HAVEN ET AL. 1996–7 *British Art Treasures from Russian Imperial Collections in the Hermitage*, exh. cat., Yale Center for British Art, New Haven; Toledo Museum of Art; The St Louis Art Museum; The State Hermitage Museum, St Petersburg, 1996–7

NEW YORK 1909 *Exhibition of Portraits by Van Dyck from the Collections of Mr. P.A.B. Widener and Mr. H.C. Frick*, exh. cat., M. Knoedler & Co., New York, 1909

NEW YORK 1939 *European Paintings and Sculpture from 1300–1500: Masterpieces of Art*, exh. cat., New York 1939

NEW YORK 1985–6 *Liechtenstein: The Princely Collections*, exh. cat., The Metropolitan Museum of Art, New York, 1985–6

NEW YORK AND CHICAGO 1988 *Dutch and Flemish Paintings from the Hermitage*, The Metropolitan Museum of Art, New York; The Art Institute of Chicago, 1988

NORDENFALK 1938 C. Nordenfalk, 'Ein wiedergefundenes Gemälde des Van Dyck', *Jahrbuch der Preußischen Kunstsammlungen*, LIX, 1938, pp. 36–48

NOTTINGHAM 1960 *Paintings and Drawings by Van Dyck*, exh. cat., Nottingham University Art Gallery, 1960

OPPÉ 1941 A.P. Oppé, 'Sir Anthony van Dyck in England', *The Burlington Magazine*, LXXIX, 1941, pp. 186–91

ORGEL AND STRONG 1973 S. Orgel and R. Strong, *Inigo Jones: the Theatre of the Stuart Court*, London 1973

OSTROWSKI 1981 J.K. Ostrowski, *Van Dyck et la peinture génoise du XVII siècle*, Cracow 1981

OTTAWA 1980 *The Young Van Dyck / Le jeune Van Dyck*, exh. cat. by Alan McNairn, National Gallery of Canada, Ottawa, 1980

OTTAWA 1983 *Essays on van Dyck*, Ottawa 1983

OXFORD 1985–6 *Patronage and Collecting in the Seventeenth Century: Thomas Howard, Earl of Arundel*, exh. cat. by David Howarth, The Ashmolean Museum, Oxford, 1985–6

PADUA 1990 *Pietro Paolo Rubens (1577–1640)*, exh. cat., ed. D. Bodart, Padua 1990

PAPEBROCHIUS c.1700 D. Papebrochius, *Annales Antverpienses, ab Urbe condita ad annum MDCC*, ed. F.H. Mertens and E. Buschmann, 5 vols, Antwerp 1847–8

PARIS 1879 *Catalogue descriptif des dessins des maîtres anciens exposés à l'Ecole des Beaux-Arts*, Paris 1879

PARIS 1936 *Rubens et son temps*, exh. cat. by René Huyghe, Musée de l'Orangerie, Paris, 1936

PARIS 1947 *Art flamand des XV*, *XVI* *et XVII*, *siècles*, exh. cat., Ecole Nationale Supérieure des Beaux-Arts, Paris, 1947

PARIS 1977–8 *Le siècle de Rubens dans les collections publiques françaises*, exh. cat., Grand Palais, Paris, 1977–8

PARRY 1981 Graham Parry, *The Golden Age Restor'd: The Culture of the Stuart Court, 1603–42*, Manchester 1981

PASSAVANT 1836 J.D. Passavant, *Tour of a German Artist in England, with Notices of Private Galleries, and Remarks on the State of Art*, 2 vols, London 1836

PEETERS 1930 F. Peeters, *Sint-Augustinuskerk te Antwerpen*, Antwerp 1930

PHILLIPE 1970 J. Phillipe, 'Nouvelles découvertes sur Jordaens', *Jaarboek Koninklijk Museum voor Schone Kunsten Antwerpen*, 1970, p. 219

PHILLIPS 1896 C. Phillips, *The Picture Gallery of Charles I*, London 1896

DE PILES 1708 R. de Piles, *Cours de Peinture par Principes*, Paris 1708

PIOT 1878 C. Piot, 'Les tableaux des collèges des Jésuites supprimés en Belgique', *Bulletin de l'Académie Royale des Sciences, des Lettres et des Beaux-Arts de Belgique*, XLVI, 1878, pp. 139–53

PIOT 1883 C. Piot, *Rapport à M. le Ministre de l'Intérieur sur les tableaux enlevés à la Belgique en 1794 et restitués en 1815*, Brussels 1883

POCH-KALOUS 1972 M. Poch-Kalous, *Katalog der Gemälde-Galerie, Akademie der bildenden Künste in Wien*, Vienna 1972

POCH-KALOUS AND HUTTER 1968 M. Poch-Kalous and H. Hutter, *Die Gemäldegalerie in Wien*, Vienna 1968

PONZ 1793 A. Ponz, *Viage de España*, 12 vols, 3rd ed., V, Madrid 1793

PRINCETON 1979 *Van Dyck as a Religious Artist*, exh. cat. by John Rupert Martin and Gail Feigenbaum, Princeton University, The Art Museum, Princeton, 1979

VAN DE PUT 1912, 1914 A. van de Put, '"The Prince of Oneglia" by Van Dyck', *The Burlington Magazine*, XXI, 1912, pp. 311–14; XXV, 1914, p. 59

VAN PUYVELDE 1937 L. van Puyvelde, 'Les Portraits des femmes de Rubens', *Revue de l'Art*, 3rd per., LXXI, 1937, pp. 5–7

VAN PUYVELDE 1940 L. van Puyvelde, 'Van Dyck's St Martin at Windsor and at Saventhem', *The Burlington Magazine*, LXXVII, 1940, pp. 36–42

VAN PUYVELDE 1941 L. van Puyvelde, 'The Young Van Dyck', *The Burlington Magazine*, LXXIX, 1941, pp. 177–85

VAN PUYVELDE 1950 L. van Puyvelde, *Van Dyck*, Brussels and Paris 1950

VAN PUYVELDE 1955 L. van Puyvelde, 'Van Dyck a Genova', *Emporium*, CXXII, 1955, pp. 99–116

RATTI 1766 Carlo Giuseppe Ratti, *Instruzione di quanto puo' vedersi di più bello in Genova in pittura, scultura et architettura*, Genoa 1766

RATTI 1780a Carlo Giuseppe Ratti, *Descrizione delle pitture, scolture, e architetture che trovansi in alcune città, borghi e castelli delle due riviere dello stato ligure*, Genoa 1780

RATTI 1780b Carlo Giuseppe Ratti, *Instruzione di quanto può vedersi di più bello in Genova in Pittura, Scultura, ed Architettura ecc.*, Genoa 1780

RÉAU 1912 L. Réau, 'La Galerie des Tableaux de l'Ermitage et la Collection Semenov', *Gazette des Beaux-Arts*, 4th series, VIII, 1912, pp. 379–96, 471–88

REYNOLDS 1781, ED. 1852 *The Literary Works of Sir Joshua Reynolds*, ed. H.W. Beechey, II, London 1852

RICKETTS 1903 C.S. Ricketts, *The Prado and its Masterpieces*, London 1903

RICKETTS 1905 C. Ricketts, 'The Portrait of Isabella Brant in the Hermitage', *The Burlington Magazine*, VII, 1905, pp. 83–4

ROGERS 1978 M.F. Rogers, 'The Meaning of Van Dyck's Portrait of Sir John Suckling', *The Burlington Magazine*, CXX, 1978, pp. 741–5

ROGERS 1980 M.F. Rogers, *Favourite Paintings from the Cincinnati Museum*, New York 1980

ROGERS 1993 M.F. Rogers, 'Golden Houses for Shadows: Some Portraits of Thomas Killigrew and his Family', in *Art and Patronage in the Caroline Courts: Essays in Honour of Sir Oliver Millar*, ed. D. Howarth, Cambridge 1993, pp. 224–6

ROLAND 1983 M. Roland, 'Some Thoughts on Van Dyck's Apostle Series', *Revue d'Art Canadienne / Canadian Art Review (RACAR)*, X, 1983, pp. 23–36

ROLAND 1984 M. Roland, 'Van Dyck's Early Workshop, the "Apostle" Series and the "Drunken Silenus"', *The Art Bulletin*, LXVI, 1984, pp. 211–23

ROME 1966 *Dipinti fiamminghi di collezioni romane*, exh. cat., Palazzo Barberini, Rome, 1966

ROOSES 1879 M. Rooses, *Geschiedenis der Antwerpse Schilderschool*, Ghent 1879

ROOSES 1886–92 M. Rooses, *L'œuvre de P.P. Rubens*, 5 vols, Antwerp 1886–92

ROOSES 1890 M. Rooses, *Rubens' Leben und Werke*, Stuttgart 1890

ROOSES 1900 M. Rooses, *Vijftig meesterwerken van Antoon van Dyck*, Antwerp 1900

ROOSES 1904 M. Rooses, 'Die vlämischen Meister in der Ermitage' *Zeitschrift für bildende Kunst*, XV, 1904, pp. 114–17

ROOSES 1905 M. Rooses, 'The Portrait of Isabella Brant in the Hermitage', *The Burlington Magazine*, VI, 1905, pp. 496–7

ROOSES 1906 M. Rooses, *Jordaens. Leven en Werken*, Amsterdam and Antwerp 1906

ROOSES 1907 M. Rooses, 'Les années d'étude et de voyage de Van Dyck', *Art Flamand et Hollandais*, VIII, 1907, pp. 1–19, 101–10

ROOSES 1911 M. Rooses, 'De Vlaamsche Kunst in de XVIIe eeuw tentoongesteld in het Jubelpaleis te Brussel in 1910', *Onze Kunst*, XIX, 1911, pp. 1–12, 41–9

ROSENBAUM 1928a H. Rosenbaum, *Der junge Van Dyck (1615–21)*, Ph.D. diss. Ludwig-Maximilians Universität, Munich 1928

ROSENBAUM 1928b H. Rosenbaum, 'Über früh-Porträts von Van Dyck', *Der Cicerone*, XX, 1928, pp. 325–32, 361–5

ROTTERDAM 1985 *Masterpieces from the Hermitage, Leningrad*, exh. cat., Museum Boijmans Van Beuningen, Rotterdam, 1985

ROUCHÈS 1924 G. Rouchès, *L'Ecole des Beaux-Arts*, Paris 1924

SANDERUS 1727 A. Sanderus, *Chorographia Sacra Brabantiae*, 3 vols, The Hague 1727

SAN FRANCISCO 1939–40 *Masterworks from Five Centuries*, exh. cat., Golden Gate International Exposition, San Francisco, 1939–40

SCHAEFFER 1909 E. Schaeffer, *Van Dyck. Des Meisters Gemälde* (Klassiker der Kunst, XIII), Stuttgart and Leipzig 1909

SCHEELEN 1988 W. Scheelen, 'Het lot van de schilderijencollecties van de Zuidnederlandse Jezuïetencolleges na de opheffing van de Orde in 1773', *Jaarboek Koninklijk Museum voor Schone Kunsten Antwerpen*, 1988, pp. 261–341

SCHINZEL 1980 H. Schinzel, *Raumprobleme des Ganzfigurenporträts in England von 1600 bis 1640*, Frankfurt 1980

SCHLUGLEIT 1939 D. Schlugleit, 'L'abbé De Scaglia, Jordaens et l'histoire de Psyche de Greenwich-House', *Revue Belge d'Archéologie et d'Histoire de l'Art*, VII, 2, 1937

SCHNACKENBURG 1985 B. Schnackenburg, *Flämische Meister in der Kasseler Gemäldegalerie*, Kassel 1985

SCHWEMMINGER 1866 H. Schwemminger, *Verzeichnis der Gemäldesammlung der K.-K. Akademie der bildenden Künste*, Vienna 1866

SCOTT 1987 M.A. Scott, *Dutch, Flemish and German paintings (Fifteenth–Eighteenth Centuries) Cincinnati Art Museum*, Cincinnati 1987

SMITH 1829–42 J. Smith, *Catalogue Raisonné of the most eminent Dutch, Flemish and French Painters*, 9 vols, London 1829–42

SMITH 1982 D.R. Smith, *Masks of Wedlock: Seventeenth-Century Dutch Marriage Portraiture*, Ann Arbor, Michigan, 1982

SOMOF 1895, 1901 A. Somof, *Catalogue de la galerie des tableaux*, St Petersburg 1895, 1901

SOPRANI 1674 R. Soprani, *Le vite de' Pittori, Scoltori et Architetti Genovesi, e de Forastieri che in Genova operarono con alcuni Ritratti de gli stessi...*, Genoa 1674

SPETH-HOLTERHOFF 1957 S. Speth-Holterhoff, *Les peintres flamands de cabinets d'amateurs au XVII siècle*, Brussels 1957

SPICER 1985–6 J. Spicer, 'Unrecognized Studies for Van Dyck's Iconography in the Hermitage', *Master Drawings*, XXIII–XXIV, 1985–6, pp. 537–44

STEWART 1983 J. Douglas Stewart, '"Hidden Persuaders": Religious Symbolism in van Dyck's Portraiture. With a Note on Dürer's "Knight, Death and the Devil"', in *Essays on Van Dyck*, Ottawa 1983, pp. 57–68

STEWART 1986 J. Douglas Stewart, '"Van Dyck" by Christopher Brown', *Revue d'Art Canadienne / Canadian Art Review (RACAR)*, XIII, 1986, pp. 138–41

VAN DER STIGHELEN 1987 K. Van der Stighelen, 'The Provenance and Impact of Anthony van Dyck's Portraits of Frans Snijders and Margaretha de Vos in the Frick Collection', *The Hoogsteder-Naumann Mercury*, V, 1987, pp. 37–47

VAN DER STIGHELEN 1994 K. Van der Stighelen, 'Young Anthony. Archival Discoveries Relating to Van Dyck's Early Career', in Barnes and Wheelock 1994, pp. 17–46

VAN DER STIGHELEN 1995 K. Van der Stighelen, 'Cornelia Pruystinck en Lynken Cuypers: over de grootmoederlijke erfenis van Anton van Dijck', *Jaarboek Koninklijk Museum voor Schone Kunsten Antwerpen*, 1995, pp. 243–87

ST LOUIS 1947 *Forty Masterpieces of Painting*, exh. cat., City Museum, St Louis, 1947

ST PETERSBURG 1870 *Ermitage impérial, Catalogue de la Galerie des Tableaux, Les Ecoles germaniques*, St Petersburg 1870

STROHMER 1943 E. von Strohmer, *Die Gemäldegalerie des Fürsten Liechtenstein zu Wien*, Vienna 1943

STRONG 1972 R. Strong, *Charles I on Horseback*, London 1972

TAGLIAFERRO 1995 L. Tagliaferro, *La magnificenza privata. 'Argenti, gioie, quadri e altri mobili' della famiglia Brignole-Sale. Secoli XVI–XIX*, Genoa 1995

TARDITO AMERIO 1982 R. Tardito Amerio, *Galleria Sabauda: 150 anniversario (1832–1982): Alcuni interventi di restauro*, Turin 1982

TESSIN 1687 N. Tessin, *Studieresor i Danmark, Tyskland, Holland, Frankrike och Italien*, ed. O. Sirén, Stockholm 1914

THE HAGUE 1993 *Mauritshuis Illustrated General Catalogue*, The Hague 1993

TIETZE-CONRAT 1932 E. Tietze-Conrat, 'Van Dyck's "Samson and Delilah"', *The Burlington Magazine*, LXI, 1932, pp. 246–7

TRNEK 1989 R. Trnek, *Gemäldegalerie der Akademie der bildenden Künste in Wien. Illustriertes Bestandsverzeichnis*, Vienna 1989

URBACH 1983 S. Urbach, 'Preliminary Remarks on the Sources of the Apostle Series of Rubens and van Dyck', *Revue d'Art Canadienne / Canadian Art Review (RACAR)*, X, 1985, pp. 5–22

VADUZ 1955 *Flämische Malerei im 17. Jahrhundert: Ausstellung aus den Sammlungen seiner Durchlaucht des Fürsten von Liechtenstein*, Vaduz 1955

VADUZ 1967 G. Wilhelm, *Flämische Malerei im 17. Jahrhundert: Ausstellung aus den Sammlungen seiner Durchlaucht des Fürsten von Liechtenstein*, Vaduz 1967

VAES 1924 M. Vaes, 'Le séjour de Van Dyck en Italie (Mi-Novembre 1621–Automne 1627)', *Bulletin de l'Institut Historique Belge à Rome*, IV, 1924, pp. 163–234

VAES 1925 M. Vaes, 'Corneille de Wael', *Bulletin de l'Institut Historique Belge à Rome*, V, 1925, pp. 137–247

VAES 1927 M. Vaes, 'L'auteur de la biographie d'Antoine van Dyck de la Bibliothèque du Musée du Louvre: Dumont, amateur d'art à Amsterdam', *Bulletin de l'Institut Historique Belge à Rome*, VII, 1927, pp. 139–141

VALENTINER 1910 W. R. Valentiner, 'Frühwerke des Anton van Dyck in Amerika', *Zeitschrift für bildende Kunst*, XXI, 1910, pp. 225–31

VALENTINER 1914 W. R. Valentiner, *The Art of the Low Countries: Studies*, New York 1914

VARSHAVSKAYA 1963 M. Varshavskaya, *Van Dyck Paintings in the Hermitage*, Leningrad 1963

VAN DE VELDE 1977 C. Van de Velde, 'Archivalia betreffende Rubens' "Madonna met heiligen" voor de kerk der Antwerpse Augustijnen', *Jaarboek Koninklijk Museum voor Schone Kunsten Antwerpen*, 1977, pp. 221–34

VENICE 1946 *Capolavori dei Musei Veneti*, exh. cat., Venice 1946

VERTUE 1757 G. Vertue, *A Catalogue and Description of King Charles the First's Capital Collection of Pictures…, and other Curiosities*, London 1757

VERTUE 1930–55 G. Vertue, 'Notebooks', *Walpole Society*, XVIII, 1930; XX, 1932; XXII, 1934; XXIV, 1936; XXVI, 1938; XXIX, 1947; XXX, 1955

VESME 1885 A. Baudi di Vesme, *Van Dyck: Peintre de Portraits des Princes de Savoie*, Turin 1885

VEY 1956 H. Vey, 'Anton van Dycks Ölskizzen', *Bulletin Koninklijke Musea voor Schone Kunsten*, V, 1956, pp. 167–208

VEY 1958 H. Vey, *Van Dyck-Studien*, diss., Cologne 1958

VEY 1960 H. Vey, 'Anton van Dyck über Maltechnik', *Bulletin des Musées Royaux des Beaux-Arts de Belgique*, IX, 1960, pp. 193–201

VEY 1961 H. Vey, 'Die Kunstsammlung Pastor Theodor van Dycks', *Bulletin des Musées Royaux des Beaux-Arts de Belgique*, X, 1961, pp. 19–28

VEY 1962 H. Vey, *Die Zeichnungen Anton van Dycks*, 2 vols, Brussels 1962

VIARDOT 1860 L. Viardot, *Les Musées d'Espagne: Guide et memento de l'artiste et du voyageur…*, 3rd ed., Paris 1860

VIENNA 1977 *Peter Paul Rubens (1577–1640)*, exh. cat., Kunsthistorisches Museum, Vienna, 1977

VIENNA 1987 *De Vlaamse schilderkunst in het Kunsthistorisches Museum te Wenen* (Flandria extra Muros), Antwerp 1987

VIENNA 1981 *Gemälde aus der Ermitage und den Pushkin Museum*, exh. cat., Kunsthistorisches Museum, Vienna, 1981

VILLOT 1852 F. Villot, *Notice des tableaux exposés dans les galeries du Musée national du Louvre, 2e partie, écoles allemande, flamande et hollandaise*, Paris 1852

VLIEGHE 1972 H. Vlieghe, 'Antoon van Dyck. De kruisoprichting', *Openbaar Kunstbezit*, X, 1972

VLIEGHE 1972, 1973 H. Vlieghe, *Saints*, 2 vols (Corpus Rubenianum Ludwig Burchard, Part VII, 1972; VIII, 1973), Brussels and London 1972–3

VLIEGHE 1994 H. Vlieghe, 'Thoughts on Van Dyck's Early Fame and Influence in Flanders', in Barnes and Wheelock 1994, pp. 199–200

VOGEL 1958 H. Vogel (ed.), *Katalog der Staatlichen Gemäldegalerie zu Kassel*, Kassel 1958

VOLL 1904 K. Voll, *Die Meisterwerke der Königlichen Gemälde-Galerie zu Cassel*, Kassel 1904

WAAGEN 1838 G. F. Waagen, *Works of Art and Artists in England*, London 1838

WAAGEN 1854 G. F. Waagen, *Treasures of Art in Great Britain: Being an Account of Paintings, Drawings, Sculptures, Illuminated MSS., &, &*, 3 vols, London 1854

WAAGEN 1864 G. F. Waagen, *Die Gemäldesammlung in der kaiserlichen Ermitage zu St Petersburg*, Munich 1864

WAAGEN 1866 G. F. Waagen, *Die vornehmsten Kunstdenkmäler in Wien*, 2 vols, Vienna 1866

WAAGEN 1868 G. F. Waagen, 'Über in Spanien vorhandene Bilder, Miniaturen und Handzeichnungen', *Jahrbuch für Kunstwissenschaft*, I, 1868, p. 98

WAGNER 1983 I. J. R. Wagner, *Manuel Godoy: Patrón de las artes y coleccionista*, unpublished thesis, Madrid 1983

WALPOLE 1762–71, ED. 1888 H. Walpole, *Anecdotes of Painting in England with some account of the principal artists*, ed. J. Dalloway, revised by R. Wornum, 3 vols, London 1888

WALSH 1994 A. L. Walsh, 'Van Dyck at the Court of Frederik-Hendrik', in Barnes and Wheelock 1994, pp. 223–46

WASHINGTON 1978–9 *The Splendor of Dresden: Five Centuries of Art Collecting*, National Gallery of Art, Washington; The Metropolitan Museum of Art, New York; The Fine Arts Museums of San Francisco, California Palace of The Legion of Honor

WASHINGTON 1985 *European Paintings: An Illustrated Catalogue*, National Gallery of Art, Washington, DC, 1985

WASHINGTON 1985–6a *Collection for a King: Old Master Paintings from the Dulwich Picture Gallery*, exh. cat., National Gallery of Art, Washington, DC, 1985–6

WASHINGTON 1985–6b *The Treasure Houses of Britain: Five Hundred Years of Private Patronage and Art Collecting*, exh. cat., National Gallery of Art, Washington, DC, 1985–6

WASHINGTON 1990–91 *Anthony van Dyck*, exh. cat., National Gallery of Art, Washington, DC, 1990–91

WASHINGTON AND NEW YORK 1975–6 *Master Paintings from the Hermitage and the State Russian Museum, Leningrad*, National Gallery of Art, Washington, DC; The Metropolitan Museum of Art, New York, 1975–6

WATERHOUSE 1938 E. K. Waterhouse, 'Seventeenth-century Art in Europe at Burlington House', *The Burlington Magazine*, LII, 1938, p. 13

WATERHOUSE 1978 E. K. Waterhouse, *Anthony van Dyck, Suffer Little Children to Come unto Me / Antoine van Dyck, Laissez les enfants venir à Moi* (Masterpieces in the National Gallery of Canada, 11), Ottawa 1978

WEINER 1923 P. P. von Weiner, *Meisterwerke der Gemäldesammlung in der Eremitage zu Petrograd*, Munich 1923

WETHEY 1969–75 H. E. Wethey, *The Paintings of Titian*, 3 vols, London 1969–75

WHITE 1995 C. White, *Anthony van Dyck: Thomas Howard, the Earl of Arundel* (Getty Museum Studies on Art), Malibu 1995

VAN DEN WIJNGAERT 1943 F. van den Wijngaert, *Antoon van Dyck*, Antwerp 1943

WILHELM 1911 F. Wilhelm, 'Neue Quellen zur Geschichte des Fürstlich Liechtensteinischen Kunstbesitzes', *Jahrbuch des Kunsthistorischen Instituts der K.-K. Zentralkommission für Denkmalpflege*, V, 1911, Beiblatt, pp. 88–142

WILHELM 1976 G. Wilhelm, 'Die Fürsten von Liechtenstein und ihre Beziehungen zu Kunst und Wissenschaft', *Jahrbuch der Liechtensteinischen Kunstgesellschaft*, I, 1976, pp. 9–179

DE WIT c. 1748, ED. 1910 J. de Wit, *De kerken van Antwerpen, met aanteekeningen door J. de Bosschere en grondplannen* (Uitgaven der Antwerpsche Bibliophilen, 25), Antwerp and The Hague 1910

WOERMANN 1887 K. Woermann, *Katalog der Königlichen Gemäldegalerie zu Dresden*, Gemäldegalerie Dresden, 1887

WOOD 1990 J. Wood, 'Van Dyck's "Cabinet de Titien": the contents and dispersal of his collection', *The Burlington Magazine*, CXXXII, 1990, pp. 680–95

WOOD 1992 J. Wood, 'Van Dyck's Pictures for the Duke of Buckingham: The Elephant in the Carpet and the Dead Tree with Ivy', *Apollo*, CXXXVI, 1992, pp. 37–47

WOOD 1994 J. Wood, 'Van Dyck and the Earl of Northumberland: Taste and Collecting in Stuart England', in Barnes and Wheelock 1994, pp. 290–303

DE WYZEWA 1890 T. de Wyzewa, *Les grands peintres de Flandres et de la Hollande*, Paris 1890

YOUNG 1823 J. Young, *A Catalogue of the Celebrated Collection of Pictures of the late John Julius Angerstein, Esq…*, London 1823

ZAREMBA FILIPCZAK 1989 Z. Zaremba Filipczak, 'Van Dyck's "Life of St. Rosalie"', *The Burlington Magazine*, CXXXI, 1989, pp. 693–8

ZURICH 1946 *Meisterwerke aus Österreich. Zeichnungen, Gemälde, Plastik*, exh. cat., Zurich 1946

Lenders to the Exhibition

Her Majesty The Queen
19, 86, 90, 95, 100

Accepted by Her Majesty's Government in Lieu of Inheritance Tax in 1999 78

Trustees of the Abercorn Heirlooms Settlement 42

Althorp
The Collection at Althorp Park 93

Amsterdam
Rijksmuseum 105

Antwerp
Koninklijk Museum voor Schone Kunsten 13, 51, 52, 85
Kerkfabriek Onze-Lieve-Vrouw 61
Kerkfabriek Sint-Paulus 7

Arundel Castle
His Grace The Duke of Norfolk KG 9

Birmingham
The Barber Institute of Fine Arts, the University of Birmingham 39, 83

Bristol Museums and Art Gallery 24

Broadlands
Lord Romsey 14

Brussels
Musées Royaux des Beaux-Arts de Belgique 5, 11, 44, 54

Budapest
Szépművészeti Múzeum 6

Chatsworth
The Duke of Devonshire and Chatsworth House Trust 101

Cincinnati Art Museum 43

Dresden
Gemäldegalerie Alte Meister 23

Edinburgh
National Gallery of Scotland 41
Scottish National Portrait Gallery 91

Firle
Trustees of Firle Estate Settlement Trust 76

Genoa
Galleria di Palazzo Bianco 38
Galleria di Palazzo Rosso 46, 47

The Hague
Koninklijk Kabinet van Schilderijen 'Mauritshuis' 48, 49, 82

Kassel
Staatliche Museen, Gemäldegalerie 81

Kroměříž
Archiepiscopal Castle and Gardens in Kroměříž 65

London
The Trustees of Dulwich Picture Gallery 21, 35, 69
English Heritage (The Iveagh Bequest, Kenwood) 74
The Trustees of the National Gallery 20, 22, 28, 40, 83, 97
National Portrait Gallery 70

Los Angeles
The J. Paul Getty Museum 25

Madrid
Museo Nacional del Prado 12, 88

Melbourne
National Gallery of Victoria 75, 104

Memphis
Memphis Brooks Museum of Art 92

Munich
Bayerische Staatsgemälde-sammlungen, Alte Pinakothek 53, 60

New York
The Metropolitan Museum of Art 71, 72

Ottawa
National Gallery of Canada 8

Oxford
The Governing Body of Christ Church 4, 26

Paris
Ecole Nationale Supérieure des Beaux-Arts 63, 84
Musée du Louvre, Département des Peintures 57, 94

Petworth
Lord Egremont 98
Petworth House, The Egremont Collection (The National Trust) 29, 30

Pommersfelden
Graf von Schönborn Collection 62

Rome
Pinacoteca Capitolina 45

St Petersburg
The State Hermitage Museum 15, 31, 73, 99, 103

The Trustees of the Rt. Hon. Olive, Countess Fitzwilliam's Chattels Settlement, by permission of Lady Juliet Tadgell 68, 102

Tatton Park
Tatton Park, The Egerton Collection (by courtesy of The National Trust and Cheshire County Council) 32

Turin
Galleria Sabauda 79, 87

Vaduz
Collections of the Prince of Liechtenstein, Vaduz Castle 9, 10, 55

Vicenza
Museo Civico d'Arte e Storia 36

Vienna
Gemäldegalerie der Akademie der bildenden Künste 1, 59
Kunsthistorisches Museum, Gemäldegalerie 50, 56, 58, 64, 77

Washington DC
National Gallery of Art 27, 33, 34, 37, 67

His Grace The Duke of Westminster OBE TD DL 66

Wilton
The Earl of Pembroke 80

The Weston Park Foundation 96

Zaventem
Kerkfabriek Sint-Martinuskerk 18

and those lenders who wish to remain anonymous

Photographic Credits

Index